SPORTS
POSTCARD
PRICE GUIDE

J. L. Mashburn

A SLIDE FOR SECOND

A COMPREHENSIVE REFERENCE

2152

COLONIAL HOUSE
Enka, North Carolina USA

Publisher: J. L. Mashburn
Editor: Emma Mashburn

Cover and Interior Design: Picture Perfect Publishing, Inc
Electronic Page Assembly: Picture Perfect Publishing, Inc.

A Colonial House Production

Printed in the United States of America

First Edition

10 9 8 7 6 5 4 3 2 1

Library of Congress Cataloging-in-Publication Data

Mashburn, J. L. (Joseph Lee)
 Sports postcard price guide : a comprehensive reference / J. L. Mashburn.
 p. cm.
 Includes index.
 ISBN 1-885940-04-1 (pbk. : alk. paper)
 1. Sports in art--Catalogs. 2. Postcards--United States--Catalogs.
 I. Title.
 NC1878.S66M37 1998
 741.6'83'0973075--DC21 98-23911
 CIP

The author and publisher have made every effort in the preparation of this book to ensure the accuracy of the information. However, the information in this book is sold without warranty, either express or implied. Neither the author nor Colonial House will be liable for any damages caused or alleged to be caused directly, indirectly, incidentally, or consequentially by the information in this book.

AN IMPORTANT NOTICE TO THE READERS OF THIS PRICE GUIDE:

The comprehensive nature of compiling data and prices on the thousands of cards, sets and series in this publication gives many probabilities for error. Although all information has been compiled from reliable sources, experienced collectors and dealers, some data may still be questionable. The author and publisher will not be held responsible for any losses that might occur in the purchase or sale of cards because of the information contained herein.

The author will be most pleased to receive notice of errors so that they may be corrected in future editions. Contact: J. L. Mashburn, Colonial House, Box 609, Enka NC 28728 USA.

This book and other Mashburn price guides are available worldwide on the Internet at Colonial House Website: http://www.postcard-books.com

Contents

ACKNOWLEDGMENTS

In order for an author to put together a good book, and especially one concerning postcards, he must be assisted by dedicated and reliable experts in their particular field. It has been these experts, all collectors or dealer-collectors, who have been responsible for making this, our eighth book on postcards, a book we hope will be well received.

To **John Monroe**, first and foremost, we wish to express our deepest gratitude for all of his tremendous input and assistance, and actually for making the start and completion of the book possible. He allowed us to use his computerized data-base which lists descriptions and publisher names of thousands of artist-drawn cards from his personal collection on all sports. John also made many trips to our home to bring the cards we needed for scanning. In addition, he edited the listings and assisted with the values.

To boxing specialists and collectors **Rick Crocker and Ben Hawes** for sharing with us scans of their many rare and desirable history-making printed and real photo cards of the early years. Their expertise on boxing postcards and their knowledge concerning values certainly made a teriffic impact on this book.

To **Steve Poteet** for allowing us to view his baseball collection and to choose many great images of rare stadiums, players, and teams. Thanks also to his son **William**, a 15 year old computer whiz, for scanning the cards.

To **Dan DePalma**, well known collector, who supplied scans of over 200 great baseball, boxing, and basketball cards from his personal collection. He, along with collector **Art Keith**, also sent cards we specifically requested, which was tremendously helpful.

To **Don Preziosi** and **Doug Alford**, both collectors and specialists for many years in the baseball postcard field, assisted with values, checklists and cards for scanning. Their expertise was a tremendous asset and helped give the baseball chapter a much needed degree of professionalism.

To **George Gibbs**, dealer-collector, who was instrumental in supplying most all of the information, cards for scanning, and values for the rare Table Tennis (Ping-Pong) chapter.

Thanks also to **Elizabeth West** for the great real photo cards of high school and college teams and players. To **Henry Reizes** who helped with basketball, **Richard North** with tennis ladies, **William Anderson** with golf, **and Audrey Buffington** and **Joseph Epler** with football in the college ladies and pennant categories. To **Fred Kahn** and **Martin Shapiro** for their continued support, and to the many collectors and dealers who suggested that we do this book; and most of all to Emma.

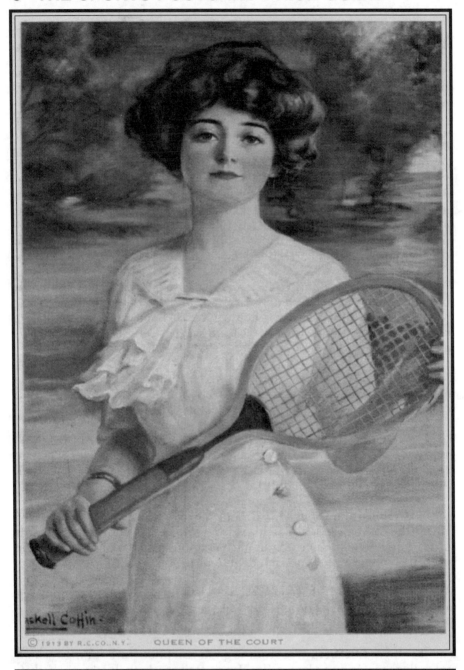

Haskell Coffin, R. C. Co., N.Y.
"Queen of the Court" — 1905-1915 Era
Price Range — VG: $25-30; EX: $30-35

INTRODUCTION

The wonderful world of Sports...the individual players, the teams, the great games that have been played, the winners that have been recorded in the history of each sport...have always been extremely important to people all over the world. Through the early years of the 20th Century these people, the fans, the photographers, the newsmen and publishers have savored the competition, and have saved the printed history pertaining to it.

One of the most factual means for recording and preserving sports history has been the ongoing use of the picture postcard. The early photographers, whether professional or amateur, recorded the history of games and players with their cameras as it happened. Many of these happenings were published in real photo or printed postcard form, and remain today for sports historians and collectors. The great players and teams live on through the efforts of those individuals. We have tried to represent and show a very good cross-section of postcards that are available for their collecting interests.

Artist-drawn postcards also played a leading role in the portrayal of the great popularity of sports throughout the 20th century. In the artist-drawn sections are works by American and European artists that were predominant in the 1905-1930 era. They painted wonderful images which illustrated beautiful ladies, loving couples, children, comics, or comical animals participating in sports or showing sports as the principal theme. Publishers reproduced these works for magazine illustrations and covers, as frameable prints, for various types of advertising, and most of all for the booming postcard trade.

As more collectors enter the market and the demand grows for varied motifs, new and important material is finding its way into dealer stocks and auctions. This is very good for the hobby and we feel that books such as ours and others in the field provide important information by letting collectors know about all the wonderful cards that are available to them.

I have been a very avid collector of baseball cards, baseball postcards, and other memorabilia for most of the last 35 years. I have been amazed at the great increase in value of most all of the better material, and specifically those in best condition, during the last 10-12 years. It is also apparent that collectors are now buying the rare and super rare cards even if they are slightly damaged, worn, or have some writing on the face because they fear that they might possibly never see them offered again. This added demand also tends to help drive the market upward as cards which previously had no buyer interest now are becoming very desirable.

—J. L. Mashburn

HOW TO USE THIS PRICE GUIDE

This price guide has been uniquely designed to serve the needs of both the beginning and advanced collector, as well as the established postcard dealer. Our attempt to provide a very comprehensive guide to sports postcards dating from the late 1890's through the 1960's makes it possible for even the novice collector to consult it with confidence and ease in finding each sport and each particular listing. The following important explanations summarize the general practices that will help in getting the most benefits from its use.

CATEGORICAL ARRANGEMENT

Each sport has it's own section or chapter. In each chapter, if applicable, the various cards are arranged by category to aid in the identification of any card in question. These categories are **Players and Teams, Artist Drawn Types, Publishers and Anonymous and are not necessarily in that order.**

Players and **Teams** cards include the name of the publisher, if known, and the approximate era or year they were produced, whether they were printed in color or black and white or if they are printed photos or real photos. Each player, the number if in a numbered series, and name of the team is also included.

Artist- drawn cards have three categorical listings: **Artist-Signed, Publishers, and Anonymous. Artist-Signed** cards are listed showing the artist's nationality (if known), the era in which the card was produced, whether in color or black and white, and whether it is a printed or real photo image. Artists are always listed alphabetically, as are the publishers if the cards are unsigned.

Publisher listings are usually those of artist-drawn cards that do not show the artist's signature. The era, type of printing, the Series number and a number

NATIONALITY OF ARTIST LISTINGS

AUS - Austria; AUST - Australia; BEL - Belgium; CZ - Czechoslovakia ; DEN - Denmark; FIN - Finland; FR - France; GB - Great Britain; GER - Germany: HUN - Hungary; IT - Italy; NETH - Netherlands; POL - Poland; RUS - Russia; SP - Spain; SWE - Sweden; SWI - Switzerland; US - United States.

or caption for each card is listed. **Anonymous** cards are those which have neither an artist's signature or a publisher's imprint.

Photo cards have two categorical listings: **Real Photos,** designated **(RP)**, are those taken with a camera and developed by a photographer in his dark room or sent to a commercial developer. They usually have "Real Photo" and the name of the method...ANSCO, AZO, CYKO, etc., in the stamp box on the back. **Printed Photos** are images that were taken with a camera and printed by commercial means. These may be in black and white or they may have been hand-colored and then reproduced by photo offset or other methods.

Each card listed has a value range for **VG** (Very Good) condition and a value range for the same card in **EX** (Excellent) condition. Grading standards are listed below. **All cards may be presumed to be in color unless they are designated otherwise.** Otherwise, they are listed as Sepia, B&W (Black & White), RP (Real Photo), Linen, or Chrome.

Topical cards are listed alphabetically with individual listings of some of the most prominent cards and their values. Otherwise, the prices quoted are for generalized cards in the particular topic or theme.

LISTINGS

Listings may be identified as follows:

1. Artist-Signed, Publishers, Anonymous, Miscellaneous, Advertising, Players and Teams, etc.
2. TOPIC is listed in bold capital letters.
3. ARTIST'S name, if the card is signed, is listed in bold capital letters and the artist's nationality, if known, and the approximate era of work is also included. The works of some artists, although unsigned, are familiar to collectors and may be listed but with a notation (Uns.)
4. PUBLISHER bylines are listed in Bold, Lower Case Letters with a date range giving the approximate era of work.
5. NAME OF SERIES; OR SERIES NUMBER.
6. NUMBER OF CARDS IN A SET OR SERIES if applicable. (Enclosed in parentheses) when available.
7. CAPTION OR TITLE OF CARD (Enclosed in Quotation Marks).
8. PRICE RANGE of one card in VG condition and price range of the same card in EX condition.

Example of the 8 listings above:

1. ARTIST-SIGNED
2. GOLF
3. HARRISON FISHER, (US) 1905-1915
4. Reinthal & Newman
5. Series 103
6. 1
7. "Fore"
8. VG - $40 - 45 EX - $45 - 50

CONDITION AND GRADING OF POSTCARDS

The condition of a postcard, as with old coins, stamps, books, etc., is an extremely important factor in determining a value for the collector or dealer, and for those having found cards they wish to sell. Damaged, worn, creased, or dirty cards—cards in less than Very Good condition—are undesirable unless they are a rarity to be used as a space filler until one in better condition is found. **Collectors should never buy a damaged card if they expect to sell it later on.** It must be noted, however, that with extremely rare cards this rule may be disregarded. This is especially true with some of the early Real Photo and printed photo cards that are listed in the *Sports Postcard Price Guide.*

It is necessary that some sort of card grading standard be used so that buyer and seller may come to an informed agreement on the value of a card. Two different collectible conditions, **Very Good** and **Excellent,** are used in the *Sports Postcard Price Guide.* There are, of course, higher and lower grades, but these two will be most normally seen and most normally quoted for postcards sold throughout the hobby.

The standard grading system adapted by most dealers and by the leading postcard hobby publications in the field, *Barr's Post Card News* and *Post Card Collector*, is listed below with their permission:

M—MINT. A perfect card just as it comes from the printing press. No marks, bends, or creases. No writing or postmarks. A clean and fresh card. Seldom seen.

NM—NEAR MINT. Like Mint but very light aging or very slight discoloration from being in an album for many years. Not as sharp or crisp.

EX—EXCELLENT. Like mint in appearance with no bends or creases, or rounded or blunt corners. May be postally used or unused and with writing and postmark only on the address side. A clean, fresh card on the picture side.

VG—VERY GOOD. Corners may be just a bit blunt or rounded. Almost undetectable crease or bend that does not detract from overall appearance of the picture side. May have writing or postal cancel on address side. A very collectible card.

G—GOOD. Corners may be noticeably blunt or rounded with noticeably slight bends or creases. May be postally used or have writing on address side. Less than VG.

FR—FAIR. Card is intact. Excess soil, stains, creases, writing, or cancellation may affect picture. Could be a scarce card that is difficult to find in any condition.

Postcard dealers always want better condition cards that have no defects. Collectors should keep this in mind if they have cards to sell. Therefore, anyone building a collection should maintain a standard for condition and stick to it.

Even if the asking price is a little higher when a card is purchased, it will be worth the cost when it is resold.

VALUATIONS

The postcard values quoted in this publication represent the current retail market. They were compiled with assistance of leading sports postcard dealers and collectors in the U.S., dealer pricing at shows, personal dealer communications, from the author's personal purchasing worldwide, from his approval sales, and from his active day-to-day involvement in the postcard field.

Some values were also compiled from observations of listings in auctions, auction catalogs (U.S., Europe, and Great Britain), prices realized and fixed price sales in the fine hobby publications, *Barr's Post Card News, Postcard Collector, Sports Collectors Digest,* and other related publications. In most instances, listings of high and low values were taken for each observation, and these were averaged to obtain the "Very Good" and "Excellent" prices quoted. It must be stressed that this price guide and reference work is intended to serve only as an aid in evaluating postcards. It should not be used otherwise. As we all know, actual market conditions change constantly, and prices may fluctuate. The trend for postcards seems, however, to always be to the upside.

Publication of this price guide is not intended to be a solicitation to buy or sell any of the cards listed.

Price ranges for cards in both **Very Good** and **Excellent** conditions are found at the end of each listing. Prices for cards in less than Very Good condition would be much lower, while those grading above Excellent might command relatively higher prices.

Without exception, prices quoted are for **one** card, whether it be a single entity or one card in a complete set or series. Note that after many entries a number is enclosed in parentheses; e.g., (6). This number indicates the total number of cards in a set or in a series. The price listed is for one card in the set and must be multiplied by this number to determine the value of a complete set.

WHY PRICE RANGES ARE QUOTED

For cards graded both **Very Good** and **Excellent**, price ranges are quoted for four major reasons. Any one, or more, of the following can determine the difference in the high or low prices in each of the listing ranges.

1. Prices vary in different geographical areas across the United States. At this time, they are somewhat higher on the Pacific coast and other western states. They tend to be a little lower in the east and somewhere in-between in the central and Midwestern states. For instance, a card with a price range of $6.00-8.00 might sell for $6.00 in the east, $7.00 in the mid-west and $8.00 in the far west.

2. Dealer price valuations also vary. Those who continually set up at postcard shows seem to have a better feel for prices and know which cards are selling well

and, therefore, can adjust their prices accordingly. Dealers who sell only by mail, or by mail auction, tend to price their cards (or list estimated values in their auctions) just a bit higher. They usually are able to get these prices because of a wider collector market base obtained by the large number of subscribers served by the nationally distributed postcard auction publications. The publications also reach collectors who are unable to attend shows.

Usually specific cards sent on approval are often priced a little higher than those at postcard shows, etc., because the dealer has spent more time selecting specific cards to help a collector build a collection. Quite often he is working from a customer "want list."

3. Cards that are in great demand, or "hot" topics, also have wider price ranges; as collector interests rise there is a greater disparity in values because of supply and demand. If a dealer has only a small number of big demand cards he will almost automatically elevate his prices. Those who have a large supply will probably not go as high.

4. Card appearance and the subject in a set or series can also cause a variance in the price range. Printing quality, more beautiful and varied colors, and sharpness of the image may make a particular card much more desirable and, therefore, it will command a higher price.

Cards that have a wide price range usually are those that are presently the "most wanted" and best sellers. Dealers, most often, will only offer a small discount when selling these because they know there is a good market for them. Cards listed with a narrow price range are usually those that have been "hot" but have settled down and established a more competitive trading range. Dealer discounting on these slow-movers tends to be much more prevalent than those in the wide price ranges.

GUIDELINES FOR BUYING AND SELLING CARDS

As noted above, the prices listed in this price guide are retail prices—prices that a collector can expect to pay when buying a card from a dealer. It is up to the collectors to bargain for any available discount from the dealer.

The wholesale price is the price which a collector can expect from a dealer when selling cards. This price will be significantly lower than the retail price. Most dealers try to operate on a 100% markup and will normally pay around 50 percent of a card's low retail value. On some high-demand cards he might pay up to 60% or 75% if he wants them badly enough. Dealers are always interested in purchasing collections and accumulations of cards. They are primarily interested in those that were issued before 1915, but may be induced to take those issued afterwards if they are clean and in good condition.

Collections: Normally, collections are a specialized group or groups of cards that a person has built over the years. They will be in nice condition, without any damage, and may contain some rarities or high-demand cards. If the collection is of a group of views from your home town or state it would be to your advantage to sell them to a collector or dealer near you. You might place

an ad in your daily paper; you will be surprised at the interest it creates. Set your price a little high; you can always come down.

You might also dispose of your collection by writing to the dealers who advertise in *Barr's Post Card News*, 70 South 6th St., Lansing, IA 5215, *Postcard Collector*, P.O. Box 1050, Dubuque, IA 52004 and *Sports Collectors Digest*, 700 East States St., Iola, WI 54990. Other publications that have postcard sections are *Collectors News*, P. O. Box 156, Grundy Center, IA 50638-0156, *Paper Collectors' Market Place*, P. O. Box 128, Scandinavia, WI 54977, and *The Antique Trader*, P. O. Box 1050, Dubuque, IA 52004. Write to these firms and ask for information on subscriptions or sample copies.

Accumulations: Accumulations are usually groups of many different kinds, many different eras, and many different topics ...with the good usually mixed in with the bad. If you have an accumulation that you wish to sell, your best bet is to contact a dealer as noted above. You may expect only 20 to 30 percent of value on a such a group. Many low demand cards are non-sellers and worthless to a dealer, but he may take them if there are good cards in the accumulation.

Buying: The best way to buy postcards is to attend a show where there is a large group of dealers. Compare prices on cards that are of interest , and return to dealers who have the best cards at the lowest price. Buy also from a dealer in your area if there is one. A good dealer will help you with your collection by searching for cards that interest you. If none are available, many dealers who advertise in the publications listed above run auctions or will send cards on approval. Also, you might try joining a postcard club. It is possible to find an excellent choice of cards at these meetings because attendees bring material that they know is of interest to their fellow members.

It is also possible to find cards at Antique Shows, Flea Markets and Antique Shops. You can, however, waste a lot of time and effort and never find suitable cards. It is best to go directly to the source, and that would be a postcard dealer or auctioneer.

IDENTIFYING THE AGE OF POSTCARDS

The dating of postcards for years or eras of issue may be accurately determined if the card is studied for identity points. Research has been done by historians and guidelines are now in place. There were seven eras in the postcard industry and each one has distinguishing points which help establish its respective identity. The following helps determine the era of the card in question:

PIONEER ERA (1893-1898)

The Pioneer Era in the U.S. began when picture postcards were placed on sale by vendors and exhibitors at the Columbian Exposition in Chicago, May, 1893. These were very popular and proved to be a great success. The profitable and lasting future of the postcard was greatly enhanced. Pioneer cards are relatively scarce. They may be identified by combinations of the following:
 - All have undivided backs.
 - None show the "Authorized by Act of Congress" byline.

- Postal cards will have the Grant or Jefferson head stamp.
- Most, but not all, will be multiple view cards.
- The words "Souvenir of ..." or "Greetings from ..." will appear on many.
- Postage rate, if listed, is 2 cents.
- The most common titles will be "Souvenir Card" or "Mail Card."
- Appeared mostly in the big Eastern cities.

PRIVATE MAILING CARD ERA (1898-1901)

The government, on May 19, 1898, gave private printers permission to print and sell postcards. They were issued with the inscription "Private Mailing Card," and are referred to as PMC's and are easy to identify because of the inscription. Many early Pioneer views were reprinted as Private Mailing Cards.

UNDIVIDED BACK ERA (1901-1907)

On December 24, 1901, permission was given to imprint the words "Post Card" on the backs of privately printed cards. Backs were undivided where only the address was to appear. The message had to be written on the picture side of the card. For this reason, writing appears on the face of many cards and is slowly becoming acceptable on cards of this era.

DIVIDED BACK ERA (1907-1915)

This era came into being on March 1, 1907. The divided back made it possible for the address and message to be on the back. This prevented the face of the card from being written on and proved to be a great boon for collectors. Normally the view colors or images filled the entire card with no white border.

WHITE BORDER ERA (1915-1930)

The White Border Era brought an end to the postcard craze era. The "Golden Age" ended as imports from Germany ceased and publishers in the U.S. began printing postcards to try to fill the void. The cards were very poor quality and many were reprints of earlier Divided Back Era cards. These are easily distinguished by the white border around the pictured area.

LINEN ERA (1930-1945)

Improvements in American printing technology brought improved card quality. Publishers began using a linen-like paper containing a high rag content, but used very cheap inks in most instances. Until recently, these cards were considered very cheap by collectors. Now, however, they are very popular with collectors of Roadside America, Blacks, Comics, and Advertising.

PHOTOCHROME ERA (1939 to present day)

"Modern Chromes," as they are now called by the postcard fraternity, were first introduced in 1939. Publishers, such as **Mike Roberts**, **Curt Teich,** and **Plastichrome**, began producing cards with beautiful chrome colors that were

very appealing to collectors. The growth has been spectacular in recent years, and many postcard dealers now specialize only in chromes.

REAL PHOTO POSTCARDS (1900 to present day)

Real Photo cards were in use as early as 1901. Many of the most valuable sports cards shown and listed in this book are Real Photos. It is sometimes difficult to date them unless they are postally used or dated by the photographer. The stamp box will usually show the process by which it was printed; e.g., AZO, CKYO, EKC, KODAK, VELOX, and KRUXO. Careful study of photo cards is essential to assure they have not been reproduced.

ART DECO ERA (1910 to early 1930's)

Beautiful **Colors!** Beautiful strong, deep, vibrant **Colors!** This wording only partially describes the new Art Deco movement that began around 1910—just as the Art Nouveau era was ebbing—and continued into the early 1930's. Due to the great influx of Art Deco postcards to the U.S., there has been a great demand for them in recent years as more and more American collectors discover their beauty. Cards of this type are listed in the Artist-Signed sections under Italian artists such as Colombo, Corbella, Chiostri, etc., and Rylander of Sweden.

ART NOUVEAU (1898-1910)

Art Nouveau postcards had their beginning at the turn of the century in Europe. Primarily, the movement began in Paris—where the great poster artists congregated—and in Vienna. This new expression of decorative art was the rage of the era, and the posters and magazines such as "*Jugend,*" "*Simplicissimus,*" "*Le Rire,*" "*Le Plume,*" and "*The Poster,*" were used as a means to transmit this expression to the art lovers of the world. There are a small number of this type listed in the Artist-Signed sections of the Sports Postcard Price Guide.

REPRODUCTION OF IMAGES IN THIS BOOK

All images in this book are the final results of using various computer programs where each card is scanned, photostyled to the best grayscale clarity, and placed in position in the text. Real photo and some black and white cards are usually the best for this process, and the images reproduce very well. However, the majority of original postcards were printed in many colors and shades, in sepia, or simply were very poorly printed in many instances. Therefore, they are sometimes difficult to reproduce for books where only black and white copy is used. Because of their great historical value, their rarity, or great interest to collectors, we have intentionally used many of these cards even though they did not reproduce well.

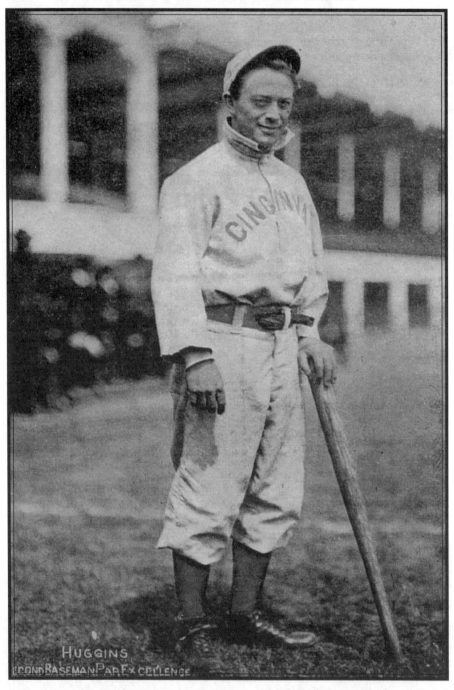

Miller Huggins — "Second Baseman Par Excellence"
Morgan Stationery Co., Cincinnati, OH 1907

BASEBALL

Baseball postcards had their beginning around 1903 with team pictures and, in 1907, A.C. Dietsche, George W. Hull and G.F. Grignon began issuing sets that featured individual players of the Detroit Tigers and the Chicago teams. These were accepted by fans and other publishers joined in. From Cleveland in 1908, the American League Publishing Company produced a set in boxtop form, featuring Cleveland Naps players. Sporting Life issued 1906 team postcards for all sixteen teams.

During 1908-1911 several great sets were produced. Among them were those by H.H. Bregstone of Cardinals and Browns players; Topping and Co., H.M. Taylor and Wolverine News issued sets with players from the Tigers; The Rose Co. produced a most beautiful and colorful set of over 200 players from all teams. Several anonymous publishers released sets of black and white and sepia postcards. Although poorly printed, these are in great demand by collectors.

Team issues of the 1950-1970 era and newer issues, especially those of Hall of Famers and those published by Perez Galleries, continue to enjoy success because of the sports autograph craze which began around 1990. The cards are purchased by collectors and dealers who take them to sports card and autograph shows where the players autograph them for a designated fee.

The Artist-Signed and designated Publisher issues listed are predominantly those of the 1905-1920 era, and are generally comical in nature. Sets and single issue cards of children, men, ladies, loving couples, drunks, animals, and even politicians playing baseball are included.

Many have only a caption relating to baseball, but they are also very collectible. Because of the scarcity of player-related material, the comic types have become highly collectible by both the baseball fraternity and those in the postcard hobby. This is especially true with cards illustrating blacks, which are notably valued the highest in this area.

Another group in the Publisher area is the printed photo types of men, ladies, and lover-types, such as the series by publishers Roth and Langley and Colonial Art Publishing Co. These are not as popular as the comical artist-drawn types, but are still held in high esteem by collectors because of the baseball theme showing subjects in uniform or with baseball captions.

Values listed here may be rather conservative in most areas or higher in others, and should be used only as a "ballpark" guide. Prices realized at specialized auctions and sales on rarer issues may be from somewhat higher to extremely higher, especially on real photos and any Cobb, Ruth, or Wagner issues by all publishers.

PLAYERS & TEAMS

	VG	EX
American League Pub. Co., Cleveland, 1908		
(B&W) Action + Oval Photo		
Harry E. Bay	$75 - 85	$85 - 100
Joseph Birmingham	75 - 85	85 - 100
W.J. Bradley	75 - 85	85 - 100
Walter Clarkson	75 - 85	85 - 100
Tyrus R. Cobb	200 - 250	250 - 300
Elmer Flick	75 - 85	85 - 100
C.T. Hickman	75 - 85	85 - 100
William Hinchman	75 - 85	85 - 100
Adrian Joss	75 - 85	85 - 100
Nap Lajoie	100 - 150	150 - 200
Glen Liebhardt	75 - 85	85 - 100
George Nill	75 - 85	85 - 100
George Perring	75 - 85	85 - 100
Honus Wagner	200 - 250	250 - 300
H. H. Bregstone, 1909-11 (45+) Unnumbered		
Real-Photo with AZO Postcard Backs		
St. Louis Browns		
Bailey	80 - 90	90 - 110
Criger	80 - 90	90 - 110
Criss	80 - 90	90 - 110
Dineen	80 - 90	90 - 110
Ferris	80 - 90	90 - 110
Graham	80 - 90	90 - 110
Griggs	80 - 90	90 - 110
Hartzel	80 - 90	90 - 100

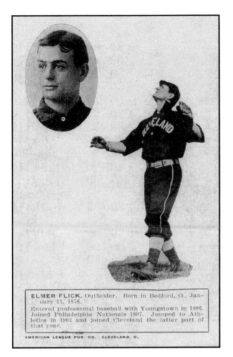

ELMER FLICK, Outfielder. Born in Bedford, O., January 11, 1876.
Entered professional baseball with Youngstown in 1896.
Joined Philadelphia Nationals 1897. Jumped to Athletics in 1902 and joined Cleveland the latter part of that year.

AMERICAN LEAGUE PUB. CO. CLEVELAND, O.

American League Publishing Co.
"Elmer Flick, Outfielder"

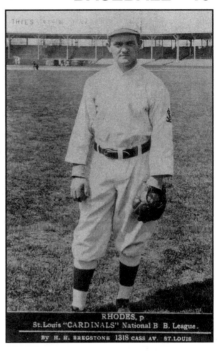

RHODES, p
St. Louis "CARDINALS" National B B. League.

BY H. H. BREGSTONE 1318 CASS AV. ST. LOUIS

H. H. Bregstone
"Rhodes, Pitcher, St. Louis Cardinals"

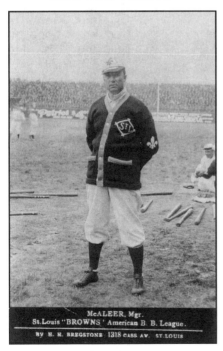

McALEER, Mgr.
St. Louis "BROWNS' American B. B. League.

BY H. H. BREGSTONE 1318 CASS AV. ST. LOUIS

H. H. Bregstone
"McAleer, Mgr. — St. Louis Browns"

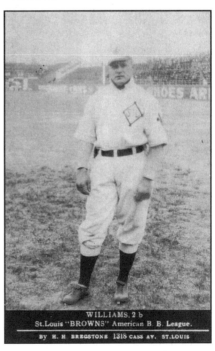

WILLIAMS, 2 b
St. Louis "BROWNS" American B. B. League.

BY H. H BREGSTONE 1318 CASS AV. ST. LOUIS

H. H. Bregstone
"Williams, 2b — St. Louis Browns"

Hoffman	80 - 90	90 - 110
Howell	80 - 90	90 - 110
Jones	80 - 90	90 - 110
McAleer	80 - 90	90 - 110
Patterson	80 - 90	90 - 110
Pelty	80 - 90	90 - 110
Schweitzer	80 - 90	90 - 110
Smith	80 - 90	90 - 110
Stephens	80 - 90	90 - 110
Stone	80 - 90	90 - 110
Waddell, Rube	125 - 150	150 - 175
Wallace	80 - 90	90 - 110
Williams	80 - 90	90 - 110
St. Louis Cardinals		
Barry	80 - 90	90 - 110
Beebe	80 - 90	90 - 110
Beltcher	80 - 90	90 - 110
Bliss	80 - 90	90 - 110
Bresnahan, Roger	100 - 125	125 - 150
Corridon	80 - 90	90 - 110
Ellis	80 - 90	90 - 110
Evans	80 - 90	90 - 110
Geyer	80 - 90	90 - 110
Harmon	80 - 90	90 - 110
Higgins	80 - 90	90 - 110
Hostetter	80 - 90	90 - 110
Huggins, Miller	125 - 140	140 - 160
Hulswit	80 - 90	90 - 110
Johnson	80 - 90	90 - 110
Konetchy	80 - 90	90 - 110
Lush	80 - 90	90 - 110
Magee	80 - 90	90 - 110
Oakes	80 - 90	90 - 110
Phelps	80 - 90	90 - 110
Reiger	80 - 90	90 - 110
Rhodes	80 - 90	90 - 110
Salee	80 - 90	90 - 110
Willis	80 - 90	90 - 110
Boston American Series, 1912		
Boston Red Sox Cream with Sepia Photos		
Forest Cady	70 - 80	80 - 90
Hub Perdue	70 - 80	80 - 90
Tris Speaker	100 - 125	125 - 140
Jake Stahl	70 - 80	80 - 90
Heinie Wagner	70 - 80	80 - 90
Joe Wood (Smoky Joe)	70 - 80	80 - 90
Boston Daily American, 1912		
Boston Red Sox (B&W)		
Forrest Cady	70 - 80	80 - 90
Ray Collins	70 - 80	80 - 90
Heinie Wagner	70 - 80	80 - 90
F.P. Burke, 1907 Bluetone		
Detroit Tigers Team Picture	600 - 700	700 - 800
Chicago Cubs Team Picture	600 - 700	700 - 800

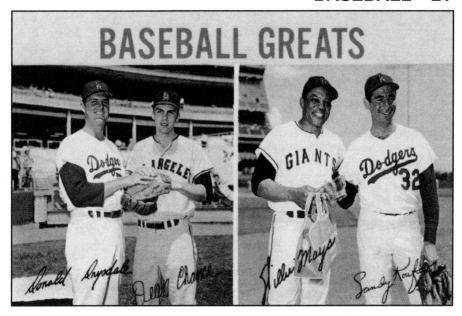

Colourpicture Publishers, P62008, "Baseball Greats"
Don Drysdale, Dean Chance, Willie Mays and Sandy Koufax

George Burke Photographer
 "Geo. Burke, Chicago" Issues from 1948-1959 era
 Hundreds issued - no checklist

Stars	10 - 15	15 - 20
Common players	3 - 5	5 - 10

Cincinnati Reds
 Championship Postcards, 1920 (B&W)
 May be listed as "World Champions" or
 "National League Champions"

Nick Allen	40 - 50	50 - 60
Rube Bressler	40 - 50	50 - 60
Jake Daubert	40 - 50	50 - 60
Pat Duncan	40 - 50	50 - 60
Hod Eller	40 - 50	50 - 60
Ray Fisher	40 - 50	50 - 60
Eddie Gerner	40 - 50	50 - 60
Heinie Groh	45 - 55	55 - 65
Larry Kopf	40 - 50	50 - 60
Adolfo Luque	40 - 50	50 - 60
Sherwood Magee	40 - 50	50 - 60
Roy Mitchell	40 - 50	50 - 60
Pat Moran	40 - 50	50 - 60
Greasy Neale	45 - 55	55 - 65
Bill Rariden	40 - 50	50 - 60
Morris Rath	40 - 50	50 - 60
Walter Reuther	40 - 50	50 - 60
Jimmy Ring	40 - 50	50 - 60
Edd Roush	80 - 90	90 - 100
Harry Sallee	40 - 50	50 - 60

Hank Schreiber	40 - 50	50 - 60
Charles See	40 - 50	50 - 60
Jimmy Smith	40 - 50	50 - 60
Ivy Wingo	40 - 50	50 - 60
Redland Field Stadium	150 - 200	200 - 250
Cincinnati Ball Park	150 - 200	200 - 250

Colourpicture Publishers Chromes
P62008 "Baseball Greats" - Drysdale, Chance

Mays, Koufax	20 - 25	25 - 30

Coral-Lee 1982-1985

1 B. Martin, G. Steinbrenner, R. Jackson &		
T. Munson	4 - 5	5 - 6
2 Pete Rose	4 - 5	5 - 6
3 President Carter & Carl Yaztrzemski	5 - 6	6 - 7
4 F. Valenzuela, Pres. Reagan, Pres. of Mexico	4 - 5	5 - 6
5 Billy Martin	3 - 4	4 - 5
6 Davey Lopes	2 - 3	3 - 4
7 Dave Winfield	2 - 3	3 - 4
8 President Reagan and Willie Mays	5 - 6	6 - 7

Crocker, H.S. 1959

Dodger Team Issues

Johnny Podres	20 - 25	25 - 30
Duke Snider	30 - 35	35 - 40

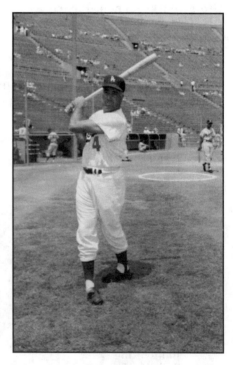

H. S. Crocker, 1959 Team Issue
Johnny Podres

H. S. Crocker, 1959 Team Issue
Duke Snider

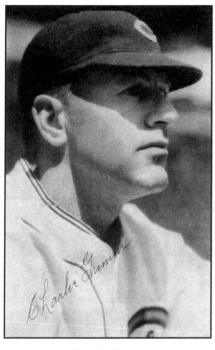

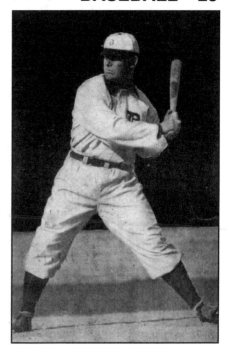

Denby Cigars
"Charles Grimm"

A. C. Dietsche
Sam Crawford

Denby Cigars
 Chicago Cubs, 1932

Cuyler	50 - 75	75 - 100
English	50 - 75	75 - 100
Grimm	75 - 100	100 - 125
Herman	75 - 100	100 - 125
Hornsby	125 - 150	150 - 175
Judge	50 - 75	75 - 100
Stephenson	50 - 75	75 - 100
Warneke	75 - 100	100 - 125
Others	50 - 75	75 - 100

Dexter Press, 1968 "31/2 x 51/2"

Henry Aaron	15 - 20	20 - 25
Rod Carew	12 - 15	15 - 20
Roberto Clemente	30 - 40	40 - 50
Harmon Killebrew	8 - 10	10 - 15
Juan Marichal	8 - 10	10 - 15
Willie Mays	15 - 20	20 - 25
Bill Mazeroski	8 - 10	10 - 15
Joe Morgan	8 - 10	10 - 15
Boog Powell	7 - 9	9 - 12
Brooks Robinson	8 - 10	10 - 15
Frank Robinson	8 - 10	10 - 15
Tony Oliva, Gaylord Perry, Rusty Staub, Joe Torre	6 - 8	8 - 10

Jerry Adair, Rich Allen, Bob Allison, Felipe Alou
 Mike Andrews, Bob Aspromonte, John Bateman
 Mark Belanger, Gary Bell, Paul Blair, Curt Blefry

Bob Bolin, Dave Boswell, Clete Boyer, Ron Brand
Darrell Brandon, Don Buford, Clay Carroll, Rico
Carty, Dean Chance, Tony Cloninger, Mike Cuellar
Jim Davenport, Ron Davis, Moe Drabowsky, Dick
Ellsworth, Andy Etchebarren, Joe Foy, Bill Freehan
Jim Fregosi, Julio Gotay, Dave Guisti, Jim Ray Hart
Ron Hunt, Sonny Jackson, Pat Jarvis, Dave Johnson
Ken Johnson, Dalton Jones, Jim Kaat, Denny Lemaster
Frank Linzy, Jim Lonborg, Mike McCormick, Dave
McNally, Denis Menke, Dave Morehead, Phil Niekro
Russ Nixon, Rico Petrocelli, Tom Phoebus, Rick
Rollins, John Roseboro, Ray Sadeki, George Scott
Cesar Tovar, Ted Uhlander, Woody Woodward

John Wyatt, Jim Wynn	4 - 6	6 - 10

A.C. Dietsche, 1907

B&W with dark Background

Chicago Cubs

Mordecai Brown	80 - 100	100 - 125
Frank Chance	80 - 100	100 - 125
John Evers	80 - 100	100 - 125
Arthur Hoffman	60 - 70	70 - 80
John Kling	60 - 70	70 - 80
Carl Lundgren	60 - 70	70 - 80
Patrick J. Moran	60 - 70	70 - 80
Orvall Overall	60 - 70	70 - 80
John Pfeister	60 - 70	70 - 80
Ed Reulbach	60 - 70	70 - 80
Frank Schulte	60 - 70	70 - 80
James Sheckard	60 - 70	70 - 80
Harry Steinfeldt	60 - 70	70 - 80
James Slagle	60 - 70	70 - 80
Joseph Tinker	80 - 80	100 - 125

A.C. Dietsche, 1907-1909 (Beware of repros of this set.)

B&W with dark Background

Series 1 - 1907 Detroit Tigers *

Tyrus Cobb (2)	100 - 150	150 - 200
William Coughlin	60 - 70	70 - 80
Samuel Crawford	90 - 100	100 - 120
William Donovan	60 - 70	70 - 80
Jerome Downs	60 - 70	70 - 80
Hughie Jennings	90 - 100	100 - 120
David Jones	60 - 70	70 - 80
Edward Killian	60 - 70	70 - 80
George Mullin	60 - 70	70 - 80
Charles O'Leary	60 - 70	70 - 80
Fred Payne	60 - 70	70 - 80
Claude Rossman	60 - 70	70 - 80
Herman Schaefer	60 - 70	70 - 80
Schaefer & O'Leary	60 - 70	70 - 80
Charles Schmidt	60 - 70	70 - 80
Edward Siever	60 - 70	70 - 80

* Titled "Hughie Jennings and his Great
1907 Tigers."

Series II Players of 1908 and 1909 (09 in bold)

B&W with dark background

Henry Beckenfort	60 - 70	70 - 80
Owen Bush	60 - 70	70 - 80
Tyrus Cobb	100 - 150	150 - 200
James Delehanty	90 - 100	100 - 120
William Donovan	75 - 85	85 - 100
Hughie Jennings	90 - 100	100 - 120
Tom Jones	60 - 70	70 - 80
Matthew McIntyre	60 - 70	70 - 80
George Moriarty	60 - 70	70 - 80
Oscar Stanage	60 - 70	70 - 80
Oren Edgar Summers	60 - 70	70 - 80
Ira Thomas	60 - 70	70 - 80
Edgar Willet	60 70	70 - 80
George Winter	60 - 70	70 - 80
Ralph Works	60 - 70	70 - 80
Team Picture	100 - 120	120 - 140

Detroit Free Press, **1908**

Cream color with dark green background
Detroit Tigers

Cobb	200 - 250	250 - 300
Jennings	125 - 150	150 - 170
Crawford, Donovan, Killian, McIntyre	90 - 100	100 - 110
Mullen, O'Leary, Schmidt, Summers, Willett	90 - 100	100 - 110

Louis Dormand 1954-55

Premiums for Mason Candy Color
Dodgers, Giants, Yankees, A's, W. Sox

101 Phil Rizzuto auto across top & angled	25 - 30	30 - 35
101 Phil Rizzuto 9x12	30 - 40	40 - 50
102 Yogi Berra	30 - 40	40 - 50
103 Ed Lopat	10 - 15	15 - 20
104 Hank Bauer	10 - 20	20 - 30
105 Joe Collins, no patch on shoulder	10 - 15	15 - 20
105 Joe Collins, patch on shoulder	15 - 20	20 - 30
106 Ralph Houk	10 - 15	15 - 20
107 Bill Miller	10 - 15	15 - 20
108 Ray Scarborough	10 - 15	15 - 20
109 Allie Reynolds	10 - 15	15 - 20
110 Gil McDougald	10 - 15	15 - 20
111 Mickey Mantle, bat on shoulder	75 - 100	100 - 150
111 Mickey Mantle, batting stance	50 - 60	60 - 80
111 Oversized Mantle, 6x9	150 - 175	175 - 225
111 Oversized Mantle, 9x12	450 - 500	500 - 550
112 Johnny Mize	35 - 40	40 - 50
113 Casey Stengel	80 - 90	90 - 100
114 Bobby Shantz — Philadelphia A's	10 - 15	15 - 20
115 Whitey Ford	20 - 25	25 - 30
116 Johnny Sain hands above head	20 - 25	25 - 30
116 Johnny Sain left leg up	10 - 15	15 - 20
116 Johnny Sain — Advertising his business	20 - 25	25 - 30
117 Jim McDonald	10 - 15	15 - 20
118 Gene Woodling	10 - 15	15 - 20
119 Charlie Silvera	10 - 15	15 - 20

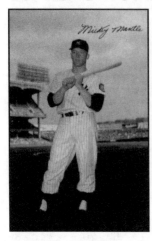

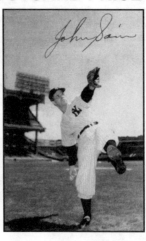

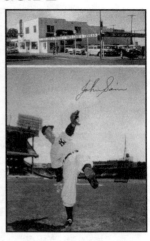

Louis Dormand
Mickey Mantle, Jumbo

Louis Dormand
John Sain

Louis Dormand
Sain Advertising Card

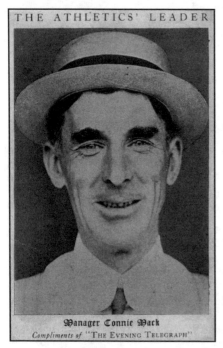

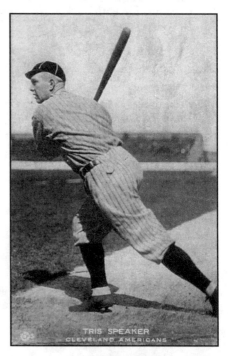

The Evening Telegraph
"Manager Connie Mack"

Exhibit Supply Co.
"Tris Speaker, Cleveland Americans"

120	Don Bollweg	10 - 15	15 - 20
121	Bill Pierce White Sox	10 - 15	15 - 20
122	Chico Carrasquel White Sox	10 - 15	15 - 20
123	Willy Miranda	10 - 20	20 - 25
124	Carl Erskine	30 - 40	40 - 50
125	Roy Campanella	30 - 40	40 - 60

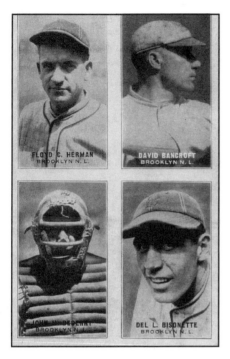

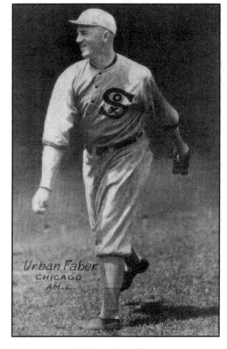

Exhibit Supply Co. — "Herman, Bancroft, Deberry and Bisonette"

Exhibit Supply Co. "Urban Faber, Chicago"

126 Jerry Coleman	10 - 20	20 - 25
127 Pee Wee Reese	30 - 40	40 - 50
128 Carl Furillo	30 - 40	40 - 60
129 Gil Hodges	300 - 350	350 - 400
130 Billy Martin	25 - 35	35 - 45
131 Not issued		
132 Irv Noren	20 - 30	30 - 40
133 Enos Slaughter	30 - 50	50 - 75
134 Tom Gorman	20 - 30	30 - 40
135 Eddie Robinson	20 - 30	30 - 40
136 Frank Crosetti	20 - 30	30 - 40
137 Not issued		
138 Jim Konstanty	70 - 90	90 - 120
The Evening Telegraph		
Manager Connie Mack	30 - 40	40 - 50
Exhibit Supply Co., Chicago, 1921-1966		
Postcard Backs only		
1929 Issues, Blue Tints with notation:		
"Not to be used in exhibit machines"		
Ty Cobb	150 - 175	175 - 200
Lou Gehrig	125 - 150	150 - 175
Babe Ruth	600 - 650	650 - 700
Other Hall of Famers	40 - 50	50 - 60
Others	15 - 20	20 - 30
1950's Issues		
Mantle, Mays	60 - 70	70 - 80
Musial, Campanella, Berra	25 - 30	30 - 40

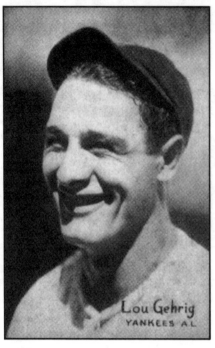

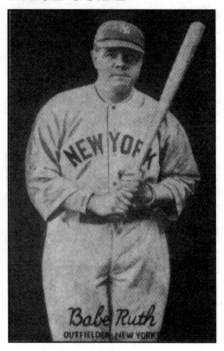

Exhibit Supply Co., 1922-24
"Lou Gehrig — Yankees A.L."

Exhibit Supply Co., 1921
"Babe Ruth — Outfielder, New York"

Feller, Lemon, Kaline, Snider	15 - 20	20 - 25
Others	10 - 15	15 - 18

G. F. Grignon Co., 1907, Green (16)
Chicago Cubs Player Insets & Big Teddy Bear

Mordecai Brown - Pitcher "Always there at the finish"	125 - 150	150 - 175
Frank Chance - First Base and Manager "Get together boys"	150 - 175	175 - 200
John Evers - Second Base "I Get Them Coming and Going"	150 - 175	175 - 200
Arthur Hofman - Utility "One of my easy stunts"	75 - 85	85 - 100
John Kling - Catcher "They come high, but we must have them"	75 - 85	85 - 100
Carl Lundgren - Pitcher "My, but it's warm"	75 - 85	85 - 100
Pat Moran - Catcher "Good Eye Good Eye"	75 - 85	85 - 100
Orvall Overall - Pitcher "I guess that's going some"	75 - 85	85 - 100
Jack Pfeister - Pitcher "I've got my eye on you, all right, all right"	75 - 85	85 - 100
Ed Ruehlbach - Pitcher "Always keep the other fellow guessing"	75 - 85	85 - 100
James Scheckard - Left Field "Nothing under the sun gets away from me"	75 - 85	85 - 100
Frank Schulte - Right Field "After them all the time"	75 - 85	85 - 100
James Slagle - Center Field "Let him hit it - I'm here"	75 - 85	85 - 100

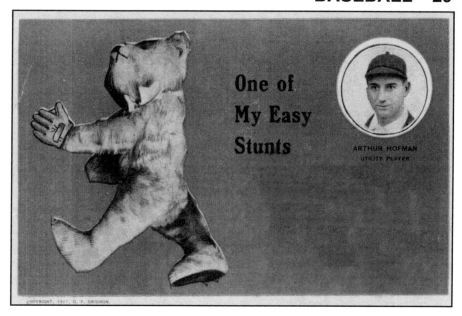

G. F. Grignon, Arthur Hoffman, Utility Player
"One of My Easy Stunts"

Harry Steinfeldt - Third Base "He eats them alive"	75 - 85	85 - 100
Jack Taylor - Pitcher "This is a cinch"	75 - 85	85 - 100
Joe Tinker - Shortstop "I am covering some		
territory nowadays"	150 - 175	175 - 200
V.O. Hammon, 1906-1907		
1906 Chicago Cubs Team	150 - 175	175 - 200
1906 Champion White Sox Team	125 - 150	150 - 175
George W. Hull, 1907 (B&W) (13)		
World Champs Chicago White Sox players		
in ovals on socks on clothesline		
Nick Altrock, George Davis	100 - 125	125 - 150
Jiggs Donohue, Pat Dougherty, Frank Isbell	100 - 125	125 - 150
Billy Sullivan	100 - 125	125 - 150
Captain Fielder Jones	125 - 150	150 - 175
Ed McFarland	100 - 125	125 - 150
Frank Owens	100 - 125	125 - 150
Roy Patterson	100 - 125	125 - 150
Frank Smith	100 - 125	125 - 150
Eddie Walsh, Doc White	150 - 175	175 - 200
J. D. McCarthy		
Photographer and Publisher of Postcards	40 - 50	50 - 60
Players — Thousands issued 1950's-1990's		
Morgan Stationery Co., Cincinnati, 1907		
Photos in the Red's Palace of Stars Stadium		
"Red Belt" Unnumbered Issues (10)		
"A Home Run" Player rounding third	65 - 75	75 - 90
"After a High One"	65 - 75	75 - 90
"Hit & Run" Player leaving home plate	65 - 75	75 - 90
"In Consultation"	65 - 75	75 - 90

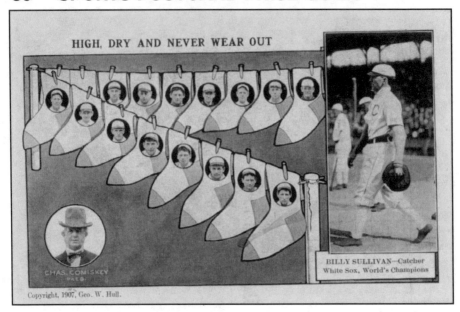

George W. Hull — Billy Sullivan, Catcher
"High, Dry and Never Wear Out"

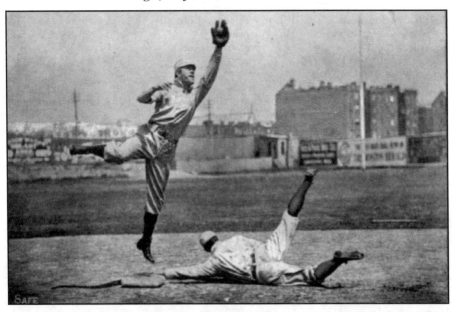

Morgan Stationery, "Red Belt" Unnumbered Series — "Safe"

"It's All in the Game 'Noise' -"	60 - 75	75 - 90
"Miller Huggins, Second Baseman Par Ex."	300 - 350	350 - 400
Variation exists with diff. background.	150 - 200	200 - 250
"Out to the Long Green"	60 - 75	75 - 90
"Practice Makes Perfect"	60 - 75	75 - 90

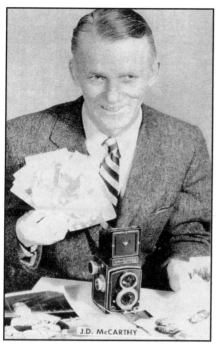

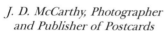

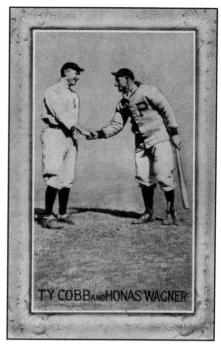

J. D. McCarthy, Photographer
and Publisher of Postcards

Novelty Cutlery Co.
"Ty Cobb and Honas Wagner"

"Safe"	60 - 75	75 - 90
"Use Two if Necessary"	60 - 75	75 - 90
"Opening of the Season 1907 - Cincinnati- Pittsburgh	350 - 400	400 - 500

Novelty Cutlery Co., Canton, O., 1910
Note: Same but smaller images as the
Anonymous "Sepia Baseball Players" Series
Players in gray color enclosed in frame

Bresnahan, Brown, Chance, E. Collins	125 - 150	150 - 175
Chase, Lajoie, Plank, Walsh, Speaker	150 - 175	175 - 200
Street, Evers/Schaefer, Crawford	140 - 160	160 - 180
Wagner, Cobb	300 - 400	400 - 500
Johnson, Mathewson	175 - 200	200 - 225
Cobb/Wagner together	500 - 600	600 - 700
Bridwell, Devlin, Dooin, Flock	100 - 125	125 - 150
Gibson, Hoffman	125 - 150	150 - 175
Lord, Overall	125 - 150	150 - 175

E. J. Offerman Co., 1908, Buffalo, Minor League (20)

Action shot & photo inset	75 - 85	85 - 100

Orcajo Photo Art, Dayton, Ohio 1939
Series I with **Orcajo** Backs (Sepia)
Cincinnati Players

Wally Berger	25 - 30	30 - 40
Bongovanni	25 - 30	30 - 40
Frenchy Bordagaray	25 - 30	30 - 40
Allan Cooke	25 - 30	30 - 40
Harry Craft	35 - 40	40 - 50

Orcajo Photo Art
"Joe DiMaggio"

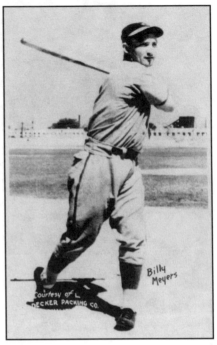

Orcajo Photo Art (Val Decker Packing)
Billy Meyers

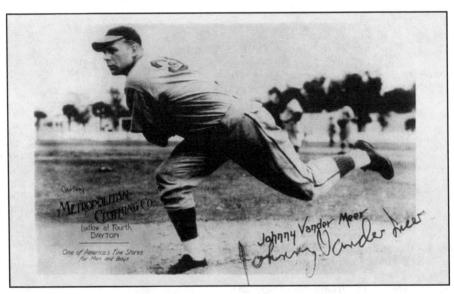

Orcajo Photo Art (Metropolitan Clothing Co.) — "Johnny Vander Meer"

Ray Davis	25 - 30	30 - 40
Paul Derringer	35 - 40	40 - 50
Linus Frey (2 images)	25 - 30	30 - 40
Lee Gamble	25 - 30	30 - 40

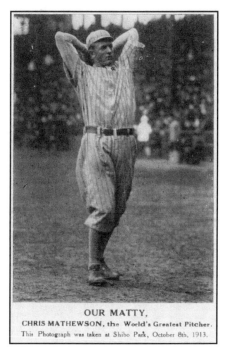

OUR MATTY,
CHRIS MATHEWSON, the World's Greatest Pitcher.
This Photograph was taken at Shibo Park, October 8th, 1913.

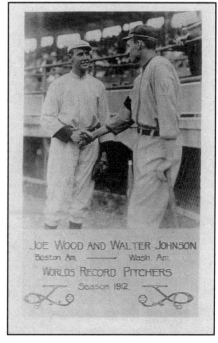

Pastime Novelty Co.
"Our Matty, Chris Mathewson ..."

The Photo Art Shop
"Joe Wood and Walter Johnson"

Ivan Goodman	25 - 30	30 - 40
Hank Gowdy	25 - 30	30 - 40
W. Hirschberger (2 images)	25 - 30	30 - 40
Edwin Joost	30 - 35	35 - 45
Ernie Lombardi (2 images)	40 - 50	50 - 60
Frank McCormick	30 - 35	35 - 45
Bill McKechnie	30 - 35	35 - 45
Billy Meyers	25 - 30	30 - 40
Whitey Moore	25 - 30	30 - 40
Lew Riggs	25 - 30	30 - 40
Les Scarsella	25 - 30	30 - 40
Junior Thompson	25 - 30	30 - 40
Johnny Vander Meer	35 - 40	40 - 50
Bucky Walters	35 - 40	40 - 50
Bill Werber	25 - 30	30 - 40
Dick West	25 - 30	20 - 40
Jimmie Wilson	25 - 30	30 - 40
Joe DiMaggio, New York Yankees	100 - 125	125 - 150

Series II "Courtesy of Val Decker Packing Co."
on front. Values same as Series I
Series III "Metropolitan Clothing Co." on front
Values same as Series I
Pastime Novelty Co.

"Our Matty, Chris Mathewson ..." (B&W Printed)	70 - 80	80 - 100

Plastichrome (Colourpicture Publishers) 1961-1962

P62008 "Baseball Greats"		
Drysdale, Chance, Mays , Koufax. All on same card	15 - 20	20 - 25

The Photo Art Shop, Swampscott, Mass.

Joe Wood and Walter Johnson, 1912	75 - 100	100 - 125
1912 Boston Red Socks Team	150 - 200	200 - 250

Requena "K" 1964-66

Color - 3 1/2" x 5 3/8"

Sal Maglie	5 - 8	8 - 10
Yogi Berra	10 - 15	15 - 20
John Blanchard	5 - 8	8 - 10
Jim Bouton	5 - 8	8 - 10
Clete Boyer	5 - 8	8 - 10
Whitey Ford	10 - 15	15 - 20
Elston Howard	8 - 10	10 - 15
Tony Kubek	5 - 8	8 - 10
Phil Linz	5 - 8	8 - 10
Joe Pepitone	5 - 8	8 - 10
Pedro Ramos	5 - 8	8 - 10
Bobby Richardson	5 - 8	8 - 10
Bill Stafford	5 - 8	8 - 10
Mel Stottlemyre	5 - 8	8 - 10
Casey Stengel	10 - 15	15 - 20
Ralph Terry	5 - 8	8 - 10
Mike Tresh	5 - 8	8 - 10

B& W - All Yankees except Mets Ron Swoboda

Rocky Bridges	4 - 6	6 - 8
Whitey Ford	10 - 12	12 - 15
Mike Tresh	4 - 6	6 - 8
Ron Swoboda	4 - 6	6 - 8

Color - 8"x10"

Berra, Ford	12 - 15	15 - 18
Howard	10 - 12	12 - 15
Mantle	20 - 25	25 - 35
Maris - with or without facsimile autograph	15 - 20	20 - 25
Mantle & Maris	25 - 30	30 - 40
Blanchard, Bouton, Boyer, Kubek, Linz, Pepitone, Richardson, Stafford, Stottlemyre, Terry, Tresh	6 - 8	8 - 10

The Rose Co., 1909

Players in Gold Frame above Diamond
on yellow/green field (200+)
National League (Note: This check list is incomplete.
The author would appreciate word on any not listed.

Boston Braves

Beaumont, Brown, Dahlen	80 - 90	90 - 100
Ferguson, Lindeman, Ritchey	80 - 90	90 - 100

Brooklyn Dodgers

Alperman, Hummel, Lumley	80 - 90	90 - 100
Maloney, McIntyre, Rucker, Sheehan	80 - 90	90 - 100

Chicago Cubs

Brown	150 - 175	175 - 200
Chance, Evers, Tinker	200 - 225	225 - 250
Hoffman, Kling, Overall, Reulbach	80 - 90	90 - 100
Schulte, Sheckard, Slagle, Steinfeldt	80 - 90	90 - 100

Cincinnati Reds

Campbell, Coakley (2), Ewing, Ganzel	80 - 90	90 - 100

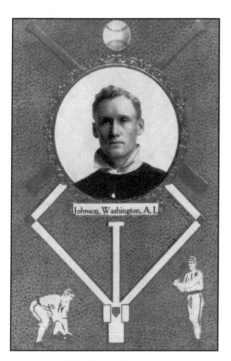

The Rose Company
Johnson, Washington, A.L.

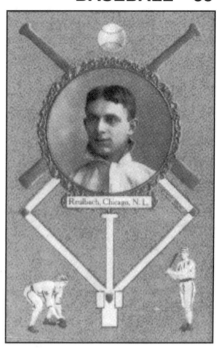

The Rose Company
Reulbach, Chicago, N.L.

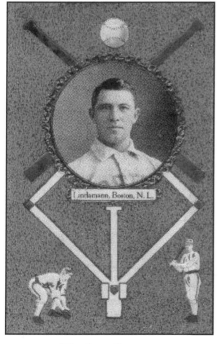

The Rose Company
Lindeman, Boston, N.L.

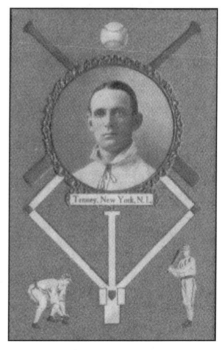

The Rose Company
Tenney, New York, N.L.

Hulswitt, Lobert, McLean, Mitchell	80 - 90	90 - 100
Mowery, Paskert, Spade, Weimer	80 - 90	90 - 100
New York Giants		
Bridwell, Donin, Doyle	80 - 90	90 - 100
Mathewson	200 - 225	225 - 250
McGinnity, Seymour, Shannon	80 - 90	90 - 100
Taylor, Tenney, Wiltse	80 - 90	90 - 100
Philadelphia Phillies		
Bransfield, Brown, Corridon, Grant, Magee	80 - 90	90 - 100
McQuillan, Osborne, Sparks, Titus, Thompson	80 - 90	90 - 100
Pittsburgh Pirates		
Camnitz, Clarke, F., Gibson, Kane	80 - 90	90 - 100
Maddox, Philippe, Thomas, Young	80 - 90	90 - 100
Wagner	900 - 1000	1000 - 1100
St. Louis Cardinals		
Barry, Beebe, Bryne, Gilbert	80 - 90	90 - 100
Delahanty	110 - 120	120 - 140
Hoesetter, Karger, Konechty	80 - 90	90 - 100
Lush, McGlynn, Murray, O'Rourke	80 - 90	90 - 100
American League		
Boston Red Sox		
Glaze, Hale, LaPorte, Lord, Prueitt	80 - 90	90 - 100
Thoney, Unglaub, Wagner, Winter, Young	80 - 90	90 - 100
Chicago White Sox		
Altrock, Anderson, Donohue	80 - 90	90 - 100
Jones, Parent, White	80 - 90	90 - 100
Cleveland Indians		
Bemis, Birmingham, Bradley, Clarke, J.	80 - 90	90 - 100
Hinchman, Joss, Leibhardt, Rhoades, Turner	80 - 90	90 - 100
Lajoie	200 - 225	225 - 250
Detroit Tigers		
Cobb	900 - 1000	1000 - 1100
Crawford	150 - 160	160 - 175
Donovan, Killian, Mullin, O'Leary	80 - 90	90 - 100
Rossman, Schaefer, Schmidt, Summers	80 - 90	90 - 100
New York Yankees		
Chase	140 - 160	160 - 180
Chesbro, Keeler	120 - 140	140 - 160
Conroy, Eberfield, Glade, Hemphill	80 - 90	90 - 100
Kleinow, Newton, Niles, Orth, Stahl	80 - 90	90 - 100
Philadelphia A's		
Bender	150 - 160	160 - 175
Coombs, Dygert, Hartsel	80 - 90	90 - 100
Nichols, Oldring, Plank	80 - 90	90 - 100
St. Louis Browns		
Ferris, Hoffman, Howell, T. Jones	80 - 90	90 - 100
Powell, Spencer, Stone, Williams	80 - 90	90 - 100
Waddell	150 - 160	160 - 175
Washington Nationals		
Clymer, Ganley, Freeman	80 - 90	90 - 100
Johnson, McBride	80 - 90	90 - 100
F. Delahanty	120 - 140	140 - 160
Milan, Patten, Shipke, Smith, Warner	80 - 90	90 - 100

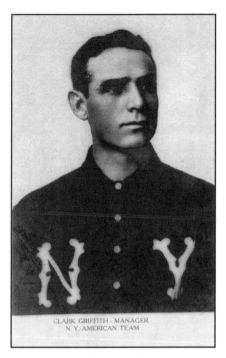

The Rotograph Co.
"Clark Griffith, Manager ..."

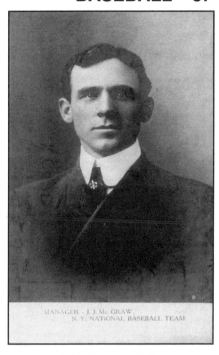

The Rotograph Co.
"Manager J. J. McGraw ..."

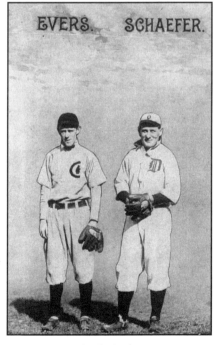

Sepia Series
"Evers — Schaefer"

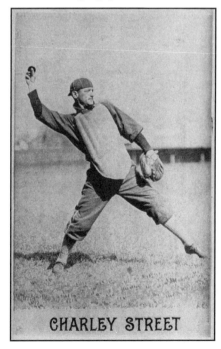

Sepia Series
"Charley Street"

Scranton Players

Halligan, Houser, Moran, Schultz, Steele	80 - 90	90 - 100

The Rotograph Co., 1905

Real Photos

George Brown, Wm. F. Dahlen	100 - 125	125 - 150
J.D. Chesbro	125 - 150	150 - 175
Clark Griffil (Clark Griffith)	150 - 175	175 - 200
Joseph McGinnity	125 - 150	150 - 175
John McGraw	150 - 175	175 - 200
A. Puttman, Luther Taylor	100 - 125	125 - 150

Sepia, Anonymous Ty Cobb 500 - 600 600 - 800

Sepia Baseball Players, 1910

Anonymous Sepia Color

Cobb	700 - 800	800 - 900
Wagner	600 - 650	650 - 700
Johnson, Mathewson	200 - 250	250 - 300
Ty Cobb-Honus Wagner	550 - 600	600 - 700
Brown, Eddie Collins, Evers-Schaefer	150 - 175	175 - 200
Mgr. Frank Chance, Lajoie, Tris Speaker	150 - 175	175 - 200
Walsh, Sam Crawford, Plank	150 - 175	175 - 200
Bresnahan, Bridwell, Chase, Devlin, Dooin	125 - 150	150 - 175
Frock, Gibson, Hoffman, Lord, Overall, Street	125 - 150	150 - 175

Spic–Span Dry Cleaners, 1956

Milwaukee Braves with Spic–Span logo

Two Sizes: 4"x5 7/8" and 5"x7" B&W Photos

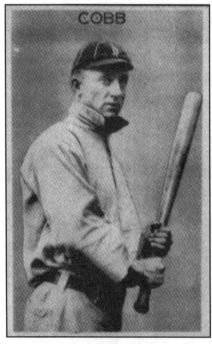

Anonymous Sepia
"Ty Cobb"

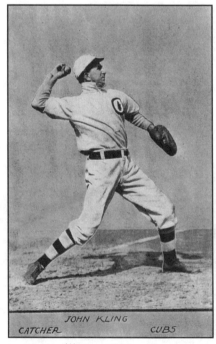

($) Crose Photo Co.
"John Kling, Catcher — Cubs"

Spic-Span Dry Cleaners
"Joe Adcock"

Spic-Span Dry Cleaners
"Dave Jolly"

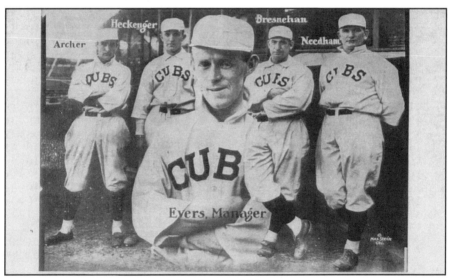

Max Stein, Chicago
"Archer, Heckenger, Bresnehan, Needham and Evers, Manager"

Values of each of the two sizes are about the same.

1	Henry Aaron	15 - 20	20 - 25
2	Billy Bruton	8 - 10	10 - 15
3	Bob Buhl	8 - 10	10 - 15

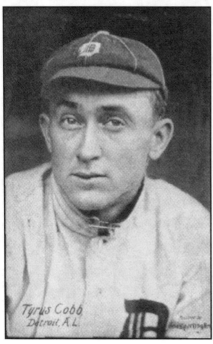

Max Stein
Buck Weaver, Chicago, A.L.

Sporting News
Tyrus Cobb, Detroit, N.L.

H. M. Taylor
Donovan, Jennings, and Chance

4	Lou Burdette	8 - 10	10 - 15
5	Gene Conley	8 - 10	10 - 15
6	Del Crandell	8 - 10	10 - 15
7	Ray Crone	6 - 8	8 - 10
8	Jack Dittmer	6 - 8	8 - 10
9	Ernie Johnson	8 - 10	10 - 12
10	Dave Jolly	6 - 8	8 - 10
11	Ed Mathews	10 - 15	15 - 20
12	Chet Nichols	6 - 8	8 - 10
13	Danny O'Connell	6 - 8	8 - 10
14	Andy Pafko	8 - 10	10 - 15
15	Bob Thompson	8 - 10	10 - 12
16	Warren Spahn	10 - 15	15 - 20
17	Joe Adcock	8 - 10	10 - 15
18	John Logan	8 - 10	10 - 12

Souvenir Postcard Shop of Cleveland
Cleveland Players, B&W Photos

Lajoie	150 - 175	175 - 200
1905 Cleveland Team	150 - 175	175 - 200

A. W. Spargo, 1908, Black & White

Minor League Hartford Players (4?)	80 - 90	90 - 100

The Sporting Life, 1906 Collage of Players
Printed from photo supplements of their weekly
magazine. Sepia — All 16 teams represented.

Brooklyn	150 - 200	200 - 250
Chicago Cubs	150 - 200	200 - 250
Chicago White Sox	150 - 200	200 - 250

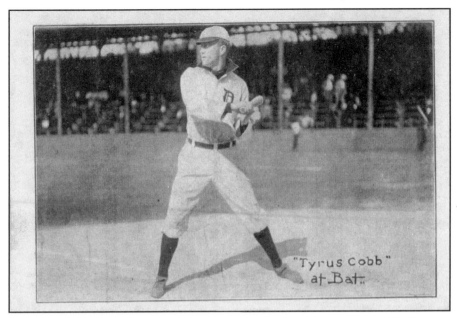

H. M. Taylor —"Tyrus Cobb at Bat"

Cleveland Indians	150 - 200	200 - 250
New York Giants	150 - 200	200 - 250
Philadelphia Athletics	150 - 200	200 - 250
Pittsburgh Pirates	150 - 200	200 - 250
Others	150 - 200	200 - 250
Sporting News, 1915 Color		
Roger Bresnahan	150 - 175	175 - 200
Ty Cobb	2000 - 2250	2250 - 2500
Eddie Collins	200 - 225	225 - 250
Vean Gregg	100 - 125	125 - 150
Walter Johnson-Gabby Street	300 - 350	350 - 400
Rube Marquard	200 - 250	250 - 300
Max Stein, P/U.S. Pub. House, 1909-1916		
35 Unnumbered Sepia		
"Postcards of Noted People"		
Cobb, Wagner	300 - 350	350 - 400
Mathewson, McGraw, Thorpe	150 - 175	175 - 200
Speaker, Marquard, Tinker, Evers, Chance	100 - 125	125 - 150
Myers, O'Toole, Walsh, Wood	90 - 100	100 - 120
Bodie, Schulte, Stahl, Weaver, Zimmerman	80 - 90	90 - 100
Cubs-Evers, Archer, Heckenger, Bresnahan		
and Needham	90 - 100	100 - 120
Cubs-Miller, Goode, Mitchell, Clymer, Schulte	90 - 100	100 - 120
Boston American Team	150 - 175	175 - 200
Chicago Cubs - 1916	150 - 175	175 - 200
Cincinnati Reds - 1916	150 - 175	175 - 200
New York National Team	150 - 175	175 - 200
Boston American Team (see 1-T on page 51)		
H. M. Taylor, 1909-11		
Detroit Tigers (B&W)		
Ty Cobb Batting	250 - 275	275 - 300

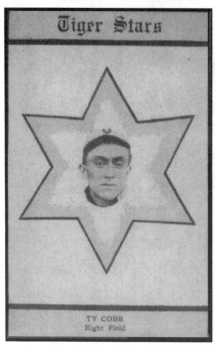

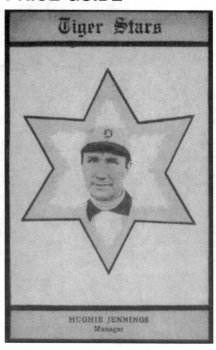

Topping & Co., "Tiger Stars"
Ty Cobb, Right Field

Topping & Co., "Tiger Stars"
Hughie Jennings, Manager

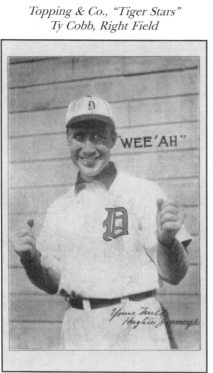

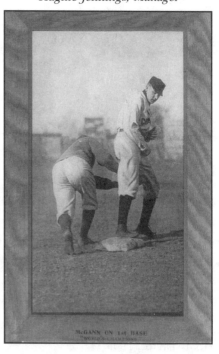

H. M. Taylor
Hughie Jennings, "WEE'AH"

Ullman Mfg. Co.
"McGann on 1st Base"

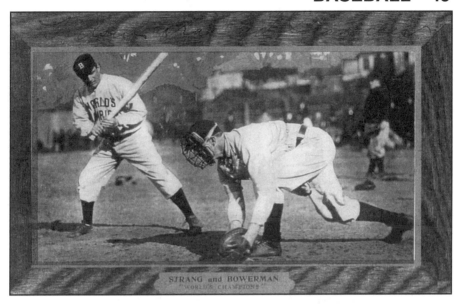

STRANG and BOWERMAN
"WORLD'S CHAMPIONS"

Ullman Mfg. Co. — World's Champion Series
"Strang and Bowerman"

Bill Coughlin	100 - 125	125 - 150
Sam Crawford	125 - 150	150 - 175
Detroit Team	150 - 200	200 - 250
"Wild Bill" Donovan presented with		
floral horse shoe	100 - 125	125 - 150
Jennings-Donovan-Chance	150 - 175	175 - 200
"WEE'AH" - Yours Truly Hughie Jennings	150 - 175	175 - 200
Comic - "Hughie" and His Tigers (see Comics)	100 - 110	110 - 125
Team Posing in Dugout (see T-2)		
St. Louis Cards "Dear Friends" Series		
Musial	25 - 30	30 - 35
Haddix, Hemus, Staley & others	15 - 18	18 - 22
Topping & Co. 1909		
"Tiger Stars" Black & yellow - Heads in star		
Beckendorf, Bush, D. Jones	90 - 100	100 - 110
Donovan	125 - 140	140 - 160
Ty Cobb	300 - 350	350 - 400
Jennings, Crawford, Delehanty	150 - 175	175 - 200
Jones, Killian	90 - 100	100 - 110
McIntyre, Moriarty, Mullin, O'Leary	90 - 100	100 - 110
Schmidt, Speer, Stanage, Summers	90 - 100	100 - 110
Willett, Work	90 - 100	100 - 110
Ullman Mfg. Co.		
World's Champion Series		
"McGann on 1st Base"	50 - 70	70 - 90
"Strang and Bowerman"	50 - 70	70 - 90
"Wiltse"	50 - 70	70 - 90
"Ferguson"	50 - 70	70 - 90
Chicago Cubs Team, 1906	200 - 300	300 - 400

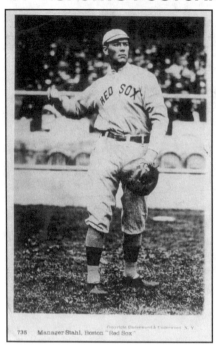

Underwood and Underwood, No. 735
"Manager, Stahl — Red Sox"

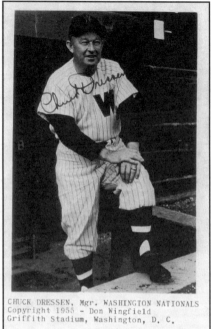

Don Wingfield, 1955
"Chuck Dressen, Mgr., Washington..."

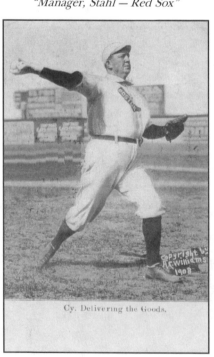

A. C. Williams
"Cy. Delivering the Goods."

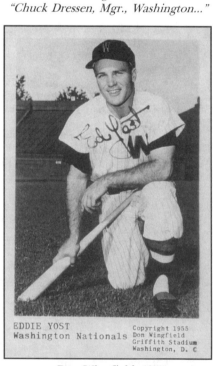

Don Wingfield, 1955
"Eddie Yost, Washington Nationals"

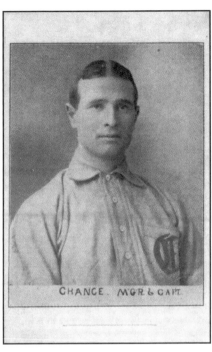

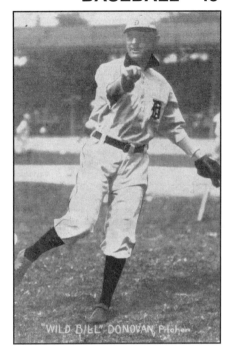

Anonymous, Real Photo
"Chance, Mgr. & Capt."

Wolverine News Co.
"Wild Bill" Donovan, Pitcher

A.C. Williams, 1908 (B&W)		
"Cy. Delivering the Goods."	70 - 80	80 - 90
Don Wingfield, 1955		
Chuck Dressen, Eddie Yost, Washington Nationals	20 - 25	25 - 30
Wolverine News Co., 1909		
Tiger Players (B&W)		
Ty Cobb (2)	200 - 250	250 - 300
Bill Coughlin, Jerry Downs, Davey Jones	80 - 90	90 - 100
Hughey Jennings	100 - 125	125 - 150
"Wild Bill" Donovan	80 - 90	90 - 100
"Wild Bill" at the Water Wagon	80 - 90	90 - 100
Ed Killian, George Mullin, Charlie O'Leary	80 - 90	90 - 100
Fred Payne, Claude Rossman, H. Schaefer	80 - 90	90 - 100
"Shaefer & O'Leary work double play"	80 - 90	90 - 100
Charlie Schmidt, Eddie Siever	80 - 90	90 - 100
Hall of Fame Issues		
Albertype Co.		
1936-1952 Inductees B&W Plaques (62)		
Ruth, Cobb, Gehrig	25 - 30	30 - 40
Others	10 - 15	15 - 20
Artvue Co. Hall of Fame (94)		
1953-1963 Inductees		
J. DiMaggio, J. Robinson	15 - 20	20 - 30
Others	3 - 5	5 - 8
Curt Teich Hall of Fame		
1964- (Yellow-Brown)	.50 - 1	1 - 2
Perez-Steele Hall of Famers	5 - 25	20 - 150

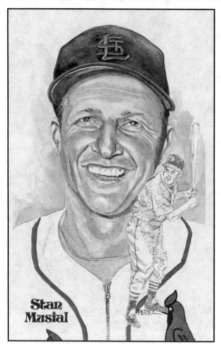

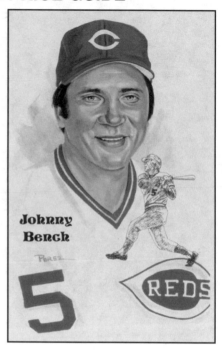

George Perez, Perez-Steele Galleries *George Perez, Perez-Steele Galleries*
"Stan Musial" *"Johnny Bench"*

By Artist George Perez, 1981 — Color. Issued in Sets. Each player card is numbered from 1 to 10,000 and all are Hall of Fame Players. New issues come out as they are voted into the Hall.

Some of the Perez-Steele cards reached astronomical values in 1990-93 because of the sports autograph scenario. DiMaggio, Williams, Musial and Mantle were sold at values of $150-200 each and many others in the $50-100 range. Collectors and dealers purchased them, as well as other Hall of Fame issues, and the players autographed them by mail or at highly attended card shows and special signings. Early inductees (those deceased) are now valued at $5-25. Living inductees images range from $20 to $150. Advertising issues are rare and are valued at $20-30.

References to confirmation of our Publishers Checklists:

1. "The Sports Collectors Bible," Burt Randolph Sugar, Wallace-Homestead Books, Des Moines, Iowa, 1975
2. "The Sports Collectors Bible," Burt Randolph Sugar, Bobbs-Merrill Co., New York, 1979
3. "The Sport Americana Baseball Memorabilia Price Guide," Dr. James Beckett and Dennis W. Eckes, Edgewater Book Co., Lakewood, OH, 1982

TEAM ISSUES

Baltimore Orioles (1954-1975) B&W, Color		
1954-60	10 - 15	15 - 25
1961-75	5 - 8	8 - 12

Cincinnati Reds Yearly Issues (1954-1966)		
1954-55	15 - 20	20 - 25
1956-75	10 - 15	15 - 20
Cleveland Indians (1948-1975) (B&W)		
Feller, Wynn, Lemon, Rosen	15 - 20	20 - 30
Others	10 - 15	15 - 20
1955-1975	8 - 10	10 - 15
Los Angeles Dodgers (1959-1973)		
Pre-1965		
Furillo (Made in Japan issue)	15 - 20	20 - 25
Hodges	20 - 25	25 - 30
Drysdale, Koufax, Snider	10 - 15	15 - 20
Others	5 - 8	8 - 10
After 1965	3 - 4	4 - 5
St. Louis Cardinals (1950-1974)		
1950-55		
Musial	12 - 18	18 - 30
Schoendiest, Marion, Slaughter	8 - 12	12 - 15
Others	8 - 10	10 - 15
1956-1974	5 - 8	8 - 12

MISCELLANEOUS & SPECIAL

Anonymous - "Youngest White Sox Rooter in America, " 1909, Boston Oyster House	70 - 80	80 - 90

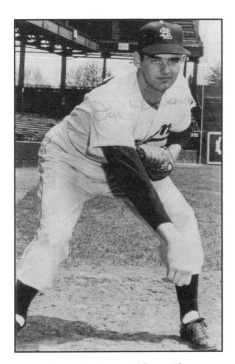

St. Louis Browns, Glossy Photo
1952 — "Don Larsen"

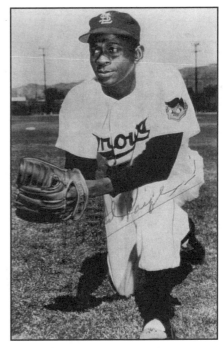

St. Louis Browns, Glossy Photo
1952 — "Satchel Paige"

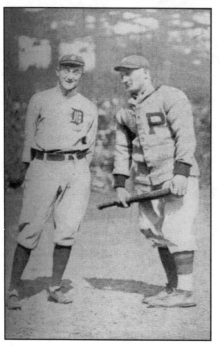

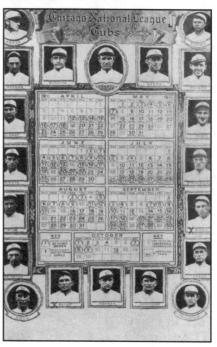

Boeres Company, Phoenix (Printed
Photo) — "Cobb Meets Wagner"

1911 Chicago Cubs
Players and Schedule

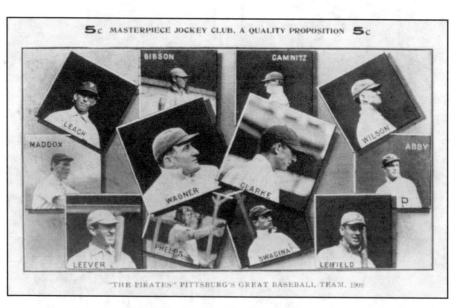

Masterpiece Jockey Club
"The Pirates -- Pittsburgh's Great Baseball Team, 1908"

Chicago Cubs, 1908 "Our Home Team"		
7 Fold-outs with 16 player pictures	650 - 700	700 - 750
Also other team fold-outs	650 - 700	700 - 750
Chicago Cubs, 1910 Team. Oval pictures of		
all team members	400 - 450	450 - 500
Chicago Cubs, 1911 Schedule and Players	225 - 250	250 - 300
Art P.C. Company		
Fold-out Cards, 1907-1910	2000 - 2500	2500 - 3000
"Cobb Meets Wagner"		
Boeres Company, Phoenix Printed Photo	500 - 600	600 - 700
Detroit Tigers Team Composite, 1907		
American League Pub. Co., Cleve. 19 players	225 - 250	250 - 300
Detroit Tigers, 1908 Fold-outs 8 sections,		
91 players **Art P.C. Company, Detroit**	300 - 350	350 - 400
Napoleon LaJoie		
Raymond Kahn Co., 1907	200 - 250	250 - 300
"Our Matty" Printed photo of Christy Mathewson		
Pastime Novelty Co., 1913	150 - 200	200 - 250
New York Giants, 1904 Team Composite		
by Horner **U.S. Souvenir P.C. Co.**	200 - 250	250 - 300
Philadelphia A's Team, 1906 Anonymous	200 - 250	250 - 300
Philadelphia A's, 1911 Fold-out 5"x6 1/2"		
10 Folds - 20 photos	300 - 350	350 - 400
Pittsburgh Pirates Team, 1909 Tri-fold picture	400 - 500	500 - 600
Pittsburgh Pirates, 1909 Pennant Postcard	150 - 200	200 - 250
"The Pirates" Pittsburgh's Great Team, 1908		
Masterpiece Jockey Club	600 - 700	700 - 800
St. Louis Browns, 1908, 7 Fold-outs - 23 players	200 - 300	300 - 350
Scorecard Mechanical Postcard, 1908		
Four wheels turn to keep score	500 - 550	550 - 600
Cy Young, 1908 (see page 44)		
by A.C. Williams "Delivering the Goods"	200 - 225	225 - 250
Black League Baseball Team (RP) AZO		
The Portland Giants of Oregon, ca. 1909	1200- 1400	1400 - 1600
Boston Red Sox		
American League Champions, 1915		
Team Photo (Including Babe Ruth) (RP)	2000 - 2250	2250 - 2500
Brooklyn Dodgers Team (from 1900 Photo)		
J.A. Hollingsworth, Jacksonville (RP)	300 - 400	400 - 500
Chicago Cubs, 1907 Fold-out Frank Chance on		
front. 5 sections - 16 players (RP, face card)	400 - 500	500 - 600
Chicago Cubs Team, 1945, Grogan Photo (RP)	40 - 50	50 - 75
Chicago Cubs Team, 1946, Grogan Photo (RP)	40 - 50	50 - 60
Chicago Cubs Team, 1947, Grogan Photo (RP)	40 - 45	45 - 50
Sac & Fox Indian Women Team, 1903 (RP)	400 - 500	500 - 600
Honus Wagner —Posing w/2 Philadelphia Players	800 - 900	900 - 1000

TEAMS

The numbered listings below correspond with the numbers on the photos in this section.

1-T.	Boston Am. League —Westside Ball Park		
	Chicago. Printed by Max Stein (B&W)	200 - 250	250 - 350

2-T.	Detroit Club, 1907 Printed Photo by		
	H. M. Taylor	150 - 175	175 - 200
2-TA.	Detroit Club RP ("1907" replaces "Club")	300 - 400	400 - 500
3-T.	Philadelphia American League Team	200 - 250	250 - 300
4-T.	The St. Louis Cardinals - 1926 "Here are	125 - 150	150 - 175
	the lads ..." A.W. Sanders	50 - 200	200 - 250
5-T.	Chicago White Sox, 1906 Printed Photo		
	by **F.P. Burke**	150 - 175	175 - 200
6-T.	Chicago National League Base Ball Club,		
	1906 "The Cubs ..." **V.O. Hammon**	150 - 175	175 - 200
7-T.	Chicago National League Championship		
	Team, 1906 E. Freiberg #2405 (RP)	150 - 200	200 - 250
8-T.	New York Giants on their own Training		
	Grounds, Marlin Springs, Tex.	150 - 200	200 - 250
9.T.	The St. Louis Cardinals		
	Block Brothers (RP)	60 - 75	75 - 100
10-T.	The St. Louis Cardinals, 1936		
	Linen by H.A. Meade	125 - 150	150 - 175
11-T.	Giants versus Red Sox, 1912 World Series		
	Anonymous Real Photo, October, 1912	200 - 250	250 - 300
12-T.	Chicago American League White Sox		
	V.O. Hammon Publishing Co.	125 - 150	150 - 175
13-T.	"Cubs" Montage paste-up of Cub players		
	Shadles Studio, Latrobe, Pa. (RP)	150 - 175	175 - 200
14-T.	Chicago White Sox, 1947		
	Grogan Photo (RP)	50 - 60	60 - 70
15-T.	St. Louis Baseball Club National League,		
	1906 Printed Photo	175 - 200	200 - 250
16-T.	Advertising Card with Chicago players		
	Barnes-Crosby Co. Black "Biotone" cards	100 - 150	150 - 200
17-T.	Philadelphia "Athletics" Champions, 1911		
	Double-card , Sporting Life (Printed Photo)	300 - 400	400 - 500
18-T.	Concordia Ban Johnson Base Ball Club		
	Champs, 1937 (RP)	40 - 50	50 - 65
19-T.	Burlington Base Ball Club, 1906		
	G.L. Gilbert, Burlington, Ia. #52 (RP)	60 - 65	65 - 75
20-T.	All-American Ladies Baseball Club		
	Printed Montage Photo	60 - 75	75 - 100
21-T.	Bremerton Base Ball Team, 1913		
	Anonymous (RP)	30 - 40	40 - 50
22-T.	San Francisco Team		
	Dingman Photo Co. (RP)	60 - 65	65 - 75
23-T.	Boston National Bloomer Girls Base Ball		
	Club (Printed Photo)	30 - 35	35 - 40
24-T.	Girls Base Ball Team, 1909		
	Anonymous (RP) AZO	30 - 35	35 - 40
25-T.	Western Bloomer Girls - Ladies Champs,		
	Watervliet, Mich. (B&W)	25 - 30	30 - 35

Additional Team Cards without photos

Boston Braves, 1935 "Braves Field, St. Petersburg,		
Fla., AZO R.P.	40 - 50	50 - 60

Boston Braves - "Boston Braves Baseball Team of 1948" Tichnor Bros. linen, color	25 - 30	30 - 35
Boston Red Sox, "Season 1912, Champions of the American League," Photo Art Shop (RP)	150 - 175	175 - 200
Boston Red Sox, R.P. #742, 1912 American League Pennant Winners - Underwood & Underwood	125 - 150	150 - 175
Boston Red Sox, "World Championship Series, Boston Americans, 1912 Riker & Hegeman Drug Stores - Sepia Printed	100 - 125	125 - 150
"Brooklyn Dodgers, 1911" Sporty Postal Card Co., Sepia Printed	150 - 175	175 - 200
"Cleveland American League Baseball Club," 1905 Real Photo by L. Van Oyen, Cleveland, O.	100 - 125	125 - 150
"Re-Union Old Timers, Cleveland, August 14th, 1909 Anonymous, B&W Printed Photo	40 - 50	50 - 60
"White Sox," 1910 Chicago White Sox Real Photo by Dingman Photo Co.	90 - 100	100 - 125
"Chicago White Sox - Hotel Oakland, Oakland, Ca. March 6th to 30th, 1913 GRL Photo	90 - 100	100 - 125
"Chicago White Sox Special Train en route to Spring Training," 1915 Carson-Harper, Denver	100 - 150	150 - 200
"Chicago White Sox at Glenwood Springs, CO." Carson-Harper, Denver	100 - 150	150 - 200
Chicago Cubs - "The National League Champions" Ullman Mfg. Co. "Art Frame" Series, Green wood, Printed B&W	110 - 120	120 - 140

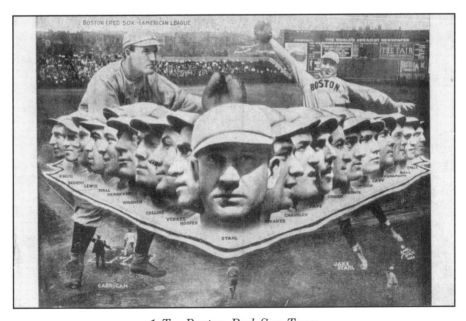

1-T. Boston Red Sox Team

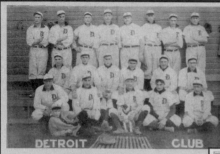

2-T. "Detroit Club"

*Printed Photo of the 1907
Detroit Tigers*

*2-TA. Note:
Same view but real photo and
"1907" replaces "Club"*

*3-T. Philadelphia American
League Base Ball Team, 1905
("Athletics")*

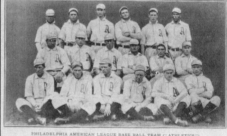

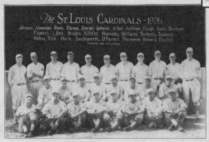

*4-T. The St. Louis Cardinals — 1926
Copyright by A. W. Sanders
"Here are the lads who brought home
the Pennant in the World Series Race
of 1926."*

*5-T. Chicago White Sox 1906
Team
Copyright 1906 by F. P. Burke*

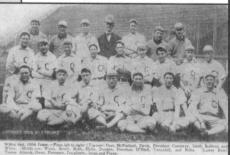

*6-T. Chicago National League Base
Ball Club 1906
"The 'Cubs' ... Pennant Winners"
By V. O. Hammon Publishing
Company, Chicago*

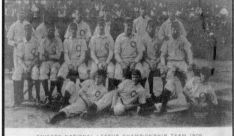

7-T. Chicago National League Championship Team, 1906.

Real Photo No. 2405
© E. Freiberg

8-T. New York Giants on their own Training Grounds Marlin Springs, Texas

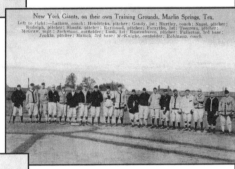

9-T. The St. Louis Cardinals

Real Photo by Block Brothers

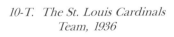

10-T. The St. Louis Cardinals Team, 1936

Linen by H. A. Meade

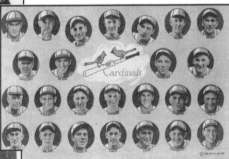

11-T. Giants versus Red Sox 1912 World Series

Anonymous Real Photo

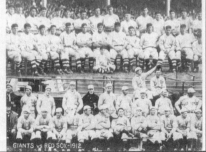

12-T. Chicago American League White Sox Team

V. O. Hammon Publishing Co.

13-T. Montage Paste-up of Cub Team Players

Anonymous Real Photo

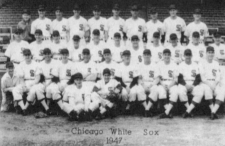

14-T. Chicago White Sox Team, 1947

Anonymous Real Photo

15-T. St. Louis Baseball Club National League, 1906

Printed Photo by Sporting Life

16-T. Advertising Card Showing Chicago Players Barnes-Crosby Company Black "Biotone" Postcards

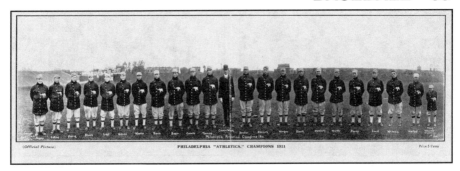

17-T. Philadelphia "Athletics" Champions, 1911 — Printed Photo

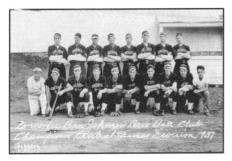

18-T. Real Photo of Concordia Ban Johnson Base Ball Club Champs, 1937

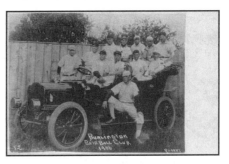

19-T. Real Photo of Burlington Base Ball Club, 1906 — No. 52 by Gilbert

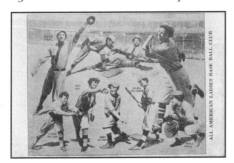

20-T. All-American Ladies Base Ball Club, Printed Montage Photo

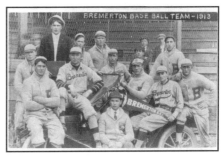

21-T. Anonymous Real Photo Bremerton Base Ball Team — 1913

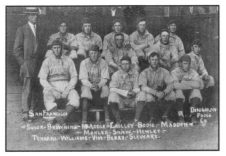

22-T. Real Photo by Dingman Photo Co. of San Francisco Team

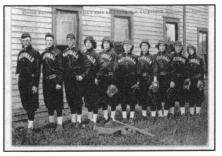

23-T. Boston National Bloomer Girls Base Ball Club, Printed Photo

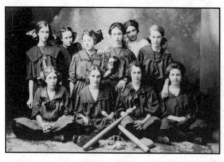

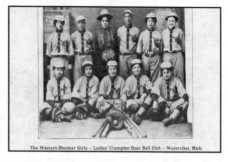

24-T. Real Photo, Anonymous Girls 25-T. Western Bloomer Girls — Ladies'
Base Ball Team, 1909 — AZO Champs, Watervliet, Michigan (B&W)

Chicago Cubs - "The National League Champions," 1907 - F.P. Burke, Blue Tint - 6 cub bears above	150 175	175 - 200
Chicago Cubs, 1946 Team, "Chicago Cubs National League Champions Real Photo by Grogan	30 - 40	40 - 50
"Chicago National League Baseball Club" "Our Cubs in 1945 - Glossy R.P. by Grogan Photo	40 - 50	50 - 60
"Chicago Cubs Around the World Tour 1888-1889" Pfeffer's Theatre Court Buffet, 1917 (B&W)	40 - 50	50 - 75
Cincinnati Reds - 1939 DOPS Sepiatone Photo	40 - 50	50 - 60
"Detroit Club, American League" American League Publishing Co., Cleveland Printed (B&W)	100 - 125	125 - 150
Detroit Tigers - "Tigers" A.C. Dietsche, Detroit, Mich., 1909 - Sepia, Printed	100 - 125	125 - 150
Detroit Tigers - "The Tigers-American League Champions 1907" - F.P. Burke, 1907 - Blue tint	100 - 125	125 - 150
"Detroit Tigers Champions of American League, 1935" - Dodge Motor Ad on back (B&W)	30 - 40	40 - 50
"Detroit Tigers 1935" Greenfield's Cafeteria Sepia. Was also issued in B&W	40 - 50	50 - 60
"Detroit Tigers - Pennant Winners, 1935" Anonymous, Sepia - Also printed in B&W	30 - 40	40 - 50
"The Detroit Tigers, 1949" - "Groganized" R.P.	30 - 40	40 - 50
"The Detroit Tigers, 1950" - "Groganized" R.P	30 - 40	40 - 50
"The Detroit Tigers, 1951" - "Groganized" R.P.	25 - 30	30 - 40
"The New York Giants, National League Team of 1903" Private Mailing Card R.P. by Photo Falk	90 - 100	100 - 125
"New York Baseball Club" Team and Scorecard **New York Giants** vs. Springfield. "Vote for Joseph Zimmerman for City Treasurer," by C. T. Carpenter, 1909 - (Red and Black)	80 - 90	90 - 110
"New York National Base Ball Team" 1904 - by The Rotograph Co. (R.P) Individual players	125 - 150	150 - 200
"New York Giants Spring Training Quarters, Marlin, Texas - Anonymous, #31304, Color 35 players named and numbered to identify	125 - 150	150 - 175
New York Giants - "Posed for the Anger Baking Co., at Mobile, Ala., 1912" - "Two National Leaders" B&W Printed, with players and positions named	175 - 200	200 - 250

New York Giants - "World Championship Series, New
 York Nationals 1912" Riker & Hegeman Drug
 Stores - Sepia. Long format. 125 - 150 150 - 175
"1917-The New York Giants-1917" - Anonymous
 Publisher, B&W Printed, Players named, oversize 70 - 80 80 - 90
"New York Highlanders, 1911" - Sporty Postal
 Card Co., Newark, N.J. - Sepia Printed 150 - 200 200 - 250
"Philadelphia Athletics, 1911" - Sporty Postal
 Card Co., Newark, N.J. - Sepia Printed 150 - 200 200 - 250
Philadelphia Athletics "The Athletic Players all
 Wear Stetson Hats - The World's Champions
 Wear the World's Best Hats" - B&W Printed 200 - 250 250 - 300
Philadelphia Athletics, 1910 - F.J. Lupp Printer,
 Chicago (Burke and Atwell) B&W Printed;
 Oversize. Also printed in regular format 150 - 175 175 - 200
Philadelphia Phillies, 1910 - Real Photo of team
 at Southern Pines, N.C. 300 - 400 400 - 500
Philadelphia Phillies, 1911 - Real Photo of team
 by Bert G. Covel in Birmingham, Ala. 300 - 400 400 - 500
"The Pirates" Pittsburgh's Great Baseball Team,
 1908" - B&W printed of individual players.
 This is non-advertising version and rarer than
 the Masterpiece Jockey Club version. 1000 - 1100 1100 - 1200
"Pittsburgh Base Ball Club and S & H Green
 Trading Stamps" - "The Two Champions"
 Individual players, B&W, Rosenbaum Co. 150 - 200 200 - 250
"The Pittsburgh Pirates in front of Hamby's Well,
 Dawson Springs, Ky." Color by Octochrome 100 - 125 125 - 150
St. Louis Cardinals, 1914 - Anonymous R.P. 200 - 225 225 - 250
St. Louis Cardinals - "1914 Cardinals" - Printed
 Blue Tint by Palfrey, St. Louis - Players named. 150 - 175 175 - 200

SPECIAL PLAYERS

Listed below are a group of individuals on special cards that are not
affiliated with the publisher groups. They were selected to give an
indication of some of the materials that are available to collectors. Listed
values of these cards may indicate a ball park figure for those of other
players in similar categories, but clearly depending upon the individual.
Many of this type are available of early players, although some are
extremely rare and hard to identify. **Real Photo postcards usually had very
short print runs and at times were one of a kind.**

1-P. **Corporal Joe DiMaggio** Playing at
 Camp Cooke, Ca., No. 67 (RP) 100 - 125 125 - 150
2-P. **Walter Johnson** - Birthplace & Boyhood
 Home, Humboldt, Kansas - Caldwell (RP) 100 - 125 125 - 150
3-P. **Harry Davis**, Athletic Base Ball
 Team, 1905-6 - Lincoln Pub. Co. (B&W) 200 - 225 225 - 250
4-P. **Grover Cleveland Alexander,** House of
 David Base Ball Club, B&W, Printed. An
 extremely rare card. He played for the
 House of David while out for one year. 40 - 50 50 - 60

5-P.	**Richard "Rube" Marquard**, N.Y. Giants U.S. Publishing House (Printed Photo) This is a card of the Max Stein group but with U.S. Publishing House imprint.	200 - 225	225 - 250
6-P.	**George Mullin,** "The Tiger's Favorite" Billie Jones, Wabash, In. (RP)	150 - 175	175 - 200
7-P.	**Lefty O'Doul,** "When Lefty was a Giant," Anonymous (Printed Photo)	25 - 30	30 - 40
8-P.	**"Joe" Tinker** Short Stop - Cubs ($) on Crest (Crose Photo Co.)	125 - 150	150 - 175
9-P.	**Honus Wagner** "The Mighty Honus" W.W. Smith, 1909 - (B&W)	200 - 250	250 - 300
10-P.	**Babe Ruth** in Japan (Color) Japanese card of Ruth on exhibition tour.	350 - 400	400 - 500
11-P.	**Honus Wagner** & Hometown views of Carnegie - Pittsburgh Gazette Times (RP)	125 - 150	150 - 200
12-P.	**Honus Wagner, Fred Clarke and Friend** Anonymous, (RP) on studio posed shot	200 - 300	300 - 400
13-P.	**Honus Wagner** & dog , Jason in auto in front of car dealership. Anonymous (RP) Extremely rare and possibly unique.	100 - 150	150 - 200
14-P.	**Babe Ruth** & First Wife in Hot Springs, Arkansas — Anonymous (RP). This may possibly be a unique card.	300 - 400	400 - 500

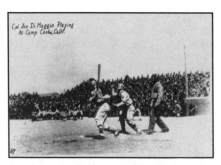

1-P. "Cpl. Joe DiMaggio Playing at Camp Cooke, Calif."

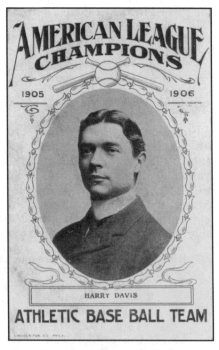

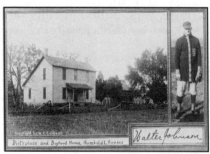

2-P. Walter Johnson Boyhood Home in Humboldt, Kansas

3-P. Harry Davis Athletic Base Ball Team, 1905-6

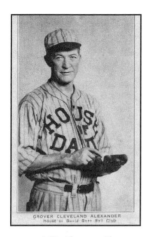

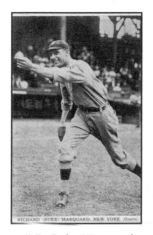

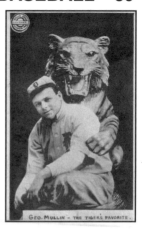

*4-P. Grover C.
Alexander, House of D.*

*5-P. Rube Marquard
New York Giants*

*6-P. George Mullin
"The Tiger's Favorite"*

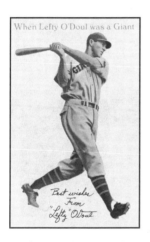

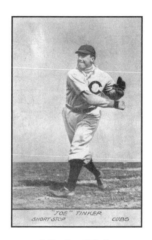

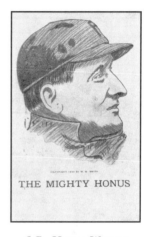

*7-P. Lefty O'Doul
"When Lefty O'Doul
was a Giant"*

*8-P. Joe Tinker
"Shortstop, Cubs"*

*9-P. Honus Wagner
"The Mighty Honus"*

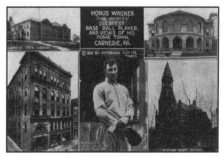

*10-P. Babe Ruth
By Japanese Publisher*

*11-P. Honus Wagner and Hometown
Views of Carnegie, PA.*

12-A. Honus Wagner and dog, Jason (RP)
Photo Taken in Front of Hupmobile Dealership

13-P. Honus Wagner, Fred Clarke
and Friend (RP)

14-P. Babe Ruth and First Wife
Hot Springs, Arkansas 1917 (RP)

ADVERTISING CARDS

1-A.	**Mr. Frank Chance** - Wearing his **Royal Tailored Suit**, Anonymous	300 - 350	350 - 400
2-A.	**Frank Chance-Connie Mack** for World Series game. (B&W) **"Makaroff"** ad.	150 - 200	200 - 250
3-A.	**Joe DiMaggio's Restaurant Fisherman's Wharf.** 3 Brothers Curt Teich (Linen)	50 - 60	60 - 70
4-A.	**Sal Maglie's Liquor Store,** N.Y., Muscato	25 - 35	35 - 40
5-A.	**Frankie Gustine's Restaurant** near Forbes Field. National Press Inc., N. Chicago (B&W)	15 - 20	20 - 30
6-A.	**Sandy Koufax's Tropicana Motel,** Plunkett	40 - 40	40 - 50
7-A.	**Jackie Robinson.** Ad for **Old Gold** Cigarettes. Anonymous (B&W)	90 - 100	100 - 125
8-A.	**Mickey Owen.** Ad for Winner, S.D, ball team, The **Winner "Pheasants"** Rosebud (RP)	30 - 35	35 - 40
9-A.	**Robin Roberts Seafood Restaurant**	75 - 100	100 - 125
10-A.	**Joe Tinker & Barney Oldfield** sit in new Case Automobile. J.I. Case T. M. Co. (B&W)	80 - 100	100 - 120
11-A.	**Roy Campanella's Wines and Liquors Store** Eagle Postcard View Co., Glossy B&W	30 - 40	40 - 50
12-A.	**Babe Ruth's Own Book of Baseball** Abercrombie & Fitch, Red on Green Card	50 - 60	60 - 70
13-A.	**Graphic All Sports Dinner**, Billy Taub Clothier, includes Babe Ruth, Tommy Burns, Max Schmeling and Jack Sharkey	300 - 400	400 - 500

2-A. "Makaroff" Advertisement
Chance and Mack, 1905 World Series

1-A. Mr. Frank Chance
"Wearing His Royal Tailored Suit"

3-A. Joe DiMaggio's Restaurant
Fisherman's Wharf, San Francisco

*5-A. Frankie Gustine's Restaurant
Near Forbes Field, Pittsburgh*

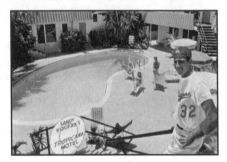

*4-A. Sal Maglie's
New York Liquor Store, Muscato, NY*

*6-A. Sandy Koufax's
Tropicana Motel, Bob Plunkett, L.A.*

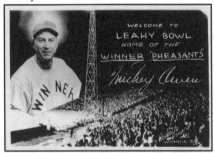

*8-A. Mickey Owen, Advertising
the Winner, S.D. "Pheasants"*

*7-A. Jackie Robinson
Advertising Old Gold Cigarettes*

*9-A. Robin Roberts'
Seafood Restaurant*

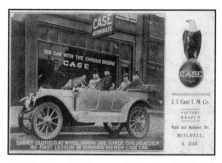

10-A. *Joe Tinker and Barnie Oldfield*
Advertising Case Automobiles

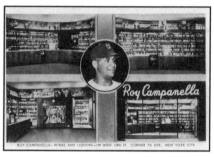

11-A. *Roy Campanella*
Wines and Liquors

12-A. *Babe Ruth's Own Book of*
Baseball — Abercrombie & Fitch

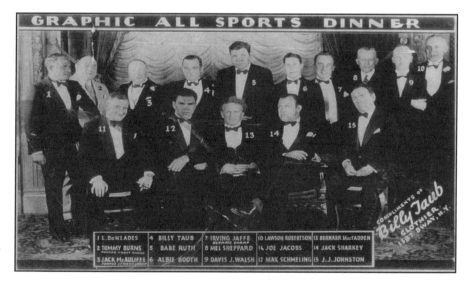

13-A. *Graphic All Sports Dinner, Workstel Studios—Compliments of Billy Taub*
Clothier. Advertises the 1932 World Heavyweight Championship between Max
Schmeling and Jack Sharkey. Group includes sports notables such as Babe Ruth,
Tommy Burns, Albie Booth, Irving Jaffe, Joe Jacobs, Schmeling, Sharkey, Billy
Taub, Bernarr MacFadden and Jack McAuliffe. (Black & White Glossy Photo)

BASEBALL STADIUMS

The tremendous numbers of baseball stadium postcards make it impossible for us to compile and list all that have been made available by publishers and photographers since 1900. It has been estimated that there have been over 8,000 different images published. Therefore, our listings include only a range of average values for various eras and recent values of some of the rarer and more desirable.

The numbered listings below correspond with the numbers on the photos in this section.

1-S.	Braves Field, Boston - "Largest Base Ball Park in the World," Ruge & Badger	50 - 60	60 - 70
2-S.	Fenway Park, Boston, Mass. - Cop on horse - A. Israelson & Co. #861	80 - 100	100 - 120
3-S.	Ebbets Field, Brooklyn. N.Y. - (B&W) Mainzer, #122 (FotoSeal version also exists)	20 - 25	25 - 30
4-S.	Cincinatti Base Ball Park, Cincinnati, Ohio Copyright by Young & Carl, #P67052	25 - 30	30 - 40
5-S.	Comisky Park, Home of the White Sox, Chicago, Ill. - Grogan Real Photo #C-100	40 - 50	50 - 75
6-S.	Night Game, Crosley Field, Cincinnati, Ohio Kraemer Art Co., #107 (Linen)	12 - 15	15 - 18
7-S.	Stadium, Cleveland, O. Brunner-State Studios, 1931 (RP)	40 - 50	50 - 75
8-S.	Cubs Ball Park, Chicago Acmegraph logo, #580 "National League ..."	25 - 30	30 - 35
9-S.	Entrance to Braves Field, Boston, Ma. Mason Bros., #5115 (White Border)	30 - 40	40 - 50
10-S.	Wrigley Field From Air, Chicago Grogan Photo, 1951, #3922 (RP)	50 - 60	60 - 75
11-S.	League Park, Cleveland, Sixth City Fenberg (White Border)	60 - 70	70 - 80
12-S.	Stadium- Cleveland, O. Grogan Photo (White Border RP)	20 - 30	30 - 40
13-S.	Navin Field, American League Park, Detroit United News Co., Stands and Outfield	30 - 35	35 - 40
14-S.	Entrance to League Park, Cleveland Anonymous	50 - 60	60 - 75
15-S.	Briggs Stadium, Home of the Detroit Tigers, Detroit , Mich., 1949 W.L. Oden Photo 1817	30 - 40	40 - 50
16-S.	Detroit Baseball Team Having a Flag Day at Season Opener, Detroit, Mi. United News Co.	100 - 110	110 - 120
17-S.	South Side Base Ball Park, Chicago - View from center Field. Empire Art Co., #78, R28993	125 - 150	150 - 175
18-S.	Philadelphia Ball Park of the National League, Philadelphia, Pa. - Man with megaphone,#263, 222179, P. Sander logo	80 - 100	100 - 120
19-S.	Columbia Ball Park, Philadelphia A & S	80 - 90	90 - 100

1-S. Braves Field, Boston

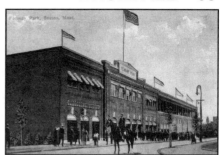

2-S. Fenway Park, Boston

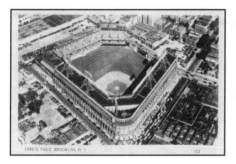

3-S. Ebbets Field, Brooklyn

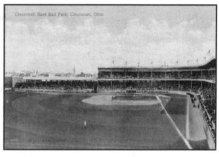

4-S. Cincinnati Base Pall Park

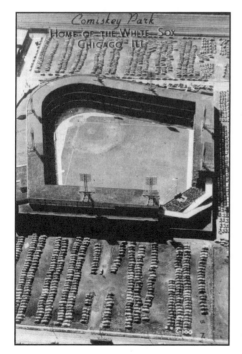

5-S. Comiskey Park, Chicago

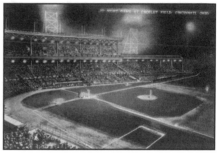

6-S. Night Game at Crosley Field

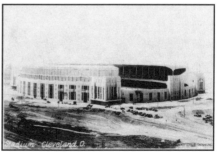

7-S. Stadium, Cleveland

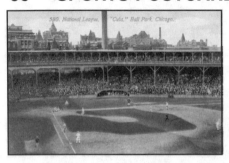

8-S. Cubs Ball Park, Chicago

9-S. Entrance to Braves Field, Boston

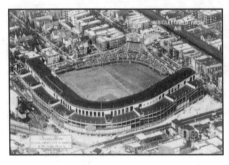

10-S. Wrigley Field, Chicago

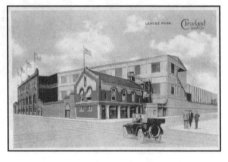

11-S. League Field, Cleveland

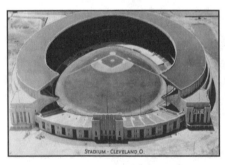

12-S. Stadium, Cleveland

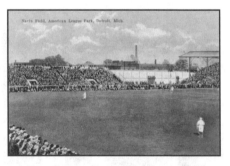

13-S. Navin Field, Detroit

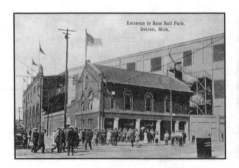

14-S. Entrance, League Park, Cleveland

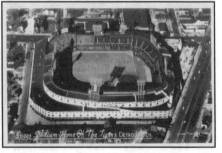

15-S. Briggs Stadium, Detroit

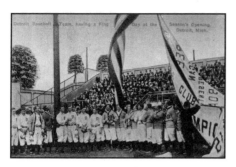

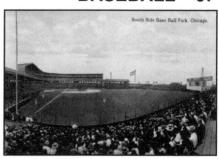

16-S. Season Opener, Detroit 17-S. South Side Base Ball Park, Chicago

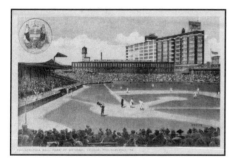

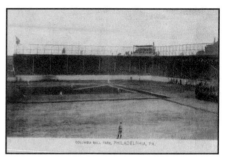

18-S. Philadelphia N. L. Ball Park 19-S. Columbia Ball Park, Philadelphia

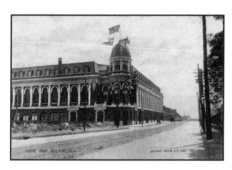

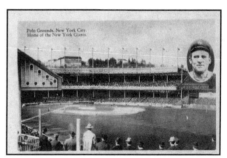

20-S. Shibe Park, Philadelphia 21-S. Polo Grounds, New York

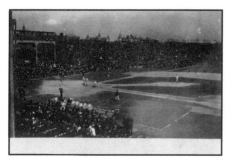

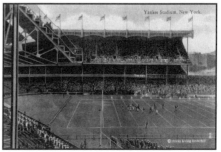

22-S. West Side Park, Chicago (RP) 23-S. Yankee Stadium, New York

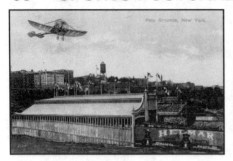

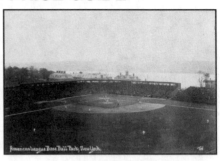

24-S. Polo Grounds, New York *25-S. A.L. Base Ball Park, New York (RP)*

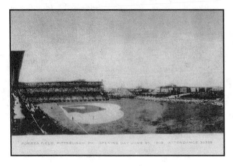

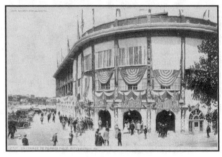

26-S. Forbes Field, Pittsburgh *27-S. Entrance, Forbes Field, Pittsburgh*

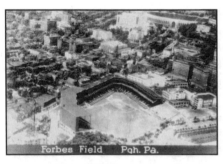

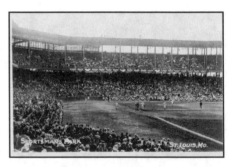

28-S. Forbes Field, Pittsburgh *29-S. Sportsman's Park, St. Louis*

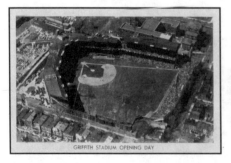

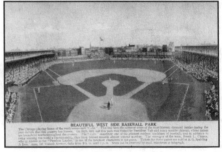

30-S. Griffith Stadium Opening Day, D.C. *31-S. West Side Baseball Park, Chicago*

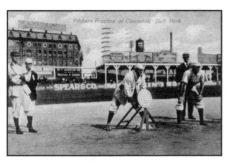

32-S. Pitchers Practice, Cincinnati

33-S. Opening of the Season, 1907

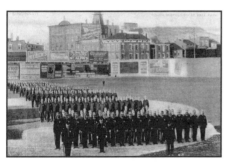

34-S. Police Inspection, Cincinnati

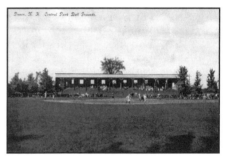

35-S. Dover, N.H., Central Park Grounds

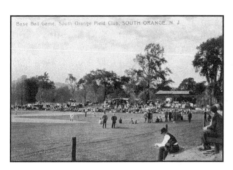

36-S. South Orange Field Game

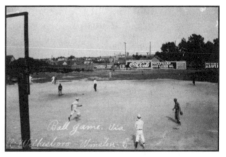

37-S. Black Game — North Carolina

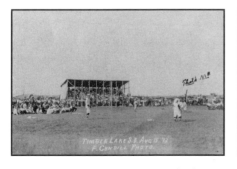

38-S. Timber Lake, S.D. (RP)

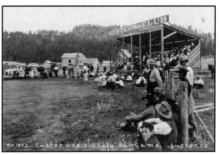

39-S. Custer Ball Club Stands, R.P.

20-S.	Shibe Park, Philadelphia		
	H.M. Rose, 1909, No. No.	100 - 125	125 - 150
21-S.	Polo Grounds, New York City "Home of		
	New York Giants" - Real Photo	10 - 15	15 - 20
22-S.	West Side Park, Chicago - Anonymous (RP)		
	1908 World Series	80 - 100	100 - 125
23-S.	Yankee Stadium, New York - Football Game		
	in progress. Irving Underhill, 1923	20 - 25	25 - 35
24-S.	Polo Grounds, New York Fake plane in air		
	McGowan-Silsbee	70 - 80	80 - 100
25-S.	American League Baseball Park, New York		
	T.W. (Thaddeus Wilkerson) (RP)	250 - 300	300 - 350
26-S.	Forbes Field, Pittsburgh - Opening day,		
	June 30, 1909 - Union News Co.	60 - 70	70 - 90
27-S.	Entrance to Forbes Field, Pittsburgh		
	Detroit Publishing Co., #12701	70 - 80	80 - 100
28-S.	Forbes Field, Pittsburgh. Pa.		
	Anonymous (RP)	60 - 70	70 - 90
29-S.	Sportsman's Park, St. Louis, Mo.		
	Anonymous	75 - 100	100 - 125
30-S.	Griffith Stadium Opening Day, (1951)		
	Wash., D.C. Anonymous	125 - 150	150 - 175
31-S.	Beautiful West Side Baseball Park, Chicago		
	With text and A.G. Spalding & Bros. ad	125 - 150	150 - 200
32-S.	Pitchers Practice at Cincinnati Ball Park		
	Kraemer Art Co. #1768, Color	100 - 110	110 - 125
33-S.	Opening of the Season, 1907, Cincinnati		
	and Pittsburgh. Morgan Stationery Co.	350 - 400	400 - 500
34-S.	Police Inspection at Ball Park, Cincinnati		
	1905 season, #617, 1907 Copyright	100 - 110	110 - 125
	Variation: "Cincinnati" then "Police		
	Inspection at Ball Park"	80 - 100	100 - 125
35-S.	Dover, N.H., Central Park Grounds	10 - 15	15 - 20
36-S.	Base Ball Game - South Orange Field,		
	South Orange, N.J.	15 - 20	20 - 25
37-S.	Black Game - N. Wilkesboro and Winston-		
	Salem, N.C. ca. 1909 (RP)	100 - 125	125 - 150
38-S.	Timber Lake, S.D., Cundill (RP) 1913	20 - 25	25 - 30
39-S.	Custer & Hill City Ball Game, Custer, S.D.		
	S.D. Butcher & Son Real Photo No. 1697	25 - 30	30 - 40

Major League Stadiums		
1900-1910 (Average)	40 - 60	60 - 80
Real Photos	80 - 100	100 - 150
1910-1920	20 - 30	30 - 40
Real Photos	50 - 60	60 - 80
1920-1940	15 - 20	20 - 30
Real Photos	30 - 40	40 - 50
Linens	5 - 15	15 - 25
Chromes	2 - 4	4 - 10
Minor League Stadiums 1900-1935	10 - 20	20 - 30
Real Photos	15 - 20	20 - 30
Linens	8 - 10	10 - 20

ARTIST-SIGNED

ALLAN (US) 1905-1915 (B&W)
 Political "Soak Him, Ted! Every time you hit ..." 40 - 50 50 - 60
 Political 118 "Back up; You've batted twice" 40 - 50 50 - 60
AVERY, A.F. (US) 1905-1915
 Motto 258 "To make you write shall I get: Baseball Bat" 18 - 22 22 - 25
BEATY, A. (US) 1905-1915
 Commercial Colortype
 325 "The Coming Champs" 25 - 30 30 - 35
 "Good Eye" 25 - 30 30 - 35
BROWNE, TOM (GB) 1905-1920
 Davidson Bros.
 "Baseball Illustrated"
 Series 2618
 1 "I am sorry I missed you" 20 - 25 25 - 30
 2 "I am sending you" 20 - 25 25 - 30
 3 "I am just having a high-ball" 20 - 25 25 - 30
 4 "I hope you will let me explain" 20 - 25 25 - 30
 5 "I want to explain why" 20 - 25 25 - 30
 6 "I am about to send you" 20 - 25 25 - 30
 Series 2619
 1 "I Intend Sending You" 20 - 25 25 - 30
 2 "I Hope to Get Home" 20 - 25 25 - 30

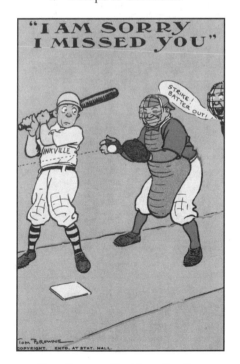

Tom Browne, Davidson Brothers
Ser. 2618-1, "'I'm Sorry I Missed You."

Political: Allan, Anonymous
"Soak him (Wilson), Ted! Every time
you hit him I get a vote."

Political: Allan, Anonymous
"Back up, you've batted twice."

Tom Browne, Davidson Brothers
Series 2619-1, "I Intend Sending You"

Fred Cavally Bears, Thayer Publishing
"Rain, Rain, Go Away

P. Crosby, Anonymous
"A Nice Little Single for an Old Bat"

3	"I'll Wait for You"	25 - 30	30 - 35
4	"I'm Sorry I Was Out"	25 - 30	30 - 35
5	"Never touched me"	25 - 30	30 - 35
6	"I hope to manage it somehow"	25 - 30	30 - 35

BW (GB) 1905-1915
 Heininger, Unger & Co. (B&W)

Valentine "Had I E'en the Batters Skill ..."	12 - 15	15 - 18

CARR, GENE (US) 1905-1915
 Rotograph Co.

Series 241-6 Children "One-O-Cat"	25 - 30	30 - 35
Series 242-1 Children "Baseball"	25 - 30	30 - 35

CASPARY, IRMA (US) 1905-1915
 D in an octagon logo (B&W and Color)

Man "A three-bagger with the bases full"	15 - 18	18 - 22
Man "I'm satisfied!"	15 - 18	18 - 22

CAVALLY, FRED L., JR. (US) 1905-1915
 Thayer Publishing Co. (Emb)

Teddy Bear "Rain, Rain, Go Away..."	35 - 40	40 - 45

C-D 1905-1915
 SB in circle logo

CS 524 Children "For Petey's sake"	15 - 18	18 - 22

COLLINS (US)
 ANL Publishing Co. Chromes

1-17-20 Nudist "Folks sure are friendly here"	6 - 8	8 - 10

CROSBY, P. (US) 1905-1915
 Anonymous Sepia

"A Nice Little Single for an Old Bat"	12 - 15	15 - 18
"A Triple Steal"	12 - 15	15 - 18
"The Ball Went Through Shortstop"	12 - 15	15 - 18
"Brought Home With a Hit"	12 - 15	15 - 18
"Going for Third"	15 - 18	18 - 22
"He Bit at Every Ball"	12 - 15	15 - 18
"He Made a Hit and Got Two Bags"	12 - 15	15 - 18
"Hitting the Out Drops"	12 - 15	15 - 18
Pretty Lady "Nice Curves"	15 - 18	18 - 22
"Out on Three Strikes"	12 - 15	15 - 18
Boy/Girl "Second Baseman Made a Swell Catch"	12 - 15	15 - 18
Skeleton "The Umpire Was Cool and Collected"	20 - 25	25 - 30
Series 565 "I've Never Touched a Drop"	12 - 15	15 - 18

DENETSOSIE, "HOKE" Linen
 L.H. "Dude" Larson (B&W)

C88 Chicken "I bet you can guess what I like ..."	8 - 10	10 - 12

DENNISTON (US) 1905-1915 *
 Gartner & Bender, Chicago Gray-White

"Ball??? Gwan - Right over de plate"	18 - 22	22 - 26
"Gee! Ain't she some fan"	18 - 22	22 - 26
"Go to it kid - Make a hit!"	18 - 22	22 - 26
"I'm due for a Hit!"	18 - 22	22 - 26
"Me for the Big League Now"	18 - 22	22 - 26
"Wee! Ain' I De Umpire?"	18 - 22	22 - 26

 *** Series also by publisher A.H. Katz**

DEWEY, ALFRED JAMES (US) 1905-1915
 Frederickson & Co. *
 Lovers Baseball Series 222 (12)

1 "Play Ball"	12 - 15	15 - 18
2 "Waiting for a good one"	12 - 15	15 - 18
3 "A Hit" (Rare!)	30 - 35	35 - 38
4 "A Sacrifice"	12 - 15	15 - 18

5 "A Single"	12 - 15	15 - 18
6 "A Double Play"	12 - 15	15 - 18
7 "Two Singles"	12 - 15	15 - 18
8 "Caught Stealing"	12 - 15	15 - 18
9 "A Costly Error"	12 - 15	15 - 18
10 "The Winning Drive"	12 - 15	15 - 18
11 "A Shut Out"	12 - 15	15 - 18
12 "The Score - One to Nothing"	12 - 15	15 - 18

Boston Sunday Post Issued with paper in various weeks. (Same Images as above)

6-18-1911 "A Sacrifice"	10 - 12	12 - 15
5-28-1911 "A Single"	10 - 12	12 - 15
5-21-1911 "A Double Play"	10 - 12	12 - 15
6-4-1911 "Caught Stealing"	10 - 12	12 - 15
6-25-1911 "A Costly Error"	10 - 12	12 - 15
6-11-1911 "A Shut Out"	10 - 12	12 - 15

DIEM, PETER (US) Linen (B&W)
 R.R. Donnelley

Advertisement "Bismark Hotel-Known for good food"	15 - 18	18 - 22

DOWNS (US) 1910-1930
 World Postcard Co.

"Dunlap's Baseball Nine"	25 - 30	30 - 40

DU WAN (US) 1920-1930 (US)
 Short Skirt Series 2353

Pretty Lady "I'm getting plenty of exersize"	15 - 18	18 - 22

DUGMORE, EDW. (US) 1940's
 M.N. Fleming

Military "Paris Island Boots"	15 - 18	18 - 22

DWIG (DWIGGINS, CLARE) (US) 1905-1915
 R. Kaplan "How Can You Do It" Series

49A "How can you do it on $4.30 per?"	22 - 25	25 - 28

E.S.H. (US) 1905-1915
 Commercial Colortype

312 Teddy Bear "Cubs at the bat"	20 - 25	25 - 30

ERICSON, ERIC (US) Linen
 Colourpicture Publishers

537 "Arrived Safely"	8 - 10	10 - 12

F 1915-1920
 Penn Publishing Co.

"Fun in the Navy" 4 "Chaplin umpires ... game"	10 - 12	12 - 15

FLC logo (US) 1905-1915
 F.J. Haffner (Emb)

Man 5475 "Three Strikes I'm Out" (B&W)	10 - 12	12 - 15

FLATO (US) 1940's (B&W)

	10 - 12	12 - 15
"For your boy a right posture suit"	10 - 12	12 - 15

FOX (US) Linen
 Tichnor Bros.

818 Boy/Girl "The new alibi, so you just went"	8 - 10	10 - 12

FRENCH, JARED (US) 1930-1940

Artvue Postcard Co. (B&W) Man "Safe"	10 - 12	12 - 15

GASSAWAY, KATHARINE (US) 1905-1915
 Rotograph Co.

F.L. 151 Children "The Baseball Player"	18 - 22	22 - 25

Denniston, Gartner & Bender
"Go to it kid—Make a hit!"

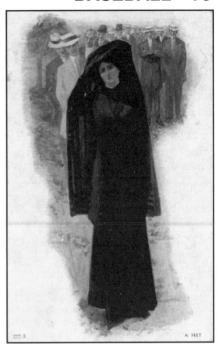

Charles Dana Gibson, Detroit Pub.
14192, "The Game Begins."

A. J. Dewey, Frederickson & Co.
Series 222-3, "A Hit"

K. Gassaway, Rotograph 151
"The Base-ball player."

Gibson
F. Derbes — "A fan out."

Button Face — Signed J.G.
"Life seems really worth..."

GIBSON, CHARLES DANA (US) 1905-1915
 G-6 "Two Strikes and the Bases Full" 12 - 15 15 - 18
F. Derbes - Published by A.H.
 "Fan" Series (B&W)
 "A Fan Out" 14 - 17 17 - 20
 "And they call that guy a pitcher" 14 - 17 17 - 20

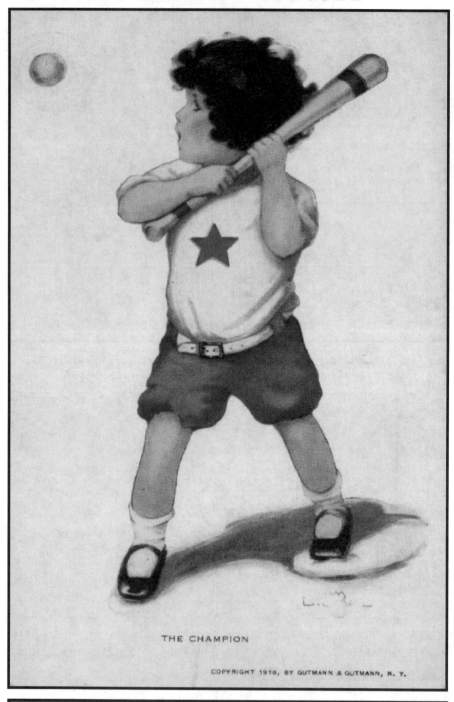

THE CHAMPION

COPYRIGHT 1910, BY GUTMANN & GUTMANN, N. Y.

"The Champion"
Meta Grimball, Gutmann & Gutmann

"Fanned Again"	14 - 17	17 - 20
"Now watch Casey bring in that run"	14 - 17	17 - 20
"Well, darn his hide, if he didn't swat it"	14 - 17	17 - 20
"Who's that guy?"	14 - 17	17 - 20

GIBSON, CHARLES DANA (USA) 1905-1915
 Detroit Publishing Co. (B&W)

14186 "Fanned Out"	16 - 20	20 - 24
14187 "Two strikes and the bases full"	16 - 20	20 - 24
14192 "The game begins"	16 - 20	20 - 24

GODFREY, WILLIAM (US) 1940's
 Albertype Co. (B&W)

Baseball Hall of Fame w/Yankee Stadium on back	5 - 7	7 - 9

GRANGIER, C.F. (US) 1905-1915
 Book Mark Co. College Series

1 Beautiful Lady Western Reserve U. Seal	20 - 25	25 - 30

GRIMBALL, META (US) 1905-1915
 Gutmann & Gutmann

"The Champion"	40 - 45	45 - 50

HAM, JOHN (US) Chromes
 Religion ST-588 "Our class is on the ball"

	5 - 7	7 - 8

HAREMS, RUSS (US) Chromes
 Charles Sanita

Man "A whollipin' St. Pats. Day From Erin, NY"	4 - 5	5 - 6

H.A.C. (US) 1905-1915
 Anonymous
 "Baseball in Rouse's Point (NY) Series (B&W)

406029 "Between the 'Mutt'a' with our friend..."	25 - 30	30 - 35
406030 "An important moment"	25 - 30	30 - 35

H.H. (H. Herman) (US) 1905-1915
 Ullman Mfg. Co.
 Blacks - Series 109 "The National Game"

2152 "A slide for second"	50 - 60	60 - 70
2153 "Out on a Fly"	50 - 60	60 - 70
2154 "A Foul Ball"	50 - 60	60 - 70
2155 "Making a Home Run"	50 - 60	60 - 75

JEFFERS, HELEN E. (US) 1905-1920
 Stecher Litho Co. (Emb)
 Series 89-D Valentine "If I were a freshman..."

	15 - 18	18 - 22

JOHNSON, J. (US) 1905-1915
 G on palette logo (Sam Gabriel)

407 Valentine "I make a hit with you"	15 - 18	18 - 22

JONES (US) 1910-1920
 Government Postal (B&W)

Boy/Girl "Baseball"	20 - 25	25 - 30

J.G. 1900-1907

Button Face "As we boldly advance ..."	50 - 60	60 - 70
Button Face "Life seems really worth the while ..."	50 - 60	60 - 70

K in box logo
 Raphael Tuck
 Series 2339 (6)

"Here's a liner straight from the bat"	22 - 25	25 - 30
"I'm greatly put out"	22 - 25	25 - 30
"I'm hurt"	22 - 25	25 - 30
"I'm waiting"	22 - 25	25 - 30

H.H. (H. Herman), Ullman Ser. 109
2152, "A Slide for Second"

H.H. (H. Herman), Ullman Ser. 109
2153, "Out on a Fly"

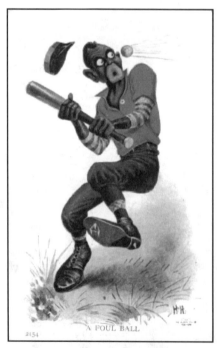

H.H. (H. Herman), Ullman Ser. 109
2154, "A Foul Ball"

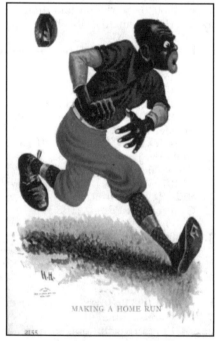

H.H. (H. Herman), Ullman Ser. 109
2155, "Making a Home Run"

Signed "K" — Raphael Tuck Baseball Series 2339
"Write Away" — "I Hope to Reach"

"I hope to reach"	22 - 25	25 - 30
"Where are you"	22 - 25	25 - 30
KEMP, SHIRLEY (US) Modern		
Memory Lane Postcards		
"Sam goes to Spring Training"	1 - 2	2 - 3
Mitchell Color Cards		
0082 "Ron Menchine, Voice of the Senators"	1 - 2	2 - 3
KETTLER, E. (US) 1905-1915 (Govt. Postal) (B&W)		
"Good Night-There goes the game"	20 - 22	22 - 26
KILVERT, CORY (US) 1905-1920		
Advertisement		
"The New American, Pittsfield, MA..." Vertical	25 - 30	30 - 35
Same - Horizontal	25 - 30	30 - 35
LAMB (US) Modern		
S.P. Co.		
490 Happy Birthday-I'm pitching right in ..."	1 - 2	2 - 3
M.D.S. (US) 1905-1915		
Ullman Mfg. Co.		
"Sporty Bears" Series 83		
"Here's for a Home Run"	25 - 30	30 - 35
MASTERS, DEL (US) 1930-1945 (Non-PC)		
Mutoscope Pinup "Hit and Miss"	10 - 12	12 - 15
McCUTCHEON, JOHN T. (US) 1905-1915		
Boys in Springtime Series		
1 "Dog Gone It! - I wish they hadn't found it ..."	15 - 18	18 - 22
McGILL, DONALD (GB) 1940's		
Bamforth Co.		
Children "An' if I catch a German Spy ..."	15 - 20	20 - 25
METCALF (US) Chromes		
Plastichrome P15581 Children No Caption	1 - 2	2 - 4

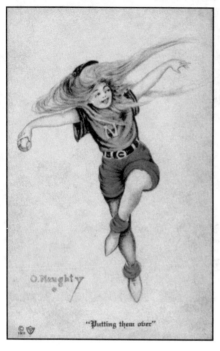
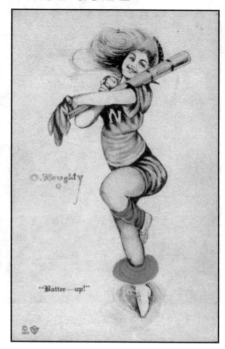

O. Naughty, Empire Art Series 769
"Putting them over"

O. Naughty, Empire Art Series 769
"Batter—up!"

MEYER (US) Linen		
Colourpicture Publishers		
Dog 1127 "Screwball Sights - Dog Catcher ..."	6 - 8	8 - 10
MITTENDORF 1905-1920 (B&W)	8 - 10	10 - 12
MUNSON, WALT (US)		
Tichnor Bros. (Linen)		
69507 **Blacks** "Let's Play Around" (Unsigned)	6 - 8	8 - 10
Also Chrome	6 - 8	8 - 10
NBC logo (US) 1905-1920		
J. Tully		
Series 249 Children No Caption	15 - 18	18 - 22
NAUGHTY, O. (US) 1905-1915		
Empire Art Co.		
Series 769 Ladies		
"Batter Up"	30 - 40	40 - 50
"Putting them over"	30 - 40	40 - 50
"Right in the mitt"	30 - 40	40 - 50
"Safe on First"	30 - 40	40 - 50
O'NEILL, ROSE (US) Reproduction		
The Ashers Kewpie eating ice cream No Caption	2 - 3	3 - 4
OUTCAULT, R.F. (US) 1905-1915		
Advertisement - Boy Blue, May, 1913 Calendar	50 - 55	55 - 60
Yellow Kid Calendar Series		
April 1915	70 - 80	80 - 100
J. Ottman Litho Co.		
"I hear you made a great hit. Take your base"	18 - 22	22 - 25
"I expect to be home soon"	18 - 22	22 - 25

The prodigal son made a home run,
Brother Noah gave out checks for rain.

L. C. Phifer,
E. L. Company

Illustrated Song
Series, 1820
"The prodigal son
made a home run,
Brother Noah gave out
checks for rain."

L. C. Phifer,
E. L. Company

Illustrated Song
Series, 1820
"Rebecca went to the
well with a pitcher and
Ruth in the field won
fame."

Rebecca went to the well with a pitcher
And Ruth in the field won fame.

Goliath was struck out by David
A base hit made on Abel by Cain.

L. C. Phifer,
E. L. Company

Illustrated Song
Series, 1820
"Goliath was struck out
by David. A base hit
made on Abel by
Cain."

L. C. Phifer,
E. L. Company

Illustrated Song
Series, 1820
"Eve stole first and
Adam second. St. Peter
umpired the game."

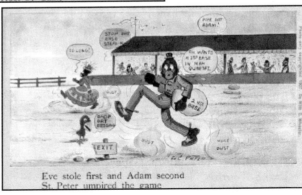

Eve stole first and Adam second
St. Peter umpired the game.

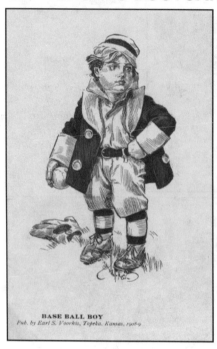

BASE BALL BOY
Pub. by Earl S. Voorhis, Topeka, Kansas, 1908-9

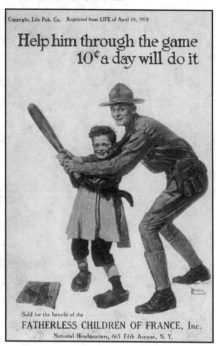

Copyright, Life Pub. Co. Reprinted from LIFE of April 18, 1918

Help him through the game
10¢ a day will do it

Sold for the benefit of the
FATHERLESS CHILDREN OF FRANCE, Inc.
National Headquarters, 665 Fifth Avenue, N. Y.

A. T. Reid, Earl S. Voorhis
"Base Ball Boy"

Norman Rockwell, Whitney Made
"Fatherless Children of France, Inc."

PHIFER, L.C. (US) 1905-1915
 Theodore Eismann 1905-1915 * **
 Blacks "Illustrated Song Series" 1820 (4)

"Eve stole first and Adam second"	40 - 50	50 - 60
"Goliath was struck out by David"	40 - 50	50 - 60
"Rebecca went to the well with a pitcher"	40 - 50	50 - 60
"The Prodigal Son made a home run"		

 * **DeWitt C. Wheeler**

Same series as above but light blue borders (4)	40 - 50	50 - 60
** Also issued in strip form (4)	30 - 35	35 - 40

PHILLIPS, CHAS. D. (US) Chrome
 Dexter Press

91420 No Caption	2 - 3	3 - 4

RMD (US) 1906 (Govt. Postal)

Hand Drawn	15 - 18	18 - 22

RS Chrome
 Baxter Lane Co.

82C Children "D'ya think the guy'sll know ..."	2 - 3	3 - 4

RAMSEY, NORMAN (US) Modern (B&W)
 Custom Art

Advertisement "Landmarkable Chicago"	3 - 4	4 - 5

RASCHEN (US) 1905-1915
 Burgess

Baseball game in progress No caption	35 - 45	45 - 55

REID, ALBERT T. (US) 1905-1915
 Earl S. Voorhis

"Base Ball Boy"	20 - 25	25 - 30

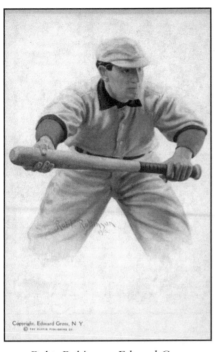

<div align="center">

Robt. Robinson, Edward Gross
The Bunter!

Cobb X. Shinn, HWB Co.
"Hot off the bat!"

</div>

ROBINSON, ROBERT (US) 1905-1915

Edward Gross		
208 Boy ready to pitch	20 - 25	25 - 30
209 Player squaring to bunt	20 - 25	25 - 30
210 Catcher doffing mask	20 - 25	25 - 30
211 Three Fans cheering	20 - 25	25 - 30

ROCKWELL, NORMAN (US) 1910-1920

Whitney Made		
"Fatherless Children of France"		
"Help Him Through the Game"	40 - 40	50 - 60
Kelley's Studio Chrome		
ICS-107213	5 - 8	8 - 10
Anonymous Umpire	2 - 3	3 - 4

ROY, TONY (US) Chrome

Dexter Press		
7571B Chicken "Somebody Goofed"	3 - 4	4 - 5

RYAN, C. (US) 1905-1915

Anononymous		
X226 "The National Pastime - Kill the Umpire"	20 - 25	25 - 30
A612 "Dictionary of Entomol, 097 - Baseball Bug"	40 - 50	50 - 60

SPS 1905-1915

Van Marter		
College "Wow, Wow ... - Rolling up a score"	12 - 15	15 - 18

S.D.Z. (US) 1905-1915

International Post Card Co.		
Comic Series 1		
Man "I was called out"	20 - 25	25 - 30

C. Ryan, Anonymous, X226
"Kill the Umpire!"

Man "I would have been home but ..."	20 - 25	25 - 30
Man "On the run home"	20 - 25	25 - 30
SHINN, COBB X. (US) 1905-1915		
H.W.P. Co. Children		
"Don't say it just think it!"	12 - 15	15 - 18
"Gee! Her dad must have been a b.b. pitcher ..."	12 - 15	15 - 18
"Go on, all ye baseball bugs ..."	12 - 15	15 - 18
"Hot off the bat! I' like to see you"	12 - 15	15 - 18
"I guess I'll stick around ..."	12 - 15	15 - 18
"I'm so sweet dat I think the flies ..."	12 - 15	15 - 18
"Say, Here's a hot one for you"	12 - 15	15 - 18
"They never stop this game on account of ..."	12 - 15	15 - 18
"You are a hit! In fact, a home run and a winner"	12 - 15	15 - 18
"You look as good to me as a home run ..."	12 - 15	15 - 18
"You look like the star of my league ..."	12 - 15	15 - 18
"You may think dat I'm a bone head..."	12 - 15	15 - 18
T.P. & Co.		
Series 875 Children		
"Daffydils - when a girl cries"	18 - 22	22 - 26
Others	18 - 22	22 - 26
SIRRET (US) 1905-1915		
T.P. & Co.		
Series 796 Man "You're all bald up"	12 - 15	15 - 18
SMITH, LARRY (US) Linen		
Asheville Post Card Co.		
Blacks GC84 "O.K. Big Boy you furnish the ..."	5 - 6	6 - 8
SMITH, R. SCHYLER 1970's		
Clearline Art		
"Forest Hills Park" on back	3 5	5 - 7

C. Twelvetrees, E. Gross — Smile
Messengers 92, "Be Careful Cutie"

C. A. Voight (@ C. A. Voight)
#12, "The Water Boy"

SPRAGUE (US) Chrome

 Coffeyville Historical Soc. "Walter Johnson" 3 - 4 4 - 6

SULLIVAN, P.D. (US) 1905-1915

 Man "How does that strike you" 10 - 12 12 - 15

T.O.J. logo (US) 1905-1915

 M.T. Sheahan

 Children "The Failures God Bless Them..." 10 - 12 12 - 15

 Children "To Boys" 10 - 12 12 - 15

TORI 1910-1920

 Anonymous

 Pitcher winding up No caption 80 - 90 90 - 100

TWELVETREES, C. (US) 1905-1925

 Edward Gross

 3 "Speaking of Curves ..." 15 - 20 20 - 25

 Smile Messengers 92 "Be Careful Cutie ..." 15 - 20 20 - 25

 "American Kid" Series 14 (B&W)

 "Our Side's ten runs ahead" 15 - 20 20 - 25

 Series 15 (B&W)

 "Two men out and three on base" 15 - 20 20 - 25

 "Baseball Kid Series" (B&W)

 "A Two Bagger" 15 - 20 20 - 25

 "Fanned Out" 15 - 20 20 - 25

 "Stealing a Base" 15 - 20 20 - 25

 Anonymous

 "A Double Play" Color 15 - 20 20 - 25

 "A Home Run" (B&W) 15 - 20 20 - 25

C. A. Voight (@ C. A. Voight)
#1, "Left Fielder"

Signed "WH" — The Rose Company
"Money to spare he never has..."

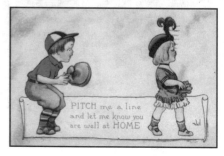

Bernhardt Wall, Bergman Series 6501
"Pitch me a line..."

"A Squeeze Play" (B&W)	15 - 20	20 - 25
"Choosin' Sides"	15 - 20	20 - 25
"His Inning" (B&W)	15 - 20	20 - 25
"His Inning" - Ad for Bickley's Worm Syrup (B&W)	15 - 20	20 - 25
"The Hope of the Team"	15 - 20	20 - 25
"The Mascot" (B&W)	15 - 20	20 - 25
"Who Said Out"	15 - 20	20 - 25

VOIGHT, C.A. (US) 1905-1915

C.A. Voight Children (12)

1 Kidville Ball Team "Left Fielder"	15 - 18	18 - 20
2 "Center Fielder"	15 - 18	18 - 20
3 Kidville Ball Team "Right Fielder"	15 - 18	18 - 20
4 "First Baseman"	25 - 30	30 - 35
5 Kidville Ball Team "Second Baseman"	15 - 18	18 - 20
6 Kidville Ball Team "Third Baseman"	15 - 18	18 - 20
7 "Shortstop"	15 - 18	18 - 20
8 "The Catcher"	15 - 18	18 - 20
9 "The Pitcher"	15 - 18	18 - 20
10 Kidville Ball Team "The Batter"	18 - 22	22 - 26
11 "The Mascot"	15 - 18	18 - 20
12 "The Water Boy"	30 - 35	35 - 40

WFD (US) 1905-1915

Anglo-American P.C. Co. Anglo Pastelle Series

123 "Putting it Over"	25 - 30	30 - 35

WH (US) 1905-1915

The Rose Co.

"Money to spend he never has"	15 - 18	18 - 22

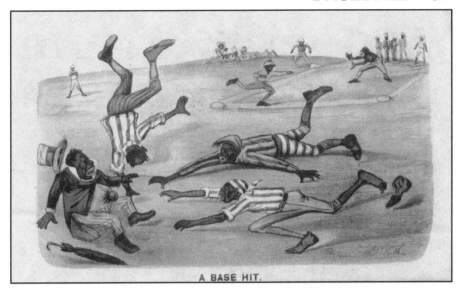

A BASE HIT.

Frank Worth, Anonymous Publisher, Undivided Back
"A Base Hit"

WALL, BERNHARDT (US) 1905-1920
 J.I. Austen Co.
 393 College girl with red "C" 18 - 22 22 - 25
 S. Bergman Children
 Series 6501 (12)
 "The FIRST BASE for writing..." 12 - 15 15 - 20
 "I'd like to CATCH a train and pay you a visit" 12 - 15 15 - 20
 "I'd like to make a home run with you" 12 - 15 15 - 20
 "I'd like to shortstop you ..." 12 - 15 15 - 20
 "I'd like to take a run home to see you" 12 - 15 15 - 20
 "I'd sooner catch that chicken than a foul" 12 - 15 15 - 20
 "I'm not a bit bitter for being a bad batter ..." 12 - 15 15 - 20
 "I'm still waiting ..." 12 - 15 15 - 20
 "Nobody loves nobody when nobody makes a hit" 12 - 15 15 - 20
 "Pitch me a line and let me know ..." 12 - 15 15 - 20
 "Put one right over here on the swatter" 12 - 15 15 - 20
 "Would I be safe if i stole a kiss instead of base?" 12 - 15 15 - 20
 Ullman Mfg. Co.
 Komic Kids Series 189 "The Home Bawl Team" 18 - 22 22 - 26
WOOD, LAWSON (GB) 1915-1930
 Brown & Bigelow 'Gran'Pop" Series
 36324 "An Eye For The Fast Ones" 10 - 12 12 - 15
WORTH, FRANK (US) 1900-1907
 Anonymous — "A Base Hit" 40 - 50 50 - 60
ZIM (US) 1905-1915
 "Play Ball" 12 - 15 15 - 18
 H.G. Zimmerman & Co., Chicago
 Heavily Emb - "Airbrushed"
 "A Slide for First" 22 - 25 25 - 28
 "Caught Between Bases" 22 - 25 25 - 28
 "Out on a Foul" 22 - 25 25 - 28

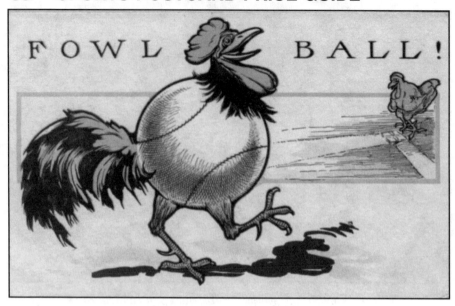

Publisher A-H Company — "Foul Ball!"

PUBLISHERS

AA in circle logo **(Anglo-American)** 1905-1915
 Baseball Notes
 Series 32 (B&W)

Man "A Good Sticker"	35 - 40	40 - 45
Man "2 Balls and 1 Strike"	35 - 40	40 - 45
Man "Catching a High Fly"	35 - 40	40 - 45
Boy/Girl "Two Men Down"	35 - 40	40 - 45
Man "3 strikes and out"	35 - 40	40 - 45
Boy/Girl "Two men down"	25 - 30	30 - 35
Black "He caught a fowl"	40 - 45	45 - 50

REPRODUCTION OF IMAGES IN THIS BOOK

All images in this book are the final results of using various computer programs where each card is scanned, photostyled to the best grayscale clarity, and placed in position in the text. Real photo and some black and white cards are usually the best for this process, and the images reproduce very well. However, the majority of original postcards were printed in many colors and shades, in sepia, or simply were very poorly printed in many instances. Therefore, they are sometimes difficult to reproduce for books where only black and white copy is used. Because of their great historical value, their rarity, or great interest to collectors, we have intentionally used many of these cards even though they did not reproduce well.

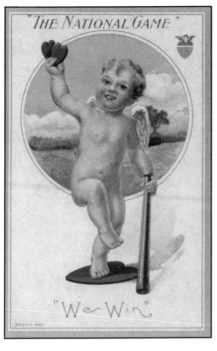

AMP Company, The National Game
Series 809, "We Win"

Publisher F. von Bardeleben
U.S. 777 —"Foul Ball"

ACP Co. in circle logo 1910-1920
 "I Married My Wife" Series 2202
 "-to avoid going to war" 15 - 18 18 - 22
A H Co. 1905-1915
 Humor Note: two varities of series-one foreign backs
 "A Fast Ball" Man 15 - 18 18 - 22
 "A Wild Pitcher" 15 - 18 18 - 22
 "Dead Ball" Man 15 - 18 18 - 22
 "Fowl Ball" Rooster 18 - 22 22 - 26
 "Safe Hit" 15 - 18 18 - 22
 "Stealing a Base" Man 15 - 18 18 - 22
AMP. Co. in a shield (Alan Moss Publishers) 1905-1915
 "To My Valentine" (Emb)
 Series 504
 "An Easy Catch" 25 - 30 30 - 35
 "Making a Home" 25 - 30 30 - 35
 "I'm On To Your Curves" 25 - 30 30 - 35
 "Take Your Base" 25 - 30 30 - 35
 "We Win" 25 - 30 30 - 35
 "You're Out" 25 - 30 30 - 35
 "The National Game" Valentines (Emb) *
 Series 809
 "An Easy Catch" 12 - 15 15 - 18
 "Making a Home" 12 - 15 15 - 18
 "I'm On To Your Curves" 12 - 15 15 - 18
 "Take Your Base" 12 - 15 15 - 18
 "We Win" 12 - 15 15 - 18

Anonymous, Balligan Series *Publisher S. Bergman, Series 8812*
"A great game, boys" *"It comes high but we must have it"*

"You're Out"	25 - 30	30 - 35
* Same as series 504 except title.		
A.T.F. Co.		
Motto Series "If baseball players contract..."	10 - 12	12 - 15
Albertype Co., The 1930-1960		
Advertisement (B&W)		
Baseball Hall of Fame/Museum, Cooperstown	10 - 12	12 - 15
F.H. Alt		
"Valuable Hints on Baseball"	12 - 15	15 - 18
Andres Product Co. Linen		
Advertisements		
"Left Field Al Schacht's Restaurant"	10 - 12	12 - 15
E-10713 "The Scouts Room Al Schacht's Restaurant"	10 - 12	12 - 15
Artvue Postcard Co. 1920-1930 (B&W)		
Man "It was a warm proposition in the old days"	12 - 15	15 - 18
B in a diamond logo 1905-1915		
113 "We Are Making a Great Hit"	10 - 12	2 - 15
B.B., London (Birn Bros.) 1905-1915		
Teddy Bears		
E318 "Wishing you everything you wish yourself"	20 - 25	25 - 30
E.B. & E. 1905-1915		
64 "An Eye Catcher"	15 - 18	18 - 22
B&B 1935-1940		
Advertisement Vy Vyan Cosmetique Studio		
"Put it over" Calendar for 1937	12 - 15	15 - 20
F. von Bardeleban, New York 1905-1915		
Sports		

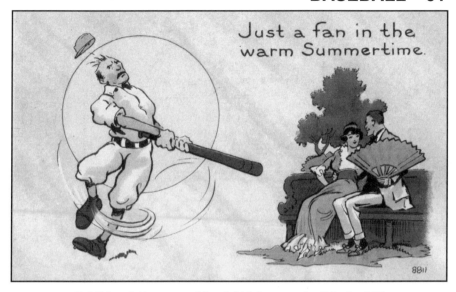

Publisher S. Bergman, "Good Old Summertime" Series 8811
"Just a fan in the warm Summertime"

U.S. 720 "Sports-Baseball"	25 - 28	28 - 32
U.S. 777 "Foul Ball"	22 - 25	25 - 28
U.S 778 "Home! Home! Slide, you lobster!!!"	22 - 25	25 - 28
U.S. 779 "Back to the Ribbon Counter for yours!"	22 - 25	25 - 28
U.S. 780 "That's going some - Wot?"	22 - 25	25 - 28
U.S. 781 "Well I guess I'm bad, eh?"	22 - 25	25 - 28
U.S. 782 "7th Inning 'Stretch'!"	22 - 25	25 - 28
Baxter Lane Co. Chrome		
57-C Boy/Girl "My boss said if I play ball ..."	3 - 4	4 - 6
Beales Litho & Printing Co. Linen		
Advertisement - "Portis Hats - Big League Style"	22 - 25	25 - 28
S. Bergman 1905-1915		
No No. Girl "Some Catcher" (Printed photo)	15 - 20	20 - 25
Series 805 Boy/Girl		
2 "I'm getting a couple of hot curves right over..."	15 - 18	18 - 22
Series 8811 "Good Old Summertime" (12)		
"A Shortstop in the Summertime"	15 - 18	18 - 22
"Come along and put one over..."	15 - 18	18 - 22
"Come to me, oh come to me..."	15 - 18	18 - 22
"Everybody wants an inning..."	15 - 18	18 - 22
"Here's a hot one in the hot Summertime"	15 - 18	18 - 22
"I can make the delivery in the good old..."	15 - 18	18 - 22
"I hope to get there soon in the gladsome..."	15 - 18	18 - 22
"I will have thee near me..."	15 - 18	18 - 22
"I will make a good run for you"	15 - 18	18 - 22
"It feels good to have won and made good"	15 - 18	18 - 22
"It's great fun studying the stars in the good..."	15 - 18	18 - 22
"Just a fan in the warm summertime"	15 - 18	18 - 22
Series 8812 Fill in the City Series		
"I **Challenge** you to come to _____"	10 - 12	12 - 16
"I guess I made a **Hit** here in _____"	10 - 12	12 - 16

"I shall try to **Put** one **Over** in _____"	10 - 12	12 - 16
"I'd like to make a **Hit** in _____"	10 - 12	12 - 16
"I'm having my **Inning** in _____"	10 - 12	12 - 16
"I never let anything **Get By** me in _____"	10 - 12	12 - 16
"It comes **High** but we must have it in _____"	10 - 12	12 - 16
"It's good to **Win** out in _____"	10 - 12	12 - 16
"**Pitch** me a line to _____"	10 - 12	12 - 16
"My **Base** is in _____"	10 - 12	12 - 16
"We should like to **Catch** you here in _____"	10 - 12	12 - 16
Series 8855 Blacks		
"I jes loves er man dat can make er squeeze play"	40 - 45	45 - 50
Julius Bien & Co. 1905-1915		
Series 16		
"You made an awful hit with me"	20 - 25	25 - 28
Series 18 (B&W)		
3 "Perhaps I'm not the best looker ..."	15 - 20	20 - 25
8 "I'm a plain little baseball fan ..."	15 - 20	20 - 25
Series 26		
"I can't seem to make a hit"	20 - 25	25 - 28
Series 36 "Will I" Series		
Will I ever again take her to a ball game?"	20 - 25	25 - 30
Will I ever again umpire another ball game ..."	20 - 25	25 - 30
Benjamin Burdick, 1907		
"It's a Three Bagger Cinch"	12 - 15	15 - 18
Carbon Photo 1910-1920 Sepia		
486 Man "You can't put 'em over"	18 - 22	22 - 25
Colonial Art Pub. Co. 1905-1915		
Printed Photos (9) (Sepia)		
"A Balk"	6 - 8	8 - 12
"A Chance to play"	6 - 8	8 - 12
"A High Ball"	6 - 8	8 - 12
"A Sacrafice"	6 - 8	8 - 12
"A Steal"	6 - 8	8 - 12
"Breaking her contract"	6 - 8	8 - 12
"Catching a Hot One"	6 - 8	8 - 12
"Covering left field"	6 - 8	8 - 12
"Delaying the game"	6 - 8	8 - 12
CO.-V.S. 1910-1920		
Two Children-Adult Photos Sepia		
Man "Born a fan"	15 - 18	18 - 22
Man "Here's a High Ball"	15 - 18	18 - 22
Colourpicture Publishers Chrome		
Advertisement SK9638 "Cooperstown, New York"	3 - 4	4 - 6
L.R. Conwell 1905-1915		
Valentine Series 415		
Children "As champion of all sporting teams..."	18 - 22	22 - 25
Curteichcolor Chrome		
Advertisement		
Holiday Inn of Joplin, MO operated by M. Mantle	20 - 25	25 - 30
3DK-1702 "John Sain - Yankee Pitching Coach"	12 - 15	15 - 20
Curt Teich & Co., Inc. Linen		
Advertisement - Florsheim Shoes		
"Don't Put An Outcurve Foot ..."	18 - 20	20 - 25
D & Co. 1910-1920		

Colonial Art Co.
"Catching a hot one"

Fond & Company, Detroit, Tiger
Pennants, 1907-8 — "It is to Laugh"

Leather 18 "Pon my Soul I'm forcibly struck ..."	25 - 28	28 - 32
Dexter Press Chrome		
Advertisement 48082 Al Schact's - Story at bottom	12 - 15	15 - 18
J.T. Dye 1930-1940		
Large Letter "Greetings from the Giants"	35 - 40	40 - 50
E.B. & E. 1905-1915		
64 "An Eye Catcher"	15 - 18	18 - 22
Eagle & Shield logo 1905-1915		
Heavily Embossed "Airbrushed" Series	20 - 25	25 - 28
Batter-Catcher-Player	20 - 25	25 - 28
Batter-Catcher-Umpire	20 - 25	25 - 28
Left handed Batter	20 - 25	25 - 28
Right handed Pitcher	20 - 25	25 - 28
Leaping catch in with fans in rear	20 - 25	25 - 28
Head-first slide - leaping fielder	20 - 25	25 - 28
Empire Art Co. 1910-1920		
769 Girl "Batter Up"	18 - 22	22 - 26
The Fairman Co. 1905-1920		
No No. "Take me out to the ball game" (B&W)	18 - 22	22 - 26
Series 74 Boy/Girl		
"A Hit"	20 - 25	25 - 30
Series 159 Blacks (8)		
"Ah guess ah must er made an error"	30 - 35	35 - 38
"Ah sho would like to make er hit with yo"	30 - 35	35 - 38
"Ah sho would love to get er liner ..."	30 - 35	35 - 38
"Ain' you nebber gwin ..." *	30 - 35	35 - 38
"Honey, yo sho he was fasinated ..." *	30 - 35	35 - 38

"I'se feelin prime and mah appetite ..." *
"I'se jest makin' er short stop here" 30 - 35 35 - 38
"I'se makin' er slide fo home - expect me" * 30 - 35 35 - 38
* Values are for cards in color. Deduct $5 for B&W.
G. Felsenthal & Co. 1905-1915
"Magic Moving Pictures" Three baseball scenes 20 - 25 25 - 30
The Frederickson Co. 1905-1915
Series 3123 "Choosing up Sides" 15 - 18 18 - 22
G. D. & D. 1905-1915
Children Series 5017 (12)
"A Good 'Catch' - Pittsburgh" 22 - 25 25 - 28
"Chase yourself kid! ... off your 'Base' - Brooklyn ..." 22 - 25 25 - 28
"Do I make a 'Hit' with you - Detroit" 22 - 25 25 - 28
"Don't judge me too harshly - Boston" 22 - 25 25 - 28
"I am studying the 'Curves' - Washington" 22 - 25 25 - 28
"I expect to 'Strike' something soon! - Philadelphia" 22 - 25 25 - 28
"I would like to 'Steal' you - Cincinnati" 22 - 25 25 - 28
"I'd like to 'Catch' on to a nice girl - New York" 22 - 25 25 - 28
"I'm all 'Put Out' about you - St. Louis" 22 - 25 25 - 28
"Practice makes perfect ...You need ... Cleveland" 22 - 25 25 - 28
"Say - I'm going 'Batty' over you - Chicago" 22 - 25 25 - 28
"The 'Bases' full - New York" 22 - 25 25 - 28
Series 5099 Valentines
"Slide 'Home!' That's it ...!" 15 - 18 18 - 22
G & W. Co. Modern
Religion 226 A baseball game needs nine to play ..." 5 - 7 7 - 9
Religion R.D. 92 Rally Day Next Sunday 5 - 7 7 - 9
J.R. George 1907 (B&W) Girl and Tiger
"Rah For The Tigers!" Season 1907 on Pennant 40 - 45 45 - 50
Gibson Art Co. 1905-1920 Sepia
"Here's to the Base Ball Fan ..." 10 - 12 12 - 15
Gospel Publicity League (B&W)
Religion 7092 "Safe I will say of the Lord ..." 6 - 8 8 - 10
Great Western PC & Novelty Co. 1905-1915
Series 11
Baseball Players should ... from Bili-can" 15 - 20 20 - 25
I. Grollman 1905-1912
Political "Presidential Camp" (4)
"Democracy at Bat" 150 - 175 175 - 200
"Democracy Makes Home-Run Democrats at Bat " 150 - 175 175 - 200
"G.O.P. at Bat" 150 - 175 175 - 200
"G.O.P. Makes Home Run" 150 - 175 175 - 200
HSV Litho 1905-1915
"There's-A-Reason" Series
26 "Baseball 50 Cents To-Day" on sign on fence 20 - 25 25 - 30
V.O. Hammon Pub. Co. 1905-1915
259 Fat Man "It went against his stomach" 10 - 12 12 - 15
H in circle 1905-1915
960 "Home Team - Visiting Team Score" 18 - 20 20 - 25
976 "Formula for Telling a Base Ball Li..." 18 - 20 20 - 25
978 "A Pitch in Time Saves the Nine" 18 - 20 20 - 25
1002 "How would you like to be the Umpire!!!?" 18 - 20 20 - 25
1007 "What is your Batting Average?" 18 - 20 20 - 25
1009 "A 'Home Run' when needed is almost..." 18 - 20 20 - 25

*1908 Political:
Publisher I. Grollman
"Democracy Makes
Home Run"*

*1908 Political:
Publisher I. Grollman
"G.O.P. at Bat"*

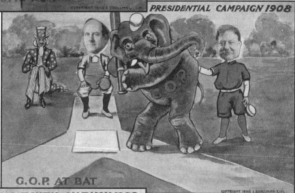

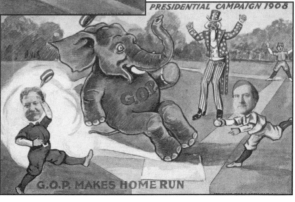

*1908 Political:
Publisher I. Grollman
"Democracy at Bat"*

*1908 Political:
Publisher I. Grollman
"G.O.P. Makes Home
Run"*

1011 "Batter Out"	18 - 20	20 - 25
1048 "Fanned Out"	18 - 20	20 - 25

H.I.R. 1910 around circle logo (B&W)
 Wide Gray Borders Girl and player photo

"A Balk"	15 - 18	18 - 22
"A Close Play"	15 - 18	18 - 22
"A Steal"	15 - 18	18 - 22
"A Tie Game"	15 - 18	18 - 22
"Breaking Her Contract"	15 - 18	18 - 22
"Catching a Hot One"	15 - 18	18 - 22
"Covering Left Field"	15 - 18	18 - 22
"Delaying the Game"	15 - 18	18 - 22
"Safe"	15 - 18	18 - 22
"1 to 1"	15 - 18	18 - 22

HSV Litho in a shield logo 1905-1915
 "That's What They All Say" Series

25 "I didn't want to hit it that time"	20 - 25	25 - 28

F. Haass 1905-1915
 "Baseball Series" 66 (B&W)

Boy/Girl "A Hit"	15 - 18	18 - 22
Drunk "The Short Stop Got Mad ..."	15 - 18	18 - 22
Man "Stopping a Hot One"	15 - 18	18 - 22
Boy/Girl "Stopping two Beauties in Center	15 - 18	18 - 22
"Getting in on a Passed Ball"	15 - 18	18 - 22

O.E. Hasselman 1908

140 "Struck Out"	20 - 25	25 - 28
142 "Out on a Fly"	20 - 25	25 - 28
144 "Ba(wl)ll 3!"	20 - 25	25 - 28
146 "A Home Run"	20 - 25	25 - 28
165 "The King of Diamonds ..."	20 - 25	25 - 28

Henry Heininger Co. 1905-1915
 Valentine Series 107

"Had I E'en the Batters Skill ..."	18 - 22	22 - 26

Hilborn Novelty Adv. 1905-1920
 Patriotic (Photo)

A10 Uncle Sam "They Can't Strike Him Out!"	25 - 28	28 - 32

H.V. Howe 1905

"You're a Knocker"	12 - 15	15 - 18

J. Raymond Howe Co., Chicago 1905-1915
 Series 2715 Boy - Brown Circle

1 "To Make a Hit in a Game of Ball..."	18 - 22	22 - 26
2 "It's easy to Catch Something..."	18 - 22	22 - 26
3 "All My Decisions Would Favor You..."	18 - 22	22 - 26
4 "Where ever you go - The home plate's.."	18 - 22	22 - 26

Franz Huld 1905-1915
 College (Emb)

"Cornell! Yell! Yell!"	20 - 25	25 - 28

I.P.C. & N. Co. 1905-1915

1371 "Baseball - The Army Game" Printed Photo	10 - 12	12 - 15
5001-5 Catcher in blue uniform tags out runner	20 - 25	25 - 30

Inter-Coll P.C. Co. 1905-1915

P 0384 batter standing in front of a "P" No caption	18 - 22	22 - 25

J.A. Co. 1905-1915 (Sepia)

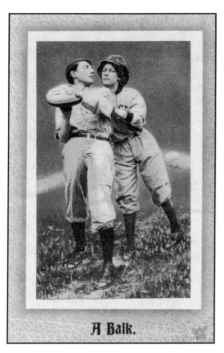

Publisher H.I.R.
"A Balk."

Publisher O. E. Hasselman
"Out On A Fly"

Publisher H in Circle, 1002 — "How
would you like to be the umpire!!!"

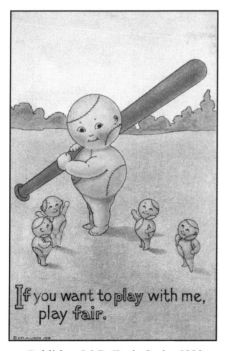

Publisher L&R, Fanie Series 1000
"If you want to play with me..."

Publisher K-Win & Co.
"A Home Run"

Political: Publisher Jones & Sellers
"Old Man, You've Got a Slim..."

Publisher P.C.K., Series B.204
"When in doubt 'Touch Second'!"

"Here's to the Baseball Fan ..."	15 - 18	18 - 22
Jones & Sellars 1905-1915		
Political "Old Man You've Got a Slim Chance ..."	50 - 60	60 - 75
A.H. Katz 1905-1915 *		
Children (B&W)		
"Ball??? Gwan - Right over the plate!"	18 - 22	22 - 26
"Gee! Ain't She Some Fan?"	18 - 22	22 - 26
"Go to it Kid - Make a Hit"	18 - 22	22 - 26
"I'm Due for a Hit"	18 - 22	22 - 26
"Me for the Big League Now"	18 - 22	22 - 26
"Wee! Ain't I De Umpire?"	18 - 22	22 - 26
* Same as **Gartner & Bender Series S/Denniston**		
K-Win & Co. 1905-1915		
Blacks "Catching a Fowl Out"	25 - 35	35 - 45
Blacks "A Home Run"	25 - 35	35 - 45
Kosmos Art Co., Boston 1905-1915		
The Richard Carle Baseball Series 1090		
1 "Play Ball"	20 - 25	25 - 30
2 "A Hit"	20 - 25	25 - 30
3 ????????	20 - 25	25 - 30
4 "Umpire's a Corker"	20 - 25	25 - 30
5 "Right in His Mit"	20 - 25	25 - 30
6 "Out"	20 - 25	25 - 30
7 "One Ball"	20 - 25	25 - 30
8 "Two Balls"	20 - 25	25 - 30
9 "Three Balls"	20 - 25	25 - 30
10 "Base on Balls"	20 - 25	25 - 30
11 "Two Out"	20 - 25	25 - 30
12 "Three Out"	20 - 25	25 - 30
13 "Another Run"	20 - 25	25 - 30

14	"Umpire's Rotten"	20 - 25	25 - 30
15	"Bases Full"	20 - 25	25 - 30
16	"Over the Fence"	20 - 25	25 - 30
17	"I told you so"	20 - 25	25 - 30

E.C. Kropp Linen
Advertisement 1243 "Health Begins in Marlin, Texas,
Famous For It's Hot Mineral Waters" 22 - 25 25 - 28

L & R, New York 1910-1920
Fan-ie Series 100 Kewpies (12)

"Am not strong on catch, But ..."	15 - 20	20 - 25
"Hello? Anything doing? ..."	15 - 20	20 - 25
"I am up in the air about you"	15 - 20	20 - 25
"If I catch you - Can I hold you?"	15 - 20	20 - 25
"If I strike it - Will you take a chance with me?"	15 - 20	20 - 25
"If you want to play with me - play fair"	15 - 20	20 - 25
"I'm in the field with a home and diamond ..."	15 - 20	20 - 25
"In the land of spirits - with fowl balls ..."	15 - 20	20 - 25
"Its better to be one out - than all in"	15 - 20	20 - 25
"One in the hand is worth - two over the fence ..."	15 - 20	20 - 25
"This Fan-ie is Home - I wish I were too"	15 - 20	20 - 25
"Will you be my catcher - If I pitch for you?"	15 - 20	20 - 25

W.M. Linn & Sons 1905-1915
Political Anti-Socialist Bigalow
"Henry, What is "The Recall? Why it's a..." 25 - 30 30 - 35

Lotus Publishing Co. 1905-1915 Sepia
Blacks "These Damn Left-Handed Pitchers Get..." 18 - 22 22 - 26

Leather Post Cards 1905-1920

Man "Easy Money"	20 - 25	25 - 30
Man "Franklin Baseball	20 - 25	25 - 30
Man "I am still waiting for it"	20 - 25	25 - 30
Man "I arrived safe"	20 - 25	25 - 30
Man "I'll send it to you at once"	20 - 25	25 - 30
Man "I'm down and out"	20 - 25	25 - 30
Man "I don't think I can get there in time"	20 - 25	25 - 30
Man "Here's to our National Baseball Game"	20 - 25	25 - 30
Man "Highball"	20 - 25	25 - 30
Religion "Mrs. Smith: Can Johnny go to Sunday..."	20 - 25	25 - 30
Boy/Girl "Struck Out"	20 - 25	25 - 30
Bat "What's the matter with the White Sox?"	25 - 28	28 - 32
D&C Co. #18 Shoe " 'Pon My Sole' ..."	20 - 25	25 - 28

B.E. Moreland 1905-1915
Advertisement Crackerjack Bears
12 "We're a Great Success Upon the Field ..." 40 - 50 50 - 60

J.D. Moreno & Co.
"Ripley's Believe It Or Not" (B&W)
"Julius B. Shuster of Jeanette, Pa. Picks up 9 Base ..." 18 - 22 22 - 26

N in triangle logo 1905-1915
Valentine "A Mighty Muscular Baseball Man..." 15 - 18 18 - 22

E. Nash 1905-1915
Black Girl Sporting Series (Emb)
"The Baseball Girl" "When at bat ..." 40 - 50 50 - 60

P.C.K. (**P.C. Kober**) 1905-1915
Series B. 204
"After All - Position is Everything!" 15 - 20 20 - 25

Publisher The Peninsular Engraving Co.
Advertising Toledo Frog, No. 1 — "Going Some"

Publisher E. Nash, "The Baseball-Girl"
"When at the bat I'm always right ..."

Publisher Parker Brawner Co.
Advertising Cherry Smash

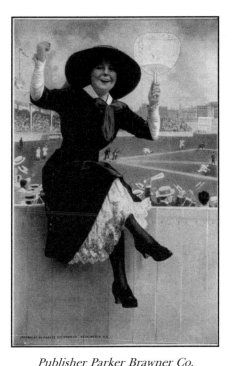

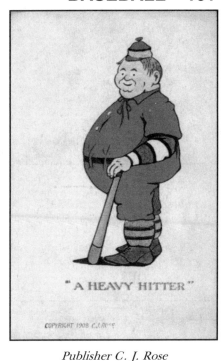

Publisher Parker Brawner Co.
No Caption

Publisher C. J. Rose
"A Heavy Hitter"

"Don't get your games mixed"	15 - 20	20 - 25
"Say! Isn't it hard to please everybody?"	15 - 20	20 - 25
"When in doubt - 'Touch Second'!"	15 - 20	20 - 25
Parker Brawner Co. 1905-1915		
Lady on Fence	35 - 40	40 - 50
Advertisement — Cherry Smash		
(also with Red Sox Beer)	75 - 100	100 - 125
Parker Mfg. Co. 1905-1915 (B&W)		
Political-Bryan "Back to the Farm! 3 Strikes And Out!"	20 - 25	25 - 30
Parkinson Art Co. 1912		
Gray and White		
"He's Easy"	20 - 25	25 - 28
"Put it Over, Bill"	20 - 25	25 - 28
Peninsular Engraving 1905-1915		
Toledo Frog Series		
1 "Going Some"	80 - 100	100 - 125
Penn Publishing Co. 1918		
"The Chaplain Umpires the Fleet Championship ..."	10 - 12	12 - 15
Pink of Perfection (Fairman Co.) 1905-1915		
Series 159 (6)		
Blacks		
"Ah guess ah must er made an error"	35 - 40	40 - 50
"I'se jes makin' er Short Stop here"	35 - 40	40 - 50
"Ah sho would like to make a hit with yo"	35 - 40	40 - 50
"Ah sho would love to get er liner two from yo"	35 - 40	40 - 50
I'se makin' er slide fo home - expect me."	25 - 30	30 - 35
Philadelphia Post Card Co. 1905-1915		
"Did It Ever Strike You?"	10 - 12	12 - 15

*Publisher: Pink of Perfection
(Fairman Co.) Series 159*

*"Ah guess ah must er made
an error."*

*Publisher: Pink of Perfection
(Fairman Co.) Series 159*

*"I'se jes makin' er short stop
here."*

*Publisher: Pink of Perfection
(Fairman Co.) Series 159*

*"Ah sho would like to make er
hits with yo."*

*Publisher: Pink of Perfection
(Fairman Co.) Series 159*

*"Ah sho would love to get er
liner two from yo"*

*Publisher: Pink of Perfection
(Fairman Co.) Series 159*

*"I'se makin' er slide fo home —
expect me."*

*Five unsigned images from a series
of six cards by artist E. B. Kemble.*

Plastichrome Chromes
 Advertisement P4894 "Fielder's Choice"

"Double Good Southern Select"	15 - 20	20 - 25
P34332 Chimp "Just waiting for the right..."	3 - 4	4 - 5
Map of Cooperstown, NY	3 - 5	5 - 6

Practical S.S. Supplies 1900-1915 (B&W)

Religious 1003 "One Player Missing"	3 - 4	4 - 5

Prudential Insurance 1905-1915

Advertisement Children "Are All Your Bases Cover..."	10 - 12	12 - 15

R&N (Reinthal & Newman) 1905-1915

896 Children-Airplane "Ace of Diamonds"	18 - 22	22 - 26

Remington Supply Co. 1905-1915

1504 "Did it Ever Strike You"	7 - 9	9 - 12

C.J. Rose 1908 (20)

"A Base Hit" Man	18 - 22	22 - 26
"A Foul Strike" Man	18 - 22	22 - 26
"A Heavy Hitter" Man	18 - 22	22 - 26
"A Pop Fly" Man	18 - 22	22 - 26
"A Slashing Single" Boy/Girl	18 - 22	22 - 26
"A Southpaw Artist" Boy/Girl	18 - 22	22 - 26
"A Terrible Whip" Man	18 - 22	22 - 26
"A Texas Leaguer" Man	18 - 22	22 - 26
"Are You a Royal Rooter?" Man	18 - 22	22 - 26
"Get a Basket" Man	18 - 22	22 - 26
"I Umpired a Game" Man	18 - 22	22 - 26
"I'm For the Foul Strike Rule" Drink	18 - 22	22 - 26
"I've Got All the Curves" Man	18 - 22	22 - 26
"I've Got My Eye on the Ball" Drink	18 - 22	22 - 26
"I've Recovered My Batting Eye" Man	18 - 22	22 - 26
"Ladies Day" Man	18 - 22	22 - 26
"My Bat-ing Average is Growing" Drink	18 - 22	22 - 26
"The Slugger" Man	18 - 22	22 - 26
"The Squeeze Play" Boy/Girl	18 - 22	22 - 26
"Two Strikes and One Down" Man	18 - 22	22 - 26

H.M. Rose 1908
 Ball and Crossed Bats (Emb) with Verse (8)

"A Hit! A Hit! ..."	20 - 25	25 - 30
"A peaceful man he claims to be ..."	20 - 25	25 - 30
"He raves and moans ..."	20 - 25	25 - 30
"He wants his meals to be serv'd hot ..."	20 - 25	25 - 30
"Hurrah! Hurrah! ..."	20 - 25	25 - 30
"Money to spare he never has ..."	20 - 25	25 - 30
"We used to say Good Evening first ..."	20 - 25	25 - 30
"The score is tied, there's two ment out ..."	20 - 25	25 - 30

The Rosenthal Co. 1905-1915

249 "A Strong Batting Team. What's your Average?"	10 - 12	12 - 15

Roth & Langley 1910
 Sepia, Glossy Finish Printed Photo-Type (26+)

"A Balk"	10 - 12	12 - 16
"A Close Decision"	10 - 12	12 - 16

"A Close Play"	10 - 12	12 - 16
"A Close Game"	10 - 12	12 - 16
"A Triple Play"	10 - 12	12 - 16
"Back Stop"	10 - 12	12 - 16
"Batter Up"	10 - 12	12 - 16
"Catching a Fly"	10 - 12	12 - 16
"Come On, Boys"	10 - 12	12 - 16
"Double Play"	10 - 12	12 - 16
"Get in the Game"	10 - 12	12 - 16
"Instructions"	10 - 12	12 - 16
"Kill the Umpire"	10 - 12	12 - 16
"Knocked Out of the Box"	10 - 12	12 - 16
"Line Hit"	10 - 12	12 - 16
"Over the Fence is Out"	10 - 12	12 - 16
"Play Ball"	10 - 12	12 - 16
"Safe"	10 - 12	12 - 16
"Safe at First"	10 - 12	12 - 16
"Score 1 to 1"	10 - 12	12 - 16
"Score 3 to 1"	10 - 12	12 - 16
"Squeeze Play"	10 - 12	12 - 16
"Strike One"	10 - 12	12 - 16
"The Hits of the Game"	10 - 12	12 - 16
"Tie Game"	10 - 12	12 - 16
"Who Wins"	10 - 12	12 - 16

"Never Again For Me" Series (Sepia)

"The Umpire's Job Looks Good..."	15 - 18	18 - 22

Series 60 Sepia

Boy/Girl "A Close Decision"	12 - 15	15 - 20

Series 110 Color

Skeleton "A Home Run"	15 - 18	18 - 22

Series III (Sepia)
"There's a Reason Series"

"Why do they wear..."	22 - 26	26 - 30

S&W 1905-1915

133 "I Believe in Playing Close Sometimes"	15 - 18	18 - 22
"They're all Pennant Winners in_____"	20 - 25	25 - 30
H592 "Caught Trying to Steal Second"	20 - 25	25 - 30
H594 "Over The Fence"	20 - 25	25 - 30

SB in circle logo (Samson Bros.) 1905-1915

Series 91

"I Should Worry ..."	12 - 15	15 - 20

Series S114

"Drop Me a Liner Too ..."	12 - 15	15 - 20

Series S 115

"I'm Up to My Neck in Work, but ..."	12 - 15	15 - 20

Series S125 Little Boys in Overalls (12) (B&W)

"Choppin' De Breezes"	15 - 18	18 - 22
"Dis is De Umpire"	15 - 18	18 - 22
"For a Three Bagger"	15 - 18	18 - 22
"Give the Wad a Wallop"	15 - 18	18 - 22
"Out"	15 - 18	18 - 22
"Pickin' It Out of the Ether"	15 - 18	18 - 22
"Shove De Pill Right Over De Plate"	15 - 18	18 - 22

CATCHING A FLY

CHOPPIN' DE BREEZES

Publisher Roth & Langley
"Catching a Fly"

Publisher S.B. (Samson Bros.)
S 125 —"Choppin' De Breezes"

"Slam Em Over the Plate"	15 - 18	18 - 22
"The Captain of the Winners"	15 - 18	18 - 22
"The Pill Receiver"	15 - 18	18 - 22
"The Pitcher at the Well"	15 - 18	18 - 22
"The Sphere Shortstop"	15 - 18	18 - 22

Series S129 Little Boy - Blue-striped Border

"A Promenade to First"	15 - 18	18 - 22
"A Short Stop"	15 - 18	18 - 22
"Dat Wuz Two Strikes See"	15 - 18	18 - 22
"Goin' to Rip Off the Cover"	15 - 18	18 - 22
"Holdin' Down Third"	15 - 18	18 - 22
"Hurrah for Us"	15 - 18	18 - 22
"Ouch! Foul!"	15 - 18	18 - 22
"Petting the Pill"	15 - 18	18 - 22
"Pickin Up a Grass Cutter"	15 - 18	18 - 22
"Say - Dis is de Plate - Shoot em Over See?"	15 - 18	18 - 22
"They All Come My Way"	15 - 18	18 - 22
"We Won"	15 - 18	18 - 22

Series S 256

"I'm Out of the Game at _____"	12 - 15	15 - 18

Series CS 459 Children

"I'm Going Away From Here"	12 - 15	15 - 18

Series CS 507 Boy & Girl

"Give Me a Chance? I Won't Muff"	15 - 18	18 - 22
"Grounders Nothing! Give Me a High Flier"	15 - 18	18 - 22
"I'd Like to Coach You"	15 - 18	18 - 22
"I'd Like to Have You in My Mitts"	15 - 18	18 - 22

"I'd Like to Slide Into Your Heart"	15 - 18	18 - 22
"I Like Your Curves"	15 - 18	18 - 22
"I'll See You Safe Home"	15 - 18	18 - 22
"I'm Tired of Outfielding. Let's Get Closer?"	15 - 18	18 - 22
"No Umpire Needed in This Game"	15 - 18	18 - 22
"Tho' On the Diamond Lets Make it Hearts"	15 - 18	18 - 22
"You're the Best in Big League Company"	15 - 18	18 - 22
"You're the Best On the Bleachers"	15 - 18	18 - 22

Series CS 508 Children

"If You Would Make a Hit..."	18 - 22	22 - 26

J. Salmon 1905-1920

Sporty Cats

2817 "Game of Rounders"	15 - 18	18 - 22

Schlesinger Bros., New York 1905-1915

Little Girl - College Pennant (Gray-White Photos)

"Columbia"	18 - 22	22 - 26
"Cornell"	18 - 22	22 - 26
"Harvard"	18 - 22	22 - 26
"Princeton"	18 - 22	22 - 26
"Vassar"	18 - 22	22 - 26
"Yale"	18 - 22	22 - 26

Children (B&W and Color) Add $3 for Color

"A Home Run!"	18 - 22	22 - 26
"Catching a Fly"	18 - 22	22 - 26
"Her Champion"	18 - 22	22 - 26
"Strike One!"	18 - 22	22 - 26
"The Pride of the Nine"	18 - 22	22 - 26

Photo-Type Children (B&W)

No Caption	15 - 18	18 - 22

F. Schmidt 1905-1915

"The Knocker Bunch..."	10 - 12	12 - 15

Schwarz & Teich 1905-1915

Children "Here's to you High Bawl" (Sepia)	12 - 15	15 - 18

M.T. Sheahan 1905-1915

B51 "Caught Stealing"	25 - 30	30 - 35
B54 "A Squeeze Play"	25 - 30	30 - 35
Religious "Say Mrs., kin your Johnny come to ..."	8 - 10	10 - 15

Simplicity Co., Chicago 1905-1915

"Died October, 1907 - Clubbed to Death - Too Bad ..." 175 - 200		200 - 225

J. Slaby 1905-1915 Sepia

"Base Ball Ballot Card"	10 - 12	12 - 15

Souvenir Postcard Store 1905-1915

2062 Children "We all can't have the same ..."	12 - 15	15 - 18

The Spearman Pub. Co. 1905-1915

"Playing Ball Atlantic City, NJ Pretty Girl	10 - 12	12 - 15

A.S. Spiegal's Patents 1905-1915 (B&W)

"Space for Advertisement Bend To and Fro"	18 - 22	22 - 25

Success Postal Card Co. 1905-1915

	15 - 18	18 - 22

Souvenir Postcard Store (B&W)

Motto "Casey at the Bat - Old, but Good"	8 - 10	10 - 12

Sprague Publishing Co. 1905-1915

American Boy Post Card #3 "Get on to my curves"	12 - 15	15 - 20

Publisher Simplicity Co.
"Died October-07 ..."

Publisher S.B. (Samson Bros.) *Publisher H. M. Taylor*
S 129 —"Holdin' Down Third" *"Hughie and His Tigers"*

Standard Publishing 1910-1920
 Religious
 A.B.C. Series 15

"You're Safe!!! As safe as in your own home..."	12 - 15	15 - 18

T.C.G. Chromes
 Wacky Plak (Small narrow cards)

53 "Keep Your Temper ..."	3 - 4	4 - 5
81 "Use Your Head ..."	3 - 4	4 - 5

T.P. & Co. logo with moosehead 1905-1915

"My Dear____I Am Very Busy ..." (B&W)	15 - 20	20 - 25

 Bug Club

"I elect you member of the Bug Club"	20 - 25	25 - 30

 Series 753

3 "Gee! Ain't it hell to be poor" Children	15 - 20	20 - 25

 Series 799

917 Comic Burglar "Dere's an awful diff-runce..."	15 - 20	20 - 25
945 "I fink I'll grow up to be a ball player..."	15 - 20	20 - 25
979 "Der next time dot Empire looks at me..."	15 - 20	20 - 25
1786 "I don't like no girls"	15 - 20	20 - 25

H.M. Taylor ca.1907-08 (Sepia)

Comic "Hughie" and His Tigers."	100 - 150	150 - 200

Tichnor Bros., Inc., Boston 1905-1920
 Pin Cushion Man

	20 - 25	25 - 30

 Chickens

"Casey at the Bat"	12 - 15	15 - 18
"Henry, the Home Run Chicken"	12 - 15	15 - 18

Publisher Valentine & Sons
"Another Muff."

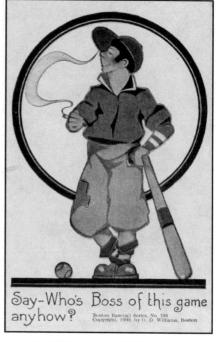

Publisher O. D. Williams, 106
"Say—Who's Boss of this game..."

Toronto Lithograph Co. 1905-1915		
Canadian Sports Series "BASE-BALL"	35 - 40	40 - 45
Curt Teich Co. Linen		
S144 "What Florida city am I in?"	5 - 7	7 - 10
Raphael Tuck 1905-1915		
"Sport"		
Series 512 Baseball	20 - 25	25 - 30
Valentine Series B "The Ball Player Thinks He's..."	20 - 25	25 - 30
Valentine Series 56 "Play Ball"	12 - 15	15 - 20
C.O. Tucker 1905-1915		
Player throwing ball righthanded - E on jersey	80 - 85	85 - 95
Ullman Mfg. Co. 1905-1915		
Baseball Kidlets Series 195		
Boy in diapers & B.B. hat		
2927 "Nailed at Second"	22 - 26	26 - 32
2928 "Missed a Foul But Caught a Dandy Fly"	22 - 26	26 - 32
2929 "Guess I'm Some Base Stealer ..."	22 - 26	26 - 32
2930 "Hit By the Pitcher"	22 - 26	26 - 32
2931 "I Had to Reach for the High Balls ..."	22 - 26	26 - 32
2932 "Gee Whiz! They Whitewashed Us"	22 - 26	26 - 32
2933 "Gee - I Guess I Ought to Know ..."	22 - 26	26 - 32
2934 "Wow, I've Been Fanned"	22 - 26	26 - 32
Number 1464 "Harvard"	25 - 30	30 - 35
Number 1495 "Play Ball"	20 - 25	25 - 28
Number 1555 "King of Diamonds"	25 - 30	30 - 35
Number 1568 "In all athletic games I shine on ..."	20 - 22	22 - 26

The Unique Studio 1910-1920
 "The Roller Skeat Craze"

"Baseball Lion"	20 - 25	25 - 30

Union Publishing Co., Cincinnati, 1900-1907
 Publisher's Proof Set of 8 Undivided back Chromo-
lithographs. No values established, but estimated at: 75 - 100 100 - 125

Valentine & Sons 1900-1910

"A Bluff"	20 - 25	25 - 30
"A Muff"	20 - 25	25 - 30
"Another Muff"	20 - 25	25 - 30
"A Bum Sacrafice"	20 - 25	25 - 30
"Game Stuff"	20 - 25	25 - 30
"Ruff Stuff"	20 - 25	25 - 30

Slightly different than above (UndB)

"A Good Hit"	20 - 25	25 - 30
"A Little Argument with the Umpire"	20 - 25	25 - 30
"A Merry Go Round"	20 - 25	25 - 30
"Safe"	20 - 25	25 - 30
"Well Stopped"	20 - 25	25 - 30
"3 Strikes Out"	20 - 25	25 - 30

W.G.M. 1905-1915
 Baseball Series (B&W) Photo-type

L. 212 "Two Strikes, Bases Full"	18 - 22	22 - 26
L. 213 "Home Run"	18 - 22	22 - 26
L. 214 "Strike Out"	18 - 22	22 - 26
L. 215 "Told You So"	18 - 22	22 - 26
L. 216 "Rain"	18 - 22	22 - 26

Warwick Bros. & Rutter 1905-1915

"Expect to get home safe"	12 - 15	15 - 18

N.A. Waters 1905-1915

1893 "Expect to Get Home Safe"	15 - 18	18 - 22

Maurice Wells (A.T.F. Co., Chicago)
 **Double line green borders, Green and White
Blacks "Base Ball Series"**

"A Base Stealer"	35 - 40	40 - 50
"A Foul Tip"	35 - 40	40 - 50
"A Good Catch"	35 - 40	40 - 50
"A High Fly"	35 - 40	40 - 50
"A Home Run"	35 - 40	40 - 50
"Caught Steeling"	35 - 40	40 - 50

H.C. Westerhouse 1905-1915

36 "The Baseball Crank"	12 - 15	15 - 18

Whitney Made 1910-1920
 Easter

"I Wish You All Easter Blessings"	15 - 18	18 - 22

 Valentines

"Has it oc-cur-red to you that ..."	15 - 18	18 - 22
"Now for a Home Run"	15 - 18	18 - 22
"Of Course I'm Fond of Candy ..."	15 - 18	18 - 22

O.D. Williams 1909
 "Boston Baseball" Series

101 "The Spit Ball"	20 - 25	25 - 28
102 "Ainet dey de crowd of Muts?"	20 - 25	25 - 28
103 "Trun it inta me mit - He can't hit it"	20 - 25	25 - 28

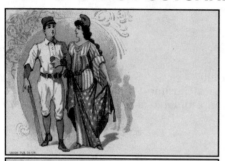

Union Publishing Co., Cincinnati, 1900-1907 — Publisher's Proof Set
7 Cards from an 8-Card Set of Undivided Back Chromolithographs

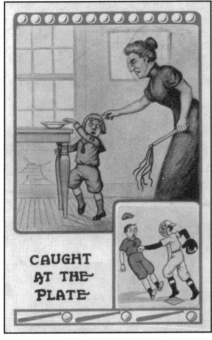

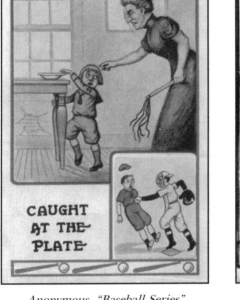

Anonymous, "Baseball Series"
"Caught at the Plate"

Anonymous, "Baseball Notes"
"Catching a High Fly"

104 "Aw! Put it over"	20 - 25	25 - 28
105 "Hey! youse watch me swipe it"	20 - 25	25 - 28
106 "Say - Who's Boss of this game anyhow?"	20 - 25	25 - 28
107 "Out!!!"	20 - 25	25 - 28
108 "Oh! You pop fly"	20 - 25	25 - 28
109 "They come high but we must have them"	20 - 25	25 - 28
110 "Just as easy"	20 - 25	25 - 28
111 "I may be a little dusty but dey ain't ..."	20 - 25	25 - 28
112 "Home in a walk"	20 - 25	25 - 28
Walter Wirths 1905-1915		
"A Long Fly"	25 - 30	30 - 35
"Hew! Use a Telephone Pole"	25 - 30	30 - 35
"One Strike"	25 - 30	30 - 35
C.E. Wood 1906 (Sepia)		
"Gee I guess Chicago can play some"	20 - 25	25 - 28
Woodward & Tiernan Printing 1908		
"The Ruling Passion"	25 - 30	30 - 35
"The Winning Run"	25 - 30	30 - 35
The World Post Card Co. 1905-1915 (B&W Photos)		
Teddy Bears "Play Ball"	30 - 35	35 - 40
YMCA 1905-1915		
Political		
"The Pinch Hitter - When I Knock The Cover Off Of That, William ..."	30 - 35	35 - 45

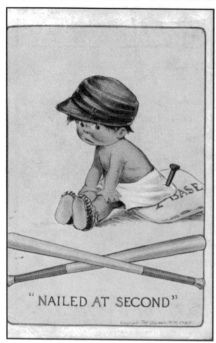

"Baseball Kidlet" Series 195
(Uns./Twelvetrees) "Nailed at Second"

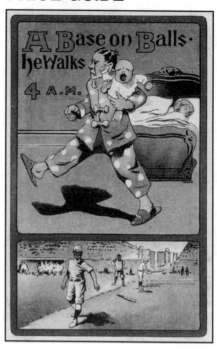

Anonymous, Series 312
"A Base on Balls ..."

Anonymous, Series 312
"A Phenomenal Stop"

Anonymous, Series 720
"A High Ball"

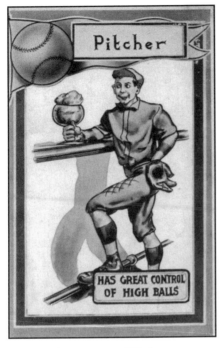

Anonymous, "Pitcher...
Has Great Control of High Balls"

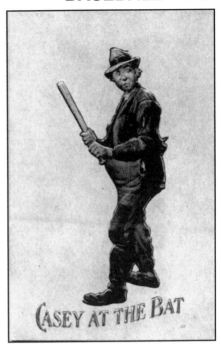

Anonymous
"Casey at the Bat"

ANONYMOUS

"Balligan" 1905-1915 (12)
 Similar to "Billikens

"A Great Game Boys"	25 - 30	30 - 35
"Come on, You Mutt, Put One Over!"	25 - 30	30 - 35
"Don't Be Afraid to Get Dirty"	25 - 30	30 - 35
"Gee He Must Be Tied To That Bag"	25 - 30	30 - 35
"Get a Bag; You Couldn't Catch Even a Cold"	25 - 30	30 - 35
"Give Him a Mattress So He Won't Get Hurt"	25 - 30	30 - 35
"Knock the Durned Cover Off"	25 - 30	30 - 35
"Run Shoe Leather is Cheap"	25 - 30	30 - 35
"Slide, Kelly, Slide"	25 - 30	30 - 35
"Some Fellows Have Sawdust in Their Heads"	25 - 30	30 - 35
"Take Me Along and You Can't Lose"	25 - 30	30 - 35
"Take Third, Then Go Home"	25 - 30	30 - 35

"Baseball Series" 1905-1915 (12)
 Red Borders - Top has 13 baseballs (B&W)

"Catching a Fly at Centre"	15 - 20	20 - 25
"Caught at the Plate"	15 - 20	20 - 25
"Caught Stealing Home"	15 - 20	20 - 25
"He Doubled on a Long Fly"	15 - 20	20 - 25
"He Hit Into the Bleachers"	15 - 20	20 - 25
"He Reached for a High Fowl" **Blacks**	25 - 30	30 - 35
"He Sacrificed on a Slow One"	15 - 20	20 - 25
"Hot Off the Plate"	15 - 20	20 - 25

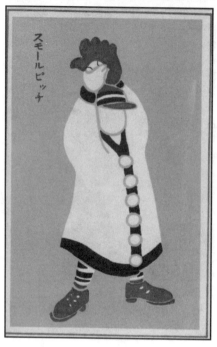

Anonymous
Japanese

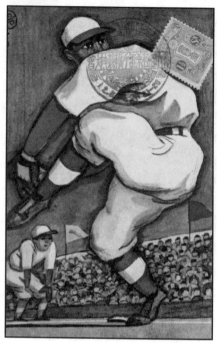

Anonymous — Pitcher
Japanese Baseball in the 1930s

"Lining 'Em Out"	15 - 20	20 - 25
"She Fumbled and He was Safe"	15 - 20	20 - 25
"Sneaking Home on a Squeeze"	15 - 20	20 - 25
"They Couldn't Touch the Pitcher"	15 - 20	20 - 25

Black Border Series 1905-1915

Wide Black Border (B&W) Girl and player

"A Close Play"	15 - 18	18 - 22
"A Steal"	15 - 18	18 - 22
"A Tie Game"	15 - 18	18 - 22
"Delaying the Game"	15 - 18	18 - 22
"Hard to Beat"	15 - 18	18 - 22
"I'll Get You Yet"	15 - 18	18 - 22
"Never Give Up"	15 - 18	18 - 22
"Teaching the Game"	15 - 18	18 - 22

Embossed Edges Series 1905-1915

Sepia and Creme

Printed Photo-types of girls and players

"A Double Steal"	15 - 18	18 - 22
"A Home Run"	15 - 18	18 - 22
"A Tight Place"	15 - 18	18 - 22
"A Triple Steal"	15 - 18	18 - 22
"A Squeeze Play"	15 - 18	18 - 22
"After the Game"	15 - 18	18 - 22
"Caught on Second"	15 - 18	18 - 22
"Coaching"	15 - 18	18 - 22
"Foul Ball"	15 - 18	18 - 22

"Good for Three Bases"	15 - 18	18 - 22
"Hugging Second"	15 - 18	18 - 22
"Instructions"	15 - 18	18 - 22
"Safe!"	15 - 18	18 - 22
"Safe on First!"	15 - 18	18 - 22
"Score 3 to 1"	15 - 18	18 - 22

Series 113 1905-1915
Shows Girls and Player (Sl. Oversize) (Sepia)

"A Double Header"	15 - 18	18 - 22
"A One Handed Catch"	15 - 18	18 - 22
"Caught on First"	15 - 18	18 - 22
"Going for a High One"	15 - 18	18 - 22
"I'm On to Your Curves"	15 - 18	18 - 22
"Striker Up"	15 - 18	18 - 22
"The Greatest Game in the World"	15 - 18	18 - 22
"The Squeeze Play"	15 - 18	18 - 22
"Two Lovely Misses"	15 - 18	18 - 22

Series 312 1905-1915
White around Brown Border
Small baseball scene at bottom

"A Base on Balls" Children	12 - 15	15 - 18
"A Delayed Steal" Boy/Girl	12 - 15	15 - 18
"A Double Steal" Boy/Girl	12 - 15	15 - 18
"A Home Run" Boy/Girl	12 - 15	15 - 18
"A Phenomenal Stop" Blacks	20 - 25	25 - 30
"A Sacrafice Hit" Boy/Girl	12 - 15	15 - 18
"A Safe Hit" Boy/Girl	12 - 15	15 - 18
"A Sensational Catch" Animal	12 - 15	15 - 18
"Forced Out at Second" Drink	12 - 15	15 - 18
"Making a Squeeze" Boy/Girl	12 - 15	15 - 18
"Stealing Home"	12 - 15	15 - 18
"Three Strikes Out" Drink	12 - 15	15 - 18

Series 529 1905-1915
Printed Photo-type - Player and Girls (B&W)

"A Backstop"	18 - 22	22 - 25
"After the Ball"	18 - 22	22 - 25
"Catching Pretty Curves"	18 - 22	22 - 25
"Evening up the Score"	18 - 22	22 - 25
"Three Full Bases"	18 - 22	22 - 25
"Trying to Steal One"	18 - 22	22 - 25
"Two Mits"	18 - 22	22 - 25
"Who Wins"	18 - 22	22 - 25

Photo Montage Series 720 1905-1915
Men/Girls on Baseball Diamond
Printed Photo-Types

"A Base Hit"	15 - 18	18 - 22
"A Base on Balls"	15 - 18	18 - 22
"A Double Play"	15 - 18	18 - 22
"A Good Stop"	15 - 18	18 - 22
"A High Ball"	15 - 18	18 - 22
"A Triple Steal"	15 - 18	18 - 22
"Batted Out"	15 - 18	18 - 22
"Caught Napping"	15 - 18	18 - 22
"Hugging First"	15 - 18	18 - 22

Anonymous Publisher
"A Base Hit"

"In a Tight Place"	15 - 18	18 - 22
"Squeeze Play"	15 - 18	18 - 22
"Three Strikes Out"	15 - 18	18 - 22
No Identification #1 1905-1915		
"A Highball"	20 - 25	25 - 28
"Casey at the Bat"	20 - 25	25 - 28
"Safe"	20 - 25	25 - 28
"The Umpire"	20 - 25	25 - 28
No Identification #2 1905-1915		
Boy with Bat-Blue, Red, and Yellow		
"A Puzzler for Fair"	20 - 25	25 - 30
"Goin Ter Be In De League Fore Long"	20 - 25	25 - 30
"Just Keep Your Eye on The Ball"	20 - 25	25 - 30
No Identification #3 1905-1915		
Baseball & Position on Pennant (B&W)		
"Pitcher - Has Great Control of High Balls"	18 - 20	20 - 25
"The Catcher - He Can' Even Catch a Cold"	18 - 20	20 - 25
"First Baseman - Stops a Lot of Wild Throws"	18 - 20	20 - 25
"Second Baseman - Stops Everything ..."	18 - 20	20 - 25
"Shortstop - Hasn't Missed a Ball This Season"	18 - 20	20 - 25
"Third Baseman - "Has a Good Eye for Fouls"	18 - 20	20 - 25
"Right Fielder - Never Misses a Fly"	18 - 20	20 - 25
"Centre Fielder - The Only Kind of a Hot one ..."	18 - 20	20 - 25
"Left Fielder - All You Can Catch is the Measles"	18 - 20	20 - 25
"The Battery - Pitcher & Catcher"	18 - 20	20 - 25
"The Mascot - Every Team Should Have One"	18 - 20	20 - 25
"The Umpire - Robber"	18 - 20	20 - 25
150 "A Good Play"	10 - 12	12 - 15
195 "A Game of Hearts" Nude Cupids playing Baseball	12 - 15	15 - 18
207 Blacks "Honey, You Sure Make A Hit With Me" Linen	8 - 10	10 - 12
978 "This Place is full of Little Bears"	10 - 12	12 - 15

A-32258 Blacks "Home Run I Ain't No Bigot"	50 - 60	60 - 75
"A Base Hit" Batter hits old man with ball	12 - 15	15 - 18
"A High Ball" Player reaches for ball as other slides in.	10 - 12	12 - 15
"Casey At Bat" Performing Chicken Chrome	3 - 5	5 - 7
"Darktown Nine" **Blacks** Newer card but not a chrome	8 - 10	10 - 12
"Did It Ever Strike You?" **Black** being hit in eye with ball	10 - 12	12 - 15
"Getting Under a High Ball" Man drinking at bar	8 - 10	10 - 12
"I Hope to Make a Hit With You"	15 - 18	18 - 22
"Now for a Home Run, Teddy" **Teddy Bear**,		
narrow thin card	30 - 35	35 - 40
"Out on A Foul" **Black** boy riding a turkey	20 - 25	25 - 30
Rebus Card 1905-1915		
Government Postal (B&W) Hand Drawn		
"I Will Fiddle at the Policeman's Ball"	150 - 160	160 - 170
Rebus Card 1905-1915		
"A 'pitcher' goes often to the 'well' but is		
'broken' at last"	12 - 15	15 - 18

ADVERTISEMENTS

A-10 "Third Warning Ad For **Walter Schroeder**		
Motors, Inc., Berwyn, Ill." Chrome	5 - 7	7 - 9
SP-2 "We Want To Make A Hit With You" Car		
Dealership Chrome	3 - 4	4 - 5
Blackwell-Wielandy Book & Stationery Co.		
Acknowledgement of Remittance. Govt. Postal	40 - 45	45 - 50
Texas Vegetable Oil "All Of Us Know Who The		
Champions Are in Baseball" Govt. Postal	5 - 7	7 - 9
Grit Publishing Co. 1905-1915		
"Money and Free Prizes For You"	15 - 18	18 - 22
Elk Outing Shoes 1905-1915		
"Larry: I Made a Home Run Hit by Buying...,"		
Signed "Wild Bill"	25 - 30	30 - 35
"Mr. Frank Chance wearing his **Royal Tailored Suit** -		
Get that Royal tailored Look!" See "Players"	100 - 125	125 - 150
Official Baseball Guide For 1953..." Govt. Postal	10 - 12	12 - 15
Horner Shoe Co. 1905-1920		
"Our Shoes Increase Your Batting Average"	20 - 25	25 - 30
"Play Safe! Change to **Alemite Summer Gear Lubricate.**		
Don't Be Caught Off Base!"	12 - 15	15 - 20
Tip Top Weekly "Brad Buckhart Safe		
Hit Never in Doubt"	18 - 20	20 - 22
RCA Radiola 46 Radio - "Thrill To The Big Games,		
Neistadt Piano Co. Govt. Postal	25 - 30	30 - 35
Western Clock Mfg. Co. "You'll have to get up early ..."	18 - 20	20 - 22
United's Pinch Hitter - Baseball Antimation - ad for		
pin ball machine (B&W)	55 - 60	60 - 65
Walkover Shoes		
"Team Work"	18 - 20	20 - 22
Foreign		
Japanese 1930s		
Batter, Pitcher, or Catcher	50 - 60	60 - 75
Fielder	50 - 60	60 - 75
Anonymous Japanese	30 - 40	40 - 50

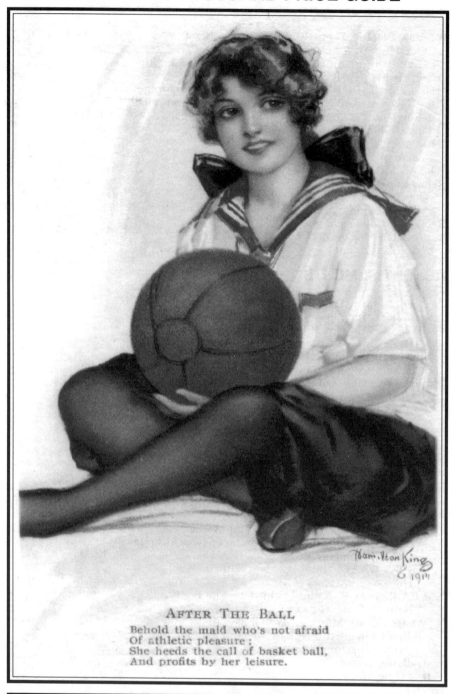

AFTER THE BALL

Behold the maid who's not afraid
Of athletic pleasure;
She heeds the call of basket ball,
And profits by her leisure.

Hamilton King, Henry Heininger, Series 41
"After the Ball"

BASKETBALL

James A. Naismith invented basketball with his basket hoop in 1891, and the first intercollegiate game was played in 1896 when the Yale Eli beat Wesleyan University by a score of 39 to 4. Basketball was in its infancy, and not as popular as baseball and football in postcards' "Golden Years." Therefore, there are relatively few images available for today's collectors. Real photos of high school and college teams, and a small amount of the works of various artists, are meager pickings for the many collectors of sports postcards.

Professional basketball had its beginning in 1898, but lasted only two years. It was tried again on a small scale in the 1920's when the Original Celtics were barnstorming throughout the states, generating renewed interest. Real photo postcards of some of these players exist, but they are very rare and elusive. Among them are images of Nat Holman, Joe Lapchick, Elmer Ripley, etc.

The professional National Basketball Association was formed in 1937, merged with the Basketball Association of America in 1949, and then merged with the American Basketball Association in 1978. In 1927, the Harlem Globetrotters started their tours of America and later began good will expeditions to foreign countries. They were very instrumental in popularizing the game. Basketball is now professionally played all over the world and is a major Olympic sport. Games are currently widely viewed on television, and basketball now ranks second to soccer as the most popular worldwide sport.

PLAYERS AND TEAMS

	VG	EX
Ivy League Championship Postcard Set, 1912 (2)		
Cornell Team	$25 - 35	$35 - 50
Yale Team	25 - 35	35 - 50
Professional Players and Teams		
Colourpicture Publishers, 1961		
St. Louis Hawks in Action	15 - 18	18 - 22
Indento Card Co.		
George Yardley, Detroit Pistons (J.D. McCarthy)	20 - 25	25 - 28
1954-55 World Champion Syracuse Nationals	25 - 28	28 - 32
Boston Celtics, 1950's		
Real Photos (22)		
Red Auerbach	20 - 25	25 - 35
Bill Russell	25 - 35	35 - 50
Bob Cousey (2)	25 - 35	35 - 50
Bill Sharman (2)	25 - 35	35 - 50
Ed McCauley (2)	25 - 35	35 - 50
Others	20 - 25	25 - 30
Original Celtics		
Real Photos		
Team	100 - 125	125 - 150
Nat Holman, Joe Lapchick	75 - 100	100 - 125

French Advertising Card of
Harlem Globetrotters Game

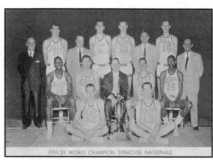

"1954-55 World Champion
Syracuse Nationals"

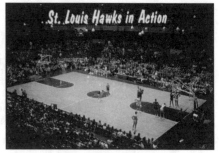

View of Basketball Court
"St. Louis Hawks in Action"

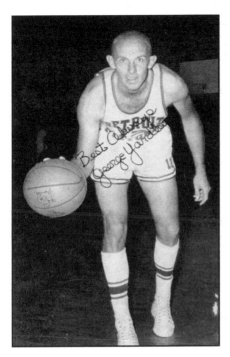

B. R. Press, Religious
"Shoot for the highest goal in life"

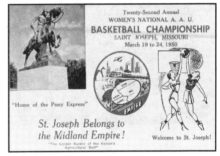

George Yardley in Action
Detroit Pistons, J.D. McCarthy

Ad for Women's National A.A.U.
Basketball Championship — 1950

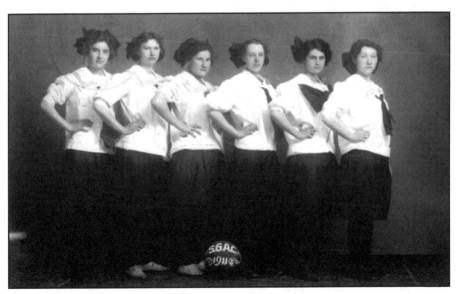

Real Photo of G.S.A.C., Hardy, Ia. — College Girls Team, 1911, AZO Photo

Harlem Globetrotters , 1973
 Autocarte Advertising Poster
 Appearing at Palais des Sports, Paris 15 - 20 20 - 25
 Early Real Photos 20 - 25 25 - 30

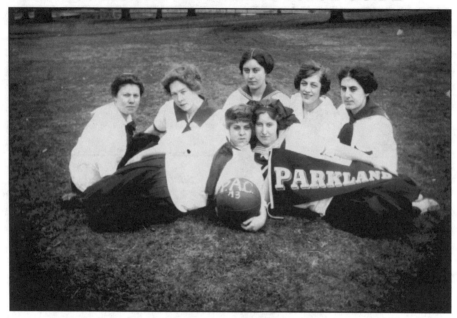

Parkland High School, 1913
Real Photo by CYKO

Green Isle Basketball Team, ca 1912
Real Photo by AZO

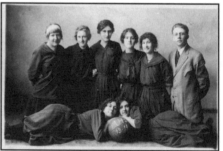

M.H.S. Girls School Team, 1913-14
Real Photo by AZO

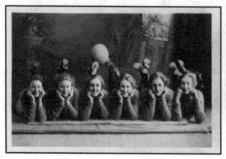

A.T. & S. Basketball Team, 1911
Real Photo by AZO

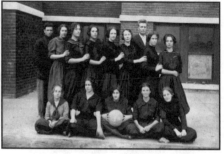

Anonymous High School Team, 1913-14
Real Photo by AZO

High School Teams, Players
 Identified
 Real Photos 30 - 35 35 - 40
 Printed Photos 15 - 20 20 - 25
 Unidentified
 Real Photos 15 - 20 20 - 25
 Printed Photos 10 - 12 12 - 15
College Teams, Players
 Identified
 Real Photo 35 - 40 40 - 50
 Girl's S.G.A.C., Hardy, IA, 1911 - AZO photo 35 - 40 40 - 50
 Girl's A.T. & S 1911 AZO photo 25 - 30 30 - 35
 Printed Photos 20 - 25 25 - 30
 Unidentified
 Real Photo 15 - 20 20 - 25
 Printed Photos 10 - 12 12 - 15
College Teams, Schedules 10 - 15 15 - 20

ARTIST-SIGNED

BRYANT, JACK (US) 1905-1915
 Knapp Co. **Series 2-31** "Taking Her Fling" 20 - 22 22 - 26
CONNELL (US) 1905-1915
 White City Art Co.
 247 Girl with basketball above head No Caption 20 - 25 25 - 30

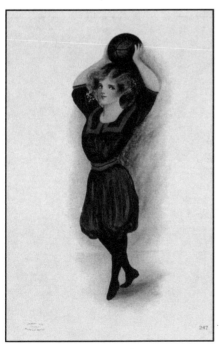 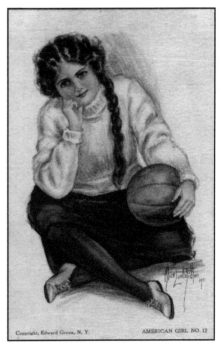

Connell, White City Art Co. *Alice Luella Fidler, Edward Gross*
No. 247, No Caption *College Series 4, American Girl No. 12*

J. Knowles Hare, Publisher J. K. Hare
No Caption

S. Norman, Reinthal & Newman
Series 1000, "After the Game"

S. Norman, Reinthal & Newman
Series 1000, "Our Captain"

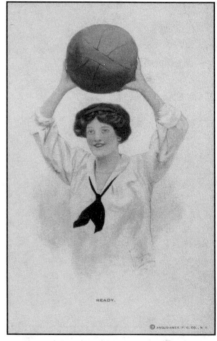

W.T.P., Anglo-Amer. P.C. Company
"Ready"

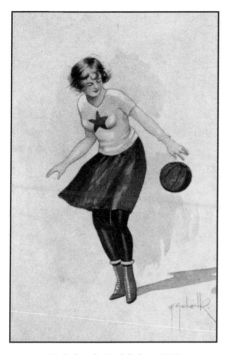

F. Schenk, Publisher H.P.
No Caption

Basketball Schedule for
Clark University — 1926-1927

FIDLER, ALICE LUELLA (US) 1905-1915
 Edward Gross "Fidler College Series 4"
 12 Beautiful Lady No caption | 25 - 28 | 28 - 32
GUNN, ARCHIE (US) 1905-1915
 S. Bergman (B&W)
 Beautiful Lady No Caption | 25 - 28 | 28 - 32
HARE, J. KNOWLES (US) 1905-1915
 J. K. Hare Sepia Beautiful Lady (2) | 15 - 18 | 18 - 22
KING, HAMILTON (US) 1905-1915
 Henry Heininger Co.
 Series 41 Beautiful Lady "After The Ball" | 28 - 32 | 32 - 36
 F.A. Schneider (Same image as Heininger)
 458 "Winner" | 28 - 32 | 32 - 36
LEONARD, H.H. (US) 1905-1920
 Ullman Mfg. Co. "Wise Sayings"
 192 "If you want to be happy ..." | 12 - 15 | 15 - 18
MALLET, BEATRICE (DEN) 1910-1920
 SSS in a shield logo
 587 Children Foreign caption | 15 - 18 | 18 - 22
NORMAN, S. (US) 1905-1910
 Reinthal & Newman
 Series 1000 (Divided Backs)
 "After the Game" (Color) | 18 - 22 | 22 - 26
 "Our Captain" (Color) | 18 - 22 | 22 - 26
 No caption (B&W) | 15 - 18 | 18 - 22
O'NEILL (US) Chrome
 Nudist 40 "Hey Bud - What's the Score?" | 3 - 4 | 4 - 6

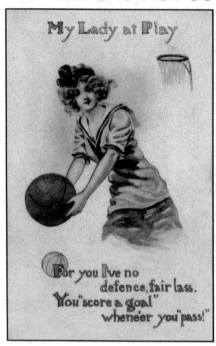

Publisher Fairman Co., Series 161
"My Lady at Play"

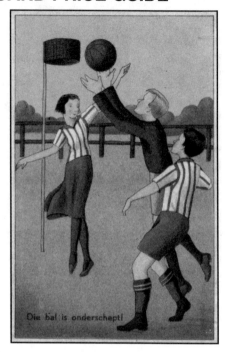

Publisher M.B., 1940's
"Die bal is onderschept!"

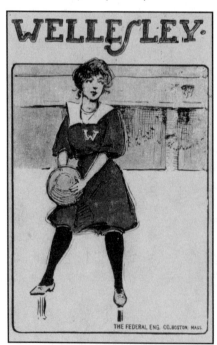

Publisher The Federal Eng. Co.
"Wellesley"

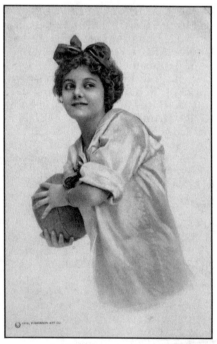

Publisher Parkinson Art Co.
No Caption

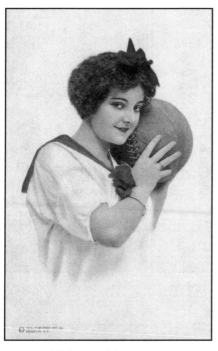

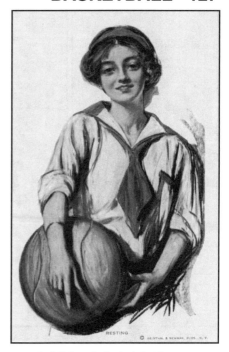

Publisher Parkinson Art Co.
No Caption

Publisher Reinthal & Newman
Series 130, "Resting"

ROBERT, JACQUES (FR) 1905-1915
 Comite National des U.C.J.G.

"Le Basket-ball	10 - 12	12 - 15

SCHENK, F. (CZ) 1910-1920
 HP in leaf logo Beautiful Lady 15 - 20 20 - 25

SHINN, COBB X. (US) 1905-1915
 Anonymous Girls Sepia 12 - 15 15 - 18

TH (US) 1915 Photo
 Spider Web
 1 "We Carnegie-Tech at Hiram, Feb. 20, 1915" 15 - 18 18 - 22

WATTS, TED (US) Chrome
 Ted Watts 178112 "Stanford" 5 - 6 6 - 8

W.T.P. (US) 1905-1915
 Anglo-American P.C. Co.
 Series 135 Beautiful Girl "Ready" 18 - 22 22 - 26

PUBLISHERS

B.R. Press Chrome
 Religious
 491-23076 125 "Shoot for the Highest Goal" 3 - 5 5 - 10

Bellman Association 1905-1915 (RP)
 Lady "After the Ball is Over" 12 - 15 15 - 20

Coloprint B 1930-1940
 7434 Children No caption 10 - 12 12 - 15

Fairman Co. 1905-1915
 Series 161 "My Lady at Play" (B&W) 12 - 15 15 - 18

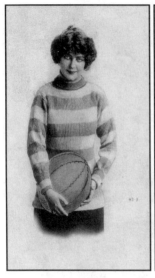

Anonymous Publisher
No. 43-3

Anonymous Publisher
"GLS" on Uniform

Anonymous Publisher
Undivided Back

Early Anonymous Publisher, Embossed — No Caption

The Federal Eng. Co., Boston (Undb)		
"Wellesley" Girl in Wellesley Player Suit	20 - 25	25 - 30
G in a triangle logo 1905-1915		
Beautiful Lady No caption (B&W & Color)	10 - 12	12 - 15
I.P.C. Co. in shield logo 1905-1915		
Beautiful Lady No caption	10 - 12	12 - 15
I.P.C. & N. Co. 1905-1915		
Series 5001 Princeton	18 - 22	22 - 26

Advertisement for Walkover Shoes — "Near the Goal"

Jansson, A.L. 1905-1915		
Series 4500 Girl "A little forward"	15 - 18	18 - 22
MB in triangle logo 1905-1915		
"Die Bal is Onderschept!"	18 - 22	22 - 26
"Die Zit"	18 - 22	22 - 26
"Geef hier die Bal!"	18 - 22	22 - 26
Parkinson Art Co. 1905-1915 (B&W and Color)		
Beautiful Lady	8 - 10	10 - 15
REB logo 1905-1915		
Series 54408-1 Students No caption	12 - 15	15 - 18
Reinthal & Newman 1905-1915		
Anonymous		
Series 130 Beautiful Lady "Resting" (2 variations)	22 - 25	25 - 28
SZ logo 1905-1915		
Series 2234 571 Foreign caption	12 - 15	15 - 18
White City Art Co. 1905-1915		
247 Beautiful Lady No caption	15 - 18	18 - 22

ANONYMOUS

Children Non-PC back (Emb) 1900-1910	25 - 30	30 - 40
Beautiful Ladies Playing in full dress 1900-1910	20 - 25	25 - 30
43-3 Girl wearing striped sweater, w/basketball		
No caption (Undb)	20 - 25	25 - 28
Girl with Basketball and "GLS" on shirt front (Undb)	20 - 25	25 - 28
Advertisements		
Harrah's SC6009 Chrome		
"I hit the jackpot at Harrah's"	5 - 6	6 - 7
Walkover Shoes 1905-1915 "Near the Goal"	15 - 20	20 - 25
Women's National AAU		
Advertising Associates, St. Joseph, Mo.	15 - 18	18 - 22

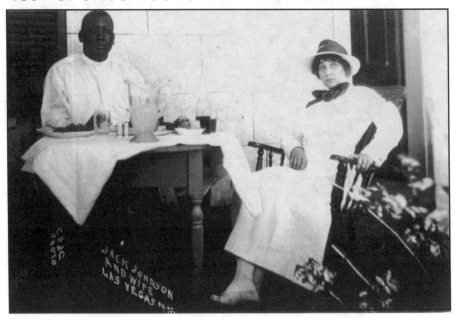

C.E.J.C. Photo, July 4th, 1912 (Real Photo)
"Jack Johnson and Wife, Las Vegas, N.M.

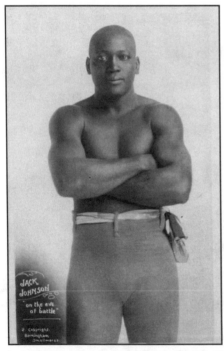

Jack Johnson — Birmingham Small
Wares, Australia, No. 2
"On the eve of battle," Dec., 1908

Stanley Ketchel, Middleweight
Champ, Weidner Real Photo, 1908
Shot and killed by irate husband.

BOXING HISTORY PRESERVED ON POSTCARDS ...

In no other sport is it more apparent that the picture postcard was the leading chronicler of its early history. During the years from 1905 to 1920 a generous number of real photo and printed postcards were published that portrayed and preserved the stories of the fighters and their important fights.

At the turn of the century, boxing was illegal in the United States. Wily promoters, therefore, headed to the wide open spaces of the west, and many of the greatest fights were staged in towns where lawmen would look the other way. Great coverage of these fights by photographers from Dana Studios, Weidner Studios, C.E.J.C. Photos, Cohn and Cann Photographers, D.W.A. Photos, and varied anonymous publishers have left a virtual fight-by-fight accounting for historians and collectors, all preserved on postcards. The pre-fight publicity, the training camps showing the fighters, the trainers, and sometimes even their families were included. This is especially true for Jack Johnson, his entourage, and his Caucasian wife as they traveled throughout the world.

THE FIGHTERS

	VG	EX
1900-1930 Era		
Abe Attell, Featherweight Champ, 1904-1912 **Dana Foto, S.F.** 102 Conley-Attell Contest, Los Angeles, Feb. 22, 1910 (RP)	$30 - 40	$40 - 50

Abe Attell-Nelson Match, 1905 Pre-fight photo with handlers. (ARTURA RP)	50 - 60	60 - 75
Fillmore & Ellis Studio, 1911		
Abe Attell vs. Murphy Fighters clinching	30 - 40	40 - 50
Al Brown - Bantamweight Champ, 1929-35		
V. Henry Studio, France (RP)		
Brown in fighting pose, facing left	35 - 40	40 - 50
"Black American Boxer" (RP)	30 - 40	40 - 50
K.O. Brown ca. 1908 Fighting pose facing left		
Photo by Kadison, N.Y. (AZO RP)	50 - 60	60 - 80
Frankie Burns		
Fillmore & Ellis Studio, 1911		
Frankie Burns and Handlers in Corner	35 - 40	40 - 45
Anonymous		
Frankie Burns-Ad Wolgast Bout, S.F., 1911	50 - 60	60 - 70
Tommy Burns - Heavyweight Champ, 1906-08		
Dana Studios, S.F., 1906		
No. 37. Burns-O'Brien Contest (Title Fight)	125 - 150	150 - 200
"Tommy Burns, Burns' brother, George Unholtz 1908 Sydney, Australia" (RP)	40 - 50	50 - 60
Burns and wife and Corbett and wife, 1910 (RP)	40 - 50	50 - 60
Kerry, Sydney Australia, 1908 (RP)		
"Tommy Burns - II. "A short left hook."	60 - 80	80 - 100
5. Burns-Squires Contest Match in progress	100 - 150	150 - 200
Philco		
3458A "Tommy Burns"	40 - 50	50 - 60
Rotary Photo Co. 1910-12 (RP)		
7161A. "Tommy Burns"	35 - 40	40 - 50
Georges Carpentier - Light Heavyweight Champ, 1920-22		
AN, Paris		
No. 4 In fighting stance, facing left (RP)	20 - 25	25 - 28
No. 10 Bust, in coat & tie, facsimile signature (RP)	20 - 25	25 - 28
Rotary Photographic Co. 1910-12 (RP)		
6787A. "Georges Carpentier"	20 - 25	25 - 30
6787B. "Georges Carpentier"	20 - 25	25 - 30
Jimmie Carroll		
Dana Foto, S.F. 1908 (AZO RP)	25 - 30	30 - 35
James J. Corbett - Heavyweight Champ, 1892-97		
Dana Studio, 1908-10 Repro Photos, F Series, F-16	80 - 125	125 - 150
Anonymous (AZO RP)		
Corbett, wearing bowler hat, with John L. Sullivan	80 - 100	100 - 200
Young Corbett - Featherweight Champ, 1901-02		
Dana Studios, 1908-10 Repro Photos	60 - 70	70 - 100
Johnny Coulon - Bantamweight Champ, 1910-14		
Anonymous - Collage of printed photos ca. 1913		
"Johnny Coulon Bantamweight Champion of the World at his training quarters"	25 - 30	30 - 35
"Yours Truly Johnny Coulon Bantamweight Champion of World" in pen. Printed	40 - 50	50 - 60
George Dawson		
Dana Studio, 1908-10 Repro Photos, F Series	30 - 40	40 - 50
Jack Dempsey (Nonpareil)		
Dana Studio, 1908-10 Repro Photos, F Series	50 - 60	60 - 80

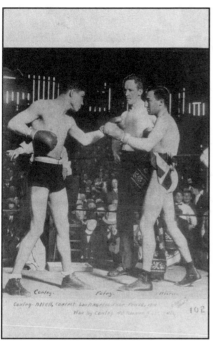

Dana Photo, 102
Conley-Attell Match—1910

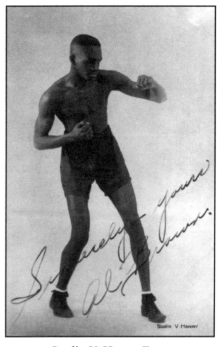

Studio V. Henry, France
Champion Al Brown

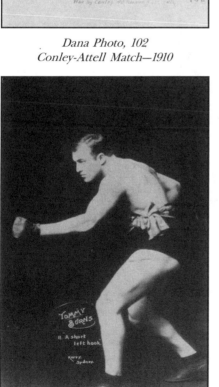

Kerry Studio, Sydney
Tommy Burns

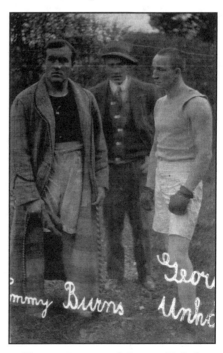

Tommy Burns and George Unholtz,
1908

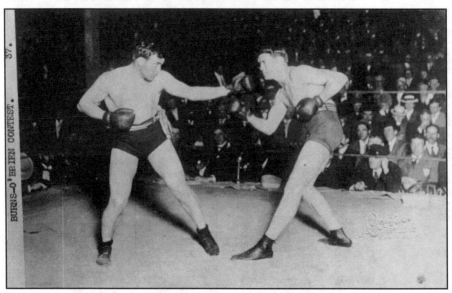

Dana Studio, 37
Tommy Burns — O'Brien Contest

Fillmore & Ellis Photo
Frankie Burns vs. Ad Wolgast, May 1911

Jack Dempsey - Heavyweight Champ, 1919-26
 Dempsey-Carpentier Fight (RP) 30 - 35 35 - 40
 I.F.S. from N. Moser, (RP) **AZO** backs
 Willard-Dempsey Match, Toledo, Ohio, 1919
 "Willard & Dempsey-World Championship Bout" 40 - 50 50 - 70
 The Ringside-Willard & Dempsey Championship ..." 40 - 50 50 - 70

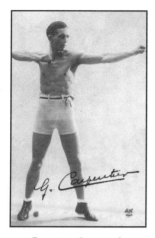

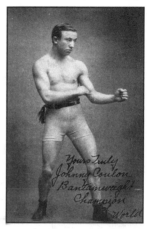

Georges Carpentier
A-N, Paris, Real Photo

Georges Carpentier
A-N, Paris, Real Photo

Anonymous Photo
Johnny Coulon

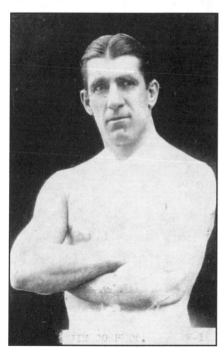

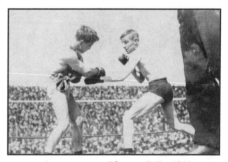

Anonymous Photo, S.F., 1911
Frankie Burns vs. Ad Wolgast

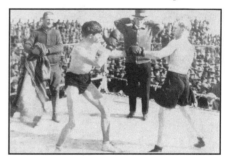

Dana Photo, F Series Reproduction
F-15 — Jim Corbett

Anonymous Real Photo, 1910
Conley vs. Moran

"Willard takes some heavy punishment in last round"	40 - 50	50 - 70
"Willard Knocked to the ropes"	40 - 50	50 - 70
"Willard Counted Out"	40 - 50	50 - 70
Advertising Collage promo (4 cameos)	40 - 50	50 - 60
DIX, Paris - (RP) Upper body, arms folded	35 - 40	40 - 50
REA Photo		
112 "Jack Dempsey" Pitching horseshoes (RP)	30 - 40	40 - 50

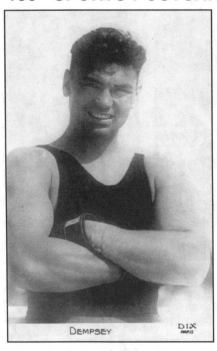

Dix, Paris — Real Photo
"Dempsey"

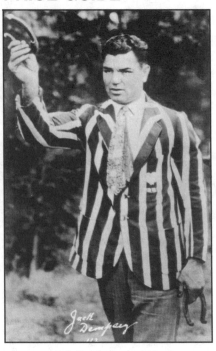

R.E.A. Photo, 112
Jack Dempsey

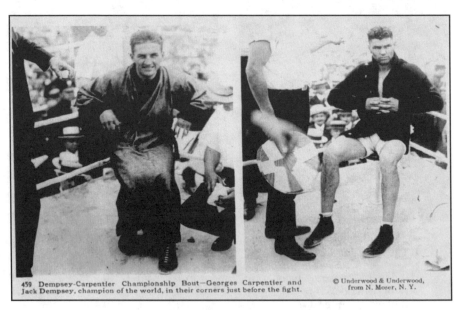

Underwood & Underwood, 459
Dempsey-Carpentier, 1921

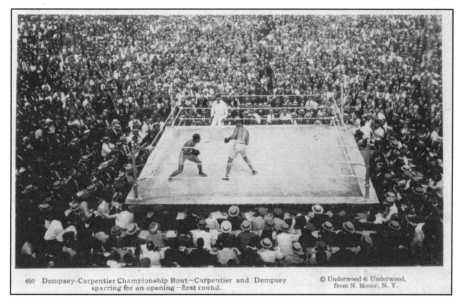

460 Dempsey-Carpentier Championship Bout—Carpentier and Dempsey sparring for an opening—first round. © Underwood & Underwood, from N. Moser, N. Y.

Underwood & Underwood, 460
Dempsey-Carpentier, 1921

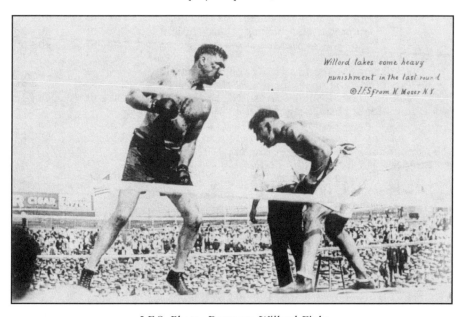

Willord takes some heavy punishment in the last round
©I.F.S from N. Moser N.Y.

I.F.S. Photo, Dempsey-Willard Fight
"Willard takes some heavy punishment."

Underwood & Underwood, from N. Moser, N.Y.
The Dempsey-Carpentier Championship Bout

458 "The Knockout. Harry Ertle counting ..."	30 - 40	40 - 50
459 Dempsey-Carpentier Champ. Bout, 1921	50 - 60	60 - 100
460 "Carpentier and Dempsey sparring for an ..."	30 - 40	40 - 50

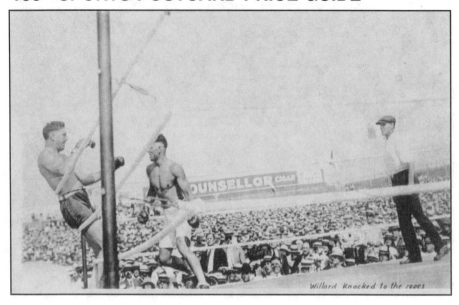

I.F.S. Photo, Dempsey-Willard, 1921
"Willard knocked to the ropes."

461 "Dempsey and Carpentier in a clinch ..." 30 - 40 40 - 50
462 "Dempsey neatly ducking a hard straight left" 30 - 40 40 - 50
463 "Panorama view of the arena Jersey City, N.J." 30 - 40 40 - 50

Anonymous
"Jack Dempsey, World's Heavyweight Champion
 Boxing Exhibition at opening of the Coliseum,
 Juarez, Mexico, Sunday, April 18, 1926. ..." (RP) 30 - 40 40 - 50

Jack Dillon - Light Heavyweight Champ, 1912-16
 Jack Dillon sits in in corner Anonymous (RP) 45 - 55 55 - 65
 Jack Dillon vs. Frank Klaus **Letol-Cal** Photo 45 - 55 55 - 65

Bob Fitzsimmons - Heavyweight Champ, 1897-99
 Beagles Postcards (British Series 157)
 157V "Robert Fitzsimmons" 40 - 50 50 - 75
 Dana Photo, S.F., 1910
 25. Fitzsimmons & Jordan - Introduction at
 Johnson-Jeffries match. 30 - 40 40 - 50
 Weidner Photo (RP)
 "Robert Fitzsimmons" Boxing pose, facing left 70 - 80 80 - 100

Jim Flynn
 C.E.J.C. Photo Flynn and crowd at train station
 "When Jim Flynn Arrived in Las Vegas" (AZO RP) 70 - 80 80 - 100

Joe Gans - Lightweight Champ, 1902-04 & 1906-08
 Weidner Photo (RP) Boxing stance, facing left 75 - 125 125 - 200

Kid Harris
 French - 1910-15 Printed Photo
 92 "La Boxe a Aurillac - Le negre Kid Harris
 champion American" 25 - 30 30 - 35

Aurelio Herrera - ca. 1908
 Dana Studio, S.F. Herrera in fighting stance. 30 - 40 40 - 50

Adrien Hogan (French Champion)
 C.M., Paris 221 "La boxe— Adrien Hogan" 25 - 30 30 - 35

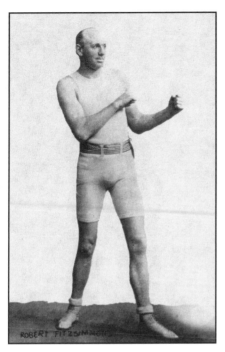

Weidner Photo
Robert Fitzsimmons

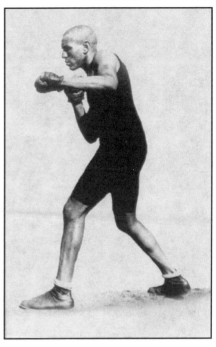

Weidner Real Photo
Joe Gans

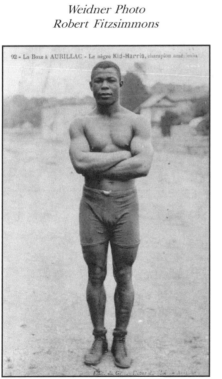

French Printed Photo
"Le negre Kid Harris"

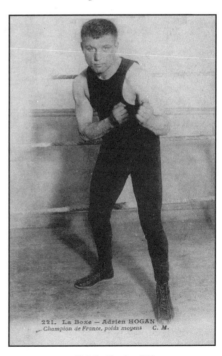

C.M., Paris, 221
"La boxe — Adrien Hogan"

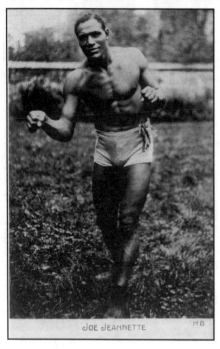

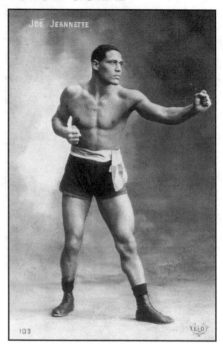

H.B., Paris Real Photo
Joe Jeannette

E.D.L. Real Photo, 103
Joe Jeannette

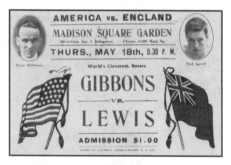

Cardinal—Vincent Co.
Souvenir of the Herman-Gans Fight
"January 1st at Tonopah, Nevada"

Empire City Job Print
Gibbons vs. Lewis Advertisement
"Admission $1.00"

One Round Hogan
 Faulkner Photo (SFICAL), ca. 1911- Lake behind. 25 - 30 30 - 35
Toby Irwin
 Anonymous "Toby Irwin" (RP) 20 - 25 25 - 30
Joe Jeannette
 Beagles Postcards (British)
 187-R Skipping rope 45 - 55 55 - 65
 C.M., Paris
 201 "Les Sports - Joe Jeannette" Printed Photo 25 - 35 35 - 40
 EDL, Paris 103 Boxing Stance (RP) 40 - 50 50 - 60
 HB, Paris (RP) Boxing stance, in grass 40 - 50 50 - 60
 "Health & Strength" Series 229 "Joe Jeannette ..." 30 - 35 35 - 40

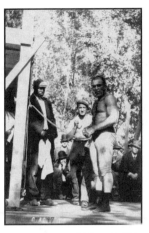

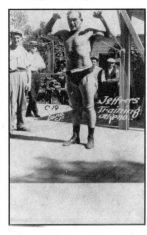

Jeffries, Corbett and Kelly *Dana Photo, C80 — Jeffries* *Dana Photo, C19 — 1910*
1910 Anon. Photo *Trains for Johnson* *Jeffries Training at Reno*

JIM JEFFRIES

James J. Jeffries was born in Carroll, Ohio and became a professional in 1896. He won the heavyweight title on June 9, 1899 by knocking out the New Zealander Bob Fitzsimmons in the 11th round. Jeffries was the champion for the next 5 years defending his title 5 times with 4 knockouts and one decision. He retired undefeated in 1905 but came out of retirement in 1910. He met the new world champion, Jack Johnson, at Reno, Nevada and was knocked out in the 15th round.

Dana Studio, S.F., 1910 (RP)		
C 19 "Jeffries Training at Reno" (AZO)	50 - 60	60 - 80
C 80 Jeffries w/rope, training for Johnson fight	50 - 60	60 - 80
"Jeffries-Johnson Fight"	50 - 60	60 - 80
C 83 Rope in hand - Training	50 - 60	60 - 80
C 103 "Gov. Dickerson & Jeffries" (AZO)	50 - 60	60 - 80
C 116 Sparring, training for Johnson fight	50 - 60	60 - 80
C 117 Jeffries & Armstrong - Reno - Sparring	40 - 50	50 - 60
C 124 Jeffries at training camp. W/gun and dog	40 - 50	50 - 60
F & W by **CM** in circle logo (B&W)		
Pre-fight comics of Jeffries-Johnson Fight		
"Jack" - "Wont it be a DARK Fourth of July"	80 - 100	100 - 150
"Jeff" - "Wont it be a LIGHT Fourth of July"	80 - 100	100 - 150
EDL, Paris (RP)		
90 "Jeffries" Bust, with arms folded	25 - 35	35 - 45
The Pictorial News Co., N.Y., 1910		
"James J. Jeffries, Undefeated Heavyweight		
of the World" (Printed Photo)	30 - 35	35 - 45
ST Printed Photo, 1910		
Group photo of " J.J. Jeffries, Joe Kennedy, Jack		
Jeffries, Bob Fitzsimmons at Harbin training		
for fight with Jim Corbett"	40 - 50	50 - 60
Anonymous		
"J.J. Jeffries" Ca. 1908, Jeffries in boxing		
stance, facing left (RP)	40 - 50	50 - 60
"Jeffries playing handball training for big		
fight" 1910 (RP)	30 - 35	35 - 45

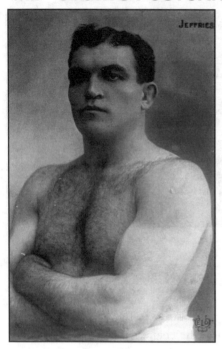

E.D.L. Photo, French
Jim Jeffries

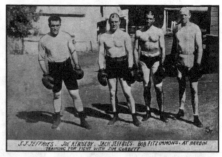

*Jeffries and Well-Known Crew Training
for Jim Corbett Fight — 1910*

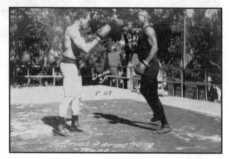

*Dana Photo, C117 —Jeffries Sparring
with Armstrong for Johnson Fight*

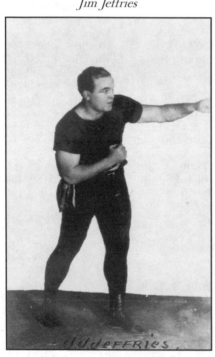

J. J. Jeffries
Anonymous Photo — 1908

*Dana Photo, J124, Hunter Jeffries at
Training Camp*

*Dana Photo, C83
Training for Jack Johnson — 1910*

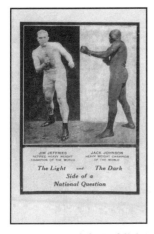
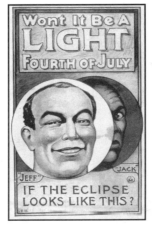
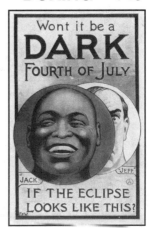

Anon. Pre-Fight Publicity CM, F&W — "Wont It Be a CM, F&W — "Wont it be
"The Light and the Dark" Light Fourth of July" a Dark Fourth of July"

World Champs **Jeffries**, in dress suit, and **Papke** (RP)	75 - 100	100 - 125
Jeffries, Jim Corbett, and Walter Kelly Judge, a comedian in outdoor pose, 1910 (RP)	75 - 100	100 - 125
Jim Jeffries - Jack Johnson Printed pre-fight photos - "The Light and The Dark Side of a National Question"	80 - 100	100 - 150

JACK JOHNSON

John Arthur "Jack" Johnson was born in Galveston, Texas in 1878 and was the first recognized black boxer to gain the heavyweight crown. He began his professional career in 1899 and won a disputed world heavyweight title match from Canadian boxer Tommy Burns in 1908 in Sidney, Australia. His most famous fight was in Reno, Nevada in 1910 when he knocked out the former heavyweight champion Jim Jeffries, who was attempting to regain the title which he held earlier.

Johnson lost the title to American boxer Jess Willard in Havana, Cuba, in 1915 when Willard knocked him out in the 26th round. There were probably more postcards made of Johnson and his fights than any other fighter in boxing history. The Real Photos by Dana Studio, Weidner Photo and C.E.J.C. Photo, especially those of Johnson and his white wife and the prefight happenings, are the most sought after. The Australian issues by Birmingham Smallwares are apparently the most elusive.

The fight world was intrigued, but many were also angered, by the first black heavyweight to claim the title because of his flamboyant and extravagant lifestyle. He was also criticized for having married three Caucasian women, the first of whom committed suicide.

Jack Johnson - Heavyweight Champ 1908-1915

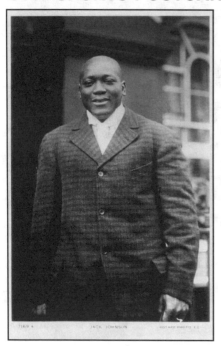

Rotary Photo, No. 7169A
"Jack Johnson"

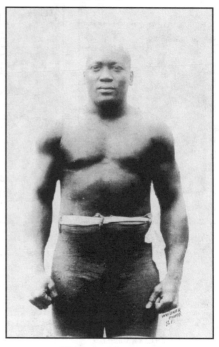

Weidner Photo, 1910
Jack Johnson

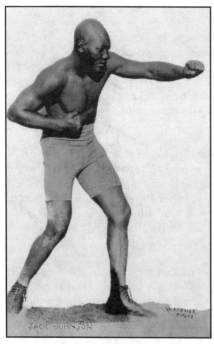

Weidner Photo, 1910
"Jack Johnson"

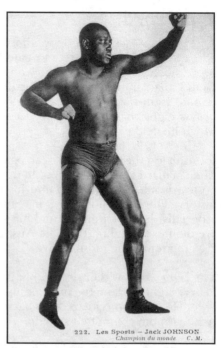

C.M., 222 "Les Sports
Jack Johnson"

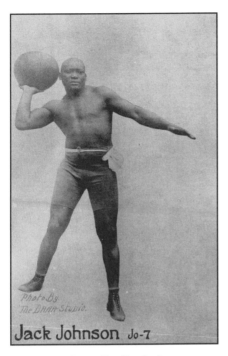

Dana Studio, Jo-7
"Jack Johnson"

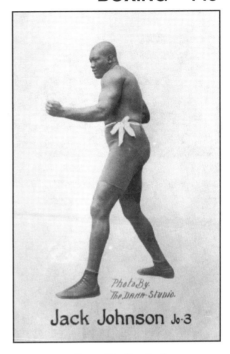

Dana Studio, Jo-3
"Jack Johnson"

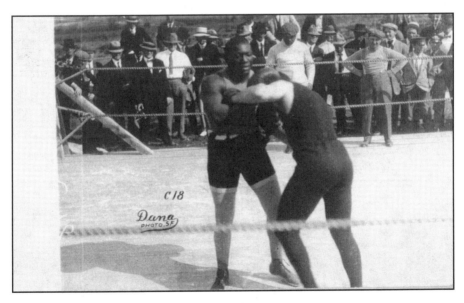

Dana Studio, C 18
Johnson Sparring for Jeffries Contest

C.E.J.C. Photo, Jack Johnson with Party and Wife, Las Vegas, N.M.

Dana Photo, Johnson-Jeffries Contest In Johnson's Corner

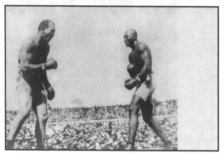

Dana Photo, No. 95 Johnson Smiles at Jeffries

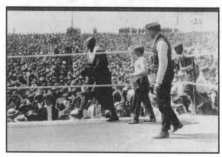

Pirated Dana Photo Johnson Enters Ring for Jeffries Fight

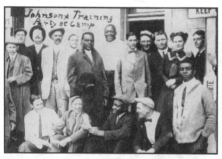

C.E.J.C. Photo — Johnson & Party Prior to Johnson-Flynn Fight

Johnson & Trainers at Rick's Resort Reno, Nevada — Dana Photo, 1910

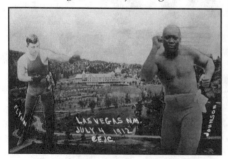

C.E.J.C. Photo — Flynn-Johnson Las Vegas, N.M. — July 4, 1912

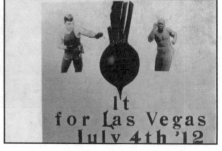

Pre-Fight Promotion Flynn-Johnson, Las Vegas, 1912

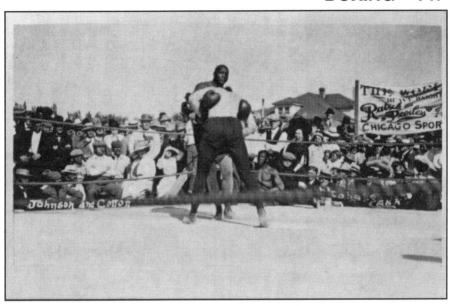

Johnson and Cotton Sparring Match
This photo (by Cohn and Cann) shows his white wife at ringside.

Birmingham Smallwares Australian, 1908 (RP)
2. "Jack Johnson - on the eve of battle"	400 - 500	500 - 600
4. "Jack Johnson - stop lead, Ready for right cross'	400 - 500	500 - 600
7. "Jack Johnson - stopping left lead"	400 - 500	500 - 600
8. "Jack Johnson - ready for Tahmmy"	400 - 500	500 - 600
9. "Jack Johnson - ready for left hook"	400 - 500	500 - 600
"Jack Johnson - ready of right or left shift"	400 - 500	500 - 600

Anonymous
"Jack Johnson, "Heavyweight Champ" 1910	60 - 70	70 - 80
"Jack Johnson, Champion of the World" In fighting pose, facing left. (Printed Photo)	60 - 70	70 - 80
"Jack Johnson-J.J. Jeffries" Facing on printed advertising card, 1910	75 - 100	100 - 150
Jack Johnson-Jess Willard, Apr. 4, 1915	125 - 150	150 - 175
Johnson with U.S. Flag as Belt (RP)	125 - 150	150 - 175
"In front of his training quarters" (RP)	125 - 150	150 - 175
"Johnson-Cotton Sparring Match" (RP)	100 - 125	125 - 150
Johnson with big smile, wears robe "Jack Johnson" (B&W)	60 - 70	70 - 80
Johnson in fighting stance, facing left "Jack Johnson" (B&W)	60 - 70	70 - 80

C.E.J.C. Photo, 1912 (RP) (Mostly AZO)
"Jack Johnson and wife, Las Vegas, N.M. Jack & white wife at dinner table. *	750 - 900	900 - 1100

* Recent auction price - $1000+.
| | | |
|---|---|---|
| "Jack Johnson out for a drive" Group sits in and around big open sedan. All are named. | 125 - 150 | 150 - 175 |
| Johnson and trainers all named | 125 - 150 | 150 - 175 |
| of Johnson (with gun) & his entourage | 125 - 150 | 150 - 175 |

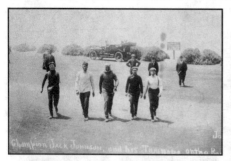

Dana Photo, Johnson & Trainers doing
Roadwork for Flynn Flight July 4, 1912

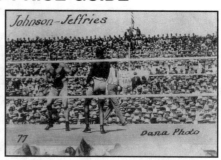

Dana Photo, No. 77
Johnson-Jeffries Contest

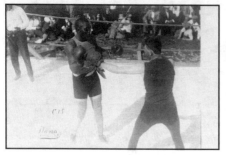

Johnson Sparring with Kaufman
Dana Photo C-15, Reno, 1910

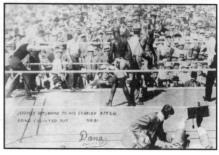

Dana Photo, No. 81 — Jeffries Returns
to Corner After Being Counted Out

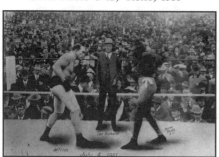

Jeffries, Rickard and Johnson Adv.
Dana Photo, July 4, 1910

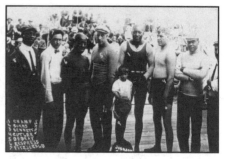

C.E.J.C. Photo
Johnson & Named Trainers, 1912

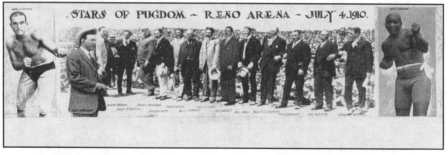

© 1910 by C.V. Estey — "Stars of Pugdom — Reno Arena — July 4, 1910."
Important Fighters and Officials at the Jeffries-Johnson Contest

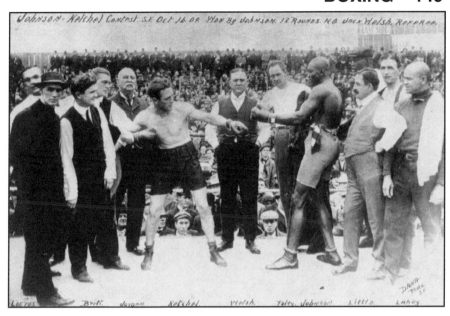

Johnson-Ketchel Contest S.F. Oct 16 09. Won By Johnson 12 Rounds. K.O. Jack Welsh Referee.

Loetus Britt Jerome Ketchel Welsh Foley Johnson Little Lahey

Dana Photo — Johnson-Ketchel Contest, San Francisco, October 16, 1909
Won by Johnson, 12-Round K.O. (Jack Welsh Referee)

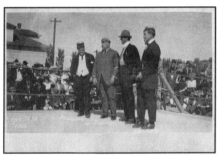

Cann Photo — Muldoon-John L. Sullivan
& Stanley Ketchel at Johnson Camp, 1910

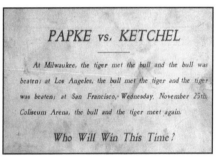

PAPKE vs. KETCHEL

At Milwaukee, the tiger met the bull and the bull was
beaten; at Los Angeles, the bull met the tiger and the tiger
was beaten; at San Francisco, Wednesday, November 25th,
Coliseum Arena, the bull and the tiger meet again.

Who Will Win This Time?

Promotion card for Championship
Fight 1908 — Papke vs. Ketchel

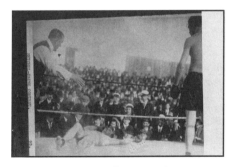

Dana Studio, No. 93
Ketchel-Papke Contest

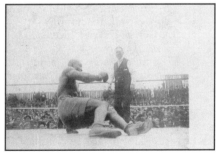

Johnson Hits Deck in
Ketchel Contest (October, 1909)

Johnson and his training team. All named	125 - 150	150 - 175
No. 29 Johnson and his entourage appear to be		
arriving or leaving train station.	125 - 150	150 - 175
"Johnson - Flynn Las Vegas, N.M., July 4, 1912"	125 - 150	150 - 175
"Johnson Training Party at Camp" Flynn fight	125 - 150	150 - 175
Johnson-Flynn pre-fight publicity: Sugar " (Beet)		
it for Las Vegas July 4th '12" between photos		
of Flynn and Johnson	125 - 150	150 - 175

C.M., Paris 1909-1915

222 "Les Sports - Jack Johnson" In		
fighting stance "Champion du monde"	60 - 70	70 - 80
222 Same, but no "Champion du monde"	60 - 70	70 - 80

Cohn & Cann Photographers Reno Fight

"Johnson & Cotton" sparring in preparation		
for fight with Jeffries. White wife sits		
at ringside wearing white dress and hat.	600 - 700	700 - 800

D.W.A. Photo

91 Arrival of Jack Johnson and party at		
Las Vegas, N.M. May 27, 1914. With white wife	300 - 350	350 - 400

Dana Photo, San Francisco (RP) 1910

Johnson in corner with handlers. Anonymous		
but Dana had rights for photography of fight.	125 - 150	150 - 175
C 13 Johnson sparring for Jeffries contest.	125 - 150	150 - 175
C 15 Johnson sparring Kaufman for		
Jeffries contest.	125 - 150	150 - 175
C 18 Johnson sparring for Jeffries contest.	125 - 150	150 - 175
C 27 Well dressed Johnson in group.	125 - 150	150 - 175
C 40 Johnson standing in crowd examining ring.	125 - 150	150 - 175
C 50 Johnson feeding chickens.	125 - 150	150 - 175
"Johnson and Cotton" Fighters clinch.	100 - 125	125 - 150
Johnson sits in group on steps of Rick's Resort,		
late June, 1910	125 - 150	150 - 175
Johnson just outside ring ropes	125 - 150	150 - 175
Johnson-Jeffries and Tex Rickard in		
ring. The three are added-in photo		
montage. "July 4, 1910"	125 - 150	150 - 175
14 Johnson, Rickard, handlers and		
man with arm raised. Crowd behind.	125 - 150	150 - 175
"Johnson-Jeffries Contest, July 4'10. Won		
by knockout..." Smiling Johnson in		
corner with his handlers.	125 - 150	150 - 175
Johnson & Jeffries face each other.		
Crowd below	125 - 150	150 - 175
77 "Johnson-Jeffries" The fight looking		
through ropes. Crowd in background.	125 - 150	150 - 175
Johnson-Jeffries fight - "The Knockout"	125 - 150	150 - 175
81 "Jeffries returning to corner after		
being knocked out"	125 - 150	150 - 175
"Johnson & Kaufman - Reno" Sparring in		
preparation for Jeffries fight.	125 - 150	150 - 175

Jo Photos by Dana Studios **Real Photos**

Jo 3 "Champion Jack Johnson"	125 - 150	150 - 175
Jo 7 "Jack Johnson Jo-7" With big hand ball	125 - 150	150 - 175

Jo 9 "Champion Jack Johnson"		
Johnson and trainers doing roadwork.	125 - 150	150 - 175
Note: Jo 9 pirated copy of original Dana photo.		
Johnson preps for "Fireman" Jim Flynn bout.	125 - 150	150 - 175
Jo 10 "Champion Jack Johnson - In front		
of his Training Headquarters"	125 - 150	150 - 175
Jo 11 "Champion Jack Johnson with his		
trainers and sparring partners"	125 - 150	150 - 175
"Mirror of Life" Series ca. 1907-1908		
"Jack Johnson"	125 - 150	150 - 200
Pictorial News Co., N.Y.		
"Jack Johnson - The Challenger" Printed		
advertising photo for the Jeffries fight.	100 - 125	125 - 150
Rotary Photo Co., England (RP)		
7169A "Jack Johnson"		
Well-dressed, bust photo	100 - 125	125 - 150
7169B "Jack Johnson"	100 - 125	125 - 150
"Jack Johnson, The King of Boxers"		
Included in montage - "Some Popular Athletes"	100 - 125	125 - 150
Sport & General, British (Printed Photos)		
"Jack Johnson"	70 - 80	80 - 100
Weidner Photo, S.F.		
"Jack Johnson" Close-up, arms at sides	100 - 125	125 - 150
"Jack Johnson" Fighting stance to left	100 - 125	125 - 150
Same photo but without name or photo byline.	100 - 125	125 - 150
Anonymous		
Jack Johnson and his white wife standing		
with others. May 19, 1920 (RP)	650 - 850	850 - 1000
Johnson shaking hands with John L.		
Sullivan. Others in crowd. (RP)	400 - 500	500 - 600
Johnson - Wearing fancy tie and straw		
hat. Crowded scene. Chicago, 1910 (RP)	125 - 150	150 - 175
Arena - where Jeffries-Johnson fight		
took place. Reno, Nv. Anonymous (RP)	30 - 40	40 - 45
Johnson posing with hands on hips.		
Anonymous Real Photo	125 - 150	150 - 175
Johnson posing in fighting stance		
Anonymous Printed photo	70 - 80	80 - 100
Jeffries-Johnson fight **Advertisement** (B&W)		
"July 4, 1910" Also lists "Big League" 2		
Games. Shows fighters & baseball game.	150 - 175	175 - 200
"Kaiser Bill and Black Johnson" Comic	40 - 50	60 - 75
CM in circle		
C.V. Estey, 1910 Double-fold Card, Printed		
"Stars of Pugdom — Reno Arena — July 4, 1910"	350 - 400	400 - 500
F & W Comics pre- Johnson-Jeffries fight		
"Jack" "Wont it be a DARK Fourth of July"	80 - 100	100 - 150
"Jeff" "Wont it be a LIGHT Fourth of July"	80 - 100	100 - 150
Anonymous		
Johnson-Jeffries "The Light and The Dark		
Side of a National Question" Printed photos	80 - 100	100 - 150

* **Auctioneers of some quality Real Photos**
 report onetime results as high as $800-1200.

STANLEY KETCHEL

Stanley Ketchel was born in Grand Rapids, Michigan in 1886 and began his professional career in 1903. Known as the *Michigan Assassin*, he has often been called the greatest fighter, pound for pound, who ever lived. Ketchel won the middleweight championship by defeating Mike Sullivan at Colma, Ca. on Feb. 22, 1908. He lost the title to Billy Papke on September 7, 1908, but won it back from him on November 26 of the same year. He was offered a big purse to fight heavyweight champion Jack Johnson, and on October 16, 1909 was knocked out by Johnson in the 12th round.

Ketchel, a nice looking man and a dandy with the ladies, was shot and killed by a jealous farm hand as he ate breakfast in 1910 while still the middleweight champion. His cards are a great favorite among today's collectors because of his fighting abilities, his early death, and his willingness to fight Johnson even though he was far outweighed.

Stanley Ketchel — Middleweight Champ, 1908; 1908-10
 Anonymous

"Ketchel, Muldoon, John L. Sullivan" , 1910		
Introduction in ring at Johnson training camp	100 - 125	125 - 150
Dana Photo, S.F.		
93. "Ketchel-Papke Contest", 1908 World Title		
Match. Ketchel on canvas.	70 - 80	80 - 100
"Johnson-Ketchel Contest, S.F., Oct. 16, '09		
Won by Johnson. 12 Rounds. K.O." (RP)	150 - 175	175 - 230
Weidner Photo, 1908		
"Stanley Ketchel"	100 - 125	125 - 200
"Papke vs Ketchel" Fight advertisement (B&W)		
"Who Will Win This Time?"	125 - 150	150 - 200
Johnny Kilbane Featherweight Champ., 1912-23		
Dana Photo, S.F., 1908		
"Johnny Kilbane"	30 - 40	40 - 50
Frank Klaus 1913 (R) Fight stance - outside pose	40 - 50	50 - 60
Langford-Flynn Contest Los Angeles Ca., March, 1910		
Dana Photo		
"Won by Langford. 8 Rounds. Knockout"	70 - 80	80 - 100
Ted "Kid" Lewis - Welterweight Champ, 1915-19		
Close-up pose with arms folded (AZO RP)	40 - 50	50 - 60
In fighting stance, with KL letters on shirt (AZO)	30 - 40	40 - 50
"America vs. England" Lewis vs. Gibbons		
Empire City Job Print Advertisement fight held in		
Madison Square Garden, Admission $1.00	40 - 50	50 - 60
Sam MacVea - French Champion		
By artist Cobrol Comical caricature		
JP, Paris	50 - 60	60 - 65
By artist Giris Comical Drawing (RP)		
Salon des Humoristes, 1909 "Sam Mac Vea"	50 - 60	60 - 70

Dana Photo, 1908
Johnny Kilbane

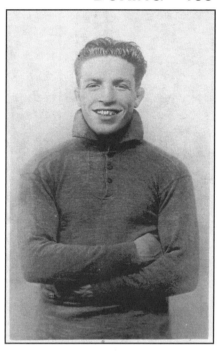

Anonymous AZO Photo
Ted "Kid" Lewis, 1908

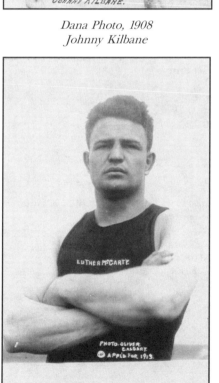

Oliver Photo, Calgary, 1913
Luther McCarty

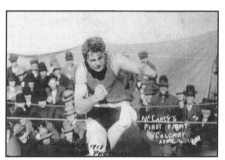

Luther "McCarty's First Fight"
Calgary, April 4, 1911

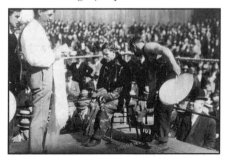

Anonymous Photo No. 107 — 1907
Owen Moran

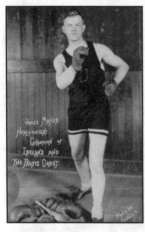
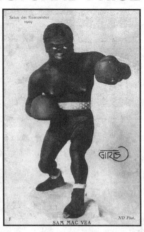

Goddard Photo, "James Maher, Heavyweight Champion of Ireland"　　*Giris, ND Photo, "Salon des Humoristes 1909" "Sam Mac Vea"*　　*Cabrol, Publisher JP French Caricature of Sam McVea*

Anonymous French 1909 (RP) | | | 40 - 50 | 50 - 60

Anonymous French 1909 (RP)		40 - 50	50 - 60
Advertising Depot Pharmacie (Printed Photo)		30 - 35	35 - 40
EDL, Paris (RP)			
92 Boxing stance, facing left "Sam Mac Vea"		50 - 60	60 - 70
102 Boxing stance, facing right "Sam Mac Vea"		50 - 60	60 - 70
Branger (RP) *			
"Match de Boxe Sam-McVea contre Joe Jeannette"			
Fight, Fighters, Ringside and Crowd		100 - 120	120 - 150
* **Longest Modern Boxing Match - 49 Rounds**			
French Chanut., Paris (Printed Photo)			
"Sam Mac Vea, Champion d'Europe ..."		30 - 35	35 - 40
"Health & Strength" Series "Sam McVea. The			
Idol of Paris" (English Printed Photo)		30 - 35	35 - 40
James Maher			
Goddard Photo (CYKO RP)			
"Heavyweight Champ. of Ireland & Pacific Coast"		20 - 25	25 - 30
Luther McCarty - Died in Ring, 1913			
Progress Photo (1913 Photo)			
"McCarty's First Fight - Calgary, April 4, 1911		50 - 60	60 - 75
"Luther McCarty" The "White Hope" posed before			
fatal bout, 1913. (RP) Oliver, Calgary		50 - 60	60 - 75

Note: McCarty was thought to be one of the best of the "White Hopes," but was killed by Arthur Pelkey with a left to the head while McCarty was not looking. He died from a brain hemorrhage.

Richie Mitchell			
Kohler, Mil. (Milwaukee) (NOKO RP)			
"Richie Mitchell" Facing left		20 - 30	30 - 40
Young Mitchell Bare knuckle Fighter			
Dana Studio, S.F. F-Series Reproductions, 1908			
F-8 "Young Mitchell" (John J. Hennet)		50 - 60	60 - 75
Frankie Neil - Bantamweight Champ., 1903-04			
Dana Photo, S.F., 1908			
Neil in boxing pose. (RP)		40 - 50	50 - 60

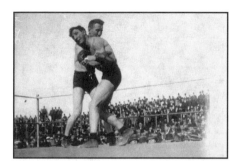

Fillmore & Ellis Studio, 1911
Murphy vs. Attell

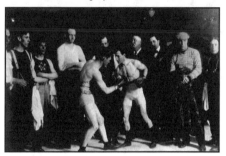

Anonymous ARTURA Photo
Nelson vs. Ab Attell, 1905

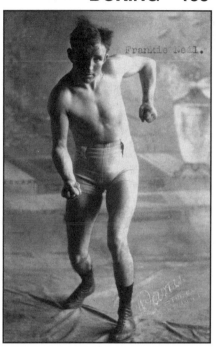

Dana Photo, 1908
Frankie Neil

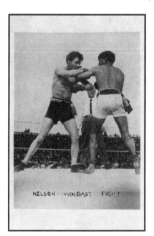

Weidner Photo, 1910
"Nelson ...Wolgast Fight"

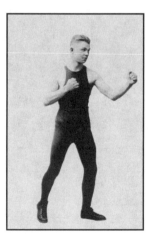

Anonymous Photo, 1912
Tommy O'Toole

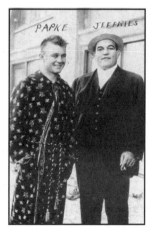

Anonymous Real Photo
Papke—Jeffries

Battling Nelson - Lightweight Champ, 1908-1910
 Anonymous
 "Nelson - Wolgast Richmond, Calif. Feb. 22, 1910

15th Round"	40 - 50	50 - 60
"Battling Nelson vs. Ad Wolgast" (RP)	50 - 60	60 - 70
"Richmond, Ca. Feb. 22, 1910.		
18,000 Present" Nelson-Wolgast fight (RP)	50 - 60	60 - 70

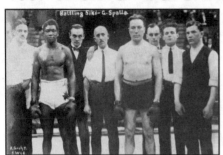

*1922 Real Photo by A. Grohs, Berlin
Battling Siki — G. Spalla Match*

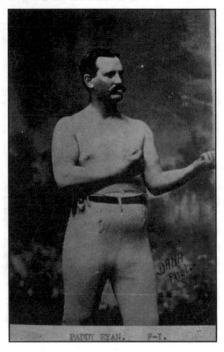

*Dana Photo, F Series, ca 1908
F-1 — Paddy Ryan*

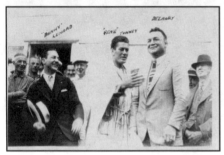

*Gene Tunney, Benny Leonard, Delaney
1920s Real Photo*

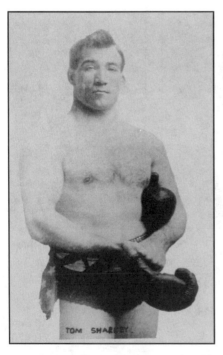

*Anon. Real Photo, ca 1908 "Tom
Sharkey"*

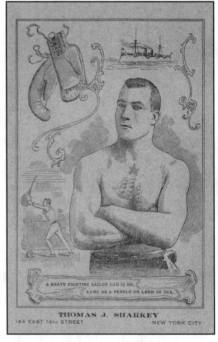

*Thomas A. Sharkey
"A Brave Fighting Sailor..."*

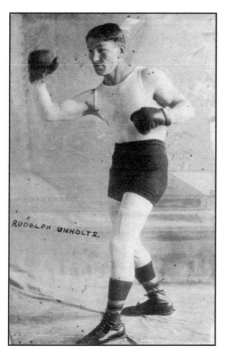

Dana Studios, ca 1908
Rudolph Unholtz

Hana Studios, 1908
Freddie Welsh

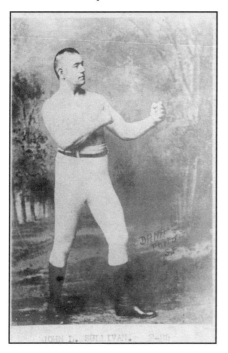

Dana , F Series, ca 1908
F-25 — John L. Sullivan

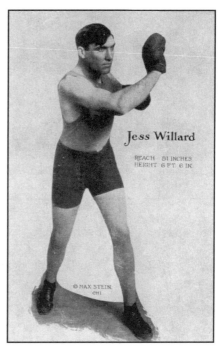

® Max Stein, Chicago
Jess Willard

Vince Dillon Photo, ca 1908
"Jess Willard, World Champion"

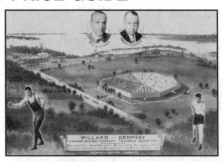

Willard — Dempsey Contest
Toledo, Ohio, 1919

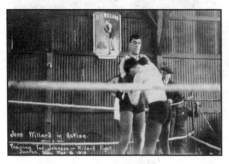

Real Photo, 1915 — Jess Willard in Action
Training for Johnson Fight, Juarez, Mex.

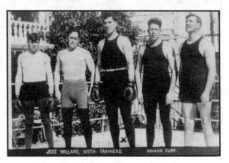

Anonymous Real Photo, 1915
Jess Willard w/Trainers, Havana, Cuba

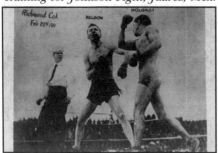

Real Photo, Dana Studios, February, 1910
Wolgast vs. Nelson Contest

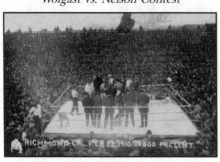

Real Photo, Richmond, Cal., 1910
Wolgast vs. Nelson

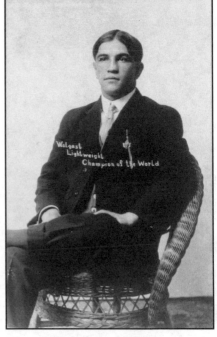

Real Photo, "Wolgast —
Lightweight Champion of the World"

Nelson vs. Abe Attell - Pre-fight photo with handlers. (ATRURA RP)	40 - 50	50 - 60
Dana Studio, S.F., 1909		
"Nelson vs. Wolgast - Sid Hester's Arena - Richmond, Ca. Pre-fight promotional photo of the two fighter with handlers, etc. (AZO RP)	60 - 80	80 - 100
Posed photo of Nelson, facing right (RP)	60 - 70	70 - 80
88-B "Nelson-Hyland Contest" May 29, 1909 23 Round K.O. (RP)	75 - 100	100 - 150
Weidner Photo		
"Nelson - Wolgast Fight" 1910 Fight in progress	30 - 40	40 - 50
Tommy O'Toole - 1912 (RP)	25 -35	35 - 50
Billy Papke - Middleweight Champ, 1908		
Billy behind wheel of touring car (AZO RP)	50 - 60	60 - 70
Dana Photo, S.F. (RP)		
89B. "Papke-Kelly Contest." Fighter on canvas with referee counting.	50 - 60	60 - 75
Weidner Photo		
Papke in fighting stance, facing left	50 - 60	60 - 80
Paddy Ryan 1880's Bare Knuckle fighter		
Dana Photo, S.F., S-Series Reproductions, 1908		
F-1 "Paddy Ryan" By John Wood	50 - 60	60 - 75
Tom Sharkey		
Real Photo	40 - 50	50 - 60
Printed Poster "A Brave Fighting Sailor Lad is He"	45 - 55	55 - 65
Battling Siki — Light Heavyweight Champ, 1922-23		
A. Grohs Real Photo	50 - 60	60 - 70
"Gunboat" Smith		
Rotary Photographic Co.		
"Gunboat Smith"	25 - 30	30 - 40
John L. Sullivan Former Bare Knuckle Champion		
Dana Photo, S.F., S-Series Reproductions, 1908		
F-25 "John L. Sullivan"	75 - 100	100 - 150
Cyclone Johnny Thompson - Middleweight, 1912		
"Johnny Thompson, Sycamore, Ill. (RP)	50 - 60	60 - 75
Gene Tunney - Heavyweight Champ 1926-28		
At his training camp, Spectator, NY, 1928 (RP)	30 - 40	40 - 50
Tunney, with B. Leonard and Jack Delaney (RP)	75 - 100	100 - 125
Rudolph Unholtz Australian 1909 (RP)		
Dana Studio, ca 1908	40 - 50	50 - 60
Rudy & Wife in touring car - Stopping by Mrs. Wilson's Half Way House	30 - 35	35 - 40
Freddie Welsh- Lightweight Champ 1914-1917		
and **Joe Rivers,** 1906		
Riding piggyback Anonymous (RP)	70 - 80	80 - 90
Hana Studios, Ltd.	50 - 60	60 - 70
Billy Wells		
Rotary Photo Co.		
"Billy Wells"	25 - 30	30 - 40

JESS WILLARD

Jess Willard was born in 1881 on Potawatomi Indian land in Kansas. He became a professional boxer late in life at the age of 28 after being a

farmer and handler of wagon trains. He won the heavyweight championship in 1915 when he defeated Jack Johnson in Havana, Cuba. This remarkable fight lasted 26 rounds. In 1919 Willard lost his title to Jack Dempsey when he was unable to answer the bell for the fourth round. He was a very big man and a heavy hitter. In 36 professional fights he scored 20 knockouts and was himself knocked out only twice.

Jess Willard - Heavyweight Champ 1915-19
Vince Dillon Photos, Fairfax, Okla.

"Jess Willard - World Champion" as a cowboy	75 - 100	100 - 150
Anonymous (RP)		
2 "Jess Willard sparring with one of his trainers Havana, Cuba." For 1915 Johnson fight	50 - 60	60 - 70
5 "World Championship Battle Jack Johnson & Jess Willard, Havana Cuba, 1915." Anonymous R.P. where Willard won title.	70 - 80	80 - 90
"Jess Willard in Action. Training for Johnson-Willard Fight, Juarez, Mex. Mar. 6, 1915." (RP)	75 - 100	100 - 125
"Jess Willard, with Trainers. Havana, Cuba. (RP) 1915	70 - 80	80 - 100

Ad Wolgast - Lightweight Champ, 1910-12
Anonymous

Studio portrait of the Lightweight Champ (RP)	50 - 60	60 - 75
"Wolgast - Lightwt. Champion of the World" (RP)	50 - 60	60 - 80
Wolgast vs. Ritchie, 1912 - Wolgast hangs on to keep from being knocked out. Possibly J.W.T. Co.	40 - 50	50 - 60
Fillmore & Ellis (RP)		
Ad Wolgast vs. Frankie Burns, May 27, 1911	50 - 60	60 - 70
J.W.T. Co.? Chicago (RP)		
"Wolgast-Ritchie Match - 8000 in Attendance"	50 - 60	60 - 80
Wolgast vs. Ritchie, 1912 Anonymous (RP)	40 - 50	50 - 60

MISCELLANEOUS

Billy Berger of Pittsburgh - Bob Deady, Mgr.		
The Sommer Studio, Philadelphia, 1908	25 - 30	30 - 35
Britt vs. McFarland - 1908 (AZO RP)		
49 Referee counting fighter on canvas	60 - 70	70 - 100
Conley vs. Moran Fight, 1910 (RP)	35 - 40	40 - 50
Adrien Hogan Printed photo - (B&W)		
C.M., Paris 1910-1920 era		
221. "Champion de France ..."	20 - 25	25 - 30
A. Kaufman - 1910		
Sommer Studio "White Hope"	30 - 40	40 - 50
Frank Klaus - 1913 (RP)	40 - 50	50 - 60
31. Bill Lang & Jordan Dana Photo, S.F. ca. 1910	20 - 25	25 - 30
Sam Langford		
Boxing Series 613		
"American Colored Heavyweight"	25 - 30	30 - 40
Maloney Bros. - Dwarf boxer (DOP RP)	12 - 15	15 - 20

Richie Mitchell

Kohler Studio, Milwaukee (NOKO RP)		20 - 25	25 - 30
Owen Moran - Bantamweight, 1907 (B&W)		30 - 35	35 - 40
Marcel Moreau French C.M., Paris (B&W)		18 - 22	22 - 26
Eddie Wimler; Jas. Mason, Manager - 1910			
Sommer Studio			
Promotional for Pittsburgh Boxing Club (RP)		20 - 25	25 - 30

PUBLISHERS

Beagles Photo Cards

British Issue The "Beagles" Photo postcards were issued beginning in 1920 to approximately 1933-1934. There were 11 groups with different numbers and each contained 24 cards. The total issue was around 264 cards. We have not attempted to list all but have concentrated on the most important boxers providing they are actually known.

Note: No cards were issued for letters "I" and "Q."

Series 156

B	Georges Carpentier	25 - 30	30 - 35
D	Jack Johnson	80 - 90	90 - 100
J	Freddie Welsh	25 - 30	30 - 35
K	Joe Beckett	20 - 25	25 - 30
P	Jim Jeffries	40 - 50	50 - 60
T	Sam Langford	40 - 50	50 - 60
U	Tommy Burns	40 - 50	50 - 60
W	Jess Willard	40 - 50	50 - 60
X	Terry McGovern	25 - 30	30 - 35

Series 157

N	Sam McVea	40 - 50	50 - 75
O	Jack Sharkey	40 - 50	50 - 75
R	Joe Jeannette	40 - 50	50 - 75
V	Bob Fitzsimmons	40 - 50	50 - 75
W	James J. Corbett	40 - 50	50 - 75

Series 158

L	Kid Lewis vs. Wells	30 - 35	35 - 40
R	Honeyman vs. Rossi	25 - 30	30 - 35
V	Pete Herman	20 - 25	25 - 30
W	Jim Higgins	20 - 25	25 - 30

Series 159

B	Joe Lynch	20 - 25	25 - 30
D	Pat O'Keefe	20 - 25	25 - 30
N	Georges Carpentier	30 - 35	35 - 40
O	Battling Levinsky	25 - 30	30 - 35
U	Tommy Burns	25 - 30	30 - 35
W	Moran vs. Willard	35 - 40	40 - 50
Y	Benny Leonard	30 - 35	35 - 40

Series 160

E	Jack Burns	20 - 25	25 - 30
L	Georges Carpentier	25 - 30	30 - 40
M	Jack Dempsey	40 - 45	45 - 50

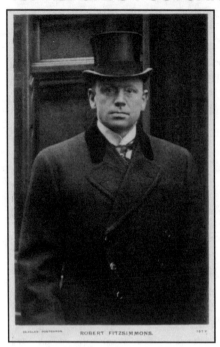

ROBERT FITZSIMMONS.

Beagles Postcards, Series 157V
Robert Fitzsimmons

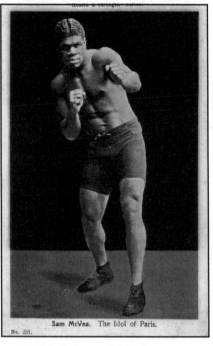

Sam McVea. The Idol of Paris.

"Health & Strength" Series, No. 231
"Sam McVea. The Idol of Paris"

N, O, P, R, S, T Dempsey vs. Carpentier	25 - 30	30 - 35	
Series 161			
N Beckett vs. McCormick	20 - 25	25 - 30	
O, P, R, T Beckett vs. McCormick	20 - 25	25 - 30	
U, W Lewis vs. Basham	25 - 30	30 - 35	
X Moran vs Beckett	20 - 25	25 - 30	
Series 174			
O, P, R Cook vs. Carpentier	25 - 30	30 - 40	
U Beckett vs. Cook	25 - 30	30 - 40	
Series 176			
B Battling Siki	30 - 35	35 - 40	
D Todd vs Kid Lewis	30 - 35	35 - 40	
H, K, L Carpentier vs. Siki	25 - 30	30 - 40	
N Ted "Kid" Lewis	25 - 30	30 - 40	
P McTuigue vs. Siki	25 - 30	30 - 40	
Series 249			
D Young Johnny Brown	25 - 30	30 - 40	
J Ted Moore	25 - 30	30 - 40	
P Kid Socki	25 - 30	30 - 40	
Series 341			
B Don McCorkindale	15 - 20	20 - 25	
C Jack Doyle	20 - 25	25 - 30	
E Max Schmeling	20 - 25	25 - 30	
Series 342			
E Alf Mancini	15 - 20	20 - 25	
F Mickey Walker	20 - 25	25 - 30	
O Benny Carter	20 - 25	25 - 30	

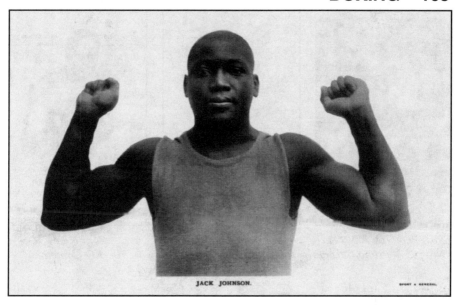

JACK JOHNSON.

"Sport & General" — British
"Jack Johnson"

X	Primo Carnera	15 - 20	20 - 25
Z	Larry Gains	15 - 20	20 - 25

"Boxing" Series

British - Issued by forerunner of the weekly **"Boxing News"** 1909-1914 in packet of 6 cards. Cards are numbered from 1 through 126 and from 600 through 616. There was one un- numbered of Jack Johnson. Some of the important fighters are listed here.

19	Frankie Burns	20 - 25	25 - 35
25	L. Kilbane	20 - 25	25 - 35
31	Frank Klaus	20 - 25	25 - 35
33	Bob Fitzsimmons	25 - 30	30 - 35
No No.	Jack Johnson	70 - 80	80 - 90

"Health & Strength" Series - British

204	Bob Fitzsimmons	40 - 50	50 - 60
212	Stanley Ketchel	50 - 60	60 - 75
216	Sid Burns	25 - 30	30 - 35
218	Jim Driscoll	25 - 30	30 - 35
219	Sam Langford	30 - 35	35 - 40
221	Ad Wolgan	30 - 35	35 - 40
222	Johnny Coulon	30 - 35	35 - 40
224	Battling Nelson	30 - 35	35 - 40
225	Owen Moran	25 - 30	30 - 35
226	Billy Papke	30 - 35	35 - 40
227	George Gunther	25 - 30	30 - 35
228	Tim Sullivan	25 - 30	30 - 35
229	Joe Jeannette	30 - 35	35 - 40
230	Harry (Young) Joseph	25 - 30	30 - 35

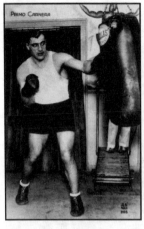

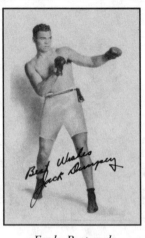

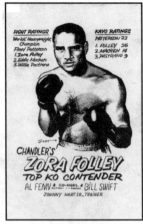

Real Photo by A.N., Paris
No. 265 — Primo Carnera

Eagle Postcards
Jack Dempsey

Zora Folley
"Top KO Contender"

231	Sam McVea	30 - 35	35 - 40
233	Freddie Welsh	30 - 35	35 - 40
234	Al Kaufmann	25 - 30	30 - 35
235	Tommy Burns	35 - 40	40 - 45
236	Tommy Burns	35 - 40	40 - 45
239	Jack Johnson	70 - 80	80 - 90
240	Tom Thomas	30 - 35	35 - 40

"Mirror of Life" Series - British
Printed photos, thick cards - non-glossy.

Bob Fitzsimmons	60 - 70	70 - 80
Iron Hague	40 - 50	50 - 60
Jack Johnson	125 - 150	150 - 200
Stanley Ketchel	80 - 90	90 - 100
Jackie McFarland	40 - 50	50 - 60
Sam McVea	50 - 60	60 - 70
Battling Nelson	60 - 70	70 - 80
Johnny Summers	40 - 50	50 - 60
Tom Thomas	40 - 50	50 - 60

"Sport & General" British 1910-12
Printed Photos

Billy Wells	25 - 30	30 - 40
Jack Johnson	70 - 80	80 - 100

Cardinell-Vincent Co. Comical 1907 Year Date
Advertisement. Promoting **Herman-Gans Fight.** 60 - 75 75 - 100
V.O. Hammon Pub. Co. White City, Chicago
Advertisement "Sullivan & Kilrain Boxing" 60 - 70 70 - 90
Geo. Rice & Sons Printed Photo collage
Advertisement
"Jack Doyles Training Camp, Vernon, Ca." 30 - 40 40 - 50
"The Arena, Jack Doyles' Training Camp, Vernon..." 30 - 40 40 - 50
Exhibit Supply Co., Chicago 1921-26
Cards have Postcard Backs
Joe Gans, Baltimore, Md. In dress clothes 25 - 30 30 - 35
Johnny Dundee, Jack Lawler 10 - 12 12 - 15
Al McCoy, Brooklyn NY Middleweight Champ 25 - 30 30 - 35

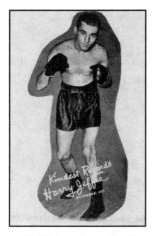

Publisher Santo Scalio
Harry Jeffra, Baltimore

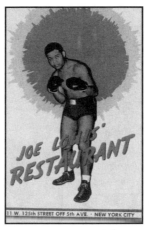

Advertising Card
"Joe Louis' Restaurant"

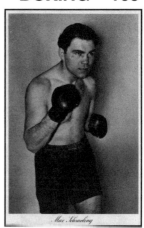

Real Photo by Schweig
Max Schmeling

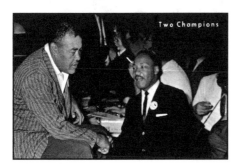

Scenic South Card Co., C-15056
Joe Louis & Martin Luther King

Eagle Postcard Co.
"Sugar Ray's Cafe" — 1950s

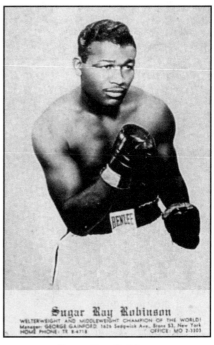

Sugar Ray Robinson
Welterweight & Middleweight Champ

Sam Langford, Boston, Mass.	40 - 45	45 - 50
Sam McVea	25 - 30	30 - 35
Aaron Brown, Frank Childs, George Dixon	15 - 20	20 - 25
Denver Ed Martin	25 - 30	30 - 35
Supply Photo Postcards 1921-1922		
Coulon	25 - 30	30 - 40

Advertisement for 2 Jacks Liquor
Joe Louis

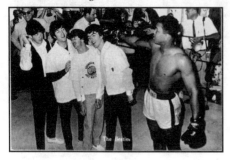

Muhammed Ali (Cassius Clay) and
"The Beatles"

Advertisement for Rose Morgan
Cosmetics featuring Joe Louis

Dempsey	40 - 50	50 - 60
Gibbons	20 - 25	25 - 35
Hart	15 - 20	20 - 25
Lomski	15 - 20	20 - 25
Mandell	15 - 20	20 - 25
Moran	20 - 25	25 - 35
Murphy	15 - 20	20 - 25
O'Brien	15 - 20	20 - 25
Perry	15 - 20	20 - 25
Schlaifer	15 - 20	20 - 25
Smith	15 - 20	20 - 25
Tendler	15 - 20	20 - 25
Walsh	15 - 20	20 - 25

Max Stein Boxing Postcards (Sepia)

Johnnie Coulon	25 - 35	35 - 45
Frank Moran	25 - 35	35 - 45
Battling Nelson	40 - 45	45 - 55
Jess Willard	40 - 45	45 - 55

1930-1960 Era

Jack Dempsey
 Eagle Postcard Co.

Dempsey in fighting stance - Restaurant ad on reverse	15 - 20	20 - 25
Linens "A Message to the Boys ..."	10 - 12	12 - 15

Real Photos		
Carnera vs. Baer - With **Dempsey** as Referee	20 - 25	25 - 30
"Ross," Berlin (RP)		
"Jack Dempsey"	25 - 30	30 - 35
Billy Conn	15 - 18	18 - 22
Zora Folley		
Ad card "Top KO Contender" 1958	20 - 25	25 - 30
Harry Jeffra Bantam and Featherweight		
Champ 1937-38 (B&W)		
Santo Scalio "Kindest Regards, Harry Jeffra"	15 - 18	18 - 22
Joe Louis		
Real Photos	25 - 30	30 - 40
Color or Black & White	15 - 20	20 - 25
Orcajo Photo Art (RP)		
"Champion of the World, Joe and Marva"	125 - 150	150 - 175
Advertising 2 Jacks Liquor Dispensor, Honolulu	30 - 40	40 - 50
Advertising "Rose Morgan Cosmetics," Hoops Studios	40 - 50	50 - 60
Advertising "Joe Louis Restaurant" - Harry Baumann	20 - 25	25 - 28
Scenic South Postcard Co., Chrome		
C15056 "Two Champions" Louis & Dr. King	10 - 12	12 - 15
Jersey Joe Walcott	12 - 15	15 - 18
Real Photos	15 - 20	20 - 25
Printed or color	8 - 10	10 - 15
"Sugar Ray" Robinson		
M. Smith Photo - "Welterweight &		
Middleweight Champion of the World"	30 - 35	35 - 45
Sugar Ray's Restaurant	30 - 35	35 - 40
Others	15 - 20	20 - 30
Jack Sharkey - Heavyweight Champ, 1932-33		
Real Photos	30 - 40	40 - 50
Printed Photos	20 - 25	25 - 30
Rocky Marciano		
Real Photos	30 - 40	40 - 50
Printed Photos	20 - 25	25 - 28
Cassius Clay	10 - 15	15 - 25
Muhammed Ali & "Beatles," Spanjersverg, NV Rotterdam	8 - 10	10 - 20
Max Schmeling		
Hans Andres, Hamburg (RP)		
S.21 "Max Schmeling" Facing left.	20 - 25	25 - 30
"Ross," Berlin		
"Max Schmeling"	20 - 25	25 - 30

ARTIST-SIGNED

A.T. (A. Taylor) (GB) 1940-1950		
Bamforth Co. "Art Comics"		
2028 Man "Watch His Right, Battler"	10 - 12	12 - 15
BEATY, A. (US) 1905-1920		
Commercial Colortype		
329 Children "The Coming Champs"	18 - 20	20 - 25
BEAUVAIS, CH. (FR) 1910-1920		
Moullot, Marseille "Les Sports"		
XXVII "La Boxe"	15 - 20	20 - 25

Unsigned Fritz Baumgarten
M&B Series #2690

Ch. Beauvais, Moullot, Marseille
"Les Sports-XXVII — La Boxe"

Tom Browne, Davidson Bros., Series
2638, "Pa Teaches Johnny the ..."

Advertisement Elixir de Menthe "La Boxe"	20 - 25	25 - 28
BERTIGLIA, A. (IT) 1910-1925		
CCM logo		
Series 2034-3 Children	15 - 20	20 - 25
BISHOP, C. (US) 1905-1915		
A H Co. "How to Succeed ..."	10 - 12	12 - 15
BOB 1905-1915		
H.M. & Co.		
Series 187 "I was never so surprised"	15 - 18	18 - 22
BORISS, MARGRET (GER) 1910-1930		
Amag in oval		
Series 0383 Children No caption	15 - 20	20 - 25
BOURET, GERMAINE 1910-1920		
P.B. in triangle logo		
Children "Arretez la Boucherie"	15 - 18	18 - 22
BROEKMAN, N. (NE) 1940's		
Anonymous		
Man "Het Boks-Wonder"	8 - 10	10 - 12
BROWNE, TOM (GB) 1905-1915		
Davidson Bros. "Pa's Adventures"		
Series 2638 "Pa Teaches Johnny the Noble Art"	22 - 25	25 - 28
CABANT, CH. (FR) 1905-1915		
L. Gorde "Cartes Satyriques" (B&W)		
Political Series 5 "La Rentree des Chambres ..."	20 - 25	25 - 30
CHIVOT, CH. (FR) 1905-1915		
Boxing Series		
"10 Rounds" (poir legus) L'attente ..."	20 - 25	25 - 30

CH. Chivot, Anonymous
"Poir legin — derrier ..."

CH. Chivot, Anonymous
"Min au froun hour le coup ..."

"Deus Amateurs"	20 - 25	25 - 30
"Grand match"	20 - 25	25 - 30
"Gran match"	20 - 25	25 - 30
"La mise a le'chev"	20 - 25	25 - 30
"Min au froun hour le coup de grace"	20 - 25	25 - 30
"Pour moyens-au genre"	20 - 25	25 - 30
"Poir legin — derrier ..."	20 - 25	25 - 30
"Un amatuer (Debut)..."	20 - 25	25 - 30

COLOMBO, E. (IT) 1910-1930
 GAM in circular logo

Series 1962-4 Children	15 - 18	18 - 22
Series 2254 (2) Children **Blacks-Whites**	20 - 25	25 - 28

COOPER, PHYLLIS (GB) 1905-1915

Series 4045 Children "My movements are ..."	20 - 25	25 - 30

CROSBY, P. (US) 1905-1915

Series 565 Man "If I don' come round soon ..."	10 - 12	12 - 15

CROUCH, BILL 1910-1920
 The Mayrose Co. (B&W)

Man "Shall we dance"	12 - 15	15 - 18

DAXHELET, P. 1910-1920

Advertisement "Gemobiliseerden Bokser"	15 - 20	20 - 25

DUNCAN, HAMISH (GB) 1905-1915
 Davidson Bros.

Series 6072 Man "Always look on the bright ..."	15 - 20	20 - 25

E.S.H. 1905-1915
 Commercial Colortype

311 Bear "A Bear Conclusion"	20 - 25	25 - 30

E. Colombo, GAM Ultra, 2254 — No Caption

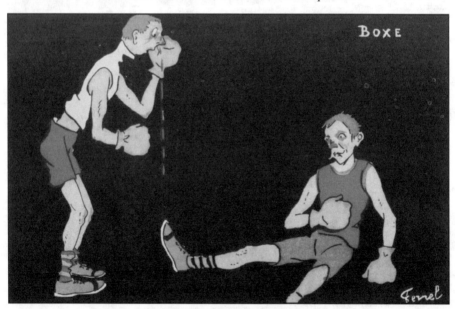

Fernel, Anonymous French Publisher — "Boxe"

ELLAM, WILLIAM (GB) 1905-1915
 Misch & Co. "Is Marriage a Failure" Series
 841 Boy/Girl "A Knock Out" 15 - 20 20 - 25
ELIOTT, HARRY (GB) 1905-1915
 Anonymous
 Men in boxing stances No caption 15 - 20 20 - 25

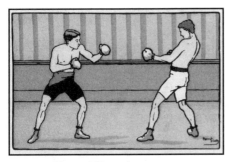

Harry Eliott, Anonymous
No Caption

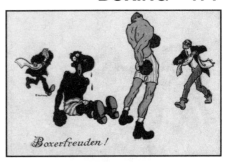

E. Kutzer, Goth=Verlag
Boxer Series 623, "Boxerfreuden!"

J. Ibanez, N. Coll Salieti
No. 602 — No Caption

E. Kutzer, Goth=Verlag
Boxer Series 621, "Boxerfreuden!"

F V in box logo 1905-1915
 LP in triangle logo

227 I Black and white boy boxing No caption	15 - 18	18 - 22

FERNEL (FR) 1905-1915

Anonymous "Boxe"	30 - 40	40 - 50

FLAGG, JAMES MONTGOMERY (US) Linen
 Colourpicture Publishers

16726 "Jack Dempsey Knocks out Jess Willard"	5 - 6	6 - 8

FLC logo (F.L. Cavelly) (US) 1905-1915
 F.A. Moss American Kid Series

6772 Children "Man's inhumanity to man ..."	8 - 10	10 - 12

G.A.S. in oval 1915-1925
 Photochrom Co., Ltd. (B&W)

Military Silhouette Series 9 "Lights Out"	10 - 12	12 - 15

GF within C in logo (George F. Christie) 1905-1910
 LG in shield logo **Political Premier Series**

"He's Going to Give Them Blow for Blow"	20 - 25	25 - 30

GALBIATI, G. (IT) 1910-1930
 T.E.L. in oval logo

Series 531 Children No caption	8 - 10	10 - 12

GLUGEON, V. 1905-1915

GOLO logo 90 Children "Le Vainawuerl!"	8 - 10	10 - 12

GOLDBERG, RUBE (US) 1905-1915
 SB in circle (Samson Bros.)

Series 212 "The Ancient Order of Glass House"	12 - 15	15 - 20

GOSS, G.W. (US) 1905-1915

Children "Keeping Fit?"	10 - 12	12 - 15

Lips, Wehrli-Vouga A.G.
No Caption

Beatrice Mallet, St. Michel Cigarettes
"La boxe"

GROLIER, J. (FR) 1905-1915
 E.S. Lyon
 Political "Spiro Boxeur - Sport a la Mode" 22 - 25 25 - 30
GUNNEPY, N. 1910-1920
 Degami
 Series 2203 Children No caption 12 - 15 15 - 18
HILTON, ALF 1910-1920
 Military - "Our Navy"
 "We have a Navy - A Fighting Navy" 10 - 12 12 - 15
HOGFELDT, R. (NOR) Modern
 Nordisk Konst
 9 Children "Knockout" 12 - 15 15 - 18
H.Z. (GER) 1905-1915
 A.R.&C.i.B.
 Series 1359 Children 10 - 12 12 - 15
IBANEZ, J. 1910-1920
 N. Coll Salieti
 602 Blacks Heads of two black boys No caption 22 - 25 25 - 30
JANSSENS, JOHN 1905-1915
 Edition Sportswoman Lady 25 - 30 30 - 35
K.V. 1905-1915
 LP in triangle
 Series 275-III Rabbits "Herzlichen Ostergruss" 10 - 12 12 - 15
KUTZER, E. (AUS) 1905-1915
 Goth=Verlag
 Boxer Series 621 "Boxerfreuden!" (2) 15 - 18 18 - 22
 Boxer Series 623 "Boxerfreuden!" (Black/White) 22 - 25 25 - 28

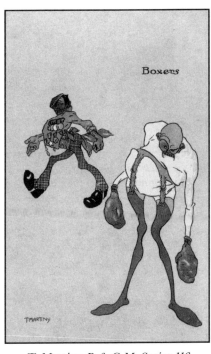

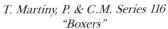

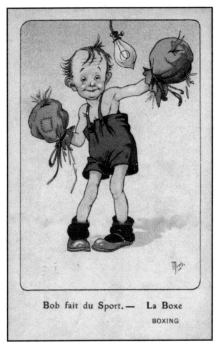

T. Martiny, P. & C.M. Series 116
"Boxers"

Mich, Sid's Editions
"Box fait du Sport — La Boxe"

LIPS 1905-1920
 P.Z. in globe logo
 Series 428 (6) No captions 15 - 20 20 - 25
 Wehrli-Vouga A.G. Black/White (B&W) 20 - 25 25 - 28
MALLET, BEATRICE (BEL) 1910-1920
 Advertisement
 Cigarettes St. Michel, Bruxelles "La Boxe" 20 - 25 25 - 30
MARTINY, T. (FR) 1905-1920
 P. & C.M.
 Series 116 "Boxers" (6) 15 - 20 20 - 25
MARY (IT) 1920-1930
 A. Trialdi, Milano
 Series 104 Children "Boxe" (6) 12 - 15 15 - 18
MAY, CH. 1905-1915
 Lonsdale & Bartholomew
 Animals "Finis" 12 - 15 15 - 20
MAY, PHIL (GB) 1905-1915
 Raphael Tuck
 Series 1295 "Fairness Which Strikes The Eye" 15 - 20 20 - 25
MICH (FR) 1905-1920
 Sid's Editions
 "The Animals are our Brothers" Series
 Series 7044-4 Rabbit "Come on, I'm ready" 12 - 15 15 - 18
 Series 7062-2 Children "La Boxe" 12 - 15 15 - 18
 Series 7076-6 Children "Nothing like boxing ..." 12 - 15 15 - 18
MORA 1905-1920 French Captions 18 - 22 22 - 26

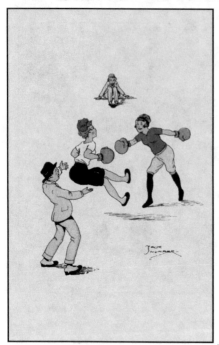

Jack Number, PFB 2119-2
No Caption

Jack Number, PFB 2116
"Bonne entrée on matiére"

Schoenpflug, B.K.W.I. 278-1
"Kampfpause"

MULLER, E. (GER) 1905-1915
 P.L., Paris
 Russo-Japanese War No caption 30 - 35 35 - 40
N (Niky) 1910-1920
 Anonymous
 Blacks Black kicks white across ring 20 - 25 25 - 30
NUMBER, JACK 1905-1915
 PFB in Diamond
 Series 2116 Children (6) French captions 12 - 15 15 - 18
 Series 2119 Girls (6) 12 - 15 15 - 18
PAHILLY (IT) 1910-1920
 Degami
 Series 2203 Children No caption 15 - 18 18 - 22
PARIS, JEAN 1930's
 A D in rounded box logo Cats No caption 10 - 12 12 - 15
RHR 1905-1915
 Anonymous
 "Jones decided to take boxing lessons ..." 10 - 12 12 - 15
RAHILLY, RH. 1905-1915
 Hippo and monkey (B&W) 10 - 12 12 - 15
ROGIND, CARL (DE) 1905-1915
 Stenters
 Pigs "Glaedeligt Nytaar" 25 - 30 30 - 35
ROWNTREE, HARRY (GB) 1905-1915
 Vivian Mansell & Co.
 Series 1077 Birds "Frightfulness!" 15 - 20 20 - 25

Carl Rogind, Stenters
"Glaedeligt Nytaar"

Schoenpflug, B.K.W.I. 278-5
"Uper Cat"

RUSSELL 1930-1940
 Advertisement Autlubo Oil
 "The Knock Out - Autlubo - That good Oil ..." 12 - 15 15 - 20
RYAN, C. (US) 1905-1915
 Anonymous
 Blacks X220 "Fake!" 35 - 40 40 - 45
 Black A-694 "It's a Cinch - Not a Hope" 30 - 35 35 - 40

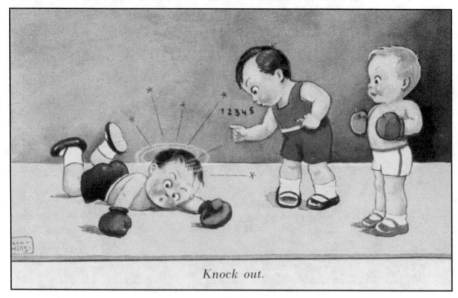

John Wills, S.W.S.B. 5071/2
"Knock out."

SAGER, XAVIER (FR) 1905-1920
 B.G., Paris
 Series 591 (4) Two wrestlers in series

Blacks	25 - 30	30 - 35
Whites	20 - 25	25 - 30

SCHÖNPFLUG, FRITZ (AUS) 1905-1915
 B.K.W.I.
 Series 278

1 "Kampfpause"	25 - 30	30 - 35
2 "In Die Stricke Gelandet"	25 - 30	30 - 35
3 "Eine Linke Aufs Auge"	25 - 30	30 - 35
4 "Out"	25 - 30	30 - 35
5 "Uper Cat"	25 - 30	30 - 35
6 "Zu Boden Gegangen"	25 - 30	30 - 35

SHAFFER, P. 1905-1915
 Political

"Amico Mio Ora Tocca Te!"	15 - 18	18 - 22

SHINN, COBB X. (US) 1905-1915
 N.A. Waters "Foolish Questions"

"What! Fighting Boys?"	12 - 15	15 - 20

STEEN (BEL) 1905-1915
 REB logo

Series K744 Man Belgian Caption	10 - 12	12 - 15

STUDDY, G.H. (GB) 1905-1920
 Valentine & Sons "Bonzo Series"

1128 "I'm Feeling Champion"	20 - 25	25 - 28

TAYLOR, A. (GB) 1940-1950
 Bamforth Co. "Taylor Tots"

K142 Children "I'll Try Anything Once"	10 - 12	12 - 15

TWELVETREES, C. (US) Linen
 Brown & Bigelow Advertisement
 39472 **Sou. Gem Coal** "I'm only warming up" 8 - 10 10 - 15
VANENT, L. (FR) 1905-1915
 Edit. Georgette
 "Le Sport Militaire" "La Boxe" 12 - 15 15 - 20
VION, RAOUL (FR) 1905-1915
 G. Delattre Co.
 Advertisement "Roue Metallic Gallia ..." 50 - 55 55 - 60
VON HARTMANN, EVELYN (US) 1905-1915
 Henry Heininger Co.
 Children "Still in the Ring" 10 - 12 12 - 15
WILLS, JOHN (GB) 1910-1920
 SWSB
 Series 5071 Children
 1 "Knock Out" 12 - 15 15 - 18
 2 "Was is dat?" 12 - 15 15 - 18
WOOD, LAWSON (GB) 1920-1930
 Valentine & Sons "Prehistoric"
 "A Round with a 'Kick' in it" 15 - 18 18 - 22
ZANY 1905-1915 Sepia
 New Years "Time Knocks Out Love" 10 - 12 12 - 15

PUBLISHERS

Amag 1905-1915
 Series 099 Children
 "Achtung" 10 - 12 12 - 15
 "Au Backe" 10 - 12 12 - 15
 "Einer ... Der Sitzt" 10 - 12 12 - 15
 "Fais Une Risette, Petit!" 10 - 12 12 - 15
 "Knock Out" 10 - 12 12 - 15
 "Zut, J'suis Moulul" 10 - 12 12 - 15
AV with lamp in circle logo 1905-1915
 Dogs
 1988 "De Boksles" 12 - 15 15 - 18
 1989 No caption 12 - 15 15 - 18
 1990 No caption 12 - 15 15 - 18
Marcel Arnac 1905-1915
 Advertisement "Koto Donne de L'Energie" 20 - 25 25 - 30
Asheville Post Card Co. Linen Multi-sport
 GC-21 Man "Never a dull moment here in ..." 3 - 4 4 - 5
B.B., London 1905-1915
 E-12 "You're a Regular Knockout" 8 - 10 10 - 12
Bamforth Co. 1940-1950
 70-B "I'm knocking the stuffing out of things ..." 4 - 5 5 - 6
 Political War Cartoons 1915-1918
 5041 "A draw be Damned ..." 15 - 20 20 - 25
F. von Bardeleban 1905-1915
 U.S. 757 "Replying to Yours" 15 - 18 18 - 22
Julius Bien & Co. 1905-1915
 "Comic Series" 15 "I'm Up Against It" 15 - 18 18 - 22

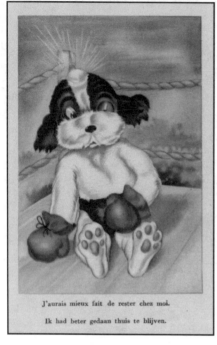

J'aurais mieux fait de rester chez moi.

Ik had beter gedaan thuis te blijven.

Coloprint B
"J'aurais mieux fais de restere ..."

Publisher Degami, Series 2203
Illegible Artist Signature

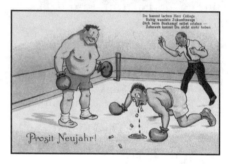

Prosit Neujahr!

Publisher HWB, Series 2848
"Prosit Neujahr!"

B.K.W.I. 1905-1915
 Series 120-2 Teddy bear No caption 15 - 18 18 - 22
C A B logo
 Rabbits Easter Greetings "All kind Thoughts ..." 15 - 18 18 - 22
N. Coll Salieti 1920-1930
 Series 589 Children "Boxeador" 15 - 18 18 - 22
Coloprint B 1940-1950
 83 Dog "Exactment comme ma femme ..." 4 - 5 5 - 8
 88 Dog "Exactment comme ma femme ..." 4 - 5 5 - 8
 225 Dressed dogs Foreign Caption 6 - 8 8 - 10
 332 Political Foreign Caption 8 - 10 10 - 12
 7437 Black Foreign Caption 6 - 8 8 - 10
Cooper Postcard Co. Chromes "Laff Cards"
 S-136 "When you finish the course..." 1 - 2 2 - 3
Degami 1910-1920
 Children No caption Two little boys boxing 10 - 12 12 - 15
G. Delattre Co. 1910-1920
 Advertisement "Roue Metallic Gallia" 50 - 55 55 - 60
F. Derbes Chromes
 A Cracked Magazine
 "Rocky's Training Camp - You'se was here! 2 - 3 3 - 4
E A S 1910-1920
 80 Children Two little boys boxing No caption 10 - 12 12 - 15
EKO in a C logo 1905-1915
 Series 1860 Blacks 12 - 15 15 - 18
E L F 1910-1930 (B&W)
 Nude Printed Photo 15 - 20 20 - 25

ES in solid diamond logo

 Lumineuse Silhouette "La Boxe" 10 - 12 12 - 15

Felsenthal & Co. 1905-1915

 Magic Moving Pictures Mechanical Boxing 25 - 30 30 - 35

GJG in circle with bird and key

 Series 59 Dressed cats No caption 12 - 15 15 - 18

Graycraft Card Co. Linen

 Series 218 "I'm beginning to learn the ropes" 4 - 5 5 - 6

H in circle logo 1905-1915

 Series 993 "It is more blessed to give ..." 12 - 15 15 - 20

HWB 1905-1915

 Series 2848 Comical boxers German captions 12 - 15 15 - 18

HSV Litho 1905-1915

 "That's What They All Say" Series 25

 Man "I'll be as strong as him in two weeks" 10 12 12 - 15

W. Hagelberg 1905-1915 (B&W)

 Christmas "A Merry Christmas - Don't Fight ..." 6 - 8 8 - 10

W.S. Heal 1905-1915

 Leather "The Long and the Short of it is" 15 - 18 18 - 22

Henderson Litho 1905-1915

 Stork 86 "Born - One White Hope" 15 - 18 18 - 22

IGA GM in circle logo

 Series 555 Foreign caption 20 - 25 25 - 30

I.P.C. & N. Co. (Ill. P.C. & Novelty Co.) 1905-1918

 Series 1351

 Patriotic "The Fist that has the Punch" 15 - 18 18 - 22

 Patriotic "Somebody is going to get ..." 15 - 18 18 - 22

International Lithographing

 "It is better to give than to receive" 8 - 10 10 - 12

K.F. in palette logo 1905-1915

 Political

 1479 "Gnon" 12 - 15 15 - 20

Kallerta Izd, G. Linen

 Silhouette #1872 "Dauds Laimez Varda Diena" 8 - 10 10 - 12

Kropp, E.C. 1905-1915

 Advertisement 25949N "Old Q, Marquis of Q ..." 5 - 6 6 - 8

 Girl Series 5

 8568 "You'll have to fight for it" 6 - 8 8 - 10

LP in triangle 1905-1915

 Series 843 (6) 10 - 12 12 - 15

 Series 885 (6) 8 - 10 10 - 12

M.D. 1905-1915

 Children "Mother always told me that singing ..." 10 - 12 12 -15

 040 Man Foreign caption 10 - 15 15 - 18

Metropolitan News Co. 1915-1930

 Series 656

 "If I can manage to get around ..." 10 - 12 12 - 15

 "4th Round - A tricky tap on the smeller" 15 - 18 18 - 22

Millar & Lang 1905-1915

 Series 369

 "3rd Round - A stiffener in the Breadbasket" 15 - 18 18 - 22

 "4th Round - A tricky tap on the smeller" 15 - 18 18 - 22

P E Co. in maple leaf logo 1905-1915

 Man "I'm glad I put on those reducing glasses" 8 - 10 10 - 12

Publisher LP, Series 885 IV
No Caption

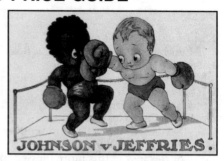

Anonymous Publisher, "Avenue" Series
"Johnson v Jeffries."

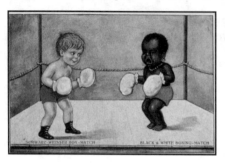

Publisher S.W.S.B., No. 1269
"Black & White Boxing Match"

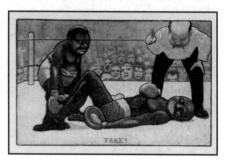

Winsch Back (Unsigned Ryan)
No. X220 — "Fake!"

E.T. Pearson 1905-1915
 Advertisement "Lactagol"

"The Lactagol Kid"	18 - 22	22 - 26

Pictorial Productions 1910-1930

Series 171-8 Elves "May you give the knockout..."	8 - 10	10 - 12

O.G.Z.-L 1910-1930
 Series 329

1642 Dressed dogs No caption	15 - 18	18 - 22

P.C.K. (Paul C. Kober) 1905-1915

Man "Always look on the bright side of things"	10 - 12	12 - 15

R (backwards) R in a box logo 1910-1920

21367 Children "Mon Dieu"	8 - 10	10 - 12

Riche, P. 1905-1915

Boy/Girl "A man should never marry out of..."	10 - 12	12 - 15

Roth & Langley 1905-1915

Skeleton 110 "Taking the count"	18 - 22	22 - 26

SWSB 1905-1915

Series 1269 Black/White Boxing match	18 - 22	22 - 26
Series 5940 Children Foreign caption	12 - 15	15 - 18
Series 5953 Children No caption	12 - 15	15 - 18

SZ logo 1930-1950
 Series 2244

571 Foreign caption	8 - 10	10 - 12

R. Salmon 1910-1920

3698 "I am in receipt of yours ..."	18 - 22	22 - 25

J. Sann 1910-1920

Children A1 No caption	8 - 10	10 - 12

Anonymous
"Emmer feste druff!"

Advertising Walkover Shoes
"The First Lesson"

Stewart & Woolf 1905-1915		
"Write On" Series 203		
"This is in response to your of ..."	10 - 12	12 - 15
Raphael Tuck 1905-1915		
No No. "Isn't it a shime-eh?"	15 - 18	18 - 22
Valentine - "In Love's Service" Printed Photo		
155 "Valentine's Morning"	10 - 12	12 - 15
"Little Men & Women" Children		
No No. "Ready for a Bout"	12 - 15	15 - 18
S.B. in circle logo 1905-1915		
"I should worry like a meal ticket ..."	10 - 12	12 - 15
TYPO 1905-1915		
"Playful Parables"		
Series 244 "A smile is as good as a biff ..."	8 - 10	10 - 12
T.P. & Co. 1905-1915		
Blacks Series 562 Sepia		
"Foul"	18 - 22	22 - 26
"Who am Champion Now?"	18 - 22	22 - 26
USA in triangle 1940's		
Dressed cats Foreign caption	8 - 10	10 - 12

ANONYMOUS

Advertisement "A Winner - **Crane Heaters**"	10 - 12	12 - 15
Advertisement "**Walkover Shoes** - The First Lesson"	12 - 15	15 - 20
Blacks "The Badger Fight"		
"Mr____the referee - Are you all satisfied?" (B&W)	12 - 15	15 - 20
Children Series 2699 Foreign	10 - 12	12 - 15
Children 1905-1915 "Een Direct"	10 - 12	12 - 15
Children Avenue Series "Johnson vs. Jeffries"	35 - 40	40 - 45
Children "Mysterious Don-Young Shrier" B&W	8 - 10	10 - 12
Children "Replying to Yours"	10 - 12	12 - 15
Children - No caption Large eyes move	8 - 10	10 - 12
Children - Dutch children boxing No caption	3 - 4	4 - 5
Man 102 "It's terrible to be parted"	6 - 8	8 - 10
Man 1905-1915 "La Boxe"	20 - 25	25 - 30
"Hitting it - Boxing Lessons"	8 - 10	10 - 12
"Myself vs Jack Johnson July 6, 1910" (B&W)	40 - 45	45 - 50
Military Linen "Slap the Jap off the Map"	6 - 8	8 - 10
Motto "A Comeback - This cat came back" (B&W)	8 - 10	10 - 12

W. Baumer & Sohn, bayrische Komiker in ihrer urkomischen Boxerparodie!

Advertising by Schmidt & Bottger
"W. Baumer & Sohn, Bayrische Komiker in ihrer urkomischen Boxerparodie!"

Motto Funnybone Series 185 "Scrap Iron" Sepia	6 - 8	8 - 10
Political Uncle Sam punches the Kaiser No caption	10 - 12	12 - 15
Political 1905-1915 "Il Se Pose La!!"	25 - 30	30 - 35
Political 1905-1915 "I am kicking"	10 - 12	12 - 15
Political 1910-1918 "A Fair Knockout - Georges Carpentier vs. Bill Kaiser	20 - 25	25 - 28
Illegible Signature, Foreign		
4169 "Leux De Maxin"	10 - 12	12 - 15
Sports Feminins 2 "La Boxe"	18 - 22	22 - 26
Valentine 193 "A Game of Hearts"	8 - 10	10 - 12
Valentine "Champion of the Wedding Ring"	8 - 10	10 - 12
Valentine "I Really Love the Manly Art"	8 - 10	10 - 12
"Die zwei wol'n ihre krafte messen ..."	10 - 12	12 - 15
Two girls engage in boxing contest Printed photo	8 - 10	10 - 12
Fight Night at Keesler Field (B&W)	4 - 5	5 - 7

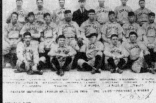

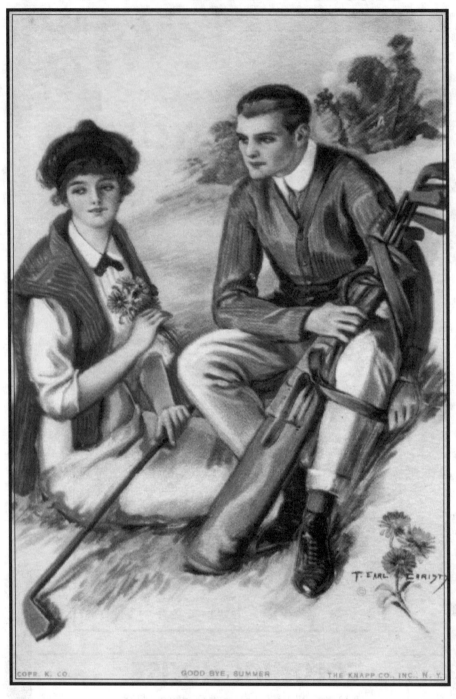

One of the Early Classics by F. Earl Christy
The Knapp Co. (H. Import No. 318) , "Good Bye, Summer"

Golf images on postcards, whether they be by the artist or by the photographer, whether they be of the golfers on the links or of a particular hole on a course — all are in great demand by collectors and participants in this wonderful sport!

Golf was probably the most popular sports theme because of the high number of participants of the era. However, it was unusual to find a complete set or series pertaining to just one sport, and it was not unusual to have a different sport illustrated on each card. Whether in sets, series, or single entities, the most popular are those done of beautiful ladies in the full dress of the day. Later came those of the great Art Deco images and casual flapper types of the Roaring Twenties.

Although their works included beautiful ladies, British and French artists were more inclined to picture the comical side with beautiful children and humorous happenings on the links. Many of these were done as full sets and series relating only to golf. Italian artists portrayed golf played after 1920; these include some of the finest glamour, Art Deco and advertising cards available.

Even though golf was not as popular in other European countries, their artists also produced large quantities during the 1900-1930 era.

Among the most famous U.S. illustrators were Harrison Fisher, F. Earl Christy, Howard Chandler Christy, Charles Dana Gibson, and James Montgomery Flagg. Their golf output was a very small portion of their overall works, and those available are in great demand. This was also

true for many European and English artists. However, the English also did many complete series relating to golf, but most were in the comical vein.

ARTIST SIGNED

	VG	EX
A.A. (GB) 1905-1915 Comics		
Millar & Lang "National" Series		
Children "Well I'm ___! He's missed it!!"	$20 - 25	$25 - 30
Children "They call me 'Breeks' but ..."	20 - 25	25 - 30
A.E.J.		
Raphael Tuck		
Series 3600		
Boy/dog "It was your country that ..."	16 - 18	18 - 20
A.T. (Arthur Taylor) (GB) 1930's-40's		
Bamforth Co. Comics		
996 Man "Gerald, Dear, I hear ..."	12 - 15	15 - 18
3085 Man "This kind of niblick ought ..."	12 - 15	15 - 18
3088 Girl "Miss Johnson flew it, missus ..."	12 - 15	15 - 18
13546 Man "It's gonna be a tight game, Lad ..."	12 - 15	15 - 18
ANTLERS (US)		
I.P.C. & N. Co.		
Boy/Girl "I have struck it right"	10 - 12	12 - 15
ATTWELL, MABEL L. (GB) 1910-1930 Children		
Raphael Tuck		
Series 841 Children, No caption	25 - 30	30 - 35
Valentine & Sons, Ltd.		
9 "Every day I seem to miss you ..."	25 - 30	30 - 35
695 Boy Golfer "Don't stand there looking at ..."	25 - 30	30 - 35
885 Girl "Don't catch me being no golf widow"	25 - 30	30 - 35
1090 Boy Golfer "Don't Cuss—Use Your Niblick"	25 - 30	30 - 35
1170 Boy "I may be only a caddie—but ..."	25 - 30	30 - 35
1504 Children "Why do you play the golf? ..."	25 - 30	30 - 35
2243 Children "If golf interferes with your ..."	25 - 30	30 - 35
2830 Boy Golfer "It's easy enough to be ..."	25 - 30	30 - 35
BARBER, COURT (GB?) 1910-1920 Glamour		
Grusi		
Series 2023/5 "A Golf Champion"	40 - 45	45 - 50
Rhen & Linzen		
Girl Golfer	40 - 45	45 - 50
BARRIBAL, L. (GB) 1905-1920 Glamour		
Alpha, London		
"True Blue" Lady in blue dress with clubs	50 - 60	60 - 70
BATCH (US) 1910-1920		
Pinnacle Art Co.		
114 Children "I'm sorry about that"	18 - 20	20 - 22
BEATY, A. (US) 1910-1920		
Commercial Colortype		
326 Children "The Coming Champions ..."	25 - 28	28 - 32
BISHOP, C. (US) 1910-1920		
Anonymous		
Children "The Coming Champs" "The Jolly ..."	12 - 15	15 - 18

*Mabel Lucie Attwell, Raphael Tuck
Series 841, No Caption*

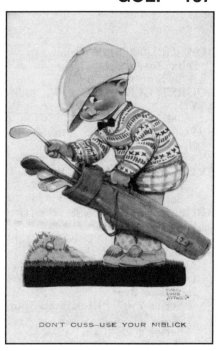

*Mabel Lucie Attwell, Valentine & Sons
1090, "Don't Cuss—Use Your Niblick"*

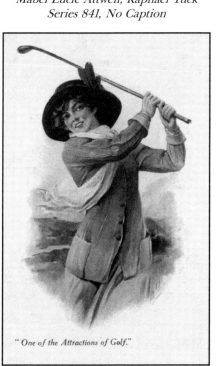

*M.B. (Maynard Brown), Henderson &
Sons 2610, "One of the Attractions..."*

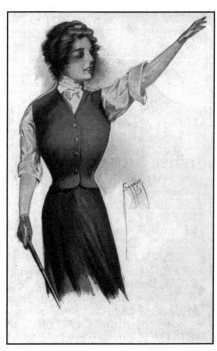

*Court Barber, Rehn & Linzen
No Caption*

BOB (GB) 1905-1910 Comics
 Felix Rosenstiel
 "A Stopped Ball! Oh!" 25 - 30 30 - 35
BOURET, GERMAINE (FR) 1920's
 YD
 631 Children "Ca C'est Envoye" 20 - 25 25 - 30
BREGER, DAVE (US) Linens
 Nyack Art Pictures
 Series 602 "Mister Breger on Vacation" 8 - 10 10 - 12
BRETT, MOLLY (GB) 1910-1925
 C.W. Faulkner & Co.
 Series 1999 Children "Fairy Games - Golf" 20 - 25 25 - 30
BRILL, G.R. (US) 1905-1915 (Uns.)
 Rose Co. "Ginks"
 Gink golfing "This is the Life - Your Gink" 10 - 12 12 - 15
BROEKMAN, N. (NETH) 1940's
 Anonymous Man "De Schrik van de golf-links" 8 - 10 10 - 12
BROWNE, TOM (GB) 1905-1920 Comics
 Davidson Bros.
 Series 2507 "Illustrated Sports"
 "Golf" 22 - 25 25 - 28
 Series 2525 (Golf) (6)
 2 "A Grand Day for Golf" 22 - 25 25 - 28
 3 "Bunkered" 22 - 25 25 - 30
 "An absorbing game" 22 - 25 25 - 30
 Series 2596 "Ma's Little Worries"
 "Ma plays golf for the first time" 22 - 25 25 - 30
 Series 2602 "Illustrated Sport"
 "Golf" 22 - 25 25 - 30
 Series 2615 "Love is Blind"
 "Her father was a champion ..." 20 - 25 25 - 28
 Series 2640 "Spooning by Moonlight"
 5 "Spooning on the links" 20 - 25 25 - 28
BUCHANAN, FRED (GB) 1905-1920
 Raphael Tuck
 Series 3410 "All Scotch III"
 Man "Just a wee wurrd tae ye" 20 - 25 25 - 30
BUTCHER, ARTHUR (GB) 1905-1920
 Inter-Art Co.
 Series 6309 "Comique"
 Children "Just Arrived" 18 - 22 22 - 25
CARTER, R.C. (US) 1905-1920
 J.I. Austen Co.
 381 "WANTED - A long ball and a highball" 15 - 18 18 - 22
 382 "When Cupid Caddies" 15 - 18 18 - 22
CARTER, REG (GB) 1915-1935 Comics
 E.T.W. Dennis & Sons, Ltd. (1920's)
 "Driving all over the place" 20 - 25 25 - 28
 Millar & Lang "National Series"
 3500 "Golfing Terms Ill.: Two up and one to play" 20 - 25 25 - 28
CHRISTIE, G.F. (GB) 1905-1915 Comics
 E.T.W. Dennis & Sons, Ltd.
 5604 Children "Golfer: What do I do now?" 25 - 30 30 - 35

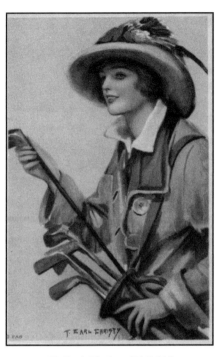

F. Earl Christy, FAS 200
No Caption

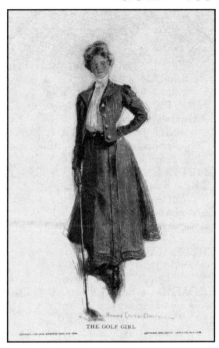

Howard C. Christy
Moffatt, Yard & Co. — "The Golf Girl"

Photochrom Co., Ltd. "Celesque" Series

2573 Golf Language..."Now, If I should miss ..."	30 - 35	35 - 38

WR & S (William Richie) "Reliable" Series

4 Man "Wanganui ... is a dormy place for a ..."	30 - 35	35 - 38
"You never shouted 'Fore'"	25 - 30	30 - 35
20 Girl "Kilgreggan ... just hits the mark and ..."	25 - 30	30 - 35

CHRISTY, F. EARL (US) 1905-1920 Glamour
Bergman Co.

Blacks Man/woman and black caddy	25 - 30	30 - 35

Robert Chapman Co., N.Y. 1910

1034 "Waiting their turn" Couple with golf club	30 - 35	35 - 40

FAS (F.A. Schneider)

200 Girl Golfer	40 - 45	45 - 55

Illustrated P.C. Co.
"Sports" Series

572 Golf Girl Pub. not listed	40 - 45	45 - 50

5006 Sports Series

7 Golf Girl	40 - 45	45 - 50

International P.C. & Novelty Co.
Series 198

1 Boy/ Girl "Is a caddy always nes(sic)essary"	30 - 35	35 - 38

Knapp Co. (Distr. by H. Import)

318 Lovers "Good Bye, Summer"	35 - 40	40 - 45

Platinachrome 1905

Woman Golfer No Caption	40 - 45	45 - 50

Reinthal & Newman (R&N)

367 "The Day's Work"	35 - 40	40 - 45

433 "Always Winning"	35 - 40	40 - 45
2105 "Always Winning" ("Printed in England")	40 - 45	45 - 50
Ullman Mfg. Co.		
501 "Golf" Lady Golfer	12 - 15	15 - 18
CHRISTY, H.C. (US) 1905-1915		
Moffat, Yard & Co.		
PMC 8 Lovers "Their First Hazard"	30 - 35	35 - 40
Unnumbered Series, 1906		
"The Golf Girl"	35 - 40	40 - 45
CORBELLA, T. (Italy) 1915-1930 Art Deco		
Rev. Stampa		
Series 316-6 Lady with Golf club	35 - 40	40 - 50
COWHAM, H. (GB) 1905-1920		
Raphael Tuck "Write Away" Series		
1271 "A Mild Game"	25 - 30	30 - 35
CRITE (US) 1905-1915		
HSV Litho, L. Gulick		
Political "Billy Possum" "It's a great game ..."	30 - 35	35 - 40
CROMBIE, CHARLES (G.B.) 1910-1920 Comics		
James Henderson & Sons		
2593 "Genius will out"	20 - 25	25 - 28
2596 "His Master's Handicap"	20 - 25	25 - 28
Valentine & Sons		
"The Rules of Golf" Series (6)		
"Local Rule, All holes made by the player in ..."	20 - 25	25 - 28
"Rule 1 Definition - Casual water ..."	20 - 25	25 - 28
"Rule 10 - Any Wheelbarrow ..."	20 - 25	25 - 28
"Etiquette 2 - No player should play up to ..."	20 - 25	25 - 28
"Rule I Definitions - The Game consists of ..."	20 - 25	25 - 28
"Rule I Definitions- A stroke is any downward ..."	20 - 25	25 - 28
"The Golf Series" (6)		
G.431 "Rule XII - When a ball lies in or ..."	22 - 25	25 - 30
"Rule XII - The player shall be entitled to find ..."	22 - 25	25 - 30
"Rule XIII - Worm Casts may be removed ..."	22 - 25	25 - 30
"Rule XVII - Any loose impediments may be ..."	22 - 25	25 - 30
G.522 "Rule XVIII - The player may remove ..."	22 - 25	25 - 30
"Rule XXXIII - A player shall not ask for ..."	22 - 25	25 - 30
Lawrence & Jellicoe		
4015 "What shall I take for this?"	25 - 30	30 - 35
CURTIS, E. (US) 1905-1920		
Raphael Tuck		
Series 7 (Leap Year) "To my Valentine ..."	10 - 12	12 - 15
Valentine Children "I swear and vow ..."	10 - 12	12 - 15
CYNICUS (GB) 1905-1915 Scottish Comics		
Cynicus Pub. Co.		
"Break, Break, Break!"	15 - 18	18 - 22
"Holed in One"	15 - 18	18 - 22
"One off Three"	15 - 18	18 - 22
"Keep your eye on the ball"	15 - 18	18 - 22
E.H.D. (Ethel H. DeWees) (US) 1905-1915		
A.M.P. Co., Alcan, Ma.		
"Billy Possum" Political Series (6)		
"Just a few lines before I get into the game"	25 - 30	30 - 35

Crite, HSV Litho Co.
"It's a Great Game for Us Fat People ..."

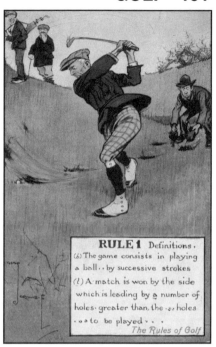

Chas. Crombie, Valentine's "The Rules
of Golf" —"Rule I"

Charles Crombie, Lawrence & Jellicoe
4015 —"What Shall I Take for This?"

EHD (E. H. DeWees), A.M.P. Co., Billy
Possum Series —"I'm going to make ..."

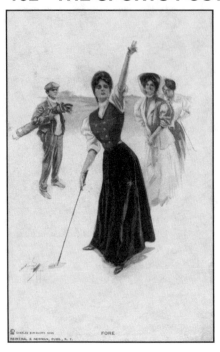

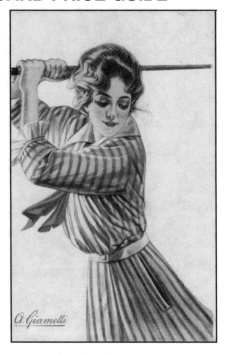

Harrison Fisher, Reinthal & Newman
Series 103, "Fore"

A. Giametti, CCM Series 2017
No Caption

C. D. Gibson, "Snap-Shot" Series
"A Good Game for Two"

"It's a bad thing to 'Put Off'"	25 - 30	30 - 35
"Yale's favorite Son"	25 - 30	30 - 35
"Arrived here just at the right time"	25 - 30	30 - 35
"I'm going to make a record this trip"	25 - 30	30 - 35
"I'll make another drive when the time comes"	25 - 30	30 - 35
Langsdorff & Co.		
Series 730 Golfing Teddy Bears (6)	25 - 30	30 - 35
EDDY, E.C. (US) 1905-1920		
E.C. Eddy color		
"Life Saving crew at 10th hole"	30 - 40	40 - 50
Real Photo by AZO		
Blacks "Life Saving crew at 10th hole"	80 - 90	90 - 100
ELCOCK		
North British Rubber Co.		
7 Man - "Etiquette of Golf ..."	15 - 18	18 - 22
13 "Rule 13-A player shall not play ..."	18 - 22	22 - 25
15 "Rule 15-Before striking at ball ..."	18 - 22	22 - 25
36 Man - "Rule 36-If a dispute arises on ..."	15 - 18	18 - 22
FEIERTAG, K. (Austria) 1910-1920 Glamour		
B.K.W.I.		
Series 237 Beauty in Red Coat, with Golf Bag	50 - 60	60 - 70
FISHER, HARRISON (US) 1905-1920 Glamour		
Reinthal & Newman		
103 "Fore"	40 - 45	45 - 50
108 "Two Up"	40 - 50	50 - 60
FITZPATRICK (US) 1950'S		
Bamforth Co. Chromes		
Comic Series 262 "What are those little things ..."	3 - 4	4 - 6
Seaside Comics Ser. 2000 Animals - "Arrived ..."	3 - 4	4 - 6
FLAGG, JAMES M. (US) 1905-1920 Glamour		
Henderson Litho		
Golf Girl	35 - 40	40 - 45
FLOHRI (US) 1905-1915		
Rotograph Co.		
Comic Set #2 - Men		
"P.S. - Mr.____has become quite a swell golf ..."	12 - 15	15 - 20
"P.S. - I made a bad foozle yesterday"	12 - 15	15 - 20
"P.S. - Mr.____has learned to play golf he now ..."	12 - 15	15 - 20
"P.S. - I made a great record on the links ..."	12 - 15	15 - 20
FULLER, EDMUND G. (GB) 1910-1920		
Raphael Tuck		
Series 958 "Shakespeare Up-to-date"		
"I'll bear him no more sticks ..."	18 - 22	22 - 25
G.M.R. 1905-1915		
M & L (Millar & Lang)		
National Series		
1097 Children "Gee! How I miss you"	20 - 25	25 - 30
2029 Children "Here's hoping for a stroke of ..."	20 - 25	25 - 30
GAWTHORN, H.G. (GB) Reproduction		
Dalkeith Classic Poster		
D27 "Cruden Bay"	2 - 3	3 - 4
GIAMETTI, A. (Italy) 1920's		
CCM		
2017 Lady Golfer	35 - 40	40 - 50

GIBSON, CHARLES DANA (US) 1905-1920
 Detroit Publishing Co. (B&W) (Undb)

14017 "Good Game for Two"	22 - 25	25 - 28
14027 "Is a caddy always necessary?"	22 - 25	25 - 28

 "Gibson" Series Sepia
 Series 149

"The Ancient and Honourable Game"	15 - 20	20 - 25

 James Henderson & Sons Sepia Series

109 Beautiful Lady	20 - 25	25 - 28

 Series 127

893 "Golf Term. Two up and the ... to pay"	15 - 18	18 - 22
"Golf is not the only game"	15 - 18	18 - 22
"Is a caddy always necessary?" (Uns)	15 - 18	18 - 22

 "Gibson" Series Sepia

763 "The Girl with a Completion"	15 - 18	18 - 22

 Life's Comedy Series Sepia

15 "One Difficulty of the ..."	15 - 20	20 - 25

 "Pictorial Comedy Series"

"Golf is not the only game on Earth"	15 - 18	18 - 22

 Sports Girls Sepia

2610 "One of the attractions of golf"	22 - 25	25 - 28

Schweizer & Co. (GER)
 Pictorial Comedy Sepia

"Golf Girl"	22 - 25	25 - 28
"Is a caddy always necessary?"	15 - 18	18 - 22

 Snap-Shots
 B&W

Girl "Advice to Caddie ... You will save time ..."	18 - 22	22 - 25
Girl "Golf is not the only game on earth"	15 - 18	18 - 22

 Color

26 "A Good Game For Two"	20 - 25	25 - 30
27 "Is a caddy always necessary?"	20 - 25	25 - 30

GOLDBERG, RUBE (US) 1905-1915
 SB (Samson Bros.)
 Foolish Question Series

213 Foolish Question #24 - "Morning, Sandy ..."	10 - 12	12 - 15

GRIMM, ARNO 1905-1920
 Th. E.L. Theochrom

1074 Man golfer	15 - 18	18 - 22

GUNN, ARCHIE (GB-US) 1905-1920 Glamour
 Anonymous

Lady Golfer (Color)	30 - 40	40 - 50
Lady Golfers (2) (B&W)	25 - 30	30 - 35
Golf Girls Series (6)	25 - 30	30 - 35

 Lowney's Chocolates 1905-1915
 Advertising W.M.L. Co.

Lady Golfer	35 - 40	40 - 45

 S. Bergman "Beautiful Lady"

	25 - 30	30 - 35

 National Art Co.

247 "Clan Lamond" Scottish girl w/golf club	25 - 30	30 - 35
252 "Gordon Plaid" Scottish girl sitting w/club	25 - 30	30 - 35

GUNNELL, N. ??? (Italy) 1920's
 Degami

Archie Gunn, National Art Co. 252
"Gordon Plaid"

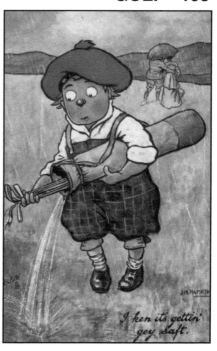

J. M. Hamilton, Raphael Tuck
Series 9461, "I ken it's gettin' gey saft."

2205 Children	20 - 25	25 - 30
GUTTANY (Germany?) 1905-1915		
E. Gross Co.		
"A Tee Party"	25 - 30	30 - 35
H.H. (H. Herman) (US) 1905-1915)		
Illustrated Post Card & Novelty Co.		
"The Athletic Girl"	15 - 18	18 - 22
5004-16 "The Golfer" (UndB)	15 - 20	20 - 25
HAMILTON, J.M. (GB) 1905-1918 Comics		
Raphael Tuck		
"Our Caddy" Series 9461 Children (6)		
"I never ken'd anything like it!"	20 - 25	25 - 30
"Golf Language"	20 - 25	25 - 30
"I ken it's gettin' gey saft"	20 - 25	25 - 30
"Injured Innocence"	25 - 30	30 - 35
"Stop Mon"	20 - 25	25 - 30
HENRY (FR) 1910-1920)		
Coloprint B		
336 French caption "Who dares to challenge ...?"	20 - 25	25 - 30
IRBY (US) 1940-1950 Linen Comics		
MWM Color Litho		
"I made a hole-in-one today"	4 - 5	5 - 7
JOHNSON, J. (US) 1910-1920		
Sam Gabriel Co.		
407 Valentine "Heart-Tee Valentine Greetings"	8 - 10	10 - 12
KING, HAMILTON (US) 1905-1915		
Anonymous (possible Hamilton King Girl)	40 - 50	50 - 60

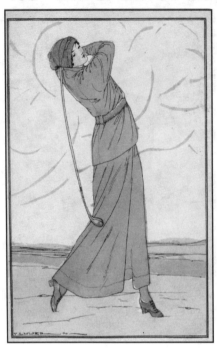

V. Lhuid, M. Munk Series 14
No Caption

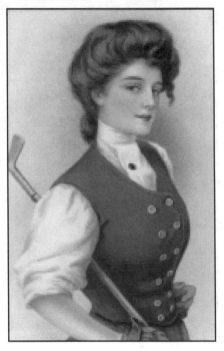

Anonymous (possibly Hamilton King)
Beautiful Red Weskit, 1910 Era

KINSELLA, E.P. (GB) 1905-1920
 Langsdorff & Co.
 Series 710 Comical Children

"Bunkered"	25 - 30	30 - 35
"Got to go over it"	25 - 30	30 - 35
"I bet ma kilts I'll win!"	25 - 30	30 - 35
"The Little Champion"	25 - 30	30 - 35
"Missed it"	25 - 30	30 - 35
"Thistles"	25 - 30	30 - 35

KÖHLER, MELA (AUS) 1905-1915
 B.K.W.I.
 Series 187-5 Beautiful lady in follow through 200 - 250 250 - 300
LEDERER (US) 1905-1915 (UndB)
 Anonymous
 Boy/girl "I've been out with my lady friend" 8 - 10 10 - 12
LEONNEC, G. (GL) (FR) 1910-1930
 R. & Cie. Beautiful Lady Golfer 40 - 50 50 - 60
LEVIN, MEYER (US) 1940-1950 Mutoscope (B&W)
 Girl - "Oh Dear, I think the ball's bewitched ..." 8 - 10 10 - 12
LEWIN, F.G. (GB) 1915-1930 Comics
 J. Salmon
 3420 Black Children Golfers 35 - 40 40 - 50
LHUID, V. (AU) 1905-1915
 M. Munk, Vienna
 Series 14 Lady Golfer 40 - 50 50 - 60
LONG, BILL (US) 1940's Linen
 P.E. Co. Man "Fore goodness sake. Write" 4 - 5 5 - 7

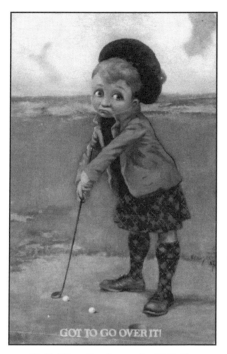

E. P. Kinsella, Langsdorff & Co.
Series 710, "Got to Go Over It!"

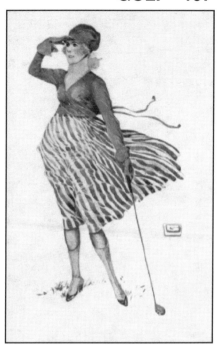

GL (G. Leonnec), R. & Cie.
No Caption

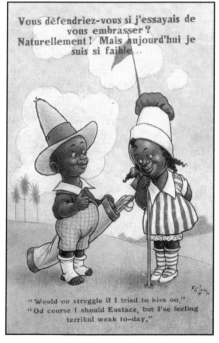

F. G. Lewin, J. Salmon Co. 3420
"Would oo struggle if I tried to kiss..."

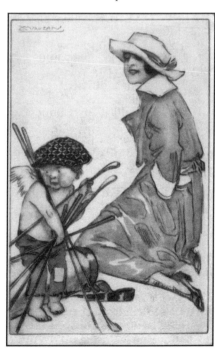

L. A. Mauzan, G.B.T. Series 10-3
No Caption

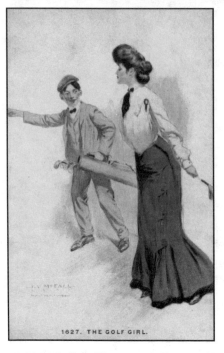

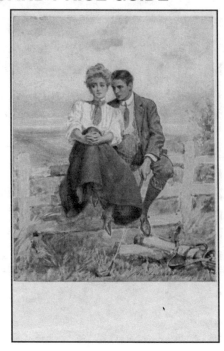

J. V. McFall, Williamson-Haffner 1627
"The Golf Girl"

Hal Ludlow, M. Munk
No. 1125, No Caption

LUDLOW, HAL (GB) 1905-1915
 M. Munk
 1125　Lovers on Fence 20 - 25　　25 - 28
LYNT, WILMONT　1905-1910　Real Photo
 Percy Redjeb (B&W)
 Lady "The Golf Girl" 15 - 18　　18 - 22
M.B.　1905-1915 10 - 12　　12 - 15
M.D.S. (US) 1910-1920　Comics
 Anonymous
 "Sporty Bears" 1929 "On the Links" 25 - 30　　30 - 35
MAC (GB) 1910-1920
 Ullman Mfg. Co.
 4566　Man "That's the last of them gone sir ..." 15 - 18　　18 - 22
MALLET, BEATRICE (GB) 1910-1930
 Raphael Tuck "Cute Kiddies" Series 10
 3628　"Getting the wind up" 25 - 30　　30 - 35
MALONEY (US) 1950's
 Plastichrome
 P31195　Golf Score Card "Rule: Out of bounds ..." 1 - 2　　 2 - 3
MARCOS, JAN (Italy) 1920-1930　Art Deco & Glamour
 Rev. Stampa
 Series 2461　Beauty swinging club 40 - 50　　50 - 65
MART (GB) 1910-1930
 E.T.W. Dennis & Sons, Ltd.
 167　Man "Just about to put one down the ..." 35 - 40　　40 - 45
 192　Boy/girl "The most difficult part of all ..." 25 - 30　　30 - 35

Phil May, Raphael Tuck Series 1008
"I miss you awfully"

Unsigned Chloe Preston, A.R. & Co.
1587-4, "Handicapped"

MARTIN, L.B. 1920'S
 J. Arthur Dixon
 Martin Series
 Man "No, t'aint that you stand too close ..." 10 - 12 12 - 15
MAUZAN, L.A. (Italy) 1915-1930
 G.B.T. Art Deco & Glamour
 Series 10 (6) Beautiful lady golfers 40 -50 50 - 60
MAY, PHIL (GB) 1900-1915 Comics
 Raphael Tuck
 Series 1008 "Write Away" Series
 "I miss you awfully" 20 - 25 25 - 30
 Also available in proof edition 70 - 80 80 - 100
MC CLURE 1910-1920 (B&W)
 Anonymous
 Rabbits (B&W) "On the golf links" 15 - 18 18 - 22
MC FALL, J.V. (US) 1910-1920
 Williamson-Haffner
 1627 Lady "The Golf Girl" 15 - 18 18 - 22
MC GILL, DONALD (GB) 1915-1940 Comics
 Bamforth Co. Kid Comics
 175 Boy/Girl - "I'd even give up a round of ...!" 12 - 15 15 - 18
MICH (FR) 1920's
 Sid's Editions
 7603-3 Children "Bob fait du Sport ... Le Golf" 20 - 25 25 - 28
MIKE (GB) 1940-50's
 Inter-Art Co.
 "Comique Series"
 476 "A man who just beats about the bush ..." 4 - 5 5 - 7
MISGROVE, EWART (GB) 1910-1920
 Valentine & Sons
 Elves "Now I wonder where that ball went" 18 - 22 22 - 25
MUNSON, WALT (US) 1940-1950 Linens
 Various Publishers 4 - 5 5 - 7
 157 "Hey Pop- I made it! A hole in one!" 4 - 5 5 - 7
MYER (US) 1910-1920
 Aurocrome
 A30 Limerick "The Golfer ..." 18 - 22 22 - 26
 68 Man "I can't say all I want to" 8 - 10 10 - 12
NANNI, G. (Italy) 1915-1930 Art Deco & Glamour
 Rev. Stampa
 Series 309-4 Lady Golfer 40 - 50 50 - 60

G. Nanni, Rev. Stampa Series 309-4
No Caption

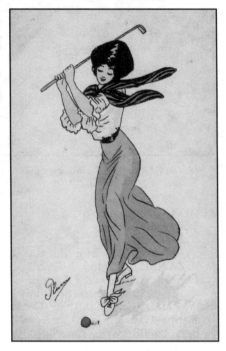

Plum, G.H., Paris, Series 25
No Caption

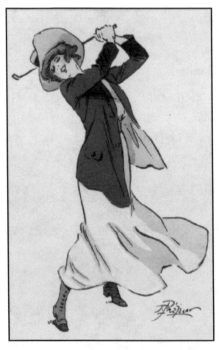

Prejelan, C. Fres, Series 0151
No Caption

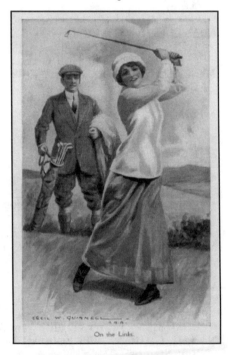

Cecil W. Quinnell, Paul Heckscher
1225/1, "On the Links"

OSSWALD, EUGEN (GER) 1905-1915
 Wilh. Stephan
 Elephants play golf 50 - 60 60 - 75
OUTCAULT, R.F. (US) 1905-1915 Comics
 J. Ottman Litho Co.
 "Your's Just Received" Comic lady hits ball. 15 - 18 18 - 22
PATERSON, VERA (GB) 1915-1935 Comical Children
 J. Salmon
 5035 Boy - "I know a feller can't always ..." 20 - 25 25 - 30
 Valentine & Sons
 1090 Boy - "A few bits of BUDE" 20 - 25 25 - 30
 2690 Children Foreign caption 20 - 25 25 - 30
 Humoresque
 2687 Boy golfers - "You seem so near and yet ..." 15 - 18 18 - 22
PEDRO Chrome
 Sunny Pedro
 125 Boy/Girl "I think I will leave it..." 1 - 2 2 - 3
PILLARD
 Langsdorff & Co.
 Teddy Bear Series "Teddy at Golf" 22 - 25 25 - 28
PIPER, GEORGE (GB) 1910-1920
 P. & C.K.
 Girl "Bournemouth's the place ... first-class drives" 15 - 18 18 - 22
PLUM (France) 1910-1925
 G.H., Paris
 Series 25 Beautiful lady swinging at golf ball 55 - 60 60 - 70
PREJELAN (GER) 1910-1920
 C. Fres
 0151 Girl Golfer 25 - 30 30 - 40
PRESTON, CHLOE (GB) 1915-1935 Children
 A.R. & Co.
 1587-4 Boy and Boy Caddie 20 - 25 25 - 28
 1587-4 Same but with caption "Handicapped" 20 - 25 25 - 28
 1587-4 Also with German caption "Gehandikapt" 20 - 25 25 - 28
 Valentine & Sons
 1022 "Where did that one go?" 25 - 30 30 - 35
 1029 "Handicapped" Same as 1587-4 20 - 25 25 - 28
PROF Chrome
 Cardtoon
 C66 "That chap should be more careful ..." 1 - 2 2 - 3
PURVIS, TOM (GB) Chrome, Reproduction
 Dalkeith Classic Poster
 D30 "Live and Golf at Moor Park" 2 - 3 3 - 4
QUINNELL, CECIL W. (GB) 1905-1920 Glamour
 Paul Hecksher
 "The Golf Girl" 55 - 65 65 - 75
 1225/1 Beautiful lady - "On the Links" 55 - 65 65 - 75
RELYEA (US) 1910-1925 Loving couples
 E. Gross Co.
 No. 9 Golf Couple 18 - 22 22 - 25
 No. 10 Golf Couple 18 - 22 22 - 25
REYNOLDS, W. (GB) Chrome, Reproduction
 Dalkeith Classic Poster
 D25 "The Golfer's Train ..." 2 - 3 3 - 4

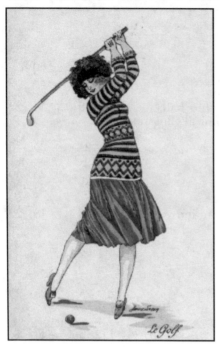

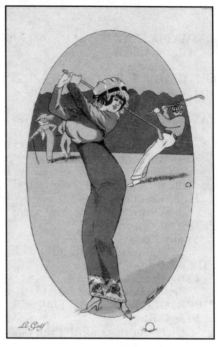

Xavier Sager, B.M., Paris 524
"Le Golf"

Xavier Sager, Raphael Tuck, Paris
"Le Golf"

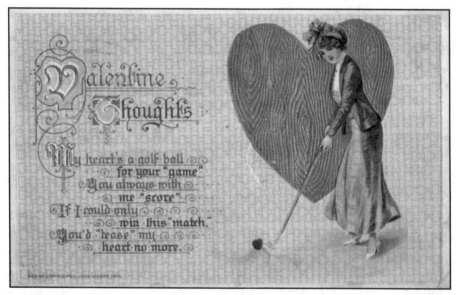

Unsigned S. L. Schmucker, Winsch ©1914 — "Valentine Thoughts"

RICHARDSON, AGNES (GB) 1910-1920
 Inter-Art Co.
 1963 Children "When you're a long, long way ..." 20 - 25 25 - 30

SAGER, XAVIER (FR) 1905-1925
 B.M., Paris

524 Lady Golfer "Le Golf"	40 - 50	50 - 60

 Raphael Tuck

No. No. Lady Golfer "Le Golf"	50 - 60	60 - 75

SANDFORD, H.D. (GB) 1905-1915
 Raphael Tuck Blacks
 Series 9427 "More Coons"

Man golfing while children watch	32 - 35	35 - 40

SCHIELE, EGON (AUS) 1900-1910

Golfing Ladies (3)	300 - 325	325 - 350

SCHMUCKER, S.L. (Unsigned) 1910-1920
 John Winsch
 Copyright, 1910, Valentine Cupid Series

"To My Valentine" "To My Valentine"	45 - 50	50 - 55

 Copyright, 1911 Gold Heart, Vertical

"Valentine" Girl "My heart's a golf ball ..."	50 - 60	60 - 70

 Copyright, 1914 Gold Heart, Horiz.

"Valentine" Girl "My heart's a golf ball ..."	50 - 60	60 - 70

SCHÖNPFLUG, FRITZ (AUS) 1905-1920
 B.K.W.I.
 Series 923-6 "Ein Machtiger Stroke"

	30 - 35	35 - 40

SHINN, COBB X. (US) 1910-1920
 N.A. Waters

Foolish Questions "Have you lost something?"	8 - 10	10 - 12

SMITH, A.T. (GB) 1905-1915
 Raphael Tuck

Golfing Jokes from "Punch" (6)	15 - 20	20 - 25

SPURGIN, FRED (LATVIA) 1910-1920
 Art & Humor Pub. Co.

2178 Man "The club that started the cross-words!"	15 - 18	18 - 22

STAN, I. (GB) 1910-1920
 E.T.W. Dennis & Sons, Ltd.

6266 Boy/Girl "His Handicap"	15 - 18	18 - 22

STUDDY, G.H. (GB) 1905-1925 "Bonzo"
 A&R Co.
 Series 1682-3 "I'm raising quite a ..."

	20 - 25	25 - 28

 B.K.W.I.

"Bonzo" Series with Golf	20 - 25	25 - 30

 Valentine & Sons "Bonzo" Series

995 "Keep your eye on the ball"	20 - 25	25 - 28
1200 "I'm missing you dreadfully"	20 - 25	25 - 28
1202 "Every dog has his day"	20 - 25	25 - 28
1310 "I'm raising quite a dust here"	20 - 25	25 - 28
1819 "You've fairly caught my eye"	20 - 25	25 - 28

 "R.P.S." Series

1013 "Lost Ball"	20 - 25	25 - 28
1021 "William Tell"	20 - 25	25 - 28
1023 "Rabbits, I Believe?"	20 - 25	25 - 28
1027 "Bogey Four"	20 - 25	25 - 28
1032 "Dormy Six"	20 - 25	25 - 28
1036 "What about me"	20 - 25	25 - 28

TAYLOR, A. (GB) 1935-1950 Comics
 Bamforth Co., New York

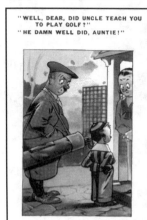

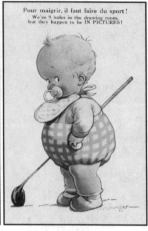

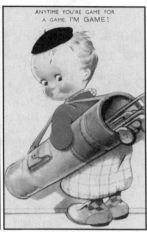

Unsigned A. Taylor
Bamforth Co.
"... He damn well did ..."

D. Tempest
Bamforth Co. 284
"We've 9 holes in the ..."

Unsigned D. Tempest
Bamforth Co. 129
"Anytime you're game ..."

005 "That's Cheating Fred ..." Chrome	2 - 3	3 - 4
116 "What did I go around in yesterday Caddie?"	12 - 15	15 - 18
117 "Well, Dear, did Uncle teach you to play ..."	12 - 15	15 - 18
192 "They say he killed his mistress ..."	4 - 6	6 - 8
"... He damn well did, Auntie!" (Uns)	12 - 15	15 - 18
1845 Golf Bag—"There is no doubt about ..." (Uns)	8 - 10	10 - 12
2011 "Nasty to be faced with a bunker ...!" (Uns)	12 - 15	15 - 18
2022 "Stop that grinning caddie ..." (Uns.)	12 - 15	15 - 18
3332 "We plough the fields and scatter!"	12 - 15	15 - 18
4304 "What's this lady gone round in ..."	12 - 15	15 - 18

TEMPEST, D. (GB) 1920-1940 Comics

Bamforth Co., New York

013 "Ah'll be deeply indebted to ye, laddie ..."	10 - 12	12 - 15
129 "Anytime you're game for a game ..." (Uns)	12 - 15	15 - 20
160 "Shay, caddie, why don't you ..." Drunk golfer	10 - 12	12 - 15
284 "We've 9 holes in the ..."	10 - 12	12 - 15
313 "Golfers have a language of their own"	12 - 15	15 - 18
484 "I've never holed in one yet ..."	15 - 18	18 - 22
1226 "I hope you'll never be seen doing this"	12 - 15	15 - 18
1230 "They have a lawn mower up at the ..."	10 - 12	12 - 15
1846 "Visitors: "That Rip Van Winkle fellow ..."	10 - 12	12 - 15
1991 ""Being on the 'tee' is alright for ..."	10 - 12	12 - 15

TETLOW (US) 1905-1915

U. of Pennsylvania Lady Golfers "At last Resort"	40 - 45	45 - 50

THACKERAY, LANCE (GB) 1905-1915 Comics

Raphael Tuck

Series 1627 "Write Away Series" (6)

"I don't mind If I ..."	25 - 30	30 - 35
"It's Just About ..."	25 - 30	30 - 35
"It's such a waste"	25 - 30	30 - 35

Series 1628 "Write Away Series" (6)

"I Thought it Best ..."	25 - 30	30 - 35
"I'll not keep you"	25 - 30	30 - 35

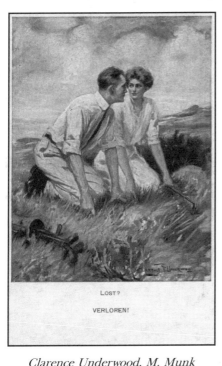

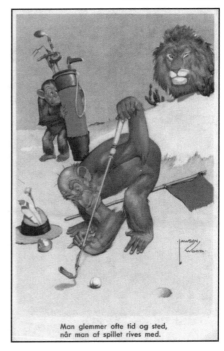

Clarence Underwood, M. Munk	*Lawson Wood, "Gran' Pop" Series*	
860C, "Lost?"	*Foreign Caption*	

"Word's fail Me"	25 - 30	30 - 35
Series 9304 (6)		
"The game of golf ... After the ball"	20 - 25	25 - 30
"The game of golf ... Take me Miss"	20 - 25	25 - 30
"The game of golf ... It's rather difficult"	20 - 25	25 - 30
Series 9305 (6)		
"The game of golf ... A Match"	20 - 25	25 - 30
"The game of golf ... A close Match"	20 - 25	25 - 30
"The game of golf ... Good Form"	20 - 25	25 - 30
Series 9499		
Golf Language	20 - 25	25 - 30
TROW (US) Chrome		
Brook Publishing Co.		
12015 Man "All these rules and regulations get ..."	2 - 3	3 - 5
Coastal Cards, Ltd.		
Lady "And how do you know my husband's ..."	2 - 3	3 - 5
TWELVETREES, C. (US) 1910-1930		
Edward Gross		
Children "Smile Messengers" Series		
81 Children "Dad's wearing mine ... He's a golfer"	12 - 15	15 - 18
140 "Women Nothin! I've taken up golf"	12 - 15	15 - 18
Ullman Mfg. Co.		
"Jungle Sports" Series (Uns.)		
1895 "On the Job" Giraffe ready to tee off.	35 - 40	40 - 45
UNDERWOOD, CLARENCE (US)		
M. Munk, Vienna		
860c "Lost" German Caption "Verloren!"	15 - 20	20 - 25

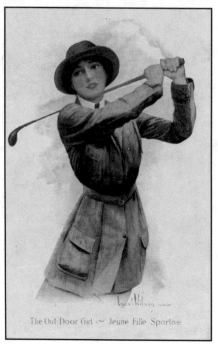

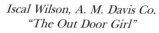

Iscal Wilson, A. M. Davis Co.
"The Out Door Girl"

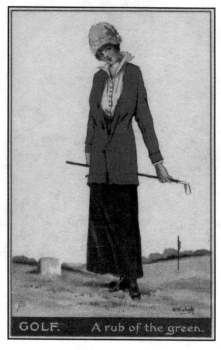

Winifred Wimbush, Raphael Tuck 3603
"Golf — A rub of the green."

VINCENT, RENE (FR) 1920-1930
 Leon Ullman, Sr.

Advertisement for "Roussel" Tonic - Golfers	80 - 90	90 - 100

WFD 1910-1920
 Anglo-American P.C. Co.

Girl "A Record"	30 - 35	35 - 40

WALL, BERNHARDT (US) 1905-1920
 Ullman Mfg. Co.

1379 Skeleton "Golf"	12 - 15	15 - 18

WHEELAN, ALBERTINE R. (US) 1905-1915
 Paul Elder & Co. "Doggeral Dodger" Series

Dressed Dog and lynx "On the Lynx"	15 - 18	18 - 22

WHITE, BRIAN (GB) 1910-1920
 Valentine & Sons "Nipper Series"

3511 Children "Just a few words"	12 - 15	15 - 20

WILKINS, BOB (US) Chromes
 Anonymous

1627 "You told me to use my brassie"	3 - 4	4 - 5
7303 "Golf? Oh, I play a filthy game ..."	3 - 4	4 - 5

WILSON, ISCAL (GB) 1910-1920
 A.M. Davis Co. "The Out Door girl"

	22 - 25	25 - 30

WIMBUSH, WINIFRED (GB) 1910-1920
 Raphael Tuck "Sporting Girls"

3603 "Golf - A Rub of the Green"	55 - 60	50 - 65

WOOD, LAWSON (GB) 1915-1935
 Brown & Bigelow

Advertisement "A difference of opinion"	15 - 18	18 - 22

Rene Vincent, Publisher Leon Ullman, Sr.
Advertisement for Dr. Roussel's HÉMOSTYL Tonic

Davidson Bros.
 6106 Prehistoric Pastimes "Golf" 12 - 15 15 - 18
Stenders
 Series 5041 Swedish Captions
 Monkeys Play golf as Lion looks on 12 - 15 15 - 18
 Monkeys Trying to crack golf balls 12 - 15 15 - 18
Valentine & Sons
 "Gran'pop Series"
 1729 Foreign caption 15 - 18 18 - 22
 2457 "Tell Mother it isn't ..." Monkeys 22 - 25 25 - 28
 2759 "The 19th Hole" Monkeys 22 - 25 25 - 28
 3269 "Gran'pop makes sure of his putt" 15 - 18 18 - 22
 3359 "I'm still waiting ..." Monkeys 15 - 18 18 - 22
 "Prehistoric Series"
 3812 "On the green in one" 25 - 30 30 - 35
 "Tough Nuts" 12 - 15 15 - 18
 Texaco Oil Ad card Calendar, June, 1936, Monkeys 15 - 20 20 - 25
YOUNCH, BERT (GB) 1905-1920
 Raphael Tuck
 No No. "De-Controlled" 30 - 35 35 - 40
ZIM (US) 1905-1915
 T.P. & Co., logo with moosehead
 680 "Now what would you do in a case like this?" 10 - 12 12 - 15

PUBLISHERS (Artist-types, but unsigned, Real Photos and Advertising)

A in circle logo 1905-1915
 Gravure Series 109 Girl carrying bag and clubs 15 - 18 18 - 22
AR Real Photos 1905-1915
 4707/10 Beauty holding golf bag in arms 30 - 35 35 - 40

A & G Bulens (BEL) 1930's
 Advertisement

3071 "Belgique Plage Dunes Golf"	12 - 15	15 - 20

AH Co. 1910-1920
 American Art

Golf Girl	25 - 30	30 - 35

Albertype Co. 1905-1920
 Black Caddy

Old man "I's ready to caddy for you"	35 - 40	40 - 50

Asheville Post Card Co. Linen

DC-39 Girl "To-morrow I'm going around in ..."	5 - 7	7 - 9

J.I. Austen Co. 1905-1915

394 Princeton Girl	25 - 30	30 - 35
Extra-large edition of Princeton Girl	200 - 225	225 - 250
212 **Black** "Caddie"	25 - 30	30 - 35

B.B., London (Birn Bros.) 1905-1915

E.85 Children "To Wish You The Same Old Wish as be-FORE" (Fur cap add-on)	40 - 45	45 - 50

Bamforth Co. 1950's
 Bamforth Comics

R-6 Girl "Another bomb outrage"	10 - 12	12 - 15

 Golf Comics

014 Man "Take care this does not happen..."	10 - 12	12 - 15
117 See artist A. Taylor (unsigned)		
1999 Man "What are you bringing that ..."	10 - 12	12 - 15
2011 "Nasty to be faced with a bunker ..." A.T.	12 - 15	15 - 18

Baxtone Chromes
 Laff-Grams

217-C "O.K. now, put some beef behind it"	2 - 3	3 - 4

B.B., London (Birn Bros.) 1905-1920

E-102 Cork Screw "When you're off the tee ..."	25 - 30	30 - 35
7030 Boy/Girl "You promised at the altar ..."	15 - 18	18 - 22

Harry H. Baumann Linen

E-4221 "Paul McWilliams - 4 balls in mouth ..."	12 - 15	15 - 18

F. von Bardeleban 1910-1920
 Sports

U.S. 718 "Sports-Golf"	12 - 15	15 - 18

J. Beagles & Co., Ltd. 1905-1915

636A - Pre-Historic Golf, "The Last Club"	22 - 25	25 - 28

Bergman Co. 1905-1920

Blacks 8803 Golfer - "Wanted, someone to play ..."	25 - 30	30 - 40

Julius Bien & Co. 1905-1915
 Song Series 70

702 "She's the Golf Queen of Paradise Alley"	12 - 15	15 - 18

Birn Bros. 1905-1920
 Romantic Series w/play on words "Golf Notes" (6)

"The Approach"	20 - 25	25 - 30

Bissel Carpet Co. 1905-1915

"Toledo Frogs" Golfers	65 - 75	75 - 85

Boston Sunday Post 1904
 Golfing Dandies (4)

1 "Off for the Links"	55 - 65	65 - 75

Carrington Co. 1930's

Valentine "No foursome for us ..."	18 - 20	20 - 22

The Albertype Co.
"I'se ready to caddy for you."

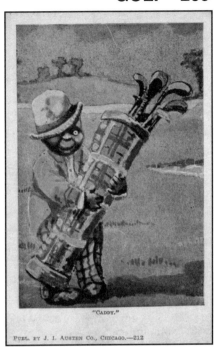

J. I. Austen Co., 212
"Caddy"

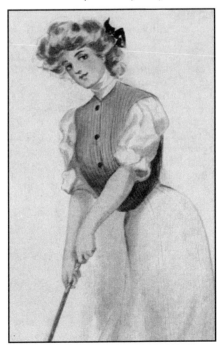

AH, American Art Series
No Caption

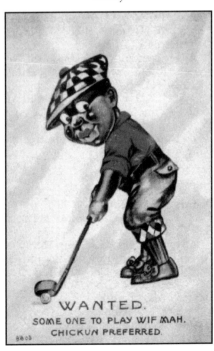

Bergman Co. 8803
"Wanted, some one to play wif mah..."

Chaussures Golf & Tennis Shoes
Louis Thambrelein/Charles Verneau	40 - 50	50 - 60

Coloprint B 1920-1930
Series 3749 Children Foreign captions	10 - 12	12 - 15
7439 Little boy in red swings & misses	5 - 7	7 - 9
54569-4 Dressed Gold fish "I'er Avril"	10 - 12	12 - 15

Colourpicture Publishers Linen
861 "Oh! Boy! A hone in one ..."	4 - 5	5 - 7

H.S. Crocker Co., Inc. Chrome
Advertisement
"San Pedro Hacienda Motor Hotel"	10 - 12	12 - 15

C.T. Art-Colortone Linens
Advertisements
No No. "The Circle, Home of Chicken in Rough"	8 - 10	10 - 12
2CH-497 "Hotel Colorado, Glenwood Springs, CO"	6 - 8	8 - 10
4AH1026 "Meet me at Cog Hill - World's Finest "	12 - 15	15 - 20
6A-H563 "Gentlemen your sports the finest ..."	15 - 18	18 - 22
7A-H3824 "Crosby Square Authentic Fashions"	15 - 20	20 - 25

C.T. Art & Sports Comics
Series C-5
C-45 "I am a golf widow. Who are you?"	3 - 4	4 - 5

C.T. Streamline Sports
C-254 Girl "Winsome"	4 - 5	5 - 6

Tropical Florida Comics
3C-H886 Boy/Girl "Ooops! Forgot to keep my ..."	4 - 5	5 - 6

Curt Teich & Co. 1915-1930
Busy Person's Correspondence Card 1930-1940
OA3232 Man Golfer & Caddy "Just drove a mile!"	5 - 6	6 - 8

Curteichcolor Linen
Advertisement "Chicken in the Rough ..."	8 - 10	10 - 12
SCK-590 Adv. "Chicken in the Rough ..." Chrome	5 - 6	6 - 7
236 Boy/Girl "I've been playing a little ..." Chrome	2 - 3	3 - 4
P-202 Man "Now, Don't you wish you ..." Chrome	2 - 3	3 - 4

Cynicus Pub. Co. 1905-1915 See Artist Cynicus
Man "Great Scot!"	15 - 18	18 - 22
Train "Our local Express - Ilfracombe to ..."	15 - 18	18 - 22

Dalkeith Classic Poster Reproductions Chromes
D26 "The Golfing Girl ... The Caledonial Railway"	2 - 3	3 - 4
D28 "Golfing in S. England and on the Continent"	2 - 3	3 - 4
D29 "North Berwick Cruden Bay ..."	2 - 3	3 - 4

Dennis & Sons, Ltd. 1910-1920
33 Boy/Girl "I want to get a particularly good ..."	12 - 15	15 - 20

De Rycker & Mendel 1905-1920
Advertisement "Coq-Sur-Mer"
"La plus pittoresque et la plus elegante ..."	22 - 25	25 - 28

Detroit Publishing Co. 1905-1915
9220 Black Girl "Golferino"	35 - 40	40 - 50

Dexter Press Chrome
27038-B "Golfer's Award"	2 - 3	3 - 4

E.B. & Co. in a shield logo 1905-1915
16 "Views of New York Riverside Drive"	30 - 35	35 - 40

ES in solid Diamond logo
Silhouettes (Lumineuse-glows in the dark)

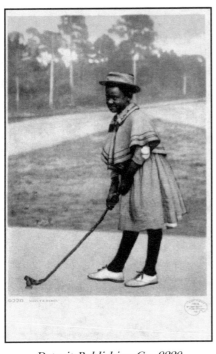

Detroit Publishing Co. 9220
"Golferino"

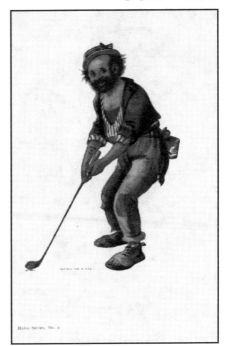

Publisher R. Hill
"Hobo" Series, No. 2

Man "Le Golf"	15 - 20	20 - 25
Fletcher & Son Scotland 1904		
Advertisement		
"Golfing at St. Andrews" Numbered set of (18)	55 - 65	65 - 75
Font-Romeu France 1910-1920		
Advertisement		
Posters-French Hotel (Set of 3)	200 - 225	225 - 250
Frank Waters French 1900-1910		
Man "The style of McManus he worked ..."	18 - 22	22 - 25
Frog in the Throat Lozenge Co. 1905-1915		
"Fore Everybody" Frog		
G in a triangle 1905-1915 (B&W)		
Girl in big hat with club and bag. No caption	15 - 18	18 - 22
"Fore Everybody" Girl Frog Caddie	40 - 50	50 - 65
P. Gordon 1905-1915		
No No. "Golf Girl"	15 - 18	18 - 22
Guiness Beer 1910-1930		
Henry Mayo Bateman		
Comics	60 - 65	65 - 70
H in logo 1920's		
"Have you any 'tainted' money to spare?"	8 - 10	10 - 12
HL & Co. 1940-1950		
Man "So you married a twin, George ..."	6 - 8	8 - 10
Happy, George C. Chromes		
"What! No Vacancy?"	2 - 3	3 - 4
Hartman 1905-1915		
Series 1645-6 Man "I am haunted by the idea"	18 - 22	22 - 25

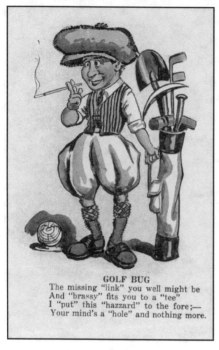

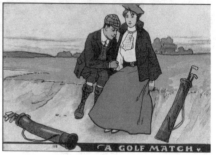

Publisher M&L, Ltd., No. 2671
"The Putting Green - Something to ..."

Metropolitan Publishing, No. 1244
"Golf Bug"

Publisher M&L, Ltd., No. 118
"A Golf Match"

R. Hill 1909-1915
 Hobo Series

2 Hobo ready to tee off	15 - 18	18 - 22

Howe, J. Raymond 1905-1920

1735 Children "I'm the golfer with name and ..."	15 - 18	18 - 22

Hutchinson Main & Co. Scotland 1905
 Advertisement

"Kite & Hawk Golf Balls" (6)	200 - 225	225 - 250

Inter-Art Co. 1910-1920

7237 Miniature golf "Do you take me for a blinkin' hazard?"	12 - 15	15 - 20

J.B. & Co. 1910-1920

Boy/Girl "And this is how golf is played"	12 - 15	15 - 18

A.L. Jannson 1910-1920

4500 "To the Golf Links"	20 - 25	25 - 30

W & A.K. Johnston, Ltd. 1910-1920
 Clan Series

"Clan MacNaughton ... badge trailing ... azalea"	12 - 15	15 - 18

KNG Real Photo 1905-1920

2262-2 Young golfer with bag on shoulder	30 - 35	35 - 45

A.H. Katz 1910-1920
 Do it Now Series

Man "Fore"	10 - 12	12 - 15

Kropp, E.C. Linen

C.M. 17 Girl "Greetings from Georgia"	4 - 5	5 - 6
C142 Boy/Girl "Am enjoying my golf ..."	4 - 5	5 - 6

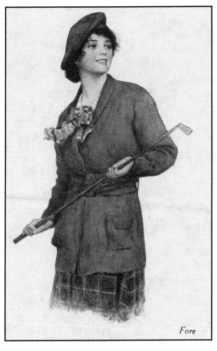

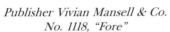

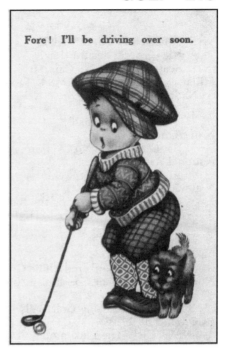

Publisher Vivian Mansell & Co.
No. 1118, "Fore"

Publisher M.M., Series 292
"Fore! I'll be driving over soon."

LG in shield logo 1910-1920
 Premier Series Silhouettes

2045 Boy/Girl "Thou canst not hit it ..."	8 - 10	10 - 12

Langsdorff & Co. 1905-1915
 State Girl Series "State of Indiana"

Embossed type	30 - 40	40 - 50
Flat type	40 - 45	45 - 55
Silk type	80 - 90	90 - 100

Arthur Livingston 1900-1910

925 Girl "How Does This Strike You"	12 - 15	14 - 18

Fred C. Lounsbury 1905-1915
 "Billy Possum" Series

2515-E "Billy Possum and Jimmy Possum on the Links"	30 - 35	35 - 40

M in bean pot (Metropolitan Publishing) 1930's
 1244

Man "Golf Bug — the missing 'link'"	8 - 10	10 - 12

M.M. 1905-1915

Series 292 "Fore! I'll be driving over soon."	10 - 15	15 - 18

M S O B
 Marcus Ward Series

14 Children "The old generation and the new ..."	12 - 15	15 - 18

MWM Color Litho Linen
 General Comic Series

GC403 "I went to the golf course ..."	4 - 5	5 - 6

Alfred Mainzer 1950's

Golfing Cats	5 - 6	6 - 8

Vivian Mansell & Co. 1905-1915

1118 "Fore" Beautiful lady	55 - 60	60 - 65
Beautiful Lady No Caption	55 - 60	60 - 65

Millar & Lang, Ltd. (Also M&L, Ltd.) 1905-1920

National Series 118

"A golf match"	15 - 18	18 - 22
"Addressing the ball"	15 - 18	18 - 22

N in triangle logo

113 Girl Golfer No Caption	12 - 15	15 - 18

National Art Co.

46 Beauty with golf club	30 - 35	35 - 40

National Series (M&L)

1580 Man "Addressing the Ball"	15 - 18	18 - 22
1896 Man "A high tee — High teas a Specialty"	15 - 18	18 - 22
2671 Boy/Girl "The Putting Green-Something ..."	25 - 30	30 - 35
Animals "Caddie, Sir?"	18 - 22	22 - 25

The Golfer's Series

1901 Girl "Bunkered ...The Golfers series at ..."	30 - 35	35 - 40

North British Rubber Co. 1910-1930

Advertisement

Comics advertising Golf Balls	15 - 18	18 - 22

PCC Co. 1910-1920

Boy/Girl "Have taken on golf, fine fun ..."	15 - 18	18 - 22

P.C.K. 1905-1915

Man "One of Three"	15 - 18	18 - 22
30 Man "Two up X one to play"	18 - 22	22 - 25
34 Man "Keep your eye on the ball"	18 - 22	22 - 25

P.E. Co. 1950's

Girl "Another birdie"	8 - 10	10 - 12
Advertisement "Lots of hazards here!" Goderich, ON	8 - 10	10 - 12
Same Boy/Girl "Getting the feel ..." Goderich, ON	8 - 10	10 - 12

Pan American Printers Chromes, B&W

Motto Series C144 "Old Golfers never die ..."

	1 - 2	2 - 3

James Patrick Real Photo 1900-1910

British Golfing Great **Tom Morris** in bunker	200 - 225	225 - 250

Plastichrome Chrome

P17119 Drinking "The Four of us were doing ..."	2 - 3	3 - 4
P31996 Boy/Girl "If shorts get any shorter ..."	2 - 3	3 - 4
P31197 Man "Fore"	2 - 3	3 - 4
P31198 Man "The Lord helps those ..."	2 - 3	3 - 4
P31199 Man "Doctors say: Golf relaxes the nerves"	2 - 3	3 - 4
P31221 Man "How to win at golf - Cheat!"	2 - 3	3 - 4
P31222 Man "Poor Loser"	2 - 3	3 - 4
P31223 Man "We always make par on the 19th"	2 - 3	3 - 4
P31224 Man "For the golfers who can't break ..."	2 - 3	3 - 4
P72014 Man "Hi! Damp weather is ruining ..."	2 - 3	3 - 4

S.S. Porter 1905-1915

Lovers sit on fence	20 - 25	25 - 28
Boy/Girl "High Ball"	20 - 25	25 - 28

J. Howard Randerson 1915-1920 (B&W)

Political "How About Shooting a Few Bucks ..."

	7 - 9	9 - 12

Ray & Co., London 1910-1920

Silverette Series (B&W)

68 "Miss Sybil Arundale" with bag of clubs	22 - 25	25 - 30

Redwine-Dexter 1905-1912 (B&W)
 Political
 "The candidates at exercise ... Taft/Bryan" 55 - 65 65 - 75
M. Rieder, Los Angeles 1910-1920
 Blacks
 174 With golf clubs 25 - 28 28 - 32
Rotary Photo Co. Real Photos 1905-1915
 British Actress Series - Close-up pose with bag/clubs
 Miss Gladys Cooper standing, with bag/clubs 40 - 45 45 - 50
 B12-1 Gladys Cooper sitting, with bag/clubs 40 - 45 45 - 50
 Kathleen Vincent standing, with bag/clubs 40 - 45 45 - 50
 Others 30 - 35 35 - 40
 (Hand-Colored issues) Add $10 per card
S in wreath logo 1910-1920
 "The golf player - this young man has 'golfitis' ..." 10 - 12 12 - 15
SB in diamond logo 1905-1915
 "What Do You Know About That" Series
 S.260 "No One to Meet You..." 12 - 15 15 - 18
S.S. Exchange 1915-1925 (B&W)
 Girl "A golfing parody" with verse 12 - 15 15 - 18
J. Salmon 1910-1920
 Sporty Cats
 2815 "The handicap" 35 - 40 40 - 45
 Series 5253
 Children "If Ye Ganna Get Married ..." 12 - 15 15 - 18
Scenic Art Chrome
 C12291F Man "Glad this is a hobby ..." 2 - 3 3 - 4
Schlesinger Bros. 1905-1920
 Girl Golfer 12 - 15 15 - 18
P. Schmidt & Co.
 Man No Caption 20 - 25 25 - 28
Shenley Co. 1905-1915
 Children "Her first lesson" 30 - 35 35 - 45
Shenvalee Hotel, Virginia 1930's
 Bobby Jones giving an exhibition to crowd 225 - 250 250 - 300
Southern Pacific Lines 1920-1940
 Advertisement "Golf at Del Monte, Ca." 15 - 18 18 - 22
Southwestern Wax Museum 1950's
 Babe Zaharias completing swing 25 - 30 30 - 35
 Evie Greene, Ellakine Terris, & others 35 - 40 40 - 45
Souvenir Postcard Co. 1905-1915
 41 "Don't be a Cad" 18 - 20 20 - 22
Edwin Stern & Co. 1905-1920
 Hobo Series
 Hobo addressing the ball 18 - 22 22 - 26
 Hobo in follow-through of swing 18 - 22 22 - 25
Surbrug's Pipe Mixture US 1909
 Advertisement (4)
 Milo Brand (2) 200 - 225 225 - 250
 Surbrug Brand (2) 200 - 225 225 - 250
Frank W. Swallow 1910-1920
 Man "The weary Farmer (Up to Date)" 10 - 12 12 - 15
T.M. in circle logo 1915-1925
 Children "Gare!" 10 - 12 12 - 15

T.P. & Co. 1905-1915

Series 217

"I expect to take you out soon"	10 - 12	12 - 15
"I have been looking for you"	10 - 12	12 - 15
"I miss you very much"	10 - 12	12 - 15
"You make a hit with me"	10 - 12	12 - 15

TR Co.

"The Golfer - You stalk all day around the green ..."	10 - 12	12 - 15
Valentine (Emb) "To My Valentine"	10 - 12	12 - 15

TS in wreath in stamp box

Man No caption	10 - 12	12 - 15

Tanner Souvenir Co. (Leather) 1910-1920

Man "A Good Drive"	12 - 15	15 - 20

Tichnor Bros. Linen

296 "Do you know what day this is?"	4 - 5	5 - 6
567 "Hoot, me laddy, find a ball ..."	4 - 5	5 - 6
736 Man "The story of my vacation"	4 - 5	5 - 6
792 Man "If I put it where I can see it ..."	4 - 5	5 - 6
249 Boy/Girl "You got me wrong ..." Chrome	2 - 3	3 - 4

E.B.Thomas Linen

Advertisement E-10214 - Nasher Clothiers	15 - 18	18 - 22

Raphael Tuck & Sons 1905-1915

"In the Open - Champion Golfers"

British Golfing Great, J.H. Taylor	200 - 225	225 - 250

Playful Pictorial Series (6)

Male Golfers, "Three Little Maids"	22 - 25	25 - 28

Series 6 Valentines

"'Tis said she is fond of the links..."	15 - 18	18 - 22
" I'd like to play with you forever..."	15 - 18	18 - 22
B. "He rants and pulls out his hair..."	12 - 15	15 - 18

Series 20 "Little Lovers" (Emb)

"To My Valentine"	15 - 18	18 - 22

Series 139 New Year (Emb)

"A Happy New Year"	12 - 15	15 - 18
Series 697 "Golf Hints" (6)	25 - 30	30 - 35

Series 743 "Golf" (6)

"Your Honor"	25 - 30	30 - 35
Series 3600 "Golf Humor" (6)	25 - 30	30 - 35
Series 1627, 1628 (6)	25 - 30	30 - 35

Series 9293 "Early Days of Sport"

"Mary Queen of Scots playing golf"	18 - 20	20 - 25
Series 9427 Blacks "More Coons" (1)	35 - 40	40 - 45
Series 9499 "Humorous Golf" (6)	20 - 25	25 - 30
Series 9641 "Golf Language" (6)	25 - 30	30 - 35

Ullman Mfg. Co. 1905-1915

183 Summer Girl's Diary "I played golf all ..."	18 - 22	22 - 25
1525 Children "Prize Golf"	15 - 18	18 - 22
1567 Valentine "I dearly love a game of golf"	15 - 18	18 - 22

Valentine & Sons, Ltd. 1905-1930

Comic Series

"The Unspeakable Scot"	15 - 18	18 - 22
"Early closing day. We're off at 1 o'clock ..."	15 - 18	18 - 22
Series 1044 "Hope This Reaches You ..."	25 - 30	30 - 35

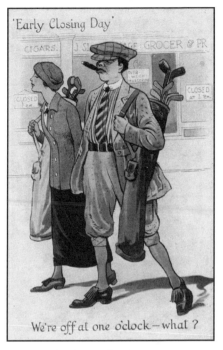

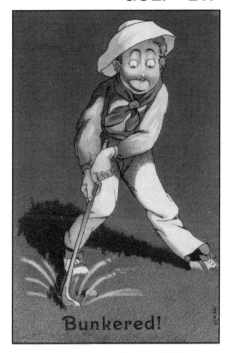

Publisher Valentine & Sons
"Early Closing Day"

Anonymous, Series 8661
"Bunkered!"

Valesque Series 1950's		
Man "Real Welsch Golf ..."	12 - 15	15 - 18
Famous Golfer Series		
Values vary depending on the golfer named	150 - 500	250 - 750
Paul Vallier 1905-1920		
Advertisement		
"La Bourboule (Auvergne), Reine de L'Arsenic ..."	50 - 75	75 - 100
Wakefield 1905-1915		
The Wakefield Series		
111 Four champs - Vardon, Braid, White, Taylor	100 - 110	110 - 125
Western News Co.		
Series 177		
Boy/Girl "Two up and one to play"	15 - 18	18 - 22
Wild Side West, Inc. Chrome		
"I'd rather be golfing"	2 - 3	3 - 4
John Winsch, Copyright		
"To My Valentine" (Emb)	12 - 15	15 - 18
Series 450 (Emb)		
43 "My Heart's a golf ball for you"	15 - 18	18 - 22
Woolstone Bros. 1910-1920		
The Milton Series		
925 "You ought to have been a man ..."	18 - 22	22 - 25
2088 "I'm aye sure that ball was lost pa ..."	18 - 22	22 - 25
Wrench (GB) 1900		
"Famous Golfers" Series		
Values depend on the golfer pictured	150 - 500	250 - 750

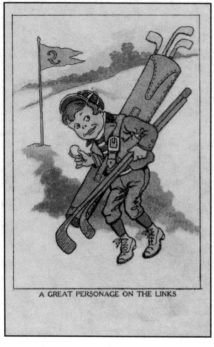

Anonymous
"A Great Personage on the Links"

Chaussures Shoe Advertisement
Louis Thambrelent, Charles Verneau

Anonymous

Sporting Series 1

1909 Girl's head in oval of crossed clubs	8 - 22	22 - 25

Sports Series 1003 Girl with bag/clubs on back — 30 - 35 — 35 - 45

Girl in red vest with iron under arm	55 - 65	65 - 75

Anonymous Linen or Chrome Comics

25 Fat Lady "Just passed a big bend on the road"	3 - 4	4 - 5
98 Man "I think I took the wrong train maybe"	5 - 7	7 - 9
140 "Tomorrow, Caddy, I'm going around in less"	4 - 6	6 - 7
159 "Help another of them darn back-seat drivers"	3 - 4	4 - 5
296 "Do you know what day this is?"	4 - 5	5 - 7
316 "Just Another Back Seat Driver!"	2 - 3	3 - 5
P9225 "Mind If I Play A Round..." Chrome	2 - 3	3 - 4
"A Nine Hole Course" (Outhouse)	7 - 8	8 - 9

Anonymous 1900-1925

1924 **U.S. Open Champ Cyril Walker** and others		
at Holly Hill	80 - 90	90 - 100
Lovers with golf bag or clubs (RP)	18 - 22	22 - 25
Royalty	20 - 25	25 - 30
"An Alphabet of St. Andrews"		
"A Great Personage on the Links" (Caddy)	12 - 15	15 - 18
Blacks - "This is a palm Garden"	8 - 10	10 - 12
"Chelsea High School" Pretty Girl (in gold)	12 - 15	15 - 18
Dressed Bird "Silence is golden ..."	10 - 12	12 - 15
"Girls I Didn't Marry" "The Athletic Girl"	10 - 12	12 - 15
010 **The Owl Series** "Ye Old Golfers"	20 - 22	22 - 25
133 Little girl holding club (Small sized card)	20 - 22	22 - 25

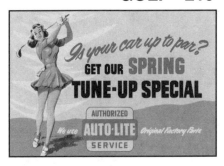

Advertising, "Burrojaps"
"The World's Famous Warranted ..."

Advertising "Auto-Lite Service"
"Tune-Up Special"

MISCELLANEOUS

Advertising

Auto-Lite Service (Chrome)	6 - 8	8 - 10
Burrojaps, The World Famous Warr. Patent Shoes	8 - 10	10 - 12
"Chicken In The Rough" (Chrome)		
Curteichcolor 6C-K590	4 - 6	6 - 8
Same card in Linen	8 - 10	10 - 12
C.T. Art-Colortone (Linen)		
"The Circle - Home of Chicken in the Rough"	10 - 12	12 - 15
"Crosby Fair - Authentic Fashions"	15 - 20	20 - 25
Duncan MacGregor Scotch Whiskey Chrome		
Elf-like golfer and bottle of scotch	10 - 12	12 - 15
Falcon Golf Balls "The Falcon Beats Bogey"	250 - 260	260 - 275
Gulf Oil "Gulf Info - SP-1368	10 - 12	12 - 15
Nasher Clothes, Stoughton, Ma. (Linen)		
E.B. Thomas E-10214 "Vacation and Play"	12 - 15	15 - 20
Palm Beach Suits 1930's		
No. No. "For Sports, Tarny's Toggery, A Man's ..."	12 - 15	15 - 18
SHELL'S "Wonderful World of Golf OFFER"	5 - 7	7 - 9
Sp-1368 "Gulf Info Series" Multi-Views	5 - 7	7 - 9
Sp-1415 "Gulf Info Series" Check Boxes	5 - 7	7 - 9
Airbrush		
"Golf" (Emb)	6 - 8	8 - 10
Hold-To-Light 1905-1915		
Lady Golfer		
"Merry Christmas & a good Look-Out ...'	150 - 200	200 - 250
Leather Cards	10 - 15	15 - 25
Mechanicals		
"A Raving Novelty" 150-L "If Ya Play Golf ..."	8 - 10	10 - 12
Real Photos, AZO, CKYO, Etc.		
Caddies	20 - 25	25 - 30
Black Caddies		
Large images	90 - 110	110 - 150
Small Images	50 - 60	60 - 70
Ladies with clubs, bag, etc.	20 - 25	25 - 35
Children, Men playing golf or with clubs, bags	15 - 20	20 - 25
Movie Stars - Ladies	20 - 25	25 - 35

 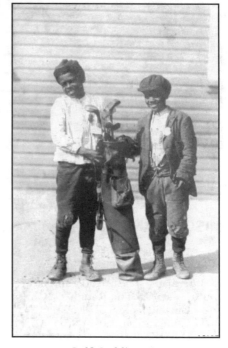

Real Photo by Rotary Photo of
Gladys Cooper, B12-1

Golf Caddies, 1905
Real Photo by A.Z.O.

Post 1930	15 - 20	20 - 25
Movie Stars - Men	15 - 20	20 - 30
Post 1930	12 - 15	15 - 18
Golfing Dogs, Cats, & other domestic animals, Average		
1900-1915	15 - 20	20 - 25
1916-1930	12 - 15	15 - 20
1931-1945	8 - 10	10 - 12
1946-1955	4 - 6	6 - 8
Others	3 - 4	4 - 5
Wild Animals, Fowl, Insects, etc., Average		
1900-1915	20 - 25	25 - 35
1916-1930	15 - 20	20 - 25
1931-1945	8 - 10	10 - 12
1946-1955	6 - 8	8 - 10
Others	3 - 4	4 - 6

GOLF COURSES

Valentine & Sons, Ltd. Real Photo 1905-1915		
"The Road Hole," The Old Course at St. Andrews	15 - 18	18 - 22
"The Mecca of Golf," Rusack's Marine Hotel, St.		
Andrews, N.B., Canada	5 - 7	7 - 9
Real Photos of St. Andrews "Holes"	15 - 18	18 - 22
U.S. Courses		
Real Photos	5 - 8	8 - 15
Color and B&W	3 - 5	5 - 8
Clubhouses	3 - 5	5 - 8

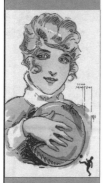

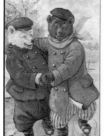

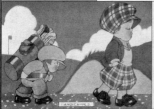
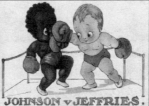

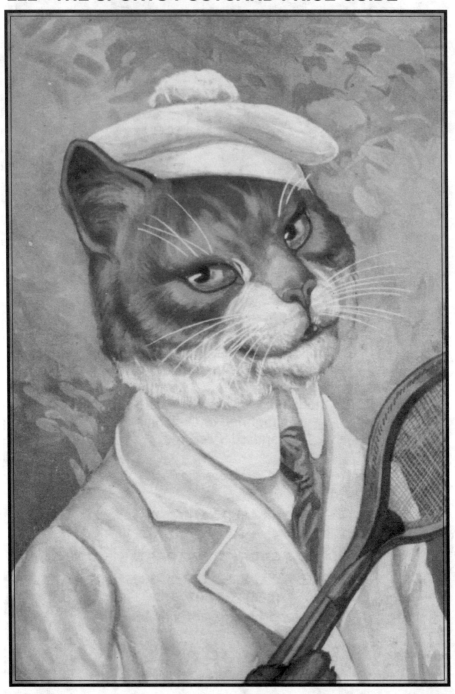

The Champion!
Beautiful Early Chromolithograph – B.K.W.I. Series 392-5

Tennis, during the early part of the century, was the sport of choice for the upper echelon of society. It had always been a game for people of wealth, and was usually played in exclusive racquet clubs and on private courts. The game was more popular in Great Britain and the continental European countries than in America. Court tennis, however, became extremely fashionable and flourished in the U.S. during the late teens and the Roaring Twenties, but the Great Depression of the 1930's brought about its decline. It has now regained and exceeded its former stature, as the interest of the public as participants and spectators has caused thousands of courts to be built all over the U.S.

American artists of the early years — Court and C. W. Barber, Earl Christy, the Fidlers, Harrison Fisher, Archie Gunn, Underwood and others — painted outstanding works of the lady at play, and numerous artists produced those of children and comical types. These were, with the exception of Earl Christy, done on a very limited scale. On the other hand, foreign issues by the great artists of France, Italy and Great Britain were produced in abundance, and have become very important to the U.S. collector. There are elegant ladies, beautiful children, dressed animals, and advertising postcards by the score.

Renditions of glamourous ladies by Barribal, Blom, Colombo, Corbella, Meunier, Nanni, Penot and Wimbush, to name a few, are wonderful to behold. These, along with the fantastic dressed animals of Arth. Thiele and A. E. Kennedy and the comical works of Earnshaw, Kinsella and others, make tennis postcards highly collectible.

ARTIST-SIGNED

	VG	EX
A.G.		
James Henderson & Sons		
Series B5 "The Sports Girls"		
2538 "The Tennis Girl"	$20 - 25	$25 - 28
ANTHONY, MARIA (US) 1915-1925		
E. Gross Co. Beautiful Lady "At Your Service"	20 - 25	25 - 30
ANTLERS (US) 1900-1915 Comics		
I.P.C. & N. Co.		
Boy/Girl "It's a great game"	12 - 15	15 - 18
ATTWELL, MABEL LUCIE (GB) 1910-1930 Children		
Valentine & Sons		
2650 "Do I look as I oughts in me shorts"	22 - 25	25 - 28
AUNTANOLA (SP) 1920-1930		
Ram Barcelona		
49 Boy/Girl Spanish Caption	12 - 15	15 - 18
A.T. (Arthur Taylor) (GB) 1930's-1940's		
Bamforth Co.		
Tennis Comics		
024 "Don't forget to give some good returns"	10 - 12	12 - 15
13561 "Don't forget to give some good returns"	10 - 12	12 - 15
B in square logo (GB) 1905-1915		
Raphael Tuck		
Poster Girl Valentines Series 231		
"Valentine Greetings"	15 - 18	18 - 22
BAIXERAS, R. (SP) 1920-1930		
N. Coll Salieti		
154 Girl No Caption	18 - 22	22 - 25
BANERAS, G. (SP) 1910-1920		
N. Coll Salieti		
154 Beautiful Lady	20 - 25	25 - 28
BARBER, C.W. (US) 1905-1920		
A.R.&C.i.B.		
Sepia Series 01370-2 Girl No Caption	12 - 15	15 - 18
Carleton Pub. Co.		
Series 704-6 Girl "Lawn Tennis"	18 - 22	22 - 25
BARRIBAL, L. (GB) 1905-1920		
Inter-Art Co. Artisque Series		
1589 Girl "For the Glory of the Empire ..."	25 - 35	35 - 45
BIGGAR, J.L. (GB) 1905-1920		
Dennis & Sons, Ltd.		
5384 Boy/Girl "Love All"	20 - 25	25 - 30
5386 Boy/Girl "15-40 at Southend-on-sea"	20 - 25	25 - 30
BLACHE, M.T. (FR) 1920-1930		
Chatenay		
Tennis Mode Series (6)	35 - 40	40 - 45
Trajane		
Same as Chatenay Series (6)	35 - 40	40 - 45
BLANCNI (IT) 1920's		
M in solid logo		
Lady No Caption	18 - 22	22 - 25

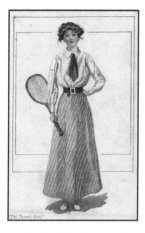

A.G., Henderson &
Sons, Series B5, 2538
"The Tennis Girl"

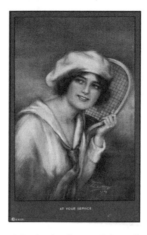

Maria Anthony, Edward
Gross, "At Your Service"

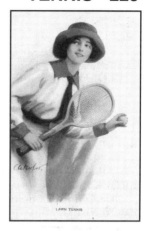

C. W. Barber, Carleton
Pub. Co., Series 704-6
"Lawn Tennis"

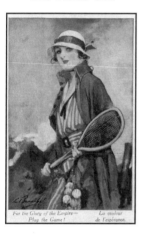

L. Barribal, Inter-Art Co.
No. 1589, "For the Glory
of the Empire ..."

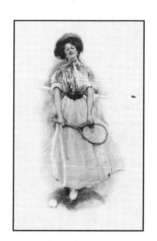

Unsigned R. Bonnett
M. Munk, Vienne
Series 702, No Caption

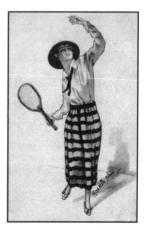

Marcelle Blom
Proprieta Artistica, 181
No Caption

BLOM, MARCELLE (IT) 1910-1930		
Proprieta Artistica		
Series 181	30 - 35	35 - 40
BONNETT, R. (Uns.) (US) 1905-1920		
M. Munk		
Series 702 Beautiful Lady	20 - 25	25 - 30
BORISS, MARGRET (Uns.) 1915-1930		
Amag		
Series 0300 Boy/Girl resting at courtside	15 - 18	18 - 22
BOURET, GERMAINE 1920'S		
Y.D.A.		
631 Children French Caption	15 - 18	18 - 22
BRILL (US) 1910-1920		
TR Co.		
"Gink" Series		

"Love thirty for this Gink"	15 - 18	18 - 22
"Leap Year Thoughts" Series		
Girl "Lets put another R in Mary"	10 - 12	12 - 15
Girl "Do you want a minister ..."	10 - 12	12 - 15
Girl "I'll get you yet"	10 - 12	12 - 15
Girl "Four years I've waited ..."	10 - 12	12 - 15
Girl "It's fashionable for girls to propose"	10 - 12	12 - 15
BROCK, M. 1905-1915		
G. Bell & Son		
French Picture Card Series II VI "Le Tennis"	7 - 9	9 - 12
BROEKMAN, N. 1940-1950		
"De Tennis Kampioen"	10 - 12	12 - 15
BROWNE, TOM (GB) 1905-1920		
Davidson Bros. "Illustrated Sports"		
2507 Boy/Girl "Tennis"	18 - 22	22 - 25
2565 "Tennis"	18 - 22	22 - 25
George Newnes, Ltd.		
"The Captain Magazine"	18 - 22	22 - 25
Man "How Jim took exercise"	18 - 22	22 - 25
BRUNING, MAX (GER) 1905-1915		
FFW (Sepia)		
Series 100a-2 Beautiful Lady "Tennisport"	25 - 30	30 - 35
BUCHANAN, FRED (GB) 1905-1915		
Woolstone Bros. The Milton Series 502		
Children "I wonder if she would make up a ..."	22 - 25	25 - 28

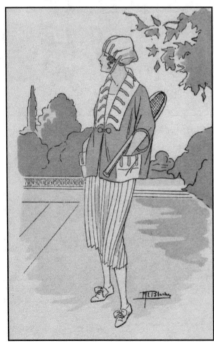

M. Blache, Trajane
Tennis Mode in the Deco Era

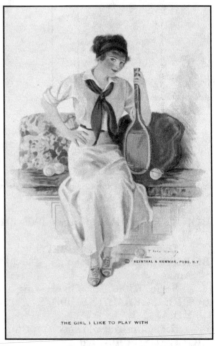

F. Earl Christy, Reinthal & Newman
622, "The Girl I Like to Play With"

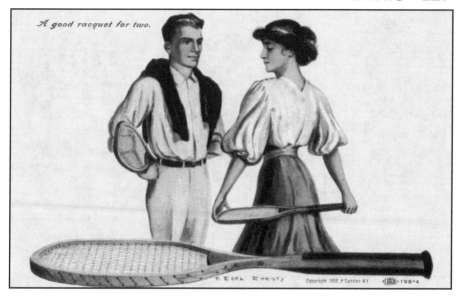

F. Earl Christy, P. Sander, Series 198-4 — "A good racquet for two"

BUNNY 1910-1920
Boy/Girl "Twenty Love"	22 - 25	25 - 28

BUTCHER, ARTHUR (GB) 1910-1920
Inter-Art Co.
Comique Series 3267 Girl "At your 'Service'"	25 - 28	28 - 32

CHAS (GB)
Bamforth Co. Comics (Chrome)
710 Man "Game to Smith ..."	3 - 4	4 - 5

CHRISTIE, G.F. (G.F. in C logo) (GB) 1905-1915
Photochrom Co., Ltd. "Celesque" Series
2297 "A Lot of Little Things Have Come To Light"	12 - 15	15 - 20

CHRISTY, F. EARL (US) 1905-1920
FAS
199 Beautiful Lady	30 - 35	35 - 40

Illustrated P.C. Co.
Sports Series 584 - Tennis	25 - 30	30 - 35

I.P.C. & N. Co. (International Postcard & Novelty Co.)
198-4 Boy/Girl	25 - 30	30 - 35
5006-2 Girl No Caption	25 - 30	30 - 35

Knapp Co.
318 "The Best of Chums"	30 - 35	35 - 40

Pain. Karjalan Kirjap. Finland
Same as R&N 173 "Love All"	35 - 40	40 - 50

Reinthal & Newman
173 Girl "Love All"	30 - 35	35 - 40
307 Girl "The Day's Work"	30 - 35	35 - 40
622 Girl "The Girl I Like to Play With"	30 - 35	35 - 40

P. Sander (I.P.C. & N. Co.)
Series 198-4 "A good racquet for two"	25 - 30	30 - 35

CHRISTY, HOWARD CHANDLER (US) 1902-1915
Moffat, Yard & Co. (B&W)
Beautiful Lady "The Summer Girl"	20 - 25	25 - 30

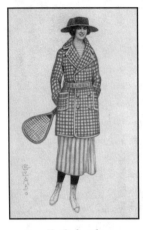

E. Colombo
Rev. Stampa, Series 974-1

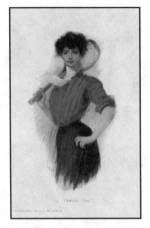

J. De Yonch, National
Art Company, 14
"Tennis Girl"

Harold Earnshaw
Valentine & Sons, 1116
"A Love Game"

Alice L. Fidler, Edward
Gross, No. 73
American Girl Series

Harrison Fisher
R&N, No No.
"A Tennis Champion"

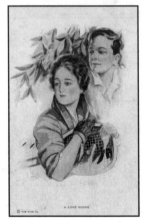

Harrison Fisher
R&N, No. 839
"A Love Score"

COLOMBO, E. (IT) 1920's
 GAM in circular logo

1693-2 Children No Caption	12 - 15	15 - 18
1962-2 Children No Caption	12 - 15	15 - 18
2098 Children No Caption	12 - 15	15 - 18
2323 Boy/Girl No Caption	12 - 15	15 - 18

 Rev. Stampa, Milano

974-1 Girl No Caption	15 - 18	18 - 22

CORBELLA, T. (IT) 1915-1930
 Dell'Anna & Gasparini

Series 316-5 Lady No Caption	30 - 35	35 - 40
Series 470-3 Boy/Girl Silhouettes	35 - 40	40 - 45

CRERE, FRANK (US) 1905-1915
 S B in circle (Samson Brothers)

S.75 Girl holding tennis racket and ball No caption	7 - 9	9 - 12

Fernel — Anonymous, "Tennis"

CURTIS, E. (US) **1905-1920**
 Raphael Tuck
 Series 7 Leap Year "I Will Court You ..." 10 - 12 12 - 15
DE YONCH, J. (US) 1910-1920
 National Art Co.
 14 "Tennis Girl" 20 - 25 25 - 28
DOCKERY, E. 1910-1920
 Girl "Du Schlimmer" 10 - 12 12 - 15
 Cupids 10 - 12 12 - 15
DOUBEK, PROF. F. (GER) 1905-1920
 Galerie Munchner Meister
 554 Couple "Komm spiel mit mir!" 15 - 18 18 - 22
EARNSHAW, HAROLD (GB) 1905-1920
 Valentine & Sons Earnshaw Series
 1113 Boy/Girl "A Single" 10 - 12 12 - 15
 1114 Boy/Girl "May all your troubles end ..." 10 - 12 12 - 15
 1116 Boy/Girl "A Love Game" 10 - 12 12 - 15
ELLAM, WILLIAM (GB) 1905-1920
 Raphael Tuck "Right Up to Date"
 3138 Military "If you'll be my little lump ..." 18 - 22 22 - 25
ELIOTT, HARRY (GB) 1905-1920
 Anonymous
 Boy/Girl No Caption 12 - 15 15 - 18
FARINI, MAY (US) 1910-1920
 Fairman Co.
 Girl No Caption 15 - 18 18 - 22
FEIERTAG, K. (AUS) 1905-1920
 B.K.W.I.
 Series 237-4 Lady No Caption 25 - 30 30 - 35
FERNEL (FR) 1905-1920
 Anonymous Man/Lady "Tennis" 30 - 35 35 - 40

Archie Gunn, P H, Series 1216-2
"Waiting for a Partner"

Mela Köhler
B.K.W.I., Series 187-4

FIDLER, ALICE LUELLA (US) 1905-1915
 Edward Gross

73 Pretty girl ready to serve No Caption	18 - 22	22 - 26

FISCHER, PAUL (DEN) 1905-1915
 Arthur Schurer & Co.

1342 Girl No Caption	10 - 12	12 - 15

FISHER, HARRISON (US) 1905-1920
 Reinthal & Newman

No No. "A Tennis Champion"	30 - 35	35 - 40
834 "Her Game"	35 - 40	40 - 45
839 "A Love Score"	35 - 40	40 - 45

FLAGG, JAMES MONTGOMERY (US) 1905-1920
 Reinthal & Newman

288 Boy/Girl "A Club Sandwich"	20 - 25	25 - 30

FONTAN, LEO. (FR) 1905-1915

Meissner & Buch 3201 Girl No Caption	25 - 30	30 - 35

FRANKLIN 1905-1920
 M.S.i.B. with **E** logo in Boat Sail

Loving couple "Words of Love"	18 - 22	22 - 25

 FV in box logo 1910-1920
 LP in triangle logo

227 III Children No Caption	10 - 12	12 - 15

GM Modern
 Anonymous Foreign Caption

	4 - 6	6 - 8

GASSAWAY, KATHARINE (US) 1905-1920
 Rotograph Co.

F.L.154 Children "The Tennis Player"	12 - 15	15 - 18

GOTTARO, E. 1905-1920
 Anonymous Children No Caption 15 - 18 18 - 22
GRIMM, ARNO (GR) 1905-1915
 Th. E.L. Theochrom
 1074 Man No caption 12 - 15 15 - 18
GUNNELL, N. (?) 1910-1925
 Degami 2205 Children No caption 10 - 12 12 - 15
GUNN, ARCHIE (US) 1905-1920
 S. Bergman
 6317 Pretty Girl No caption 15 - 18 18 - 22
 National Art Co.
 14 Tennis Girl 20 - 25 25 - 28
 PH in diamond
 1216-2 Lady "Waiting for a Partner" 22 - 25 25 - 28
 1216-2 Same as above but no caption 22 - 25 25 - 28
HARE, J. KNOWLES (US) 1905-1920
 Beautiful Girl Sepia 12 - 15 15 - 18
HNATKOVA, M. 1905-1915
 Anonymous French
 "Costumes De Sport Autrefois Et A Present" 25 - 30 30 - 35
HUTCHINSON (US) 1910-1920
 K. Co., Inc.
 160 Girl "Tennis" 22 - 25 25 - 30
INIFRON (IT) 1920's
 PAM Logo Man Foreign caption 10 - 12 12 - 15
JOBBE'DUVAL, FELIX 1910-1925
 Anonymous
 Lady "Tennis" 15 - 18 18 - 22
JOHNSON, J. (US) 1910-1920
 Sam Gabriel Co. (G on Palette logo)
 407 "Valentine Greetings - A Love Game" 8 - 10 10 - 12
K dot logo (AUST) 1905-1920
 B.K.W.I.
 Series 486 (6)
 4 Boy/Girl "Game" 30 - 35 35 - 40
 6 Boy/Girl "Net Ball" 30 - 35 35 - 40
K.V. 1905-1915
 LP in triangle
 Rabbits & Chicks Series 275-1 Foreign caption 15 - 18 18 - 22
KENNEDY, A.E. (GB) 1905-1920
 BD logo (B backwards) B. Dondorf
 Series 629 Dressed Dogs (2) 15 - 18 18 - 22
 C.W. Faulkner & Co.
 Series 1404-F Dressed Dogs "Volleyed" 15 - 18 18 - 22
 1507 Cats "Love All" 15 - 18 18 - 22
KINGSLEY-SMITH, C. (GB) 1905-1915
 Harding and Billing "Limerick" Series
 2 "There was a young lady of Venice ..." 15 - 18 18 - 22
KINSELLA, E.P. (GB) 1905-1920
 Langsdorff & Co.
 Series 695 (6)
 "Deuce" 20 - 25 25 - 30
 "Game" 20 - 25 25 - 30
 "Let 'em All come" 20 - 25 25 - 30

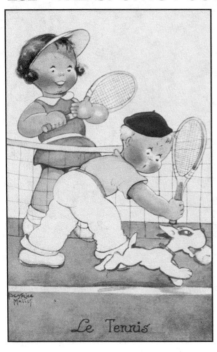

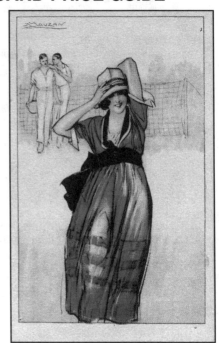

Beatrice Mallet, Delrieu, Paris
"Le Tennis"

L. A. Mauzan, Dell'Anna & Gasparini
Series 414-6

"Love"	20 - 25	25 - 30
"Vantage In"	20 - 25	25 - 30
"Vantage Out"	20 - 25	25 - 30
KIRCHNER, RAPHAEL (IT) 1910-1930		
T.S.N.		
5534 Lady	70 - 80	80 - 90
KLINGE 1920-1930		
Anonymous		
1038 Children Foreign caption	7 - 9	9 - 12
KÖHLER, MELA (AUS) 1905-1925		
B.K.W.I.		
Series 187-4 Lady	80 - 90	90 - 100
KOSEL, H.E. (GER) 1910-1920		
Albert Eber		
Political 48 "Der Deutsche Tennisball ..."	25 - 30	30 - 35
LANGFITE, A. (GB) 1905-1915		
Raphael Tuck "Girls to Know"		
3601 "Let's play the Game"	20 - 25	25 - 30
LARSON 1910-1920		
764 Girl "Will he venture it?"	22 - 25	25 - 28
LAWRENCE, F. (US) 1910-1920		
E in sail logo		
Lady "My Partner"	15 - 18	18 - 22
LEITER, HANS (GER) 1905-1915		
Raphael Tuck		
Series 280B "Tennispieler"		
Lady-Man	25 - 30	30 - 35

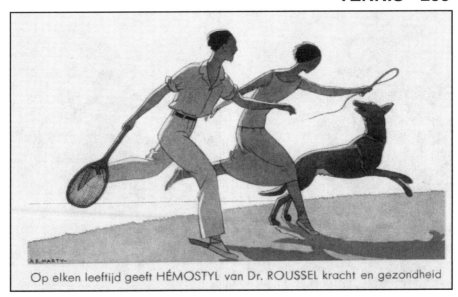

A. E. Marty, Cromo, Madrid — Ad for Dr. Roussel HEMOSTYL Tonic

LEVIN, MEYER (US) 1930-1940
 Mutoscope (Non-PC)
 Pinup "One day upon the Tennis Court ..." 12 - 15 15 - 18
M.D.S. (US) 1905-1915
 Ullman Mfg. Co. "Sporty Bears"
 83 "Love All" 20 - 25 25 - 30
MAAJORDIN 1910-1920
 Anonymous
 21248 Children Foreign caption 5 - 7 7 - 9
MALLET, BEATRICE (GB) 1910-1930
 Delrieu, Paris "Le Tennis" 15 - 18 18 - 22
 Raphael Tuck "Cute Kiddies"
 Series 707
 "Wishing you a champion birthday" 20 - 25 25 - 28
 10 "Maintenant, a nous deux!" 20 - 25 25 - 30
 Series 3628
 "Looking for a good Court" 20 - 25 25 - 30
 Belgium Series
 "Le Tennis" 15 - 18 18 - 22
 "Cigarettes St. Michel - Bruxelles Tennis" 18 - 22 22 - 25
MALUGANI, G. (IT) 1910-1920
 Rev. Stampa, Milano
 148-4 Beautiful Girl No caption 18 - 22 22 - 26
MARCHAUX, GASTON (FR) 1910-1920
 Anonymous
 Advertisement - Les Biscuits Olibet 25 - 30 30 - 35
MARTY, A.E. (SP) 1915-1930
 Cromo, Madrid
 Advertisement - Hemostyl Tonic, Dr. Roussel 40 - 50 50 - 60
MARY 1915-1925
 Traldi, Vetta
 Boy/Girl "Tennis" 20 - 25 25 - 28

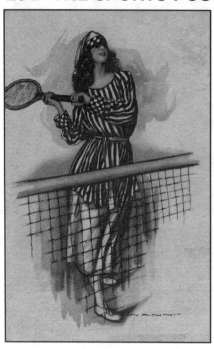

G. Nanni, Dell' Anna & Gasparini
434 B-2

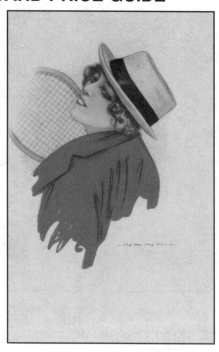

G. Nanni, Rev. Stampa, Milano
Series 309-1, No Caption

A. Penot, Delta Series 9
"Tennis Feminin"

A. Penot, Delta Series 9-44
"Tennis Feminin"

C. Preston, A.R. & C.i.B., Ser. 1523-1
Who says it ain't gonna rain ...?"

Remitz, B.K.W.I. Series 377-1
No Caption

MAUZAN, L.A. (IT) 1915-1930

 Dell'Anna & Gasparini

 Series 414-6 25 - 30 30 - 35

 Rev. Stampa, Milano

 162-5 Boy/Girl 15 - 18 18 - 22

MEUNIER, SUZANNE (FR) 1915-1935

 Marque L-E

 Series 62-2 "Parisiennes a la mod" Series 30 - 35 35 - 40

MICH (FR) 1915-1925

 Sid's Editions

 7069-9 Children "Bob Fait Du Sport - Tennis" 15 - 20 20 - 25

MIGNOT, V. (BEL) 1910-1925

 Dietrich & Co. (Art Nouveau) Lady 100 - 110 110 - 130

MILLER, LAWRENCE (GB) 1905-1915

 Birn Bros.

 Series 730 Beautiful Lady 25 - 30 30 - 35

MORGAN, F.R. (GB) 1910-1920

 A-414 Monkeys "The Tennis Kiss" 15 - 18 18 - 22

NAGEL, GUNTHER 1910-1925

 KVML in shield logo

 670 Boy/Girl No Caption 15 - 18 18 - 22

NANNI, G. (IT) 1915-1935

 Dell'Anna & Gasparini

 Series 434 (6) Beautiful Ladies 30 - 35 35 - 40

 Series 434 also seen with other foreign captions 30 - 35 35 - 40

 Series 434 also in narrow card series 15 - 18 18 - 22

 Series 479-5 Beautiful Lady 30 - 35 35 - 40

Rev. Stampa, Milano
 Series 309-1 Beautiful Lady 30 - 35 35 - 40
E. Sborgi
 Beautiful Lady "Tennis" 35 - 40 40 - 45
NAST, THOMAS, JR. (US) 1905-1915
 Anonymous
 Beautiful Lady "Love Game" 20 - 25 25 - 28
NECLEM & APPEL Linen
 Man "Sporting Life in Woodstock" 4 - 5 5 - 6
NORMAN, S. (US) 1905-1915
 Reinthal & Newman
 1001 Lady
 "A Champion" 20 - 25 25 - 30
NUMBER, JACK 1910-1920
 P.F.B. in diamond
 Series 2118 Children
 4 "Pardon, Monsieur ..." 15 - 18 18 - 22
 5 "Porvu Qu'il alt le nez bien plante ..." 15 - 18 18 - 22
O'NEILL, ROSE (US) 1905-1925
 The Ashers
 130613 Kewpie Chrome 3 - 4 4 - 5
OUTCAULT, R.F. (US) 1905-1915
 Advertisement Buster Brown
 "This Month is all vacation" 100 - 110 110 - 120
PAYNE, C.M. 1910-1920
 "The Stone Age"
 "A Love Game" 15 - 20 20 - 25
PENOT, ALBERT (FR) 1910-1930
 Delta
 Series 9 41-45 (5) **"Tennis Feminin" Series** 30 - 35 35 - 40
PIRKIS 1915-1930
 "Yes or No" Series (B&W)
 "Have you got it ... Just over" 10 - 12 12 - 15
 "Sketchy Bits" Series (B&W)
 "Just a knock up" 12 - 15 15 - 18
 "My Ball. Leave it." 12 - 15 15 - 18
 "Love Forty" 12 - 15 15 - 18
 "Vantage Out" 12 - 15 15 - 18
PLANTIKOW (GER) 1910-1920
 S.W.S.B.
 Series 6495 Windblown ladies 15 - 18 18 - 22
PLUM (FR) 1910-1930
 G.H., Paris
 Series 25 Beautiful Lady 35 - 40 40 - 45
POWELL, LYMAN (US) 1910-1920 (B&W)
 Beautiful Lady No Caption 15 - 18 18 - 22
PRESTON, CHLOE (GB) 1910-1930
 A.R.&C.i.B.
 Series 1523-1 Little Girl "Who says it ain't ..." 20 - 25 25 - 28
 Valentine & Sons Chloe Preston Series
 960 Children "Who says it ain't gonna rain ..." 15 - 18 18 - 22
P.V.B. (GB) 1905-1920

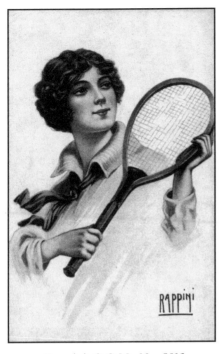

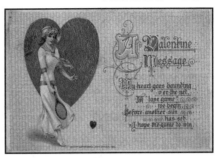

Unsigned S. L. Schmucker, Winsch, 1914
"My heart goes bounding..."

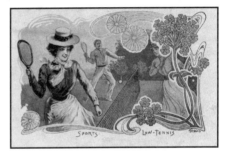

Rappini, C.C.M., No. 2016
No Caption

Tamagno, Anonymous French
Publisher, "Sports — Law-Tennis"

Raphael Tuck		
Series 1002 Tennis Illustrated		
"Weak Return" Drinking	20 - 25	25 - 28
"Our Advantage"	20 - 25	25 - 28
"Doubles" Drinking	20 - 25	25 - 28
"Our Game"	20 - 25	25 - 28
"Smart Service" Military	20 - 25	25 - 28
RAME, N. 1905-1915		
Anonymous		
181 Girl sitting on wall. No caption	12 - 15	15 - 20
RAPPINI (IT) 1910-1930		
C.C.M. logo		
2016 Beautiful Lady	25 - 30	30 - 35
REID, ALBERT T. (GB) 1910-1920		
Earl S. Voorhis Children "Tennis Boy"	15 - 18	18 - 22
REMITZ (GER) 1905-1920		
B.K.W.I.		
Series 366-5 Man wearing tremendous hat	30 - 35	35 - 40
Series 377-1 Lady wearing tremendous hat	30 - 35	35 - 40
ROBERT, JACQUES (FR) 1905-1915		
Comite National des U.C.J.G.		
"Le Tennis"	12 - 15	15 - 20
RUTINO, JOS. 1940's		
Children Foreign caption	8 - 10	10 - 12
SAGER, XAVIER (FR) 1910-1930		
A. Noyer "Sports Parisiens"		
69 Beautiful Lady	30 - 35	35 - 40

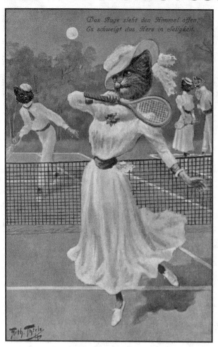

Arth. Thiele, T.S.N., Series 851
German Caption

Arth. Thiele, T.S.N., Series 871
No Caption

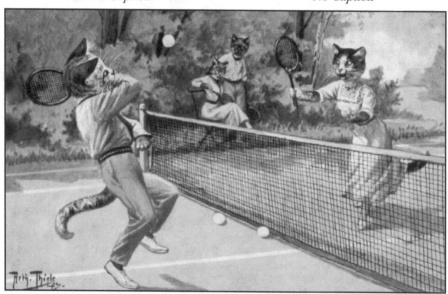

Arth. Thiele, T.S.N., Series 1214 — No Caption

B.M., Paris 524 Beautiful Lady		30 - 35	35 - 40
Raphael Tuck & Fils			
No No. Pretty Lady "Le Tennis"		65 - 70	70 - 75
SCHENK, F. 1915-1930			
HP in logo Man		15 - 20	20 - 25

SCHLEH. , C.F.W. (GER) 1905-1915
Paul Hinsche

"Baden-Baden, Lawn-Tennisplatz"	20 - 25	25 - 30

SCHMUCKER, S.L. (US) 1905-1915
John Winsch, Copyright

Copyright, 1910 "Sports Cupid" Tennis	30 - 35	35 - 40
Copyright, 1914 Gold Heart Tennis	40 - 45	45 - 50
Series 450-43 Valentine "A Valentine Message"	40 - 45	45 - 50
Valentine "My heart goes bounding over the net"	30 - 35	35 - 40

SHINN, COBB X. (US) 1905-1920
N.A. Waters

"Foolish Questions - Mowing the grass?"	10 - 12	12 - 15

SPARKHUL, CHICKY 1910-1920
AV with lamp in circle logo

977 Children "Love All"	15 - 18	18 - 22

SPURGIN, FRED (LAT) 1905-1920
W. & K.

2020 Children "When my love plays tennis-see"	15 - 18	18 - 22

STEEN 1920-1930
REB logo

K744 Boy/Girl "Jou Beurt, Partner?"	10 - 12	12 - 15

STUDDY, G.H. (GB) 1910-1930
B.K.W.I. "Bonzo" Series

VIII-1 "Keine Rose Ohne Dornen"	18 - 22	22 - 25

"R.P.S." Series Bonzo

1014 "Fred the Ball Boy"	18 - 22	22 - 25
1062 "Deuce"	18 - 22	22 - 25

Valentine & Sons "Bonzo Series"

1949 "You weren't expecting this"	18 - 22	22 - 25
2694 "Give me shorts for freedom!"	18 - 22	22 - 25

TAMAGNO 1915-1930

Beautiful Lady "Sports Law-Tennis" (B&W)	18 - 22	22 - 25

TANQUEREY, L. 1915-1930
Horseshoe logo

229 Beautiful Lady "Tennis"	15 - 18	18 - 22

TEMPEST, D. (GB) 1930-1940
Bamforth Co.

028 Tennis Comic "People who say tennis ..."	12 - 15	15 - 18
224 Kiddy Series "Twosomes is lovely!"	12 - 15	15 - 18
545 Kid Comic "Gee Whiz! I'm glad I'm free ..."	12 - 15	15 - 18

THAMBRELENT, LOUIS (FR) 1920-1930
Charles Vernau

Advertisement French Caption - "Tennis and Golf"	25 - 30	30 - 35

THIELE, ARTH. (GER-DEN?) 1905-1925
German Am. Novelty Co.

* **Series 871 Black** man	40 - 50	50 - 60

T.S.N. (Theo Stroefer, Nürnburg)

Series 851 Cats German caption	35 - 40	40 - 50
* **Series 871 Black** man Same series as above	50 - 60	60 - 70
Series 1214 Cats	35 - 40	40 - 50
* Same without T.S.N. & German Am. N. byline	40 - 50	50 - 60

TORI (JAP) 1910-1930

Man	80 - 90	90 - 100

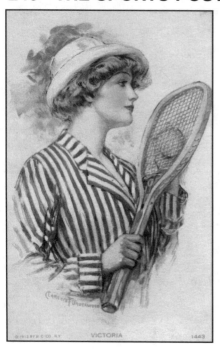

Clarence Underwood, R. C. Company
No. 1443, "Victoria"

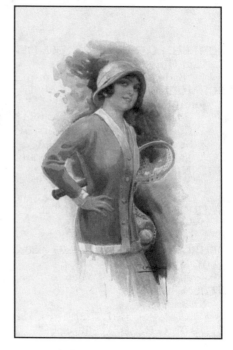

L. Usabal, R&K "Erkal" — Series 336
No Caption

TOUSSAINT (FR) 1910-1920		
Beautiful Lady	25 - 30	30 - 35
TRUDE (FR) 1910-1920		
Beautiful Lady	25 - 30	30 - 35
TWELVETREES, C. (US) 1905-1930		
Ullman Mfg. Co. "Jungle Sports" Series 77		
1893 Hippo "Sweet Little Buttercup"	30 - 35	35 - 40
UNDERWOOD, CLARENCE (US) 1905-1920		
R.C. Co.		
1443 Most Beautiful Lady "Victoria"	30 - 35	35 - 45
USABAL, L. (IT) 1910-1930		
R&K "Erkal"		
Series 336 (6) Beautiful Ladies 1-6	20 - 25	25 - 35
VOGL, R. (AUS) 1905-1915		
M. Munk, Vienna		
Series 339 (6) (Red Background)		
Downcast Man	50 - 60	60 - 70
Others	50 - 60	60 - 70
VOLKER, CURT (US) 1905-1920		
Paul Bendix		
121 "Her Sport"	20 - 22	22 - 26
W.S. 1930-1940		
Colortint		
235 Dogs Playing Tennis	10 - 12	12 - 15
WFD (GER) 1905-1915		
S.W.S.B.		
Series 437-1 Boy/Girl "Es Spielt die Jugend ..."	10 - 12	12 - 15

R. Vogl, M. Munk, Series 339
No Caption

R. Vogl, M. Munk, Series 339
No Caption

W.S., Colortint 235 — No Caption

WAIN, LOUIS (GB) 1905-1915
 Philco Publishing Co.
 2084 "We're All In The Finals!!!" 50 - 60 60 - 70

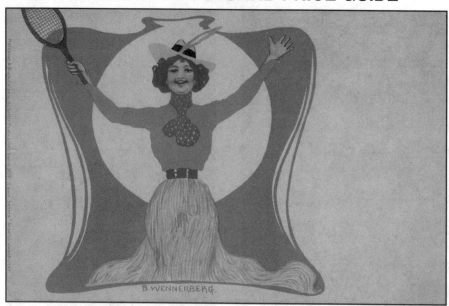

B. Wennerberg, Meissner & Buch —"Lawn-Tennis" Series 1039

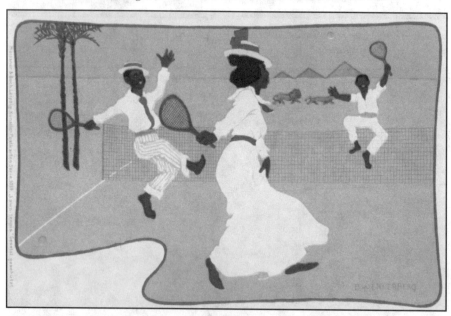

B. Wennerberg, Meissner & Buch —"Lawn-Tennis" Series 1039

WALL, BERNHARDT (US) 1905-1920
 J.I. Austen Co.
 389 College - Pennsylvania 20 - 25 25 - 30
WEBER, L. 1910-1920
 B.V.B. in shield logo
 4162 Lady 15 - 20 20 - 25

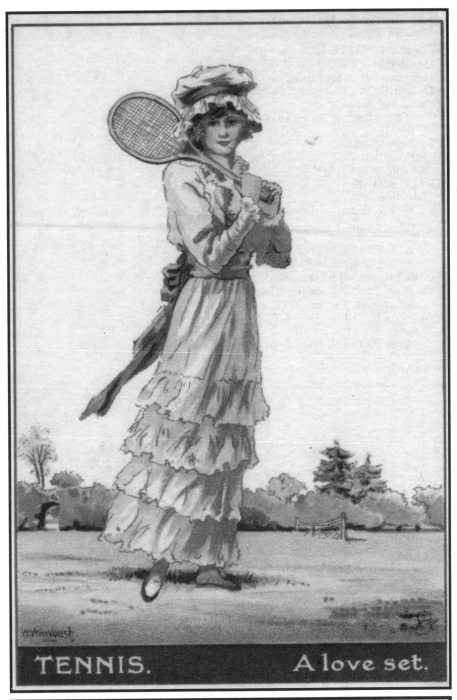

TENNIS. A love set.

Winifred Wimbush, Raphael Tuck "Sporting Girls"
Series 3603, "Tennis — A love set."

WELLMAN, WALTER (US) Linen
 Manhattan Postcard Co.

Series 391 "My Daily Diary"	6 - 8	8 - 10

WENNERBERG, B. (GER) 1905-1920
 Meissner & Buch
 "Lawn Tennis" Series 1039 (6)

Blacks	45 - 50	50 - 60
Beautiful Lady	35 - 40	40 - 50
Boy/Girl	35 - 40	40 - 45
Children	35 - 40	40 - 45

WHITE, BRIAN (GB) 1910-1920
 Valentine & Sons

3384 Children "How about a little love game?"	15 - 20	20 - 25

WILCAR 1910-1920
 RB in circle logo

21316-1 "Play" Girl	10 - 12	12 - 15
21316-2 2 Men "Ready"	10 - 12	12 - 15

WIMBUSH, WINIFRED (GB) 1905-1920
 Raphael Tuck "Sporting Girls"

Series 3603 "Tennis - A Love Set"	25 - 30	30 - 40

ZASCHE, TH. (GER) 1905-1915
 T.S.N.

Sport Post-Postkarten Series 195-2 Beautiful Lady	15 - 20	20 - 25

Publisher Amag, 011
No Caption

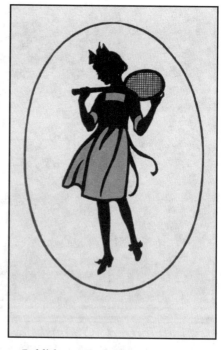

Publisher A.R. & C.i.B., No. 1305-4
No Caption

PUBLISHERS

A.G.F., Dresden
 Advertisement
 Standard Hamburg-Wien Tennis-Balle 40 - 50 50 - 60
A H Co. 1905-1915
 American Art (Undb)
 Beautiful Lady "Tennis Girl" 20 - 25 25 - 30
A & H 1905-1915
 504 Boy/Girl "Always Winning" 12 - 15 15 - 20
Aldine Series
 228 Lady 20 - 25 25 - 30
Alpha Publishing
 Moveable eyes
 1355 Children "Love All" 15 - 18 18 - 22
Amag 1905-1920
 011 Beautiful Lady with dogs 20 - 25 25 - 28
 Series 0294 Children "Coupe Davis" 12 - 15 15 - 20
 Series 0300
 "Pan dans L'oeil" 12 - 15 15 - 20
 "Raffraichissment" 12 - 15 15 - 20
 Children No Caption 12 - 15 15 - 20
 Children No Caption 12 - 15 15 - 20
American News Co.
 Series 93 Photo-types
 1, 2, 4, and 5 Boy/Girl 15 - 18 18 - 22
Ant-Bitek Junr
 "Service KK" 10 - 12 12 - 15
AN, Paris 1920's
 Real Photo of 1924 Olympics
 450 "Miss H. Wills" 25 - 30 30 - 35
A.R.&C.i.B. 1905-1915
 Series 1305-4 Silhouette Lady 20 - 25 25 - 30
 Series 1356-1 Lady "Play!" 20 - 25 25 - 28
ASM 1905-1915
 Series 1086 Man No Caption 12 - 15 15 - 18
B. Arnaud 1920-1930
 French Advertisement "Manufacture de Chemises" 20 - 25 25 - 30
J.I. Austen Co. 1905-1915
 Series 325
 Children "He couldn't stand the racquet!" 12 - 15 15 - 18
B.B., London (Birn Bros.) 1905-1915
 Excelsior Series E
 200828 Boy/Girl No caption 12 - 15 15 - 20
B.K.W.I. (Bruder Kohn, Vienna) 1905-1915
 Series 362-3 Lady "Grand Chic" 35 - 40 40 - 50
 Series 377-1 Beautiful Lady 25 - 30 30 - 35
 Series 392-5 Big colorfully dressed cat 25 - 30 30 - 35
Bamforth Co. 1905-1915
 Tennis Comic
 021 "This game beats tennis ..." 12 - 15 15 - 20
 023 "All sorts of things come out ..." 12 - 15 15 - 20
 025 "They are always rolling ..." 12 - 15 15 - 20
 026 "Tennis is good in many ways ..." 12 - 15 15 - 20

Publisher B. Arnaud, Paris
"Manufacture de Chemises"

Publisher D Company, Chicago
No Caption

13560 "I can see you do try ..."	12 - 15	15 - 18
13562 "They are always rolling ..."	12 - 15	15 - 18
13563 "The country's full of courts ..."	12 - 15	15 - 18
13564 "Tennis is good in many ways ..."	12 - 15	15 - 18
RB (Backward in square logo) 1905-1915		
21561 Little Girl arriving by car No caption	7 - 9	9 - 12
F. von Bardeleban 1905-1915		
U.S. 719 Boy/Girl "Lawn Tennis-Vantage Out"	15 - 18	18 - 22
Beckman (German) 1905-1915		
Real Photo of German Crown Princess		
"Unsere Kronprinzessin"	10 - 12	12 - 15
Bergman Co. 1905-1920		
8807 Man "Vacation - It's within the law ..."	8 - 10	10 - 15
8815 Boy/Girl "Getting back some health ..."	8 - 10	10 - 15
8821 Girl "Some summer believe me"	12 - 15	15 - 18
Julius Bien & Co. 1905-1915		
"Simple Life" Series 65		
Children "After the Ball"	15 - 18	18 - 22
Burgess Children 1905-1915	8 - 10	10 - 12
Byrrh 1905-1910		
Artist - M. Cleret		
Advertisement "Byrrh - Tonic Hygienique, etc."	90 - 100	100 - 125
C.C. & G.P. 1905-1915		
Advertisement		
"De Continental Tennis Bal" Men's Doubles	30 - 35	35 - 40
Same in Russian Caption	35 - 40	40 - 45
"Continental - Tennisbal" Mixed Doubles	30 - 35	35 - 40

"Continental - Tennis bal" Girl German Caption	30 - 35	35 - 40
"Continental - Tennis bal" 2 men	30 - 35	35 - 40
CO.-V.S. 1910-1920		
"Love All Duece All" 2 photos	3 - 5	5 - 7
C.T. Art-Colortone Linen		
Series C-5		
C-48 "I'm too heavy for the game"	3 - 5	5 - 7
Everyday Comics		
C-41 "Same old racket ..."	3 - 5	5 - 7
Fresh Air Comics		
C-1149 "I miss my mark, I miss my step"	3 - 5	5 - 8
Colonial Art Pub. Co. 1905-1915 (Sepia)		
Boy/Girl "The American Service"	12 - 15	15 - 18
Boy/Girl "Back Volley"	12 - 15	15 - 18
Boy/Girl "Could you beat it?"	12 - 15	15 - 18
Boy/Girl "A Summer Racket'`	12 - 15	15 - 18
Boy/Girl "A Ticklish Play"	12 - 15	15 - 18
Boy/Girl "Double Service"	12 - 15	15 - 18
Boy/Girl "Love Sixteen"	12 - 15	15 - 18
Boy/Girl "Forty Love"	12 - 15	15 - 18
Boy/Girl "Service in the wrong Court"	12 - 15	15 - 18
Coloprint B 1940-1950 (BEL)		
235 Dressed Dogs Foreign Caption	8 - 10	10 - 12
369 Children Foreign Caption	6 - 8	8 - 10
4460 Dressed Rabbit holding racket. No caption	8 - 10	10 - 12
53998 Man	6 - 8	8 - 10
7433 Children	6 - 8	8 - 10
Continental Tennis Ball 1905-1920		
Advertisement		
Blacks playing tennis	80 - 100	100 - 120
Dennis & Sons, Ltd. 1905-1920		
Boy/Girl "A Love Game"	12 - 15	15 - 18
30 Boy/Girl "The 'Love' Game" (H-T-L)	30 - 35	35 - 40
5720 Boy/Girl Hold-to-Light "This is the place ..."	20 - 25	25 - 30
D in octagon logo 1910-1920 (B&W and Color)		
Beautiful Lady	10 - 15	15 - 18
DEGI on palette 1915-1930		
1063 Boy/Girl	25 - 30	30 - 35
D.S.N. in a diamond logo 1905-1915		
2347 Valentine	10 - 12	12 - 15
B. Dondorf 1905-1920		
Series 257 (6)		
Man	18 - 22	22 - 26
Boy/Girl	18 - 22	22 - 26
Beautiful Lady	20 - 25	25 - 30
E.C.C. 1905-1915		
1 145 Man- girl walking in woods. No caption	7 - 9	9 - 12
EB in a C logo (Emb) 1905-1915		
Series 1953-6 Lady "The Tennis Girl"	12 - 15	15 - 20
ES in solid diamond logo		
Lumineuse Boy/Girl Silhouette "Le Tennis"	12 - 15	15 - 20
E.S.D. 1905-1915		
1028 Girl about to hit ball (Emb. Airbrush)	7 - 9	9 - 12

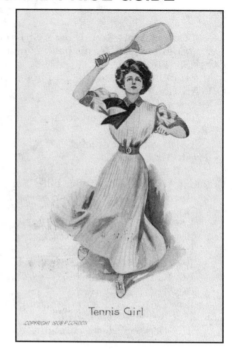

Publisher B. Dondorf, No. 257
No Caption

Publisher P. Gordon, 1908
"Tennis Girl"

Eagle & Shield logo 1905-1915
 Boy/Girl "At home by Meisner" 12 - 15 15 - 18
FW in circle logo 1905-1915
 100a 2 Girl standing with racket No caption 18 - 22 22 - 26
Fasto 1920-1930
 602 Beautiful Lady Silhouette Foreign Caption 12 - 15 15 - 20
G in a triangle logo 1915-1925
 Beautiful Girl 15 - 18 18 - 22
 Beautiful girl with racket (B&W) 8 - 10 10 - 12
G.A.L. 1920-1930
 756 Boy/Girl 10 - 12 12 - 15
GAM in circular logo 1905-1915
 Series 553
 4. Beautiful Lady 15 - 18 18 - 22
GB 1915-1925
 Dressed Cats 35 - 40 40 - 45
Gartner & Bender 1905-1915
 "Heeza Korker" Series
 Man "In life as in tennis you raise a racket ..." 15 - 18 18 - 22
J. Goffin Fils 1905 - 1915
 Advertisement "La Panne-Bains" 25 - 30 30 - 35
P. Gordon 1908 (B&W)
 "Tennis Girl" 12 - 15 15 - 18
D. Grodel (Emb) 19105-1915
 Cats (Squeeker) 15 - 20 20 - 25
Edward Gross 1905-1915
 American Girl 73 Beautiful Lady 20 - 25 25 - 30

James Henderson & Sons 1905-1915
 Sports Girls G-2

2613 "A Love Match"	12 - 15	15 - 18

 Summer Sports (Sepia)

130 Boy/Girl "Lawn Tennis - Vantage out"	12 - 15	15 - 18

Huntley & Palmers 1905-1915 Non-PC Back

Advertisement "Huntley & Palmers Biscuits"	10 - 12	12 - 15

International Art 1905-1915
 Series 947 (Emb)

"My Love to You"	12 - 15	15 - 20

 Series 2017 (Emb) Children

"All happiness for Easter"	12 - 15	15 - 18
"A very happy Easter to you"	12 - 15	15 - 18
"Best Easter Wishes"	12 - 15	15 - 18

 Series 1225

"Easter Greeting"	12 - 15	15 - 18
"A Joyful Easter"	12 - 15	15 - 18

Inter-Art Co. 1910-1930
 Sporty Cats

4095 "This is just between ourselves"	12 - 15	15 - 20

International Post Card Co. (I.P.C. Co.) 1905-1915

Beautiful Lady	15 - 18	18 - 22

JLW 1910-1920

Valentine "Loving Greeting" (Emb)	10 - 12	12 - 15

J.M. & Co. 1910-1920
 Series 901

Boy/Girl "Well served"	10 - 12	12 - 15

Jester Chromes
 Jester Edition

"He used to complain!"	2 - 3	3 - 4

Johnson, Ltd. 1905-1915
 Clan Series

Boy/Girl "Clan MacDonald - Common Heath"	18 - 22	22 - 26

Kallerta Izd, G. 1905-1920

1892 Silhouette "Dauds Laimez Varda Diena"	18 - 22	22 - 26

Kanesaka, T. 1915 - 1930

Children	25 - 30	30 - 35

Knapp Co. 1905-1915

2 51 "Love All The game's the thing ..."	18 - 22	22 - 26

Kock & Bitriol (K.&B. D) 1905-1915

Couple playing tennis. Inset of girl	25 - 30	30 - 35

L.S.C. 1910-1920
 Santa Series 213

B. Christmas Greeting (Emb)	8 - 10	10 - 12

M Co. in shield logo

812 Girl "Having a fine time"	8 - 10	10 - 12

M & M Co. Chrome

M-15 Boy/Girl "How's my form today?" (B&W)	2 - 3	3 - 4

Vivian Mansell & Co. 1905-1920

Beautiful Lady "My Chum"	20 - 25	25 - 28
1118 Beautiful Lady "My Partner"	25 - 28	28 - 32

Meissner & Buch or **M&B** 1905-1925
 Deutscher Sport

1070 Man "Lawn Tennis"	20 - 25	25 - 28

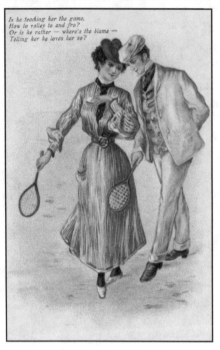

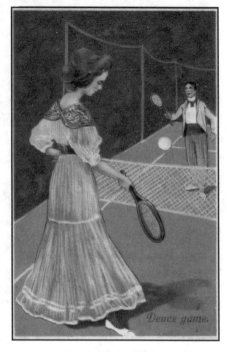

Publisher P.F.B., Series 6517
No Caption

Publisher P.F.B., Series 9333
"Deuce game."

M. Munk, Wien 1905-1920		
Series 209 Boy/Girl	20 - 25	25 - 30
Series 677 Beautiful Lady	25 - 30	30 - 35
Series 702 Beautiful Lady	20 - 25	25 - 30
Series 1126 Tennis Lovers	15 - 18	18 - 22
Nelly 1910-1920		
Little boy and girl holding racket. No caption	7 - 9	9 - 12
The Nuener Co. 1920's		
Advertisement		
1744 "Long Beach Sanitarium-Every Day ..."	12 - 15	15 - 18
O.G.Z.-L 1905-1915		
329 Dressed dogs No caption	15 - 18	18 - 22
O.P.F. logo 1905-1915		
Lady "Meet me at ..."	35 - 45	45 - 55
P in circle logo 1920's		
"In the tennis court"	15 - 18	18 - 22
Pen & Ink logo Linen		
391 Boy/Girl "My Daily Diary-Gosh! I'm worried"	5 - 7	7 - 9
P.F.B. (Paul Finkenrath, Berlin) 1905-1915		
Series 9333 (Emb)		
"A smart volley"	25 - 30	30 - 35
"Deuce Game"	25 - 30	30 - 35
"Returned"	25 - 30	30 - 35
Lady French Caption "Tl me seraitbien doux de..."	25 - 30	30 - 35
Series 4339 "Deutsche Meister"		
"Ballspiel" on back	30 - 35	35 - 40

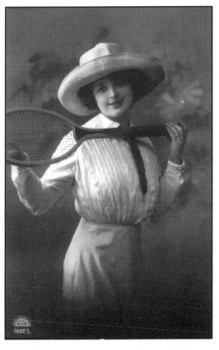

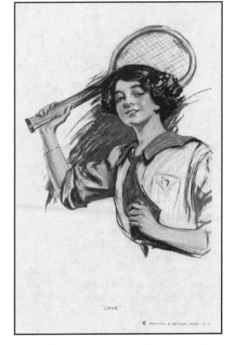

Publisher R&K, Series 5637/1
Tinted Real Photo

Publisher Reinthal & Newman, 128
"Love"

Series 6517 (Emb)		
"Is he teaching her the game ..."	25 - 30	30 - 35
C.E. Perry 1910-1920		
Girls No caption	12 - 15	15 - 18
Philco Publishing Co. 1920-1940		
Comic Series		
5605 "Mary used to play mixed singles ..."	10 - 12	12 - 15
F. Polenghi 1905-1915		
21-6 Girl reaching overhead with racket. No caption	18 - 22	22 - 26
S.S. Porter 1905 - 1915		
Series 190		
Boy/Girl "A Love Game"	15 - 18	18 - 22
REB logo 1905-1920		
Series 54408 3 Girls	10 - 12	12 - 15
R&K 1905-1915		
Tinted Real Photos	15 - 20	20 - 25
Reinthal & Newman or **R&N** 1905-1920		
Beautiful Lady "Best Love Game"	20 - 25	25 - 30
Series 128		
Beautiful Lady "Love"	20 - 25	25 - 30
Geo. Rice & Sons 1910-1930		
Advertisement "Long Beach Sanitarium"	15 - 20	20 - 25
Mike Roberts Chromes		
Fun Cards by Gad		
30 Nudist "I'd certainly like to know..."	3 - 4	4 - 5
Charles Rose 1905-1920		
Boy/Girl "Business Opportunities Wanted..." (B&W)	6 - 8	8 - 10

S in wreath logo
Girl "The Tennis Girl" — 12 - 15 — 15 - 18
SB "Special" 1905-1915
2676 Children on linen-like card stock — 15 - 18 — 18 - 22
SO in block logo 1910-1920
Series 114 (4) (Emb)
Men — 12 - 15 — 15 - 18
S.W.S.B. 1905-1920
5710 Silhouette Boy/Girl — 15 - 18 — 18 - 22
5932 Children Foreign Caption — 12 - 15 — 15 - 20
5933 Children — 12 - 15 — 15 - 20
6495 Beautiful Lady — 18 - 22 — 22 - 26
6552 Beautiful Lady — 18 - 22 — 22 - 26
J. Salmon Co. 1920-1940
Sporty Cats Series
2816 "Oog Om Oog..." — 15 - 18 — 18 - 22
A. Schnakenburg 1920-1930
Advertisement Papirosi Cigars — 50 - 55 — 55 - 60
Soaga Trademark 1910-1930
Advertisement "Lawn Tennis Balls Semperit ..."
"Le Lieger" — 20 - 30 — 30 - 40
"Lob" — 20 - 30 — 30 - 40
"Out-Side" — 20 - 30 — 30 - 40
"Play" — 20 - 30 — 30 - 40
"Ready" — 30 - 30 — 30 - 40
Souvenir Postcard Co. 1905-1915
Dressed Cats 750 "A Hot Game" (Emb) — 12 - 15 — 15 - 20
"Love's Fortune"
Series 4709 "A Lady will give you her heart" — 10 - 12 — 12 - 15
Edwin Stern & Co. 1905-1920
Hobo Series 4 Man — 15 - 18 — 18 - 22
T in triangle logo 1910-1920
Series 114 Man (Emb) (2) — 12 - 15 — 15 - 18
TC logo 1915-1930
Series 2173
5 Boy/Girl "Bonne Année" (B&W) — 8 - 10 — 10 - 12
T.P. & Co. 1905-1920
969 Man "I love the country ..." — 8 - 10 — 10 - 12
TS logo 1910-1920
Series 203-4 Beautiful Lady — 25 - 30 — 30 - 35
TC, Paris 1905-1915
Political "Welcome to the American" — 25 - 30 — 30 - 35
T.S.N. (Theo Stroefer, Nürnburg) 1905-1915
Series 891 (6) Tennis couples — 20 - 25 — 25 - 28
Th. E.L. Theochrom 1905-1915
Series 1063
"O Love Sweet Love" — 8 - 10 — 10 - 15
"Telling the old, old story" — 8 - 10 — 10 - 15
Angus Thomas, Ltd. 1905-1920
Mechanical
105 Girl "The Tennis Girl" — 100 - 110 — 110 - 125
Raphael Tuck 1905 -1920
French Tuck Beautiful Lady "Heureuse Année" — 25 - 30 — 30 - 35

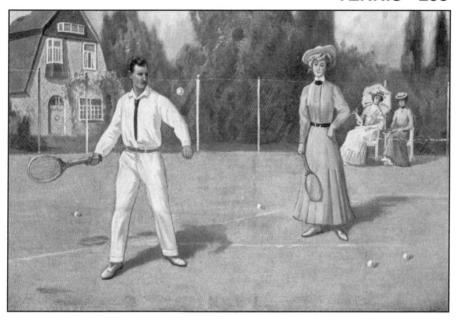

Publisher T.S.N., Series 891 — No Caption

"Valentine"		
Series 6 "The Tennis girl wants to play ..."	15 - 20	20 - 25
"Little Bears"		
Series 118 "One in the Eye"	25 - 30	30 - 35
Unnamed Series		
Series 843-III Beautiful Lady (Emb)	15 - 18	18 - 22
"Pickings from Puck"		
Series 2416 Boy/Girl "Among the Orange Blossoms"	12 - 15	15 - 18
"Girl's to Know"		
Series 3601 Lady "Let's Play the Game"	20 - 25	25 - 30
"Early Days of Sport"		
Series 9293 "Tennis in the time of Henry VII"	20 - 25	25 - 30
Leon Ullman, Sr. 1920-1930		
Advertisement		
"Les Sports Modernes" "l'Hemostyl-Hepamoxyl"	50 - 60	60 - 70
Ullman Mfg. Co. 1905-1915		
1524 Children "Prize Tennis"	12 - 15	15 - 18
UNICO in diamond logo 1910-1920		
Girl "Will you play the game with me?"	8 - 10	10 - 12
Universal-Kunstverlag 1905-1920		
20501 Children	10 - 12	12 - 15
Valentine & Sons, Ltd. 1905-1915		
Beautiful Lady "A Strenuous Game"	25 - 30	30 - 35
Valentine's 1910-1920		
Boy/Girl "First Come, First Served - Deuce!"	15 - 18	18 - 22
Man "Holiday Lies - Your religious wealthy aunt ..."	12 - 15	15 - 18
W.R. & Co. 1910-1920		
Series 6685 Dressed Rabbits Foreign Caption	12 - 15	15 - 18
Whitney Made 1910-1930		
Children "Tis a secret that she hears!"	10 - 12	12 - 15

 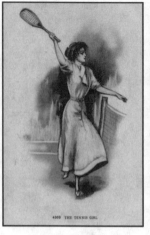 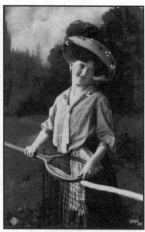

Anonymous, Italian
No. 3203-5, No Caption

Anonymous No. 4009
"The Tennis Girl"

Tinted Real Photo
No. 01497/98

John Winsch, Copyright 1905-1915
 Valentine (Emb) 15 - 18 18 - 22
Williamson Bros. 1905-1915
 Advertisement "Brewed Malt"
 "The Tonic That Makes You New All Over..." 130 - 140 140 - 150
Woolstone Bros. 1905-1920
 The Milton Series
 Series 60 Folder of pictures "Love-One" 30 - 35 35 - 40
 Series 515 "Love All Indeed!" 12 - 15 15 - 20

ANONYMOUS

70 D Comic Series "Just Here For Awhile ..."	5 - 7	7 - 9
122 "Love's First Token"	7 - 9	9 - 12
133 Little Girl holding a racket Small card	20 - 22	22 - 25
194 "A Game of Hearts" Nude Cupids	12 - 15	15 - 18
295 "I Am On The Same Old Racket"	5 - 7	7 - 9
306 E "Easter Greetings & Sincere Wishes" (Emb)	5 - 7	7 - 9
325 E "All Kind Thoughts" (Emb)	5 - 7	7 - 9
526 "Our Sports Love All"	10 - 12	12 - 15
2010 H-T-L reveals a goat pulling cart Easter Greeting	15 - 18	18 - 22
2015 "Dream of My Valentine" Pretty Girl (Emb)	15 - 18	18 - 22
2104 "All Easter Joys" Rabbits playing (Emb)	10 - 12	12 - 15
3203-5 Italian Beautiful Lady with Adoring Males	20 - 25	25 - 30
3639 "Nartelyk Gefelicteerd" Children	8 - 10	10 - 12
4009 "The Tennis Girl" (Sepia)	10 - 12	12 - 15
6566 "Die Favoritin" Beautiful Girl	15 - 18	18 - 22
A-189 "I'm Longing For You" Beautiful Girl	10 - 12	12 - 15
Fresco Clubhuis Sportterrein Klarenbeek Arnhem Ser.		
"Mixed Doubles"	18 - 22	22 - 26
"De Heeren Double"	18 - 22	22 - 26
"The Umpire"	18 - 22	22 - 26
Japanese Characters Girl kneeling a low table writing	30 - 35	35 - 40
"Je Fais Du Sport, Pour Gardner Ma Ligne Zoo ..."	10 - 12	12 - 15

Japanese Tennis Player
Anonymous

Advertisement for Walkover Shoes
"Quick Service"

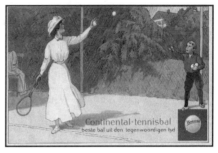

Advertisement for "Continental
tennisbal -- beste bal in den ..."

Advertisement for Lawn Tennis Balls
F. Schönpflug -- "Play!"

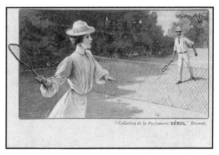

Advertisement for Perfume Xerol
"Collection de la Parfumerie Xerol"

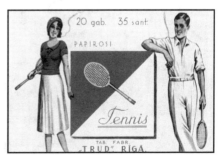

Advertisement for Tennis Racquets
"Trud Riga"

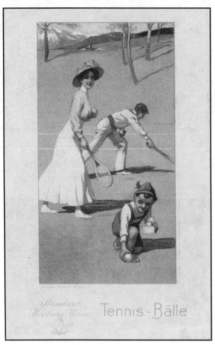

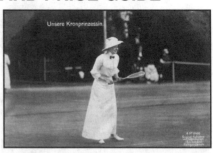

*Real Photo of the German Crown
Princess — "Unsere Kronprinzessin"*

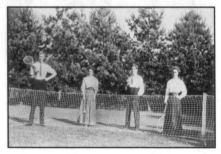

*Advertisement for Standard Harburg-
Wien, "Tennis-Bälle"*

*Real Photo of Early
Tennis Enthusiasts*

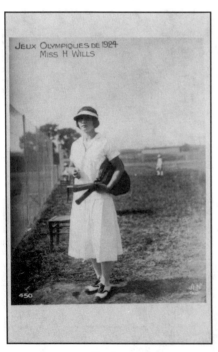

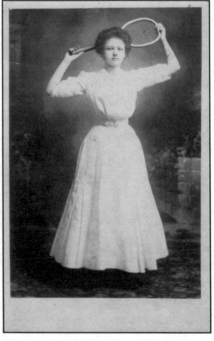

*Real Photo of Miss H. Wills
1924 Olympics*

*Real Photo of Tennis Beauty
1910 Era*

"Lawn Tennis Match"	12 - 15	15 - 18
"Love All"	7 - 9	9 - 12
"To My Love" (Emb) 2 cupids playing	7 - 9	9 - 12
"To My Love" H-T-L 2 cupids playing	20 - 25	25 - 30
Two Cupids playing tennis (Emb)		
"A Message of True Love"	7 - 9	9 - 12
"To My Valentine"	7 - 9	9 - 12
434 Ten Babies on the face of a racket Photo	5 - 7	7 - 9
562 Boy and Girl playing - Wide Green Border	10 - 12	12 - 15
Button Face - 1905-1915 "Love One, Love Two"	50 - 60	60 - 70
Advertisement - F-43 "Hints for a happy vacation"	10 - 12	12 - 15
Beautiful Lady - 139 Risque red film reveals		
Nude "La Tennis"	30 - 35	35 - 40
Loving Couples	10 - 12	12 - 15
Children	10 - 12	12 - 15
Animals playing Tennis	12 - 15	15 - 20
Tennis Comics	10 - 12	12 - 15

ADVERTISING

Cafe Martin - "All Roads Lead to Cafe Martin"	30 - 35	35 - 40
Munsingwear - "Perfect Happiness in Perfect Fitting..."	20 - 25	25 - 35
Standard Tennis Bälle - Harburg-Wien	30 - 40	40 - 50
Paris-Cognac-Routier - **"Cognac Sauvion"**	30 - 40	40 - 50
Polygrafa, Brno P/Hnatkouva - "Costumes de Sport ..."	25 - 30	30 - 35
Wm. Rinkenberger Washington III		
"Merry Christmas Happy New Year" Undb	15 - 18	18 - 22
"Tennis-Balle Standard - Harburg-Wien"	25 - 30	30 - 35
"Cafe Torrefies Gebrande Koffies - Rotterdam"	12 - 15	15 - 18
"Viuctoria-Water Oberlahnstein ..." - Man in ten. whites	25 - 30	30 - 35
Walk Over Shoes - "Quick Service"	12 - 15	15 - 20
XEROL - "Collection de la Parfumerie Xerol Reservee"	22 - 25	25 - 30

LEATHER CARDS		
"A Game of Hearts"	5 - 7	7 - 9
"I Consider This a Fair Return For Your Favor"	5 - 7	7 - 9
22 15A Man/Girl "Happy Days"	15 - 18	18 - 22
31 34 "They're A Perfect Couple —They Go..."	7 - 9	9 - 12

REAL PHOTOS		
Pre-1930		
Famous Players	25 - 30	30 - 40
Players with racket	15 - 18	18 - 22
Children with racket	15 - 18	18 - 22
Tennis Courts, named	8 - 10	10 - 5
Tennis Courts, unnamed	5 - 6	6 - 8
Matches in progress	8 - 10	10 - 12
Post-1930		
Famous Players	12 - 15	15 - 25
Players	8 - 10	10 - 12
Tennis Courts	3 - 5	5 - 7

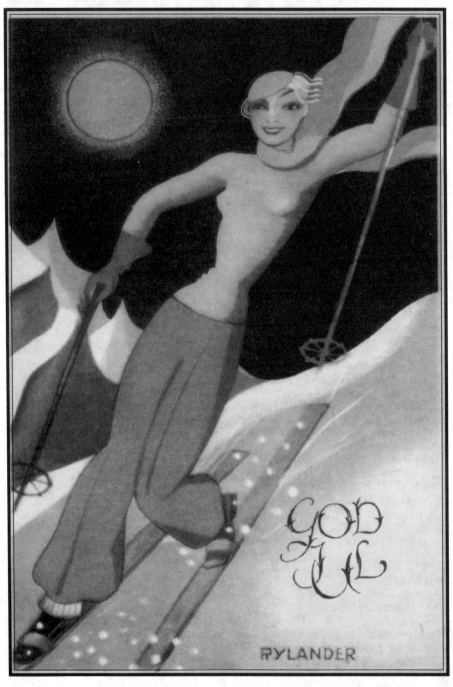

Rylander, Axel Eliassons, Stockholm
No. B, Art Deco, "God Jul"

People who ski must have an enthusiasm that makes them willing to dare most anything and to brave most any weather in order to have fun, whether it be on skis or watching as others indulge in the sport. Although warmly clothed, the skier must risk great discomfort from the weather and take more rough hits than a football player. Even with all these drawbacks, skiing gains in popularity year after year.

In the early 1900's skiing was principally a European winter sport. On the American continent the main activity was centered around the northern Mid-West, in upper New England, and northern New York State. The advent of the Winter Olympics of 1924 in Chamonix, France and the 1932 Winter Olympics in Lake Placid finally made competitive skiing extremely popular. Ski jumping, downhill, slalom, and cross-country skiing became the rage for enthusiasts. However, skiing really took off in the states when snowmakers were introduced to keep snow on the slopes at hundreds of locations that otherwise would have little or no snow.

On the postcard scene, the artists of the early years portrayed the beautiful lady as she thrilled onlookers by her presence on the slopes. As can be expected, the artists in European and Scandinavian countries, where winter sports are a ritual, produced the finest works. The great beauties by Chiostri, Bianchi, Mauzan, Fasche, E. Martin, O. Merté, and Carlo Pellegrini are in great demand by both European and U.S. collectors. There are also some great advertising cards of resorts and ski slopes.

ARTIST-SIGNED

	VG	EX
AB (GER) 1905-1915		
M Co.		
Series **1241** Man/Lady	$15 - 20	$20 - 25
Series **1300** Man/Lady	15 - 20	20 - 25
A.C.P. (FIN) 1905-1915		
Man "Finmarken"	15 - 18	18 - 22
ARANKA, GYORI 1905-1915		
Anonymous		
No No. Pretty Lady No caption	30 - 35	35 - 40
ASO logo 1905-1915 (B&W)		
Anonymous (B&W)		
Man No caption	10 - 12	12 - 15
Lady No caption	10 - 12	12 - 15
BAKER, DAVID Chrome		
S23630SC Man "Bushwhacking Skis"	2 - 3	3 - 4
S23598SC Man "Climbing Skis"	2 - 3	3 - 4
S23597SC Man "Slalom Skis"	2 - 3	3 - 4
S23600SC Man "Snowplow Ski"	2 - 3	3 - 4
F.B. (Fritz Baumgarten) (GER) 1905-1925		
Meissner & Buch		
Series **2761** Boy "Gluckliches Neujahr"	15 - 18	18 - 22
EAS (Uns)		
M 543 Boy "Viel Gluck im neuen Jahr"	15 - 18	18 - 22
BARBER, COURT (US) 1905-1915		
Minerva		
Series **690-1** Beautiful Lady No caption	15 - 20	20 - 25
BARTH, OTTO (AUS) 1900-1910		
M. Munk, Vienne (B&W)		
Series **171** Beautiful Lady	15 - 18	18 - 22
BEATY, A. 1905-1915		
National Postcard System		
Series **5** Beautiful Lady "Come Ski With Me"	15 - 18	18 - 22
BERTIL, A. 1930-1940		
Eric Gerhards		
Blacks "Sadan Blir Man"	15 - 20	20 - 25
Others	8 - 10	10 - 12
BIANCHI (IT) 1910-1930		
Anonymous		
Series **835-3** "La Neve La Neige"	25 - 28	28 - 32
BIRGER (SWE) 1920-1930		
Axel Eliassons Art Deco		
Man/Lady "Gott Nytt Ar"	25 - 30	30 - 35
BROEKMAN, N. 1910-1920		
Man "De Ski-Virtuoos"	12 - 15	15 - 18
BRYANT, JACK (US) 1905-1915		
Knapp Co.		
Series **306-2** Beautiful Lady "On the Skis"	15 - 18	18 - 22
CHIOSTRI, S. (IT) 1910-1930		
Ballerini & Fratini Art Deco		
Series 219 (4) Beautiful Ladies	35 - 40	40 - 45

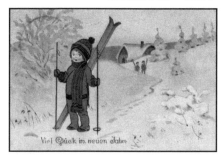

Unsigned F. Baumgarten, EAS M543
"Viel Gluck im neuen Jahre"

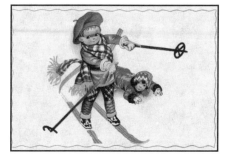

A.B., M Company, Series 1300
No Caption

Unsigned V. Castilli, Degami
No Caption

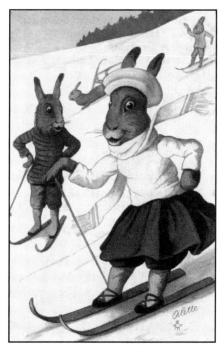

F. B. (Fritz Baumgarten), M&B 2761
"Glückliches Neujahr"

Anonymous, Raphael Tuck
No Caption

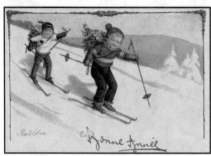

Pauli Ebner, A.G.B., No. 3740
"Bonne Année"

Max Erler, A.G.W., Series 1001
No Caption

Th. Fasche, Novitas, No. 019
"Frohliche Fahrt in's neue Jahr!"

Series 302 (4) Man/Beautiful Lady	35 - 40	40 - 45
DAMSLETH (FIN) 1910-1920		
Dreyers Grafiske		
Series 163 Man/Lady "Finmarken"	15 - 18	18 - 22
EJO 1950's		
P.Z. in globe logo		
Series 438		
3 "Slalom"	3 - 5	5 - 7
4 "Christiana"	3 - 5	5 - 7
7 "Telemark"	3 - 5	5 - 7
8 "Quersprung"	3 - 5	5 - 7
Series 439		
5 "Der Ski-Lehrer" Man/Lady	3 - 5	5 - 7
6 "Der Pechvogel" Boy	3 - 5	5 - 7
7 "Der Angstliche" Man	3 - 5	5 - 7
Series 440		
8 "Der Gipfelsturmer"		
Series 458		
2 "Sie Und Der - Lift	3 - 5	5 - 7
3 "Sie und Er-Stop"	3 - 5	5 - 7
Series 459		
8 "Gewichtsausgleich"	3 - 5	5 - 7
Series 460		
4 "Die Federn!"	3 - 5	5 - 7
5 "Die Aufnahme"	3 - 5	5 - 7
6 "Die Rennkanone!"	3 - 5	5 - 7

Grünewald, A.E., Series A
No Caption

Klinge, Anonymous No. 1039
Foreign Caption

EBNER, PAULI (AUS) 1905-1915
A.G.B.
3740 Children	20 - 25	25 - 28

EDGREN, JAC (NOR) 1910-1920
Nordisk Konst
Series 176 Man "Skidsport"	8 - 10	10 - 12

ERLER, MAX 1905-1915
A.B.W.
Series VI (6)
1000 Man - Lady at a distance	15 - 20	20 - 25
1001 Man in flying jump - lady below	15 - 20	20 - 25
1002 Large mass of singular skiers	15 - 20	20 - 25

FASCHE, TH. (GER) 1905-1915
Novitas 019 Man/Lady (B&W)	15 - 18	18 - 22

FITZPATRICK (US) Chrome
Bamforth Co. Comic
744 Boy/Girl "Damn It -This Would happen"	3 - 4	4 - 5

GALBIATI, G. (IT) 1910-1930
T.E.L.
Man "Principianti Fortunati"	10 - 12	12 - 15

GEERD 1910-1920
Sago Konst AB
4310-9 Skier and pink pig No caption	10 - 12	12 - 15

GRIFF (FR) 1910-1920
En Brocherioux "Sports"
Man/Lady French caption	10 - 12	12 - 15

Mela Köhler, B.K.W.I., Series 271-3
No Caption

Korstes, Meissner & Buch, Series 2008
No Caption

GRÜNWALD 1910-1930
 A.E.
 Series A 18 - 22 22 - 26
H.K.R. 1895-1900
 Anonymous
 No No. "Heil Neujahr! der Deutschen in ..." 10 - 12 12 - 15
HADJUK, AUGUST 1905-1915
 Ludwig Simon
 Series 1002-6 Beautiful lady 15 - 18 18 - 22
HOFFMAN, AD 1905-1915
 NVSB logo
 Series 1117 (2) Dressed dogs 18 - 22 22 - 26
JONAS, EDITH 1930-1940
 P.Z. in globe logo
 a 2028 Children 5 - 6 6 - 8
 a 2030 Children 5 - 6 6 - 8
JORDAN, C. 1910-1920
 Mecanophot VB
 S18 Man/Lady 20 - 25 25 - 28
KAUFMANN, H. (GER) 1905-1915
 Anonymous
 581 "Schi-Heil" 10 - 12 12 - 15
KLINGE 1905-1915
 Anonymous 1039 Children Foreign caption 10 - 12 12 - 15
KOCH, WALTHER (GER) 1905-1915
 Anstalt Gebr. Fretz
 "Wintersport im Kanton Graubunden" 20 - 25 25 - 28

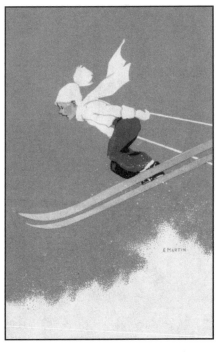

E. Martin, St.F., Zurich — No. 612
No Caption

Corneille Max, Wohlgemuth & Sissner
No. 5042, "Winter"

KÖHLER, MELA (AUS) 1905-1915
 B.K.W.I.
 Series 271-3 Beautiful Lady 90 - 100 100 - 110
KORSTES (GER) 1905-1915
 Meissner & Buch
 "Wintersport" Series 2008 Men 25 - 30 30 - 35
LENHART, F. (GB) Modern Reproduction
 Dalkeith Classic Poster
 P176 Val Gardena Grodental-Dolomite 2 - 3 3 - 4
LUND 1905-1915
 Solveg Lund Eneret
 Series 77-1 Beautiful Lady 10 - 12 12 - 15
MARTIN E. (SWISS) 1915-1930
 St.F., Zurich
 #604 through #614
 Children 15 - 18 18 - 22
 Beautiful Ladies 18 - 22 22 - 26
MARTINE (US) Chrome
 H.S. Crocker Co.
 HSC-126 "Remember Joe?" 1 - 2 2 - 3
 HSC-130 "Next Year - Hawaii" 1 - 2 2 - 3
MAUZAN (IT) 1910-1930
 Rev. Stampa, Milano
 Series 83-1 Beautiful lady 20 - 25 25 - 30
MAX, CORNEILLE (GER) 1905-1915
 Wohlgemuth & Sissner "Primus"
 Series 5042 Boy holding skis "Winter" 12 - 15 15 - 18

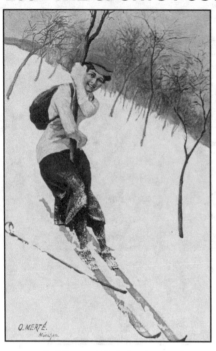 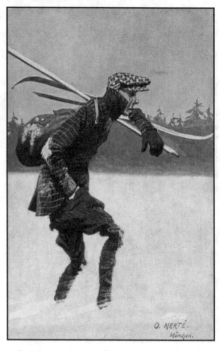

O. Merté, ASM, Series 556
No Caption

O. Merté, Rommler & Jonas, Dresden
Series IX-4, Wintersport

MEGGENDORFER, L. (GER) 1905-1915
 Anonymous
 264 Dressed monkey No caption 18 - 22 22 - 26
MERTÉ, O. (GER) 1905-1915
 ASM in a shield logo
 Series 556 (6)
 Ladies 18 - 22 22 - 26
 Men 15 - 18 18 - 22
 Rommler & Jonas
 Advertisements for Krone-Brikett
 IX-1 Beautiful Lady 25 - 30 30 - 40
 IX-4 Comical Man 25 - 30 30 - 35
MICH (FR) 1915-1925
 Sid's Editions "Bob Fait Du Sport"
 Series 7064-4 Children "Le Sky" 15 - 18 18 - 22
MMM logo 1940's
 CEC Art Deco
 Series 4278 (6) 15 - 18 18 - 22
MOOS, KARL (GER) 1905-1915
 CA & Co. "Wintersport"
 Series 8 Man "Ski-Heil" 15 - 18 18 - 22
NANNI, G. (IT) 1910-1930
 E. Sborgi "Scki" (6) 25 - 30 30 - 35
NEUMANN, PAUL (GER) 1905-1915
 Anonymous
 Rabbits "Schneebasen Fahrt" 15 - 18 18 - 22

NUMBER, JACK 1905-1915
 PFB in diamond Children

Series 2105		
3 "Descente Vertigineuse"	12 - 15	15 - 18
Series 2126 1-6	10 - 12	12 - 15

NYSTROM, JENNY (SWE) 1905-1920
 Granbergs Konstindustri

8466 "Et Godt Nytt Ar!"	12 - 15	15 - 20

PELLEGRINI, CARLO (IT) 1905-1915
 Vouga & Cie., Geneve

13 Man/Lady	25 - 28	28 - 32
24 Beautiful Lady	18 - 22	22 - 26
30 Man/Lady	25 - 28	28 - 32
37 Lady	25 - 30	30 - 35
39 Lady	25 - 30	30 - 35
40 Lady	25 - 30	30 - 35
59 Lady	25 - 30	30 - 35
106 Lady	25 - 30	30 - 35
107 Man/Lady	25 - 28	28 - 32
108 Man/Lady	25 - 28	28 - 32
109 Man	20 - 25	25 - 28
110 Lady	25 - 30	30 - 35
111 Lady	25 - 30	30 - 35
144 Man/Lady	25 - 30	30 - 35
201 Lady	25 - 30	30 - 35
202 Lady	25 - 30	30 - 35
235 Man/Lady	25 - 28	28 - 32

PENOT, A. (FR) 1905-1920
 Delta **"Sports D'Hiver ..."**

Series 7 (7) Beautiful Ladies	25 - 30	30 - 35

PLATZ, ERNST (GER) 1905-1915
 CA & Co. logo "Wintersport"

Series 3115-2 Man/Lady	20 - 25	25 - 30
Ottmar-Zieher		
Series 509 Man/Lady	20 - 25	25 - 30

POLENGHI, F. ?? 1905-1915
 Fenit

Series 23-4 Beautiful Lady	20 - 25	25 - 30

PREJELAN 1905-1915

C. Fres **Series 0151** Beautiful Lady	22 - 26	26 - 30

QUINNELL, CECIL W. (GB) 1905-1915
 E.J. Hey & Co.

Series 351 "The Winter Girl"	20 - 25	25 - 30

R 1905-1915
 Sporthaus Freunir

"Adscho"	15 - 18	18 - 22
"Bahnfrei!!!...Bumm"	15 - 18	18 - 22
"Die Scharfe Kurve"	15 - 18	18 - 22
"Eine Sau"	15 - 18	18 - 22
"Ja Un Jez?"	15 - 18	18 - 22
"Verkehrt Aufgestanden"	15 - 18	18 - 22

RENAULT, A. (FR) 1900-1910
 A.N., Paris "Luxotype"

105 "Wishing you a Merry Christmas"	12 - 15	15 - 18

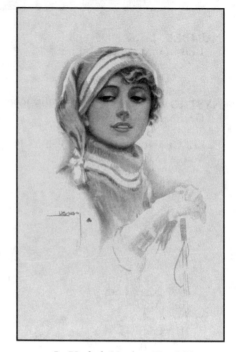

F. Schenk, Publisher H. P.
No Caption

L. Usabal, Novitas No. 330
No Caption

ROKOS, L.B. 1950's		
E.T. Apple		
"The Hard Beginning"	5 - 7	7 - 9
RYLANDER, C. (SWE) 1920-1930		
AE in circle logo		
B. Beautiful Deco Lady "God Jul"	50 - 60	60 - 70
SACKS, C.O. 1950's		
Green Mtn. Artcraft (B&W)	2 - 3	3 - 4
SAMIVEL 1905-1915		
Gardet et Garin		
13 "Le Maitre a Skier"	12 - 15	15 - 18
SAND, ADINA (SWE) 1915-1930		
Axel Eliassons Children "Gott Nytt Ar"	10 - 12	12 - 15
SCHENK, F. (GER) 1905-1915		
HP in a leaf logo		
Man	12 - 15	15 - 18
Comical Man - No. 13 on shirt	12 - 15	15 - 18
SCHILBACK (GER) 1905-1915		
PH in diamond logo		
Series 1216-4 "The Snow Princess"	20 -25	25 - 35
SCHÖNPFLUG, FRITZ (AUS) 1905-1915		
B.K.W.I.		
Series 371 (6) Men	15 - 20	20 - 25
Series 560 (8) Men	15 - 20	20 - 25
SHAFFER, L. (GER) 1920-1925		
R. & J.D.		
Series 484 Beautiful Deco Lady	20 - 25	25 - 28

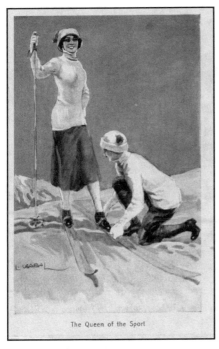

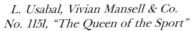

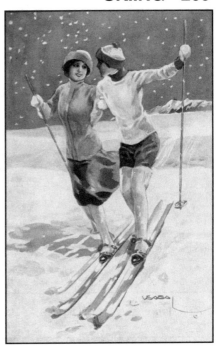

L. Usabal, Vivian Mansell & Co.
No. 1151, "The Queen of the Sport"

L. Usabal, Vivian Mansell & Co.
No Caption

SIMPSON, C.W. (GB-CAN?) 1905-1920
 Valentine & Sons, Ltd.

Canadian Series 3 "The Ski-ing Girl"	12 - 15	15 - 20
American Child Studies "Ski-ing"	12 - 15	15 - 20
Canadian Child Studies "Ski-ing"	12 - 15	15 - 18

STENBERG, AINA (SWE) 1915 - 1925
 Eskil Holm

Children "Gott Nytt Ar"	18 - 22	22 - 26
Series 28 Children "Lappland"	10 - 12	12 - 15
Series 54 Children "Blekinge"	10 - 12	12 - 15

STUDDY, G.H. (GB) 1910-1930
 B.K.W.I. "Bonzo"

Series 60-1 Bonzo	15 - 20	20 - 25

THIELE, ARTH. (GER-DEN?) 1905-1920

Egemes Series 71 Man/Lady (6)	25 - 30	30 - 35

USABAL, L. (IT) 1910-1925
 SWSB

Series 1151 Man/Ladies (6)	20 - 25	25 - 28

 Novitas

Series 330 (6) Skiing Ladies	20 - 25	25 - 30

 R&K "Erkal"
 Series 343 (6)

1 Beautiful Head	20 - 25	25 - 35
Others	20 - 25	25 - 30

VARLEY Chrome
 Green Mtn. Artcraft

Advertisement "Thorn Mtn. Area, Jackson, NH"	2 - 3	3 - 4

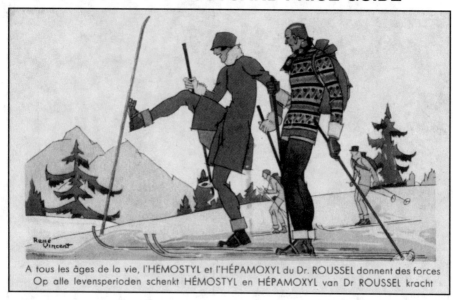

A tous les âges de la vie, l'HÉMOSTYL et l'HÉPAMOXYL du Dr. ROUSSEL donnent des forces
Op alle levensperioden schenkt HÉMOSTYL en HÉPAMOXYL van Dr ROUSSEL kracht

René Vincent, Leon Ullman, Sr. — Advertisement "Dr. Roussel l'Hémostyl Tonic"

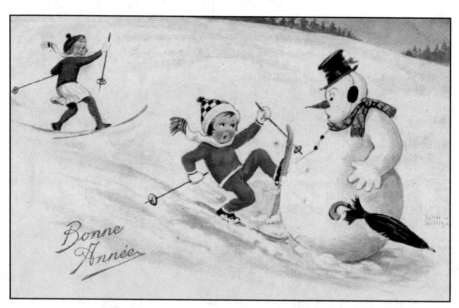

John Wills, S.W.S.B., No. 6059 — "Bonne Année"

VINCENT, RENÉ (FR) 1920-1930
 Leon Ullman, Sr.
 Advertisement "Dr. Roussel l'Hémostyl Tonic" 40 - 45 45 - 50
WILLS, JOHN 1905-1915
 S.W.S.B.
 Series 5061 Comical Children 12 - 15 15 - 18

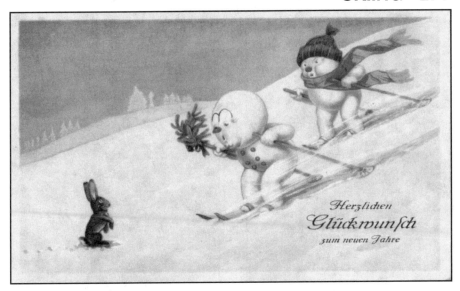

Publisher B. Dondorf, Series 531 — German Caption

Series 6059 Comical Children	12 - 15	15 - 18
With Snowman	15 - 18	18 - 22

PUBLISHERS

CCM logo 1920's		
Series 2575-2 Lady	15 - 18	18 - 22
C.T. Art-Colortone (Curt Teich) Linen		
Christmas		
8A-H1035 "Merry Christmas" Santa skiing	10 - 12	12 - 15
C.T. Wintersports		
C-286 "Come Up and Ski Me Sometime"	5 - 6	6 - 7
C-288 "I'm On My Way and Doing Fine"	5 - 6	6 - 7
C-289 "Wish You Were Here ..."	5 - 6	6 - 7
Advertisement "The Hotel Atop Mount Summit ..."	12 - 15	15 - 18
Coloprint B 1930-1940		
Series 7429 Children	6 - 8	8 - 10
Como Co. 1910-1915		
Advertisement "Boston Shoe Store" 1911 Calendar	15 - 18	18 - 22
Degami (FR-IT?) 1910-1920		
Series 1076 Beautiful Lady "Buon Natale"	15 - 18	18 - 22
Dell'Anna & Gasparini 1910-1930 (Artist?)		
Series 474 (6) Beautiful Ladies	25 - 30	30 - 35
Deutsches Schulverein 1900-1915		
263 Man	15 - 20	20 - 25
264 Beautiful Lady	20 - 25	25 - 28
265 Man	15 - 20	20 - 25
266 Man/Lady	15 - 20	20 - 25
A. Dieno 1910-1920 Art Deco		
8 Two Beautiful Ladies	20 - 25	25 - 35
10 Man/Lady	25 - 30	30 - 35

Publisher A. Dieno, Torino — No. 10
No Caption

Publisher J. E. Eneret
No Caption

B. Dondorf 1905-1915		
Series 531 Snowmen skiing	18 - 22	22 - 26
E.L.P. Co. 1905-1915		
Pre-Historic Sports Man "Bird Nesting"	8 - 10	10 - 12
Elce 1950's		
Silhouette Man (B&W)	8 - 10	10 - 12
J. E. Eneret		
Beautiful Girl No Caption	15 - 18	18 - 22
Enit 1910-1925		
Advertisement "Sports Invernali in Italia"	30 - 35	35 - 40
F F 1905-1915		
832 Cat	10 - 12	12 - 15
GOM in shield logo 1905-1915		
Series 3387 Beautiful Lady	15 - 18	18 - 22
Green Mtn. Artcraft Chrome (B&W)		
Advertisement "White Mountain Ski Shop"	3 - 4	4 - 5
Holger Bonderup 19156-1925		
Beautiful Lady	15 - 18	18 - 21
J.C. 1920's		
No No. "C'est parce qu'au lieu de skis..."	5 - 7	7 - 9
L.P. 1915-1930		
Series 104 Blue color		
1 "Ski-Heil!" Lady	10 - 12	12 - 15
3 "Ski-Heil!" Couple	10 - 12	12 - 15
L & E 1905-1915 (Emb)		
Series 7038 "Wishing You a ... Christmas"	12 - 15	15 - 18

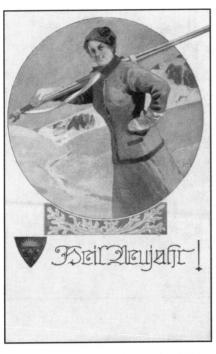

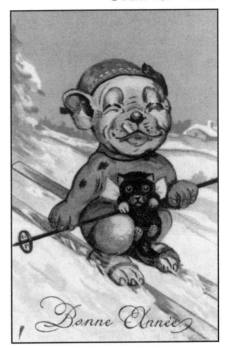

Publisher W. R. & Co., Series 5608
"Bonne Année"

Publisher W. R. & Co., Series 5608
"Bonne Année"

Miller & Trub 1905-1915

 Advertisement 128 **"Bear Hotel, Grindelwald"** 12 - 15 15 - 20

Mittet & Co. 1905-1915

 Series 591 Lady 8 - 10 10 - 12

N in 6-pointed star logo (Novitas) 1905-1915

 Series 573 Ladies; Men 12 - 15 15 - 18

Noble Chrome

 Series 315 Beautiful Lady 5 - 6 6 - 8

A. Norgeu 1905-1915

 Advertisement - Chocolat Lombart

 "Costume Canadien" 25 - 30 30 - 35

Orbis 1905-1915

 Series 10-294-10 Group 6- 8 8 - 10

P in logo 1905-1915

 Children "The Champion" 10 - 12 12 - 15

PVKZ in shield logo (B&W)

 14189 Man No caption 10 - 12 12 - 15

P.Z. in globe logo 1920-1930 Illegible Artist

 Children (6) 10 - 12 12 - 15

Panophot, Vienne 1905-1915

 Series 22

 123 "Sport und Liebe" Man/Lady 15 - 18 18 - 22

Plastichrome Chrome

 P31409 Man "The Old Pro" 3 - 4 4 - 5

 P31410 Man "The Diehard" 3 - 4 4 - 5

Mike Roberts Chrome

 Motto TS-63 "If the Good Lord had intended ..." 2 - 3 3 - 4

Real Photo, Ladies Relay Ski Team, 1918 Klamath Falls, OR

Ruegg & Cie. 1920's

 Series 480 Children No caption 10 - 12 12 - 15

S in solid circle logo Illegible artist

 31945 Man has fallen No caption 12 - 15 15 - 18

SB "Special" in a circle logo 1905-1915

 Series 3227 Lady 10 - 12 12 - 15

SWSB 1905-1915

 Series 8599

 2 "Bonzo" Foreign caption 15 - 18 18 - 22

 Series 8370 "Bonne Année" overprint 15 - 18 18 - 22

 Series 9555-3 Children 10 - 12 12 - 15

 Series 9556-11 Children 10 - 12 12 - 15

 Series 9960 Animals "Skispringen" 15 - 18 18 - 22

Sang-Konst A.B. 1910-1920

 Series 4310-9 Animals "Glad Helg" 8 - 10 10 - 12

Scenic Art Modern

 C227786F Skier with broken leg No caption 1 - 2 2 - 3

Deutsches Schulverein

 949 Beautiful Lady "Herzliche Neujahrsgrusse!" 15 - 20 20 - 25

Stanberg & Co., Oslo 1905-1920

 Series 2006 Children 12 - 15 15 - 20

A. Torello 1905-1910

 Man/Lady 10 - 12 12 - 15

Raphael Tuck

 Series 319

 Dressed Rabbits Skiing 15 - 18 18 - 22

 Opossums and Rabbit Skiing 18 - 22 22 - 26

 Wintersports Canada

 Series 2624 "Ski-ing - The High Jump" 15 - 18 18 - 22

W in circle logo 1910-1920

 21270 Heavily bandaged man No caption 5 - 7 7 - 9

Real Photo
Lady Skier, 1915 Era

Real Photo by Schindler, 1936
Foreign Skiers

WR & Co. 1910-1920
 Series 5608
 Bonzo-like dog and cat skiing 12 - 15 15 - 20

ANONYMOUS

 Advertisements
 No No. "Sports d'Hiver, Bobsleigh ..." 15 - 18 18 - 22
 "Bouteille Thermos" **(Artist - A.v.N.)** 12 - 15 15 - 18
 Japanese characters **"Skee Yarn"** 20 - 25 25 - 30
 "St. Paul Outdoor Sports Carnival - 1917" 15 - 18 18 - 22
 "Ski Tournament Feb. 16th, Fergus
 Falls, Mn." (B&W) 12 - 15 15 - 18
 "Wintersport in der ... - **Chocolats Lindt & ...**" 20 - 25 25 - 30
 Beautiful Lady 1910-1930
 Series 104-4 "Glad Jul" 12 - 15 15 - 18
 Series 5547 "Ski Girl" 12 - 15 15 - 18
 Christmas 1905-1915 "Christmas Greetings" 6 - 8 8 - 10
 College 1905-1915 Series 112 "Ski Girl" 15 - 18 18 - 22
Miscellaneous
 Beautiful Ladies, Real Photos, pre-1930 15 - 20 20 - 25
 Ski Teams, Real Photos, Named, pre-1930 15 - 20 20 - 25
 Olympic Skiers, U.S., Named, pre-1936 20 - 25 25 - 30
 Real Photos of skiers, pre-1930 10 - 15 15 - 18
 Printed photos of skiers, pre-1930 5 - 8 8 - 10

Beautiful Ice Skater of the 1910-20 Era
Anonymous, Unsigned (Calderara ?) Series No. 2805-5

The form and grace of an accomplished and beautiful lady ice skater is a pleasure to behold. In the early years of the century cold weather, both outside and inside the arena, made beautiful, warm clothing a necessity for the lady. The artists who portrayed her assured that she would be seen as beautiful and dressed in the grandest fashion possible. Prominent, too, is the lady and her beau skating on a secluded pond or stream. Postcards of these motifs are those which dominate the ice skating scene of the early part of the century.

Among the most artistic are those by Carlo Pellegrini of Switzerland, Prejelian of Austria, and several Italians. Tom Browne's renditions of the family in comical escapades lead in that category.

The "Roller Skating Craze" years coincided with the Golden Years of Postcards era of 1905 to 1920, and many wonderful postcards were drawn by artists in the U.S., Great Britain, as well as other European countries. Since the competitive or artistic roller skating did not come into prominence until the 1930's, the early sport consisted mainly of racing and marathons, and was enjoyed mostly by family members. Therefore, beautiful ladies in fashionable attire and comical children with their parents trying to retain or regain their balance dominate the offerings for collectors. Also available are real photos of early skaters and action at local roller rinks.

ICE SKATING

ARTIST-SIGNED

	VG	EX
AIO 1915-1925		
Meissner & Buch		
Series 2549 Children & Penguin	$18 - 22	$22 - 26
A.M. (FIN) 1905-1920		
Ed.F.PH		
Series 2631 Children (6)		
All with Caption "Gott Nytt Ar"	10 - 12	12 - 15
B		
ADG		
Series 4201 Man "Pattinaggio"	20 - 25	25 - 30
BAILIE, S. (BEL) 1940-1950		
De Rycker & Mendel People in formal dress	20 - 25	25 - 30
Advertisement "Saint-Sauveur-Montagne-Aux ..."	30 - 35	35 - 38
BAITES, ROMAN Chrome		
Arthur E. Lux Advertisement		
"St. Paul's Original Fabulous Musical Ice Revue"	10 - 12	12 - 15
BARBER, C.W. (US) 1905-1915		
Carleton Pub. Co.		
Series 739-1 "The January Girl"	20 - 25	25 - 28
BEAUVAIS, CH. (FR) 1905-1915		
Moulett "Les Sports" Series XVIII		
Man "La Glissade"	10 - 15	15 - 20
BENNETT, R. 1905-1915		
M. Munk, Vienne		
Series 1114		
Beautiful Lady "Eisblume"	22 - 25	25 - 28
BORISS, MARGRET (GER) 1910-1920		
Amag in an oval		
Series 0419 Children (4)	15 - 18	18 - 22
BORRMEISTER, R. (GER) 1905-1915		
H W B		
Series 1494 Boy/Girl Silhouette "Wintersport"	12 - 15	15 - 18
BRILL (US) 1905-1915		
TR Co. logo (The Rose Co.) 1905-1915		
Leap Year Thoughts		
"My Love (in Tenths) has ..."	12 - 15	15 - 18
"Will I be Yours"	12 - 15	15 - 18
BROWNE, TOM (GB) 1905-1915		
Davidson Bros.		
Series 2534		
"United We Stand — Divided We Fall"	12 - 15	15 - 18
"This is Ripping"	12 - 15	15 - 18
Series 2536		
"A Clean Cut"	12 - 15	15 - 18
Raphael Tuck		
Dutch Studies Series 6413 "Winter in Holland"	12 - 15	15 - 20

R. Bennett, M. Munk 1114
"Eisblume"

F. Doubek, Galerie Munchener Meister
556, "Darf ich's glauben?"

Signed "B" — AIDGI 4201 — "Pattinaggio"

BRYANT, JACK (US) 1905-1915
 Knapp Co.
 Series 306-1 "Cutting a Figure" 12 - 15 15 - 18

E. Colombo, G.P.M. 1961-1
No Caption

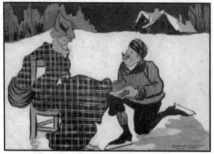

E.M., French Publisher P.L.
No Caption

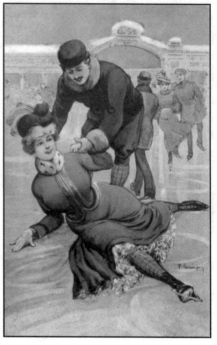

F. Eurich, Publisher "SECT"
No Caption

BRYSON (US) 1905-1915
 Home Life Pub. Co.

Man Silhouette "P.S. I'm trying to break the ice"	12 - 15	15 - 18

BUNNELL, C. (US) 1905-1915

Anonymous Children "Happy New Year"	5 - 6	6 - 8

CALDERARA (IT) 1905-1915
 Anonymous and unsigned

Series 2805-5 Most Beautiful Lady	25 - 30	30 - 35

CARR, GENE (US) 1905-1915
 Rotograph Co.

Series 242-8 Children "Skating"	12 - 15	15 - 18

CHAMOIUN, F. (FR) 1905-1915
 Clover Leaf logo **"Aux Allies"**

Beautiful Lady	18 - 22	22 - 26

CHERET (FR) 1900-1910
 Cinos

Beaut. Lady "Palais de Glace - Champs Elysees"	165 - 175	175 - 180

CHIOSTRI, S. (IT) 1910-1930
 Ballerini & Fratini

Series 302 Man/Lady	25 - 30	30 - 40

CHRISTY, F. EARL (US) 1905-1915
 FAS

198 Beautiful Lady No Caption	25 - 28	28 - 32

COFFIN, HASKELL (US) 1905-1915

R.C. Co. Beautiful Lady "Winter's Charm"	20 - 25	25 - 30

COLOMBO, E. (IT) 1910-1930
 GAM Art Deco

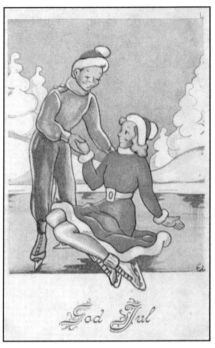

E.L., Anonymous
"God Jul"

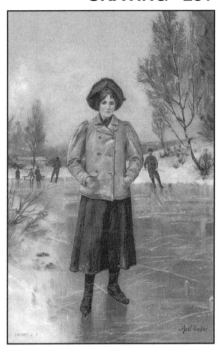

Axel Ender, J. F. Eneret
No Caption

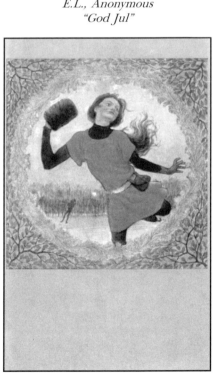

Fidus, St. Georgs-Bundes
79 — "Eislauferin"

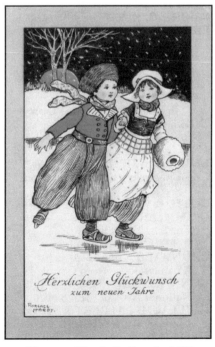

Florence Hardy, B. Dondorf 336
"Herzlichen Gluckwunsch"

Series 1961 Children (4)	18 - 22	22 - 26
DAMM, A.S. (GER)		
Novitas Sepia (4)		
"L'inevitable" Beauty skating with Death	20 - 25	25 - 28
DOUBEK, F. (GER) 1905-1915		
Galerie Munchner Meister		
Series 556 Man/Lady	15 - 18	18 - 22
E.L. Scandinavia 1920-1930		
Girl/Boy "God Jul"	10 - 12	12 - 15
EM **(FR)** **1905-1915**		
P.L.		
Man/Lady	20 - 25	25 - 30
ELLAM, WILLIAM (GB) 1905-1915		
Anonymous		
Series 2036 Girl "Do I Cut Any Ice With You?"	15 - 20	20 - 25
ENDER, AXEL 1905-1915		
J.F. Eneret		
Beautiful Lady	25 - 28	28 - 32
EURICH, F. 1905-1915		
SECT		
Man helps girl who has fallen	20 - 25	25 - 30
F.S.M. (US) 1905-1915		
Henry Heininger Co.		
Children "A Slippery Proposition"	12 - 15	15 - 18
FERNEL (FR) 1905-1915		
Anonymous		
Man/Lady "Patinage"	45 - 50	50 - 60
FEIERTAG, K. (AUS) 1905-1915	15 - 18	18 - 22
FIDUS (GER) 1905-1915		
St. Georgs-Bundes		
34 "Schlittschuhlaufer" Boy/Girl (B&W)	30 - 35	35 - 38
79 "Eislauferin" Color	35 - 40	40 - 45
GEXEY (IT) 1910-1930		
Rev. Stampa, Milano		
Series 144 Beautiful Lady	15 - 20	20 - 25
GIRIS, C. (IT) 1910-1920		
Rev. Stampa, Milano		
Series 44 Girl skating with little dogs (6)	15 - 20	20 - 25
GOLDBERG, RUBE 1905-1915		
SB in circle "Foolish Questions"		
Series 213 "Skating, Percy? - No I'm playing..."	12 - 15	15 - 18
GOTH, F. (CZ) 1905-1915	12 - 15	15 - 18
GRIMM, ARNO 1905-1915		
Th. E.L. Theochrom		
1074 Man No caption	12 - 15	15 - 18
GRÜNWALD (Uns) 1920-1930		
AE in circle Deco Couple	22 - 25	25 - 28
GUNN, ARCHIE (US) 1905-1915		
National Art Co. 15 Skating Girl	20 - 25	25 - 30
GUILLAUME, ALBERT ANDRE (FR) 1900-1910		
Cinos 31 Boy/Girl "Le Pole Nord"	70 - 75	75 - 80
HBG (H.B. Griggs) (US) 1905-1915		
L & E New Years Series 2225 (Emb)		
"Happy New Year"	8 - 10	10 - 15

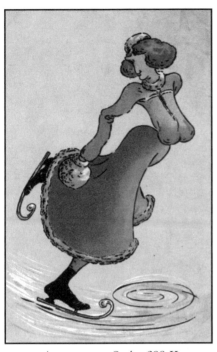

Anonymous, Series 399-II
No Caption

Julia, Alfred Legres
Sport Series 301, No Caption

HARDY, FLORENCE (GB) 1905-1925		
BD (B. Dondorf)		
Series 336 New Year Caption	22 - 25	25 - 28
C.W. Faulkner & Co.		
Series 1050-D Children "The Silvery Moon"	18 - 22	22 - 25
HESSE, K. (GER) 1905-1915		
H & S in triangle		
No No. or caption Dressed cats skating	12 - 15	15 - 18
HICKS 1910-1920		
Advertisement "St. Moritz at the Coliseum"	15 - 18	18 - 22
HILSHER, H. (GER) 1986		
L. Dabritz Advertisement (oversized)		
"Read The Sun" Poster	3- 5	5 - 8
HOFFMAN, AD (GER) 1905-1915		
NVSB logo		
1114 Dressed dachshund — No caption	20 - 22	22 - 25
HUTCHINSON (US) 1910-1920		
K. Co., Inc.		
164 Beautiful Lady "Skating"	15 - 20	20 - 25
J.P. (GB) 1905-1915		
Raphael Tuck		
Series 1812 Christmas Greetings	10 - 12	12 - 15
JANSER 1940-1950		
Editions Superluxe		
Children — Foreign caption	5 - 7	7 - 9
JAPHET (FR) 1900-1910		
Cinos Beautiful Lady "Le Pole Nord"	120 - 130	130 - 140

JOZSA, CARL (HUN) 1900-1910
BSW in clover logo
 VI "La Parisienne" 60 - 65 65 - 75
JULIA (FR) 1905-1920
Alfred Legras
 Series 301 Lady smoking 20 - 25 25 - 35
C.H.F., Paris
 Series 301 Lady smoking (same image as above) 20 - 25 25 - 35
KING, HAMILTON (US) 1905-1915
Henry Heininger Co.
 Beautiful Lady "On a Skate" 22 - 25 25 - 28
KÖHLER, MELA (AUS) 1905-1915
B.K.W.I. (Bruder Kohn, Wien)
 Series 271-5 Beautiful Lady 50 - 60 60 - 70
L 1905-1915
Anonymous Girl or Boy/Girl Series
 "I got in a mix-up today" 8 - 10 10 - 12
 "If you see a good thing grab it" 8 - 10 10 - 12
 "I'm expecting to make a hit - wait" 8 - 10 10 - 12
 "I'm on my way but- ..." 8 - 10 10 - 12
 "I'm putting on some weight" 8 - 10 10 - 12
 "I'm seeing some ups and downs" 8 - 10 10 - 12
 "It's hard to get up these winter mornings" 8 - 10 10 - 12
 "There are some good openings here" 8 - 10 10 - 12
LASKOFF, F. (PO) 1905-1915
G. Ricordi
 Series 128 Man/Lady No caption 150 - 160 160 - 175
MB (FR) 1905-1915
Fox, Paris
 Series 1502-1 Boy/girl "Bonne Année" 12 - 15 15 - 18
MALLET, BEATRICE (FR) 1905-1920
Advertisement "Cigarettes St. Michel**, Le Patinage
Brusselles" 20 - 25 25 - 30
MARCHAUX, C. (FR) 1905-1915
Anonymous
 5A7 Man/Lady "Le Palais de Glace" 20 - 25 25 - 28
MARTIN, L.B. (GB) 1905-1915
Valentine & Sons, Ltd.
 Series 1178 Man "Too much of a good thing" 12 - 15 15 - 18
MIGNOT, V. (BEL) 1900-1910
Dietrich & Co. Beautiful Lady 100 - 125 125 - 150
MORGAN, F.R. 1910-1920
Advertisement (B&W)
 "Stone & Darling - Comedians on Ice" 18 - 20 20 - 25
MYER (US) 1905-1915
Douglass Postcard Co. (B&W)
 Girl "My Winter Girl" 8 - 10 10 - 12
NANNI, G. (IT) 1910-1930
E. Sborgi Beautiful Lady "Pattinaggio" 25 - 28 28 - 32
NUMBER, JACK 1905-1915
PFB in diamond
 Series 2128-4 Children Foreign caption 12 - 15 15 - 20
OSSWALD, EUGEN (GER) 1905-1915
Wilh. Stephan **Bears** "Kuntslaufer" 30 - 35 35 - 40

C. Pellegrini, Vouga & Cie. 56
No. Caption

C. Pellegrini, Anonymous 236
No Caption

C. Pellegrini, Vouga & Cie., D-12
No Caption

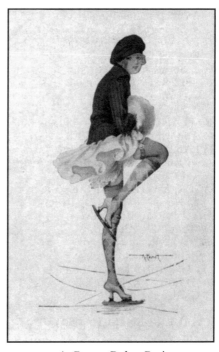

A. Penot, Delta, Paris
Sports d'hiver" Series 7 — 33

OUTCAULT, R.F. (US) 1905-1920
 Raphael Tuck
 Valentine "Wouldn't you think it would be nice..." 20 - 22 22 - 26
PELLEGRINI, CARLO (SW) 1905-1915
 Anonymous
 Series 236 Beautiful Lady putting on skates 18 - 20 20 - 22
 Vouga & Cie., Geneva
 D-12 Couple Skating 18 - 20 20 - 22
 31 Boy/Girl 18 - 20 20 - 22
 55 Boy/Girl 18 - 20 20 - 22
 56 Lady 18 - 20 20 - 22
 113 Boy/Girl 18 - 20 20 - 22
 139 Boy/Girl 18 - 20 20 - 22
 307 Boy/Girl 18 - 20 20 - 22
 312 Boy 18 - 20 20 - 22
 501 Girl 18 - 20 20 - 22
PENOT, A. (FR) 1910-1930
 Delta "Sports D'hiver de la..."
 Series 7 Glamourous Ladies (3) 25 - 30 30 - 40
PREJELAN (AUS) 1905-1915
 M. Munk, Vienne
 Series 676 Beautiful Ladies
 "Gare La Chute" 15 - 20 20 - 25
 "Grisse de Vitesse" 15 - 20 20 - 25
 "Une Artiste" 15 - 20 20 - 25
RECKZIEGEL, E. (GER) 1905-1915
 A.M.S. in shield logo
 Series 635 (6) 20 - 22 22 - 26
RELYEA (US) 1905-1915
 Edward Gross
 Series 1 Boy/Girl 18 - 22 22 - 26
ROSSLER, E. (GER) 1905-1915
 G.G.W.
 Series 304 Couples 15 - 18 18 - 22
ROWLANDSON, G.D. 1905-1915
 Anonymous Series 11828 Man 12 - 15 15 - 20
RYLANDER, C. (SWE) 1920-1930
 AEK
 C "God Jul" 50 - 60 60 - 75
SAGER, XAVIER (FR) 1905-1920
 A. Noyer "Sports D'Hiver"
 24 Beautiful Lady 25 - 28 28 - 32
 "Fantaisies Parisienne"
 100 Beautiful Lady 25 - 28 28 - 32
 Raphael Tuck
 Beautiful Lady "Le Patinage" 25 - 28 28 - 32
SAMIVEL (FR) 1905-1920
 Gardet et Garin
 11 No caption 20 - 25 25 - 30
SCHAUER-BENESCH 1905-1920
 W.P. & Co.
 Series 104 Girl "Vesele Vanoce" 15 - 20 20 - 25

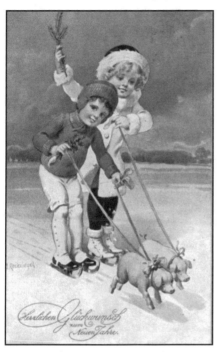

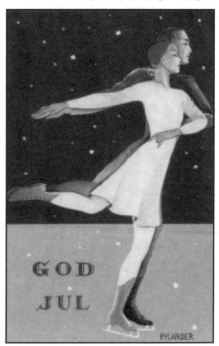

E. Reckziegel, A.M.S., Series 635
"Herzlichen Gluckwunsch"

Rylander, AEK, Stockholm
"God Jul"

SCHÖNPFLUG, FRITZ (AUS) 1905-1915
 B.K.W.I.
 Series 556-7 Man/Lady 18 - 22 22 - 26
SCHUBERT, H. (GER) 1905-1915
 Anonymous Series 22
 212 Children German caption 18 - 22 22 - 26
SCOLIK, CH. (AUS) 1905-1915
 Anonymous
 Series 832 (8) (B&W) 12 - 15 15 - 18
SEILER (GER) 1905-1915
 P.Z. in globe logo
 Series 421-4 Man "Die Elegant Linie" 15 - 18 18 - 22
SIMPSON, C.W. (GB) 1905-1915
 Valentine & Sons, Ltd.
 Canadian Series "Canada Skating Girl" 10 - 12 12 - 15
SMALE, B.H. (GB) 1905-1915
 Valentine Series
 Boy/Girl "Chairing" 12 - 15 15 - 18
 Man "Cutting a Figure" 12 - 15 15 - 18
 Boy/Girl "Skating" 12 - 15 15 - 18
STARR, W.F. (GB) 1905-1915
 Valentine & Sons, Ltd.
 Shakespeare Series
 "And he that stands upon a slippery place" 15 - 18 18 - 22
 "The course of true love never did run smooth" 15 - 18 18 - 22
 "For sufferance is the badge of all our race ..." 15 - 18 18 - 22
 "Here will be an old abusing of ..." 15 - 18 18 - 22

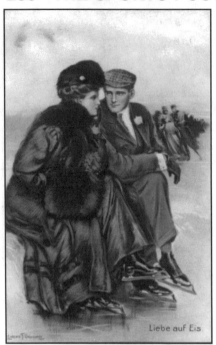

Clarence F. Underwood, Novitas 20454
"Liebe auf Eis."

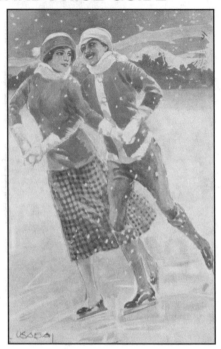

L. Usabal, SWSB 1186
No Caption

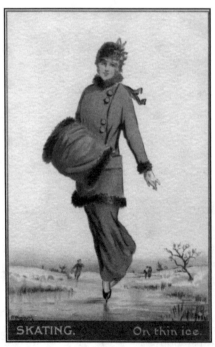

W. Wimbush, R. Tuck "Sporting Girls"
Series 3603, "Skating — On thin ice."

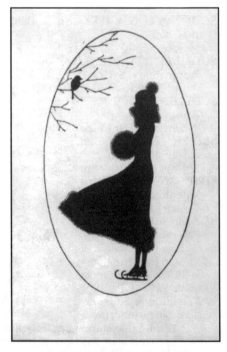

Publisher F-F, Series 26326
No Caption

"He does it with better grace ..."	15 - 18	18 - 22
"I am not worth this coil ..."	15 - 18	18 - 22
"Nobody seems to care what happens to me"	15 - 18	18 - 22

STEINER, BERNO (AUS) 1905-1915
M. Munk

Series 1344 (6)	10 - 15	15 - 18

STUDDY, G.H. (GB) 1910-1925
Valentine & Sons, Ltd. Bonzo Series

4123 "Nobody Seems to Care"	18 - 22	22 - 26

THIELE, ARTH. (DEN-GER) 1905-1915
T.S.N.

Series 1195 Dressed Dachshunds	25 - 28	28 - 32

UNDERWOOD, CLARENCE (US) 1905-1915
M. Munk

Series 742 "Love Laughs at Winter"	18 - 22	22 - 26

Novitas

20454 Loving Couple "Liebe auf Eis"	20 - 25	25 - 28

USABAL, L. (IT) 1905-1920
SWSB

1186 Couple Skating No Caption	18 - 22	22 - 26

WAIN, LOUIS (GB) 1905-1915
Valentine's Series

Cat "Ice Safe Til It Thaws"	50 - 60	60 - 75

WALL, BERNHARDT (US) 1905-1915
J.I. Austen Co.

391 College	15 - 18	18 - 22

WERTH, P. (GER) 1905-1915
HMS logo

Series 618 Boy/Girl Silhouette	18 - 22	22 - 26

WIMBUSH, WINIFRED (GB) 1905-1915
Raphael Tuck
"Sporting Girls" Series 3603

Beautiful Lady "Skating — On thin ice."	25 - 30	30 - 35

WOOD, LAWSON (GB) 1910-1920
Brown & Bigelow Linen "Gran'pop Series"

39652 Monkey "Bringing up the rear"	8 - 10	10 - 12

Valentine & Sons, Ltd. "Gran'pop Series"

1128 Chimp "Gran'pop gives a skating lesson"	15 - 18	18 - 22

PUBLISHERS

A.E. 1905-1920

Couple Skating	15 - 20	20 - 25

A.F.W. 1905-1920

Series III-2 Man/lady kissing	15 - 18	18 - 22

AMB in hexagon logo 1900-1915

Beautiful Lady "To My Valentine" (Emb silk dress)	20 - 25	25 - 30

ASM logo 1900-1910

1086 Man skating — No caption	10 - 12	12 - 15

ASW logo 1905-1915

1049 Beautiful Lady	15 - 18	18 - 22

Vouga & Cie. 1905-1915
Aluminum card

7 Boy/Girl	15 - 18	18 - 22

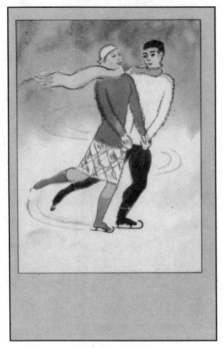

Publisher A.E.
No Caption

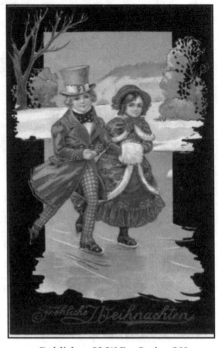

Publisher H.W.B., Series 201
"Fröhliche Weihnachten"

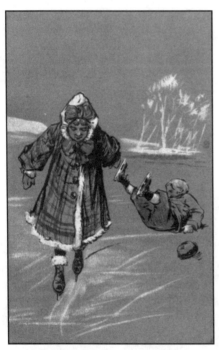

Publisher P.F.B., Series 1964
No Caption

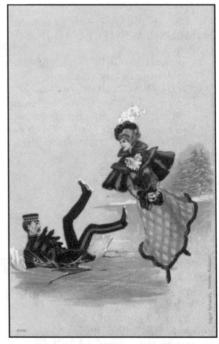

Publisher Edgar Schmidt, No. 6006
No Caption

B.K.W.I. 1905-1915
 Series 412-4 Man (Illegible artist signature) 18 - 22 22 - 26
Harry H. Baumann Linen
 Advertisement E-6902 "Skating today at Iceland" 40 - 45 45 - 50
C.T. Art-Colortone (Curt Teich) Linen
 C.T. Wintersports
 C-287 Man "This is the time ..." 5 - 6 6 - 8
 SC.3 Girl "Hell, Sitting Pretty ..." 5 - 6 6 - 8
Camis, Paris 1905-1915 (Illegible artist signature)
 Man/Lady "Le Patinage" 10 - 15 15 - 20
Coloprint B 1940-1950
 7432 Children 8 - 10 10 - 12
Commercial Colortype 1920-1930
 Advertisement "**Terrace Garden,** Chicago"
 54063 "Chicago's Wonder Restaurant – Ice Skating" 10 - 12 12 - 15
 54690 "One of the many acts seen in ..." 10 - 12 12 - 15
 55549 "Home of the World's Greatest Ice ..." 10 - 12 12 - 15
D.T.C., L. 1905-1915
 Series 249-3 Two girls skating 15 - 18 18 - 22
Decorative Poster Co. 1905-1915
 Series 208-3 Beautiful Lady 15 - 18 18 - 22
Dell'Anna & Gasparini 1910-1930 (Illegible artist sig.)
 Series 474 (4) Beautiful Ladies 20 - 25 25 - 30
DeMuinck & Co. 1905-1915
 Series 35
 739 Dressed Dogs 10 - 15 15 - 20
Douglass Postcard Co. 1905-1915
 "My Winter Girl" 8 - 10 10 - 12
Dutton, E.P. 1905-1915
 Valentine 462 "A Danger Foreseen is Half Voided" 15 - 18 18 - 22
EB in a C logo 1905-1915
 Series 1925-1 Lady "January" (Emb) 15 - 18 18 - 22
 1953-2 Lady "The Winter Girl" (Emb) 18 - 22 22 - 26
EB. & E. 1905-1915
 Man "I'm cutting quite a figure" (Anti-Jewish) 35 - 40 40 - 45
E.C.C. 1905-1915
 Series 1-145 Man/Lady (Emb) 10 - 12 12 - 15
E.S.D. 1905-1915
 Series 1843 No caption 15 - 18 18 - 22
Eagle & Shield logo 1900-1915
 Girl "A (N)ice Girl" 12 - 15 15 - 18
F-F backwards
 26326-6 Silhouette — No caption 12 - 15 15 - 18
F.W. Falke 1900-1910
 Gruss Aus Multi-view "Grossengarten, Dresden ..." 15 - 20 20 - 25
Frog in the Throat Lozenge Co. 1905-1915
 Advertisement Oversize card
 Lady and Frog Skaters 50 - 60 60 - 70
G on palette 1905-1915
 Valentine Series 1402 "Just One Little Word Dear" 12 - 15 15 - 18
G-A Novelty Art 1905-1915
 Series 783 Three girls skating 12 - 15 15 - 18
Gold Dust Twins 1905-1915
 Advertisement Unsigned E.B. Kemble

Publisher SPL
Foreign Caption

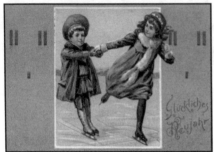

Publisher W.W. 6409
"Gluckliches Neujahr"

Anonymous Real Photo
663/3

Blacks "How would you like to skate ..."	50 - 60	60 - 70
Gold Metal Art 1905-1915		
Series 641-4 "A Merry Christmas" (Emb)	6 - 8	8 - 10
P. Gordon 1905-1915 Lady "Skating Girl"	12 - 15	15 - 18
H in circle logo 1905-1915		
Series 973 Man "Every Dub lands on his own..."	12 - 15	15 - 18
HWB 1905-1915		
Series 201 Children	15 - 18	18 - 22
Henry Heininger Co. 1905-1915 (Unsigned F.S.M.?)		
Children "Who Said Cold Feet?"	10 - 12	12 - 15
Hold-To-Light 1905-1915		
1018 Man/Lady "Patinage"	45 - 55	55 - 65
No Number Man "Moontime (Spoontime)"	25 - 30	30 - 35
Meteor-type		
D.R.G.M. 16532 Man/Lady "Winter U Sommer"	25 - 30	30 - 40
Paul Kaufmann		
Advertisement "Berliner Eispalast"	20 - 25	25 - 30
L & E 1905-1915 (Emb)		
New Years		
2276 "A Bright & Glad New Year"	8 - 10	10 - 12
Landeher & Brown 1905-1915		
"Ellenbee Sporting" 134 Boy/Girl	10 - 12	12 - 15
McCaw, Stevenson & Orr 1905-1915		
Marcus Ward's 8 Prehistoric man		
"Skating in the Glacial ..."	8 - 10	10 - 12
McLoughlin Bros. 1905-1915		
No No. Frogs "Who bravely dares must ..."	20 - 25	25 - 30

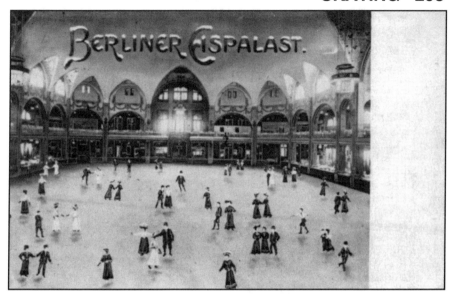

Publisher Paul Kaufmann — "Berliner Eispalast"

Meissner & Buch 1905-1915
 Series **2042** Beautiful Ladies (2) 15 - 18 18 - 22
 "Deutscher Sport"
 1070 Man "Eislauf-Sport" 40 - 50 50 - 60
 1070 Beautiful lady 90 - 100 100 - 110
M. Munk 1905-1915
 Series **89** Man/Lady 15 - 20 20 - 25
 Series **702** Beautiful Lady 15 - 20 20 - 25
E. Nister 1905-1915
 Man/woman skating in park 15 - 20 20 - 25
 332 Dressed Elephant — No caption 25 - 35 35 - 45
Nyomda 1940-1950
 Series **90** 553 Children 6 - 8 8 - 10
O.P.F. 1900-1915
 No No. Four skaters Silhouettes 45 - 55 55 - 65
P in circle logo 1905-1915
 Children "The Skater" 8 - 10 10 - 12
P.C.K. (Paul C. Kober) 1905-1915
 L-367 Boy/girl "The Ice Trust" 12 - 15 15 - 18
P.F.B. 1900-1910
 Series **S.1964** Comical skaters (3) (Emb) 20 - 22 22 - 26
SB in circle logo (Samson Bros.) 1905-1915
 CS 442 Man/Lady "I'm having a fine time in ..." 8 - 10 10 - 12
SPL (GR) 1910-1920
 Pigs Skating Foreign Caption 15 - 18 18 - 22
J. Sann 1940's
 A2 Little boy in short pants skating — No caption 4 - 6 6 - 8
Edgar Schmidt, Dresden 1900-1910
 Series **6006** Chromolithos Ladies-Comical men 18 - 22 22 - 26
Edwin Stern & Co. 1905-1915
 Art Series 247 Lady "Winter Sport" 18 - 22 22 - 26
TC logo 1905-1915

Series 2063-3 Two Girls	12 - 15	15 - 18
TF		
Silhouettes Series 26326 (6) No Captions	15 - 20	20 - 25
T.S.N. (Theo Stroefer, Nürnburg) 1905-1915		
Series 208 (Illegible artist signature)		
Girl leaning against tree putting on skates	15 - 20	20 - 25
Series 931 Boy/Girl (6) "Bonne Année" overprint	12 - 15	15 - 18
Raphael Tuck 1905-1915		
Series 102 Girl "Christmas Greetings" (Emb)	8 - 10	10 - 12
Series 319 Dressed Opossums and Rabbit	20 - 25	25 - 30
Series 8436 Cats "Merry Days"	15 - 20	20 - 25
"American Humor from Puck"		
Series 9333 "Lived & Learned"	15 - 18	18 - 22
"Holland" Series 7556 "Old Dutchmen on Skates"	8 - 10	10 - 12
"Little Bears" Series 118 "The Ice Bears Beaut ..."	20 - 25	25 - 30
"Pickings From Puck"		
Series 2416 "Live and Learned ..."	15 - 18	18 - 22
"Winter Sports-Canada"		
2624 "Skating Race – The Start"	12 - 15	15 - 18
7798 Same as above – overprint "Bonne Année"	12 - 15	15 - 18
T.P. & Co. 1905-1915		
Series 235 Boy/Girl		
"I am on to a good thing here"	8 - 10	10 - 12
"I would like to hold on to you"	8 - 10	10 - 12
"I would like to see more of you"	8 - 10	10 - 12
"You and I will soon be parted"	8 - 10	10 - 12
Series 910 "Pennant" Series		
"I vas just hittin' der high spots ..."	8 - 10	10 - 12
J. Tully 1905-1915		
Man "Come on in fellers, de waters fine!"	8 - 10	10 - 12
Series 260 Children "My First Skate"	12 - 15	15 - 20
Valentine's Series 1905-1915		
Polar Bears "May You Slide Along Smoothly ..."	15 - 18	18 - 22
P.F. Volland Co. 1905-1920		
806 Boy/Girl "Happy New Year"	8 - 10	10 - 12
WW in oval logo 1905-1915		
Series 6409 Children (Emb)	15 - 18	18 - 22
Walk Over Shoes 1905-1915		
Advertisement "Thin Ice"	15 - 18	18 - 22
Wezel & Nauman 1905-1915		
Series S.485 Ice Skating Snowmen (6)	20 - 25	25 - 30
Whitney Made 1910-1920		
Christmas "Wish I could slide in ..."	8 - 10	10 - 12
Walter Wirths 1900-1907		
Riddle Series 9 "When do skates resemble the ..."	15 - 20	20 - 25

ANONYMOUS

Advertisements		
"The College Inn, Hotel Sherman, Chicago" (B&W)	12 - 15	15 - 20
Elves "Little Skaters from 6 to 60 ..."	18 - 22	22 - 26
"Iceland - Broadway at 52nd St."	12 - 15	15 - 20
"Terrace Garden," Chicago	12 - 15	15 - 18

Anonymous, Series 485 — No Caption

"Weather Vane - **Cambridge Skating Club"**	12 - 15	15 - 20
Animal 1905-1915 Dressed Bear "Bruins - Play Time"		
Silhouette (B&W)	15 - 18	18 - 22
Dressed Cats 1307 "Where Ignorance is Bliss"	20 - 25	25 - 30
Frog 1900-1907 "Need no introduction"	10 - 12	12 - 15
Boy/Girl 1913 (B&W)		
"Get onto the fatted calf with the skate on"	6 - 8	8 - 10
"Manners for Men" "Always endeavor ..."	10 - 12	12 - 15
Boy helps girl on bench adjust skate — No caption	10 - 12	12 - 15
Children		
Series 2774-5 Boy/Girl — German caption	10 - 12	12 - 15
C-362 "Christmas Greetings and a Bright New Year"	5 - 6	6 - 8
Girl in coat with big buttons skating — No caption	5 - 7	7 - 9
Children-goggle eyes — Blond child falling on ice	3 - 5	5 - 7
Lady Series 139 "Le Patinage"	20 - 25	25 - 30
Lady Series 5544 "The Skating Girl"	15 - 18	18 - 22
Lady Series 65-5	20 - 25	25 - 28
Lady "Skating Girl"	12 - 15	15 - 18
Lady Beautiful redhead dressed in green — No caption	20 - 25	25 - 30
Lady - Series 399 II Comical type	15 - 18	18 - 22
Lady Series 2805-5 Beautiful lady No caption	18 - 22	22 - 25
Leather Girl "I'm cutting quite a figure"	12 - 15	15 - 18
Leather 26 Ugly Girl "Something is going to ..."	15 - 18	18 - 22
Man 1905-1915 "The Dutch Roll"	10 - 12	12 - 15
Man skating pushing girl in sled chair — No caption	5 - 7	7 - 10
Man in tights skating with girl in long coat — No caption	5 - 7	7 - 9
Snowmen Anonymous Series 485 (6)	20 - 25	25 - 28
Series also published by Wezel & Naumann	20 - 25	25 - 28
Real Photos		
Real Photo Series 663/3 Beautiful Lady	20 - 25	25 - 28
Real Photo Beautiful girl on ice 1910-1920	15 - 20	20 - 25
Real Photo Beautiful lady with skates 1910-1920	15 - 20	20 - 25

ROLLER SKATING

ARTIST-SIGNED

ANGELL, CLARE (GB) 1905-1915
Bamforth Co.
 Military "We don't have to go ashore to go ..." 10 - 12 12 - 15
BRELIGE, E. (GER) 1905-1915
 N.K.G. Series 3010 Man/Beautiful Ladies 20 - 25 25 - 28
BRILL (US) 1905-1915
 S in wreath logo **"Roller Skating"**

1 "The Real Thing"	12 - 15	15 - 18
2 "Stealing a Ride"	12 - 15	15 - 18
3 "Bang!"	12 - 15	15 - 18
4 "A Mile a Minute"	12 - 15	15 - 18
5 "A Good Thing - Push it Along"	12 - 15	15 - 18
6 "Oh, Joy!"	12 - 15	15 - 18
7 "Willing to Learn"	12 - 15	15 - 18
8 "Hully Gee"	12 - 15	15 - 18
9 "Who's Afraid?"	12 - 15	15 - 18
10 "In a Minute"	12 - 15	15 - 18

BRILLIANT, ASHLEIGH (US) Modern (B&W)
 Brilliant Enterprises "Pot Shots"
 955 "I need more ways to save time ..." 1 - 2 2 - 3

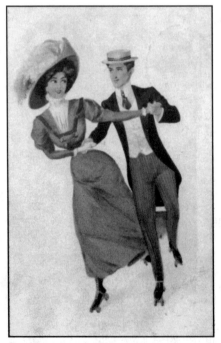

Buliger, N.K.G. Series 3010
No Caption

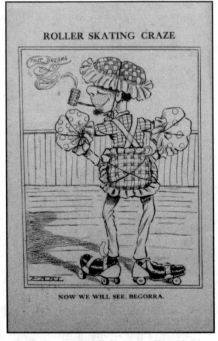

Earl, Anon. Publisher, "Roller Skating
Craze" Series — "Now we will see ..."

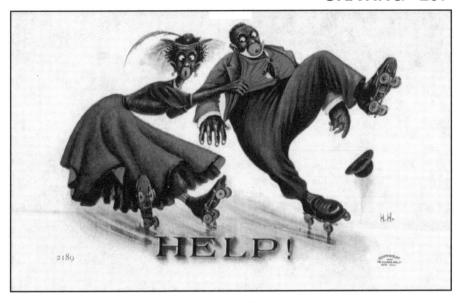

H.H., Ullman Mfg. Co.
No. 2189 — "Help!"

BROWNE, TOM (GB) 1905-1915
 Davidson Bros. "Never Touched Me"
 Series 2623 "Is Der Room Fer Me, Jimmy?" 15 - 18 18 - 22
BULIGER 1905-1915
 N.K.G.
 Series 3010 12 - 15 15 - 20
CH logo 1910-1920
 Wood's Postcards
 127 Man "At Idora Park - Weather Bulletin ..." 15 - 18 18 - 22
COLOMBO, E. (IT) 1910-1930
 GAM Series 1693 Children 18 - 22 22 - 26
EARL 1905-1915
 "Roller Skating Craze" Series (B&W)
 "A Suggestion to the Woman ..." 5 - 8 8 - 10
 "A Great Catch" 5 - 8 8 - 10
 "Exceedingly incompatible with my disposition" 5 - 8 8 - 10
 "Haven't Had a Chance to Look for ..." 5 - 8 8 - 10
 "If Nothing Happens I'll Blow in Soon" 5 - 8 8 - 10
 "I'll Be Up as Soon as Possible" 5 - 8 8 - 10
 "I've Certainly Got a Good Start" 5 - 8 8 - 10
 "Laid Up for Repairs" 5 - 8 8 - 10
 "Now We Will See, Begorra" 5 - 8 8 - 10
 "The Only Kind I can Use" 5 - 8 8 - 10
 "Ready for Another Fad" 5 - 8 8 - 10
 "There is More Than One Way to Go" 5 - 8 8 - 10
 "Well I B Damm" (Puzzle Card) 12 - 15 15 - 18
 "The Whole Damn Family on Roller Skates" 10 - 12 12 - 15
FARDY, J. (FR) 1905-1915
 A.H.K.
 1451 Beautiful Girl "La Mode Nouvelle" 18 - 22 22 - 26

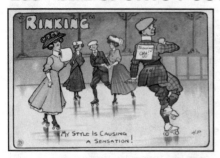

*H.P., A&G. Taylor, "Rinking" Series
No. 2830, "My Style is Causing a ..."*

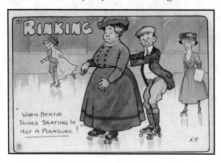

*H.P., A.&G. Taylor, "Rinking" Series
No. 2833, "When Bertie thinks ..."*

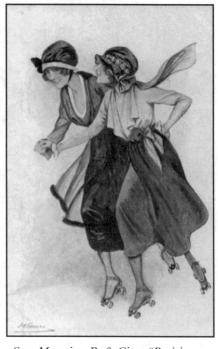

*Suz. Meunier, R. & Cie., "Parisiennes
a la Mode de 1918" — Ser. 62, No. 3*

GUNN, ARCHIE (US) 1905-1915
 National Art Co.

174 "Roller Skating Girl"	18 - 22	22 - 26

H.H. (H. Herman) (US) 1905-1915
 Ullman Mfg. Co.
 Series 116 Black Skaters

2189 "Help"	25 - 30	30 - 35
2190 "Extremes Meet"	25 - 30	30 - 35
2191 "Her First Lesson"	25 - 30	30 - 35
2192 "So Easy"	25 - 30	30 - 35

 White City Art Co.
 Series 234

"Rollerskating"	25 - 28	28 - 32
"Golly, it's good"	25 - 28	28 - 32

H.P. (GB) 1905-1915
 A.&G. Taylor
 "Rinking" (6)

2830 "My Style is Causing a Sensation"	18 - 22	22 - 25
2831 "Oh George This is so Sudden"	18 - 22	22 - 25
2832 "When Awkwardness is Useful!"	18 - 22	22 - 25
2833 "When Bertie Thinks Skating is not a ..."	18 - 22	22 - 25
2834 "I Became Greatly Attached to You ..."	18 - 22	22 - 25
2835 "Sorry If I Intrude"	18 - 22	22 - 25

JULIA (FR) 1910-1920
 Alfred Legras
 Series 301

Lady in Blue No Caption	20 - 25	25 - 30

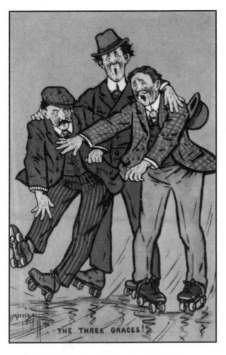

M. Morris, Langsdorff & Co.
Series 741, "The Three Graces!"

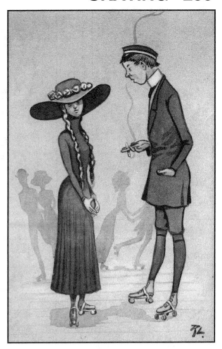

R.L., Knackstedt & Nather
Series 3054-2, No Caption

LeSUR, E. 1905-1915		
E L D logo Beautiful Skating Ladies (5)	20 - 25	25 - 30
Marque "Etoile" (5)		
4261 Beautiful Lady	20 - 25	25 - 30
4262 Beautiful Lady	20 - 25	25 - 30
4263 Beautiful Lady	20 - 25	25 - 30
MMM logo (IT) 1915-1930		
Degami		
1010 Boy bumping into man	18 - 22	22 - 25
MEUNIER, SUZANNE (FR) 1910-1930		
L-E "Parisiennes a la Mod de 1918"		
Series 62-3 Pair of ladies	30 - 35	35 - 40
MIKI (FR)		
Za Vadl 1001 Beautiful Lady	20 - 25	25 - 30
MORISS, M. (US) 1905-1915		
Langsdorff & Co.		
Series 741		
"Adolphus Cuts a Figure"	15 - 18	18 - 22
"Maud is Admired By All"	15 - 18	18 - 22
"Pa Takes the Floor"	15 - 18	18 - 22
"The Three Graces"	15 - 18	18 - 22
NAILLOD, CH. (FR) 1905-1920		
A.T., Paris		
"Skating Rink" Series 108 (10)	20 - 25	25 - 28
Breger & Lang		
"Skating Rink" Series 108 (10)		
All W/Beautiful Ladies - One has Man/Lady	20 - 25	25 - 30

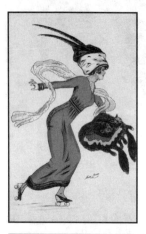
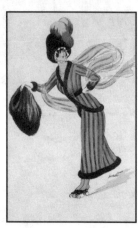
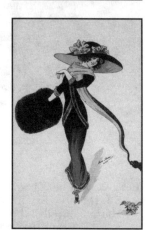

Series of Six Glamorous Skaters by Xavier Sager
Showing Mode of the Early 1900s, K.F. Paris, Series 4278

G.H., Paris
 Series 7 Beautiful Ladies 20 - 25 25 - 30
NANNI, G. (IT) 1910-1930
 E. Sborgi Beautiful Lady "Pattinaggio" 25 - 28 28 - 32
OUTCAULT, R.F. (US) 1905-1920
 Raphael Tuck
 Valentine Series 106
 "I Hope That Any Little Slip ..." 22 - 25 25 - 28
PACK (US) 1910-1920
 Wood's Postcards
 131 Man "Long Beach - Just Bumped Into a ..." 10 - 12 12 - 15
PERO (FR) 1910-1930
 Marque L-E "Trajane" "Petites Annonces"
 Series 28-624 "Jeune Fille Aimant Les Sports ..." 18 - 22 22 - 26
RL 1905-1915
 Knackstedt & Nather
 Series 3054 (6) (B&W) 12 - 15 15 - 18

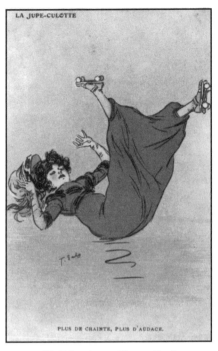

Witt, Anonymous, Series 853
"I don't see how I can get away"

T. Sala, Aqua Photo, Paris
"Plus De Crainte, Plus D'Audace."

Witt, Anonymous, Series 851
"Gee Vizz! I chust took an awful ..."

RS (GER) 1905-1915
 AMS
 1073 Man/dog Skating "The Sportsman" 20 - 25 25 - 30
SAGER, XAVIER (FR) 1905-1920
 B.M., Paris
 Series 502 (6) Beautiful Ladies
 "Angoisse" "L'Audacieuse" 20 - 25 25 - 30
 "Hardiesse" "Promenade Hygienque" 20 - 25 25 - 30
 "Indifference" "Prudence" 20 - 25 25 - 30
 K.F., Paris
 Series 4278 (10) Beautiful Ladies
 "Ca va Comme Our des Roulettes" 25 - 30 30 - 35
 "Eh, Lait Pas de Badinage ..." 25 - 30 30 - 35
 "Tourant Dangereux" 25 - 30 30 - 35
 S.R.A.
 Series 5 "La Mode en 1910" 25 - 30 30 - 35
SALA, T. (FR) 1905-1915
 Aqua Photo, Paris
 "La Jupe-Culotte" Series "Plus de Crainte ..." 20 - 22 22 - 25
SPATZ 1905-1915
 Thomas Hind
 "On The Rink"
 Series 6027 "A Star Turn - I'm Making ..." 8 - 10 10 - 12
SYLLIKUSS (GB) 1905-1915
 E.R.G. & Co.
 "Victoria Series"
 94 "Frolics At The Rink" 18 - 22 22 - 26

THACKERAY, LANCE (GB) 1905-1915
 Raphael Tuck "Roller Skating"
 Series 9919

Boy/Girl "A Clean Cut"	18 - 22	22 - 26
Boy/Girl "So Sorry"	18 - 22	22 - 26

WHEELAN, ALBERTINE R. (US) 1905-1915
 Paul Elder & Co. "Doggeral Dodger"

Dressed Rabbits "I send you food ..."	20 - 25	25 - 30

WITT (US) 1905-1920
 Anonymous Children Skating
 No Number Series

"Gee, I am going to hang on to you for dear life"	8 - 10	10 - 12
"I don't see how I can get away"	8 - 10	10 - 12
"I may be a little stingy but ..."	8 - 10	10 - 12
"It ain't no fun to have a girl throw you down"	8 - 10	10 - 12
"Nobody ever asks to skate with me"	8 - 10	10 - 12

 Series 851 Dutch Children

"Der goils shtick to me chust like glue ..."	8 - 10	10 - 12
"Gee Vizz! I chust took an awful tumble ..."	8 - 10	10 - 12
"I haf ter vatch mine goil..."	8 - 10	10 - 12
"Off all der goils dot I like de best ..."	8 - 10	10 - 12
"Right in mine arms, Honey Bunch"	8 - 10	10 - 12

 Series 853

"Believe me, I've been going some around ..."	8 - 10	10 - 12

PUBLISHERS

B in diamond logo 1905-1915

Valentine "Where are you going?"	2 - 3	3 - 4

Bamforth Co. 1905-1915
 Printed Photos

1453 Boy/Girl "My words, Do you ..."	10 - 12	12 - 15
1552 Boy/Girl "There's nothing like ..."	10 - 12	12 - 15
1566 Boy/Girl "I've discovered the pole ..."	10 - 12	12 - 15
4048 Boy/Girl "John Willie! Come On"	10 - 12	12 - 15

 Color

2057 Boy/Girl "She: I'm Right off, Somehow"	12 - 15	15 - 18
2058 Boy/Girl "She: The whole place ..."	12 - 15	15 - 18
2060 Boy/Girl "He: Awfully fine sport ..."	12 - 15	15 - 18
S100 Boy/Girl "My view of Tower City ..."	4 - 6	6 - 8

Julius Bien & Co. 1905-1915
 Embossed Comic Series 204

"They Glided Around the Rink ..."	10 - 12	12 - 15

 Song Series 70

704 "Merrily We Roll Along"	10 - 12	12 - 15

 "Will I" Series 36

"Will I - Ever Again Have Another Skate - Nix!"	12 - 15	15 - 18

Colourpicture Publishers Linen

143 Children "The Boys around here fall for me"	3 - 4	4 - 5

C.T. American Art (Curt Teich) Chrome
 Advertisement

97P.52 "For Health's Sake - Roller Skate"	15 - 18	18 - 22

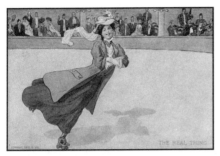

Publisher R. Hill, Roller Skating Series 1, "The Real Thing"

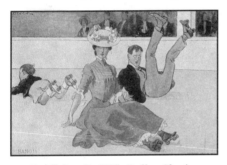

Publisher R. Hill, Roller Skating Series 1, "Bang!!"

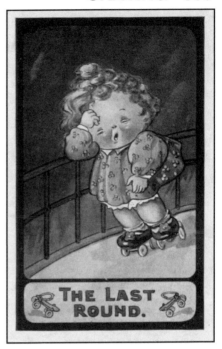

Publisher Inter Art Co., "Kute Kiddies" Series 624, "The Last Round."

Delta Fine Art 1910-1920
Political "The Skating Girl" With French/British flags.	15 - 18	18 - 22

B. Dondorf (BD) 1905-1915
166 Beautiful little Girl	20 - 25	25 - 30

Douglass Postcard Co. 1905-1915
Boy/Girl "I'll Meet You at the Rink"	15 - 18	18 - 22

E.L.P. Co. 1905-1915
"We had a ripping time"	10 - 12	12 - 15
"Skating is a very em-bracing pastime"	10 - 12	12 - 15

GL (FR) 1910-1920
Real Photo 2482-2 2 little girls on skates	25 - 30	30 - 35

H.A. in box with bird's head 1905-1915
Children — No Caption	10 - 12	12 - 15

HCL in box camera logo 1905-1915
"Don't go drinking when rinking at ..."	12 - 15	15 - 18
"Be Careful when on the Rink ..."	12 - 15	15 - 18

H.R.Z. 1905-1915
Beautiful Lady pulled by pig (Emb)	22 - 25	25 - 28

R. Hill 1905-1915
Roller Skating Series 1
"Bang!!"	15 - 18	18 - 22
"The Real Thing"	15 - 18	18 - 22

I.B. in shield logo 1905-1915
Series 848 No Captions	10 - 12	12 - 15

Inter-Art Co. 1905-1915
"Kute Kiddies"
620 "It's a bit off"	12 - 15	15 - 18

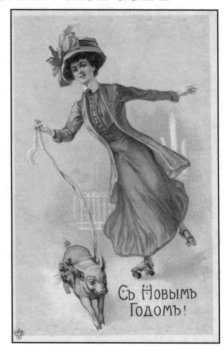

Anonymous, P.P.
Maikäfers, "Frohe Pfingsten"

Anonymous, H.R.Z.
Russian Caption

621	"Here endeth the first lesson"	12 - 15	15 - 18
623	"Skates off"	12 - 15	15 - 18
624	"The last round"	12 - 15	15 - 18
625	"The girl who took the wrong turning"	12 - 15	15 - 18
626	"Reverse"	12 - 15	15 - 18

KN in diamond logo 1905-1915
Series 1642

6	Man smoking cigar	22 - 25	25 - 28
7	In fur jacket	25 - 30	30 - 35
12	Man	25 - 30	30 - 35

M in bean pot logo 1905-1915
"Auto Comics"

Series 619 "She wasn't a bad skate" 8 - 10 10 - 12

Moody Brothers 1910-1920

Advertisement "International Skating Rink" 25 - 28 28 - 32

N.K.G. 1905-1915

3010 Man/Girl skating hand in hand No caption 15 - 18 18 - 22

NPG (FR) 1910-1920

Real Photo montage of many children on big skate 30 - 35 35 - 40

National Series
"Roller Skating"

" All hands to the rescue" 10 - 12 12 - 15

Series 341

"If you want to be graceful learn to skate" 10 - 12 12 - 15

Series 705 Boy/Girl

"Hold Me Tight, Darling!" 10 - 12 12 - 15

"Tackle Him Low!" 10 - 12 12 - 15

Olympia American Roller Rink, Vienna
 Advertisement (B&W) Couple skating 25 - 30 30 - 35
PP 1905-1915
 Maikäfirs (May Bugs) on skates "Frohe Pfingsten" 20 - 25 25 - 30
Philco Publishing Co. 1905-1915
 "Rinking"
 4092 Children "I'll be with you presently" 12 - 15 15 - 18
 4097 Children "Tum and tuddle me 'oo silly" 12 - 15 15 - 18
 4099 Boy/Girl "Next time I'll wear trousers" 12 - 15 15 - 18
 4101 Boy/Girl "Which is mine" 12 - 15 15 - 18
Riverside Printing Co. 1915-1925
 Advertisement "Richardson Skates"
 A-102309 "If you can walk you can skate" 40 - 45 45 - 50
The Rose Co. 1905-1915
 Boy/Girl "Everybody skates but Mother..." 15 - 18 18 - 22
TR & Co. (The Rose Co.)
 "You think of course that you can skate ..." 15 - 18 18 - 22
SB in circle logo (Samson Bros.) 1905-1915
 "Get Out and Get Under"
 Series 144 Boy/Girl
 "When Her Roller Skate Gets Loose" 12 - 15 15 - 18
 Series 233 "Won't you come and take a skate ..." 10 - 12 12 - 15
Shamrock & Co. 1905-1915
 "Humorous Art Studies" Children
 "Accidents Will Happen" 15 - 18 18 - 22
 "All on His Own" 15 - 18 18 - 22
 "Did I Fall or was I Pushed" 15 - 18 18 - 22
 "Funny Ain't It" 15 - 18 18 - 22
 "Giving the Girls a Treat!" 15 - 18 18 - 22
 "I Wish I Could Talk Like Daddy!" 15 - 18 18 - 22
 "It's a Shame to Take the Money" 15 - 18 18 - 22
 "P.T.O." 15 - 18 18 - 22
 "Rinking Revels" Series
 "United We Stand - Divided We Fall" 15 - 18 18 - 22
Valentine & Sons, Ltd. 1905-1915
 "Roller Skating in the Stone Age"
 "A Bashful Pupil" 10 - 12 12 - 15
 "A Wheel Off" 10 - 12 12 - 15
 "The Beginners" 10 - 12 12 - 15
 "The Queen of the Rink" 12 - 15 15 - 18
 "Off to the Rinks" 10 - 12 12 - 15
 "The Race" 10 - 12 12 - 15
 "Valentine's Series"
 "This Is So Sudden" 12 - 15 15 - 18
 "Who's To Blame" 12 - 15 15 - 18
 "Millinery Masterpiece" Series
 "If you would be graceful don't rink in a 'hobbler'." 15 - 18 18 - 22
H. Vertigen & Co. 1905-1915
 6084 Girl "A Fast Skater! A Hot Favorite ..." 15 - 18 18 - 22
Warner Press 1910-1920
 J2301 Children "Thinking of You ..." 3 - 4 4 - 5
H.C. Westerhouse 1905-1915
 Cat Series 3
 15 "Cat-ch Me If You Can" 8 - 10 10 - 12

16 "Do You Ever Skate"	8 - 10	10 - 12
17 "The Real Thing"	8 - 10	10 - 12
18 "I Wish You Were Here"	8 - 10	10 - 12
19 "We Are Old Pals"	8 - 10	10 - 12

Whitney Made 1905-1920

Christmas "Rolling Along With A Christmas ..."	3 - 5	5 - 7
New Years "A New Year Greeting is your due ..."	3 - 5	5 - 7

Wood's Postcards 1905-1915

Kendrick's Skating Rink

129 "Was Down at the Rink Last Night"	15 - 18	18 - 22

ANONYMOUS

Advertisement Chrome

BFI (Bismuth Formic Iodine Compound)	10 - 12	12 - 15
Serie 695		
"The Irish are noted for bluffing"	10 - 12	12 - 15
"This looks like old Count Boni"	10 - 12	12 - 15
Rollicking Girl 1910-1920 "Coliseum: Roller Skating:		
Rink on West Street, Foot of Jefferson ..."	28 - 32	32 - 36
Children Comic Series 3075 "I'll be rolling along ..."	8 - 10	10 - 12

Children 1905-1915 (Emb)

5231 "A Joyous Birthday"	8 - 10	10 - 12

Ugly Lady 1905-1915 (Emb)

945 "I'm looking for someone to support me"	8 - 10	10 - 12

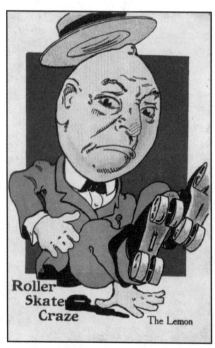

Anonymous, "Roller Skate Craze"
Series — "The Lemon"

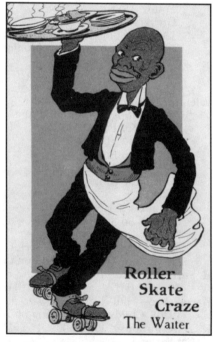

Anonymous, "Roller Skate Craze"
Series — "The Waiter"

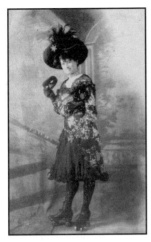
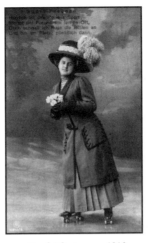
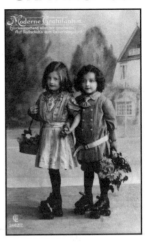

Real Photo, ca 1910
Dressed for Party

Real Photo, ca 1910
Publisher FR, No. 2810/5

Real Photo, ca 1910
Pub. GL Co., 2842/2

Real Photo Montage of Children on Huge Roller Skate

Kismet Series 1905-1915		
142 Man Hints to Beginners	8 - 10	10 - 12
Man 1905-1915 **Series 969** "I'm Coming Some"	8 - 10	10 - 12
Religion Chrome		
CRG895 "Hope We'll See You Next Week"	2 - 3	3 - 4
"Roller Skate Craze" Series 1905-1915		
"Baseball Lion"	25 - 28	28 - 32
"The Bride"	15 - 20	20 - 25
"The Candy Girl"	15 - 20	20 - 25
"The Iceman"	15 - 20	20 - 25
"The Lemon"	15 - 20	20 - 25
"Mercury - The Messenger Boy"	15 - 20	20 - 25
"The Nursemaid and Baby"	15 - 20	20 - 25

"The Policeman"	15 - 20	20 - 25
"The Postman"	15 - 20	20 - 25
"The President"	25 - 28	28 - 32
"School Teacher"	15 - 20	20 - 25
"The Stork"	15 - 20	20 - 25
"Street Car Conductor"	15 - 20	20 - 25
"Traveling Salesman"	15 - 20	20 - 25
"The Waiter"	15 - 20	20 - 25

MISCELLANEOUS

Skaters

Real Photos, pre 1930	15 - 20	20 - 30
B&W and Color, pre-1930	12 - 15	15 - 20
Post 1930	8 - 10	10 - 12

Skating Rinks

Real Photo Interiors & Advertising, pre-1930	20 - 30	30 - 40
B&W and Color, pre-1930	15 - 18	18 - 25
Real Photo Exteriors & Advertising, pre-1930	15 - 20	20 - 25
B&W and Color, pre-1930	10 - 12	12 - 15
Post 1930 and Linen	8 - 10	10 - 16

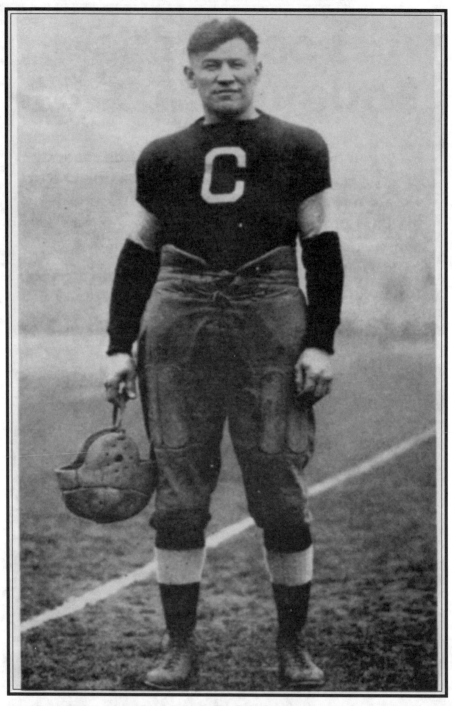

Jim Thorpe of Carlisle University, Real Photo

Football, as it is known by Americans today, is a far cry from its predecessor, soccer, which came into being as early as the 11th Century. The first games were played between Harvard and McGill University of Montreal, Canada as they faced each other on consecutive days in Cambridge, Massachusetts, May 14 and 15, 1874. These games set the stage for the formation of the American Intercollegiate Football Association by Princeton, Yale, Rutgers, Columbia, Harvard and Yale. The rest is history.

College football became a world of football heroes, with beautiful girls cheering them on. The best of the early gridiron teams were from Michigan University and the teams of Knute Rockne of Notre Dame, plus members of the the big eastern schools.The forward pass became a weapon in 1913 as Notre Dame used it to defeat a mighty Army team in 1913. Professional football came in later years, and postcards of players and teams are very elusive.

Since football had become so popular in the 1900-1920 era, it is reasonable that the artists of the period were inspired to paint the college sports heroes and the beautiful ladies waving their banners. Without doubt, the most prolific painter of this group was F. Earl Christy. His works of players and college girls, especially Tuck's Series 2766 and 2767 of the College Queens and College Kings, are classics. Christy's images, produced in sets or series, are in great demand by most all collectors. Production of images from small colleges and high schools are somewhat rare and elusive.

PLAYERS & TEAMS

	VG	EX
Red Grange	$25 - 30	$30 - 40
Real Photo	50 - 70	70 - 80
Jim Thorpe	30 - 40	40 - 50
Real Photo	50 - 70	70 - 90
Professional Stars, early	15 - 20	20 - 30
New York Football Giants — World Champions		
1938, Anonymous Real Photo - Team issue?	40 - 50	50 - 60

COLLEGE PLAYERS, TEAMS

	VG	EX
Central University with Captain Seelbach, Jr.		
With Season's Record & Scores, 1910 (B&W)	25 - 28	28 - 32
K.U. (Kansas) Football Team of 1908 (B&W)		
Squires Photo — "Ever Victorious"	25 - 28	28 - 32
Champions of Maine , with Captains, 1905 (B&W)		
U. of Maine Captain Bennett & Captain		
Chapman of **Bowdoin** (Maine 18 - Bowdoin 0)	25 - 28	28 - 32
Indian-Villanova Football Game Carlisle		
Carlisle Printing Co. (B&W)	25 - 30	30 - 35
Michigan Team, 1906 (In Letter "M") (B&W)		
White Postcard Company, Ann Arbor	20 - 25	25 - 30
Michigan Team, 1908 With Scoreboard		
C.T. Carpenter (B&W, with colored pennants)	20 - 25	25 - 30
Michigan U. Football Team, 1907		
A.C. Dietsche, Detroit (15)		
Allerdice, Casey, Embs, Flanagan, Graham	18 - 22	22 - 26
Hammond, Loell, Magofin, Miller, Rheinschild	18 - 22	22 - 26

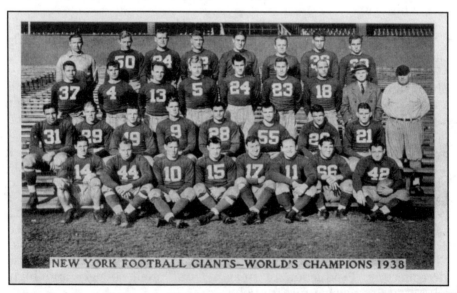

New York Football Giants — World's Champions 1938 , Anonymous (Real Photo)

University of Michigan Football Team, 1908

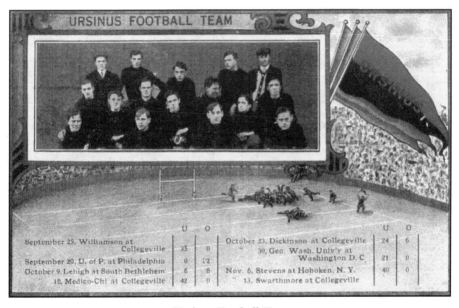

Ursinus Football Team

Rummey, Schultz, Wasmund, Coach Yost	18 - 22		22 - 26
O.S.U. 9 vs. Case 0 (B&W)			
With Captain Lincoln and Captain Bradford	25 - 28		28 - 32
Penn and Harvard , 1905			
Boston Post Card Co.			
Announces game and pictures captains	25 - 28		28 - 32
Penn Team in P, '07			

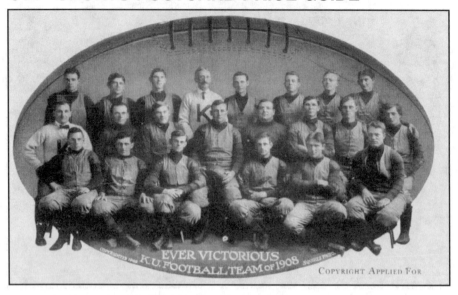

K.U. (Kansas) Football Team of 1908 — Squires Photo — "Ever Victorious"

Publisher Kugler Co., Newark, N.J.
1907 Pennsylvania Team

Publisher Kugler Co., Newark, N.J.
1907 Yale Team

Kugler Co. Color		20 - 25	25 - 30
Yale Team in Y, '07			
Kugler Co. Color		20 - 25	25 - 30

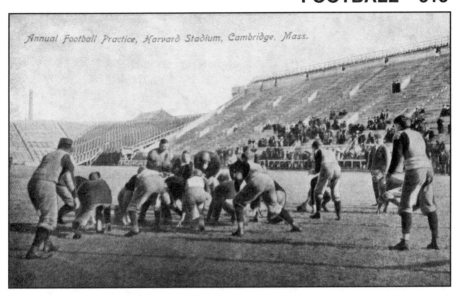

Publisher The Metropolitan News Co., Boston, Mass., No. 8440
Annual Football Practice, Harvard Stadium, Cambridge, Mass.

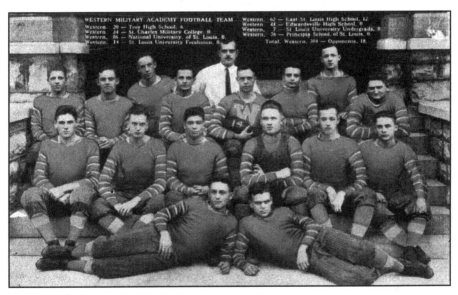

Anonymous —Western Military Academy Football Team with Scores

Others in series	20 - 25	25 - 30
Ursinus Team and scores for 1906		
C.T. Carpenter Color	25 - 28	28 - 32
Western Military Academy Team, 1914		
Record and Scores Color	25 - 28	28 - 32
High School Players, early Teams	8 - 10	10 - 12
American Photo Co., 1931 Real Photos		
Notre Dame		

Publisher White Postcard Company, 1906 Michigan Football Team
Coached by Fielding H. Yost

Knute Rockne	30 - 35	35 - 40
1931 Team	30 - 35	35 - 40
Culver, Hunk Anderson, others	15 - 20	20 - 25
Cleveland Browns Jumbo Cards, 1954-55 6"X9"		
Bassett, Colo, Gatski	15 - 20	20 - 25
Lou Groza, George Ratterman, Dante Lavelli	20 - 25	25 - 35
Dexter Press 1966		
Green Bay Packers		
1961 World Champions Team	25 - 30	30 - 40
1963 Team	20 - 25	25 - 35
1965 World Champions Team	20 - 25	25 - 35
1966 World Champions Team	20 - 25	25 - 30
Bart Starr	15 - 20	20 - 25
Exhibit Supply Co., B&W and Tints (32)		
Postcard Backs Only		
Baugh, Graham, Connerly, Waterfield	30 - 40	40 - 50
Hirsch, Matson, Layne, Ratterman	20 - 25	25 - 30
Fears, Motley, Matson, Trippi	20 - 25	25 - 30
Others	10 - 15	15 - 20

ARTIST-SIGNED

A C (US) 1905-1915		
Raphael Tuck		
New England College Series 2514		
"Amherst"	25 - 30	30 - 35
"Dartmouth"	25 - 30	30 - 35
"Wesleyan"	25 - 30	30 - 35

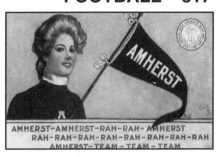

AC, Raphael Tuck, New England College Series 2514 — Amherst

Touch = Down = Out

Bristow Adams, A. G. Comings
No Caption

Anonymous
"Touch = Down = Out"

"Williams"	25 - 30	30 - 35
ADAMS, BRISTOW (US) 1910-1920		
Potomac Press		
Ohio Punter No caption	25 - 28	28 - 32
BEATY, A. (US) 1910-1920		
Commercial Colortype		
Man "Rah! Rah!"	15 - 18	18 - 22
Children 331 "The Coming Champs"	20 - 25	25 - 35
BIRD (US) 1915-1915		
M.T. Sheahan		
Yale-Harvard "May time ne'er efface ..."	15 - 20	20 - 25
BLUMENTHAL, M.L. (US) 1905-1915		
Decorative Poster Co.		
B2-6 Man "Touchdown"	25 - 30	30 - 35
Man "End of First Half-No Score-Giving ..."	25 - 30	30 - 35
Boy/Girl "Dear Jack - How Beautiful you ..."	25 - 30	30 - 35
BOURET, GERMAINE (FR) 1910-1920		
YDA logo		
Series 631 Children "C'est pas des violettes ..."	18 - 22	22 - 26
CARR, GENE (US) 1905-1915		
Rotograph Co.		
Series 242-11 Children "Foot-Ball"	18 - 22	22 - 26

F. EARL CHRISTY

F. Earl Christy helped make the beautiful lady a tremendous part of the early game of football. His renditions of the superbly fashioned ladies "cheering" for

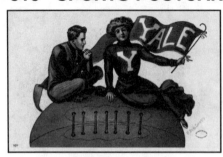

No. 950 — Yale

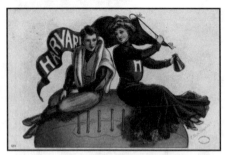

No. 951 — Harvard

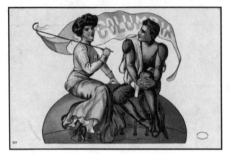

No. 952 — Columbia

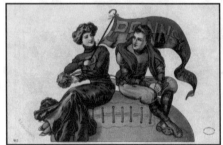

No. 953 — Penn

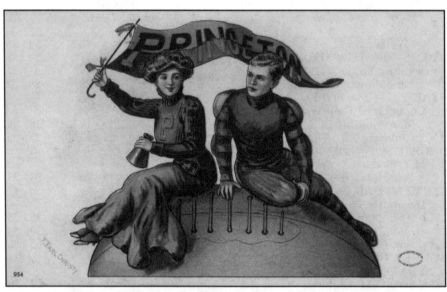

954 — Princeton

Five of the Series 95, College Girls & Players by
F. Earl Christy, Published by Julius Bien Company.
The Missing Card is No. 955, Cornell.

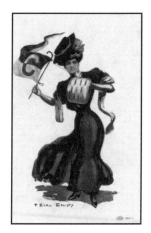

150-1 — Cornell

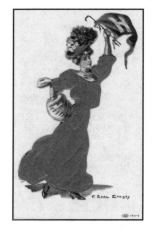

150-2 — Harvard

150-3 — Yale

150-4 — Penn

150-5 — Princeton

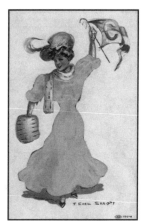

150-6 — Columbia

> ## *Series of Six Glamorous College Girls by F. Earl Christy*
> ## *Illustrated Postal Card & Novelty Company*

their team or favorite football hero, became his trademark and brought him fame and fortune within a very short time. While he painted ladies from several geographical areas, most of his series were done portraying ladies from the schools of the Ivy League, where football, at that time, was king.

Christy did work for many publishers, but his most rewarding efforts were for Raphael Tuck & Sons. His two series by Tuck of the College Kings (2766) and College Queens (2767) were outstanding. They are very rare, valued highly, and are greatly desired by collectors throughout the hobby.

CHRISTY, F. EARL (US) 1905-1920
 Atkinson News Agency
 "Tilton Seminary" (Uns.) 30 - 35 35 - 40

F. E. Christy, R. Tuck
Kings Series 2766

F. E. Christy, R. Tuck
Kings Series 2766

F. E. Christy, R. Tuck
Queens Series 2767

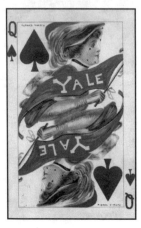

F. E. Christy, R. Tuck
Queens Series 2767

F. E. Christy, Ullman Mfg.
1990 — Chicago

F. E. Christy, Ullman Mfg.
1997 — Harvard

Julius Bien & Co.
 College Series 95 (6)
 Lady/Player sit on Football

950 "Yale"	25 - 30	30 - 35
951 "Harvard"	25 - 30	30 - 35
952 "Columbia"	25 - 30	30 - 35
953 "Penn"	25 - 30	30 - 35
954 "Princeton"	25 - 30	30 - 35
955 "Cornell"	25 - 30	30 - 35

Robert Chapman Co. 1905-1915

1040 "Off for the Game"	15 - 20	20 - 25

EAS (Ea. Schwerd Teger) 1905-1910
 Girl on Brick Wall Series (6)

"Columbia"	20 - 25	25 - 28
"Cornell"	20 - 25	25 - 28
"Harvard"	20 - 25	25 - 28

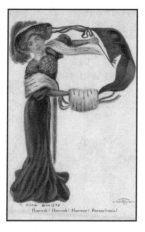 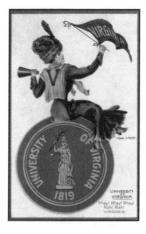 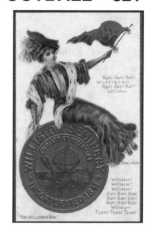

F. E. Christy, Penn	*F. E. Christy, R. Tuck*	*F. E. Christy, R. Tuck*
Platinachrome	*U. of Virginia, 2627*	*Williston Girl, 2627*

"Penn"	20 - 25	25 - 28
"Princeton"	20 - 25	25 - 28
"Yale"	20 - 25	25 - 28
Illustrated Post Card & Novelty Co. 1905-1915		
College Girls		
Series 133 * (6) Numbers on backs		
1 "Cornell"	20 - 25	25 - 28
2 "Harvard"	20 - 25	25 - 28
3 "Yale"	20 - 25	25 - 28
4 "Penn"	20 - 25	25 - 28
5 "Princeton"	20 - 25	25 - 28
6 "Columbia"	20 - 25	25 - 28
* With Silk Applique Dress, add $10-15.		
There are also both flat & embossed issues.		
Series 150 * (6) Numbers on front & back.		
1 "Cornell"	20 - 25	25 - 28
2 "Harvard"	20 - 25	25 - 30
3 "Yale"	20 - 25	25 - 30
4 "Pennsylvania"	20 - 25	25 - 30
5 "Princeton"	20 - 25	25 - 30
6 "Columbia"	20 - 25	25 - 30
* With Silk Applique Dress, add $10-15.		
There are also both flat and embossed issues.		
Platinachrome, 1907 (8)		
Girl/Pennant form College Letter.		
"Chicago"	25 - 30	30 - 35
"Columbia"	25 - 30	30 - 35
"Cornell"	25 - 30	30 - 35
"Harvard"	25 - 30	30 - 35
"Michigan"	25 - 30	30 - 35
"Pennsylvania"	25 - 30	30 - 35
"Princeton"	25 - 30	30 - 35
"Yale"	25 - 30	30 - 35
Souvenir Postcard Co. 1907		
College Series 1 (8)		

Girl & Football Player with Banner

1	"Michigan"	25 - 30	30 - 35
2	"Chicago"	25 - 30	30 - 35
3	"Princeton"	25 - 30	30 - 35
4	"Pennsylvania"	25 - 30	30 - 35
5	"Cornell"	25 - 30	30 - 35
6	"Yale"	25 - 30	30 - 35
7	"Harvard"	25 - 30	30 - 35
8	"Columbia"	25 - 30	30 - 35

Raphael Tuck University Girls

Series 2453 (6)

"Georgetown"	25 - 28	28 - 32
"Oberlin College"	25 - 28	28 - 32
"Syracuse U."	25 - 28	28 - 32
"West Point"	25 - 28	28 - 32
"Tennessee"	25 - 28	28 - 32
"U.S. Naval Academy"	25 - 28	28 - 32

Series 2590 (6)

"Ames" Iowa State	28 - 32	32 - 36
"U. of Arkansas"	28 - 32	32 - 36
"Iowa"	28 - 32	32 - 36
"Kentucky"	28 - 32	32 - 36
"Penn State"	28 - 32	32 - 36
"Valpariaso U."	28 - 32	32 - 36

Series 2593

"Bucknell"	28 - 32	32 - 36
"Colby"	28 - 32	32 - 36
"U. of Maine"	28 - 32	32 - 36
"U. of Notre Dame"	28 - 32	32 - 36

Series 2625 (6)

"Columbia"	25 - 28	28 - 32
"Cornell"	25 - 28	28 - 32
"Harvard"	25 - 28	28 - 32
"Pennsylvania"	25 - 28	28 - 32
"Princeton"	25 - 28	28 - 32
"Yale"	25 - 28	28 - 32

Series 2626 (6)

"U. of Chicago"	25 - 28	28 - 32
"U. of Illinois"	25 - 28	28 - 32
"Indiana U."	25 - 28	28 - 32
"U. of Michigan"	25 - 28	28 - 32
"U. of Minnesota"	25 - 28	28 - 32
"U. of Wisconsin"	25 - 28	28 - 32

Series 2627 (6)

"Brown U."	25 - 28	28 - 32
"Tulane of La."	25 - 28	28 - 32
"Vanderbilt U."	25 - 28	28 - 32
"U. Virginia"	25 - 28	28 - 32
"Williston Seminary"	25 - 28	28 - 32
"McGill College"	25 - 28	28 - 32

Series 2678

"Milliken" (Uns.)	30 - 35	35 - 38

Series 2717 (1)

"Mary Baldwin"	35 - 40	40 - 45

Series 2766 College Kings (4)

"Chicago"	90 - 100	100 - 110
"Columbia"	90 - 100	100 - 110
"Cornell"	90 - 100	100 - 110
"Michigan"	90 - 100	100 - 110

Series 2767 College Queens (4)

"Harvard"	90 - 100	100 - 110
"Pennsylvania"	90 - 100	100 - 110
"Princeton"	90 - 100	100 - 110
"Yale"	90 - 100	100 - 110

Series 2794

"Williston" Extremely Rare!	90 - 100	100 - 125

Ullman Mfg. Co., 1905

569 "Princeton"	15 - 20	20 - 25
574 "Penn"	15 - 20	20 - 25
575 "Harvard"	15 - 20	20 - 25
582 "Yale"	15 - 20	20 - 25

Series 24 1905 (16) (Unsigned)

College Girls

1498 "Pennsylvania"	15 - 20	20 - 25
1499 "Columbia"	15 - 20	20 - 25
1512 "Yale"	15 - 20	20 - 25
1513 "Harvard"	15 - 20	20 - 25
1514 "Leland Stanford"	15 - 20	20 - 25
1515 "Cornell"	15 - 20	20 - 25
1516 "Princeton"	15 - 20	20 - 25
1517 "Chicago"	15 - 20	20 - 25

Series 24, College Football Players (Uns.)

1465 "Princeton"	25 - 30	30 - 35
1466 "Pennsylvania"	25 - 30	30 - 35
1467 "Yale"	25 - 30	30 - 35
1518 "Columbia"	25 - 30	30 - 35
1519 "Leland Stanford"	25 - 30	30 - 35
1520 "Chicago"	25 - 30	30 - 35
1521 "Cornell"	25 - 30	30 - 35

Ullman Mfg. Co., 1907

Girl in Big College Letter Series (8)

1990 "Chicago"	25 - 28	28 - 32
1991 "Cornell"	25 - 28	28 - 32
1992 "Michigan"	25 - 28	28 - 32
1993 "Columbia"	25 - 28	28 - 32
1994 "Pennsylvania"	25 - 28	28 - 32
1995 "Yale"	25 - 28	28 - 32
1996 "Princeton"	25 - 28	28 - 32
1997 "Harvard"	25 - 28	28 - 32

U.S.S.P.C. Co., 1905

College Seal Series (8)

1 "Pennsylvania"	20 - 25	25 - 28
2 "Princeton"	20 - 25	25 - 28
3 "Harvard" (also leather) Add $5-10 for leather	20 - 25	25 - 28
4 "Yale"	20 - 25	25 - 28
5 "Michigan"	20 - 25	25 - 28

Pearl Eugenia Fidler, Edward Gross Co.
Poster No. 42, "RH"

Will Grefe, T. P. & Co., Series 592
"The Hero of the Day"

6 "Chicago"	20 - 25	25 - 28
7 "Columbia"	20 - 25	25 - 28
8 "Cornell"	20 - 25	25 - 28
Valentine & Sons, Ltd. 1905-1910		
"Artotype" Series, No Numbers		
"Columbia"	20 - 25	25 - 28
"Pennsylvania"	20 - 25	25 - 28
"Princeton"	20 - 25	25 - 28
FIDLER, PEARL EUGENIA (US) 1905-1915		
Edward Gross Co. 1909		
Poster No. 40 College Girl - Harvard	15 - 20	20 - 25
Poster No. 42 College Girl - Columbia	15 - 20	20 - 25
Poster No. 44 College Girl	15 - 20	20 - 25
Poster No. 45 College Girl - Billiken	15 - 20	20 - 25
Taylor and Carpenter 1905-1915		
"Cornell I Yell Yell Yell Cornell"	12 - 15	15 - 20
FLAGG, JAMES MONTGOMERY (US) 1905-1915		
T.P. & Co.		
Series 818-10 "In the hands of the receiver"	18 - 22	22 - 26
GASSAWAY, KATHARINE (US) 1905-1915		
Rotograph Co.		
F.L. 148 Children "The Football Player"	18 - 22	22 - 26
GREFE, WILL (US) 1905-1915		
T.P. & Co. "Courtship Days"		
952 "The Hero of the Day"	20 - 25	25 - 28
GRONINGER, N. (US) 1900-08		
Anonymous		
Various Small College Beautiful Ladies	20 - 25	25 - 30

N. Groninger
Manhattan College

N. Groninger
West Virginia University

N. Groninger
Wake Forest College

N. Groninger
Wake Forest College

N. Groninger
Wake Forest College

N. Groninger
Wake Forest College

College Girls by N. Groninger (1906) Are Those of Smaller
Colleges and Are Rarer Than Those of Larger Schools

HA 1905-1915
 Illustrated Post Card & Novelty Co.
 Series 500

2 College No Caption	18 - 22	22 - 26

H.B.G. (H.B. Griggs) (US) 1905-1915
 L & E (Emb)

Series 2218 Valentine "Doughty deeds my ..."	18 - 22	22 - 26
Series 2233 Thanksgiving "Wishing you a ..."	18 - 22	22 - 26
Series 2263 Thanksgiving "May you always ..."	18 - 22	22 - 26
Series 2273 Thanksgiving "Here's to Thanks ..."	18 - 22	22 - 26

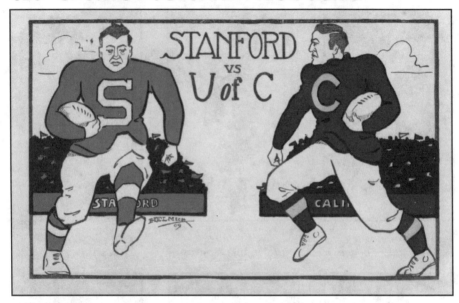

Helmick, Stuart — "Stanford vs. U of C"

ICK, Anonymous
University of California

A. Muller, Anonymous French
Publisher — "3 L'Œuf poché"

H.H. (US) 1905-1915
Illustrated Post Card & Novelty Co.
Series 5004-4 "The College Girl"

22 - 25 25 - 28

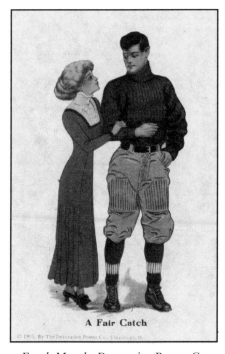

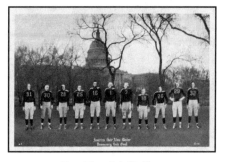

R. F. Outcault, R. Tuck, Series No. 7
"If you will only be my goal..."

Frank Murch, Decorative Poster Co.
"A Fair Catch"

Presidential Collage

H.H.B. (US) 1910-1920		
Art Color Co.		
Series 65 "Something to kick about ..."	18 - 22	22 - 26
HELMICK (US) 1910-1920		
Stuart		
College "Stanford vs. U of C"	18 - 22	22 - 26
ICK (US) 1905-1915		
Anonymous		
University of California, College Yell	15 - 18	18 - 22
LANGLIES, C. (US) 1905-1915		
Roth		
"U" Series Ladies	18 - 22	22 - 26
MBG logo (US) 1905-1915		
Advertisement November		
Weatherbird Shoes "Kicking that goal is easy"	20 - 25	25 - 30
MAHIER 1910-1920		
Anonymous		
Tiger "Fate can not harm me, I have dined ..."	12 - 15	15 - 20
McGILL, DONALD (GB) 1915-1940		
Bamforth Co.		
Children "Working, Playing, Eating ..."	12 - 15	15 - 18
MORISS (GB) 1905-1915		
The Ja-Ja Series Cat		
"Black Smut is the Queen of the Thrum Hall ..."	15 - 20	20 - 25
MULLER, A. (GER 1905-15		
Anonymous		
"3 K'CEuf poché"	30 - 35	35 - 40

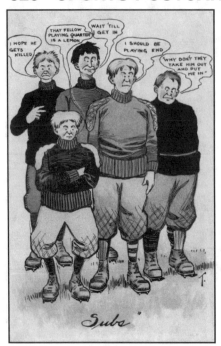

Signed "T." — Curt Teich
"Subs"

Signed "T." — Curt Teich
"The Hero"

Signed "T." — Curt Teich — "First Down"

MURCH, FRANK (US) 1905-1915
 Decorative Poster Co.
 Series P1-6
 "A Fair Catch" 18 - 22 22 - 26
 "Coaching the Team" 18 - 22 22 - 26

Maud Stamm, Rotograph, F 100/3
University of Chicago Cheer

Stuart Travis, Brown & Bigelow, 1908
No. 110 — "The Man of the Hour"

NBC 1905-1915
 J. Tully

Series 255 Children No caption	15 - 18	18 - 22

O'NEILL, FRANK G. (US) 1905-1920
 Ullman Mfg. Co. Colorgravure

138 Girl "Study Hour"	20 - 25	25 - 28

O'NEILL, J.R. (US) 1905-1915

Government Postal No caption	20 - 25	25 - 30

OUTCAULT, R.F. (US) 1905-1920
 J. Ottman Litho Co.

"Go as far as you like"	20 - 25	25 - 28
"I hope you're on for the Ball"	20 - 25	25 - 28
"You're always kicking"	20 - 25	25 - 28

 Raphael Tuck "New Outcault"
 Series 7

Valentine "If you will only be my goal ..."	20 - 25	25 - 30

RASCHEN (US) 1905-1915

Burgess No caption	8 - 10	10 - 12

RYAN, C. (US) 1905-1915
 Anonymous "Dictionary of Entomology"

A614 "Football Bug"	20 - 25	25 - 28

SPS (US) 1905-1920
 Van Marter
 College Series

"Princeton — Yale"	18 - 22	22 - 26

SCHMUCKER, S.L. (US) 1905-1915 (Uns)
 See listing under Publisher John Winsch

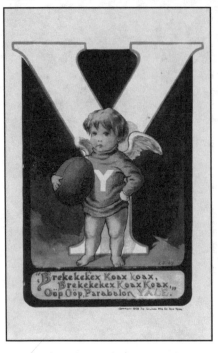

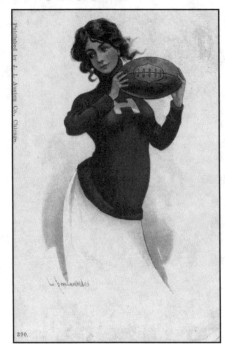

S/C.T. (Twelvetrees), Ullman Mfg. Co.
No. 2452, Yale Cupid

Bernhardt Wall, J. I. Austen
Harvard — No. 390

SIMPSON, C.W. (US) 1920-1930
 Anonymous "News of the Week"
 Series 7 "First Week - 1922" 12 - 15 15 - 18
STAMM, MAUD (US) 1905-1915
 Rotograph Co.
 F100/3 University of Chicago Cheer 15 - 20 20 - 25
T (Tingle) (US) 1905-1915
 C.T. Co. (Curt Teich)
 Man "First Down" 20 - 25 25 - 28
 Boy/Girl "The Hero" 20 - 25 25 - 28
 Man "Subs" 20 - 25 25 - 28
TINGLE (US) 1905-1915
 C.T. Co.
 Man "All together Fellers ..." 20 - 25 25 - 28
 Boy/Girl "Why don' you play football, Lawrence?" 15 - 18 18 - 22
TRAVIS, STUART (US) 1905-1920
 Brown & Bigelow
 Advertisement 110 "The Man of the Hour" 25 - 30 30 - 35
TWELVETREES, C. (US) 1905-1920
 Edward Gross "Smile Messengers"
 156 Children "Cheer Up. I'm on Your Side" 12 - 15 15 - 18
 National Art Co.
 268 Teddy Bear "Watch Me" 20 - 25 25 - 30
 Ullman Mfg. Co. Colorgravure
 College Girls Series 138
 2452 "Yale" 18 - 22 22 - 26
 2454 "Princeton" 18 - 22 22 - 26

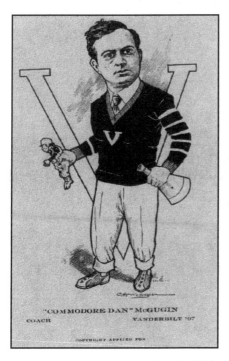

C. H. Wellington, Anon. (Vanderbilt)
"'Commodore Dan' McGugin"

Publisher J. I. Austen
No. 421, No Caption

Jungle Sports Series 77		
1894 Elephant "Harry Halfback"	30 - 35	35 - 45
UNDERWOOD, CLARENCE (US) 1905-1915		
N in star logo (Novitas)		
20451 Boy/Girl "Who will be the Winner?"	25 - 28	28 - 32
WFD (US) 1905-1915		
Anglo-American P.C. Co. (AA) 1905-1915		
Series 120 Man "Near the Line"	18 - 22	22 - 26
WALL, BERNHARDT (US) 1905-1920		
J.I. Austen Co. College		
390 No Caption	15 - 18	18 - 22
WATTS, TED (US) Chromes		
Ted Watts College		
185279 "Auburn Tigers Football"	2 - 3	3 - 4
176634 "Bear Bryant"	2 - 3	3 - 4
185398 "George Gipp - Notre Dame"	2 - 3	3 - 4
185397 "Knute Rockne - Notre Dame"	2 - 3	3 - 4
No No. "Kansas Jayhawk Football"	3 - 4	4 - 5
171055 "Notre Dame"	3 - 4	4 - 5
185278 "Notre Dame Fighting Irish Football"	3 - 4	4 - 5
176635 "Oklahoma Football"	3 - 4	4 - 5
M-319 "Ole Miss Rebels - Football"	3 - 4	4 - 5
M-80321-D "Razorback Football"	3 - 4	4 - 5
WELLINGTON, C.H. (US) 1900-10		
Anonymous		
"'Commodore Dan' McGugin" — Vanderbilt	20 - 25	25 - 30

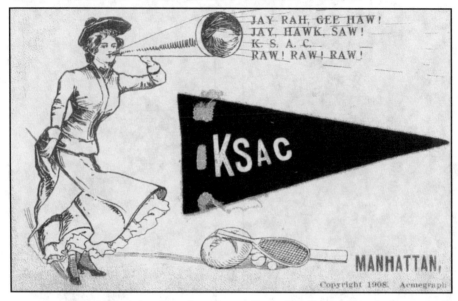

Publisher Acmegraph — Kansas State, Manhattan, Kansas
Real Felt Pennant

WILLIAMS, MADGE (GB) 1905-1915
 J. Salmon
 5030 Children "He would have the whistle" 10 - 12 12 - 15
ZIM (US) 1905-1915
 H.G. Zimmerman & Co.
 Man "I'm all broke up over the game" 12 - 15 15 - 18

PUBLISHERS - Artist Drawn & Others

A.C. Press Linen
 Religious 803 "No Interference next Sunday ..." 3 - 4 4 - 6
A.H. (see Albert Hahn) 1905-1910
 "College Girls Series" 15 - 18 18 - 22
Acmegraph Co. 1900-1910
 Real Felt Pennants "Kansas State, Manhattan, Ks." 15 - 20 20 - 25
 Other Schools 15 - 20 20 - 25
Annin & Co. 1905-1915
 "Digby 5 - R M (Randolph-Macon) 1" 10 - 12 12 - 15
Asheville Post Card Co. Chrome
 Bulldog K-A-14 No caption 3 - 4 4 - 5
Atkinson News Agency 1910-1920
 Man "Tilton" 10 - 12 12 - 15
J.I. Austen Co. 1905-1915
 Children Series Printed Photos
 421, 422, 423 10 - 12 12 - 15
Bamforth Co. 1905-1950
 3028 Animals "The Halfback" 15 - 20 20 - 25
F. von Bardeleban 1905-1915
 "Sports"
 U.S. 716 Man "Sports-Football" 15 - 18 18 - 22

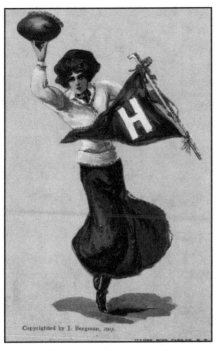

Publisher J. Bergman, 1905
Harvard

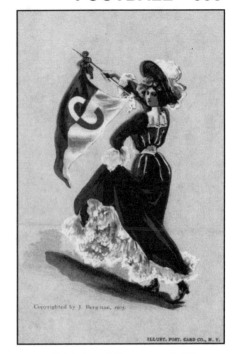

Publisher J. Bergman, 1905
Columbia

J. Bergman 1905-1915
 College Girl Series
Columbia	22 - 25	25 - 28
Harvard	22 - 25	25 - 28

Carbon Photo 1905-1915
 Series 530 Man "I'm Going Some" Sepia — 12 - 15 — 15 - 18

C.T. Carpenter 1905-1915
 College Printed Photo
 "Harvard Football Team - First Half Score ..." 15 - 18 18 - 22

Carrington Co. 1905-1915
 Valentine "I'm gonna tackle the job ..." 8 - 10 10 - 12

Carson-Harper 1905-1915
 Mines - Colorado Score 18 - 22 22 - 26

Chatenay 1905-1920
 Advertisement
 Hind's "Football's exposure to November's ..." 15 - 18 18 - 22

The College Press 1905-1915
 College
 "Bates Rah Rah, etc." 20 - 22 22 - 26
 "Bates Spirit - Rah Rah, etc." 20 - 22 22 - 26

Colonial Art Pub. Co. 1905-1915
 Boy/Girl Comics Printed Photos Sepia
 "A Place Kick" 15 - 18 18 - 22
 "A Punt" 15 - 18 18 - 22
 "A Touchdown" 15 - 18 18 - 22
 "Interference" 15 - 18 18 - 22
 "Piling Up" 15 - 18 18 - 22

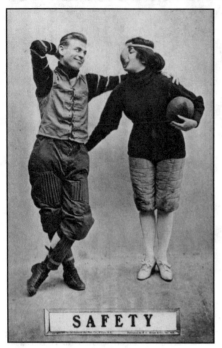

Publisher Colonial Art Company
"Safety"

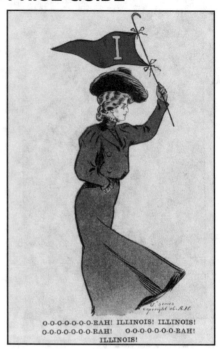

Publisher A.H., 1906
Illinois Yell

Publisher P. Gordon, 1907 — Harvard

"The Real Game"	15 - 18	18 - 22
Also as a Pin Cushion	22 - 26	26 - 30
"Safety"	15 - 18	18 - 22
"Scrimmage"	15 - 18	18 - 22
"Scoring"	15 - 18	18 - 22

"Sure Goal"	15 - 18	18 - 22
C.T. Art-Colortone Linen		
Boy/Girl C-775 "Met a football player here, and ..."	4 - 5	5 - 6
Advertisement 18 "150,000 Seating Capacity at Chicago's Soldier Field	8 - 10	10 - 12
Advertisement 7B-H1523 "World's largest player ..."	8 - 10	10 - 12
Cunningham & Co., Williamsport (Undb)		
Ladies with Pennants		
"Irving College" Mechanicsburg, Pa.	20 - 25	25 - 28
"Susquehanna University" Selinsgrove, Pa. (2)	20 - 25	25 - 28
Curteichcolor Chrome		
Advertisement 7DK-1221 New Orleans Saints	6 - 8	8 - 10
Ecdall & McCarty 1910-1920		
College 102 "Allah Rah ... Emporia, Kansas	10 - 12	12 - 15
Elite Postcard Co. 1910-1920		
College Rah! Rah! Mizzou ..."	12 - 15	15 - 18
Ely, Boynton & Ely 1905-1915		
College Indiana and Purdue Score Card	12 - 15	15 - 18
Emanuel Co. 1905-1915		
College "Yale"	10 - 12	12 - 15
Fabric Art Co. 1910-1920		
Children "I got a kick coming"	10 - 12	12 - 15
Federal Eng. Co., Boston 1905-1910		
Player & Girl "Brown"	18 - 22	22 - 26
Player "Harvard"	18 - 22	22 - 26
Player "U of P"	18 - 22	22 - 26
Player & Girl "Yale"	18 - 22	22 - 26
Gibson Art Co. 1905-1920		
Motto "Here's to the Dear Old College..."	10 - 12	12 - 15
P. Gordon 1905-1910		
Harvard Coat of Arms	15 - 20	20 - 25
AH (Albert Hahn) 1905-1910		
"College Girls Series"	15 - 18	18 - 22
Henderson Litho 1905-1915		
"Ish Ka Bibble" 99 "I should worry like a foot..."	12 - 15	15 - 18
Hiawatha Co. 1905-1920		
2 Man "The First Down"	12 - 15	15 - 18
No No. "The Two Ends"	12 - 15	15 - 18
R. Hill 1905-1915		
University Series		
7 Michigan	15 - 20	20 - 25
8 Chicago	15 - 20	20 - 25
Hotel & Railroad News 1905-1915		
Harvard Series 11 Harvard & Yale Seals		
Harvard player running with ball	20 - 22	22 - 25
H.V. Howe 1905-1915		
Man "Quarterback"	8 - 10	10 - 12
Franz Huld 1902-1905		
College Girl Series		
402 "Yale University"	20 - 25	25 - 30
409 "Columbia College"	20 - 25	25 - 30
I.P.C. & N. Co. 1905-1915		
Girl H(arvard)	18 - 22	22 - 26
Girl P(rinceton)	18 - 22	22 - 26

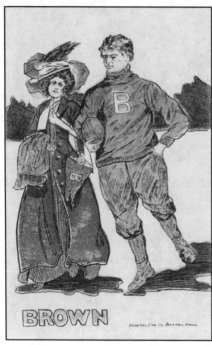

*Publisher Federal Eng. Co.
Boston, Mass. — "Brown"*

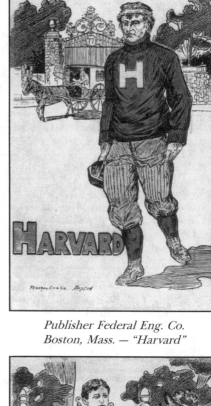

*Publisher Federal Eng. Co.
Boston, Mass. — "Harvard"*

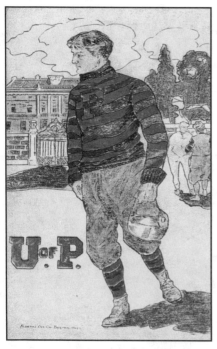

*Publisher Federal Eng. Co.
Boston, Mass. — "U. of P." (Penn)*

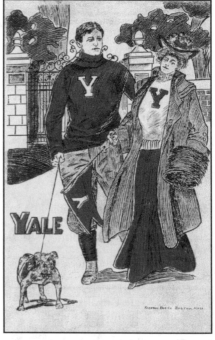

*Publisher Federal Eng. Co.
Boston, Mass. — "Yale"*

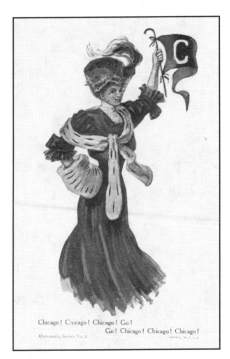

Publisher R. Hill, U. Series No. 8
Chicago

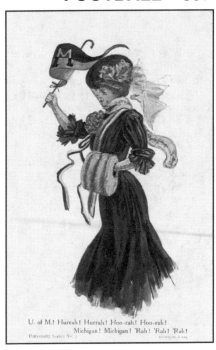

Publisher R. Hill, U. Series No. 7
Michigan

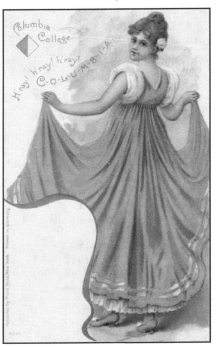

Publisher Franz Huld, No. 409
Columbia College Yell

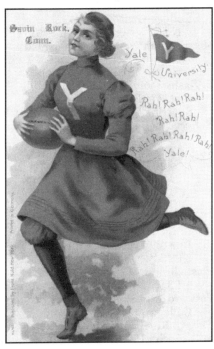

Publisher Franz Huld, No. 402
Yale University Yell

P 0048 Man "P" (Pennsylvania)	12 - 15	15 - 18
5006 - 11 "P"	15 - 20	20 - 25
Jaco-Lac Decal Co. Chrome		
Notre Dame University Postcard Decal	6 - 8	8 - 10
K in a diamond logo Chrome		
FNC-5228 "Original Miami Dolphin"	5 - 6	6 - 8
A.H. Katz 1905-1915 Sepia		
Foolish Questions		
"Playing football there, young man..."	15 - 18	18 - 22
Kawin & Co. 1905-1915		
"Making a Kick" (Same image as **K-Win & Co.** "An Athletic Kid)	8 - 10	10 - 12
E.C. Kropp Linen		
Large Letter 6151 N "U. of Notre Dame ..."	4 - 5	5 - 6
K-Win & Co. 1920-1940		
Children "An Athletic Kid"	8 - 10	10 - 12
Langsdorff & Co. (SL & Co.) 1905-1915 * **		
College Girls		
Columbia	20 - 25	25 - 30
Harvard	20 - 25	25 - 30
Princeton	20 - 25	25 - 30
Vassar	20 - 25	25 - 30
Yale	20 - 25	25 - 30
* Produced also in Silk dress - add $10-20 each.		
** Also with no initial or name on pennant.	15 - 20	20 - 25
Manhattan Postcard Co., Chicago 1905-1915		
College Girls		
Northwestern Yell	15 - 18	18 - 22
Metropolitan News Co. 1905-1920		
619 Children "To Make a Kick is Quite a Trick"	12 - 15	15 - 18
No No. Man No Caption	12 - 15	15 - 18
E. Nash (N in triangle) (1905-1915		
Blacks (Emb)		
Sporting Series 131 "The Football Girl Kick-Off..."	40 - 45	45 - 55
National Collegiate Marketing Chromes		
"The Ivy League Family Portrait"	3 - 4	4 - 5
"The ACC Family Portrait"	3 - 4	4 - 5
"The Big 8 Family Portrait"	3 - 4	4 - 5
"The Big 10 Family Portrait"	3 - 4	4 - 5
"The Pacific 8 Family Portrait"	3 - 4	4 - 5
"The South Easter Conference Family Portrait"	3 - 4	4 - 5
"The S.W. Conference Family Portrait"	3 - 4	4 - 5
P.S. & Co. 1905-1920		
Dog 69 "An End Run"	12 - 15	15 - 18
88 "After the Ball"	12 - 15	15 - 18
Plastichrome Chromes		
P319521 "Looking Good - Iowa Hawkeyes"	4 - 5	5 - 6
Postcard Exchange (Same as Ecdall & McCarty)		
College "Jay Rah, Gee Haw..."	8 - 10	10 - 12
Geo. C. Rianhard 1905-1915		
Series 101 Man "I'm making for my goal"	12 - 15	15 - 18
G.M. Rose 1905-1915		

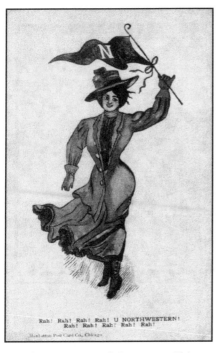

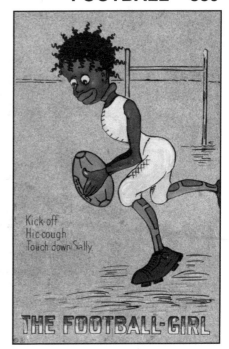

Manhattan Postcard Company, Chicago
Northwestern Cheer

E. Nash, Series 131
"The Football-Girl"

Man "An International Collegiate Sport"	25 - 30	30 - 35
Reinthal & Newman 1905-1920		
133 Girl "At the Game"	18 - 22	22 - 26
Roth & Langley 1905-1915		
"Never Again For Me" Series Sepia		
Man "Football may be quite a Sport"	18 - 22	22 - 26
The Rose Co. 1905-1915		
Anonymous Ladies with College Pennants		
L.S.U. "Rah Rah Rah!"	22 - 25	25 - 28
Rotograph Co. 1905-1915		
College Girls Series F100 (6)	15 - 18	18 - 22
S in wreath logo 1905-1920		
"The Football Player"	15 - 18	18 - 22
S.P. Co. 1950-1960		
Religion 918 "Help us hold that line" Modern	8 - 10	10 - 12
Religion 1143 "It takes teamwork" Linen	8 - 10	10 - 12
Souvenir Postcard Co. 1905		
College Girl Series (6)		
1 Princeton	15 - 18	18 - 22
2 Cornell	15 - 18	18 - 22
3 Columbia	15 - 18	18 - 22
4 Yale	15 - 18	18 - 22
Sprague Publishing Co. 1905-1915		
"American Boy" Postcard		
7 "Got a Kick Coming"	8 - 10	10 - 12
Edwin Stern & Co. 1905-1915		
"University Series" (Ladies with school yells) (10)	15 - 18	18 - 22

Publisher T.P. & Co., Series 978
"I am in a tight place but will see you soon"

Limerick "The Football Player"	20 - 25	25 - 28
Stecher Litho Co. 1910-1930 (Emb)		
Christmas Series 525-C "Christmas Greetings"	12 - 15	15 - 20
TR Co. logo (The Rose Co.) 1905-1915		
"The Football Player"	12 - 15	15 - 18
"College Girl - No matter what the game ..."	12 - 15	15 - 18
T.P. & Co. logo with moosehead 1905-1920		
Series 902		
"Dey call dis de 'Week End' but I'm goin' strong"	15 - 18	18 - 22
Children Series 978		
"Don' you think we would make a good team?"	15 - 18	18 - 22
"Gee, that's a fine way to throw a fellow down"	15 - 18	18 - 22
"I am good at team work - How about you?"	15 - 18	18 - 22
"I am good in a squeeze play"	15 - 18	18 - 22
"I am in a tight place but will see you soon"	15 - 18	18 - 22
"I am kicking because you do not write"	15 - 18	18 - 22
"I am waiting for an engagement"	15 - 18	18 - 22
"Look out you don't tackle the wrong party"	15 - 18	18 - 22
"Say—it's great to be a fullback"	15 - 18	18 - 22
"Won't be able to see you for awhile"	15 - 18	18 - 22
Tanner Souvenir Co. 1905-1920		
Man "Catching a Punt" (Emb)	18 - 22	22 - 26
Leather 1192 Man "Catching a Punt"	28 - 30	30 - 35
Leather Girl "Hur-Rah"	18 - 22	22 - 25
Toronto Lithograph Co. 1905-1915		
"Canadian Sports" "Foot-Ball"	10 - 12	12 - 15
Raphael Tuck 1905-1915		
6 Valentine "He has figured in many a fight..."	15 - 18	18 - 22
Series 2344 "Football" Oilettes (6)		
"Columbia"	25 - 30	30 - 35
"Cornell"	25 - 30	30 - 35
"Harvard"	25 - 30	30 - 35

Publisher T.P. & Co., Series 978
"I am good at Team Work — How about you?"

"Princeton"	25 - 30	30 - 35
"Pennsylvania"	25 - 30	30 - 35
"Yale"	25 - 30	30 - 35
Series 2413 "Write Away" (6)		
"Here's one for you"		
"How does this strike you"	22 - 25	25 - 28
"I am undecided"	22 - 25	25 - 28
"I'm detained"	22 - 25	25 - 28
"I'm on my way"	22 - 25	25 - 28
"I'm so disappointed"	22 - 25	25 - 28
Series 2828 "Iowa State University"		
"Iowa"	25 - 28	28 - 32
Series 7383		
"The University of Toronto"	22 - 25	25 - 28
Series 9280 "Write Away"		
"I'm so disappointed"	15 - 18	18 - 22
Series 9293 "Early Days of Sport"		
"Ancient Football in the 14th century"	22 - 25	25 - 28
Ullman Mfg. Co. 1905-1915		
College Men		
1466 Pennsylvania	22 - 25	25 - 28
1467 Yale	22 - 25	25 - 28
College Ladies		
1512 Yale	22 - 25	25 - 28
1516 Princeton	22 - 25	25 - 28
U. S. Lithograph Co. 1905-1915		
Ladies head in football	20 - 25	25 - 28
Others in series	20 - 25	25 - 28
Valentine & Sons, Ltd. 1905-1915		
Football Series		
"A Flying Tackle"	15 - 20	20 - 25
"A Touchdown"	15 - 20	20 - 25

"I am undecided"

"How does this strike you"

"I'm so disappointed"

"I'm on my way"

"Here's one for you"

"I'm detained"

Anonymous, Publisher Raphael Tuck
"Write Away" Series 2413

"Bucked!"	15 - 20	20 - 25
"Down!"	15 - 20	20 - 25
"The Roll Call"	15 - 20	20 - 25
Guy Varney		
Kansas U. Boy "Jay Rah, Gee Haw! Jay, Hawk ..."	15 - 20	20 - 25
Warwick Bros. & Rutter 1905-1915		
"Am Suddenly Detained"	15 - 18	18 - 22
Walkover Shoes 1905-1920		
Advertisement Walkover Shoes -		
"The Dreamer"	18 - 20	20 - 25

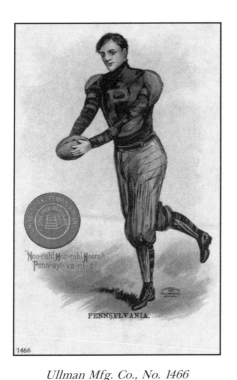

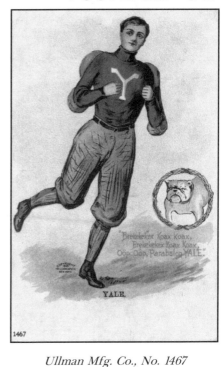

Ullman Mfg. Co., No. 1466
Pennsylvania (with Yell)

Ullman Mfg. Co., No. 1467
Yale (with Yell)

"Hard to Stop"	18 - 20	20 - 25
"The Leader"	18 - 20	20 - 25
"Tackling the Dummy"	18 - 20	20 - 25
Weatherbird Shoes 1905-1920		
Advertisement "Weatherbird Shoes are dandy for ..."	18 - 22	22 - 26
M.A. Wheadon 1905-1920 (B&W)		
Children No caption	12 - 15	15 - 18
Whitney Made		
Christmas "Wake Up! It's Christmas"	15 - 18	18 - 22
Valentine "O Cupid, Cupid, How Can You Be So ..."	15 - 18	18 - 22
John Winsch, Copyright 1909-1918 (Emb) *		
Unsigned issues of artist S.L. Schmucker		
Valentine, 1911 "You Make a Football of My Heart"		
Girl in red sweater kicks football Vertical	50 - 55	55 - 60
Valentine, 1914 Same as above but horiz. image	60 - 65	65 - 70
Valentine, 1911 Same as above but girl kicks		
heart. Very Rare!	60 - 70	70 - 80
Valentine, 1911 "My Valentine"	45 - 50	50 - 55
Valentine, 1910 Cupid "A Valentine Message"	45 - 50	50 - 55
* With silk inserts, add $10 each.		

ANONYMOUS

Advertisements
 Bigger than Weather 1905-1915

1 Dear Pal____. We Bigger-than-weather boys ..."	12 - 15	15 - 18
B.F. Goodrich "Tough Breed of Tires..." Chrome	3 - 4	4 - 5

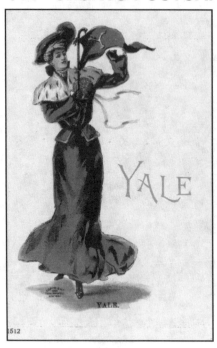

Ullman Mfg. Co., No. 1512
Yale

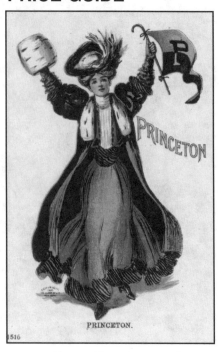

Ullman Mfg. Co., No. 1516
Princeton

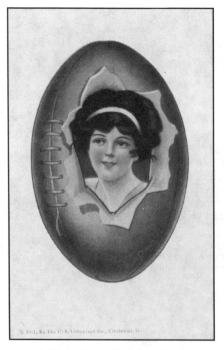

Valentine & Sons, Ltd.
Football Series, "A Flying Tackle"

Publisher U.S. Lithograph Co.
Cincinnati, O., ©1911

Valentine & Sons, Ltd.
Football Series, "Down!"

Boys & Girls of New England 1905-1915

3 "Uphold the Honor of the School - Jack Lorimer"	15 - 18	18 - 22
Chevrolet "Nova Custom Coupe" Chrome	3 - 4	4 - 5
Goldsmith Sporting Goods "Guaranteed Sporting		
Goods 1905-1915	20 - 25	25 - 28
Hinds Honey and Almond Cream		
"Football" Printed photo	12 - 15	15 - 20
Richard-Wilcox Mfg. Co. Non-PC back	12 - 15	15 - 18
Stadler Photographing Co. (RP) Calendars		
"Our Captain Making a Kickoff" (Oct. 1913)	35 - 40	40 - 45
"A Clear Field" (November 1913)	35 - 40	40 - 45
Texaco "Take time out for Texaco Fall Check-up"		
Chrome	3 - 4	4 - 5
Tip Top Weekly "Ideal Publication for Am. Youth"		
Dick Merriwell 1905 era	25 - 30	30 - 35
United Cigar Co. logo "Yale-Princeton, New		
Haven - Nov. 18, 1905 - Score ..."	15 - 20	20 - 25
Walk Over Shoes See Publishers		
Weatherbird Shoes See Publishers		

Colleges

Marquette University Various Sports		
6242 Lady cheerleader sits on big football	28 - 32	32 - 36

Children

Series 133	18 - 22	22 - 26
Dartmouth Boy player with football	15 - 18	18 - 22
Other schools	15 - 18	18 - 22
Uncle Sam		
"World's 20th Century Champion"	20 - 25	25 - 28

Game Advertisement

Andover vs. Exeter		
November 7, 1903 Color	18 - 22	22 - 26
Worcester plays Williston (B&W)		
"Come and help win the Prep Championship"	20 - 25	25 - 28
Others	20 - 25	25 - 28

Game Scores

"Andover - Exeter" Game of 1908		
O.P. Chase		
Scores 1877 through 1907	25 - 28	28 - 32
"California - Stanford Score" 1905-1915	15 - 18	18 - 22
"Dartmouth 22 - Harvard 0 Nov. 16, 1907	15 - 18	18 - 22
"Maine 18 - Bowdoin 0 "Champions of Maine, 1905"	15 - 18	18 - 22
"Tilton 46 - New Hampton 0 At Tilton 1904"	15 - 18	18 - 22
"Virginia Tech 35 - N.C. 6, Football - 1905"	18 - 22	22 - 26

Government Postal 1902

"Please fill out the attached postal card and mail		
at your earliest convenience. R.P. Kerman, Captain		
Harvard U Foot Ball Team"	15 - 18	18 - 22

Ladies with Pennants, Cheerleaders, etc.

College, Color	15 - 18	18 - 22
College, B&W	10 - 12	12 - 15
High School, Color	18 - 22	22 - 26
High School, B&W	12 - 15	15 - 18

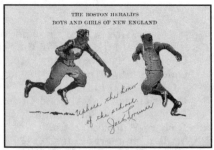

Ad for Boston Herald's Boys & Girls of New England, "Uphold the honor of the school." — Jack Lorimer

Advertisement for Tip Top Weekly
"Dick Merriwell"

Advertisement for Walkover Shoes
"Hard to Stop"

Sunbury High School, Sunbury, Pa.	18 - 22	22 - 26
Embroidered Flag Cards		
Anonymous		
"Princeton" and Others	10 - 12	12 - 15
Saxe Embroidery Co.		
Cornell	10 - 12	12 - 15
Others	10 - 12	12 - 15
Leather Postcards 1905-1920 *		
K in circle logo		
"Here's something to kick about"	12 - 15	15 - 20
Children "I've got a kick coming"	12 - 15	15 - 20
Football with Ribbons Chicago Yell	12 - 15	15 - 20
Man "I've got a kick coming"	12 - 15	15 - 20
Crossed Pennants No caption	12 - 15	15 - 20
"Yale" with football and scoreboard	20 - 22	22 - 26
Others	15 - 18	18 - 22
*** Also see Tanner Souvenir Co. & Anonymous**		
Pennants		
Annin & Co.		
"Bucknell" and others	20 - 22	22 - 26
Other Publishers		
Color	15 - 18	18 - 22
B&W	12 - 15	15 - 18
With School Views		
Fred C. Lounsbury	15 - 18	18 - 22
Other Publishers	12 - 15	15 - 18
School Seal & Colors	10 - 12	12 - 15

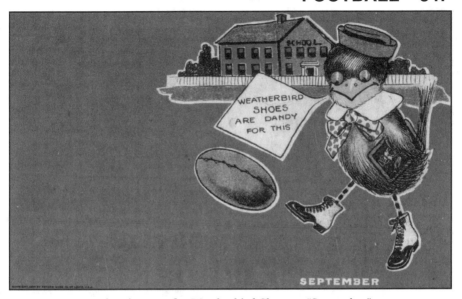

Advertisement for Weatherbird Shoes — "September"
"Weatherbird Shoes are Dandy for This"

Anonymous, Leather
Yale Cheer

Anonymous
Harvard Banner

Publisher Walker Litho. Co., Boston
Andover and Exeter Scores

School Name and Flags 10 - 12 12 - 15
Political
"Repeal of Prohibition"

Anonymous
"Dartmouth"

Anonymous, No. 4103
"World's 20th Century Champion"

"Changing Quarterbacks"	20 - 25	25 - 35
Political (RP)		
A9 "Our Quarterback" F. D. Roosevelt	20 - 25	25 - 35
A3 "America their Alma Mater ..."	20 - 25	25 - 35
Thanksgiving		
4103 "World's 20th Century Champion"	15 - 18	18 - 22
4106 "Thanksgiving"	8 - 10	10 - 12
Series 4806 "Thanksgiving Greetings"	8 - 10	10 - 12
Others		
22, 16A 1905-1915 "Friends Ever"	10 - 12	12 - 15
218 "It is time for me to kick"	10 - 12	12 - 15
"Don't Imagine that to Shine in Football ..."	15 - 18	18 - 22
"It' Great to be popular"	18 - 22	22 - 26
"So Young, So Fair yet what an awful kicker"	10 - 12	12 - 15
Girl - "To Make the Marriage rite right ..." Printed	10 - 12	12 - 15
Girl - "Hold Down Your Job, Clarence ..." Printed	10 - 12	12 - 15
Girl - "Don't Imagine Because I Look ..." Printed	10 - 12	12 - 15
Girl - C on red sweater, carrying football No caption	15 - 18	18 - 22
Same, but with gold background No caption	15 - 18	18 - 22
Home-Made		
"I'm kicking cause you don't write, Hull, Ia."	10 - 12	12 - 15
"Merry X-Mas Dad"	12 - 15	15 - 18
Little boy, red sweater, kicks with bare foot No caption	5 - 8	8 - 10
Real Photo "Owl Football Team" (Wesleyan??)	18 - 22	22 - 26
Valentine		
190 "A Game of Hearts" Cupid	8 - 10	10 - 12
"O cupid Cupid, How can you be so Cruel!"	10 - 12	12 - 15
Wooden card Little boy w/football under left arm	8 - 10	10 - 12

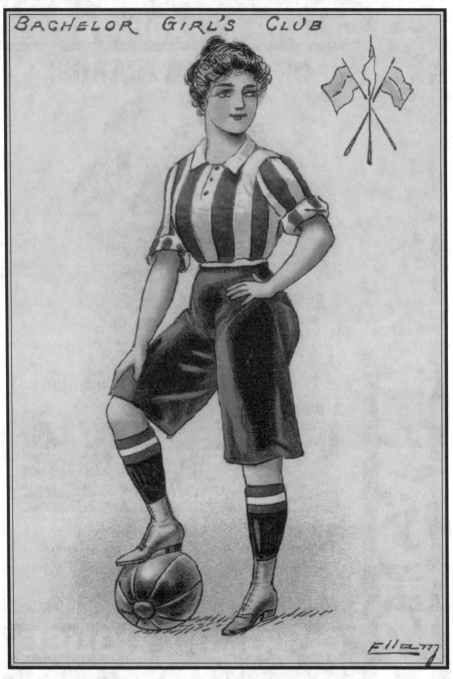

William H. Ellam, Hildesheimer & Co., Ltd.
Series 5245, "Bachelor Girl's Club"

In Great Britain they call it football. The French call it Le Foot-Ball. Other countries on the European continent call it voet bal, Fussball, Fut-bal, etc. The Americans call it SOCCER. Whatever the sport is called, it is the most popular, and it is played by more people, than any other competitive sport in the world.

During the 1900-1920 postcard era, soccer held very little interest in the states, and it was the European and English artists, and not the Americans, who capitalized on the popularity of the sport. It has in recent years, with the advent of television and the World Cup, gained in stature to the point that almost every high school and college in the U.S. now have teams. Many communities also have children's leagues for both boys and girls. This growth and high interest in the game has encouraged many postcard collectors to add soccer images to their most wanted categories, making it another motif in the already terrific sports collectibles field.

Available to collectors are great issues by English artists and publishers, both in the realistic and the comical vein. The works of artists Tom Browne, E. P. Kinsella, KV, and Fred Spurgin, all comical, are comprised of classic sets, and their values are still low in comparison to other sports. Publishers such as Raphael Tuck, Millar & Lang, Valentines, and P.F.B. released many unsigned sets that are also very much in demand. Popular, and good values also, are the many advertising cards issued throughout Europe during postcard's "Golden Years."

ARTIST-SIGNED

	VG	EX
A.A. (GB) 1905-1915		
National Series Children		
No No. "The hope of his team"	$12 - 15	$15 - 18
No No. "Well Saved"	12 - 15	15 - 18
X2 "After the match was over"	10 - 12	12 - 15
X3 "A header into goal"	10 - 12	12 - 15
X4 "Goal!"	10 - 12	12 - 15
B D logo (GB) 1905-1915		
Vivian Mansell & Co.		
1092 Children "The Captain"	18 - 22	22 - 26
BEAUVAIS, CH. (FR) 1905-1915		
Moulett		
Advertisement "Le Football – Place Darcy ..."	18 - 22	22 - 26
BERTIGLIA, A. (IT) 1910-1930		
Edizioni, Milano		
Series 3011 Children (6)	18 - 22	22 - 26
BOB 1905-1915		
Felix Rosenstiel		
Religious "Interrupted Studies"	8 - 10	10 - 12
BORISS, MARGRET (NETH) 1910-1930		
Rokat		
No No. Children	8 - 10	10 - 12
Series 141 (2)	10 - 12	12 - 15
BOTH, MAX 1905-1915		
Anonymous		
6 Man in white has just kicked ball with left foot	80 - 90	90 - 100
BROEKMAN, N. (BEL) 1910-1930		
Anonymous Man Foreign caption	10 - 12	12 - 15
BROWNE, TOM (GB) 1905-1915		
Chimera Arts (Reproductions)	1 - 2	2 - 3
Davidson Bros.		
Series 2520 "After the Ball"	25 - 30	30 - 35
Series 2546		
"A Full Back"	15 - 20	20 - 25
"Captain Blow Your Whistle"	15 - 20	20 - 25
"Fisting Out the Ball"	15 - 20	20 - 25
"Goal!"	15 - 20	20 - 25
"Headwork"	15 - 20	20 - 25
Series 2547		
"Foul"	15 - 20	20 - 25
"Hands"	15 - 20	20 - 25
"The Kick-Off"	15 - 20	20 - 25
"Well, that's a try anyway"	15 - 20	20 - 25
"Rival Captains - Was that a goal or not?"	15 - 20	20 - 25
Series 2633		
1 "Who'll Volunteer To Get The Ball?"	15 - 20	20 - 25
2 "Beg Pardon - My Mistake"	15 - 20	20 - 25
3 "Stiff Charge"	15 - 20	20 - 25
5 "Who's Got The Ball?"	15 - 20	20 - 25

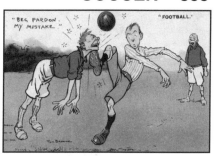

Tom Browne, Davidson Bros.
Ser. 2633-2, "Beg Pardon, my mistake"

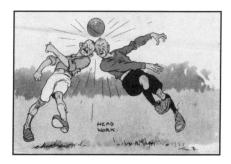

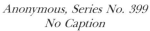

Anonymous, Series No. 399
No Caption

Tom Browne, Davidson Bros.
Series 2546, "Head Work"

CERVELLO 1910-1930
N. Coll Salieti

1221	"Remate de Cabeza"	15 - 20	20 - 25
1222	"Plongeon Sin Efecto"	15 - 20	20 - 25
1223	"Bolea"	15 - 20	20 - 25
1224	"Plongeon"	15 - 20	20 - 25
1226	"Despejandro en Peligro"	15 - 20	20 - 25
1230	"Un Schoot Sesgado"	15 - 20	20 - 25

CHANDLER, C. 1905-1915

Anonymous Man/Lady "He – I was inside right ..."	10 - 12	12 - 15

COLOMBO, E. (IT) 1910-1930
GAM

Series 1693 Children	15 - 18	18 - 22
Series 1962 Children	15 - 18	18 - 22
Series 2121 Children	15 - 18	18 - 22
Series 2171 Children	15 - 18	18 - 22
"Ultra" Series 2324 Children	15 - 18	18 - 22

Rev. Stampa

Series 479 Children	15 - 18	18 - 22

CROMBIE, CHARLES (GB) 1905-1915
Valentine & Sons
Series 1523 "Canny Scott"

"I'm enjoying the sights here"	15 - 18	18 - 22

DADD, S.T. (GB) 1905-1915
Raphael Tuck "Football Incidents"
Series 1746 (6) (3 Soccer; 3 Rugby)

"A Close Shave" (Association)	18 - 22	22 - 26
"Charged Through" (Association)	18 - 22	22 - 26

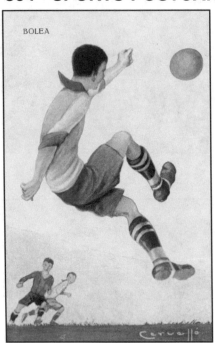

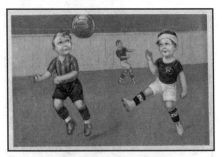

E. Colombo, GAM 2324
No Caption

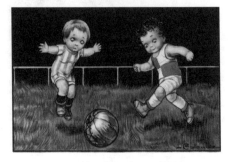

Cervello, C.S., Barcelona
"Bolea"

E. Colombo, GAM 2121
No Caption

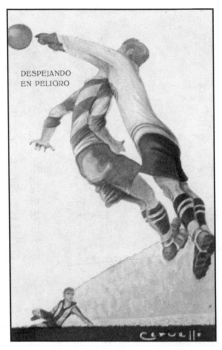

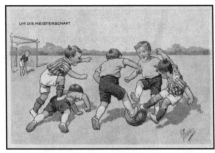

K. Feiertag, B.K.W.I. Series 401-4
"Um Die Meisterschaft"

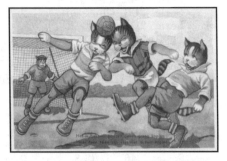

Cervello, C.S., Barcelona
"Despegando En Peligro"

Anonymous
"Het is bekend, poezen geven greag ..."

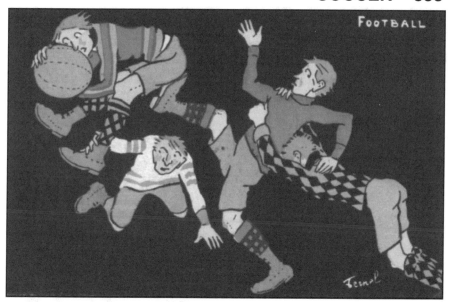

Fernel — Anonymous French Publisher — "Football"

"Football Incidents Oxford vs. Cambridge"	18 - 22	22 - 26
DUDA, M. 1920's		
D N over triangle logo		
912 Player standing on hands w/bandaged knees	8 - 10	10 - 12
E K 1950's		
A F K H in oval		
4189 Dressed Cats	10 - 12	12 - 15
E.S.H. 1905-1915		
E. Nister		
Series 42		
"I have had a good game"	15 - 18	18 - 22
"I hope to see you soon"	15 - 18	18 - 22
ELLAM, WILLIAM (GB) 1905-1915		
Hildesheimer & Co.		
Series 5245 "Bachelor Girl's Club"	15 - 18	18 - 22
FEIERTAG, K. (AUS) 1905-1920		
B.K.W.I.		
Series 401-4 Children "Um die Meisterschaft"	15 - 18	18 - 22
FERNEL (FR) 1900-1910		
Man "Football" (Possibly Rugby)	30 - 35	35 - 40
GOTTARO, E. 1905-1915		
Children (B&W)	10 - 12	12 - 15
GRENALL, JACK (GB) 1905-1915		
Raphael Tuck "Useless Eustace"		
Series 47 "And if sports is your line, sir ..."	12 - 15	15 - 18
GRIMM, ARNO 1905-1915		
Th. E.L. Theochrom		
Series 1074 Man	10 - 12	12 - 15
GUNNELL, N. 1905-1915		
Degami **Series 2206** Children (2)	10 - 12	12 - 15
GUSSYE, N. 1905-1915		
Anonymous Children "The Football Club ..."	5 - 7	7 - 8

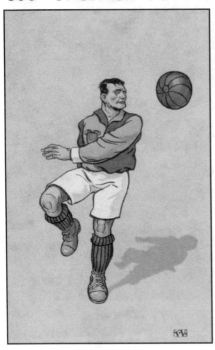

K.V., LP, 222-1
No Caption

E. P. Kinsella, Langsdorff & Co.
690, "Fisting Out."

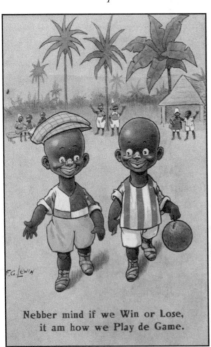

F. G. Lewin, J. Salmon , N-S8
No. 3153, "De voet bal club ..."

F. G. Lewin, J. Salmon, No. 4172
"Nebber mind if we Win or Lose ..."

Anonymous
"Die besten Pfingstgrusse"

G.A.S. in oval 1905-1915
 Photochrom Co., Ltd.

Political 6 "John Bull Foots the Bill"	15 - 20	20 - 25

HYDE, GRAHAM (GB) 1905-1915
 Raphael Tuck "Write Away"

Series 1372 Children "I am surprised at you"	15 - 18	18 - 22

H.E. (GB) 1905-1915
 W.&K. (Wildt & Kray)

Series 4874 Couple "They can keep their old ..."	20 - 25	25 - 30

Janssens, John 1905-1915

"Editions Sportswoman" Lady	20 - 25	25 - 30

K.V. in box logo 1905-1915
 LP in triangle logo (6)

Series 922 I-VI	18 - 22	22 - 26
Series 223 I-VI	18 - 22	22 - 26

KAISER 1930-1940
 Coloprint B

Series 53637 Man	8 - 10	10 - 12

KENNEDY, A.E. (GB) 1905-1915
 B. Dondorf

Series 629 Dressed Dogs	18 - 22	22 - 26

 C.W. Faulkner & Co.

Series 1404 C Dressed Dogs "Well Passed"	18 - 22	22 - 26

KINSELLA, E.P. (GB) 1905-1915
 Langsdorff & Co.
 Series 690 (6)

"A Dash for the Ball"	18 - 22	22 - 26
"The Captain"	18 - 22	22 - 26
"A Shot at Goal"	18 - 22	22 - 26
"Fisting Out"	18 - 22	22 - 26
"Hard Luck, Sir!"	18 - 22	22 - 26
"Heading the Ball"	18 - 22	22 - 26

LAFON, F. (FR) 1905-1915
 EDL logo "Le Sports Feminins"

"Le Foot-Ball"	18 - 22	22 - 26

LEPAGE, PAUL 1905-1920
 Anonymous

Political 10 "Goal" w/foreign caption (B&W)	8 - 10	10 - 12

LEWIN, F.G. (GB) 1905-1915
 E. Mack
 Political Series 684

"Goal!"	15 - 18	18 - 22
"Goal! What the R.F.A. are going to do"	15 - 18	18 - 22

 J. Salmon
 Series 684

Political "Goal! What the R.A.M.C. are going ..."	15 - 18	18 - 22
2657 Man "Hurrah! We've scored again!"	15 - 18	18 - 22

 Blacks

3153 "De Voetbal Club"	18 - 22	22 - 26
4172 "Nebber mind if we win or lose ..."	20 - 25	25 - 28

 Children

2369 "Hi! Where's the Ball?"	18 - 22	22 - 26

LIPS 1930-1940
 P.Z. in globe logo

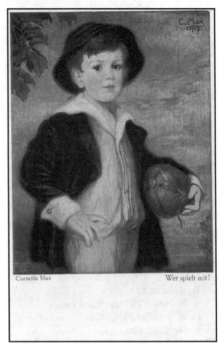

Mac, IXL Series 20,101
"A Foul"

Corneille Max, Wohlgemuth & Sissner
5083, "Wer spielt mit?"

Series 424 Man (6)	10 - 12	12 - 15
Series 426 Man (6)	10 - 12	12 - 15
LOE, JOE 1905-1915		
RHB in shield logo		
Series 692 Man	12 - 15	15 - 18
LUMOCH (AUS) 1905-1915		
B.K.W.I.		
Series 346 (6)	18 - 22	22 - 26
MAC (GB) 1905-1915		
Anonymous "Football Studies"		
Series 20101 (6)		
"A Bold Charge"	18 - 22	22 - 26
"A Centre Forward"	18 - 22	22 - 26
"A Free Kick"	18 - 22	22 - 26
"A Foul"	18 - 22	22 - 26
"A Full Back"	18 - 22	22 - 26
"A Goal Keeper"	18 - 22	22 - 26
MALLET, BEATRICE (BEL) 1910-1920		
Advertisement		
"Cigarettes St. Michel - Le Football"	18 - 22	22 - 26
MASSE, JOAN 1905-1915		
JG in horseshoe logo		
Series 85114 Man	10 - 12	12 - 15
Series 85116 Man	10 - 12	12 - 15
MAX, CORNEILLE (GER) 1905-1915		
Wohlgemuth & Sissner		
Series 5083 Young boy "Wer spielt mit?"	12 - 15	15 - 20

"Joe: Now, boys, no more kicks in the back in future..."

"Joe: You stick to me, John, and I'll see you through it."

"A Tough Game. Chamberlain in Fine Form."

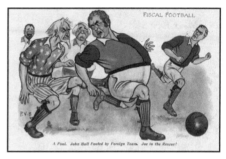

"A Foul. John Bull Fowled by Foreign Team. Joe to the Rescue!"

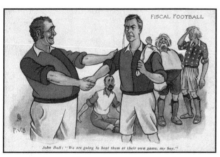

"John Bull: We are going to beat them at their own game, my boy."

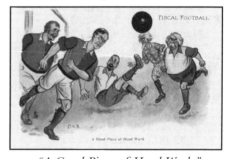

"A Good Piece of Head Work."

Political, "Fiscal Football" By P.V.B.
Raphael Tuck Series 6142

MIGNOT, V. (BEL) 1900-1905
 Dietrich & Co.
 Man/Lady 125 - 130 130 - 140
MILO 1905-1915
 Anonymous 15 - 18 18 - 22
MMM (IT) 1910-1920
 Degami
 Series 1010 (4) 10 - 12 12 - 15

MONTEGUE, R. 1905-1915
 Photochrom Co., Ltd.

Series 2048 Cats "My wishes to you ..."	15 - 18	18 - 22

MORISS 1905-1915

Anonymous "20 Ans la Toilette le Sport"	15 - 18	18 - 22

MULLER, E. (GER) 1905-1915
 Anonymous, Political
 Series 3

"Une partie de football - Football game"	15 - 20	20 - 25
N 1905-1915 Anonymous (B&W)	10 - 12	12 - 15

NANNI, G. (IT) 1910-1925
 E. Sborgi

"Il Calico" (2)	20 - 25	25 - 30

NUMBER, JACK 1905-1915
 PFB in diamond logo
 Series 2120

1 "Les Adversaries en position"	10 - 12	12 - 15
3 "Un pied Bien Applique"	10 - 12	12 - 15
4 "Ca se Corse"	10 - 12	12 - 15
5 "La Balle n'en veut plus"	10 - 12	12 - 15
6 "Das Schlachtfeld"	10 - 12	12 - 15

ORDNER, PAUL 1950's
 Spanjersberg "Voetbal Spelregels"

Series 1408 (4)	5 - 7	7 - 9

OSSWALD, EUGEN 1905-1915
 Wilh. Stephan

Elephant "Der Torwart"	40 - 50	50 - 60

PENOT, A. (FR) 1905-1920
 Marque L-E

Series 309	20 - 25	25 - 30

PRAILL, R.G. 1910-1920
 Advertisement

"Weekly Dispatch - Fullest Football Reports"	70 - 80	80 - 90

P.V.B. (GB) 1905-1915
 Raphael Tuck
 Series 1365 "Humorous" Football Terms Ill. (6)

"On the Bawl!"	20 - 25	25 - 28
"A Penalty Kick!"	20 - 25	25 - 28
"A Plucky Try!"	20 - 25	25 - 28
"Two Good Full Backs!"	20 - 25	25 - 28
"Well Collared!"	20 - 25	25 - 28

 Series 6142 - Political "Fiscal Football" (6)

"A Good Piece of Head Work"	22 - 25	25 - 30
"A Tough Game - Chamberlain in Fine Form"	22 - 25	25 - 30
"Joe: Now, Boys, No More Kicks ..."	22 - 25	25 - 30
"Joe: You Stick to Me ..."	22 - 25	25 - 30
"A Foul John - Bull Fouled by Foreign Team"	22 - 25	25 - 30
"John Bull: We are going to beat ..."	22 - 25	25 - 30

R.M.S. (GB) 1905-1915
 W R & S in shield logo
 Reliable Series 9323

"The Referee"	20 - 25	25 - 28
"Well Saved"	20 - 25	25 - 28
"Well Tried"	20 - 25	25 - 28

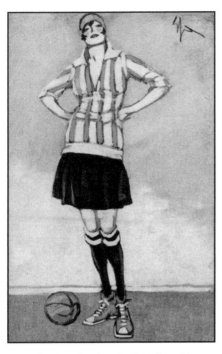

Enrico Sacchetti, F. Polenghi
Series 23, No Caption

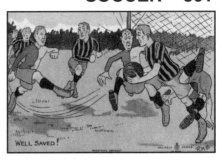

R.M.S., W.R. & S.
Reliable Ser. No. 9323 — "Well Saved!"

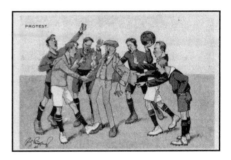

F. Schönpflug, B.K.W.I., No. 400-1
"Protest"

RIGSKY, G.G. (RUS) 19-10-1920
Art Publishing House, Moscow
"Sportswoman" | 25 - 35 | 35 - 45
ROBERT, JACQUES 1905-1915
Comite National des U.C.J.G.
Player running - "Le FOOTBALL" | 10 - 12 | 12 - 15
ROLAND 1905-1915
H.M. & Co. Series 25 | 25 - 30 | 30 - 35
ROWLAND, RALPH (GB) 1905-1915
Aldine Series 229
"If you should be down my way" | 18 - 22 | 22 - 26
"I'm very sorry I missed you" | 18 - 22 | 22 - 26
RUSNAK, ANN (US) Modern
Political "Timely Topics" (B&W)
3 "Send Soccer Hooligans to Beirut!" | 2 - 3 | 3 - 4
ROWNTREE, HARRY (GB) 1905-1915
Valentine's Series
"A Friendly Meeting" | 25 - 30 | 30 - 35
"Too Much Headwork" | 25 - 30 | 30 - 35
SACCHETTI, ENRICO (IT) 1905-1920
F. Polenghi
Series 23 Beautiful Lady | 25 - 28 | 28 - 32
SAGER, XAVIER (FR) 1905-1920
Anonymous "Foot-Ball-Bien" | 18 - 22 | 22 - 26
SALZEDO, MAGGIE 1910-1920
J. Goossens
Advertisement - 5 "CroiX-Rouge de la Jeunesse" | 15 - 20 | 20 - 25

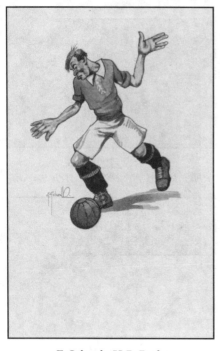

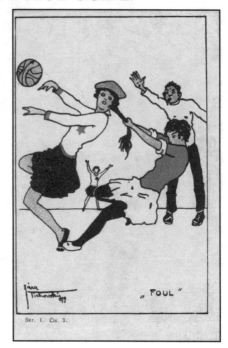

F. Schenk, H-P, Praha
No Caption

Jara Tichnovosky, Koppe Bellman
"Foul"

SCHENK, F. (CZ) 1910-1920		
H-P in leaf logo		
With the head	15 - 18	18 - 22
With the foot	15 - 18	18 - 22
SCHÖNPFLUG, FRITZ (AUS) 1905-1915		
B.K.W.I.		
Series 228 (6)	20 - 25	25 - 28
Series 260 (6) Silhouettes	20 - 25	25 - 30
Series 271 (6)	20 - 25	25 - 28
Series 335 (6)	20 - 25	25 - 28
Series 400 (6)	20 - 25	25 - 28
Series 539 (6)	20 - 25	25 - 28
SPURGIN, FRED (LAT) 1905-1915		
Art & Humor Pub. Co.		
"A&H Footer Series" Pretty Girls		
765 "A Football Match Oh! What a Game It Is"	25 - 30	30 - 35
766 "A Fine All-round Player"	25 - 30	30 - 35
767 "We Love to See a Good Half Back"	25 - 30	30 - 35
768 "Playing the Game With the Boys"	25 - 30	30 - 35
769 "Making Up for the Other Players"	25 - 30	30 - 35
770 "What's the Game? Kiss or Kick?"	25 - 30	30 - 35
771 "Football Results" Children	15 - 20	20 - 25
STEEN 1920-1930		
REB logo "De Aftrap"	8 - 10	10 - 12
THACKERAY, LANCE (GB) 1905-1915		
Raphael Tuck **Series 1373** "Journals Illustrated"		
"The Referee"	`30 - 35	35 - 38

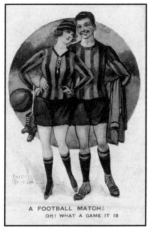 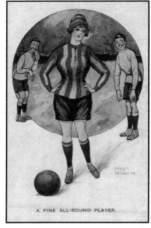 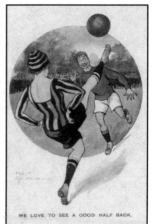

| No. 765 — "A Football Match..." | No. 766 — "A Fine All-Round Player." | No. 767 — "We Love to See a Good Half Back." |

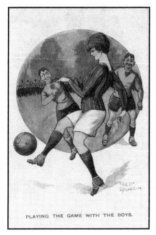

| No. 768 — "Playing the Game with the Boys." | No. 769 — "Making Up for the Other Players." | No. 770 — "What's the Game? Kiss or Kick?" |

Fred Spurgin, Art & Humor Publishing Company
A & H Footer Series

THIELE, ARTH. (GER-DEN?) 1905-1915

 T.S.N. (Theo Stroefer)

Series 871 Black	40 - 50	50 - 60
Series 1428	30 - 40	40 - 45
Also by Anonymous publisher	30 - 40	40 - 45

THIELE, WALTER (GER) 1905-1915 (B&W)

W.K.B, a Rh. **Series 2125**	18 - 22	22 - 26

THIRAR, JAMES 1910-1920

Anonymous Military "Une Partie de Football"	15 - 20	20 - 25

Arth. Thiele, TSN Series 871
No Caption

Publisher Amag, No. 0100
No Caption

TICHOVOSKY, JARA (CZ) 1910-1920
 Koppe Bellman
 Series 1-3 "Foul" 20 - 25 25 - 28
W.E.T. (GB) **1905-1915**
 British Showcard & Poster Co.
 British Sportsmen Series "The Muddied Oaf" 12 - 15 15 - 20
W on top of **W** logo 1905-1915
 P in circle logo
 Advertisement - M'J Debetue Limonade
 Siroop - II-2 Teddy Bear kicking soccer ball 50 - 55 55 - 60
WFD (GER) 1905-1915
 SWSB **Series 461** "Sich im Fussballspiel su Uben ..." 12 - 15 15 - 18
WAIN, LOUIS (GB) 1905-1915
 Davidson Bros.
 6085 **Frogs** "We are putting in some hard work" 44 - 55 55 - 65
 Valentine's
 "Our Football Match" 100 - 110 110 - 125
WOOD, LAWSON (GB) 1905-1915
 Davidson Bros. "Prehistoric Pastimes"
 Series 6106 "Football" 22 - 25 25 - 28

PUBLISHERS

A.R. & Co. 1905-1915
 Sporty Cats **Series 1510-3** "You'll go through it ..." 18 - 22 22 - 26
Aldine 1905-1915
 Series 228 Pretty Girl 15 - 18 18 - 22

Amag 1905-1915
 Series 0100 Children

"Der Champion"	12 - 15	15 - 20
"Ein Meister Schuss"	12 - 15	15 - 20
"Ein Verfehlter Ball"	12 - 15	15 - 20
"Ein Vorltresser"	12 - 15	15 - 20

 Series 0100 Children with no captions 12 - 15 15 - 20

Art Vienne 1905-1815
 Series 1882 (B&W) 12 - 15 15 - 18

Atlas Society 1900-1910
 Player with oversize head and foot 15 - 18 18 - 22

B.K.W.I. 1905-1915
 Series 279 (6) 15 - 18 18 - 22
 Series XVII Bonzo Series "Goal Keeper" 22 - 25 25 - 28
 Series 426 (6) Silhouettes
 6 "Out" 12 - 15 15 - 20

Bamforth Co. 1905-1915
 Series 4107 Children "Rubbering Again" (Photo) 10 - 12 12 - 15

Birn Bros. 1905-1915
 158 "The Referee was particularly struck ..." 25 - 30 30 - 35

Bruckmann, F. 1905-1915
 Silhouette (B&W) "Der Champion" 15 - 18 18 - 22

C C M logo 1905-1915
 Political - Kaiser and Franz Joseph play with globe 30 - 35 35 - 40

Coloprint B 1930-1940
 Series 76 St. Bernard dog as goalie 10 - 12 12 - 15
 Series 7436 Children 8 - 10 10 - 12
 53317 Children 8 - 10 10 - 12
 Series 53767 (6) 10 - 12 12 - 15
 Series 54238 (6) 10 - 12 12 - 15

Davidson Bros. 1905-1915
 Newspaper Series 6047 "The Referee" 10 - 12 12 - 15

Degami 1950's
 Series 974 Children 12 - 15 15 - 18

ELCE 1905-1915
 Silhouette (B&W) 10 - 12 12 - 15

ELF 1910-1930
 Series 9 Nude Real Photos 12 - 15 15 - 20

ES in solid diamond logo 1905-1915
 Lumineuse Silhouette Series "Le Football Association" 12 - 15 15 - 18

Ensamratt 1910-1920
 Series GK 5302-5 "Cupfina" 10 - 12 12 - 15

Eurodonal 1905-1920 Sepia
 Advertisement "Vanqueur, Grace au Globeol" 30 - 35 35 - 40

F A S (F.A. Schneider) 19005-1915
 3609 Little boy leans against goal post "Torwart" 10 - 12 12 - 15

Fenit 1905-1915
 Series 23-3 15 - 20 20 - 25

GOM in solid shield logo 1905-1915
 3029 Cats No caption 12 - 15 15 - 20

Hartman 1905-1915
 Series 3039
 2 "The referee's decision is final" 18 - 22 22 - 26
 3 "When Greek meets Greek" 18 - 22 22 - 26

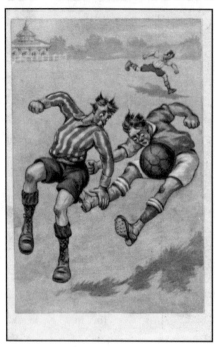

Publisher B.K.W.I., Series 426-6
"Out"

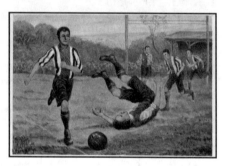

Publisher S.B.
Excelsior No. 7517

Publisher Raphael Tuck
Fussballspieler No. 595B

Inter-Art Co. 1905-1915
 Comique Series 3073
 Silhouette "A nice left–and a right too" 12 - 15 15 - 18
 Sporty Cats
 4183 "Oh! How I've missed you" 12 - 15 15 - 18
 4187 "Many Happy Returns" 12 - 15 15 - 18
International Art 1905-1915 Printed Photo
 Series 29515 "Saving a Hot Shot" 12 - 15 15 - 18
JC in circle logo 1950-1960
 French (6) 8 - 10 10 - 12
J.H.P. logo 1915-1915
 Illegible artist — Girl sitting on a chair; ball in hand 18 - 22 22 - 25
J.M. & Co. 1905-1915 (Also see Atlas Society)
 901b "After the Ball" 15 - 18 18 - 22
Kismet Series 1905-1915
 Illegible artist
 139 "I was much struck by the straight shooting ..." 25 - 30 30 - 35
M.N. & C. 1905-1915
 Series 6583 12 - 15 15 - 18
M and L National Series 1905-1915
 "Half-Time" 15 - 20 20 - 25
Millar & Lang, Ltd. 1905-1915
 Series 484 "Away yerself" 15 - 20 20 - 25
 Series 879 "The Backyard Team Captain" 15 - 20 20 - 25
National Series (**Millar & Lang, Ltd.**) 1905-1915
 Serie 909 "Our heroes can neither ..."
 (Printed photo) 15 - 20 20 - 25

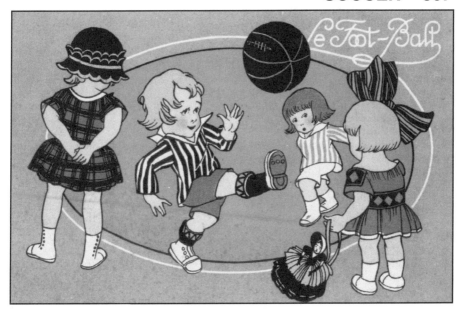

The Soccer Hero -- Publisher B. Sirven, Paris — "Le Foot-Ball"

Series 1549 (6)

"Football Jottings - Well Shied" 15 - 20 20 - 25

"Football Jottings Half Time" 15 - 20 20 - 25

Series 1809 (6)

"Go for the Puddin Head" 18 - 22 22 - 26

"The Hero of the Match" 18 - 22 22 - 26

Series 2118 (6)

"A hen in kilts could referee better than that" 12 - 15 15 - 18

"The charge of the heavy brigade" 12 - 15 15 - 18

"This side can't be beat" 12 - 15 15 - 18

Series 2270 (6)

"Everybody's Doing It, Doing It!" 12 - 15 15 - 18

"It's a Goal! It's a Goal! ..." 12 - 15 15 - 18

"Well Save Ma' Son" 12 - 15 15 - 18

P in circle logo 1920's

Children "The Match" 25 - 28 28 - 32

P.S. & Co. 1900-1910

Series 50-100 "After the Ball" 10 - 12 12 - 15

Photochrom Co., Ltd. 1905-1915

Football Silhouettes (B&W)

Series 3 "Heads I Win" 30 - 35 35 - 40

REB logo 1930-1940

Series 54408 (2) Children 12 - 15 15 - 18

S.B. 1905-1915

Series 7517 Comical men 12 - 15 15 - 18

S.O. in block logo **Series 113** (2) (Emb) 15 - 18 18 - 22

S.W.S.B. 1905-1915

Series 5071 (6)

3 "Heisser Kampf" 15 - 18 18 - 22

5972-5975 Children German captions 12 - 15 15 - 18

Savory, E.W. 1910-1920
 Military Series 2227 "The Allies at Play" 15 - 20 20 - 25
Karl W. Schilling
 Advertisement
 "Rooschuz Waffeln Bern - Sparkling
 Bouvier Ferres, Neuchatel" (2) 30 - 35 35 - 40
Shorthouse Publishing 1920's
 "Football on the Brain" 12 - 15 15 - 18
B. Sirven 1900-1910
 Children "Le Foot-Ball" 15 - 20 20 - 25
A.C. Sparty 1910-1920
 "Jada-D'anunnzio" 30 - 35 35 - 40
T in triangle logo
 Series 113 (Emb) 15 - 18 18 - 22
Raphael Tuck 1905-1915
 Series 129 "Write Away" (6)
 "I mustn't pass this" 18 - 22 22 - 26
 "I will run down" 18 - 22 22 - 26
 "Just in time" 18 - 22 22 - 26
 "Sorry I couldn't get away" 18 - 22 22 - 26
 "Fussballspieler"
 Series 595-B (6) 18 - 22 22 - 26
 Series 6884 "Outdoor Games"
 Children "Football" 18 - 22 22 - 26
Valentine & Sons Series 1905-1915
 "Football Series 1"
 "A Friendly Game, Halftime" 18 - 22 22 - 26
 "A Record Punt" 18 - 22 22 - 26
 "Well Saved" 18 - 22 22 - 26
W.C., S. & Co. 1905-1915
 Herriot Series 235 "Football Phrases Illustrated" (6)
 "A Corner" 18 - 22 22 - 26
 "A Penalty" 18 - 22 22 - 26
 "A Smart Pass" 18 - 22 22 - 26
 Prehistoric Sports "Football" 15 - 18 18 - 22
W.R. & S. in a shield logo 1905-1915
 "What's Your Crest"
 Series 9308
 "The Footballer's Crest" 18 - 22 22 - 26
 Series 9323 (6)
 "A Forward Rush" 18 - 22 22 - 26
 "Foul There" 18 - 22 22 - 26
 "Tackle em, You" 18 - 22 22 - 26
W.E.B. & Co. 1905-1915
 The Favorite Series 661
 "Well Saved" 25 - 30 30 - 35
Wilkinson & Trowbridge 1905-1915
 Pre-Historic Football 12 - 15 15 - 18
Woodall, Minshall, Thomas 1905-1915
 Pre-Historic Manx
 Series 90 "Paly up Barowl" 15 - 18 18 - 22
Z.H.Z, K.V. 1905-1915
 Series 5652 "Pron Oal" 15 - 18 18 - 22

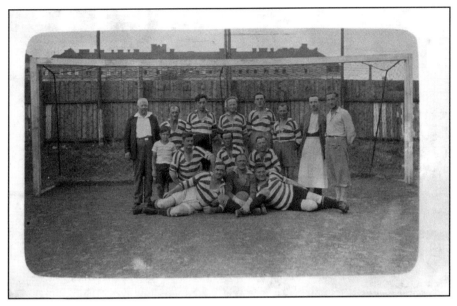

Real Photo, 1908 — German Village Soccer Team

ANONYMOUS

S. No. 399 V. Large Image Comical Series 1905-1915	15 - 18	18 - 22
Series 424 (6)	25 - 30	30 - 35
No. 434 - 8 little babies sitting on top of soccer ball	5 - 7	7 - 9
No. 5008 - Player kicks at ball and misses	5 - 7	7 - 9
No. 5009 - Player kicks ball that hits spectator	5 - 7	7 - 9

MISCELLANEOUS

Advertising

Gold Leaf (BEL?) 1960-1970 (10)		
Series B 1-10	10 - 12	12 - 15
Sportbeef - Players sitting around table drinking		
Sportbeef "L'Eqiipe Victorieuse"	22 - 25	25 - 30
Real Photos		
Early Important players	20 - 25	25 - 30
Soccer Teams	20 - 25	25 - 30
Soccer games in action	10 - 12	12 - 15
Village Soccer Team 1908	12 - 15	15 - 18
Others		
Frogs - "Die Besten Pfingstgruss"	15 - 20	20 - 25
Japanese Characters (Little boy in kimono with ball)	15 - 18	18 - 22
Real Photos		
Early teams	12 - 15	15 - 25

Beautiful Lady Billiards Player!
Anonymous French Publisher

Billiards, or "Pool," as it is known to many Americans, had become a very popular game by the turn of the century. The first professional billiards tournament was held in the U.S. in 1869. Championship matches and exhibitions by professionals from all over the world were staged throughout the U.S. and Europe, and pool became the rage in cities and towns throughout the country. It soon experienced a bad name, however, as early pool rooms and billiard halls seemed to attract loafers and "hustlers" who tried to take advantage of regular "shooters." This caused the pastime sport to lose much of it's popularity.

Today, pool has regained it's popularity and has become much more sophisticated. There are now very elaborate emporiums, plush clubs and resorts available. Shooters of both sexes can now match their skills, and even bring their children to enjoy the sport.

Television has helped to further revolutionize the game with its coverage of championship matches by the best men and women players in the world. Willie Hoppe, an American, has been called the greatest billiards player of all times, and in his competitive years won 51 world titles. Postcards with his image, as well as those of Mosconi and other famous players, and those taken of various exhibitions and championship play are very collectible, and are very much in demand by today's sports collector.

To postcard enthusiasts, however, the works of early artists of postcard's Golden Era of 1900-1915 are the most important. Although they adapted most of their works concerning billiards to those in a comical vein,

which included ladies and children, they also utilized the "riff raff" and the proverbial hustler. Among the most adored are colorful series by Tom Browne, Arth. Thiele, Fritz Schönpflug, and publishers PFB, National Series and Raphael Tuck. The French also published some great caricature series which are very collectible today.

ARTIST-SIGNED

	VG	EX
BARBER, COURT (US) 1905-1915		
Anonymous Series 2031-2 "The Rivals"	$18 - 22	$22 - 25
BEATY, A. (US) 1905-1915		
Commercial Colortype		
330 Children "The Coming Champs"	20 - 25	25 - 30
BEAUVAIS, CH. (FR) 1905-1915		
Moullet "Les Sports"		
XX "Le Billiard"	12 - 15	15 - 18
BOBY (FR) 1905-1915		
I.C.A. Advertisement "Henin Aine"	25 - 30	30 - 35
BROEKMAN, N. (NE) 1940's		
Anonymous Foreign caption	8 - 10	10 - 12
BROWNE, TOM (GB) 1905-1915		
Davidson Bros. "Billiards Made Easy"		
Series 2578 (6)		
"A Little Mixed"	22 - 25	25 - 28
"A Masse Shot"	22 - 25	25 - 28
"An Anxious Moment"	22 - 25	25 - 28
"Have the Rest Old Chap"	22 - 25	25 - 28
"Not His Own Table"	22 - 25	25 - 28
"The Long and Short of It"	22 - 25	25 - 28
Series 3044 (Same images as 2578)		
"The Long and Short of It"	22 - 25	25 - 28
"Overworked Clerk"		
Series 2590		
3 "After Lunch"	18 - 22	22 - 26
BUCHANAN, FRED (GB) 1905-1915		
Woolstone Bros. The Milton Series		
Series 503 Children "I think Billiards would ..."	18 - 22	22 - 26
BULL, RENE (GB) 1905-1915	12 - 15	15 - 18
CADET, J. 1905-1915		
Anonymous		
691 Pigs "Et bien mon cocha ..."	25 - 28	28 - 32
CARTER, REG (GB) 1905-1915		
J. Salmon		
2837 Man "Full up, Fed up, Far from Home"	15 - 18	18 - 22
CASELLA (IT) 1910-1925		
Varsi Hnos (B&W)		
Devil and Girl Series (8)	10 - 12	12 - 15
COLOMBO, E. (IT) 1910-1920 (Uns.)		
Anonymous Series 2326 Children (6)	12 - 15	15 - 20
CRACKERJACK (GB) 1905-1915		
Davidson Bros. Series 7000		
1 Children "Following in Father's footsteps"	18 - 22	22 - 26

A. Beaty, Commercial Colortype, Series 330 —"The Coming Champs"

Tom Browne, Davidson Brothers
Series 2578, "The Long and Short of it"

J. Cadet, Anonymous No. 651
"Et Dien Mon Cochon ..."

Casella, Varsi Hnos
No Caption

L. Daumier, Collections D'Art
"Les Jouers de Billa ..."

D., FRED 1905-1915
Advertisement Hood's Pictorial Cards
1 "Spot-Barred Rest & Spider ..." 20 - 25 25 - 30

Ellam, S. Hildesheimer & Co., No. 5249 -- "Hard Workers! Special."

Fernel, Anonymous French Publisher -- "Billard"

DAUMIER, L. (FR) 1905-1915
 Collections D'art (B&W) (10)
 "Les Jouers de Billa" Series 18 - 22 22 - 26
DAVEY, GEORGE (GB) 1905-1915
 Misch & Stock "Comic Billiards"
 Series 114 "Very effective stroke ..." 25 - 30 30 - 35
ELLAM, WILLIAM (GB) 1905-1915
 Hildesheimer & Co.
 5249 Man "Hard Workers! Special" 18 - 22 22 - 26

M.B., Anonymous French Publisher
"Le Billard"

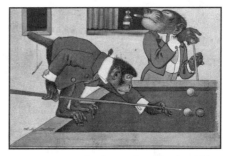

Ruab Gnischaf, John Neury, Geneva
"A lost game"

L. Meggendorfer, MIXT Series 224
No Caption

FERNEL (FR) 1905-1915		
French Back "Billiard"	30 - 40	40 - 50
GNISCHAF, RUAB 1905-1915		
John Neury, Geneva		
"A lost game"	15 - 18	18 - 22
GRIFF 1905-1915		
Sports Series 286 Man "Au Billiard"	20 - 25	25 - 28
GUSTAVE, L. 1905-1915		
Political "Les Carambolages d'Armand"	18 - 20	20 - 25
H.B.S. (GB) **1905-1915**		
Stewart & Woolf		
"Write On" Series 342		
"Billiards - A Long Jenny"	15 - 20	20 - 25
"Billiards - A losing Hazard"	15 - 20	20 - 25
"Billiards - Nursing Can(n)ons"	15 - 20	20 - 25
"Billiards - One Point Behind"	15 - 20	20 - 25
"Billiards - Putting on Side"	15 - 20	20 - 25
L.S. 1905-1915 *		
Raphael Tuck		
Comical Series (6)	18 - 22	22 - 26
* **Set is also distributed by J.V.A.**		
LUDOVICI, A. 1905-1915		
Davidson Bros. "Fiscal Games"		
Series 6103 "Billiards"	15 - 20	20 - 25
M.A. 1905-1915		
E.F.A. logo		
561 Girl	35 - 40	40 - 45

Colorful Comic Billiards Set by Artist L. S.
Published by Raphael Tuck and Distributed by J.V.A.

M.B. 1905-1915
 Anonymous French Publisher
 "Le Billard" 30 - 35 35 - 40
MMM 1910-1920
 Degami
 Series 1010 10 - 12 12 - 15
MALLOCK, R.M. 1905-1915
 Series 453 Man "Billiards" 15 - 20 20 - 25
MEGGENDORFER, L. (GER) 1905-1915
 MIXT in rectangle logo
 224 Monkeys 18 - 22 22 - 26
MICH (FR) 1905-1915
 Sid's Editions "Kids & Kiddies" Series
 Series 7039-9 "Hello! A Real Billiard Table!" 12 - 15 15 - 18
MORTINI 1905-1915
 Anonymous **Series 2372**, No Caption 15 - 20 20 - 25

Mortini, Anonymous Publisher
Series 2372, No Caption

G. Mouton, Anon. French Publisher,
"Au Billard"

R. F. Outcault, J. Ottmann Litho.
"A Dangerous Game"

F. Schönpflug, B.K.W.I., Series 907-4
"Ein serie ... oser Spieler!"

MOUTON, G. (FR) 1905-1915
 French Back
 Beautiful Lady "Au Billard" 35 - 40 40 - 50
OUTCAULT, R.F. (US) 1905-1915
 J. Ottman Litho Co.
 Boy/Girl "A Dangerous Game - They are kissed" 20 - 25 25 - 30
P.V.B. (GB) 1905-1915
 Raphael Tuck "Humorous" (6)
 "Billiard Terms Illustrated" Series 1288
 "A Kiss" 25 - 30 30 - 35
 "A Kiss. In for a big break!" 25 - 30 30 - 35
 "A little too fine" 25 - 30 30 - 35
 "Spot Bared" 25 - 30 30 - 35
 "Trying for the pocket!" 25 - 30 30 - 35
REED, E.T. (GB) 1905-1915
 Punch
 Series 2589 Prehistoric Peeps "Primeval Billiards" 10 - 12 12 - 15
SCHÖNPFLUG, FRITZ (AUS) 1905-1915
 B.K.W.I. (Bruder Kohn, Wien)
 Series 907 (6) With French/German Captions
 1 "Coup Avec Dommages" 25 - 30 30 - 35
 3 "Lassen Sie Sich Anstucken" 25 - 30 30 - 35
 4 "Ein Serie-oser Spieler!" 25 - 30 30 - 35
 5 "Marche Bien A L'Envers" 25 - 30 30 - 35
 6 "Der Goldene Mitteweg" 25 - 30 30 - 35

Lance Thackeray, Raphael Tuck Series 1328 — "I am pleased to learn"

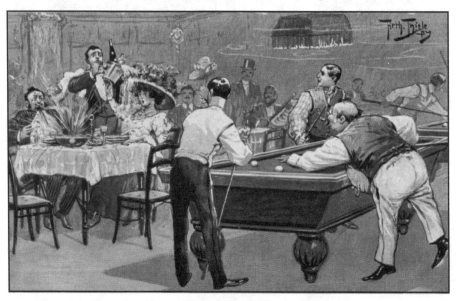

Arth. Thiele, T.S.N. Series 1155 — No Caption

SPURGIN, FRED (LAT) 1905-1920
 Avenue Pub. Co.
 Boy/Girl "I Wish You a Merry Game for Two ..." 15 - 18 18 - 22
STEEN 1930-1940
 REB logo
 Series K744 Belgian Captions (2) 10 - 12 12 - 15
TAYLOR, A. (GB) 1930-1950
 Bamforth Co. Comic Series
 730 Man "Bloody Hell" Chrome 8 - 10 10 - 12

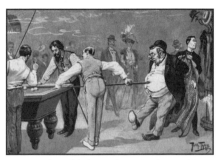

Arth. Thiele, T.S.N. Series 1155
No Caption

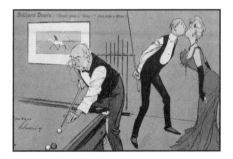

Lawson Wood, Valentines, "Billiard
Don'ts: Don't miss a kiss"

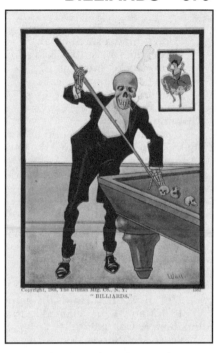

Bernhardt Wall, Ullman Mfg. Co.
No. 1382 -- "Billiards."

1033 Boy/Girl "Blimey - This looks like being ..."	10 - 12	12 - 15
THACKERAY, LANCE (GB) 1905-1915		
Raphael Tuck "Write Away"		
Series 1328		
Boy/Girl "I am pleased to learn"	25 - 30	30 - 35
Man "I hope this will reach"	25 - 30	30 - 35
Series 1381		
"There is just room"	25 - 30	30 - 35
THIELE, ARTH. (GER-DEN??) 1905-1920		
T.S.N. (Theo Stroefer, Nürnburg)		
Series 1155 Comical Players (6)	35 - 40	40 - 50
Series 1942 Comical Players (6)	35 - 40	40 - 50
URTZO 1905-1915		
LMM logo		
Series 36 612-617 Men (6)	15 - 20	20 - 25
VALKONEN (FIN) 1940's		
S P Oy H.P.		
Man Finnish Caption	25 - 28	28 - 32
WALL, BERNHARDT (US) 1905-1915		
Ullman Mfg. Co.		
500 Drink "Froze"	12 - 15	15 - 18
508 Drink "Kiss"	12 - 15	15 - 18
1382 Skeleton "Billiards"	15 - 18	18 - 22
WOOD, LAWSON (GB) 1910-1940		
Valentine's Series		
"Billiard Don'ts" Series		
"Don't mark a marker"	20 - 25	25 - 28

"Don't mind a small break"	20 - 25	25 - 28
"Don't miss a kiss (but Kiss a Miss)"	20 - 25	25 - 28
"Don't pocket everything"	20 - 25	25 - 28
"Don't stop a nursery cannon"	20 - 25	25 - 28
"Don't use the table for a rest"	20 - 25	25 - 28

Valentine & Sons
"Gran'pop Series"

1128 Chimps "Gran'pop tries a difficult shot"	15 - 18	18 - 22

ZABOKRTSKY, FR. (CZECH) 1905-1915
 Anonymous

Two men banging heads, viewing balls	20 - 25	25 - 30

PUBLISHERS

B.B., London (Birn Bros.) 1905-1915

E.14 Boy/Girl "His Reactions - Thro' slavish ..."	10 - 15	15 - 18

Bamforth Co. 1905-1915
 Printed Photos

1251 Boy/Girl "A Kiss Off the Red"	10 - 12	12 - 15
1744 Boy/Girl "How's the game, marker? ..."	10 - 12	12 - 15
1821 Man "I am detained in town on business"	10 - 12	12 - 15

Julius Bien & Co. 1905-1915
 "Excuse Me" Series 35

"Excuse Me, said the Billiard Sharp ..."	18 - 22	22 - 26

Publisher P. Sander, 1908
"Hello, is that you Darling?"

Publisher L.G. Premier Series 2009
"I am advised to take a rest"

Publisher Raphael Tuck Impressionist
Series 1302 — "A long shot."

Publisher National Series, No. 240
"The famous 'push, screw-back, and tear the cloth' shot!"

Coloprint B 1940-1950
 Dressed Dogs 112 Foreign Caption 8 - 10 10 - 12
 Chicks 7261 Foreign Caption 8 - 10 10 - 12
Colourpicture Publishers Linen
 722 Man "Say - Here's your Cue!" 6 - 8 8 - 10
E.M. in diamond 1905-1915
 Series 1001 Boy/Girl "Where's the Spot, Dearie?" 10 - 15 15 - 18
Eagle & Shield logo 1905-1915
 Man "Hello, is that you Darling ..." 10 - 15 15 - 18
F A S 1905-1915
 Boy/girl 19 "The only two ..." 15 - 18 18 - 22
Gale & Polden, Ltd. 1905-1915
 Military
 Series 90 "Prince of Wales Battle Honors" 18 - 22 22 - 26
H.B. Ltd. 1905-1915
 2857 Drink "Wot yer mean, playin' with nine ..." 15 - 18 18 - 22
H.M. & Co. 1905-1915 (B&W)
 Series 21 Dressed Animals 12 - 15 15 - 18
Rose Hyman 1905-1915
 16 Man "A Combination Shot" 10 - 15 15 - 18
K & B, C. 1905-1915
 Series 3117 (2) German captions 12 - 15 15 - 18
A.H. Katz 1905-1915
 Series 314 Boy/Girl "Le Billiard" 10 - 15 15 - 18
Leo Kemper & Co. 1910-1920 12 - 15 15 - 18
 "Gruss vom Wulfeller Thurm" 20 - 25 25 - 30
LG in shield logo
 Premier Series
 2009 "I am advised to take a rest" 30 - 35 35 - 40
L H, Paris 1910-1920
 Man "La Partie de Billiard" 15 - 18 18 - 22

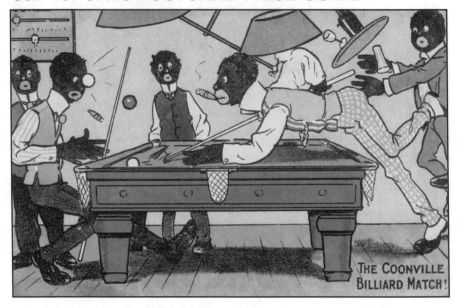

Publisher Valentine & Sons, Ltd. —"The Coonville Billiard Match!"

LMM logo

Series 36 613 No Caption		15 - 18	18 - 22
Metrocraft Linen			
510 "All men here are broad minded!"		4 - 5	5 - 6
National Series 1905-1915			
Series 240			
"A Push Stroke"		15 - 20	20 - 25
"An Anxious Moment"		15 - 20	20 - 25
"Beastly Fluke"		15 - 20	20 - 25
"Cannon off the Red"		15 - 20	20 - 25
"The Famous 'Push, Screw-back, and tear the' ..."		15 - 20	20 - 25
"You're Another!"		15 - 20	20 - 25
"Billiard Tips" Series (6)			
1377 Man "A Fluke"		15 - 20	20 - 25
1380 Man "A Cannon"		15 - 20	20 - 25
Others			
1834 Drinking "Cannon off the Red"		15 - 20	20 - 25
2810 Drinking "In off the Red"		15 - 20	20 - 25
John Neury (GB) 1905-1915			
Boy/Girl "A Lost Game"		15 - 18	18 - 22
O.G.Z.-L 1905-1920			
Series 246			
1483 Dressed dog "Eine Gute Stellung"		15 - 20	20 - 25
P.F.B. (Paul Finkenrath, Berlin) 1905-1915			
Series 8174 (6) Comical Players Embossed *			
"Cannon off the cush!"		25 - 28	28 - 32
"My Fault. Don't Apologize, Old Chap!"		25 - 28	28 - 32
"Um! That shot will cost more than the game"		25 - 28	28 - 32
"Yes, They are Touching"		25 - 28	28 - 32

*** Set also has German and French captions
and a set without captions.**

Brunswick-Balle-Collender Co.
"FROZE?"

Publisher Woolstone Brothers
Milton Series 496, "It strikes me ..."

Biljart "Monarch"
"Specialiteit in Tafelbiljarts"

*Jackie Gleason and Willie Mosconi, Former World Champion of Pocket Pool
Anonymous Publisher, Real Photo*

Wiener Rotophot 1905-1915		
Series 2372	20 - 25	25 - 28
Woolstone Bros. 1905-1915		
The Milton Series 496 (6)		
"I Felt Inclined"	20 - 25	25 - 30
"It strikes me"	20 - 25	25 - 30
"I Was in Grand Form"	20 - 25	25 - 30

ANONYMOUS

"L'Accident"	15 - 20	20 - 25
Series 137 Foreign Caption	12 - 15	15 - 18
Series 150 "A cannon off the Red"	15 - 18	18 - 22
French Card (Undb)		
Le Billard Oversized bearded men at table	30 - 35	35 - 45
French Card (Undb.)		
Beautiful Lady - Head in rack	25 - 30	30 - 35
Imps Children Series 5		
"The Imps Billiard Tournament"	10 - 12	12 - 15
Men		
"If You and I were Billiard Balls"	10 - 12	12 - 15
"It were not best that we should ..."	10 - 12	12 - 15
Skeleton Series 5 "They try a Cue. Satan ..."	12 - 15	15 - 18

MISCELLANEOUS

Advertising		
Brunswick-Balle-Collender Co., "FROZE"	30 - 35	35 - 40

Iris Pastel AMPN Patent		
Anonymous French "Il n' usait pas l' Iris Pastel!"	25 - 30	30 - 35
St. Michels Cigarettes 1905-1915		
"Les Heures de al Cigarettes"	25 - 30	30 - 35
Monarch Cushions 1910-1920		
"The B B C Co. - Monarch Cushion ..."	20 - 25	25 - 30
Tafel Biljarts 1910-1920		
"Biljart Firma Monarch, Amsterdam"	90 - 100	100 - 110
Walkover Shoes 1905-1915		
"Take Your Cue"	12 - 15	15 - 20
Pool Rooms, Pool Rooms, Parlors, etc.		
1900-1940		
Real Photo		
Interiors	30 - 40	40 - 60
Exteriors	20 - 30	30 - 40
Color & printed photos		
Interiors	15 - 18	18 - 25
Exteriors	12 - 15	15 - 20
Post 1940		
Real Photo		
Interiors	10 - 12	12 - 20
Exteriors	8 - 10	10 - 15
Color & printed photos	6 - 8	8 - 12
Players		
Movie stars, etc.	15 - 20	20 - 25
Famous players		
Real Photos		
Willie Hopp	30 - 40	40 - 50
Willie Mosconi	25 - 30	30 - 40
Others	15 - 20	20 - 25
Unidentified	10 - 12	12 - 15
Printed Photos		
Willie Hopp	20 - 25	25 - 28
Willie Mosconi	15 - 20	20 - 22
Others	10 - 12	12 - 15
Unidentified	8 - 10	10 - 12
Tournaments, Exhibitions		
1900-1930		
Real Photo	40 - 50	50 - 75
Printed Photo	20 - 30	30 - 40
Artist drawn	25 - 30	30 - 35
Post 1930		
Real Photo	20 - 30	30 - 40
Printed or Color	15 - 20	20 - 25
Artist drawn	20 - 25	25 - 30

Die ist richtig!

Arth. Thiele, S.W.S.B., No. 5351
"Die ist richtig!"

Although the game of bowling has been traced back for centuries, it first became popular in the U.S. around 1900. In 1875 the American Bowling Congress was formed in New York City, and its first tournament was held in 1901. It was this spirited competition that started bowling's spectacular growth. It is a sport for the entire family, as well as for team play and professionals, and it has been estimated that more than 40 million people bowl at least once during a year.

In the early part of the century, bowling was a fun sport and the artists of the era dramatized it that way. Most of the participants are shown at the approach giving a great effort to release the heavy ball without fouling or following it down the alley. Onlookers seem to revel at the antagonism suffered by each kegler.

The German artists, led by Arth. Thiele, A. Greiner, and R. Carl (who did an unusual and rare series on the plight of pin boys) produced some of the better material. Publishers PFB, R&K and Raphael Tuck also released some great sets that are among those desired by collectors. As is true in most of the other sports, there are very few postcards showing famous or professional bowlers.

ARTIST-SIGNED

	VG	EX
A.A. 1905-1915		
National Series		
Series 559 "The Bowling Supper"	$10 - 12	$12 - 15
ANDERSON, ELMER 1905-1915 Chrome		
H.K. Kittrell & Co.		
Series 52 "I knocked the little boy down ..."	2 - 3	3 - 4

BAILIE, S. (BEL) 1905-1915
 De Rycker & Mendel
 Advertisement "Saint-Sauveur Montagne-Aux ..." 30 - 35 35 - 38
BEATY, A. 1905-1915
 Commercial Colortype
 Series 328 - "The Coming Champs" 20 - 25 25 - 30
 Anonymous Children "Auf-Setzen" 12 - 15 15 - 20
BEAUVAIS, CH. (FR) 1905-1915
 Moullet
 Advertisement "Les Sports" XXXI
 "La Boulomanie - 100,000 Corsets ..." 20 - 25 25 - 28
BORISS, MARGRET (NETH) 1910-1920
 Amag
 Series 0384 Children 10 - 15 15 - 20
BUCHANAN, FRED (GB) 1905-1915
 Raphael Tuck "Bowls Illustrated"
 Series 3638 (6)
 "The Deciding Shot" 15 - 20 20 - 25
 "The Skips" 15 - 20 20 - 25
CARL, R. (GER) 1905-1915
 Bernhard Friede
 Children Pinsetter Series
 "Da steht der Essigmann!" 50 - 55 55 - 65
 "Da steht der Gerbertor!" 50 - 55 55 - 65
 "Der Kegelmorder!" 50 - 55 55 - 65
 "Der Spitswurf!" 50 - 55 55 - 65
 "Hamburg mit Sauce!" 50 - 55 55 - 65
 "Victoria! Victoria! Alle Neune liegen da!" 50 - 55 55 - 65

Margret Boriss, Amag, 0384 — No Caption

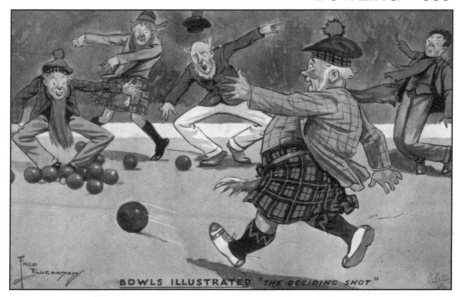

Fred Buchanan, Raphael Tuck 3638 — "Bowls Illustrated -- That Deciding Shot"

CARRERE (FR) 1905-1920 (Also see O-Carrere)
 Marque L-E "Sports Feminins"
 Series 100 25 - 28 28 - 32
CHAS (GB) Chrome
 Bamforth Co.
 Series 1054 "They win it every year" 3 - 5 5 - 7
CHRISTY, F. EARL (US) 1905-1920
 Anonymous
 554 Lady Bowling - No caption 12 - 15 15 - 18
 Illustrated Post Card & Novelty Co.
 Sports Series
 554 Lady Bowling (Same as Anonymous) 15 - 18 18 - 22
 5006-6 18 - 22 22 - 26
 Platinachrome, 1905
 No No. Lady Bowler 20 - 25 25 - 30
COLOMBO, E. (IT) 1910-1930
 A. Guarneri
 Series 2328 (6) Children 15 - 20 20 - 25
DAVIS, S.E. 1905-1915
 Anonymous "The Haunts of Rip Van Winkle" 15 - 18 18 - 22
DE YONCH (US) 1905-1915
 National Art Co.
 13 "Bowling Girl" 15 - 20 20 - 25
E.G. 1905-1915
 B.K.W.I.
 Series 925-2 "Wehe Wenn sie Losgellassen!" 20 - 25 25 - 28
FV in box logo 1905-1915
 LP in triangle logo
 Series 228 (I-VI) Children 15 - 20 20 - 25
GALBIATI, G. 1905-1920
 T.E.L. in oval logo
 "Un Magnifico Colpo" 15 - 18 18 - 22

R. Carl, Bernhard Friede
"Victoria! Victoria! Alle Neune ..."

A. Greiner, C.A. & Co., 4117
No Caption

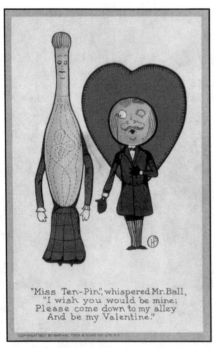

H.B., Raphael Tuck, "Coupling Pins"
No. 4, "Miss Ten-Pin ..."

Am. Lynen, Brabant, Brussels, No. 33
No Caption

K.V., LP 228/VI
No Caption

GREINER, A. (GER) 1905-1915
C.A. & Co.

4117 Dressed Dog No caption	20 - 25	25 - 30

GUNN, ARCHIE (US) 1905-1920
National Art Co.

13 Bowling Lady	22 - 25	25 - 28

H 1900-1910

Anonymous "Don't waste your time and money ..."	8 - 12	12 - 15

HB in circle logo (GB) 1905-1915
Raphael Tuck "Coupling Pins" Valentine

Series 4 "Miss Ten-pin ..."	10 - 12	12 - 15

HENDSCHEL, A. (GER) 1905-1915
Martin Rommel & Co. (B&W)

24 "Kegelbub"	12 - 15	15 - 18

HOFFMAN, AD (GER) 1905-1915
SWSB
Series 9974 (4)

"Die Kegelschwester"	15 - 20	20 - 25
"Ein Volltreffer"	15 - 20	20 - 25

JIRAS, A. 1905-1915
Raphael Tuck "Kegler"

Series 519 (6)	20 - 25	25 - 30

K.V. 1905-1915
LP in triangle

228/VI No caption	15 - 18	18 - 22

LUDOVICI, A. 1905-1915
Davidson Bros. "Fiscal Games"

Series 6103 "Fiscal Games - Skittles"	15 - 18	18 - 22

LYNEN, AM. 1905-1915
Brabant, Bruxelles

33 No caption	15 - 20	20 - 25

Anonymous
"De-Ci De-La" Series

"De-Ci De-La" Series	15 - 20	20 - 25

M.D.S. (US) 1905-1915
Ullman Mfg. Co. "Sporty Bears"

83 "King of the Alley"	25 - 30	30 - 35

MALLET, BEATRICE (FR) 1905-1920

Advertisement "Cigarettes St. Michel"	15 - 20	20 - 25

MALLOCK, R.M. (GB) 1905-1915
Anonymous

452 "Quoits"	12 - 15	15 - 20
454 "Bowling"	12 - 15	15 - 20

MYER (US) 1905-1915
Aurocrome "Limerick"

A37 "The Bum Bowler ..."	10 - 12	12 - 15

NAILLOD, CH. (FR) 1905-1915
Breger & Lang
Series A

1 "Bowling a Londres"	40 - 45	45 - 50
2 "Bowling a Berlin"	40 - 45	45 - 50
3 "Bowling a Petersbourg"	40 - 45	45 - 50
4 "Bowling a Madrid"	40 - 45	45 - 50
5 "Bowling a Bruxelles"	40 - 45	45 - 50
6 "Bowling a Rome"	40 - 45	45 - 50

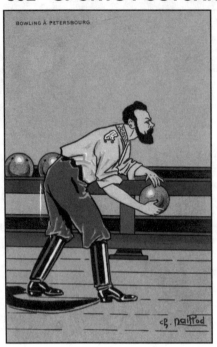

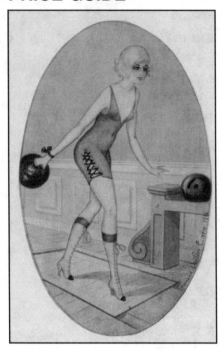

Ch. Naillod, Breger & Lang, Paris
"Bowling Á Petersbourg"

Ouillon-Carrere, L-E
"Sports feminins" Series 100

OUTCAULT, R.F. (US) 1905-1920
 J. Ottman Litho Co.

"Spare. Oh, Spare Us"	20 - 25	25 - 28

QUISTERRANT, F. 1905-1915
 A C & Co.

3604 Man "Gut Holz!"	12 - 15	15 - 18

R.W. (GER) 1905-1915
 Meissner & Buch Silhouette

Series 1929 (6) "Gut Holz"	15 - 20	20 - 25

RIGHT 1905-1920
 I. Lapina

Political 2750 "A Ton Tour. Down Him Sammy"	20 - 25	25 - 30

SAGER, XAVIER (FR) 1905-1920
 S.R.A.

4 "Le Bowling du Bal Tabarin ..."	25 - 30	30 - 35
Anonymous "Le Bowling"	20 - 25	25 - 28

SCHÖNPFLUG, FRITZ (AUS) 1905-1915
 B.K.W.I.

Series 417-4 "Le Debutant"	20 - 25	25 - 30
Series 925 (8)	20 - 25	25 - 28

THIELE, ARTH. (GER-DEN?)
 G.D.L.
 Series 266 (6)

3 "Hamburg mit Bruhe!"	20 - 25	25 - 35

 Gebruder Dietrich
 Military Series 153 (8)

7 "Unter alten Freunden"	18 - 22	22 - 26

R. W., Meissner & Buch, Series 1929
"Gut Holz!"

Right, I. Lapina, 2750
"A Ton Tour!"

Fritz Schönpflug, B.K.W.I., 417-4
"Le Débutant"

Carl Rogind, Stenders — "Glaedeligt Nytaar"

T.S.N. (Theo Stroefer, Nürnburg)

Series 1427 (6)	18 - 22	22 - 26
Series 1682 (6)	22 - 26	26 - 32

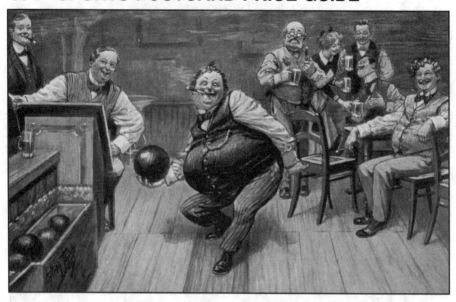

Arth. Thiele, T.S.N., 1682 — No Caption

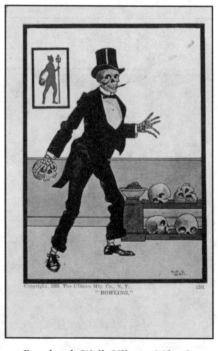

C.H. Twelvetrees, National Art, 269
"A Sure Strike"

Bernhardt Wall, Ullman Mfg. Co.
No. 1381 — "Bowling."

SWSB
 Series 5351 (6)
 "Alle Neune!" 25 - 30 30 - 35

"Die is Richtig!"	25 - 30	30 - 35
"Schweres Kaliber"	25 - 30	30 - 35
TWELVETREES, C. (US) 1905-1920		
National Art Co.		
269 "A Sure Strike"	12 - 15	15 - 20
W.F.D. 1905-1915		
SWSB		
Series 13 "Gut Holz"	18 - 22	22 - 26
WALL, BERNHARDT (US) 1905-1915		
Ullman Mfg. Co.		
510 "A Poodle"	10 - 12	12 - 15
511 "A Strike"	10 - 12	12 - 15
1381 "Bowling" (Undb)	15 - 20	20 - 25

PUBLISHERS

A H Co. 1905-1915		
Anonymous "A Strike Agitator"	10 - 12	12 - 15
Amag 1905-1915		
Series 2908 Children "Boldog uj Evet"	10 - 12	12 - 15
F. von Bardeleban 1905-1915		
"Sports" U.S. 7?? "Sports - Bowling"	10 - 12	12 - 15
Julius Bien & Co. 1905-1915		
Series 17 "Sally in Our Alley"	10 - 12	12 - 15
"Excuse Me" Series 35 "The Bowler"	12 - 15	15 - 18
Coloprint B 1930-1940		
Series 230 Animals	8 - 10	10 - 12
Colourpicture Publishers Linen		
634 "Oh Boy! This Place is ..."	3 - 4	4 - 6
741 "For Real Fun - This Place is Right ..."	3 - 4	4 - 6
Dexter Press Chrome		
SS-54560-B "How to prevent a 'split' - wear ..."	2 - 4	4 - 5
SS-54561-B "How to improve your score ..."	2 - 4	4 - 5
E.S.W. 1900-1910		
Animals	15 - 20	20 - 25
Erika 1905-1915		
Series 3023 Animals Embossed "Christmas Greeting"	8 - 10	10 - 12
Louis Glasner 1900-1910		
Series 1005	10 - 12	12 - 15
Graphismes 1905-1915	10 - 12	12 - 15
Hatchette & Cie. 1900-1910		
"Sports & Jeux" Advertisement		
6 "Le jeu de Boules - La Belle Jardiniere ..."	15 - 20	20 - 25
Unger Heininger & Co. 1905-1915		
Valentine 107 "Among all the hearts that now ..."	6 - 8	8 - 10
International Art Pub. Co. 1905-1915		
Anonymous	10 - 12	12 - 15
International P.C. & Novelty Co. 1905-1915		
Series 197-1 "I'll Strike You Out"	12 - 15	15 - 18
V. Kolbra 1905-1915 (Polish)		
Series 57 "Kuzelkarske Spolecnosti"	15 - 20	20 - 25
Arthur Livingston 1900-1915		
Limerick Series 1131 "The Bowler"	8 - 10	10 - 12

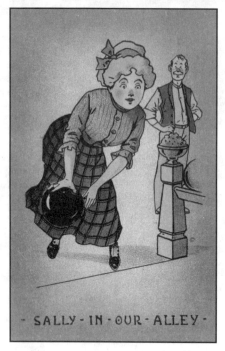

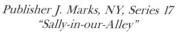

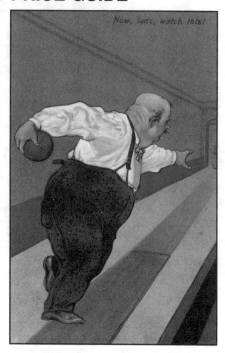

Publisher J. Marks, NY, Series 17
"Sally-in-our-Alley"

Publisher P.F.B., Series 8372
"Now, Lads, watch this!"

Luna 1905-1915
 Hold-To-Light

157 "Alle Neune"	25 - 30	30 - 40

M.N. & C. 1905-1915
 Series 6605

	10 - 12	12 - 15

J. Marks, N.Y. 1905-1915
 Series 17 "Sally-in-our-Alley"

	15 - 18	18 - 22

Meissner & Buch 1905-1915
 Silhouette Series 1929 (See artist R.W.)
NPG logo 1905-1915
 Series 8152-6

	10 - 12	12 - 15

National Art Co. 1905-1915

286 "An Exasperating Miss"	15 - 20	20 - 25
287 "I'm On"	15 - 20	20 - 25
289 "How Does This Strike You"	15 - 20	20 - 25

National Series 1905-1915
 Series 459 (6)

"Blow Her Up! Blow Her Up!"	12 - 15	15 - 18
"Settling Up the Score"	12 - 15	15 - 18
"The Skip's Last Effort"	12 - 15	15 - 18
Series 1187 "Man You're No Up"	12 - 15	15 - 18

 Bowling Series 1312 (6)

"Carrying the winner ..."	15 - 18	18 - 22
"The Champions Disagree"	15 - 18	18 - 22
"The Last Throw"	15 - 18	18 - 22
"Laying It Dead"	15 - 18	18 - 22

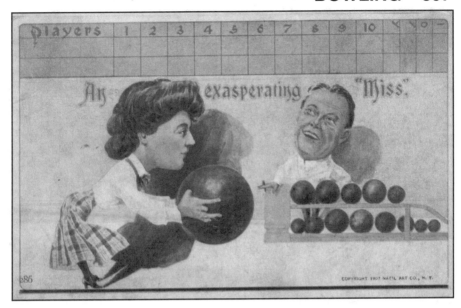

Publisher National Art, No. 286 — "An Exasperating Miss"

A. Norgeu 1905-1915		
Chocolat Lombart Advertisement	12 - 15	15 - 20
Nu-Print Chrome		
"The Bowling Trio"	1 - 2	2 - 3
Oxford U. Press 1910-1920		
"Mediaeval Sports"		
LVIII-14 "Ninepins"	6 - 8	8 - 10
PFB (Paul Finkenrath, Berlin) 1905-1915 (Emb)		
Series 8372		
"Attitude is Everything"	15 - 20	20 - 25
"Now Lads, Watch This!"	15 - 20	20 - 25
"Rotten!"	15 - 20	20 - 25
"So Easy, Don't You Know!"	15 - 20	20 - 25
"That'll Fetch 'Em"	15 - 20	20 - 25
"This is the Correct Pose, Dear Boy!"	15 - 20	20 - 25
Plastichrome Chrome		
P36025 "Mary had a little swing ..."	2 - 3	3 - 4
P55280 "Now or never 300 Club"	2 - 3	3 - 4
Proga, Paris 1905-1915		
Children	10 - 12	12 - 15
R&K in a sunburst logo 1905-1915		
Series 1728		
"Ja, so sind wir!"	15 - 20	20 - 25
"Man hat's nich Leichtig"	15 - 20	20 - 25
"Noblesse Oblige"	15 - 20	20 - 25
"Sie-wird-dach-nicht"	15 - 20	20 - 25
SWSB 1905-1915		
Series 641 "Alle Neune!"	12 - 15	15 - 18
Schlesinger Bros. 1905-1915 (B&W)	10 - 12	12 - 15
Walter Schott 1910-1920		
Real Photo "Jeu de Boule"	18 - 22	22 - 26

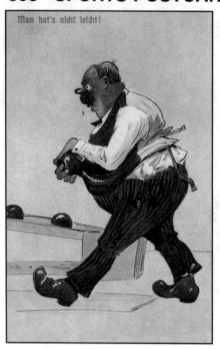

Publisher R&K, Series 1728
"Man hat's nicht leicht!"

Anonymous, Series 576
No Caption

T.P. & Co. 1905-1915 (Emb)
 "Bug Club" "I elect you member of the Bug Club" 12 - 15 15 - 18
TR Co. (The Rose Co.) 1905-1915
 "A Bum Bowler" 10 - 12 12 - 15
Tichnor Bros. Linen
 "It Strike Me ..." 4 - 5 5 - 6
Raphael Tuck 1905-1915
 Valentine Series 6 (Undb)
 "The Bowler has a record fine ..." 8 - 10 10 - 12
 "Old English Sports"
 Series 7018
 "Bowls" 12 - 15 15 - 18
Ullman Mfg. Co. 1905-1915
 1523 Children "Prize Bowling" 10 - 12 12 - 15
V.E.D. 1905-1915 (B&W)
 Political "Resultat Uitslag: Brouette, 27 Mai, 1906" 20 - 25 25 - 30
H.C. Westerhouse 1900-1910
 Series 35 "The Lady Bowler" 6 - 8 8 - 10

ANONYMOUS

Advertisement 1905-1920
 P-1390 "The Brunswick-Balke-Collender Co." 40 - 45 45 - 50
Blacks (B&W) "Gut Hol" 25 - 30 30 - 35
Imps
 Series 1 "The Imps Bowling" 12 - 15 15 - 20
Series 119 "Troubles of a pin boy" 10 - 15 15 - 18

Series M.280 (B&W)

"Always put it to 'em straight ..."	8 - 10	10 - 12
"Be moderate. Don't play the alleys ..."	8 - 10	10 - 12
"Don't let this lead to this"	8 - 10	10 - 12
"If you want to win never show the white feather"	8 - 10	10 - 12
"Let me be your duckpin ..."	8 - 10	10 - 12
"Never acquire a taste for highballs"	8 - 10	10 - 12
"Never be Hasty. You may get eleven ..."	8 - 10	10 - 12
"Never miss the head pin Mr. Handsome"	8 - 10	10 - 12
"Rolling in the alley is all right ..."	8 - 10	10 - 12
"Your score is bad with me"	8 - 10	10 - 12
"When you are down this way ..."	8 - 10	10 - 12
"When you are 'round this way"	8 - 10	10 - 12
"With a handsome bowler ..."	8 - 10	10 - 12
"You always do things so gracefully"	8 - 10	10 - 12
"Your score is high with me"	8 - 10	10 - 12

Series 576 15 - 18 18 - 22

MISCELLANEOUS

Advertising
"The Brunswick-Balke-Collender Co."

Anonymous P-1390	35 - 40	40 - 45
"Chocolat Lombart" Signed **A. Norgeu**	10 - 12	12 - 15

"Le Jeu de Boules" Sports & Jeux

Hachette & Cie. "Édition de la Belle Jardinere"	15 - 20	20 - 25

Animals Bowling
Pre-1920

B&W	10 - 12	12 - 15
Color	15 - 18	18 - 25

Post 1920

B&W	6 - 8	8 - 10
Color	10 - 12	12 - 16

Bowling Alleys
Early 1900-1930

Exteriors Color, B&W	10 - 12	12 - 15
Interiors Color, B&W	15 - 18	18 - 22
Exteriors Real Photo	20 - 25	25 - 30
Interiors Real Photo	25 - 30	30 - 35

Post 1930

Exteriors	6 - 8	8 - 12
Interiors	8 - 10	10 - 15

Religious Bowling 6 - 8 8 - 10
Tournaments, Exhibitions, early

Color, B&W	15 - 20	20 - 25
Real Photo	25 - 30	30 - 35

Post 1950

Color	8 - 10	10 - 15
Real Photo	12 - 15	15 - 20

Famous Bowlers

Pre-1930	20 - 25	25 - 35
Post-1930	10 - 12	12 - 18

Xavier Sager, Aux Courses, Series 162
"Le bon tuyau"

RACING

Whether it be horse racing, steeplechase, harness racing, or the fox hunting days of old, each tend to dramatize the power, the elegance and the speed of majestic thoroughbreds doing their utmost to heed the commands of their rider or driver. The use of the horse in sports has always had very wide universal appeal, and in recent years has increased in popularity. This success has brought about modernization of tracks and parks, and has increased attendance worldwide.

Love of horses induces collectors to search for their postcards and love for wagering brings millions of people to the thoroughbred tracks to watch them run. These factors also contributed to the choices by early artists to use horse racing in their works for the postcard industry. Many show the majestic beauty of the horse in various stages of races, and others illustrate the comical side. Collectors find that the better artists usually produced different series from racing, steeplechase, trotting and fox hunting, while others sometimes painted one or two cards of each sport and incorporated them for use in a single set or series.

Images by artists Ludwig Koch, C. Becker, Harry Elliott, J. Thomas and Donadini, Jr. are greatly pursued by collectors. Very much in demand are postcards of the champions of the sports, especially those of the famous trotters Dan Patch, Loudillion, Adios Boy, Adios Butler and Billy Direct in harness racing. The great racing horses Man-of-War, Citation, Bold Ruler, Native Dancer, Secretariat, Spectacular Bid, Whirlaway, Armed, Beldame, Count Fleet, Discovery and Commando are also very collectible.

HORSE RACING

ARTIST-SIGNED

	VG	EX
AK (AUS) 1905-1915		
B.K.W.I.		
Series 724 (6)		
3 "Concurrent Du Derby"	$15 - 18	$18 - 22
5 "Le Favour!"	15 - 18	18 - 22
BECKER, C. (GER) 1905-1915		
Meissner & Buch		
Series 1003 (**Series also contains steeplechase**)		
"Aufdem Sattleplatz"	20 - 25	25 - 28
"Der Start"	20 - 25	25 - 28
"Der Sieger"	20 - 25	25 - 28
"Finish"	20 - 25	25 - 28
"Nach Dem Rennen"	20 - 25	25 - 28
"Vor Dem Rennen"	20 - 25	25 - 28
BROEKMAN, N. 1950's		
Anonymous		
"De Favoriet Van Duindigt"	8 - 10	10 - 12
BROWN, TOM (GB) 1905-1915		
Davidson Bros.		
Series 2513 "In the Paddock"	12 - 15	15 - 18
Series 2638 "Pa meets a nice affable gentleman ..."	12 - 15	15 - 18
BUSI, ADOLPHO (IT) 1915-1925		
Dell'Anna & Gasparini		
Series 569-1	25 - 28	28 - 32
CARTER, SYDNEY (GB) 1905-1915		
S. Hildesheimer & Co.		
"Race Horse Impressions" Series		
"The Finish"	10 - 12	12 - 15
"The Latest Tips"	10 - 12	12 - 15
""Ere' Y are Sir {Race Card and Yeller Card'"	10 - 12	12 - 15
CENNI, Italo (IT) 1910-1920		
Rev. Stampa, Milano		
Series 145-1 Animal	12 - 15	15 - 20
COLOMBO, E. (IT) 1910-1930		
GAM in circular logo		
Series 1847 (6)	18 - 22	22 - 26
Lixoni Amical		
Series 2414 No caption	15 - 20	20 - 25
Rev. Stampa		
Series 6225 (407) No caption	20 - 25	25 - 30
DONADINI, JR. (IT) 1905-1915		
R. Tuck		
Series 6163 "Won in a Canter"	15 - 20	20 - 25
DRUMMOND, NORAH (GB) 1905-1915		
"Man's Best Friend" Series 8650 (6) (some not racing)	15 - 20	20 - 25
DWIG (Clare Dwiggins) (US) 1905-1915		
R. Kaplan "How Can You Do It On___?"		
Series 49 $7.50 Per	12 - 15	15 - 18

C. Becker, Meissner & Buch
Series 1003 -- German Caption

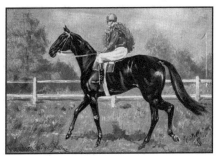

Donadini, Jr., R. Tuck, Series 6163
"Won in a Canter"

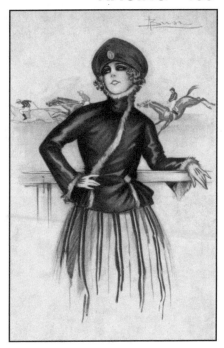

A. Busi, Dell' Anna & Gasparini
Series 569-1 — No Caption

ELLAM, WILLIAM (GB) 1905-1915
 Hildesheimer & Co.
 "Bachelor Girl's Club" 20 - 22 22 - 26
ELIOTT, HARRY (GB) 1905-1915
 Anonymous French Publisher 18 - 22 22 - 25
 E.D.S
 2 No caption 18 - 22 22 - 26
F.M. 1905-1915
 G.S.B.
 Series 136 "'Whoa' Emma" (Golliwogg) 25 - 30 30 - 35
FLESSOR, H. 1905-1915
 GD&D "Only a Neck in it" 20 - 25 25 - 28
FLEURY, H. (GB) 1905-1915
 GD&D "Star Series"
 "A Fair Winner" 12 - 15 15 - 18
 "A Promising Winner For the Next Derby" 12 - 15 15 - 18
 "Bookie Paying Out Winners" 12 - 15 15 - 18
 "One on Pretty Polly" 12 - 15 15 - 18
 "Only a Neck In It" 12 - 15 15 - 18
 "Winners Returning Home" 12 - 15 15 - 18
G.D.R. 1905-1915
 Anonymous "Racing Colours"
 Series 4607 (6)
 "At the Post - Mr. L. Rothchild's Duke of Portland" 15 - 20 20 - 25
 "The Parade - Duke of Westm. Mr. Jersey's" 15 - 20 20 - 25
 "Pulling Up - Lord Rosebery's Mr. J. Gubbins" 15 - 20 20 - 25
 "They're Off - Capt.'s Loder's Mr. T. Cannon ..." 15 - 20 20 - 25

H. Eliott, Anon. French Publisher
No Caption

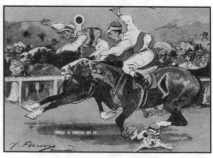

H. Flessor, GD&D
"Only a Neck in it."

F.M., G.S.B., Series 136
"Whoa" Emma

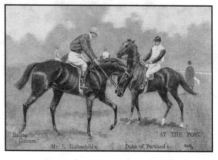

G.D.R., Anonymous, "Racing Colours"
Series 4607, "At the Post."

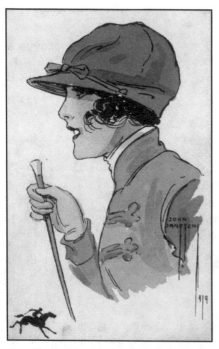

John Janssens, Publisher Janssens
Edition Sportswoman, No. 19

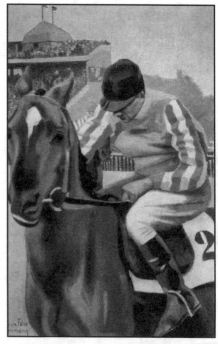

Felix Lehmann, O.G.Z.-L., Series S.32
No. 328 —"Vor dem Start"

Felix Lehmann, O.G.Z.-L., 329
No Caption

Ludwig Koch, B.K.W.I., 473-2
No Caption

Ludwig Koch, B.K.W.I., 377-4
"Flachrennsport"

"Up the Straight - M.E. Blanc's Lord Falmouth's"	15 - 20	20 - 25
GF within C logo (G.F. Christie) 1905-1915		
WR&S in shield "What's Your Crest"		
Series 9321 "The Sportsman's Crest"	12 - 15	15 - 20
GK (George King) (GB) 1905 -1915		
Hartmann		
987 No caption	12 - 15	15 - 18
GASSAWAY, KATHARINE (US) 1905-1915		
Rotograph Co.		
F.L. 152 Children "The Would-Be Sport"	12 - 15	15 - 18
HC logo (Hans Christiansen) (GER) 1900-1010		
Anonymous "Paris"	150 - 160	160 - 170
JANSSENS, JOHN (GB) 1905-1915		
Janssens		
Edition Sportswoman, 19 No caption	25 - 30	30 - 35
JUNKER, HERMAN (GER) 1905-1915		
E. Nister		
Series 362-21 No caption	18 - 22	22 - 26
KING, G. 1905-1915		
P.F.B. (Emb)		
Series 3027 No caption	15 - 18	18 - 22
KOCH, LUDWIG (GER) 1905-1915		
B.K.W.I.		
Series 377-4 "Flachrennsport"	20 - 25	25 - 28
Series 473-2 Race horse vs. Trotter	20 - 25	25 - 28

KV, LP, No. 224-V
No Caption

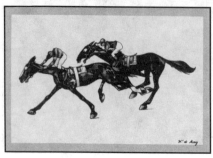

W.R. de May, Sauberlin & Pheiffer
No Caption

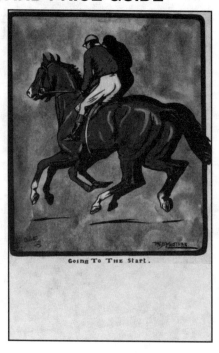

F.N.D. Masters, R. Tuck, Series 9419
"Going to the Start"

LEHMANN, FELIX (GER) 1905-1915		
O.G.Z.-L		
Series S. 32		
328 "Vor dem Start"	18 - 22	22 - 26
MASTERS, F.N.D. (GB) 1905-1915		
Raphael Tuck		
Series 9419 (6)		
"The Favourite"	15 - 18	18 - 22
"Going to the Start"	15 - 18	18 - 22
"The Preliminary Canter"	15 - 18	18 - 22
de MAY, W.R. (SWI) 1905-1915		
Chartreuse Suisse Ad for Liquor Clementine	15 - 20	20 - 25
Sauberlin & Pheiffer Comical	15 - 18	18 - 22
MICH (FR) 1905-1915		
Sid's Editions Children		
7080-10 "Le Celebre Jockey ..."	12 - 15	15 - 18
Grands Et Petits		
Wall, Paris		
Advertisement "Turin Mazza - Premier des ..."	125 - 135	135 - 150
MIGNOT, V. (FR) 1905-1915		
Deitrich & Co.		
Art Nouveau Girl watching race horses go by.	100 - 110	110 - 125
NBC 1905-1915		
J. Tully 259 No caption	12 - 15	15 - 18
OPPER, F. (US) 1900-1910		
Mutual Book Co.		
"Just Been to the Races"	12 - 15	15 - 18

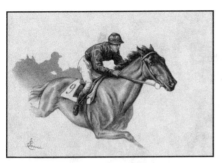

Penni, Rev. Stampa, Series 145-1
No Caption

Publisher M. Munk, Series 437
No Caption

Lance Thackeray, R. Tuck, Series 984
"I am up to the Neck..."

Publisher B. B., London, Series E44
"A Preliminary Spin"

P.V.B. (GB) 1905-1915
 Raphael Tuck
 Humorous Series 1178 (6)
 Racing Illustrated - "Won by a Neck" 15 - 18 18 - 22
 Racing Illustrated - "A Doubtful Starter" 15 - 18 18 - 22
PAYNE, C.M. (GB) 1905-1915
 Gale & Polden, Ltd.
 Prehistoric "Two to One - Bar None" 10 - 12 12 - 15
PENNI (IT) 1905-1915
 Rev. Stampa
 Series 145-1 No Caption 15 - 20 20 - 25
PEYTON 1905-1915
 Anonymous Skeleton "On the Dead" (B&W) 8 - 10 10 - 12
PRESTON, CHLOE (GB) 1910-1920
 Valentine & Sons, Ltd.
 Series 1233 "I'm Coming Romping Home" 18 - 22 22 - 26
ROWLANDSON, G.D. 1905-1915
 Series 11827 No caption 12 - 15 15 - 18
SAGER, XAVIER (FR) 1905-1915
 E.P.J. Series 686 No caption (6) 12 - 15 15 - 18
 A. Noyer "Aux Corses"
 Series 162 (6)
 "Le Bon Tuya" 18 - 22 22 - 26
 "Le Cheri Il Arrive Dans un Fautuil" 18 - 22 22 - 26
 "Le Favori est Dans Les Choux" 18 - 22 22 - 26
 "Le Grand Favori" 18 - 22 22 - 26

Louis Wain, Valentine & Sons
"Our Races"

"L'Heureux Gagnant"	18 - 22	22 - 26
"Resultat Complet des Courses"	18 - 22	22 - 26
SULLIVAN, P.D. 1905-1915		
Anonymous "Just Tell Them You Saw Me"	8 - 10	10 - 12
TAM, JEAN (FR) 1905-1915		
Marque L-E		
"Les Fetiches Parieiene" 70-1 No caption	25 - 30	30 - 40
TAYLOR, A. (GB) 1940-1950		
Bamforth Co. General Comics		
602 "Trust not women ..."	5 - 8	8 - 10
THACKERAY, LANCE T. (GB) 1905-1915		
Raphael Tuck **"Write Away"**		
Series 984 "I am up to the neck ..."	15 - 18	18 - 22
THIELE, ARTH. (GER-DEN?) 1905-1915		
I.P.C. & N. Co.		
Series of 6 (Flat & Emb)	30 - 35	35 - 38
T.S.N. Black Jockey	45 - 55	55 - 65
German Am. Novelty Co. Same image	45 - 50	50 - 55
Anonymous Same image	35 - 40	40 - 45
The Tout 1905-1915		
Anonymous Caricatures with oversize heads of well known people at the track.		
"Sir Abe Bailey and Michael Beary"	25 - 30	30 - 35
"The Marquis of Blandford and Lord Stanley"	25 - 30	30 - 35
"Capt. Humphrey de Trafford and Billy Payne"	25 - 30	30 - 35
"HRH The Duke of York-With the Pytchley"	30 - 35	35 - 40
"Major The Hon. Lionel Montagu and F. Hartigan"	25 - 30	30 - 35
"Sir George Thursby Bart"	25 - 30	30 - 35
"Lord Westmorland and 'Old Kate'"	25 - 30	30 - 35
"Stanley Wootton and C. Smirke"	25 - 30	30 - 35

WAIN, LOUIS (GB) 1905-1915		
Hartman "Welsher!!!"	60 - 70	70 - 80
Raphael Tuck		
Series 1261 "The Favourite"	80 - 90	90 - 100
Valentine & Sons		
"Our Races"	100 - 125	120 - 140
WOOD, LAWSON (GB) 1910-1930		
Valentine & Sons		
Gran'pop Series 1908 "Gran'pop Weighs In"	18 - 22	22 - 26

PUBLISHERS

A.H. Co. 1905-1915		
"A Pipe Dream - Wake Up"	10 - 12	12 - 15
Political "To__With Politics! I don't care who wins"	50 - 55	55 - 60
ASM logo 1905-1915		
Series 1086 No caption	10 - 12	12 - 15
B.B., London 1905-1915		
2100 "To be called out of town"	6 - 8	8 - 10
Bamforth Co. 1940's		
Comic Series 1773	4 - 5	5 - 7
Comic Series 2175 (Chrome)	2 - 3	3 - 4
Breger & Lang 1905-1915		
"Gruss Aus vom Eastroper Pennplatz"	12 - 15	15 - 18
C.T. Art-Colortone Linen		
328 "You bet you'll feel like a million at Saratoga	2 - 3	3 - 4
4B-H596 "Today's Long Shot at Churchill Downs"	2 - 3	3 - 4
Colourpicture Publishers Linen		
63 "Miami's Long Shot"	3 - 4	4 - 5
1272 "My Favorite is always behind"	3 - 4	4 - 5
Curteichcolor Chrome		
6C-K3102 "Greetings from Louisville, Ky"	2 - 3	3 - 4
Advertisement		
Bridles "Wanamaker Harness Store"	25 - 30	30 - 40
Dexter Press Chrome		
41663-C "The First Futurity Stakes - L. Maurer"	3 - 4	4 - 5
Eagle & Shield 1905-1915 (Emb)		
Racing Action (4)	8 - 10	10 - 12
Fair Publishing 1905-1915		
Advertisement		
3035 "Coos & Essex Fair, Lancaster, NH, 1911"	20 - 25	25 - 30
Gardner-Thompson Linen		
45168 "Today's long shot at Santa Anita"	3 - 4	4 - 5
Gray & Thompson Chrome		
GS-6C "Horse Racing at Pinehurst, NC"	3 - 4	4 - 5
H.H.I.W. 1905-1915		
Series 493 (2) No caption	6 - 8	8 - 10
H.S.V. Litho 1905-1915		
"That's what they all say" 25 "I'd won if I hadn't ..."	8 - 10	10 - 12
Herman Hilger 1905-1915 Real Photo		
Race horse "Fels" and jockey O'Connor	20 - 25	25 - 28
D. Hillson 1905-1915		
"At the Races"	8 - 10	10 - 15

J.M. & Co., London, Series 901/D
"On the Flat!"

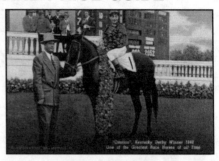

"Citation"—Kentucky Derby Winner 1948
Curt Teich, No. 9B-H1487

Real Photo of "Fels" — Jockey O'Connor
Hermann Hilger, No. HH37

"Man O'War, The Wonder Horse"
Curt Teich, No. 3A-H230

J.M. & Co. 1905-1915		
Series 901-d "On the Flat"	12 - 15	15 - 18
Also a variation exists without caption	12 - 15	15 - 18
Johnson, Ltd. 1905-1915		
Series 137-5 "The Jockey's Favourite"	8 - 10	10 - 12
Kropp, E.C. Linen		
C89 "Picked an easy winner - Ah Sweet Dreams"	3 - 4	4 - 5
Lange & Schwalbach 1905-1915		
Race Horse Series		
"Do You See The Point?"	10 - 12	12 - 15
"Every Little Bit Helps"	10 - 12	12 - 15
"Nothing Doing"	10 - 12	12 - 15
Millar & Lang 1905-1915		
National Series		
483 "Are We Downhearted? No!!"		
"A Bad Day for Backers"	12 - 15	15 - 18
M. Munk, Vienne 1905-1915		
Series 437 No caption Boy with wooden racers (2)	18 - 22	22 - 26
Series 462 No caption	15 - 18	18 - 22
National Art Co. 1905-1915		
Series 51		
"I'm on the Water Wagon Now"	8 - 10	10 - 12
PFB 1905-1915 (Emb)		
Series 7434 (6)	12 - 15	15 - 20
Series 8108 "Dog dressed in jockey outfit"	18 - 22	22 - 26
Peluba 1905-1915		
Series 237 Two horses crossing finish line. No caption	6 - 8	8 - 10

Plastichrome Chrome

P26038 "Horse Sense is something ..."	2 - 3	3 - 4

R.S. Reiman, Budapest 1900-1910 No caption 15 - 18 18 - 22

Reno Printing Chrome

 Advertisement "Nevada Horse Club Book" 8 - 10 10 - 12

Roth & Langley 1905-1915

 Skeleton

 110 "The Last Lap" 15 - 18 18 - 22

SB in diamond logo 1905-1915

 "What Do You Know ..."

 S.260 "Race over - still ..." 6 - 8 8 - 10

S.O. in block logo 1905-1915

 Series 115 (6) 12 - 15 15 - 18

Star Co. 1905-1915 (Emb)

 Mutt & Jeff Series 692 "Ain't It Hell to be Broke" 15 - 20 20 - 25

 Variation - Reversed pringing 15 - 20 20 - 25

Raphael Tuck 1905-1915

 "Art" Series 947 No caption 15 - 18 18 - 22

 "Racing Illustrated" Series 6448 "Our Lassie" 18 - 22 22 - 26

West Printing Service 1920-1930

 Advertisement "Avery Hotel, Boston" Blue 10 - 12 12 - 15

ANONYMOUS

Advertisements

 "Bond Lilliard" on Whiskey Label 1905-1915 12 - 15 15 - 20

 "Champagner-Kellerei Schloss Vaux bei Metz" 8 - 10 10 - 12

 "The Kentucky Colonel ..." 10 - 12 12 - 15

 "Le bon Tuyau" Comme aperitif prendre un ..." (B&W) 7 - 9 9 - 12

 "Saratoga Centennial 1863-1963 (Chrome} 3 - 4 4 - 5

 "Waterson Berlin & Snyder Tips..." 8 - 10 10 - 12

Miscellaneous

 Series 22 17A "Best Wishes" (Emb) 6 - 8 8 - 10

 Children **"Anglo Series" 124** "Riding" 8 - 10 10 - 12

 Frogs riding Grasshoppers No caption 12 - 15 15 - 20

 Racing "Le Vanqueur" (Metamorphic R.P.) 20 - 25 25 - 28

 Owl Series 002 "The Winning Post" 10 - 12 12 - 15

Famous Horses

 Man O' War

 Curt Teich 3A-8230 Linen 12 - 15 15 - 18

 Other Linen or printed photos 12 - 15 15 - 18

 Real Photos 20 - 30 30 - 40

 Citation, Count Fleet

 Whirlaway, Bold Ruler

 Native Dancer, Secretariat

 Spectacular Bid

 Chromes 3 - 5 5 - 8

 Linen or Printed Photos 5 - 8 8 - 10

 Real Photos 15 - 20 20 - 25

 "Fels," with Jockey O'Connor (RP) 20 - 25 25 - 30

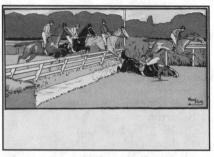

Harry Eliott, Anon. French Publisher
No Caption

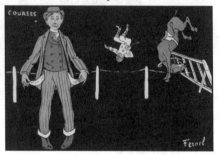

Jos. Correggio, B. Dondorf, No. 833
No Caption

Fernel, Anon. French Publisher
"Courses"

STEEPLECHASE

ARTIST-SIGNED

A.W. 1905-1915
 Anonymous No caption 10 - 12 12 - 15
BEAUVAIS, CH. (FR) 1905-1915
 Moullet **"Les Sports II"** "Courses de Haies" 12 - 15 15 - 18
BECKER, C. (GER) 1905-1915
 Meissner & Buch
 Series 1003 (Others in series are racing)
 "Ausgebrochen" 20 - 25 25 - 28
 "Farewell" 20 - 25 25 - 28
 "Hurdensprung" 20 - 25 25 - 28
 "Schlechte Ayssicgten" 20 - 25 25 - 28
BEBEER, F. (GB) 1900-1005
 M. Ettlinger & Co.
 Series 4651 "The Grand National, 1904" 15 - 20 20 - 25
BROWNE, TOM (GB) 1905-1915
 Davidson Bros.
 "Are We Downhearted" Series 2598
 "No!!!" 12 - 15 15 - 18
CORREGGIO, JOS. 1905-1915
 B. Dondorf
 Series 833 (6) 12 - 15 15 - 18

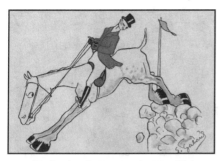

E. Garland, M. Munk, No. 384
No Caption

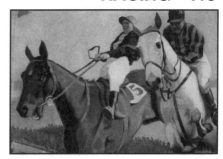

Felix Lehmann, O.G.Z.-L.
"Im Sprung"

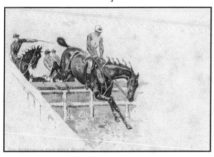

Albert Richter
"Aquarellen" Series — No Caption

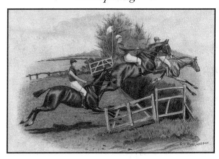

G. D. Rowlandson, Anon., No. 11827
No Caption

DONADINI, JR. (IT) 1905-1915
 N in star (Novitas)
 Series 237 (6) 15 - 20 20 - 25
 Raphael Tuck "Steeplechasing"
 Series 6163 (6) 15 - 18 18 - 22
 Peluba
 Series 237 15 - 18 18 - 22
ELIOTT, HARRY (GB) 1905-1915
 Anonymous (6) No captions 18 - 22 22 - 25
FERNEL (FR) 1905-1915
 Anonymous French publisher
 "Courses" 35 - 40 40 - 45
G.K. (George King) (GB) 1905-1915
 Hartmann Series 987 No caption 15 - 18 18 - 22
GARLAND, E. 1905-1915
 M. Munk
 Series 384 No Caption 20 - 25 25 - 28
HANSTEIN (GER) 1905-1915
 Raphael Tuck Series 810 (6) 15 - 18 18 - 22
HOFFMANN, ANTON (GER) 1905-1915
 H.K. & Co. Series 526 (6) 12 - 15 15 - 18
KV 1905-1915
 LP in triangle I-IV
 Series 224 Boy Jockeys 18 - 22 22 - 26
KOCH, LUDWIG (AUS) 1905-1915
 B.K.W.I.
 Series 494-2 Off at the Hedge 15 - 18 18 - 22

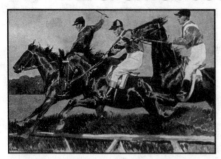

Anton Hoffmann, H.K. & Co.
Series 526, No Caption

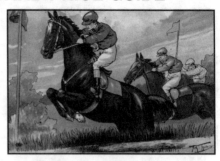

Arth. Thiele, I.P.C. & N. Co.
No Caption

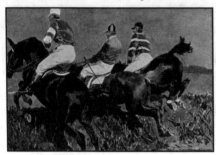

Anton Hoffmann, H.K. & Co.
Series 526, No Caption

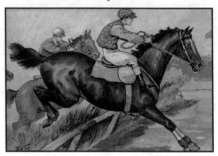

Arth. Thiele, I.P.C. & N. Co.
No Caption

LEHMANN, FELIX (GER) 1905-1915
 O.G.Z.-L
 Series S. 32

329 "Nach dem Start"	18 - 22	22 - 26
330 "Im Sprung	18 - 22	22 - 26

MASON, FINCH (GB) 1905-1915
 J.A. Co.

"After carefully looking into the matter ..."	10 - 12	12 - 15
"Excuse haste won't you"	10 - 12	12 - 15
"However we pulled it off between us"	10 - 12	12 - 15
"I must impress upon you"	10 - 12	12 - 15
"I'm rather late for the post"	10 - 12	12 - 15
"It was the coolest proceeding I ever knew"	10 - 12	12 - 15

RICHTER, ALBERT (GER) 1902-1910

"Aquarellen" Series	18 - 22	22 - 26

ROWLANDSON, G.D. 1905-1915

Anonymous Series 11827	12 - 15	15 - 18

SAGER, XAVIER (FR) 1905-1915
 B.G, Paris

576 "L'Heurex gagant"	15 - 18	18 - 22

SCHÖNPFLUG, FRITZ (AUS) 1905-1915

B.K.W.I. (6)	15 - 18	18 - 22

THIELE, ARTH. (GER-DEN?) 1905-1915

I.P.C. & N. Co. Series of 6 (Flat & Emb)	18 - 22	22 - 26

 Silk Jockey Shirts - Add $10 each.

THOMAS, J. (GB) 1905-1915
 Raphael Tuck

Series 579 (6) (Oilettes)	18 - 22	22 - 26

WHALMAN, CHARLES (US)
 Advertisement "Brockton Fair, MA, 1915" 50 - 60 60 - 70

PUBLISHERS

B.B., London (Birn Bos.) 1905-1915
 Series E44 (6)
 "A Close Finish" 12 - 15 15 - 18
 "A Preliminery Spin" 12 - 15 15 - 18
 "Leading in the Winner" 12 - 15 15 - 18
 "Waiting for the Signal" 12 - 15 15 - 18
 "The Water Jump" 12 - 15 15 - 18
 "Well Over" 12 - 15 15 - 18
ESD 1900-1907
 Series 3171 Chromolithographs 18 - 22 22 - 26
Eagle & Shield 1905-1915 (Emb Airbrush) (2) 10 - 12 12 - 15
F.P.S. 1905-1915
 Series 469 20 - 25 25 - 28
Felsenthal & Co. 1905-1915
 Magic Moving Picture Mechanical 30 - 35 35 - 45
Gray & Thompson Chrome
 CS-1C "Up and Over" 3 - 4 4 - 5
L.V & Cie. 1905-1915
 "Les Courses" (Baby Jockeys)
 3 "Le Depart" 12 - 15 15 - 18
 4 "Les Haies" 12 - 15 15 - 18
 6 "L'Arrivee" 12 - 15 15 - 18
Misch & Stock 1905-1915
 The Sportsman Series
 257 "The Last Hurdle" 8 - 10 10 - 12
O.P.F. logo 1905-1915
 "My Little Vices" 40 - 50 50 - 55
 Horse/Rider jump through boot stirrup 40 - 45 45 - 55
Phila Post Card Co. 1905-191
 Series 103 "I am rather upset" 8 - 10 10 - 12
PVKZ in shield logo (Kunzli Freres, Zurich) 1905-1915
 Series 7466 12 - 15 15 - 18
 Series 7468, 7469 15 - 18 18 - 22
TC logo 1905-1915
 Series 2004-3 No caption 8 - 10 10 - 12
T.S.N. 1905-1915
 11108 Two May Bugs (Maikafirs) riding caterpillars 12 - 15 15 - 20
Raphael Tuck 1905-1915
 Series 579 (6) 12 - 15 15 - 18
 "Steeplechasing" Series 9118 (6)
 "A Gallop Across the Flat" 12 - 15 15 - 20
 "The Big Jump" 12 - 15 15 - 20
 "The Last Mile" 12 - 15 15 - 20
 "Neck and Neck" 12 - 15 15 - 20
 "The Open Ditch" 12 - 15 15 - 20
 "Taking the Hurdle" 12 - 15 15 - 20
 Series 9509 (6) 12 - 15 15 - 20
 Series 9522 (6) 12 - 15 15 - 20

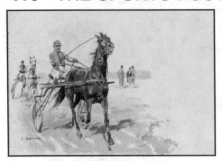

C. Becker, Meissner & Buch
Series 1003 — "Trabrennen"

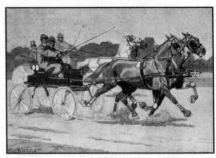

Ludwig Koch, B.K.W.I., Series 865-7
"Buggy"

Ludwig Koch, B.K.W.I., Series 473-5
No Caption

Fritz Schönpflug
B.K.W.I., Series 678-5 — No Caption

Trenkler Co. 1905-1915
 "Les Courses" Series 93 (B&W) 8 - 10 10 - 12

ANONYMOUS

 Series 56 (6) Printed photos 1905-1915 10 - 12 12 - 15
 Series 305 with Flag 10 - 12 12 - 15

HARNESS RACING

ARTIST-SIGNED

BECKER, C. (AUS) 1905-1915
 Meissner & Buch
 Series 1003 "Trabrennen" 18 - 22 22 - 26
BERTIL, A. (AUS) 1950's
 Anonymous "Efter Krocken" 15 - 18 18 - 22
CENNI, ITALO (IT) 1910-1920
 Dell'Anna & Gasparini
 Series 291 (6) No caption 12 - 15 15 - 18
 Series 482 (6) No caption 12 - 15 15 - 18
DIENST, P. (AUS) 1900-1907
 B.K.W.I.
 Series 770-7 (B&W) 10 - 12 12 - 15

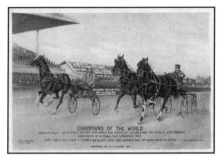

W. F. Young, "Champions of the World" Advertising Absorbine

"Lady Maud and Hedgewood Boy"
Western Livestock Insurance Co.

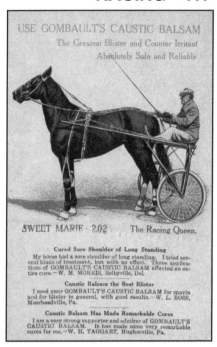

Advertising Gombaults Caustic Balsam
"Sweet Marie" (The Racing Queen)

KOCH, LUDWIG (AUS) 1905-1915
B.K.W.I.
 Series 473

2 Race horse and jockey passing trotter	18 - 22	22 - 26
3 Going left	18 - 22	22 - 26
5 The Crash	18 - 22	22 - 26
Series 865		
7 "Buggy"	18 - 22	22 - 26

SCHÖNPFLUG, FRITZ (AUS) 1905-1915
B.K.W.I.

Series 678 (6)	15 - 18	18 - 22

TENNI 1905-1915

Harness Racing Series	12 - 15	15 - 18

THOMAS, P. (GB) 1905-1915
 Raphael Tuck

Series 575-B (6)	15 - 18	18 - 22

PUBLISHERS

A. Noyer, Paris 1905-1915 Real Photo

"Tiego" In Action	30 - 35	35 - 45

G in diamond logo 1905-1915
 Series 83

"A Dead Heat"	10 - 12	12 - 15

SB in circle logo (Samson Bros.) 1905-1915

CS 133 "There were some races"	10 - 12	12 - 15

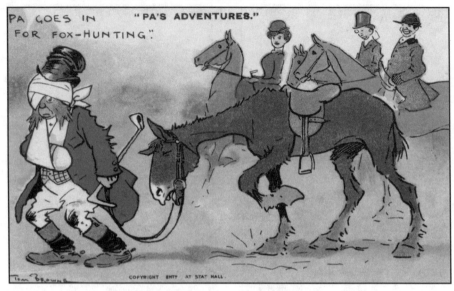

Tom Browne, Davidson Brothers, Series 2638-6
"Pa Goes in for Fox-Hunting."

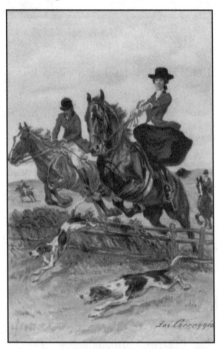

E. Colombo, GAM, Series 1675-4	*Jos. Correggio, B. Dondorf, No. 893*
No Caption	*No Caption*

ADVERTISING
"World's Best Harness Racing at the Carlisle Fair"
Chrome (B&W) 3 - 4 4 - 6

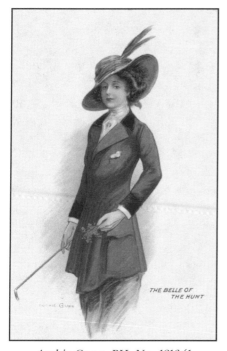

Archie Gunn, PH, No. 1216/1 *G. Koch, Meissner & Buch, Series 1415*
"The Belle of the Hunt" *No Caption*

Absorbine — W.F. Young 1905-1915		
"Harness Racing" "Champions of the World"	20 - 25	25 - 30
Gombaults Caustic Balsam		
"Sweet Marie" (The Racing Queen)	20 - 25	25 - 30

FAMOUS HORSES

Dan Patch		
V.O. Hammon 155	20 - 25	25 - 30
T.P. & Co. Series	20 - 25	25 - 28
"Dan Patch At Great Allentown Fair"	30 - 40	40 - 50
Wright, Bartnett and Stilwell Co.	25 - 30	30 - 40
Real Photo #155 Circa 1910	100 - 110	110 - 120
Other Real Photos	30 - 40	40 - 50
Other Printed Photos	25 - 30	30 - 35

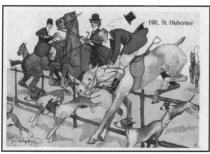

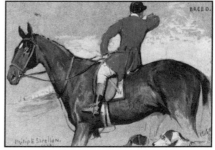

Fritz Schönpflug, B.K.W.I. *Philip E. Sirelion, R. Tuck*
Series 723-5, "Hilf, St. Hubertus!" *Series 2765, "Breed"*

Goldsmith Maid		
Printed Photos	15 - 20	20 - 25
Real Photos	20 - 25	25 - 35
Lady Maud & Hedgewood Boy		
Advertising Western Love Stock Ins. Co. (B&W)	20 - 25	25 - 30

FOX HUNTING

ARTIST-SIGNED

BELIAN, FREUND (GER) 1905-1915		
B. Dondorf		
Series 781 Silhouette Horse/Rider & dog	15 - 20	20 - 25
BROWNE, TOM (GB) 1905-1915		
Davidson Bros.		
Series 2638 "Pa Goes in for Fox Hunting"	15 - 18	18 - 22
Series 2502 "Pride Will Have A Fall"	15 - 18	18 - 22
COLOMBO, E. (IT) 1910-1930		
GAM Series 1675 (6) Art Deco	15 - 20	20 - 25
CORREGGIO, JOS. 1905-1915		
B. Dondorf 893 (6) No Caption	18 - 22	22 - 26
DRUMMOND, NORAH (GB) 1905-1915		
Raphael Tuck		
Series 2924 **"In the Hunting Field"** (6)	15 - 18	18 - 22
Series 3296 (6)		
"Across Country" "A Hard Scent"	15 - 18	18 - 22
"A Hot Scent" "Crossing the Ford"	15 - 18	18 - 22
"Full Cry" "On the Scent"	15 - 18	18 - 22
GABARD, E. (AUS) 1905-1915		
M. Munk, Vienne Series 384 (6)	12 - 15	15 - 20
GUNN, ARCHIE (US) 1905-1915		
PH in diamond logo		
1216/1 "The Belle of the Hunt"	20 - 25	25 - 30
HOFFMANN, A. (GER) 1905-1915		
H.K. & Co. Series 291 (6)	12 - 15	15 - 20
III logo 1905-1915		
Raphael Tuck		
Series 1303 "Tally Ho Series"		
"Worry Worry"	12 - 15	15 - 18
Series 1371 "Our Hunt Series"	12 - 15	15 - 18
JANK, ANGELO (GER) 1905-1915		
E.A. Seeman		
Series 162 Ladies & men hunting	10 - 12	12 - 15
KING, G. 1905-1915		
P.F.B. Series 8126 (6) (Emb)	15 - 18	18 - 22
KOCH, G. (GER) 1905-1915		
Meissner & Buch Series 1415 No Caption	15 - 18	18 - 22
NAP 1905-1915		
RPPC in diamond logo		
"Sports" Series 15 "Hunting"	12 - 15	15 - 18
P in circle 1905-1915		
De Buenraat Boy hunter and wooden horse & dog	15 - 18	18 - 22

SW in box logo 1905-1915
> **Valentine Series**
>> **Hunting Series 2 (6)**
>> "Getting the Brush" "Taking the Fence" 12 - 15 15 - 18
>> "They're Off" 12 - 15 15 - 18

SCHÖNPFLUG, FRITZ (AUS) 1905-1915
> **B.K.W.I. Series 723** (6) 15 - 18 18 - 22

SIRELION, PHILIP E. (GB) 1905-1915
> Raphael Tuck **"Hunting" Series 2765** "Breed" 15 - 18 18 - 22

THACKERAY, LANCE T. (GB) 1905-1915
> **Raphael Tuck**
>> **Series 60** "If I can manage ..." 15 - 18 18 - 22
>> **Series 984** "I am fixed ..." 15 - 18 18 - 22

PUBLISHERS

A. & M. B. 1900-1910
> **Series 560** (6) No caption 15 - 18 18 - 22

A SM logo 1905-1915
> **Series 1086** No caption 12 - 15 15 - 18

J.I. Austen Co. 1905-1915
> **Series 378** "Off to the Hunt" 12 - 15 15 - 18

B&R in M 1905-1915 "Ein Frohes Fahr!" 12 - 15 15 - 18

C.W. Faulkner & Co. 1905-1915
> **Series 325** (6)
>> B "A Hunting We Will Go" 18 - 22 22 - 26
>> C "A Hunting Gossip" 18 - 22 22 - 26

TF logo 1905-1915
> **Series 26494** No caption 8 - 10 10 - 12

Raphael Tuck 1905-1915
> **"Early Days of Sport"**
>> 9293 "Fox Hunting in the 14th Century" 12 - 15 15 - 18

Valentine's Series 1905-1915
> **Hunting Series 3** (6)
>> "A Glorious Run Home" 10 - 12 12 - 15
>> "A Noble Thirst" "Full Cry" 10 - 12 12 - 15

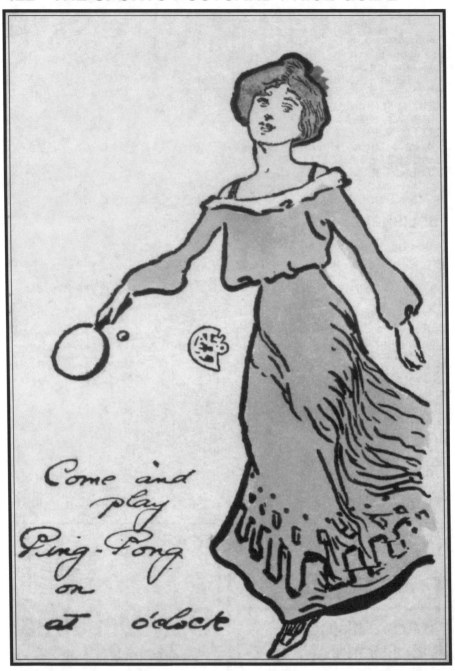

Galysto, Anonymous Publisher
"Come and play Ping-Pong ..."

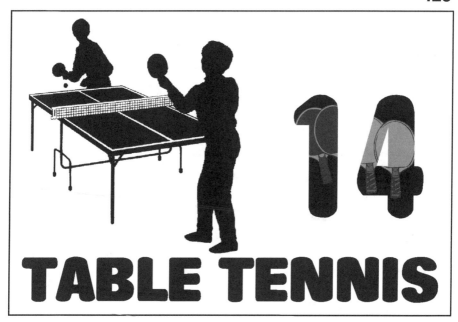

TABLE TENNIS

Table Tennis (Ping-Pong), an Olympic sport since 1988, is the most popular racket sport in the world and the second most popular participation sport, played by more people each year in the U.S. than baseball or soccer.

It began as a fashionable parlor game around 1899, using cork balls and hollow, vellum-covered rackets whose sound gave it the name "Ping-Pong." Though the fad had died by 1905, ping-pong was revived as a serious sport in the 1920's, largely through the efforts of such tennis stars as Tilden and Lenglen. In 1934 the U.S. Table Tennis Association was formed, dropping the name "Ping-Pong," which was at that time a copyrighted trademark of Parker Brothers. While the sport was played until the mid-50's with pimply hard rubber bats, for the last 40 years smooth rubber over sponge has turned it into a game of speed and, above all, spin.

Forrest Gump aside, the Chinese reigned supreme from the early 1960's until 1989, when the Swedes swept the competition. Jan-Ove Waldner, World Champion 1989-91, regained the title in 1997 and is widely considered one of the best players of all time.

References:

Hodges, Larry, *Table Tennis—Steps to Success,* Champaign, IL, 1993
Purves, Jay, *Table Tennis,* New York, 1942
Schaad, Cornelius G., *Ping-Pong,* Boston, 1930

ARTIST-SIGNED

	VG	EX
ETA (Edith T. Andrews) (GB) 1900-1910		
Raphael Tuck		
Series 1156 "Ping-pong in Fairyland" (6)	$40 - 45	$45 - 50
CYRERE, R. (FR) 1905-1915		
E.A., Paris		
Series 452 Children "Quelle chance que Papa ..."	25 - 30	30 - 35
DISNEY, WALT (US) 1930-1950		
K.K. Publications, Advertising Card		
"Yo, ho, ho, and a stick of gum"	40 - 45	45 - 50
1930's Hungarian (B&W)		
Artist - Bisztriczky	40 - 45	45 - 50
E.S. (GB) 1900-1905 (B&W)		
"Ping Pong"		
"A crack shot!"	20 - 25	25 - 30
"Nothing like enthusiasm!"	20 - 25	25 - 30
"Such a nice quiet game!"	20 - 25	25 - 30
F. (GB) 1905-1915		
Anonymous		
"Ping Pong. A Smash Return"	20 - 25	25 - 28
GALYSTO 1900-1910		
Anonymous		
Art Nouveau Shows paddle or table	30 - 35	35 - 45
LEWIN, F.G. (GB) 1905-1915		
Punch		

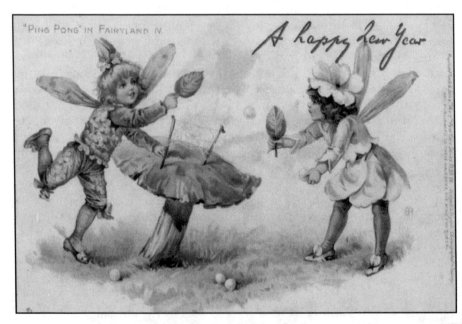

E.T.A. (Edith T. Andrews), Raphael Tuck, Art Series 1156 IV
"Ping Pong in Fairyland"

Unsigned Walt Disney, K.K. Publications Advertising Card
"Yo, ho, ho, and a stick of gum ..."

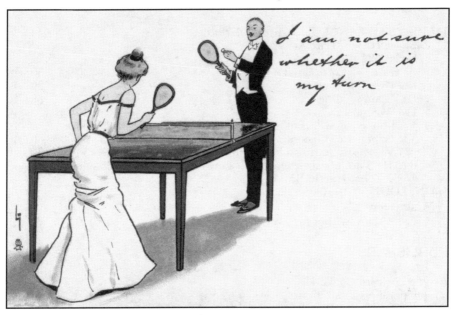

L.T. (L. Thackeray), Raphael Tuck, Series 642 II
"I am not sure whether it is my turn"

Wrench Series 2645 "Ping Pong in the kitchen" 20 - 25 25 - 30
STEEN 1920-1930
 REB logo
 Series K744 Man/Lady Foreign captions 20 - 25 25 - 30

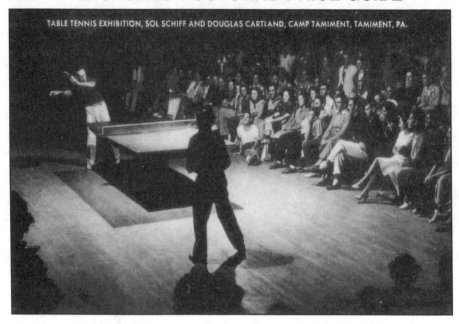

Artvue Postcard Company, December 1941
Table Tennis Exhibition, Sol Schiff and Douglas Cartland, Camp Tamiment, Pa.

THACKERAY, LANCE T. (GB) 1905-1915
 Raphael Tuck "Write Away"
 Series 623

I "Have you ever played ..."	25 - 30	30 - 40
II "How shall I begin"	25 - 30	30 - 40
III "I am sending"	25 - 30	30 - 40
IV "We must fix"	25 - 30	30 - 40
V "I hope you will find"	25 - 30	30 - 40
VI "When are you coming in ..."	25 - 30	30 - 40
624 V "We are having a little ping ..."	25 - 30	30 - 40
642 II "I am not sure whether it's my turn"	25 - 30	30 - 40
1798 "That Horrid Boy!"	25 - 30	30 - 40

WAIN, LOUIS (GB) 1905-1915
 Anonymous

Cat "Many Wishes for a Merry ..."	50 - 60	60 - 75

PUBLISHERS

Artvue Postcard Co. 1941
 Table Tennis Exhibition

Sol Schiff and Douglas Cartland	30 - 35	35 - 40

B G Co. logo 1905-1915

Series 180-1 Man "Bat and Ball"	15 - 20	20 - 25

JC in circle logo 1905-1915

Boy/Girl "La Balle Introuvable"	15 - 20	20 - 25
Mita Kobunsha 1905-1915 (Emb)	15 - 20	20 - 25

LG in shield logo 1905-1915
 Premier Series - Shakespeare

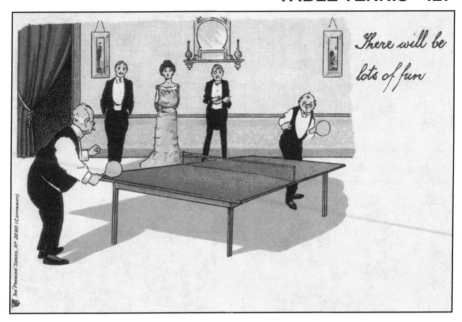

Publisher L.G., Series 2020 — "There will be lots of fun"

Publisher L.G., Series 2020 — "I hope you will manage"

Series 1975 (6)

"Come let me clutch thee ..."	18 - 22	22 - 26
"Excellent! Why this is the best ..."	18 - 22	22 - 26
"Faith, there's bee too much to do on both sides"	18 - 22	22 - 26
"I've done the deed"	18 - 22	22 - 26

Anonymous Publisher, Series 372
"When are you coming in to Ping-Pong"

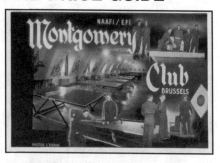

Montgomery Club, Brussels
Photo by L'Essor

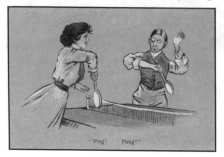

Publisher W. C., S. & Company
Herriot Series, "Ping! Pong!"

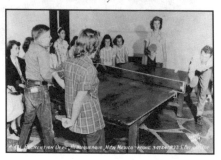

Real Photo No. 481 by Caplin
Recreation Dept., Albuquerque, N.M.

"Look, when I serve him so ..."	18 - 22	22 - 26
"Your man and you ..."		
Series 2020 (6)		
Man/Lady "I hope you will manage"	22 - 25	25 - 28
Man "If anything should come in the way ..."	22 - 25	25 - 28
Man/Lady "There will be lots of fun"	22 - 25	25 - 28
Man "We are having a sing song racket"	22 - 25	25 - 28
Man/Lady "You can depend on me ..."	22 - 25	25 - 28
Man/Lady "You'll not forget"	22 - 25	25 - 28
Premier 1905-1915		
Series 1975	20 - 25	25 - 30
Series 2020	20 - 25	25 - 30
Punch 1900-1910		
The Wrench Series		
Series 2640 Couple "Ping Pong in the Stone ..."	25 - 30	30 - 35
Red Star Line 1900-1915		
J-4 Man/Lady **"Red Star Line**		
Antwerp-Dover-New York"	40 - 50	50 - 60
S.H. Co. logo 1905-1915		
Motto Leather "Play a game of Ping Pong ..."	20 - 25	25 - 28
S.P. Co. Modern		
Religion Series 1109 "Return That Ball!!"	4 - 5	5 - 6
Raphael Tuck 1905-1915 See artist ETA		
Series 11561 Fairies "Ping Pong in Fairyland" (6)	40 - 45	45 - 50
Walts Photo, Hawaii 1940's Real Photos		
USO club interiors with service men posed at tables		
"USO Ewa Village"	30 - 35	35 - 40

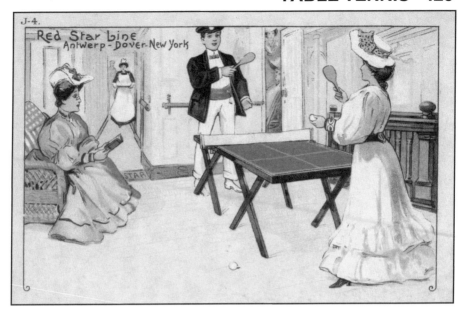

Red Star Line Advertising Card, Series J, No. 4 — No Caption

"USO Hale Koa Club"	30 - 35	35 - 40
"USO Nawiliwili Club"	30 - 35	35 - 40
"USO Rainbow Club"	30 - 35	35 - 40

W.C.
S. & Company
 Herriot Series, "Ping! Pong!" 22 - 25 25 - 28

ANONYMOUS

Advertising for Ping-Pong
 German Chromolithograph ca 1900 30 - 50 50 - 75
Animal Fantasy
 Cats or chicks playing, 1900-1950 15 - 25 25 - 40
 Post 1950 6 - 10 10 - 15
Blacks playing 25 - 30 30 - 35
 Native types 20 - 25 25 - 35
 Post 1950 10 - 12 12 - 15
British Series 1900-1905 (B&W) Hand-colored
 "Got it!" 30 - 35 35 - 40
 "Love, one" 30 - 35 35 - 40
 "Smash! 30 - 35 35 - 40
 "Vantage out" 30 - 35 35 - 40
Comic Series, miscellaneous, 1900-1910
 Color 15 - 20 20 - 30
 Black & White 10 - 15 15 - 25
 Post 1950 8 - 10 10 - 12
Japanese Ping-Pong, 1905-10
 At amusement parks, printed 12 - 15 15 - 20
 Real Photo Exteriors 25 - 50 50 - 75
 Real Photo Interiors 50 - 100 100 - 200

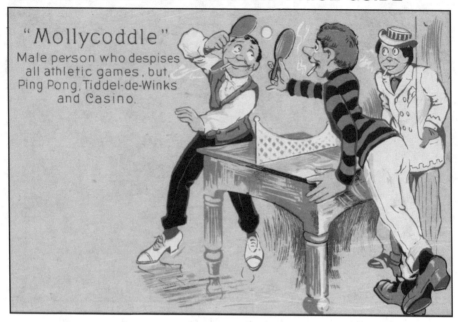

Anonymous Publisher, Mollycoddle Series No. 1
"Mollycoddle — Male person who despises all athletic games ..."

Man/Lady 1905-1915

"When are you coming in to Ping Pong?" (B&W)	15 - 18	18 - 22
372 "When are you coming in to Ping Pong?"	18 - 22	22 - 26
437 "Do You Play Ping Pong?" ca. 1915	15 - 18	18 - 22

Man "Mollycoddle" 1905-1915 · 15 - 18 · 18 - 22

Movie Stars

"Alice Faye--20th Century Fox Player"	15 - 20	20 - 25
"Richard Greene"	15 - 20	20 - 25
"Maureen O'Sullivan, Metro Goldwyn" — #432	15 - 20	20 - 25
"Esther Williams" MGM #665	15 - 20	20 - 25
"Gene Tierney" by W.J. Gray, L.A.	15 - 20	20 - 25

Nudist Camps

Players, Real Photos	30 - 35	35 - 40
Comics	6 - 9	9 - 12

Ocean Liners

Advertising, early	30 - 45	45 - 65
Advertising, post-1940	8 - 12	12 - 20

Olympics 1988-1996 · 6 - 9 · 9 - 12

Other International Tournaments, pre-1960 · 25 - 50 · 50 - 100

Post-1960 · 8 - 12 · 12 - 20

Players

Movie stars, etc., with paddle	18 - 22	22 - 25
Famous players (Barna, Bellak, etc.) 1925-1960	20 - 35	35 - 50
Unidentified players		
Pre-1920 printed B&W or color	10 - 15	15 - 20
Pre-1920 Real Photos	12 - 20	20 - 30
1920-1950	10 - 18	18 - 25
Post-1950	6 - 10	10 - 15

Resorts, Hotels, Motels

Pre-1950, with players posed	10 - 20	20 - 30
Same, tables only	4 - 8	8 - 12
Post-1950	5 - 9	9 - 12
Same, tables only	3 - 4	4 - 6

Walt Disney

Mickey Mouse, Hungarian, 1930's	50 - 55	55 - 65
Donald Duck, Disney Comics Adv., ca 1950	50 - 55	55 - 65

Tournaments

Local	10 - 18	18 - 25
Regional or National, views	15 - 22	22 - 30
Same - Artist drawn	25 - 50	50 - 75
VII Italian Table Tennis Championships, Parma, 1954	60 - 65	65 - 75
Post-1960	8 - 12	12 - 20

USO & other Military

Pre-1950, Real Photos	15 - 30	30 - 40
Same, printed	6 - 10	10 - 15
Post-1950	4 - 7	7 - 10
Also see Walt's Photo in Publisher section		

Miscellaneous

President Clinton & Hillary playing	20 - 25	25 - 30
Leather	15 - 18	18 - 22
Incidental, Product Advertising	15 - 30	30 - 50

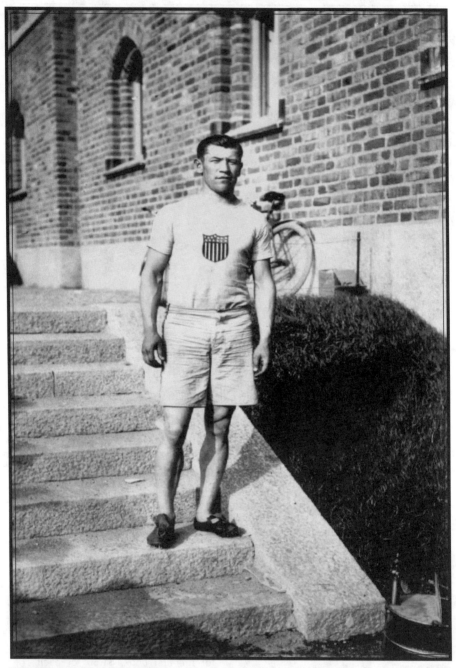

17-O-238 — Jim Thorpe, Star of 1912 Stockholm Olympics
Official Card by Granbergs, No. 238, Real Photo
"J. Thorpe, Winner of the Pentathlon and Decathlon"

CRICKET

ARTIST-SIGNED

	VG	EX
BARNES-AUSTIN, EDGAR 1905-1915		
Pictorial Post Card Co.		
Porcine Sports Series (Animals)	$35 - 40	$40 - 45
BIMBI (GB) 1905-1915		
Vivian Mansell & Co.		
Series 2128 Set 1 Children	10 - 12	12 - 15
BROWNE, TOM (GB) 1905-1915		
Davidson Bros.		
Series 2504 "Cricket Phrases Illustrated"		
"A Cut for Two"	20 - 25	25 - 28
"Drive For Two"	20 - 25	25 - 28
"No Ball"	20 - 25	25 - 28
Series 2506 "Cricket Illustrated"		
"Long Field"	20 - 25	25 - 28
Series 2593 "Uncle Podger"		
"Uncle Podger shows the children how to ..."	20 - 25	25 - 28
Series 2602 "Illustrated Sports"		
6 "Well Thrown Sir!"	20 - 25	25 - 28
Series 2616 "Humors of Cricket"		
"Head or Tail"	22 - 25	25 - 28
"Too Many Cooks Spoil the Broth"	22 - 26	26 - 30
BULL, RENE (GB) 1905-1915		
Davidson Bros.		
Series 6136		
"Batsman to Umpire ..."	12 - 15	15 - 20

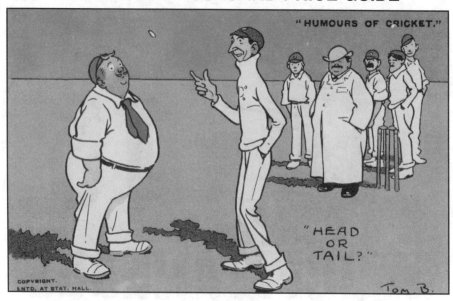

Tom Browne, Davidson Brothers, "Humours of Cricket" — Series 2616-4
"Head or Tail?"

"Novice - Which am I to catch ..."	12 - 15	15 - 20
"Well Fielded"	12 - 15	15 - 20
"Well Held, or a Long Slip"	12 - 15	15 - 20
ELLAM, WILLIAM (GB) 1905-1915		
Hildesheimer & Co., Ltd.		
Bachelor Girl's Club		
Series 5245 No caption	25 - 28	28 - 32
FITZPATRICK 1905-1915		
Bamforth Co. (Chrome)		
"I knew Fred would get caught out ..."	5 - 7	7 - 8
HOWARD, FRED S. (GB) 1905-1915		
Misch & Co.		
Series 478 "Caught and Bowled"	12 - 15	15 - 18
J.W.G. 1905-1915		
Philco Publishing Co.		
Series 2213 F. "Captain of the Eleven"	15 - 18	18 - 22
KINSELLA, E.P. (GB) 1905-1915		
Langsdorff & Co.		
Series 675		
"The Boss"	18 - 22	22 - 26
"The Catch of the Season"	18 - 22	22 - 26
"Good Enough for His Country"	18 - 22	22 - 26
"The Hope of His Side"	18 - 22	22 - 26
"How's That?"	18 - 22	22 - 26
"Out First Ball"	18 - 22	22 - 26
LYNT, WILMONT 1905-1915		
C.W. Faulkner & Co.		
Series 1267 "Well Hit!"	18 - 22	22 - 26
MAURICE, REG (GB) 1905-1915		
Regent Publishing		
4263 "Sorry I Was Out"	15 - 18	18 - 22

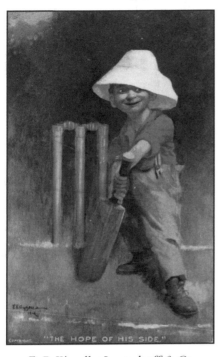

E. P. Kinsella, Langsdorff & Co.
"The Hope of His Side."

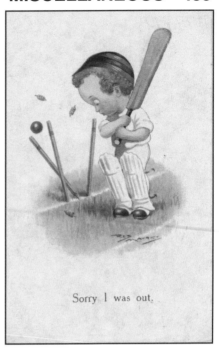

Sorry I was out.

Reg. Maurice, Regent Publishing Co.
No. 4263 —"Sorry I was out."

4264 "Yours to Hand"	15 - 18	18 - 22
MAY, PHIL (GB) 1905-1915		
Raphael Tuck "Phil May Series"		
Series 1778 "Say Brown, Will You Play Cricket ..."	20 - 25	25 - 30
MC GILL, DONALD (GB) 1940's		
E.S., London		
111 "Will yer throw us up our ball ..."	5 - 8	8 - 12
P.V.B. 1905-1915		
Raphael Tuck "Humorous"		
Series 1324 "Cricket Illustrated"		
"A Good Catch"	20 - 25	25 - 30
"The Hat Trick"	20 - 25	25 - 30
"No Ball"	20 - 25	25 - 30
PRESTON, CHLOE (GB) 1905-1915		
A.R. & Co.		
Series 1523-2 Children "The Conquering Hero"	15 - 18	18 - 22
REED, E.T. (GB) 1905-1915		
Punch		
"The Wrench Series"		
2594 "Prehistoric Peeps - A Cricket Match ..."	18 - 22	22 - 26
ROWLANDSON, G.D. (GB) 1905-1915		
C.W. Faulkner & Co.		
Series 328 A "Cricket: Net Out"	18 - 22	22 - 26
SANDFORD, H.D. (H.D.S.) (GB) 1905-1915		
Raphael Tuck		
"Happy Little Coons" Series 9049 "Great Sport"	25 - 30	30 - 35

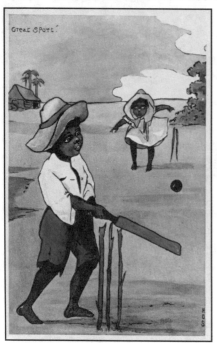

H.D.S. (H. D. Sandford), R. Tuck
Series 9049, "Great Sport"

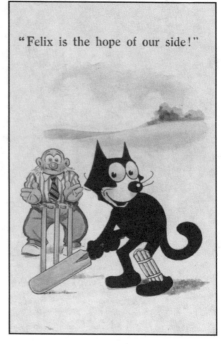

Pat Sullivan, Copyright Pat Sullivan
"Felix is the hope of our side!"

SHEPHEARD, G.E. (GB) 1905-1915
 Raphael Tuck
 Series 9060 "How's That, Impire?"
 "Bowled" "Caught" 20 - 25 25 - 30
 "Hit Wicket!" "L.B.W." 20 - 25 25 - 30
 "Run Out!" "Stumped" 20 - 25 25 - 30
 Series 9375 "A Coming Cricketer"
 "A Boundary" "A Cut" 18 - 22 22 - 26
 "Out" "Play" 18 - 22 22 - 26
SMITH, MAY (GB) 1905-1915
 Valentine & Sons
 Series 3341 "One more run to win the match ..." 12 - 15 15 - 20
SPURGIN, FRED (LAT) 1905-1915
 I A Co.
 "Quaint Kid Series" "If I Dare - But I Daresn't" 15 - 18 18 - 22
STUDDY, G.H. (GB) 1905-1915
 Valentine & Sons "Bonzo" Series
 1078 "I can't say how I've missed you" 15 - 20 20 - 25
SULLIVAN, PAT (US) 1920's
 Pat Sullivan "Felix is the hope of our side!" 25 - 30 30 - 35
TAYLOR, A. (GB) 1940's
 Bamforth Co.
 "New Ball Please" 8 - 10 10 - 12
THACKERAY, LANCE (GB) 1905-1915
 Raphael Tuck
 Series 955 "At the Wicket"
 "Proof. Limited to 1000 Copies."

"Now for a Boundary" "Ready!" "O! O!"

"Centre" "Out!" "Going in"

Lance Thackeray, Raphael Tuck Series 955
"Proof. Limited to 1000 Copies"

"Centre"	70 - 80	80 - 90
"Going in"	70 - 80	80 - 90
"Now for a boundary"	70 - 80	80 - 90
"O! O!"	70 - 80	80 - 90
"Out!"	70 - 80	80 - 90
"Ready!"	70 - 80	80 - 90
Series 955 "At the Wicket"		
Regular Series		
"Centre"	25 - 30	30 - 35
"Going in"	25 - 30	30 - 35
"Now for a boundary"	25 - 30	30 - 35

"O! O!"	25 - 30	30 - 35
"Out!"	25 - 30	30 - 35
"Ready!"	25 - 30	30 - 35
"Write Away" Series 983 (Undb)		
"I hope to catch you"	18 - 22	22 - 26
"It's quite an age since"	18 - 22	22 - 26
Series 1007		
"Most Important"	18 - 22	22 - 26
THORNTON, WILL (GB) 1905-1915		
Anonymous "Cricket Term - Bowling a Maiden Over"	15 - 18	18 - 22
TUCK, A.L. (GB) 1905-1915		
Anonymous "Cricket Phrases"		
"A Maiden Over"	15 - 18	18 - 22
"A Neat Cut For Two"	15 - 18	18 - 22
"Caught"	15 - 18	18 - 22
"The Last Man In"	15 - 18	18 - 22
"Out First Ball"	15 - 18	18 - 22
TURNER, JAMES (GB) 1905-1915		
Henderson & Sons (Gibson Series) (Sepia)		
124 "As it seemed to him"	12 - 15	15 - 18
WAIN, LOUIS (GB) 1905-1915		
Anonymous		
Cat "I am Running Away"	50 - 70	70 - 90
Valentine & Sons		
Cats "Our Cricket Match"	90 - 100	100 - 110
WIMBUSH, WINIFRED (GB) 1905-1915		
Raphael Tuck "Sporting Girls"		
Series 3603 "Cricket - You Can Bowl Me Out"	25 - 30	30 - 35
WOOD, LAWSON (GB) 1905-1920		
Davidson Bros. "Prehistoric Pastimes"		
61006 "Cricket"	15 - 18	18 - 22
Valentine & Sons "Gran'Pop" Series		
2843 "Caught in the Slips"	18 - 22	22 - 26

PUBLISHERS

AJ & Co. 1905-1915		
Kismet Series 288 "Look 'ere Gouv'nor ..."	12 - 15	15 - 18
B.B., London 1905-1915		
Christmas Series X581 (Hair Add-on)		
"Hoping you will always manage ..."	30 - 35	35 - 40
Davidson Bros. 1905-1915		
Comic "I am so sorry I was out"	12 - 15	15 - 18
Delgado, G. 1905-1915		
"Union Jack" Series 131d		
"Stump in the lower jaw ..."	12 - 15	15 - 18
E.S., London 1905-1915		
"Prehistoric Sports" Series 3022 "Krikit"	12 - 15	15 - 20
William Foster (Chrome)		
Anonymous Series 92 "I'm out for a duck down here"	3 - 4	4 - 6
H.B., Ltd. 1905-1915		
"Humorous Relations" "You're a young 'un ..."	8 - 10	10 - 12
Henderson & Sons 1905-1915		
"Summer Sports" 130 "Cricket - An exciting moment ..."	10 - 12	12 - 15

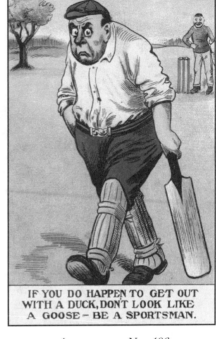

B. B., London
"Hoping you'll always manage..."

Anonymous, No. 406
"If you do happen to get out ..."

A.H. Katz 1905-1915		
"Do It Now" Series No caption	12 - 15	15 - 18
King's Printers 1905-1915		
Series 4072 "I Shall Be Out"	15 - 18	18 - 22
McCaw, Stevenson & Orr 1905-1915		
Marcus Ward's		
8 "L.B.W. Old Style. A Hot Un"	10 - 12	12 - 15
12 "The Match of the Season - Ladies vs Gentlemen"	10 - 12	12 - 15
13 "It's all very well to shout ..."	10 - 12	12 - 15
Millar & Lang, Ltd. 1905-1915		
"National Series" S-47 "The Backyard Captain"	12 - 15	15 - 18
Rotary Photographic Co. 1905-1915 (B&W Photo)		
3983 "Cricket II Wicket, Catch & Stumped"	10 - 12	12 - 15
J. Salmon 1905-1920		
2846 "Twenty-seven runs to git in seven minutes ..."	12 - 15	15 - 18
2984 "The Demon Bowler ..."	12 - 15	15 - 18
A. & G. Taylor 1905-1915		
Animals		
ZO 2783 "Our - First Ball Too"	20 - 25	25 - 28
Raphael Tuck 1905-1915		
"Write Away" Series 235 (UndB)		
"I hope you are not put out"	18 - 22	22 - 26
Series 6445 "Cricket Illustrated"		
"A Long Stop"	25 - 28	28 - 32
"Caught"	25 - 28	28 - 32
"Stumpt"	25 - 28	28 - 32
"Thank You Sir!"	25 - 28	28 - 32

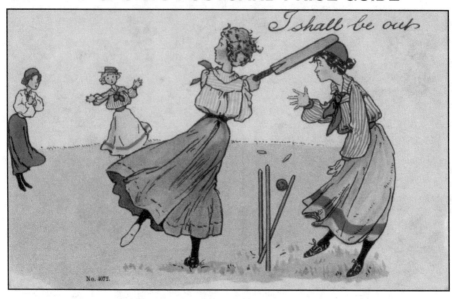

Publisher Kings Printers, No. 4072
"I shall be out ..."

Series 6446 "Cricket Illustrated"		
"A Late Cut"	18 - 22	22 - 26
"Carried His Bat"	18 - 22	22 - 26
"Clean Bowled"	18 - 22	22 - 26
"Yah! Butter Fingers"	18 - 22	22 - 26
Series 8121		
Rapholette Glosso "Well Caught, Sir!"	12 - 15	15 - 18
Valentine & Sons 1905-1915		
"The hope of his side - Out First Ball"	15 - 18	18 - 22

ANONYMOUS

22 - 19A "Happy Memories" (Emb) Greetings	6 - 8	8 - 10
403 Man "Don't Stop The Ball In This Way"	20 - 25	25 - 28
404 Man "Stumped - His First Match ..."	20 - 25	25 - 28
405 Man "If You Do Happen to Get Out With a Duck"	20 - 25	25 - 28
525 Equipment "Our Sports" "No Blobs"	8 - 10	10 - 12
Animals "I was much Struck"	6 - 8	8 - 10

ADVERTISEMENTS

H.P. "Margarine Deluxe Gloria - Primes"	10 - 12	12 - 15
Huntley & Palmers Biscuits (Non-Postcard Back)	8 - 10	10 - 12

FISHING

ARTIST SIGNED

BARNES-AUSTIN, EDGAR (GB) 1905-1915		
Pictorial Post Card Co. "Porcine Sports"		
Animals No caption	40 - 45	45 - 50

BEATY, A. (US) 1905-1915
 Anonymous
 Children "Fisherman's Luck" 15 - 18 18 - 22
 Commercial Colortype "The Coming Champs" 20 - 25 25 - 28
BEAUVAIS, CH. (FR) 1905-1915
 Moullet
 "Les Sports XI" "La Peche" 18 - 22 22 - 26
BECKMAN 1940's
 eMNA
 Blacks 190-199 Foreign caption 10 - 12 12 - 15
BELCHER (GB) 1905-1915
 Raphael Tuck "Humorous"
 6004 "Oh! That my tongue could utter ..." 12 - 15 15 - 18
BIMBI (GB) 1905-1915
 Vivian Mansell & Co.
 2128 Set 1 Children "There's oceans of fun here" 10 - 12 12 - 15
BONNETT, R. (US) 1905-1915
 M. Munk
 Series 1114 Lady Fishing No caption 20 - 25 25 - 28
BROWNE, TOM (GB) 1905-1915
 Davidson Bros.
 Series 2541 "Fishing Phrases Illustrated"
 "Caught" 12 - 15 15 - 18
 "Landing His Fish" 12 - 15 15 - 18
 Series 2602 "Illustrated Sports"
 3 "Fishing" 15 - 18 18 - 22
 Series 2613 "Sea-Side Pleasures"
 "Pa Lands a Flounder" 12 - 15 15 - 18
BUCHANAN, FRED (GB) 1905-1915
 Raphael Tuck
 Series 6083 "Popular Phrases - On His Own Hook" 15 - 18 18 - 22
C N B 1905-1915
 Anonymous Children No caption 12 - 15 15 - 18
CARMICHAEL (US) 1905-1915
 T.P. & Co. "Never Again" Series 6 - 8 8 - 10
CHAMOIUN, F. (FR) 1905-1915
 H & S in rectangle logo Beautiful Girl 18 - 22 22 - 26
CHEN 1905-1915
 J.P., Paris
 "Garconi un ver" 8 - 10 10 - 12
 "Ca A'Apprendra a Taquiner le Goujon" 8 - 10 10 - 12
CHRISTY, F. EARL (US) 1905-1920
 IPC & Co.
 198-5 Beautiful Lady fishing (also without caption) 15 - 20 20 - 25
CHRISTY, H.C. (US) 1905-1920
 Moffat, Yard & Co.
 "A Fisherman's Luck" 15 - 20 20 - 25
CLARK, ANTOINETTE (US) 1905-1915
 Ullman Mfg. Co. "Love's Young Dream"
 194 "A Fishing Smack" 8 - 10 10 - 12
COLLIER, NATHAN (US) 1905-1915 (B&W) 8 - 10 10 - 12
COLOMBO, E. (IT) 1905-1920
 GAM
 2321 Children No caption 12 - 15 15 - 18

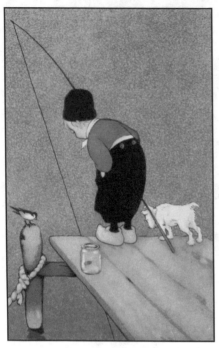

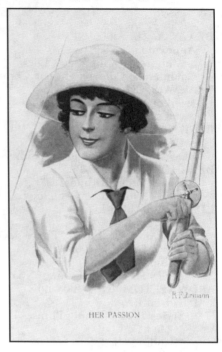

Uns. Fritz Baumgarten
Anonymous, No. 7412, No Caption

R. Fuhrman, Gruner & Simon
Series 2028-6, "Her Passion"

COWHAM, H. (GB) 1905-1915
 Raphael Tuck "Seaside" Series (Undb)
 1322 "An Unexpected Haul" 12 - 15 15 - 18
CROMBIE, CHAS (GB) 1905-1915
 Valentine & Sons "Humor of Fishing" (Undb)
 "Don't try to pull the trees down ..." 10 - 12 12 - 15
 "Hints to Fishermen - Always take plenty ..." 10 - 12 12 - 15
 "Humors of Fishing - When you get a bite ..." 10 - 12 12 - 15
 "Sometimes you may be in doubt ..." 10 - 12 12 - 15
CURTIS, E. (US) 1905-1915
 Raphael Tuck "Leap Year Valentine"
 "You're the lad I've sought ..." 12 - 15 15 - 18
DWIGGINS, CLARE (Dwig) (US) 1905-1915
 Raphael Tuck
 Series 176 "Cheer Up" "If you don't land your fish" 10 - 12 12 - 15
 Series 182 "Everytime" "Everytime I see a Lake" 10 - 12 12 - 15
F F 1905-1915
 Raphael Tuck "Connoisseur" Series 2553
 "Fishing for Salmon" 12 - 15 15 - 20
 "Fly Fishing Confound the Dog" 12 - 15 15 - 20
F R 1905-1915
 Raphael Tuck (Undb)
 Series 972 Children "I am quite content" 12 - 15 15 - 18
FARINI, MAY L. (US) 1905-1915
 Fairman Co. (Undb) Beautiful Girl 10 - 12 12 - 15
FERNEL (FR) 1905-1915 (Undb)
 Anonymous French "Peche" 30 - 35 35 - 40

FISHER, HARRISON (US) 1905-1920
 Reinthal & Newman
 Series 103 "Fisherman's Luck" | 25 - 30 | 30 - 35
FITZPATRICK (GB) 1950's
 Bamforth Co.
 Series 70 and **Series 1088** Comics | 3 - 5 | 5 - 7
FUHRMANN, R. (GER) 1905-1915
 Gruner & Simon
 Series 2028-6 "Her Passion" | 20 - 25 | 25 - 30
GILLIS, RENE (FR) 1905-1915
 Em. Brocherloux
 "1er Avril" Series (6) | 18 - 22 | 22 - 26
GILSON, T. (GB) 1905-1915
 E.J.H. & Co.
 491 "War time Economy" | 20 - 25 | 25 - 28
GUNNELL, N. (IT) 1905-1915
 2202 Children No caption | 8 - 10 | 10 - 12
HAMISH (GB) 1905-1915
 Raphael Tuck "Highland Laddie"
 1437 "Better Small Fish - Than Nane" | 8 - 10 | 10 - 12
HARDY, DUDLEY (GB) 1905-1915
 Hartman
 Series 1504 "Sporting Girls" No caption | 15 - 18 | 18 - 22
J.L. (NE) 1918-1925
 W.D.B. Political
 German prince fishes "St. Helena in Holland" | 20 - 25 | 25 - 28
KONING, AB 1930-1940
 K 390 Fishing frog | 10 - 12 | 12 - 15
LOTHELY, V. 1905-1920
 975 Lovers fishing | 12 - 15 | 15 - 18
M.D.S. (US) 1905-1915
 Ullman Mfg. Co. "Sporty Bears"
 83 "An Unexpected Bite" | 20 - 25 | 25 - 28
MALLET, BEATRICE (FR) 1905-1920
 Anonymous
 55650 Little Girl No Caption | 12 - 15 | 15 - 18
 55659 Children No caption | 12 - 15 | 15 - 18
MARTIN, B.L. (GB) 1905-1915
 Valentine & Sons Comics | 6 - 8 | 8 - 10
MAY, PHIL (GB) 1905-1915
 Raphael Tuck
 300 Man No caption | 12 - 15 | 15 - 18
 1296 "Perhaps you will drop in" | 15 - 18 | 18 - 22
MAX, CORNEILLE (GER) 1905-1915
 Wolgemuth & Sissner
 Series 3046 "Ein guter Fang" Boy with fishnet | 10 - 12 | 12 - 15
 Series 5044 "Anglergluck" Boy with big fish | 12 - 15 | 15 - 18
MC GILL, DONALD (GB) 1940's
 Bamforth Co. "Vacation Comics"
 303 "What bally fool thing have I caught now?" | 5 - 6 | 6 - 9
 D. Constance
 1626 "I just scatter a few on the water ..." | 8 - 10 | 10 - 12
 I.A. Co Art (Inter-Art Co.)
 701 "The fisherman: He riseth up early ..." | 8 - 10 | 10 - 12

J.L., W.D.B. — German Prince
"Wieringen, Nov. 1918"

V. Lothely, Anonymous No. 975
No Caption

Beatrice Mallet, R.C. Seine
No. 55650 — No Caption

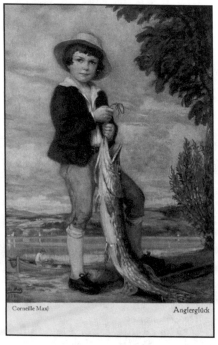

Corneille Max, Wohlegemuth & Sissner
No. 5044 — "Anglerglück

7025 "This is the ideal spot for fishing"	6 - 8	8 - 10

MC MEIN, MARJORIE (US) 1905-1915
 D in an octagon logo

Beautiful Girl No caption	12 - 15	15 - 18

MORELAND, ARTHUR (GB) 1905-1915
 C.W. Faulkner & Co.

Political Series 248 D "Now then John. Move Up"	15 - 18	18 - 22
Series 240 B "The Coracle"	10 - 12	12 - 15
MUNSON, WALT (US) Linens Many publishers	2 - 3	3 - 4

NEWAL, PETER 1905-1915 (Undb)
 National Art Co.

52 "A Promising Bite"	8 - 10	10 - 12

NUMBER, JACK (GER) 1905-1915
 PFB in diamond logo

Series 2130-5 Foreign caption	8 - 10	10 - 12

OPPER, F. (US) 1900-1910 (Undb)
 Raphael Tuck "Hooligan"

11 "I thought I would drop a line"	10 - 12	12 - 15

OUTCAULT, R.F. (US) 1900-1920
 J. Ottoman Lithograph

Girl "Not on Your Life"	15 - 18	18 - 22

 Yellow Kid Calendar Series

"June, 1915" Calendar	80 - 100	100 - 125

OUTER, NESTOR 1905-1915
 J. Goffin Fils

"Floreville Villegiature"	8 - 10	10 - 12

PREJELAN **1905-1915**
 C. Fres

0151 Beautiful Girl	20 - 25	25 - 28

QUINNELL, CECIL W. (GB) 1905-1915
 J. Salmon

Series 2633 Beautiful Girl "The Fishing Here is ..."	18 - 22	22 - 26

RALPH, LESTER (US) 1905-1915
 Knapp Co.

Series 302-7 "Two is Company Enough"	18 - 22	22 - 26

REED, E.T. (GB) 1905-1915
 Punch "The Wrench Series" (B&W)

2566 "The Gentle Craftsman?"	8 - 10	10 - 12
REYNOLDS (US) Series 6305 (Emb)	6 - 8	8 - 10

REZNICEK (GER)
 Simplicissimus

Series II-4 Lady fishing and reading book	25 - 30	30 - 35

ROBINSON, ROBERT (US) 1905-1915
 Edward Gross Co.

207 Young fisherman with big trout	20 - 25	25 - 30

RUDI, M. 1915-1925
 B in shield

Boy/girl fishing	10 - 12	12 - 15

RYAN, C. (US) 1905-1915

Winsch back A-731 "Always be sure - that the signs ..."	15 - 18	18 - 22

SAGER, XAVIER (FR) 1905-1915
 K.F. with crown logo

4572 Boy-Girl "La Vaison de Pecher ca Mord!"	15 - 18	18 - 22

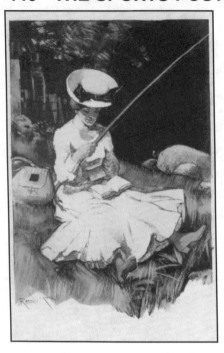

Reznicek, Simplicissimus-Karte
Series 2, No. 4, No Caption

Robt. Robinson, E. Gross Co.
No. 207, No Caption

SANDFORD, H.D. (GB) 1905-1920
 Raphael Tuck
 Blacks Series 9050 "Happy Little Coons" "Fishing" 20 - 25 25 - 30
SCHMUCKER, S.L. (US) 1905-1915
 John Winsch, 1910 Sports Cupids
 Valentine "To My Valentine" 40 - 45 45 - 50
 John Winsch, 1911
 Valentine "To My Valentine" 40 - 45 45 - 50
SHALLOT 1905-1915
 Raphael Tuck (Undb)
 Series 871 "Art" "A Day's Sport" 15 - 18 18 - 22
SHEPHEARD, G.E. (GB) 1905-1915
 Raphael Tuck Series 8621 "Ye Anglers of Ye Fish" 15 - 18 18 - 22
SHINN, COBB X. (US) 1905-1915
 N.A. Waters "Foolish Questions"
 "Fishing today, my good man?" 10 - 12 12 - 15
SHUBERT, H. (AUS) 1905-1915
 M. Munk
 379 Beautiful Girl with Fish and Fishing Pole 18 - 22 22 - 26
 Pantaphot, Vienna
 Series 22-197 "A Catch Imminent" 15 - 18 18 - 22
STUDDY, G.H. (GB) 1905-1920
 B.K.W.I. "Bonzo Series"
 XVII-1 "Just a Line" 15 - 18 18 - 22
TEMPLETON, W.A. (US) 1905-1915
 Anonymous "The Little Fisher Maiden" (Undb) 8 - 10 10 - 12

H. Shubert, M. Munk, No. 379
No Caption

H. Shubert, Pantaphot, Vienna
No. 22-197, "A Catch Imminent"

THACKERAY, LANCE (GB) 1905-1915
 Anonymous "Dear_____...Believe Me" 12 - 15 15 - 18
 Raphael Tuck
 Series 268 "Write Away"
 "I wont stand upon any ceremony" 15 - 18 18 - 22
 Series 6402 "Popular Songs"
 "There's a Land" 15 - 18 18 - 22
 Series 9170 "The Gentle Art of Fishing" (6)
 "After Jack" 18 - 22 22 - 26
 "Good Tackle" 18 - 22 22 - 26
 "Have you got a worm?" 18 - 22 22 - 26
THIELE, ARTH. (GER-DEN) 1905-1915
 L&P
 1613 No Caption 18 - 22 22 - 26
TWELVETREES, C. (US) 1905-1920
 National Art Co.
 45 "Fishing Girl" 10 - 12 12 - 15
UNDERWOOD, CLARENCE (US) 1905-1915
 T.P. & Co.
 Series 782 "A Fisherman's Luck" 18 - 22 22 - 26
UNK (US) Linen
 MWM
 Motto Series 1001 "Arm Extension for Fishermen" 8 - 10 10 - 12
WAIN, LOUIS (GB) 1905-1915
 Davidson Bros.
 6091 "Tomorrow will be Friday ..." 50 - 60 60 - 70
 9081 "The Fisherman's Dream ..." 70 - 80 80 - 90

Anonymous, No. 7014
No Caption

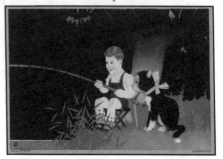

Arth. Thiele, L&P, No. 1613
No Caption

Publisher M.B. & Z.
No. 1072, No Caption

Raphael Tuck
 1004 "It Seems a Long Time" 75 - 85 85 - 95
Valentine & Sons
 "A Fishy Story" 60 - 70 70 - 80
WALL, BERNHARDT (US) 1905-1915
 Ullman Mfg. Co.
 138 "Life is just one damn thing after another" 10 - 12 12 - 15
WERTH, P. (GER) 1905-1915
 H M S logo
 618 Silhouette No caption 10 - 12 12 - 15
WFD 1905-1915
 Anglo-American P.C. Co.
 121 "At Last" 8 - 10 10 - 12
 Valentine & Sons
 "Puzzle - Find the Fish" 6 - 8 8 - 10

PUBLISHERS

Asheville Post Card Co. (Linens) Many Comics 2 - 3 3 - 4
S B in circle logo (Samson Bros.)
 Series 144
 "When Home From Fishing" 6 - 8 8 - 10
 "When you meet September Morn" 10 - 12 12 - 15
 Series CS 462 "Why don't you drop me a line" 6 - 8 8 - 10
Julius Bien & Co. 1905-1915
 "Country Life" 90 "If Fish Could Talk" 8 - 10 10 - 12
 "Summer Girl Series" 155 "A Fresh Fish Every Day" 6 - 8 8 - 10

"Summer Scene Series" 165 "Pleasant Reflections"	8 - 10	10 - 12
C in circle 1905-1915		
Ladies watch as man catches trout	12 - 15	15 - 20
Chantreau & Cie. 1905-1915		
"Tri-tou - Pecheurs!"	22 - 25	25 - 28
Colourpicture Publishers (Linens) Many different comics	2 - 3	3 - 4
Curteichcolor (Chromes) Many different comics	1 - 2	2 - 3
C.T. Art-Colortone (Linen) Many different comics	2 - 3	3 - 4
A.M. Davis Co. 1905-1915 Comical Greetings	3 - 5	5 - 8
D.S.N. 1905-1915 Comical Greetings	3 - 5	5 - 10
E.A.S. 1905-1915 Comical Photo types	3 - 5	5 - 10
E.L.P. Co. 1905 - 1915 "Prehistoric Sports - Fishing"	8 - 10	10 - 12
GAM in circular logo 1905-1915		
Series 2042-4 Children - No caption	10 - 12	12 - 15
H in circle logo 1905-1915	4 - 6	6 - 9
Henderson & Sons 1905-1915		
Gibson Series 1024 "Fishing Time" (Sepia)	8 - 10	10 - 12
Summer Sports 130 "Fishing - hooked but not landed ..."	8 - 10	10 - 12
Franz Huld 1905-1915		
Huld's Name Series 3 - A Good Catch "Bill,"		
"Bob," "Lizzie"	8 - 10	10 - 12
Series CS 51 "I will catch you also"	8 - 10	10 - 12
K.F. in palette logo		
Series 632 Animals "Au Printemps - Paris"	8 - 10	10 - 12
E.C. Kropp (Linens) Many different		
M.B. & Z., Holland 1920-1930		
1072 Boy and cat fishing	10 - 12	12 - 15
Vivian Mansell & Co. 1905-1915		
1118 Pretty Girl No caption	12 - 15	15 - 18
1152 Pretty Girl No caption	12 - 15	15 - 18
Millar & Lang 1905-1915		
Children "Fishing is good here"	8 - 10	10 - 12
E. Nister 1905-1915		
Valentine Series 1847		
Fisherman Cupid "I've caught it"	12 - 15	15 - 18
Roth & Langley 1905-1915		
87 "Love is a little golden fish"	6 - 8	8 - 10
110 "Fisherman's Luck"	10 - 12	12 - 15
111 "There's a reason ..."	6 - 8	8 - 10
Rotograph Co. 1905-1915		
F.L.320 "The Fisherman"	8 - 10	10 - 12
S in wreath 1905-1915 (Undb)		
"The Sportsman"	6 - 8	8 - 10
Scenic Art (Chromes) Many different	1 - 2	2 - 3
M.A. Sheehan 1905-1915		
Mermaid No caption	12 - 15	15 - 18
Mermaid "Port of Malibu, CA"	5 - 6	6 - 8
Edwin Stern & Co. 1905-1915		
"The Sportsman"	10 - 12	12 - 15
Raphael Tuck 1905-1915		
"Little Bears" 118 "The Jolly Angles'	20 - 25	25 - 28
"Valentine" "He tells of the fish he has caught"	8 - 10	10 - 12
T.P. & Co. 1905-1915 (Emb)		
"The Bug Club" "I elect you member of the bug club"	15 - 18	18 - 22

Ullman Mfg. Co. 1905-1915
 "Summer Girl's Diary"
 183 "The Fishing is Fine Here" 6 - 8 8 - 10
Valentine & Sons
 "Fishing" 6 - 8 8 - 10
White City Art Co. 1905-1915
 Black 239 No caption 15 - 20 20 - 25
Whitney Made 1905-1915
 "Valentine - You don't need ..." 6 - 8 8 - 10
John Winsch 1911-14
 Valentine (Emb)
 "My Sweetheart Has a Pretty Wit ..." 25 - 30 30 - 40
 "St. Valentine's Greetings" 12 - 15 15 - 18

ADVERTISEMENTS

Weatherbird Shoes "Bet You My Weatherbird Shoes" 15 - 18 18 - 22
Men-Tho-La-Tum "For Sunburn and Insect Bites ..." 25 - 28 28 - 32
Footwarmer Hosiery "How many do you want?" 12 - 15 15 - 20
Cacao Bensdorp "Pur Exquis Digestible" 18 - 22 22 - 26
Blue Seal Extract 12-102 "Fishing for Kicks" (Govt. Postal) 10 - 15 15 - 18
Boy Blue
 R.F. Outcault June 1913 Calendar 15 - 18 18 - 22

HUNTING

ARTIST-SIGNED

AUST, R. (GER) 1905-1915
 R&M Lady Hunter 20 - 25 25 - 30
BARBER, COURT (US) 1905-1915
 Anonymous Beautiful Girl 18 - 22 22 - 26
BEATY, A. (US) 1905-1915
 Anonymous Man "After Big Game" 12 - 15 15 - 18
 Commercial Colortype
 332 Children "The Coming Champs" 15 - 18 18 - 22
BORISS, MARGRET (NETH)
 Amag 0318 Children 10 - 12 12 - 15
BROWNE, TOM (GB) 1905-1915
 Davidson Bros.
 Series 2532 "Pay up and look pleasant" 12 - 15 15 - 18
 Series 2537
 "Beware of Man Traps" 15 - 18 18 - 22
 "Is that all you have brought home?" 15 - 18 18 - 22
 "The safest place for the keepers" 15 - 18 18 - 22
 "Tiens I haf'im now" 15 - 18 18 - 22
 Series 2602 "Illustrated Sports"
 "Shooting" 18 - 22 22 - 26
 Series 2607 "A Thing of the Past"
 "You quite sure you shot it?" 15 - 18 18 - 22
 Series 2630 "You Can't Diddle Me"
 "You sure that you shot this" 18 - 22 22 - 26

R. Aust, R&M
No Caption

R. Aust, R&M
No Caption

C. W. Barber, Carleton
Pub. Co., Ser. 704-1

E. Colombo, Rev. Stampa
Series 479, No Caption

T. Corbella, Rev. Stampa
Series 316-4, No Caption

CHRISTY, F. EARL (us) 1905-1915
 I.P.C. & N. Co.
 Series 198-3 "Trying to make a Hit" 18 - 22 22 - 26
 Same image without caption 18 - 22 22 - 26
COLLIER, NATHAN (US) 1905-1915
 Hoover Watson Printing (B&W)
 "Am having some Great Sport" 18 - 22 22 - 26

"There are some Big Ones"	18 - 22	22 - 26
COLOMBO, E. (IT) 1905-1920		
Anonymous Series 479 Children No caption	18 - 22	22 - 26
GAM		
Series 1902 Children No caption	22 - 25	25 - 28
Series 2213 Children No caption	22 - 25	25 - 28
Series 2322 Children No caption	18 - 22	22 - 26
Rev. Stampa		
Series 479 Children	15 - 18	18 - 22
CORBELLA, T. (IT) 1905-1920		
Rev. Stampa		
Series 316-4 Beautiful Girl No caption	18 - 22	22 - 26
DESCH, FRANK (US) 1905-1915		
H. Import 336 Beautiful Huntress	25 - 28	28 - 32
EDGREN, JAC (NOR) 1905-1915		
Nordisk Konst		
95 "Jaktsallskap"	12 - 15	15 - 18
122 "Algjakt"		
134 "Till Skogs"		
ELIOTT, HARRY (GB) 1905-1915		
Anonymous		
Blacks on hunting trip	30 - 35	35 - 40
FLEURY, H. 1905-1915		
G D & D "The Star Series"		
"A Case for Compensation"	10 - 12	12 - 15
"A 'Tail' of woe"	10 - 12	12 - 15
"Falling on a soft spot"	10 - 12	12 - 15
"Inspecting the day's 'Bag'"	10 - 12	12 - 15
"Nothing like carrying a bag home"	10 - 12	12 - 15
"Old Chums - No Danger"	10 - 12	12 - 15
GOTTARO, E. 1905-1915		
Anonymous Children No caption	12 - 15	15 - 18
HUTCHINSON, K. (US) 1905-1915		
K Co., Inc. 165 "Hunting"	20 - 25	25 - 30
H.H. (US) 1905-1915		
I.P.C. & N. Co. 5004-14 "The Sportsman"	8 - 10	10 - 12
LAWRENCE, F. (US) 1905-1915		
M.S.i.B. Beautiful Girl "Good Sport"	15 - 18	18 - 22
M.D.S. (US) 1905-1915		
Ullman Mfg. Co. Series 1925 "Sporty Bears"		
83 "Out for Big Game"	20 - 25	25 - 30
MICH (FR) 1905-1915		
Sid's Editions		
Series 7605-5 "Bob Fait du Sport - Hunting"	12 - 15	15 - 18
MIGNOT, V. (FR) 1905-1915		
Dietrich & Co. (Undb)		
Boy/Girl No caption	120 - 30	130 - 140
PAYNE, C.M. (US) 1905-1915		
Anonymous "Hints to Shootists"		
"Always get into a comfortable position"	12 - 15	15 - 18
"Don't be disheartened if you make a bad score"	12 - 15	15 - 18
"It is advisable not to practice in your bedroom"	12 - 15	15 - 18
"On a warm day more elevation is required"	12 - 15	15 - 18
"Remember nervousness never gets a bulls-eye"	12 - 15	15 - 18

Frank H. Desch, H. Import, 336
No Caption

M.D.S., Ullman Co., "Sporty Bears"
Series 1925, "Out for Big Game"

Mich, Sid's Editions, Paris
"Hunting"

Prejelan, J. Fres, Paris
No. 0151, No Caption

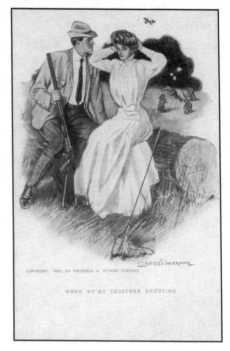

Jos. Ringeilen, Anonymous
No Caption

Clarence Underwood, Edward Stokes
"When We're Together Shooting"

"Try and find the direction of the wind"	12 - 15	15 - 18
PREEN, H. (US) 1905-1915		
Anonymous Series 374	6 - 8	8 - 10
PREJELAN (FR) 1905-1915		
C. Fres		
Series 051 Pretty Girl	15 - 18	18 - 22
REED, E.T. 1905-1915		
Punch - "The Wrench Series" (B&W)		
2598 "Prehistoric Peeps - A little cover shooting ..."	10 - 12	12 - 15
RINGEILEN, JOS. (GER) 1905-1915		
Anonymous The Hunter	15 - 18	18 - 212
RITTER, PAUL (GER) 1905-1915		
Ritter & Kloedon Advertisement		
"XII Deutsches Bundesschieffen Nürnburg ..."	40 - 50	50 - 60
ROLAND 1905-1915		
E.S.W.	8 - 10	10 - 12
SAGER, XAVIER (FR) 1905-1915		
B.G., Paris		
Series 554	12 - 15	15 - 18
SCHÖNPFLUG, FRITZ (AUS) 1905-1915		
B.K.W.I.		
Series 306 (6)	15 - 18	18 - 22
THACKERAY, LANCE (GB) 1905-1915		
Raphael Tuck		
Series 1007 "Write Away" "Urgent"	12 - 15	15 - 18
Series 1383 "Journals Illustrated" "The Sportsman"	15 - 18	18 - 22
Series 9046 "Holiday Making"	15 - 18	18 - 22

Aldine, Series 220
No Caption

National Art
No. 47, No Caption

Novitas, No. 34463
"Out to Kill"

WITT (US) 1905-1915

ACP Co. in circle logo "Preparedness"	5 - 6	6 - 8
Anonymous Valentine 2285 "A Bum Sportsman"	6 - 8	8 - 10

WOOD, LAWSON (GB) 1905-1920

Davidson Bros. "Prehistoric Pastimes"		
6106 "Shooting"	12 - 15	15 - 18

PUBLISHERS

A G M logo 1905-1915		
Series 258 (3)	8 - 10	10 - 12
Aldine 1905-1915		
220 Pretty Girl No caption	15 - 18	18 - 22
Julius Bien & Co. 1905-1915		
Series 33 "Comic" Series		
"I Came Out Ahead of the Game"	8 - 10	10 - 12
Series 80 - "Wild Animals"		
"Back to the Woods"	6 - 8	8 - 10
"Skidoo"	8 - 10	10 - 12
Series 90 "Country Life"		
"Tale of the hare"	8 - 10	10 - 12
Series 155 "Summer Girl Series"		
"I came out ahead of the Game"	12 - 15	15 - 18
"The Game is small but plentiful"	12 - 15	15 - 18
Series 211 Embossed Comic Series		
"I can not make my eyes behave"	6 - 8	8 - 10
B.K.W.I. 1905-1915		
Series 915 (6) No captions	10 - 12	12 - 15
Series 954		
1 "A Bad Handicap"	10 - 12	12 - 15
2 "One of Old Pa's Jokes"	10 - 12	12 - 15
3 "Oh, What a Surprise"	10 - 12	12 - 15
4 "Up the White Nile"	10 - 12	12 - 15
9 "Wait a Bit"	10 - 12	12 - 15
R.A. Haase 1905-1915		
Series 618 Beautiful Girl "November"	30 - 35	35 - 40

A.G., Henderson & Sons
"The Cycling Girl"

Will Adams, J.W.A. & Co.
"— A fall"

I.P.C. & N. Co. 1905-1915		
Series 5002 (2)	10 - 12	12 - 15
A. H. Katz 1905-1915		
Foolish Questions		
"Been hunting ducks, Bub?"	8 - 10	10 - 12
Landeher & Brown 1905-1915		
"Ellanbee Sporting" 136 No caption	12 - 15	15 - 18
Meissner & Buch 1905-1915		
"Deutscher Sport" 1070 "Jagd-Sport"	80 - 90	90 - 100
N in star (Novitas) 1905-1915		
43463 "Out to Kill - Schussbereit!"	15 - 18	18 - 22
National Art Co. 1905-1915 (Undb)		
47 "Hunting Girl"	8 - 10	10 - 12
Oxford University Press 1950's		
"Mediaeval Sports" (8) (Sepia)	2 - 3	3 - 4
Ridgley Calendar Co. 1905-1915		
"Heavens! A Grizzly Bear"	4 - 5	5 - 6
P. Sander 1905-1915		
Valentine "Diana scoffs at Sparrows ..."	3 - 4	4 - 5
Raphael Tuck 1905-1915		
Valentine		
6 "He brags about shooting big game"	4 - 6	6 - 8
T.P. & Co. 1905-1915		
Children	3 - 5	5 - 8
Valentine & Sons 1905-1915		
Boy-Girl "Gunning"	5 - 8	8 - 10

Tom Browne, Davidson Bros., Series 2587, "Cycling Series" — "Married"

CYCLING

ARTIST-SIGNED

ADAMS, WILL (US) 1905-1915
JWA & Co. Children Series
"A Fall"	12 - 15	15 - 18
"Dad Does This"	12 - 15	15 - 18
"Help"	12 - 15	15 - 18
"Oh! Crumbs"	12 - 15	15 - 18
"Pride Goes Before ..."	12 - 15	15 - 18
"What Will Dad Say?"	12 - 15	15 - 18

A.G. (US) 1905-1915
Henderson & Sons "The Sports Gals"
B-5 2541 "The Cycling Girl"	15 - 18	18 - 22

BERTIGLIA, A. (IT) 1905-1915
Edizioni, Milano
Series 3018 Children No captions	12 - 15	15 - 18

BOURET, GERMAINE (FR) 1905-1915
M.D. Series 675 Children French caption	10 - 12	12 - 15

BROEKMAN, N. (NETH) 1910-1920
Anonymous "De Kilometer-vreter"	10 - 12	12 - 15

BROWNE, TOM (GB) 1905-1915
Series 2587 "Cycling"
"After the Spill"	12 - 15	15 - 20
"Give us a Light Guvnor"	12 - 15	15 - 20
"Love is Blind"	12 - 15	15 - 20
"Married"	12 - 15	15 - 20
"Sixpence an Hour"	12 - 15	15 - 20
"The Triplet Comes to Grief"	12 - 15	15 - 20

CARMICHAEL (US) 19015-1915
T.P. & Co.
668 "Anybody seen Kelly?"	10 - 12	12 - 15

Anonymous
"Sport staalt spieren"

James M. Flagg, Anonymous
"The Cycling Girl"

Fernel, Anonymous French Publisher — "Cyclisme"

DUDLEY, BUD (US) (Linens)
 Metrocraft
 362 "Yoo-Hoo! Couldn't pass you without ..." 1 - 2 2 - 3
FERNEL (FR) 1905-1915
 Anonymous French Publishers
 "Cyclisme" 35 - 40 40 - 45

Raphael Kirchner, Anonymous
"All Heil" Series — No Caption

Antonio Marchisio, Rev. Stampa
Series 3371-6, No Caption

FLAGG, JAMES M. (US) 1905-1915
Anonymous "The Cycling Girl" ... 20 - 25 ... 25 - 28
FLEURY, H. 1905-1915
GD&D "Star Series"
"A Labor of Love" ... 12 - 15 ... 15 - 18
"Pleasing Ma-in-law" ... 12 - 15 ... 15 - 18
"Racing the Grand Final" ... 12 - 15 ... 15 - 18
"The Road Hog" ... 12 - 15 ... 15 - 18
"Shocking His Modesty" ... 12 - 15 ... 15 - 18
"The up-to-date out-of-date" ... 12 - 15 ... 15 - 18
GF within C logo 1905-1915
WR&S in shield logo
9321 "The Cyclist's Crest" ... 12 - 15 ... 15 - 18
GUNNELL, N. (IT) 1910-1920
Degami 2201 Children No caption ... 8 - 10 ... 10 - 12
KAISER 1940's
Coloprint B Series 53637 (3) ... 6 - 8 ... 8 - 10
KINSELLA, E.P. (GB) 1905-1915
Langsdorff & Co.
Series 726 (6)
"A Pointed Argument" ... 15 - 18 ... 18 - 22
"I Got Medals For This" ... 15 - 18 ... 18 - 22
"See Me Climb Hills" ... 15 - 18 ... 18 - 22
"This is Better Though" ... 15 - 18 ... 18 - 22
KIRCHNER, RAPHAEL (AUS) 1905-1920
Anonymous
"All Heil" Girl Cyclists (10) ... 175 - 200 ... 200 - 250

Eugen Osswald, Wilhelm. Stephan
"Der Sieger"

Rossetti, P&M Company
"New - York"

Back & Schmitt, Vienna		
"**Radlerei**" Girl Cyclists (6)	275 - 300	300 - 350
MARCHISIO, ANTONIO (IT) 1910-1920		
Rev. Stampa		
Series 3371-6 Beautiful Girl No caption	15 - 18	18 - 22
MAY, PHIL (GB) 1905-1915		
Raphael Tuck		
300 No caption	15 - 18	18 - 22
1296 "Who do you think I ran across"	15 - 18	18 - 22
MIGNOT, V. (FR) 1900-1910 (Undb)		
Dietrich & Co.		
Boy-Girl No caption	120 - 125	125 - 135
MOUTON, G. (FR) 1905-1915		
Anonymous "Souvenir de Paris - Sur la Pente"	112 - 15	15 - 18
MUNSON, WALT (US) (Linen)	2 - 3	3 - 5
NUMBER, JACK 1905-1915		
PFB in diamond		
Series 2124 (6) Foreign captions	8 - 10	10 - 12
OSSWALD, EUGEN (GER) 1905-1915		
Wilh. Stephan		
Elephant "Der Sieger"	30 - 35	35 - 45
PLATZ, ERNST 1905-1915		
SM ST in shield logo		
Boy-Girl No caption	20 - 25	25 - 30
QUINNELL, CECIL W. (GB) 1905-1915		
J. Salmon		
2632 Boy-Girl "This is the place for a good spin"	15 - 18	18 - 22

Lawson Wood, Davidson Bros.
"Prehistoric Pastimes — Cycling"

Arth. Thiele, T.S.N., Series 871
No Caption

B. Wennerberg, Gebr. Gerbhardt
No Caption

RASSENFOSSE, ARMAND Reproduction
Dalkeith Classic Poster

P73 "Tournoi de Lutte ..."	1 - 2	2 - 3

REED, E.T. (GB) 1900-1910 (Undb)
Punch "The Wrench Series" (B&W)

2632 "Misunderstood"	6 - 8	8 - 10

ROGINDY, CARL 1905-1915

Anonymous 475 "Maren Med Tilbehor Skipter"	8 - 10	10 - 12

ROSSETTI, T. 1900-1910 (Undb)
PVKZ in shield logo
National Cities Cyclists

6092 Paris	25 - 30	30 - 35
6093 Berlin	25 - 30	30 - 35
6095 Londred	20 - 25	25 - 35
6097 Rome	25 - 30	30 - 35
6098 Madrid	25 - 30	30 - 35
6100 Bombaay	25 - 30	30 - 35
6101 Pequin	25 - 30	30 - 35

P.M. Co., London
Cyclists Of All Nations Series 4019

Berlin	25 - 30	30 - 35
Cairo	25 - 30	30 - 35
Constantinople	35 - 40	40 - 45
Londred	25 - 30	30 - 35
New York (Uncle Sam)	35 - 40	40 - 45
New-York (Uncle Sam)	35 - 40	40 - 45
St. Petersburg	35 - 40	40 - 45

Anonymous
 9052 Wien 25 - 30 30 - 35
 9059 New York Uncle Sam 35 - 40 40 - 45
ROWLANDSON, G.D. (GB) 1905-1915
 C.W. Faulkner & Co. (Undb)
 328C "Cycling: At the top of the hill" 18 - 22 22 - 26
SAUTER, HENRI (FR) 1905-1915 25 - 28 28 - 32
STUDDY, G.H. (GB) 1905-1915
 Valentine & Sons
 Bonzo 3030 "Shall I never see your face again?" 15 - 18 18 - 22
THACKERAY, LANCE (GB) 1905-1915
 Raphael Tuck "Write Away" Series
 543 "I need not explain" 12 - 15 15 - 18
THIELE, ARTH. (GER-DEN) 1905-1915
 E.F.A. logo
 533 "The Messenger Boy" 25 - 28 28 - 32
 T.S.N.
 Series 871 Black cyclist 35 - 40 40 - 50
TOCHER, GUS 1905-1915
 L. Klement
 525 "Ostergrusse" 6 - 8 8 - 10
TRISKA 1905-1915 "All Heil" 6 - 8 8 - 10
WENNERBERG, B. (GER) 1905-1915
 Kunstenstalt V Gbbr. (2) 35 - 40 40 - 45
WERTH, P. 1905-1915
 HMS logo
 618 Silhouette 18 - 22 22 - 26
WILLIAMS, MADGE (GB) 1905-1915
 J. Salmon
 4527 "The sound of the bicycle bell" 6 - 8 8 - 10
WILLS, JOHN (GER) 1905-1915
 SWSB Series 1009 (4) 6 - 8 8 - 10
WOOD, LAWSON (GB) 1905-1920
 Davidson Bros.
 "Prehistoric Pastimes" 6106 "Cycling" 10 - 12 12 - 15

PUBLISHERS

Anstalt 1940's
 Series VII Pretty Girl No caption 8 - 10 10 - 12
Coloprint B 1940's 5 - 6 6 - 8
Dalkeith Classic Poster Reproductions P-73- 78 3 - 4 4 - 6
Davidson Bros. 1905-1915
 "Little Jim's Bike" Series 7003
 1 "Punctured" 10 - 12 12 - 15
 3 "An Obstacle" 10 - 12 12 - 15
 4 "A Full Stop" 10 - 12 12 - 15
 5 "Uphill" 10 - 12 12 - 15
Doyen 1900-1910
 Military "12 Regiments Bersalaglieri" on back 100 - 105 105 - 110
E.S.D. 1905-1915
 Series 1744 No caption 6 - 8 8 - 10

G.P. in anchor logo 1905-1915		
32 Boy-Girl "Brevet de Cycliste"	10 - 12	12 - 15
Louis Glasner 1905-1915		
"All Heil Gruss"	40 - 50	50 - 60
Franz Huld 1900-1910 (Undb)		
Series 406 "University of Pennsylvania"	20 - 25	25 - 28
JC in circle logo 1910-1920 Children	6 - 8	8 - 10
E. Lauterburg 1905-1915 (B&W)		
Animals No caption	20 - 25	25 - 30
Herman Ludewig 1900-1910		
Series 100 German caption	10 - 12	12 - 15
LMM logo 1905-1915		
Series 898 Boy-Girl Foreign caption	10 - 12	12 - 15
M and L (Millar & Lang) 1905-1915		
Girl "Help"	12 - 15	15 - 18
MSOB 1905-1915		
11 "A Beginner"	10 - 12	12 - 15
Meissner & Buch 1900-1910 (Undb)		
"Deutscher Sport" 1070 "Radfahr-Sport"	100 - 110	110 - 120
National Series (Millar & Lang) 1905-1915		
"Unnecessary Questions" Series 650 (6)	10 - 12	12 - 15
O.P.F. logo 1905-1915		
Girl cyclist	35 - 40	40 - 50
L.A. Saloshin & Co. 1900-1910 (Undb)		
"Greetings from New York"	25 - 30	30 - 35
J.F. Scheiber 1905-1915		
Series 10 "Modern"	15 - 20	20 - 25
Edgar Schmidt 1905-1915		
7015 Boy-Girl "Ja Oder Nein"	22 - 26	26 - 32
A. Sockl, Wien 1900-1910 (Undb)		
Series 272 "Wiener Strassenleben"	10 - 12	12 - 15
Raphael Tuck 1905-1915		
"The Humor of Life" Series 9063 "Punctured"	10 - 12	12 - 15
Valentine & Sons 1905-1915		
"There's many a slip"	8 - 10	10 - 12
Von Gerlach & Schenk 1905-1915 (Sepia)		
Series 39 Beautiful Girl No caption	18 - 22	22 - 26
Ottmar-Zieher 1900-1910 (Undb)		
Boy-Girl "All Heil!"	10 - 12	12 - 15

ADVERTISING

"Attila-Fahrrad-Werke,"		
Publisher **Kunstdruck-Anstalt**	15 - 20	20 - 25
"Berry's Boot Polish," Signed **P. Lehmann**		
"An Easy Winner"	30 - 35	35 - 38
"Bradbury Cycles," Signed **B. Faustin**		
"Dignity and Impudence"	40 - 50	50 - 60
"Byrrh" Tonic "Tonique Hygeine Byrrh" (Undb)	80 - 90	90 - 100
"Cigarettes St. Michel, Bruxelles," Signed **by**		
Beatrice Mallet "Le Cyclisme"	12 - 15	15 - 20
"Continental -Pneumatic ," Signed by **A.L.** (Undb)	25 - 30	30 - 35
"Continental-Pneumatic," Signed by **F. Schon**	20 - 25	25 - 30
"Continental-Pneumatic," Publisher CC & GP	30 - 35	35 - 40

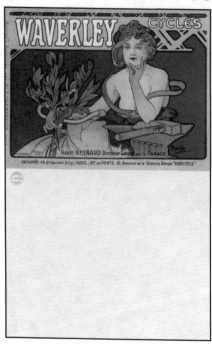

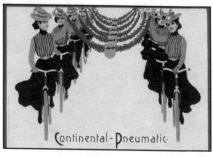

Continental-Pneumatic
Anonymous

Advertising Card for "Waverley Cycles"
By Alphonse Mucha, Collections Cinos

Corbin Coaster Brakes
"Lady Godiva's Ride"

"Continental Pneumatic," Publisher **Edler &**		
Kirsche (Undb) "Continental Pneumatic"	55 - 60	60 - 65
"Continental Pneumatic," **Anonymous** (Undb)	35 - 40	40 - 45
"Corbin Coaster Brakes"		
"General Putnam's Ride"	25 - 30	30 - 35
"Lady Godiva's Ride"	30 - 35	35 - 38
"Mezeppa's Ride"	25 - 30	30 - 35
"Paul Revere's Ride"	25 - 30	30 - 35
"Excelsior Pneumatic," Publisher **Edler &**		
Kirsche (Undb)	20 - 25	25 - 30
"Eclipse Brakes" Publisher **Blanchard Press**		
30308 "Hickety-Dickety-Day!"	20 - 25	25 - 28
30311 "There was an old woman ..."	20 - 25	25 - 28
30312 "Humpty-Dumpty rode on his bike ..."	28 - 32	32 - 36
"Hush-a-bye, Rider!"	20 - 25	25 - 28
"Engelbert Fils & Co.," Amsterdam	25 - 28	28 - 32
"Hobart, The Perfect British Bicycle," **Anonymous**	65 - 75	75 - 85
"La Touricyclette" **Anonymous**	15 - 20	20 - 25
"Le Cycles Robust," Signed by **Martin Pulp**		
"Portent le Monde" - by **R. Robert**	110 -120	120 - 130
"Moderne Falle" - Publisher **Frd. A. Keller** (Undb)	25 - 30	30 - 35
"Neckarsulmer Fahrzeugwerke A-G." (NSU)	15 - 20	20 - 25
"New Departure Coaster Brakes,"		
4 "When Parson Goode went out for a spin"	15 - 20	20 - 25
Pneumatiques Michelin Series 2	35 - 40	40 - 45
"Waverley Cycles," Signed by **Alphonse Mucha** (Undb)		
Collections Cinos Last recorded sale in 1990 was ...		13,500

Americans in the 1912 Stockholm Olympics
Track & Field Events

Jim Thorpe was the most famous of all Olympians. An Indian athlete from tiny Carlisle Indian Industrial School, he was called "the greatest athlete in the world" by King Gustaf V of Sweden after he won both the decathlon and pentathlon at the 1912 Stockholm Olympic Games. His medals were later taken away by officials who charged that he had previously played professional baseball. Although he never regained the medals, he was later voted the outstanding U.S. athlete of the first half of the 20th Century.

Thorpe was not the only great performer for the U.S. Other Americans in the Track and Field events were outstanding. Ralph Craig, for instance, was the fastest human of that year as he won both the 100 and 200 meter dashes.

Recording of the participants and winners of each event on postcards was perhaps the best in Olympic history. A Stockholm postcard publisher, Granbergs *Konstindustri-Aktiebolags Furlag,* produced the Official Olympic series of around 250 real photo cards entitled "Olympiska Spelens I Stockholm 1912 Officiella." Some of the postcards showing and naming the athletes and their events are shown below. The numbers beneath each photo correspond with numbers in the listing. This is truly a terrific series of cards and are very much in demand by collectors of Olympic memorabilia.

1-O. 86	"Platt Adams, U.S.A., second in standing broad jump."		40 - 50	50 - 60
2-O. 103	"G. Horine, U.S.A., in running high jump."		40 - 50	50 - 60
3-O. 108	"Ralph Craig, U.S.A., winner of the 100 meters."		50 - 60	60 - 70
4-O. 131	"Mac Donald, winner of putting the shot, best hand."		40 - 50	50 - 60
5-O. 135	"Mac Donald, Witney and Rose, 1st, 3rd and 2nd in putting the shot."		40 - 50	50 - 60
6-O. 157	"Applegarth 3rd, Lippincott 2nd and Craig 1st in the 200 m. race."		40 - 50	50 - 60
7-O. 160	"The winners of the pole jump, F. T. Nelson, H. S. Babcock and M. S. Wright, U.S.A."		40 - 50	50 - 60
8-O. 161	"F. N. Kelly, J. Wendell and W. M. Hawkins, who won the hurdle race."		40 - 50	50 - 60
9-O. 164	"J. H. Duncan, 3rd in throwing the discus with best hand."		40 - 50	50 - 60
10-O. 177	"R. L. Byrd, U.S.A., 2nd in throwing the discus, best hand."		40 - 50	50 - 60
11-O. 189	"P. Adams, C. Tsiclitiras and B. Adams, winners of the standing high jump."		40 - 50	50 - 60
12-O. 192	"The American team, winner of the 3000 m. team race."		40 - 50	50 - 60
13-O. 196	"Mac Grath, Gillis and Childs, winners of the hammer throw."		40 - 50	50 - 60
14-O. 207	"Lindberg, Reidpath and Braun, winners of the 400 m. race."		40 - 50	50 - 60
15-O. 238	"J. Thorpe, winner of the pentathlon and decathlon." (See large photo on page 432.)		90 - 100	100 - 120

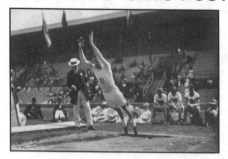

1-O. 86

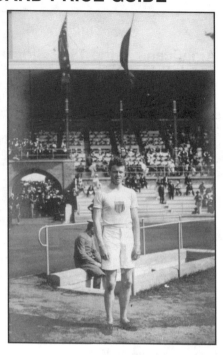

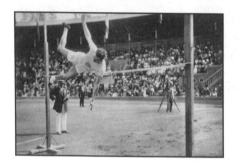

3-O. 108

2-O. 103

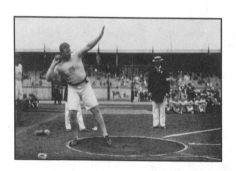

4-O. 131

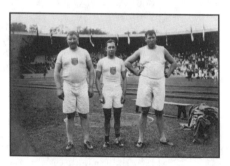

5-O. 135

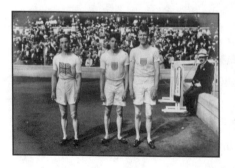

6-O. 157

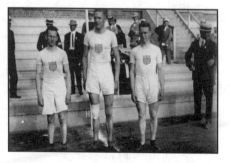

7-O. 160

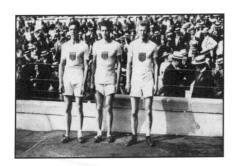

8-O. 161

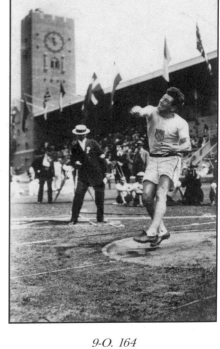

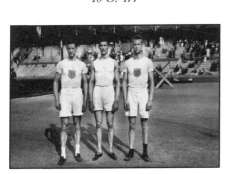

10-O. 177

9-O. 164

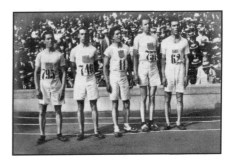

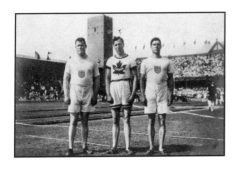

11-O. 189

12-O. 192

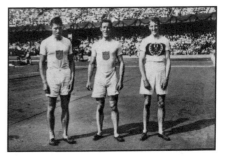

13-O. 196

14-O. 207

APPENDIX

BIBLIOGRAPHY

The following publications are related to or contain information concerning subjects for study of sports cards and sports postcards, as well as all other postcard motifs, are recommended for further reading.

American Advertising Postcards, Sets and Series, 1890-1920, Fred and Mary Megson, Martinsville, NJ, 1987

The American Postcard Journal, Roy and Marilyn Nuhn, New Haven,CT 1980's Publication

The Black Americana Postcard Price Guide, 1995, J.L. Mashburn, Colonial House, P.O. Box 609, Enka, NC 28728

The Postcard Price Guide, 1st, 2nd, and 3rd Editions, J. L. Mashburn, Colonial House, 1992, 1994, and 1997

The Baseball Encyclopedia, MacMillan, New York, 1972

The Big Punchers, Reg Gutteridge, Stanley Paul, London, 1989

A Directory of Postcard Artists, Publishers & Trademarks, B. Andrews,1975

The Encyclopedia of Sports, 5th Revised Ed., Frank G. Menke, Revisions by Suzanne Treat, A.S. Barnes and Co., 1975

Encyclopedia of Antique Postcards, Susan Nicholson, Wallace-Homestead,1994

Guide to Artists' Signatures & Monograms on Postcards, Nouhad A. Saleh.,1993 *Minerva Press*, Boca Raton, FL 33429-0969, USA

Legendary Champions, Rex Lardner, American Heritage Press, N.Y., 1972

The Trader Speaks, Lake Ronkonkoma, NY, by Dan Dischley, Monthly Sports Publication of the late 70's and early 80's.

The World Book Encyclopedia, Field Enterprises Educational Corp., 1972

PERIODICALS

The following trade publications all contain articles, auctions, and advertisements concerning postcards and includes sports postcards. They may be contacted for subscription rates or cost of sample copies.

Antique Trader Weekly, P.O. Box 1050, Dubuque, IA 52004-1050

Barr's Post Card News, 70 South Sixth St., Lansing, IA 52151-9680

Boxing Collector News, 3316 Luallen Drive, Carrollton, TX 75007 (Monthly)

Collector News & Antique Reporter, P.O. Box 156, Grundy Center, IA 50638

New England Antiques Journal, 4 Church St., Ware, MA 01082

Paper Collectors' Marketplace, P.O. Box 128, Scandinavia, WI 54977-0128

Picture Post Card Monthly, 15 Debdale Lane, Keyworth, Nottingham NG12 5HT - The leading postcard magazine in Europe.

Postcard Collector, P.O. Box 1050, Dubuque, IA 52004-1050

Sports Collectors Digest, 700 East State St, Iola, WI 54945 - Has numerous collector and dealer ads and auctions containing sports postcards.

MAJOR POSTCARD AUCTION HOUSES

Antique Paper Guild, P.O. Box 5742, Belleview, WA 98006
 Real Photo Specialists

Bennett's, Pickering Road, Dover, NH 03820

Colonial House, P.O. Box 609, Enka, NC 28728 Write your wants for next issue. Auctions are occasionally in full color.

Butterfield & Butterfield, 220 San Bruno Ave., San Francisco, CA 90046

Greg Manning Auctions, 775 Passaic Avenue, West Caldwell, NJ 07006

Lew Lipset, P.O. Box 5092, Carefree, AZ 85377

Mastro Fine Sports Auctions, 1515 W. 22nd Street, Suite 125, Oak Brook, IL 60523

Postcards International, P.O. Box 185398, Hamden, CT 06518

Rotman Collectibles Auction, 4 Brussels St., Worcester, MA 01610

Ron Oser Enterprises, P.O. Box 101, Hunting Don Valley, PA 19006

Swann Galleries, Inc., 104 East 25th St., New York, NY 10010

Index